Cisco Networking Academy Program Fundamentals of UNIX Companion Guide, Second Edition

Dan Myers

Jim Lorenz

Sponsored by Sun Microsystems, Inc.

Cisco Systems, Inc.

Cisco Networking Academy Program

Copyright © 2004 Cisco Systems, Inc.

Published by: Cisco Press
800 East 96th Street
Indianapolis, Indiana 46240 USA

Printed in the United States of America 1 2 3 4 5 6 7 8 9 0

Library of Congress Cataloging-in-Publication Number: 2003114383

ISBN: 1-58713-140-4

First Printing February 2004

Trademark Acknowledgments

Warning and Disclaimer

This book is designed to provide information about the Cisco Networking Academy Program Fundamentals of UNIX course. Every effort has been made to make this book as complete and as accurate as possible, but no warranty or fitness is implied.

The information is provided on an "as is" basis. The author, Cisco Press, and Cisco Systems, Inc. shall have neither liability nor responsibility to any person or entity with respect to any loss or damages arising from the information contained in this book or from the use of the discs or programs that may accompany it.

The opinions expressed in this book belong to the authors and are not necessarily those of Cisco Systems, Inc.

Cisco Networking Academy Program
Fundamentals of UNIX Companion Guide,
Second Edition

Focusing on Solaris and Linux

Cisco Systems, Inc.

Cisco Networking Academy Program

CISCO SYSTEMS

Cisco Press

800 East 96th Street

Indianapolis, Indiana 46240 USA

Feedback Information

At Cisco Press, our goal is to create in-depth technical books of the highest quality and value. Each book is crafted with care and precision, undergoing rigorous development that involves the unique expertise of members from the professional technical community.

Readers' feedback is a natural continuation of this process. If you have any comments regarding how we could improve the quality of this book, or otherwise alter it to better suit your needs, you can contact us through e-mail at feedback@ciscopress.com. Please make sure to include the book title and ISBN in your message.

We greatly appreciate your assistance.

Publisher	*John Wait*
Editor-in-Chief	*John Kane*
Executive Editor	*Mary Beth Ray*
Cisco Representative	*Anthony Wolfenden*
Cisco Press Program Manager	*Nannette M. Noble*
Acquisition Editor	*John Kane*
Production Manager	*Patrick Kanouse*
Development Editor	*Tracy Hughes*
Project Editors	*Keith Cline, San Dee Phillips*
Technical Editor	*Mark Anderson*
Cover and Book Designer	*Louisa Adair*
Compositor	*Interactive Composition Corporation*
Indexer	*Eric T. Schroeder*

CISCO SYSTEMS

Corporate Headquarters
Cisco Systems, Inc.
170 West Tasman Drive
San Jose, CA 95134-1706
USA
www.cisco.com
Tel: 408 526-4000
 800 553-NETS (6387)
Fax: 408 526-4100

European Headquarters
Cisco Systems International BV
Haarlerbergpark
Haarlerbergweg 13-19
1101 CH Amsterdam
The Netherlands
www-europe.cisco.com
Tel: 31 0 20 357 1000
Fax: 31 0 20 357 1100

Americas Headquarters
Cisco Systems, Inc.
170 West Tasman Drive
San Jose, CA 95134-1706
USA
www.cisco.com
Tel: 408 526-7660
Fax: 408 527-0883

Asia Pacific Headquarters
Cisco Systems, Inc.
Capital Tower
168 Robinson Road
#22-01 to #29-01
Singapore 068912
www.cisco.com
Tel: +65 6317 7777
Fax: +65 6317 7799

Cisco Systems has more than 200 offices in the following countries and regions. Addresses, phone numbers, and fax numbers are listed on the
Cisco.com Web site at www.cisco.com/go/offices.

Argentina • Australia • Austria • Belgium • Brazil • Bulgaria • Canada • Chile • China PRC • Colombia • Costa Rica • Croatia • Czech Republic
Denmark • Dubai, UAE • Finland • France • Germany • Greece • Hong Kong SAR • Hungary • India • Indonesia • Ireland • Israel • Italy
Japan • Korea • Luxembourg • Malaysia • Mexico • The Netherlands • New Zealand • Norway • Peru • Philippines • Poland • Portugal
Puerto Rico • Romania • Russia • Saudi Arabia • Scotland • Singapore • Slovakia • Slovenia • South Africa • Spain • Sweden
Switzerland • Taiwan • Thailand • Turkey • Ukraine • United Kingdom • United States • Venezuela • Vietnam • Zimbabwe

About the Authors

Dan Myers, of Highlands Ranch, Colorado, is an international program manager for the Cisco Networking Academy Program. He is responsible for the international implementation of Academy curriculum sponsored by various global computer technology companies. Prior to joining Cisco, Dan was the curriculum and operations manager for the Sun Microsystems Academic Initiative and the subject matter expert in the development of the Sun-sponsored Fundamentals of UNIX course.

As a technical instructor for 15 years, Dan taught Solaris system administration, backup administration, Lotus Domino administration, and computer-aided design courses at vendor-authorized education centers and the University of Colorado. He earned his bachelor of science degree in technology education at Ohio State University and his master's degree in technology education at Colorado State University.

Jim Lorenz is an instructor, a senior technical writer, and curriculum developer for the Cisco Networking Academy Program. He has more than 20 years of experience in information systems and has held various positions ranging from programming and system administration to network support and program management. He was also manager of information technology and a UNIX system administrator for a major publishing company. Jim has developed and taught computer and networking courses for both public and private institutions for more than 15 years. He is also a contributing author for the Cisco Networking Academy Program Lab Companion manuals and technical editor for the Companion Guides. Jim is a Certified Novell Netware Engineer (CNE), a Microsoft Certified Trainer (MCT) and a Cisco Certified Network Academy Instructor (CCAI). Jim earned his bachelor's degree in computer information systems from Prescott College.

About the Contributor

Brad Johnson is a project manager for the Cisco Networking Academy Program. He has worked in the design and development of many courses offered through the CNAP. He has a bachelor of arts degree from Central Michigan University and a law degree from the University of Denver College of Law. Brad was the project manager in the design, development, and implementation of the Fundamentals of UNIX course.

Dedications

This book is dedicated to my wonderful wife, Jamie, and our kids, Daniel, Audrey, and Grace, who endured my late nights and weekends as I worked on its completion. I would also like to dedicate this book to my parents, Stephen and Margaret, who have always had an endless supply of encouragement and love.

—Dan Myers

This book is dedicated to the three most important people in my life: my wife, Mary, and my daughters, Jessica and Natasha. Thanks for your patience and support.

—Jim Lorenz

Contents at a Glance

Table of Contents

Cisco Systems Networking Icon Legend

Cisco Systems, Inc. uses a standardized set of icons to represent devices in network topology illustrations. The icon legend that follows shows the most commonly used icons that you will encounter throughout this book.

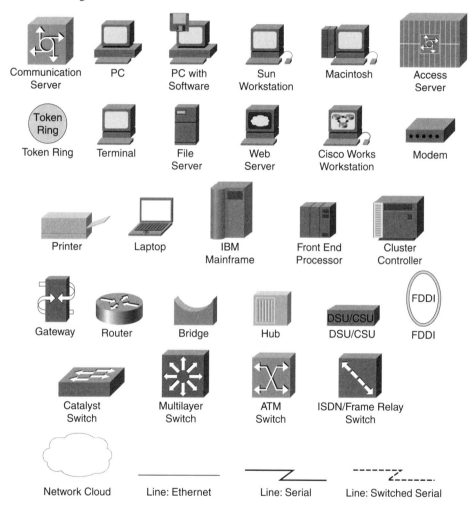

Command Syntax Conventions

The conventions used to present command syntax in this book are the same conventions used in the Cisco IOS Software Command Reference. The Command Reference describes these conventions as follows:

- Vertical bars (|) separate alternative, mutually exclusive elements.
- Square brackets ([]) indicate optional elements.
- Braces ({ }) indicate a required choice.
- Braces within brackets ([{ }]) indicate a required choice within an optional element.
- **Boldface** indicates commands and keywords that are entered exactly as shown.
- *Italic* indicates arguments for which you supply values.

Foreword

Dear Colleague:

Chosen as the first outside vendor to join the Cisco Networking Academy Program, Sun Microsystems is proud to collaborate with Cisco Systems, Inc. to train students worldwide on the fundamentals of UNIX. Those with direct experience in the deployment and support of enterprise applications fully appreciate the importance of the operating system and computing hardware upon which those applications reside—in simple terms, the platform matters.

Because Solaris is widely recognized as the premiere platform for creating and deploying mission-critical networked applications, Cisco and Sun have joined forces to provide the Fundamentals of UNIX course to the Cisco Networking Academy community worldwide.

We invite you to become part of the global Solaris community, built around the operating environment that received top marks from InfoWorld's UNIX survey (*InfoWorld*; 18 January 2001) and leapt ahead of the competition to be named the highest-rated UNIX operating system, according to the results of the D.H. Brown's *2001 UNIX Function Review*. To fully benefit from Sun's resources, you might want to check out the comprehensive list of Sun.com URLs provided at the back of this book.

Welcome to the world of UNIX operating environments and especially to Solaris, the leading UNIX operating environment.

Best regards,

Andy Ingram
Vice President Solaris Marketing
Solaris Software
Sun Microsystems, Inc.

Introduction

The Fundamentals of UNIX course and the accompanying Companion Guide and Lab Companion were developed as a cooperative effort between Cisco Systems and Sun Microsystems to provide an introduction to the UNIX operating system for end users and potential system administrators. The course is offered as part of the Cisco Networking Academy Program. Version 2 of the course and the second editions of the Companion Guide and Lab Companion include an introduction to the Linux operating system and additional information on various UNIX utilities.

This course is complementary to the other Cisco networking courses, such as Routing and Switching, because it provides network operating system (NOS) exposure. Although it would be helpful, it is not necessary to have taken the Cisco networking courses before taking this one. Basic knowledge of UNIX will broaden the skills of the Cisco Academy students to include a major NOS. This course provides a strong foundation for those who want to move on to more advanced courses in UNIX system administration. You will become familiar with powerful UNIX command-line utilities as well as the Common Desktop Environment (CDE) and GNOME graphical user interfaces. By successfully completing this course, you will be well on your way to becoming a power user, and you will feel comfortable with most varieties of UNIX, including Sun's own Solaris and Linux.

UNIX Careers

Knowledge of UNIX is quite valuable in the field of information technology (IT) today. Many of the world's most powerful computer networks and Internet sites are based on UNIX. There is a tremendous demand for people with skills in UNIX system administration and especially those with knowledge of Solaris and Linux. UNIX is a world-class operating system that supports mission-critical applications. One inhibitor to the growth of UNIX is the lack of trained, qualified personnel who know and understand the UNIX environment. Knowledge of Cisco networking technology along with knowledge of the UNIX network operating system is a strong combination when seeking employment. UNIX system administrators, or "sysadmins," are among the highest-paid IT professionals. To gain an appreciation of the demand for UNIX professionals and find out the types of UNIX job opportunities available, look at the job ads in any major newspaper or any job-search site on the Internet.

The Goal of This Book

This book is designed to complement the Cisco Networking Academy Fundamentals of UNIX course sponsored by Sun Microsystems. It contains additional content to enhance the online materials, and it offers a variety of learning options. The book contains a hard-copy version of the online curriculum, with added content and supplemental materials to assist in studying.

The following is a summary of the additional features provided in this book to supplement the online curriculum:

- It contains all the information in the online content, providing additional information and going into greater depth on some topics.
- Each chapter has a "Key Terms" section for focused study.
- A list of commands and utilities introduced is found at the end of each chapter.
- UNIX commands quick reference—Alphabetical listing of all commands used in the book/course. Provides definitions and examples of use.
- Commonly used vi editor commands reference.
- The class file system tree structure (inside-front cover)—Graphical hierarchy showing all directories and files.
- UNIX command summary (inside-back cover)—Lists all commands in the book grouped by function and indicates the chapter number where they are introduced.

This Book's Audience

This book is intended for students enrolled in the Cisco Networking Academy Program Fundamentals of UNIX course. It also can be used as a standalone reference for anyone wanting to gain a good basic knowledge of the current UNIX environment while focusing on Sun Microsystems Solaris and Linux. It is introductory in nature and does not presume any previous knowledge of the UNIX operating system, although knowledge of another network operating system, such as Novell or Microsoft would be helpful. Familiarity with command-line syntax and graphical windowing desktops would also be beneficial. This course along with this Companion Guide and the Lab Companion will provide a strong foundation for those who want to move on to more advanced UNIX system administration.

This Book's Features

Many of this book's features help facilitate a full understanding of the information covered in this book:

- **Chapter Objectives**—At the beginning of each chapter is a list of objectives to be mastered by the end of the chapter. In addition, the list provides a reference to the concepts covered in the chapter, which can be used as an advanced organizer.
- **Figures, Examples, and Tables**—This book contains figures, examples, and tables that help explain theories, concepts, and commands; they reinforce concepts and help you visualize the content covered in the chapter. In addition, examples and tables provide such things as command summaries with descriptions, examples of screen outputs, and practical and theoretical information.
- **Chapter Summaries**—At the end of each chapter is a summary of the concepts covered in the chapter; it provides a synopsis of each chapter and serves as a study aid.

- **"Check Your Understanding" Questions**—The end of each chapter presents review questions that serve as an end-of-chapter assessment. In addition, the questions reinforce the concepts introduced in the chapter and help you test your understanding before you move on to the next chapter.

- **UNIX Command Summary**—In most chapters a list of newly introduced commands is provided along with definitions and examples of their use. A master command listing is found in Appendix B, "Master Command List." A listing of commands grouped by function is found on the inside-back cover. This listing also shows the chapter number where the command is first introduced. These provide quick reference guides.

- **Key Terms**—All chapters include a "Key Terms" section at the end. These terms serve as a study aid. In addition, the key terms reinforce the concepts introduced in the chapter and help your understanding of the chapter material before moving on to new concepts. You can find the key terms highlighted with ***bold/italic*** throughout the chapter where they are used in practice. A master glossary containing all chapter key terms is located at the end of the book.

- **Lab Activities**—Throughout this book, you see references to the lab activities found in the *Cisco Networking Academy Program Fundamentals of UNIX Lab Companion*, Second Edition. These labs allow you to make a connection between theory and practice.

- **e-Lab Activities**—Throughout this book, the e-Lab Activities found on the accompanying CD-ROM are referenced.

Conventions Used in This Book

Key terms, defined at the end of each chapter and in the Glossary, appear in a ***bold/italic*** font.

About the CD-ROM

The CD-ROM provided with this book contains all interactive media activities from the online curriculum.

This Book's Organization

This book is divided into 17 chapters, 7 appendixes, and a Glossary. The following is a brief description of each chapter. Refer to Appendix G, "Summary of Chapter Changes—From 1st Edition to 2nd Edition," for an overview of changes, by chapter, between the first and second editions of this book.

Chapter 1, "The UNIX Computing Environment," presents the history and the main components and capabilities of the UNIX operating system. It reviews operating systems in general and compares UNIX to other operating systems in use today. This chapter introduces Sun Microsystems' version of the UNIX operating system, known as Solaris and the Linux operating system.

Chapter 2, "Accessing a System and UNIX Graphical Interfaces," discusses the requirements for user accounts and passwords, as well as the procedure for logging in and out of the system using both the command-line and graphical login environments The features, functions, and customization of the CDE and GNOME graphical desktops also are covered.

Chapter 3, "Graphical User Applications," presents several useful graphical applications that are included with the graphical CDE, including the Mail Tool for viewing and managing e-mail messages, the Calendar Manager for managing dates and appointments, Voice Notes and Text Notes, the Address Manager, Calculator, and Clock. Comparable GNOME and KDE graphical applications are also covered.

Chapter 4, "Getting Help," introduces the various forms of help provided by the Solaris environment, including the graphical help available with the CDE; AnswerBook2, an online version of the Solaris manuals; and command-line help known as manual or "man" pages. Linux HOWTOs, which are procedures for accomplishing tasks in the Linux environment, are covered as is the **info** command. This chapter also reviews basic troubleshooting techniques and provides a DOS-to-UNIX cross-reference table for those with a DOS background.

Chapter 5, "Accessing Files and Directories," reinforces file system concepts covered earlier and also introduces the major concept of absolute and relative path names used to identify locations in the directory tree. In addition, commands used to navigate the file system and list the contents of directories are covered. Lastly, the chapter presents metacharacters as a way to manipulate groups of files and directories.

Chapter 6, "Basic Directory and File Management," presents how to create, view, and manipulate files and directories using the UNIX command line, CDE File Manager, and GNOME Nautilus. Commands such as **cat**, **more**, **mkdir**, **touch**, **diff**, and **rm** are covered.

Chapter 7, "Advanced Directory and File Management," explores more advanced file- and directory-management tasks using the command-line interface, CDE File Manager and GNOME Nautilus. Commands used to copy, link, move, and rename files and directories are covered. In addition, the concepts of pipelines and input/output redirection are introduced. Copying files to a disk under Solaris and Linux are also covered.

Chapter 8, "File Systems and File Utilities," presents an overview of hard drive technology, physical and logical disk partitions, and file systems. General information on partitioning and file systems as well specific information on Linux partitions and file system statistics is presented. Additionally, file-processing commands used to locate files on a hard drive, search for strings of characters within files, and sort file contents are introduced. Finding files with graphic tools such as CDE, GNOME and KDE is also covered.

Chapter 9, "Using Text Editors," presents an overview of several text editors available in UNIX including the vi editor, the Emacs editor, plus the CDE and GNOME Windows-based text editors. In addition to presenting how to use these text editors to create and modify files, there is a discussion of why it is important to learn how to use a text editor from both a user and a system administrator perspective. Finally, there is a short discussion about other popular text editors and UNIX word processor programs.

Chapter 10, "File Security," provides some guidelines for an overall security policy and then focuses on file system security. Specific attention is given to determining and modifying file and directory access permissions, including user, group, and other permissions. Changing permissions using command-line methods, CDE File Manager, and GNOME are covered. Lastly, this chapter presents how to identify which users are logged on and how to switch to other user accounts.

Chapter 11, "Printing," discusses the various hardware and software elements that provide printing services in the UNIX environment. Information on printing with Solaris and Linux is presented. Printing and print job management from the command line, CDE, and GNOME are covered.

Chapter 12, "Backing Up and Restoring," discusses the important topic of backing up and restoring data. Focus is given to the most common network- and workstation-backup strategies and the built-in UNIX backup and restore utilities such as **tar**, **jar**, and **cpio**. There is also a discussion of third-party compression programs used in both UNIX and the PC world. This chapter includes information on accessing floppy disks and CD-ROM devices with Solaris and Linux. The Solaris volume-management feature as well as formatting and mounting in both environments are discussed.

Chapter 13, "System Processes," presents the concept of foreground and background processes, demonstrating the power and flexibility of UNIX. Special attention is given to commands used to identify and manage system processes. This chapter provides information on Solaris and Linux startup processes, process management, and scheduling utilities.

Chapter 14, "Shell Features and Environment Customization," provides a brief review of the function of the shell and focuses on two of the most widely used shells today: the Korn and Bash shells. The Korn shell is the default shell for Solaris users, and the Bash shell is the default for Linux users. This chapter goes into greater detail about the unique features of each shell and provides information on how to become more efficient by using custom prompts, aliases, history, and re-execution of commands. Lastly, the chapter discusses variables and initialization files used to customize your work environment.

Chapter 15, "Introduction to Shell Scripts and Programming Languages," builds on the basic shell concepts and UNIX commands covered in previous chapters. It includes how to use the built-in shell programming language to create simple and complex shell scripts that

can be used to automate tasks. Students learn how to write, execute, and debug shell scripts. Today's most popular programming languages for the UNIX/Linux environment are also identified and discussed.

Chapter 16, "Network Concepts and Utilities," explains the concept of client/server computing and describes the benefits in networked environments. Network commands and utilities such as **ping**, **telnet**, **trace**, **rlogin**, and **ftp** are covered. Additionally, this chapter contains a discussion of network naming services such as Domain Name Service (DNS) and Network Information Service (NIS). Resource sharing protocols such as Network File System (NFS) and Server Message Block (SMB) also are explained.

Chapter 17, "Career Guidance," This chapter provides information and resources for students who want to learn more about UNIX, specifically Solaris and Linux. It discusses careers in UNIX system administration and covers the process for obtaining certification in Solaris system administration. An overview of the Sun Academic Initiative, a program that offers Solaris system administration courses from Sun Education to authorized educational institutions, is presented. The chapter concludes with information about the vendor-neutral CompTIA Linux+ certification and vendor-specific certifications.

Appendix A, "Answers to Chapter "Check Your Understanding" Quizzes," provides the answers to the "Check Your Understanding" questions that you find at the end of each chapter.

Appendix B, "Master Command List," provides an alphabetized list of commands used in this book.

Appendix C, "vi Editor Quick Reference," provides a list of the most frequently used vi editor commands.

Appendix D, "e-Lab Activities Listing," lists all the activities on the accompanying CD-ROM.

Appendix E, "Hands-On Lab Listing," provides an outline of the lab activities that are referenced throughout this book. The full labs can be found in *Cisco Networking Academy Program Fundamentals of UNIX Lab Companion*, Second Edition.

Appendix F, "Website Resources," provides recommended sites for further study.

Appendix G, "Summary of Chapter Changes—From 1st Edition to 2nd Edition," provides an overview of changes, by chapter, between the first and second editions of this book.

Glossary, defines the terms and abbreviations used in this book.

> **NOTE**
>
> Instructors: Support, information, downloads, and tools can be found at cisco.netacad.net.

Objectives

After reading this chapter, you will be able to

- Describe the main components of a computer.
- Identify computer roles and compare operating systems.
- Describe the features common to all versions of the UNIX operating system.
- Describe the UNIX operating environment including Solaris and Linux.

Chapter 1

The UNIX Computing Environment

Introduction

This chapter discusses the history, the main components, and the capabilities of the UNIX operating system. There is a review of operating systems in general, and a comparison of UNIX to other operating systems. This chapter introduces the Sun Microsystems version of the UNIX operating system, known as the Solaris Operating Environment or Solaris. An overview of the *Linux* operating system, which is based on UNIX, is also provided. Most of the information presented here is applicable to all varieties of UNIX including Solaris and Linux.

Main Components of a Computer

As illustrated in Figure 1-1, the four main components of a computer are as follows:

- The central processing unit (CPU)
- RAM
- Input/Output (I/O) devices
- The hard disk or other mass storage devices

Figure 1-1 Main Components of a Computer

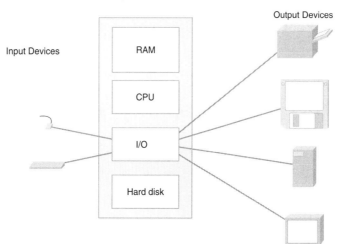

CPU

The *CPU* is the computer logic microprocessor chip that processes instructions that are received from the primary computer memory (*RAM*). These instructions are stored in binary language. The CPU typically plugs into the motherboard of the computer. Modern CPUs have cache memory onboard to speed up operation. Examples of CPUs include the proprietary Sun Ultra *SPARC (Scalable Processor Architecture)*, which is designed strictly for the Sun line of workstations and *servers*. The following is a list of better-known CPUs designed for microcomputers:

- Intel x86, Pentium, Celeron, Xeon, and Itanium
- AMD K6 series, Athlon, Duron, and Opteron
- Power PC (PPC), which is a joint venture by Apple, IBM, and Motorola
- Motorola 68000 Series
- Compaq (formerly DEC) Alpha

RAM

RAM is physical memory in the form of microchips. It is normally located on either the motherboard or the memory board of the computer. It is the main computer memory, often referred to as primary memory or working memory. Primary memory is the part of memory in which the activity of the running system takes place. The phrase, "The system has 128 MB (megabytes) of memory," is referring to primary memory (RAM).

Operating systems and software programs usually reside on the hard disk. When the computer is booted, an image or copy of the operating system is loaded into RAM. When a program is started, an image or copy of that program is loaded into RAM. Images in RAM remain as long as they are needed. When these images are no longer required, they are overwritten by other images. If power is lost or the system is rebooted, images in RAM disappear. RAM is available in many different form factors and performance levels. It is common to add RAM in computers to increase the size of programs they can run and also to improve performance.

I/O Devices

The I/O portion of the computer accepts or reads input from a device into memory, or it writes output from memory to a device. There are many types of *I/O devices*. For example, the keyboard and the mouse are the primary user input devices. The monitor and the printer

are the primary output devices. Disk drives and *tape drives* are considered both input and output because they can be read from as well as written to. A normal CD-ROM drive is an input device, but a CD-R (recordable) and CD-RW (read/write) are considered both input and output devices. A monitor can also be an input device if it has a touch screen.

Hard Disks and Other Forms of Mass Storage

The hard disk is a magnetic storage device in which information is stored. All *files*, including the operating system and applications or utilities, are stored on a hard disk. The contents of the hard disk are managed by the file system, which will be covered later. Forms of optical storage, such as CD-ROMs, DVDs, and CD-Rs, are becoming standard components on many new computers. Tape drives are also very common as a backup device used primarily on high-end workstations and servers.

Disk drives typically communicate with the computer using Enhanced Integrated Drive Electronics (EIDE) or Small Computer Systems Interface (SCSI). Disk drive technology is covered in more detail in Chapter 8, "File Systems and File Utilities." CD-ROMs and tape drives typically connect using the AT Attachment Packet Interface (ATAPI), which is an extension to EIDE. ATAPI, EIDE, and SCSI are industry standards that are widely supported on all modern operating systems.

Peripheral Components

Peripheral components are those that are independent of the CPU, RAM, and mass storage. Some of the more common peripherals are discussed here. These include I/O devices and other components such as video hardware, audio hardware, and networking devices found in most modern computers. (See Figure 1-2.)

Figure 1-2 Peripheral Components of a Computer

Keyboard and Mouse

As previously mentioned, the keyboard and mouse are the primary input devices. The keyboard and mouse typically interface to the computer using either a PS/2 or universal serial bus (USB) connection. USB is becoming more common.

Video Components

The primary video components are the video adapter and the monitor. The video adapter provides the ability to display text and graphics. The amount of video memory determines the resolution and number of colors that can be displayed. Video cards are installed in an Accelerated Graphics Port (AGP) slot, Peripheral Components Interface (PCI) slot, or can be built in to the motherboard. Most modern PCs use an AGP interface for video.

Monitors are characterized by screen size, resolution capabilities, refresh rate, and display precision known as *dot pitch*. The monitor connects to the video card using a 15-pin RGB (Red, Green, Blue) connector. Flat-panel LCD displays are becoming increasingly popular. Video components can also include motion video capture and editing systems.

Audio Components

Audio usually includes a sound card and speakers. In some cases, audio includes a microphone. Sound cards typically use an Industry Standard Architecture (ISA) or PCI slot on the motherboard. The microphone can be separate or built in to the monitor. In either case, it plugs into the sound card. Multimedia, music, and voice-recognition applications take advantage of the sound components.

Printing Devices and Scanners

Printing devices are output-only and include printers and plotters. There are hundreds of different kinds of printers and they can be attached to a workstation, a server, or directly to a network. Plotters are less common than printers and are primarily use for large-scale drawings. Printing devices can be attached to the computer using various interfaces such as parallel, serial, USB, and IEEE 1394 (FireWire). Scanners can serve as copiers and fax machines as well as devices with which to capture high-resolution graphical color images. Scanners typically attach to the computer using a serial or USB interface.

Networking Components

Many computers today come with an Ethernet ***network interface card (NIC)*** or adapter. This adapter allows computers to communicate with each other through a central hub device using a cabled or wireless connection. This connection forms a LAN. Most newer network adapters plug into a PCI slot on the motherboard. Older network adapters use the ISA interface.

Modems are also considered networking devices, which allow remote dial-up to private networks and ***Internet service providers (ISPs)***. Modems can be either internal or external. The current standard modem speed is 56 kilobits per second (kbps, or 56K).

Computer Roles and Operating Systems

All computers require an operating system (OS) to manage their functions. This is true regardless of the manufacturer of the computer or whether it is a microcomputer, midrange computer, or mainframe computer. OSs can be divided into two major categories:

- Single user (desktop)
- Multiuser (network)

Single-User Desktop Systems

Early desktop operating systems were single-user systems. This means that they could track only one user at a time and were designed to run on a Personal Computer (**PC**) desktop or laptop. DOS and Windows 3.x are examples of true single-user desktop operating systems. The activities of only one user can be managed; so only one user can be logged in at a time. Modern operating systems such as Windows 9x, NT Workstation, Windows 2000 Professional, Windows XP, and Mac OS have some networking capabilities for peer-to-peer workgroup networking. However, they are largely employed as single-user desktop operating systems. (See Figure 1-3.)

Figure 1-3 Single-User Desktop System

Workstation and Desktop Applications

UNIX can serve as a desktop operating system, but is most commonly found on high-end computers known as UNIX workstations. Sun Microsystems Ultra and Sun Blade line of workstations are UNIX workstations that have powerful CPUs and ample memory. These workstations are employed in engineering and scientific applications, which require dedicated high-performance computers.

Some of the specific applications that are frequently run on UNIX workstations are included in the following list:

- Computer-aided design (CAD)
- Electronic circuit design
- Weather data analysis
- Computer graphics animation
- Medical equipment management
- Telecommunications equipment management

Most current desktop operating systems include networking capabilities and support *multiuser* access. For this reason, it is becoming more common to classify computers and operating systems based on the types of applications they run. This classification is based on the role or function that the computer plays, such as workstation or server. Typical UNIX desktop or low-end workstation applications might include word processing, spreadsheets, and financial management. On high-end UNIX workstations, the applications might include graphical design or equipment management and others as listed above.

The UNIX operating system can run on a personal computer. Any system that is running UNIX is referred to as either a workstation or a server. A PC is a system running any of the other popular operating systems originally designed for the PC.

Network Operating System Capabilities

All versions of UNIX and most other modern *network operating systems (NOS)* support advanced features:

- Multiuser capability
- Multitasking
- Distributed processing
- High level of security

Multiuser capability enables more than one user to access the same resources and provides support for many users simultaneously. The OS keeps track of each resource, such as CPU, RAM, hard disk, and printers, and allows them all to be shared. Each program or application that runs is referred to as a task or process. *Multitasking* enables the OS to keep track of multiple processes simultaneously. This allows more than one tool or application to be used at one time. *Distributed processing* enables the use of resources across the network.

For example, a user at a workstation would be able to access files and applications on the hard disk of another computer, or a printer, located on a remote part of the network. (See Figure 1-4.)

Figure 1-4 Distributed Computing Environment

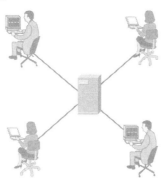

Network operating systems are also very secure. Beyond the basic username/password security, there are many other security features. These features can be turned on or off, depending on the function of the system and the level of security the user or administrator desires.

Servers and the Network Environment

Network operating systems (NOS) have additional network management tools and features that are designed to support access by large numbers of simultaneous users. On all but the smallest networks, NOS are installed on powerful servers or central *host* systems. The focus is on server-based or host-based NOS. Servers are powerful computers that run a NOS and applications. Many users, known as clients, share these servers. Servers usually have high-capacity/high-speed disk drives, large amounts of RAM, high-speed NICs, and in some cases multiple CPUs.

Server applications and functions include web services using *Hypertext Transfer Protocol (HTTP)*, *File Transfer Protocol (FTP)*, and Domain Name Server (DNS). Standard e-mail protocols supported by network servers include *Simple Mail Transfer Protocol (SMTP)*, *Post Office Protocol (POP3)*, and *Internet Messaging Access Protocol (IMAP)*.

File sharing protocols include Sun *Network File System (NFS)* and Microsoft *Server Message Block (SMB)*, which allow files to be shared between same and different OS types. NFS and SMB are discussed in more detail in Chapter 16, "Network Concepts and Utilities." Network servers, in conjunction with file services, also frequently provide print services. The UNIX print server uses the Line Printer Daemon (LPD) to schedule and manage print requests. A server can also provide the Dynamic Host Control Protocol (DHCP), which automatically allocates IP addresses to client computers. In addition to running services for the clients on the network, servers can be set to act as a basic *firewall* for the network. This is accomplished

using **proxy** or network address translation (NAT), both of which hide internal private network addresses from the Internet for increased security. Server applications such as the following are not normally implemented on a home desktop or LAN workstation:

- Web services (HTTP)
- File transfer (FTP)
- Domain Name Service (DNS)
- E-mail (POP3, SMTP, and IMAP)
- File sharing (NFS, SMB)
- Print services (LPD)
- Dynamic IP allocation (DHCP)

e-Lab Activity 1.1 Server Functions and Protocols

In this activity, you identify protocols and services that provide key server functions. Refer to e-Lab Activity 1.1 on the accompanying CD-ROM.

OS and CPU Relationship

Most OSs, in general, are designed to work with the CPUs of a particular manufacturer. Some can run on CPUs from different manufacturers, and some can support multiple CPUs of the same type. The various Windows operating systems (9x/ME/NT/2000/XP) run primarily on Intel-based CPUs. Solaris and Linux run on several different manufacturers' CPUs, including Intel and AMD. Server versions of the Windows OSs (NT and 2000) support multiple CPUs, as do most versions of UNIX, including Solaris and Linux. Solaris supports servers running over 100 CPUs concurrently. OSs and CPUs often are classified based on the number of bits they can manipulate. The more bits they can manipulate, the more powerful the CPU and the OS are. Most early NOS and CPUs were 16-bit, although the first PCs used 8-bit CPUs. Most modern NOS and CPUs are 32-bit, with some being 64-bit. The Intel x86 CPU architecture is 32-bit and the Intel Itanium, or IA-64 architecture, is 64-bit. Sun Systems SPARC CPU is 32-bit and the Ultra-SPARC is 64-bit.

Examples of NOS include UNIX, Windows NT/2000 Server, Novell NetWare, and various mainframe NOS. (See Figure 1-5.) Mainframe NOS include Digital Equipment VMS, Hewlett-Packard MPE, IBM MVS, and several varieties of UNIX. Solaris or SunOS is the Sun Microsystems version of UNIX. A Sun workstation or server comes with Solaris. However, Sun has a new line of inexpensive, Intel-based servers that supports both Solaris and Linux. It is possible to order Intel-based servers with Windows 2000, Novell NetWare, or Linux pre-installed.

Figure 1-5 Network Operating Systems

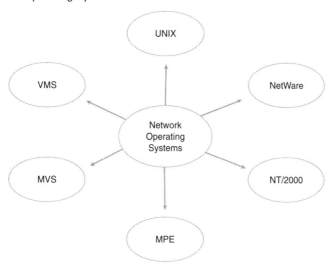

Although UNIX is used frequently as a workstation OS for high-performance applications, it is not generally considered an end-user desktop OS. It is most often used as a NOS on servers, and is often used with Internet web servers. Linux can be used as a server or a high-end workstation, and is becoming increasingly popular as a desktop operating system for home or office use.

Operating Systems, Hardware, and Drivers

Operating systems such as Windows XP, Windows 2000, Solaris, and Linux interact with computer hardware through the use of device drivers. A *driver* is a piece of software written for a particular operating system that allows the system to control a particular hardware device properly. Nearly all major computer components and peripherals, such as keyboards, mice, videos, printers, scanners, and disk drives, require a driver to operate. Most operating systems come with basic drivers for the most common types of hardware and peripherals. (See Figure 1-6.)

Figure 1-6 Role of the Device Driver

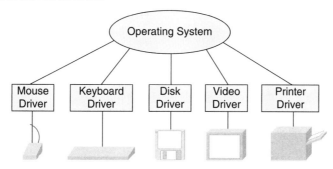

Solaris and Drivers

The original Sun operating system, based on UNIX, was designed to run on computers manufactured by Sun Microsystems. The Sun operating system comes pre-installed on a consistent and stable hardware platform. This allows for maximum compatibility between the OS, the drivers, and the hardware. Solaris for Intel is designed to run on Intel-compatible (x86) computers, with a considerable variety of hardware, and with many different peripheral manufactures. Either the operating system or the hardware manufacturer provides drivers. Drivers might not be available for all types of peripheral hardware.

Linux and Drivers

Linux was also developed to run on Intel-based computers. The OS may not support some types of hardware, especially the latest peripherals. Linux, in the Intel-compatible environment, supports most CPUs including Intel and AMD, most types of RAM, and standard mass-storage interfaces such as EIDE, ATAPI, and SCSI. Standard USB and PS/2 keyboards and mice are also well supported. Other USB devices may not be and will need to be checked. Most video card chip sets that are compatible with the XFree86 graphics system, which comes with Linux, are not a problem. However, the latest technology devices might not have drivers available yet. NICs and modems are generally well supported, except for some internal modems that may require a special driver.

Overview of the UNIX Operating System

Even though the UNIX operating system is the one of the oldest in existence, its popularity is still increasing due to its stability, scalability, security, broad industry support, and continued enhancements.

Brief History

In the mid-1960s, the UNIX operating system was developed at AT&T Bell Labs with involvement from General Electric and the Massachusetts Institute of Technology. UNIX was developed as a multiuser operating system called *Multiplexed Information and Computing Service (Multics)*. Multics was an interactive operating system written for a specific General Electric computer. After several years of development, Multics proved to be too expensive and Bell Labs withdrew from the project.

Ken Thompson, a Multics programmer at Bell Labs, wrote a space-travel game for the GE computer before the Multics project lost funding. With the help of another programmer, Dennis Ritchie, he rewrote the game to run on a Digital Equipment Corporation (DEC) PDP-7

computer that had a better graphics display. The DEC computer was great for running the space-travel game, but it lacked a viable OS. In 1969, Thompson got the urge to develop his own OS. Originally, Thompson called the new OS that he had developed, with a colleague, *Uniplexed Information and Computing Service (UNICS)*. The name was eventually changed to UNIX. The space-travel game later was modified to run under UNIX.

UNIX was first written in Assembly language, a primitive set of instructions that control the internal instructions of the computer. However, UNIX could run only on a specific computer. In 1971, Ritchie created the *C language*. In 1973, he and Thompson rewrote the UNIX system programs in C language. Because C is a higher-level language, UNIX could be moved (or ported) to another computer with far less programming effort. The decision to develop this portable operating system proved to be the key to the success of UNIX.

The early UNIX source code was made available to universities all over the United States. Programmers at the University of California at Berkeley made significant modifications to the original source code and called it **Berkeley Software Distribution (BSD)** UNIX. They sent this new version of the UNIX environment to other programmers around the United States. These programmers added tools and code as they saw fit. Possibly the most important advance made to the software by the programmers at Berkeley, was the addition of networking software. The networking software allowed the OS to function in a LAN. BSD UNIX became popular with computer manufacturers such as Hewlett-Packard, Digital Equipment Corporation, and Sun Microsystems.

The Sun Microsystems original version of UNIX, the Sun operating system (SunOS) was based on BSD UNIX Version 4.2. At that time, the AT&T version of the UNIX environment was known as System V (system 5). The Microsoft version of UNIX, developed for PCs with Intel processors, was known as XENIX. In 1988, Sun OS/BSD, AT&T System V Release 3, and XENIX were combined into what became **System V Release 4 (SVR4)**. This new generation of the OS was an effort to combine the best features of both BSD and AT&T UNIX, to create an industry standard for the OS. This enabled software to be developed for UNIX without consideration for whether it was System V or BSD 4.2. The new SVR4 became the basis for most of the current varieties of UNIX. The timeline shown in Figure 1-7 lists some of the major events in the evolution of the UNIX OS.

The Open Group (www.opengroup.org) currently owns the UNIX standard and now guides UNIX development using a set of standard operating interfaces called POSIX (Portable Operating System Interface) and the Single UNIX Specification with the goal of increasing the compatibility of the UNIX operating system between vendors.

Figure 1-7 Brief History of UNIX

A Brief History of UNIX

1969—Ken Thompson and Dennis Ritchie of AT&T Bell Laboratories start developing what was to become UNIX.
1973—UNIX was rewritten in C making it a portable operating system able to run on different computers.
1975—Version 6 distributed outside of Bell Labs. The first BSD version (1.x) was derived from V6.
1980—Microsoft introduces Xenix and 4.2 BSD becomes widely used.
1982—AT&T's UNIX System Group (USG) release System III, the first public release outside Bell Labs.
1984—University of California at Berkeley releases 4.2BSD, includes TCP/IP and much more.
1984—SVR2 System V Release 2 introduced. Approximately 100,000 UNIX installations around the world.
1986—4.3BSD released, including internet name server.
1987—System V Release 3 (SVR3) released. Approximately 750,000 UNIX installations around the world.
1988—UNIX System V Release 4 (SVR4) released, unifying System V, BSD and Xenix.
1991—UNIX System Laboratories (USL) becomes a company - majority-owned by AT&T. Linus Torvalds begins development of Linux.
1992—USL releases UNIX System V Release 4.2 (SVR4.2). Novell announces intent to acquire USL.
1993—4.4BSD the final release from Berkeley. Novell acquires USL.
1996—The Open Group forms as a merger of OSF and X/Open.
1999—UNIX turns 30. Linux 2.2 kernel released.
2001—Version 3 of the Single UNIX Specification unites POSIX, The Open Group and the industry efforts. Linux 2.4 kernel released.

UNIX Varieties

The two main versions of UNIX are System V (SVR4) and BSD. Currently, a number of varieties of UNIX exist. Most are similar because they are based on the industry standard SVR4. The other varieties are based on BSD. Most commands are the same on both SVR4 and BSD systems. However, some commands and command options are slightly different. For example, the command used for printing on System V-based systems is **lp** (line printer) and the command used for BSD-based systems is **lpr**. System V uses the **ps -ef** (process status) command to determine what processes are running and BSD uses **ps -aux**. Other differences exist with system administration commands.

UNIX is now a trademarked name owned by The Open Group (www.opengroup.org), so each vendor called its version of UNIX by a unique name. Sun's version of UNIX is called Solaris and is the most widely used version in networking today. The AT&T version is referred to as UNIX, the IBM version is AIX, and the Hewlett-Packard version is HP-UX. Digital Equipment, which is now Compaq, has a version called Tru64, which was formerly called Digital Unix. These versions of UNIX are designed to run on the hardware and CPUs made by the specific vendor. Solaris runs not only on Sun computers, but also on Intel-based machines. Linux, another version of UNIX that is becoming increasingly popular, also runs on different CPUs. By learning any one of these UNIX varieties, it is fairly easy to move to one of the

others. Figure 1-8 shows some of the CPU manufacturers, and the various UNIX versions and operating systems that they can run.

Figure 1-8 UNIX Varieties

CPU Manufacturer	UNIX OS Version	Propriety
IBM	AIX, Linux	MVS, VM
Hewlett Packard	HP-UX, Linux	MPE
Digital Equipment (Compaq)	Tru64, Ultrix, Linux	VMS
Sun Microsystems	Solaris, Linux	
Intel	Solaris, Linux	NetWare, Win9x, NT, Win2000

Overview of Linux

The latest version of UNIX to emerge is called Linux. Linux was developed in 1991 by Linus Torvalds at the University of Helsinki, Finland. Torvalds posted it on the Internet and encouraged others to contribute to its development. It has features from both SVR4 and BSD. Linux has become very popular among computer enthusiasts, those looking for an alternative to traditional PC operating systems, and companies looking for a stable, low-cost OS. The icon for Linux, chosen by Linus Torvalds, is the little penguin whose name is "Tux," shown in Figure 1-9. The Linux website is www.linux.org and includes information on the following:

- **Applications**—Programs written to run on Linux
- **Documentation**—Linux documentation project and HOWTOs
- **Distributions**—Organizations providing Linux packages
- **Hardware**—Compatible systems and components
- **Courses**—Tutorial for new users - Getting started with Linux
- **Projects**—General, hardware, software, and scientific
- **News**—Linux news and articles

Permission to use is granted by Larry Ewing (lewing@isc.tamu.edu). The GIMP drawing tool was used to create this imageLinux was originally developed to run on the Intel x86 microprocessor (starting with the 80386) as a workstation or server. The Linux kernel has since been modified to run on several different CPUs in addition to the Intel x86 based. These CPUs include Intel IA-64, DEC Alpha, SUN SPARC/UltraSPARC, Motorola 68000, MIPS, PowerPC, and even the IBM mainframe S/390. Linux now runs on CPUs from a wider variety of manufacturers than any other OS.

Figure 1-9 Linux Penguin

GNU/Linux

Many other components of the OS have been added through the efforts of independent developers and the Free Software Foundation's *GNU* (GNU's not UNIX) project (www.gnu.org). The GNU operating system uses the Linux kernel. The *kernel* is the heart of the OS that controls interaction between the hardware and applications. The GNU project refers to Linux as GNU/Linux, because many components of the OS are GNU applications. A good source of information and resources is the Linux documentation website: www.linuxdoc.org.

Open Source Software

Linux is available at no expense under the GNU General Public License (GPL), as are other versions of UNIX such as FreeBSD and NetBSD. Linux is *open source software*, which means that the source code is publicly available and can be modified to suit specific needs. It can also be distributed freely among users. This concept is the opposite of commercial software, where the source code is not publicly available and each user must pay a license fee. Commercial software is based on copyright laws, which seek to limit what the user can do with respect to source code and distribution. Linux can be downloaded at no cost from various

websites. Although there is a fee to purchase packaged versions of Linux, it is intended to cover the cost of packaging and support and is not a license fee.

Linux Distributions

A number of for-profit companies and non-profit organizations make Linux available along with various combinations of applications, utilities, and other software. These combinations of the OS and software are called *distributions*. As an example, Red Hat, Inc. bundles the Linux CD-ROMs, source code, and manuals along with a collection of applications and other products for a modest fee. These additional products include an office suite, a choice of graphical desktops, web server software, and so on. A level of customer support is also provided. Red Hat Linux 9 includes the OpenOffice.org suite of productivity software. Prior versions of Red Hat and other distributions of Linux include Sun Microsystem's StarOffice productivity suite. Sun has contributed much of StarOffice software's functionality to the open source community through openoffice.org.

The primary component of any distribution is the Linux kernel itself. In addition to the kernel and applications, other components in a distribution include installation tools, the boot loader, and utility programs. Some distributions are more graphical and oriented toward the new user. Others are more basic and focus on developers and people who are already familiar with UNIX. Linux distributions are available in many different languages. There are currently more than 100 different distributions in English alone. These are listed, along with a description, on the www.linux.org website where they can be downloaded. Some of the more common Intel-compatible Linux distributions intended for the mainstream general public are as follows:

- Debian GNU/Linux (http://www.debian.org)
- MandrakeLinux (http://www.mandrakelinux.com)
- Red Hat Linux (http://www.redhat.com)
- Slackware Linux (http://www.slackware.com)
- SuSE Linux (http://www.suse.com)
- Turbo Linux (http://www.turbolinux.com)

Benefits of UNIX

UNIX is a standards-based operating system and, although it varies somewhat from one version to another, the basis of the system is still UNIX. Nearly all-major computer manufacturers support some form of UNIX, which is a tribute to its importance as an operating system. It is one of the most powerful, flexible, secure, and scalable OSs in the world. Most versions of UNIX in use today are commercial versions such as IBM AIX or Sun Solaris. The source

code is not modifiable by the end user and there is a license fee for the OS. This is one of the reasons for the increasing popularity of Linux, which is open source and is relatively low cost to deploy. Nearly every computer manufacturer, in addition to having their own commercial version of UNIX, now offers and supports the Linux OS. These include Sun, HP/Compaq, IBM, and others.

In general, UNIX in its various forms, continues to advance its position as the reliable, secure OS of choice for mission-critical applications that are crucial to the operation of a business or other organization. UNIX is also tightly integrated with the Transmission Control Protocol/Internet Protocol (TCP/IP). TCP/IP basically grew out of UNIX because of the need for LAN and WAN communications. TCP/IP is the acknowledged standard protocol of the Internet and many private networks. All workstations and servers running the TCP/IP protocols are referred to as "hosts" and are given an IP address and a host name. The IP address is what allows the host to be uniquely identified on the Internet. If a local translation file or a name server is available, the computer can be referred to by its name, which then is translated to its IP address. TCP/IP, IP addresses, and name servers will be covered more in Chapter 16.

Sun Solaris Benefits

The Sun Microsystems Solaris Operating Environment and its core OS, SunOS, is a high-performance, versatile, 64-bit implementation of UNIX. Solaris runs on a wide variety of computers, from 32-bit Intel-based personal computers to powerful mainframes and supercomputers. Solaris is currently the most widely used version of UNIX in the world for large networks and Internet websites. Sun is also the developer of the "Write Once, Run Anywhere" Java technology. The benefits of UNIX and Solaris are summarized as follows:

- Industry standards-based operating system
- Powerful, flexible, scalable, and secure
- Supported by various equipment manufacturers
- Mature and stable operating system
- Tightly integrated with TCP/IP protocols
- Widely used for mission-critical applications

Linux Benefits

In general, Linux includes the same benefits as UNIX. It is most often used for workstations and for small to medium servers. It is not currently widely implemented on high-end servers, but this is changing. In addition to those listed, Linux has the added benefit of being open source software and is available at low cost. There is also a huge Internet user community that supports and promotes Linux.

UNIX Operating Environment

UNIX is a collection of components that together make up an operating environment. Each version of UNIX varies somewhat from the others but all share the same basic characteristics.

Solaris

The OS environment on Sun systems is called the *Solaris Operating Environment*. The Solaris environment consists of the SunOS 5.x operating system, the ***Open Network Computing (ONC)*** protocols, and a ***graphical user interface (GUI)***. SunOS 5.x is a multiuser, multitasking network operating system that is based on the standard SVR4 UNIX operating system. ONC is a family of published networking protocols and distributed services that enable remote resource sharing, among other things. The Solaris 9 environment supports several graphical interfaces: ***Common Desktop Environment (CDE)***, the ***GNU Network Object Model Environment (GNOME)*** (pronounced "Ga-nome") and the ***K Desktop Environment (KDE)***, which come unbundled but are supported. This course introduces CDE, GNOME, and KDE but focuses on CDE and GNOME. You can summarize the key components of the Solaris operating environment as follows:

- SunOS 5.x UNIX operating system
- Open Network Computing (ONC) protocols
- GUI (CDE or GNOME)

Linux

The Linux operating environment is similar to that of Solaris but the components can vary depending on the distribution. All distributions include, at a minimum, the Linux kernel, standard TCP/IP networking protocols, an installation package, the GNOME or KDE graphical desktop, and various configuration and management utilities.

Sun and Linux

Linux is consistent with Sun's computing vision of employing open standards and to develop products and services that address the needs of a variety of environments.

Sun's high-end servers support Solaris. For their next-generation, x86-based, entry-level servers (Sun Fire V60x and V65x) Sun has partnered with Linux vendors Red Hat and SuSE to make sure their OS is supported on the x86 platform in addition to Sun's own Solaris. Additional x86-based systems will be available from Sun in the future.

In addition, Sun has collaborated with the lxrun open development effort to enable Linux applications to run without modification on the Solaris Operating Environment on Intel platforms.

Sun also developed the Sun Java Desktop System. It is an affordable, comprehensive, simple to use, and secure enterprise-grade desktop solution that is an alternative to Microsoft Windows. The software consists of a fully integrated graphical client environment based on open source components and industry standards, including a GNOME desktop environment, StarOffice Office Productivity Suite, Mozilla browser, Evolution mail and calendar and Java 2 Standard Edition. It will run on either a Linux operating system or Solaris x86 Platform Edition. Key features include a well-defined, integrated look and feel, familiar desktop themes, as well as file, folder, and print interoperability with Microsoft Windows and Linux/ UNIX environments.

OS and the Kernel

The OS is a set of programs that manages all computer operations. It also provides a link between the user and system resources, converting requests that come from the mouse or the keyboard into computer operations. Most operating systems, including UNIX, have four main components:

- The *kernel* manages the operation of the computer.
- The *shell* provides for interaction between the user and the computer.
- The *file system* provides a way to organize and manage the information on the computer's hard disk(s).
- The **commands**, or utilities, are used to instruct the computer to perform tasks.

Much of the following information applies to all varieties of UNIX, although some of the information is Solaris or Linux specific.

UNIX Kernel Overview

The kernel is the core OS with the necessary basic capabilities to run the computer. The kernel is the closest to the CPU and hardware. It is an executable file that gets loaded when the computer boots and is conventionally named *unix* in System V-based systems or *vmunix* in BSD-based systems. Solaris contains two kernel files: a platform-independent generic kernel file that is combined with a platform-specific kernel file for a specific Sun system. These two combined files create the static core kernel that initializes and controls the system.

Linux Kernel

The development process for the Linux kernel is interesting and somewhat unique. Linus Torvalds maintains control of how the Linux kernel evolves, with input from people all over the Internet. Periodically, a group of developers review and test the latest contributions and

release a stable version of the OS kernel. The most current version of the kernel is 2.4.20. In this numbering sequence, the numeral 2 represents the major version number and the numeral 4 represents the minor version number. The numeral 20 in the kernel number is a release or patch number.

If the minor version is even, then this indicates a stable version of the OS that can be distributed to the Linux community. If the minor version is odd, then this is a development version.

Kernel Functions

After the kernel loads, it performs the following functions, as shown in Figure 1-10:

- Manages devices, memory, and processes
- Controls the functions, or transmission of information, between the system programs and the system hardware

Figure 1-10 Kernel Functions

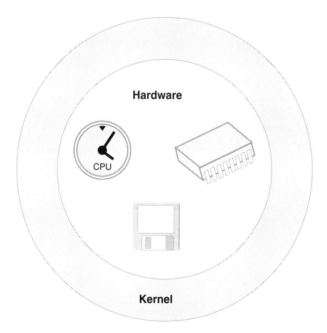

- Manages functions such as swap space, daemons, and file systems:
 - *Swap space* is a reserved part of the hard disk that the kernel uses during processing. Portions of running programs can be "swapped out" of RAM into the hard disk, and then brought back into RAM if necessary. This swap space is actually on the hard disk, but it looks like additional memory to a running program. Swap space

is a raw slice, or disk file, that is set aside during system installation. As previously mentioned, RAM is physical memory. The swap space on the hard disk represents "virtual memory" and is used to increase the size and number of programs that can be run. Most UNIX systems set up a swap space of twice the amount of RAM, or a minimum of 32 MB. Swap space is not RAM, but the operating system treats it like RAM to provide extra memory to the programs that are running. In Figure 1-11, the kernel is swapping programs in and out of the swap space on the hard disk.

— *Daemons* (pronounced either "daymens" or "deemens") are programs that perform a particular task, or monitor disks and program execution. Daemons are special processes that begin after the OS loads. Daemons then wait for something to do in support of the OS. They can be started or stopped as necessary. An example is the printer daemon, line printer scheduler (lpsched). It starts when the system starts up and then waits in the background until someone needs to print something. Daemons in the UNIX world are similar to services with Windows NT/2000 or NetWare loadable modules (NLMs) with Novell NetWare.

— File systems are a hierarchy of directories, subdirectories, and files that organize and manage the information on hard disks. File systems can be either local or remote. Local file systems are located on the hard disk of your workstation. Remote file systems are located on another computer, which is usually a server.

Figure 1-11 Kernel and Swap Space

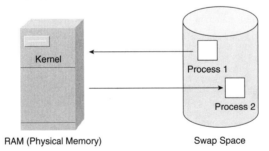

RAM (Physical Memory) Swap Space

OS Shell

A shell is an interface between the user and the kernel. (See Figure 1-12.) It acts as an interpreter or translator. In other words, the shell accepts commands issued by the user, interprets these commands, and executes the appropriate programs.

Shells can be command-line driven or graphical. Three command-line shells are available in the Solaris UNIX environment. It is possible to initiate or switch between these shells when working on the computer. The process status (**ps**) or **echo $SHELL** commands are used to

determine which shell is in use. The Solaris Operating Environment has six available shells that come with Solaris and supports many other third party shells. The three primary command-line shells that are available in most UNIX versions follow:

- Bourne shell
- Korn shell
- C shell

Figure 1-12 OS Shell

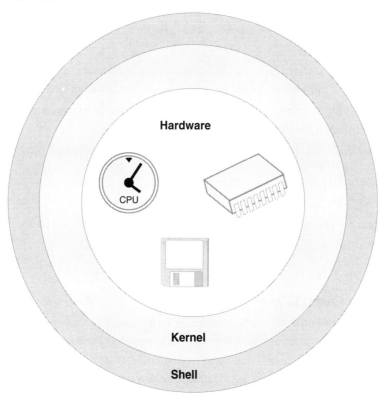

These are common to most commercial versions of UNIX. The other three shells, Bash, Z shell, and TC shell, have been gaining in popularity among UNIX users. The Bash shell is the default for most Linux distributions, though others are also supported. CDE, GNOME, and KDE are sometimes considered to be graphical shells.

The following list explains the different shells available within a UNIX environment:

- ***Bourne shell*** (*/bin/sh*) was the original shell program for UNIX. It is the default shell for the Solaris computing environment. Stephen Bourne developed the Bourne shell for the AT&T System V.2 UNIX environment. This shell does not have aliasing or history

capabilities. (See Chapter 14, "Shell Features and Environment Customization.") System administrators mostly use it. The Bourne shell prompt is a dollar sign (**$**), which is similar to a DOS **C:\>** prompt.

- *Korn shell* (*/bin/ksh*) is a superset of the Bourne shell and was developed by David Korn at Bell Labs. It has many of the Bourne shell features, plus added features such as aliasing and history. This is the most widely used shell and is the industry standard for system users. The Korn shell prompt is also a dollar sign (**$**).

- *C shell* (*/bin/csh*) is based on the C programming language. Similar to the Korn shell, it has additional features such as aliasing and history. The C shell was developed by Sun's Bill Joy and is still widely used today. The C shell prompt is a percent sign (**%**).

- **Bourne-Again shell** (*bash*) has the feel of the Bourne and Korn shells and incorporates features from the C and Korn shells. Bash is the most popular shell with Linux and is the default for most distributions. Bash can be downloaded from GNU (www.gnu.org).

- **TC shell** (*tcsh*) is a popular variant of the C shell that supports command-line editing and command-line completion.

- **Z shell** closely resembles the Korn shell, but it has many other enhancements.

NOTE

Examples given in this book are based primarily on the Korn and Bash shells.

File System

The file system provides a way to separate and keep track of the information on a hard disk. The file system determines the type, characteristics, and arrangement of files that can be stored on disk.

File System Overview

A file system is created on a disk partition using the formatting process. A partition can occupy the entire hard disk or can be a subdivided segment of the disk. Partitions will be discussed further in Chapter 8. Formatting is similar to putting up street signs in a new residential area. No one lives there yet, but the streets and home locations are identified.

Many different types of file systems are supported by various operating systems. Those file systems common in the Windows environment include the File Allocation Table 32-bit (FAT32) and New Technology File System (NTFS). Sun Solaris uses the UNIX File System (UFS). Linux uses primarily the Second Extended File System (ext2) or Third Extended File System (ext3). A hard disk may have one or more partitions or file systems defined on it.

The file system provides for the definition of a file structure. The file structure is a hierarchy of directories, subdirectories, and files that are grouped together for a specific purpose. File system support is integrated with the kernel to provide an organizational structure for your software and data. (See Figure 1-13.)

Figure 1-13 File System Organization

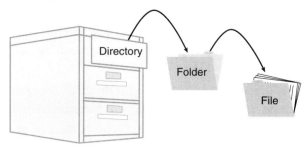

The file structure organizes the information on hard disks to make them more manageable, and it enables users to locate files. Hard disks can be divided into partitions with file systems, directories, subdirectories, and files. The file system organizes your data similar to the way a file cabinet stores information. The file system is like the file cabinet, directories are like drawers, subdirectories are like folders, and files are like the pages in a folder.

Directory Hierarchy

A directory hierarchy looks like an inverted tree, with the root at the top. (See Figure 1-14.)

Figure 1-14 The File System Directory Hierarchy

```
                        ┌──────────────────────┐
                        │  Hard Disk Structure  │
                        └──────────────────────┘
              ┌──────────────────┐      ┌──────────────────┐
              │  File System A   │      │  File System B   │
              └──────────────────┘      └──────────────────┘
         ┌───────────────┐ ┌───────────────┐  ┌───────────────┐
         │ Directory A1  │ │ Directory A2  │  │ Directory B1  │
         └───────────────┘ └───────────────┘  └───────────────┘
        ┌──────────────┐ ┌──────────────┐     ┌──────────────┐
        │ Subdir A2-1  │ │ Subdir A2-2  │     │ Subdir B1-1  │
        └──────────────┘ └──────────────┘     └──────────────┘
  ┌────────────┐┌────────────┐┌────────────┐  ┌──────────────┐
  │ File A2-1-1││ File A2-1-2││ File A2-1-3│  │ File B1-1-1  │
  └────────────┘└────────────┘└────────────┘  └──────────────┘
```

The following is the hierarchy of the UNIX file system:

■ The file system is a formatted structure set up on one or more partitions to store files and directories. Partitions and the associated file systems are similar to the drive C: or D:, in the Windows/DOS world or like volumes with Novell NetWare. File systems can be either local, meaning on the user's computer, or remote, meaning on another computer but accessed as if it were local.

- The *directory* is a location for files and other subdirectories. The file system, or directory structure, enables the user to create files and directories accessed through a hierarchy of directories. A directory is like a file drawer in a file cabinet. The highest directory in the directory structure of a file system is the root directory, which is designated as a single forward slash (/).

- The *subdirectory* is any directory below another directory. For example, some of the subdirectories under the root (/) directory are */usr*, */etc*, and */home*.

- The files are contained in directories and subdirectories. They are the lowest level of the file system. There are usually thousands of files on a hard disk and there are several different types:

 — Directories are considered a type of file under the UNIX file system.

 — American Standard Code for Information Interchange (ASCII) files are pure text files, with no special formatting characters in them.

 — Application files are created by an application such as a word processor, spreadsheet, or database program.

 — Executable programs are UNIX utility commands and application programs.

Common UNIX Directories

The topmost directory in a file system is called the **root directory**. It is the starting point of the file system hierarchy. The root directory (/) is required for the operating system to function, and it contains critical system files such as the kernel. The list following Figure 1-15 contains some of the more important directories and their purposes. The slash in front of these directories indicates that they are actually subdirectories of the root directory. (See Figure 1-15.) UNIX directory structures such as directory names, locations, and contents can vary from one version to another. Linux directory structures are relatively consistent with most distributions adhering to the Linux File System Standard (FSSTND) or the File System Hierarchy Standard (FHS).

Figure 1-15 Common UNIX Directories

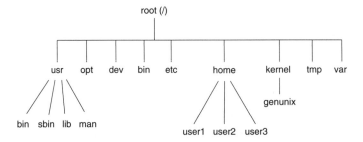

The following list of directories is not intended to be all-inclusive, but does include those most commonly found on UNIX systems:

NOTE

The directories followed by a * (single asterisk) are specific to Solaris. Those followed by a ** (double asterisk) are specific to Linux. All others are common to both.

- The */bin* (binary) directory contains many of the UNIX commands.

- The */boot* directory** contains most of the files necessary to boot a Linux system.

- The */dev* (devices) directory contains files that are pointers to device filenames. All devices in UNIX have standard filenames.

- The */etc* (etcetera) directory contains system administration files, such as the password file. This directory is commonly referred to as et-cee.

- The */export/home* directory* contains the user home directories. Depending on how the system has been set up by the administrator, the home directories could be found in /home.

- The */home* directory contains the user home directories.

- The */kernel* directory* contains the basic operating system files, such as the main UNIX kernel genunix.

- The */lib* (library) directory contains common library files used by programs in the /bin and /sbin directories.

- The */mnt* (mount) directory** is the standard mount point for files systems such as the floppy disk and CD-ROM.

- The */opt* (optional) directory contains Sun's unbundled software applications and third-party applications. This directory is not always used with Linux.

- The */proc* (process) directory** contains files relating system information used by the kernel.

- The */root* directory** is the super users home directory.

- The */sbin* (single user binaries) directory contains essential executables used in the booting process and in system failure recovery. This directory also includes some system-administration utilities.

- The */tmp* (temp) directory contains temporary files placed by users. Occasionally, files in /tmp get deleted by an administrator or automatically are deleted as part of system startup.

- The */usr* directory contains files and programs used by all users.

- The */usr/bin* (user) directory contains executable commands, system administration utilities, and library routines.

- The */usr/src* directory** contains the Linux source code.

- The */usr/ucb* directory contains commands originally developed under BSD UNIX. They exist because some users prefer the BSD version of a command to the System V version.

- The */var* (variable) directory contains dynamic and variable data such as print spooling and mail system error messages.

UNIX Commands

UNIX commands are key to maintaining the file system. The UNIX operating system comes with more than 350 commands and utility programs. These UNIX commands and utility programs are used to perform the following functions:

- File maintenance such as creating, editing, copying, deleting, and so on
- Administration such as adding new users, printers, disks, and so on
- Printing
- Networking and communication
- Programming
- Obtaining help

Commands tell the shell what to do, such as "list the contents of a directory" or "copy a file." Some commands are built into the shell program, such as **cd** (change directory) and **exit**. Most commands reside on the hard drive in a directory named */bin*, which is short for binary code.

Graphical User Interface (GUI) Options

All modern operating systems include a graphical user interface (GUI). Popular GUIs include Microsoft Windows and UNIX desktop environments such as CDE, GNOME, KDE, BlueCurve, and the Sun Java Desktop. This section introduces these most popular UNIX GUIs.

Common Desktop Environment (CDE)

Sun Microsystems was the first company to use a windowing environment in conjunction with the UNIX OS. In 1993, a consortium of UNIX platform vendors was formed to develop an integrated, standard, and consistent GUI desktop environment. The contributors included Hewlett-Packard, IBM, Novell, and Sun Microsystems. Many other companies and members of the Open Software Foundation (OSF), X/Open, and the X Consortium also contributed. CDE is Motif-based and users of other UNIX and PC desktops should be comfortable using CDE. Many of the features of CDE are common to other desktop environments.

The CDE offers the following for users:

- Provides a GUI between the user and the OS
- Includes built-in menus for users to select and run utilities and programs without using Solaris Environment commands
- Provides more than 300 utility programs and tools
- Enables users to control multiple documents or applications on the screen at the same time
- Controls activities in windows using both the mouse and the keyboard

Figure 1-16 shows a typical CDE screen. CDE is discussed in greater detail in subsequent chapters.

Figure 1-16 CDE Graphical User Interface

Open Windows

Open Windows is Sun's original GUI developed for the Solaris environment. (See Figure 1-17.) It is similar to CDE, but it is proprietary and not well supported. In Solaris versions 2.6, 7, and 8 the user has a choice when logging in to a Solaris workstation to select either CDE or Open Windows. The Open Windows environment is no longer supported in Solaris 9.

Figure 1-17 Open Windows Graphical User Interface

GNU Network Object Model Environment (GNOME)

The latest windowing system to emerge in the UNIX world is GNOME. GNOME, pronounced "ga-nome," is part of the *GNU*, pronounced "ga-new," open source software project. GNOME provides an easy-to-use desktop environment for the user, a powerful application framework for the software developer, and it is free of cost. GNOME (http://gnome.org) is included in most BSD versions of UNIX and with GNU/Linux distributions. GNOME also works with many other UNIX systems, including Solaris (www.sun.com/gnome).

GNOME combines advanced desktop organization and navigational features that enable easy access to information. (See Figure 1-18.) It provides usability, appearance, and personalization to match a user's unique working style.

The GNOME desktop key features include the following:

- Attractive, intuitive user interface
- Personalization capabilities
- Convenient front panel for rapid access to favorite programs
- Full suite of powerful applications
- Capability to run existing CDE and Java-based applications

Figure 1-18 GNOME Graphical User Interface

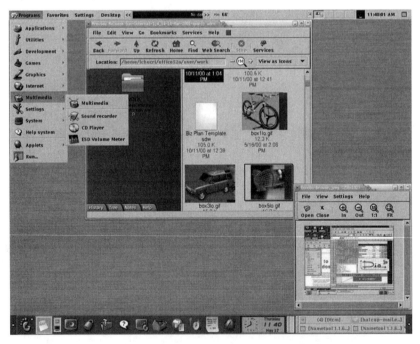

K Desktop Environment (KDE)

KDE is a mature, full-featured desktop environment that is used primarily with Linux. (See Figure 1-19.) As with GNOME, KDE is also open source software and is freely available. KDE can run with several varieties of UNIX. Most distributions of Linux come with KDE as well as GNOME. The K does not stand for anything in particular. It is just the first letter in the alphabet before L, which represents Linux. Solaris also supports KDE and is available on the Solaris Software Companion CD-ROM copackaged with Solaris or downloaded from http://wwws.sun.com/software/solaris/freeware/.

Figure 1-19 KDE Graphical User Interface

Red Hat BlueCurve

BlueCurve is a Red Hat GUI that combines elements of both GNOME and KDE. (See Figure 1-20.) It was introduced with Red Hat 8, has been upgraded in Red Hat 9, and now extends to more areas of the operating system, including the menu and layout of the desktop. The user can log in to either the GNOME or KDE environment and will find many similarities in the applications and menus.

Figure 1-20 BlueCurve Graphical User Interface

Sun Java Desktop

The Sun Java Desktop System is a fully integrated desktop environment with familiar desktop look and feel. It includes office productivity (StarOffice), Mail/Calendaring client, web browser, instant messaging, and other productivity applications based on open source components and standards.

Designed as a secure, low-cost alternative for the Linux and Solaris operating systems, the Sun Java Desktop System will provide interoperability with Microsoft Office and Exchange, Lotus Notes productivity and communications tools and the enhanced security and authentication services of Java Card and the Sun ONE stack.

Lab 1.4.3 UNIX Computing Environment

This lab exercise reviews UNIX computing environment terminology and helps reinforce the concepts introduced in this chapter. You can also investigate the use of UNIX at your institution or another organization, and research websites to see what organizations are using Solaris UNIX. Refer to the *Cisco Networking Academy Program Fundamentals of UNIX Lab Companion*, Second Edition.

Figure 1-21 The Sun Java Desktop System

Summary

Now that you have completed this chapter, you should have an understanding of the following:

- The main components of a computer are RAM, CPU, I/O, and disk. They are controlled by the operating system.

- Most desktop operating systems are intended for use by a single user. Network operating systems such as UNIX are usually installed in servers that can support many users and large networks.

- UNIX originally was developed at Bell Labs, and significant improvements were made at UC Berkeley, including the addition of networking capabilities. The industry standard SVR4 led to the development of several current varieties of UNIX, including Sun Microsystems Solaris.

- The key pieces of the Solaris Operating Environment are the SunOS, the Open Network Computing (ONC) protocols, and the Common Desktop Environment (CDE) GUI.

- The main components of the UNIX OS are the kernel, the shell, the file system, and commands. The kernel manages hardware, daemons, swap space, and the file system.

The shell is an interpreter that provides an interface between the kernel and the user. The file system manages and organizes information on the hard disk. Commands dictate what action the shell is to take.

- Several graphical desktop shells are available for UNIX. CDE is used primarily in the commercial environment. GNOME and KDE are open source desktops used primarily with Linux.

Check Your Understanding

1. Which three of the following are CPUs?

 A. Sun Ultra SPARC

 B. Itanium

 C. Carnivore

 D. Omega

 E. Power PC

2. Most modern PCs use a _____ interface for video.

3. Select four interfaces that can be used to *directly* attach a printer to a PC.

 A. EIDE

 B. SCSI

 C. FireWire

 D. RS-232 Serial

 E. Parallel

 F. USB

4. The capability of UNIX to track multiple processes concurrently is called _____ .

5. Match the proper term to the descriptions of the capabilities of the UNIX operating system.

Multiuser	1. an example would be : username / password
Distributed processing	2. allows more than one tool or process to be used at one time
Multitasking	3. enables many users to access the same resources
Security	4. allows the use of resources over the network

6. Operating systems such as Windows 2000, Solaris, and Linux interact with computer hardware through the use of _____ drivers.

7. Which UNIX operating system became the industry standard for many of today's varieties of UNIX including Solaris?

 A. AT&T System 3

 B. SVR4

 C. BSD 4.2

 D. AIX

8. The GNU General Public License (GPL) is the licensing scheme used by Linux. Which two of the following apply to the GPL?

 A. Users must purchase a site license.

 B. Users may modify the source code.

 C. Users may install the software on any computer.

 D. Programs are free, but users must purchase the source code.

9. A user wishes to refer to UNIX workstations by host name rather than by IP address. Which two of the following will allow them to accomplish this?

 A. DHCP server

 B. Name server

 C. Local host name translation file

 D. SMTP server

10. The _____ is the core of the OS with the necessary basic capabilities to run the computer.

11. Which shell is the default shell in Solaris but lacks aliasing and history capabilities?

 A. Bash

 B. Bourne

 C. C

 D. Korn

12. Which three of the following directories are commonly found on most UNIX systems including Linux?

 A. /etc

 B. /swap

 C. /bin

 D. /deleted

 E. /dev

UNIX Command Summary

Ctrl d Indicates end of file or exit. Example:

```
$ bc
5280/3
1760
<Ctrl d>
$
```

Ctrl u Erases the entire command line.

echo Echos (displays) arguments. Example:

```
$ echo "hi mom"
hi mom

$ echo $SHELL
/bin/ksh
```

ps Prints information about active processes. Example:

```
-e, -f, -u
$ ps
```

Key Terms

Bourne shell The default shell for the Solaris computing environment. It does not have aliasing or history capabilities. The Bourne shell prompt is a dollar sign ($).

BSD (Berkeley Software Distribution) One of two main versions of UNIX that is not an industry standard but is still fairly widely used. Some varieties of UNIX, such as Linux, are based on BSD.

C shell A shell (/bin/csh) based on the C programming language. Like the Korn shell, it has additional features such as aliasing and history. The C shell was developed by Sun's Bill Joy and is still widely used today. The C shell prompt is a percent sign (%).

CDE (Common Desktop Environment) A standard and consistent GUI desktop developed by a consortium of UNIX platform vendors, including Hewlett-Packard, IBM, Novell, and Sun Microsystems, along with many other companies and members of the Open Software Foundation, X/Open, and the X Consortium. CDE is Motif-based.

CPU (central processing unit) The brains of the computer that performs calculations and data manipulation. Usually a microchip, the CPU moves from RAM to the CPU and back.

daemon Programs or processes that perform a particular task or monitor disks and program execution. Daemons are special processes that begin after the OS loads. Daemons then wait for something to do in support of the OS. For instance, the lpsched daemon exists for the sole purpose of handling print jobs. When no printing is taking place on the system, the lpsched daemon is running but inactive. When a print job is submitted, this daemon becomes active until the job is finished.

directory A location for files and other directories. The Solaris file system or directory structure enables you to create files and directories, which can be accessed through a hierarchy of directories.

distributed processing Enables the use of resources across the network. For instance, a user might be sitting at a workstation and be able to access files and applications on the hard disk of another computer or a printer located on a remote part of the network.

driver A piece of software written for a particular operating system to allow it to control a particular hardware device properly.

file A named collection of related data stored on a disk.

file system A hierarchy of directories, subdirectories, and files that are usually organized or grouped together for a specific purpose.

firewall A machine running special software to protect an internal network from attacks outside. Internal hosts connect to external networks and systems through the firewall. Can be configured with additional software to act as a proxy server.

FTP (File Transfer Protocol) A protocol for transferring files over TCP/IP networks.

GNOME (GNU Network Object Model) The latest windowing system to emerge in the UNIX world. GNOME is part of the GNU open source software project. GNOME has been developed as an easy-to-use desktop environment for the user and a powerful application framework for the software developer, free of cost.

GNU Pronounced "ga-new." Means Gnu's Not UNIX. Mainly refers to the components of the OS have been added through the efforts of independent developers and the Free Software Foundation's GNU project (www.gnu.org). The GNU operating system uses the Linux kernel.

GUI (graphical user interface) An alternative to a command-line interface. A GUI enables users to use a mouse to access programs, run commands, and change configuration settings.

host A computer or device in a network having a separate IP address.

HTTP (Hypertext Transfer Protocol) A protocol used for transferring web pages from a web server to a web browser.

IMAP (Internet Messaging Access Protocol) A protocol for exchanging mail messages. The recipient initiates an IMAP session. IMAP differs from POP in that IMAP allows the recipient to leave messages in organized folders on the server; POP requires that the recipient download the messages to organize them.

I/O device Peripheral devices provide a means to get data into and out of a computers. Input devices include a keyboard, mouse, and scanner; output devices include a printer and a monitor.

ISP (Internet service provider) A company that provides Internet access and other related services for a fee.

K Desktop Environment (KDE) A Windows-like GUI popular in Linux, similar in function to GNOME.

kernel The master program (core) of the UNIX operating system. It manages devices, memory, swap, processes, and daemons. The kernel also controls the functions between the system programs and the system hardware.

Korn shell A shell (/bin/ksh) that is a superset of the Bourne shell and that has many of the Bourne shell features, plus added features such as aliasing and history. This is the most widely used shell and is the industry standard for system users. The Korn shell prompt is also a dollar sign ($).

Linux Another version of UNIX that is becoming increasingly popular and runs on different CPUs.

modem (modulate/demodulate) A device that allows remote dial-up to private networks and Internet service providers (ISPs).

multitasking A feature of the Solaris computing environment and UNIX that enables more than one tool or application to be used at a time. Multitasking enables the kernel to keep track of several processes simultaneously.

multiuser A feature of UNIX that enables more than one user to access the same system resources.

NIC (network interface card) Allows computers to communicate with each other via a central hub device using a cabled or wireless connection.

NFS (Network File System) A file-sharing protocol developed by Sun Microsystems. It is a network service that allows users to transparently access files and directories located on another disk on the network. NFS has become adopted as the industry standard networked file system for most UNIX vendors.

NOS (network operating system) A group of programs that runs on servers and provides access to network resources for users.

ONC (Open Network Computing) protocols A family of published networking protocols and distributed services that enable remote resource sharing, among other things.

open source software Software that can be modified and redistributed without a fee or restrictions.

Open Windows Sun's original GUI developed for the Solaris environment. It is similar to CDE, but it is proprietary and not as well supported. The user has a choice when logging in to a Solaris workstation to select either CDE or Open Windows.

peripheral components Components independent of the CPU, RAM, and mass storage. Some of the more common peripherals are keyboard, printer, audio, and video components.

POP3 (Post Office Protocol) A mail server protocol in which the recipient initiates transfer of messages. Differs from IMAP in that POP doesn't provide any means for the recipient to organize and store messages on the server.

proxy server A server on the network that stands in for remote servers. Proxy servers provide security and access control.

RAM (random-access memory) The microchips that make up the real memory of a computer. RAM is the working storage area of the computer where programs (sequence of instructions) and data related to the programs are stored while the program is running. When a program is running, it is copied off the hard disk into RAM, and space is allocated in RAM for the program to do its work.

server Provides resources to one or more clients by means of a network. Servers provide services in an UNIX environment by running daemons. Examples of daemons include Printer, FTP, and Telnet.

service A process that provides a service such as remote file access, remote login capability, or electronic mail transfer.

shell An interface between the user and the kernel. It acts as an interpreter or translator. The shell accepts commands issued by the user, interprets what the user types, and requests execution of the programs specified. Execution is performed by the kernel.

SMTP (Simple Mail Transfer Protocol) The TCP/IP protocol used to transfer e-mail across the Internet. SMTP communicates with the SMTP server at the other end and directly delivers the message. Sendmail is the most common implementation of SMTP.

SMB (Server Message Block) A file-sharing protocol developed by Microsoft. Computers running one of the Microsoft operating systems such as Windows 9x, NT, 2000, or XP use the SMB protocol for sharing files and printers on a network. SMB performs a similar function for Microsoft clients as NFS does for UNIX clients or Netware Core Protocol (NCP) does for Novell clients. The SMB/CIFS protocol also provides for sharing of files and printers between Microsoft and UNIX systems.

SPARC (Scalable Processor Architecture) Sun Microsystems' proprietary CPU chip designed strictly for Sun's line of workstations and servers.

subdirectory Any directory below another directory. For example, the /usr directory is a subdirectory of the root (/) directory.

SVR4 (System Five Release Four) One of the two main versions of UNIX. Currently, a number of varieties or "flavors" of UNIX exist, and most are similar because they are based on the industry standard SVR4. System V is a version of the UNIX operating system developed by AT&T. Sun Solaris SunOS is based on SVR4.

swap space A reserved part of the hard disk for the kernel to use during processing. Portions of running programs can be "swapped out" to the hard disk and then brought back in later, if needed. This swap space is actually on the hard disk, but it looks like additional memory or RAM; it sometimes is called virtual memory. Swap space is a raw slice or disk file that is set aside during system installation for the purpose of paging programs out to disk temporarily while they are not being used.

tape drive Common backup device used primarily on high-end workstations and servers.

Objectives

After reading this chapter, you will be able to

- Describe different types of UNIX user accounts.
- Use the Common Desktop Environment (CDE) windowing system.
- Customize the CDE workspace with Style Manager.
- Work with CDE subpanels to add and remove applications.
- Use GNOME and KDE windowing systems in Linux.
- Customize GNOME.

Chapter 2

Accessing a System and UNIX Graphical Interfaces

Introduction

In this chapter, you learn the requirements for user accounts and passwords. Also covered in this chapter is the procedure for logging in and out of the system using both the command line and graphical login manager. Students will become familiar with the UNIX Common Desktop Environment (CDE), basic features and functions of CDE, and how to use the *Style Manager* to customize the CDE *workspace*. GNU Network Object Model Environment (GNOME) and K Desktop Environment (KDE) graphical desktop managers will be introduced as well as working with GNOME panels and menus.

UNIX Login Accounts

Users must have an account to access resources on a UNIX system. User accounts identify a user to the system. Accounts also determine what activities a user can perform and what files a user can access. Two types of accounts exist on a UNIX computer. They are the *root* or *superuser* account and user accounts.

The Root Account

The root account is the system administration account and is created automatically during the operating system installation process. The root account is the only account on the system when the OS is first installed. The root account owns all system files and has access to all files. It is similar to the Administrator account with Windows NT/2000 and the Admin account with Novell NetWare.

The root account creates new users, manages file systems, installs software, and performs other high-level system administration tasks. The root account can access and modify any file or directory on the system. Because it is "all powerful," the root account should be used sparingly.

Most UNIX administrators have a user account with special administrative privileges that they use on a daily basis and log in as root only when necessary. This minimizes the risk of leaving the root account exposed by accidentally walking away from the system while logged in as root and potentially having the system compromised. Figure 2-1 summarizes the characteristics of the root account.

Figure 2-1 Root Account Characteristics

- The superuser account
- Default account created during operating system installation
- Used for system administration

User Accounts

User accounts are created and maintained by the system administrator when logged on as root or at the end of the installation process in some Linux distributions. Every user who needs access to the system must have a user account to log in and use the computer. Regular users can run applications and customize their work environment. They also can create and modify files in their *home directory* and subdirectories below it. Figure 2-2 summarizes the characteristics of a user account.

Figure 2-2 User Account Characteristics

- All other users
- Access to applications and printers
- Access to personal files

Login ID and Password Requirements

System administrators and users must adhere to certain rules when creating user accounts and passwords.

Login ID

For users to log in, they must have a user account that includes a *login identification (ID)* and password. The login ID is the user's public name and is commonly referred to as the username. Depending on the system administrator, login IDs are usually some combination of a user's

first and last names. For example, user Bob Wood's login ID might be bobw, bwood, woodb, or bw2. The login ID must be unique on the system and there are usually some limitations on the type and number of characters that can be used. Login IDs on Solaris systems are limited to eight alphanumeric characters. Solaris system login IDs can be any combination of upper- or lowercase letters, numbers, and special characters such as: !, $, -, _, and so on as demonstrated in Figure 2-3. Most versions of Linux limit the login ID to 32 alphanumeric characters or fewer. It is best to keep login IDs to eight or fewer alphanumeric characters and use special characters sparingly. Dashes and underscores are recommended. When creating the user, the administrator can also include the user's full name. The login ID, user's full name, and other account information are stored in the password (*/etc/passwd*) file, which can be viewed by all users. User passwords, in encrypted form, are stored in the /etc/shadow file.

Figure 2-3 Solaris User Account Login ID Requirements

- Limited to eight alphanumeric characters
- Must be lowercase characters only
- Must be unique for this system
- Can contain numbers

Passwords

The user's password protects the account from unauthorized access. In both Solaris and Linux, there are specific rules for creating passwords to help ensure system security.

Solaris and Linux passwords must be at least six characters in length and different from the login ID. The first six characters of the Solaris password must contain at least two alphabetic characters and at least one numeric or special character. Linux passwords can be any combination of alphanumeric or special characters, and there is no requirement for what the first six must contain.

Passwords are case sensitive. This means that they can be created with uppercase or lowercase letters and must be entered exactly the same way when logging in. For example, the password ABc123 is different from the password ABC123. When changing Solaris passwords, the new password must differ from the previous password by at least three characters. When changing Linux passwords, the new password must contain no more than two successive characters from the previous one and cannot contain dictionary words. Passwords may contain spaces and special characters. As an example, the password a9$B7 c5 is perfectly valid. The length is six or more characters, it also has upper- and lowercase letters, numbers, a special character, and a space. A list of Solaris password requirements that apply to user accounts follows:

- Must be no fewer than six characters
- Must contain at least two alphabetic characters (upper- or lowercase)

NOTE

The password require-
ments discussed here do
not apply to the Solaris
root account password
or to any user password
assigned by the root
user. These rules apply
when a Solaris user
changes his password.
The Linux root user
password follows the
same rules as a regular
user account.

- Must contain at least one numeric or special character
- Must differ from the user's login ID
- Must differ from previous password by three characters
- Can contain spaces and special characters
- Is case sensitive (letters must be typed in as upper- or lowercase)

Accessing the System

A UNIX system can be accessed (logged in to) locally or remotely, and the user has a choice
either using the command line or a GUI such as CDE or GNOME.

Local Access

Most UNIX systems provide two ways to directly access a system. The user can log in using
either a graphical interface such as CDE, or the standard character-based login.

Remote Access

Character based—A user can also access a UNIX system from another computer such as
a Windows PC, Apple Macintosh, or another UNIX system. To log in to a remote UNIX
workstation or server, the character-based Telnet program or the UNIX command rlogin,
for "remote login," can be used.

Graphically based—Remote login with a UNIX GUI (CDE, GNOME, KDE, and so on)
can also be accomplished from a Windows PC using an X Windows terminal emulator pro-
gram. Once logged in the user can also use graphical programs. X Windows is the standard
graphical support system for UNIX. More information about X Windows can be found
at http://www.opengroup.org/desktop.

Emulators are available from such companies as StarNet (www.starnet.com), Hummingbird
(www.hummingbird.com), and Tarantella (www.tarantella.com). When finished working
with UNIX, exit the emulator program and return to Windows. It is also possible to cut, copy,
and paste between the two environments.

CDE Login Manager

Most Solaris workstations have the graphical CDE installed and will boot automatically to a
graphical environment. Before logging in to the account, CDE displays the graphical Login
Manager screen shown in Figure 2-4.

Figure 2-4 CDE Login Manager

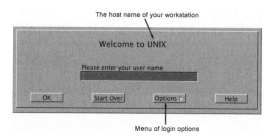

Four buttons are located at the bottom of the Login Manager screen:

- **OK**—Accepts the username and password as entered
- **Start Over**—Clears the username and password fields
- **Options**—Provides several choices for logging in
- **Help**—Provides assistance for using Login Manager

Logging in identifies the user to the system. To log in, use the login screen shown or log in at the command line. When the CDE Login Manager screen is used, the user enters the CDE GUI environment.

Options Button

The CDE Login Manager Options drop-down menu provides a set of choices for logging in. Five choices are available with the Options menu, as summarized here:

- The **Language** option typically is set at installation and is not used often.
- The **Session** option offers a choice of GUI desktop environments (CDE or Sun's original GUI called Open Windows available with Solaris 2.6, 7, or 8) and provides a Failsafe login option, which can be used for troubleshooting.
- **Remote Login** allows the user to log in to another UNIX machine, such as a server or another workstation on the network.
- The **Command Line Login** option bypasses the GUI environment and goes directly to a console prompt. It stays at the command line.
- The **Reset Login Screen** option restores all settings to their defaults.

Logging In with CDE

The CDE login screen shown in Figure 2-4 replaces the usual login prompt common in UNIX systems. The Login screen is the entry point into the system. If a login ID, or username,

> **NOTE**
>
> Two unique usernames are user2 and user02. The usernames user01 through user20 are used by students taking the Fundamentals of UNIX course. user2 is the username used for all interactive e-Lab activities found in the curriculum and on the accompanying CD-ROM.

and password have not been assigned, the system cannot be accessed. The username for all interactive e-Lab activities will be user2.

Enter the login name in the appropriate boxed area and then press the Return (Enter) key or click the OK button. If the login name or password are typed incorrectly, the process must be repeated using the correct information.

The Start Over button completely refreshes the screen and removes any typed entries. Once logged into the CDE graphical desktop, a *front panel* is presented, which is the primary desktop management tool.

Exiting from CDE

Logging out prevents unauthorized users from gaining access to personal files. Logging out should occur whenever the user is going to be away from the system for an extended period of time. To leave the CDE session and log out of the UNIX system, click the Exit button on the front panel. It is not necessary to shut down the typical UNIX computer because these computers are designed to be left running. However, if the system must be shut down, always be sure to exit (log out) first. By default, the user will be asked to confirm that log out is desired. Confirmation is done by clicking the OK button or by pressing Return when the OK button is highlighted, as shown in Figure 2-5.

Figure 2-5 Exiting from CDE

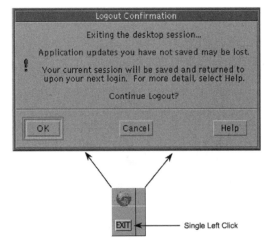

The current CDE session is saved automatically so that the user can return to the same workspace windows at the next CDE session. However, any data contained in the current set of open windows will be lost. Therefore, save all data before exiting from the CDE session. It is possible to

change the default activities of the Exit button so that confirmation is not required. This is discussed later, in the section "Customizing the Workspace with Style Manager." Upon exiting the system, return to the CDE Login Manager screen. Use the interactive e-Lab Activity to practice logging in using the CDE login screen.

 e-Lab Activity 2.1 Using the CDE Login Screen

In this activity, you practice logging in and out of a UNIX system using the CDE Login Manager screen. Refer to e-Lab Activity 2.1 on the accompanying CD-ROM.

Command-Line Login

An alternative to logging in with the CDE login screen is to bypass the CDE graphical desktop and go directly to the command line. To log in from the command line, display the Options drop-down menu and select Command Line Login. Press Return quickly, or the Login Manager will restart.

Enter the username at the console login and then the password at the password prompt.

Command-line login is quick because the CDE graphical desktop is not loaded. Use this option to do file management or troubleshooting from a shell prompt.

Exiting from the Command Line

To log out while at the command prompt, simply type **exit** and press Enter. This exits the user from the system and redisplays the console login prompt. If the user does not log back in within 30 seconds, the CDE Login Manager screen is displayed again. Use the accompanying e-Lab Activity to practice logging in and out as user2 using the command line.

Remote Access Using Telnet

Another way to access the command line of a remote UNIX system is to use the *Telnet* program. The procedure for accessing a remote UNIX system depends on what Telnet program is in use. Telnet programs include the UNIX **telnet** command, Windows Telnet, NCSA Telnet for Macintosh users, and a shareware Telnet program. To Telnet to another system, the IP address or host name of the remote UNIX workstation or server must be specified. When a connection is established with the remote host, the user will be asked to enter a valid username and password. IP addresses and the UNIX Telnet program are covered in Chapter 16, "Network Concepts." Figure 2-6 shows the connection screen when using the Windows Telnet program. After connection is established, another screen appears requesting a valid username and password.

NOTE

The password does not appear as typed. By default, if the user does not have a password, an automatic prompt will ask that one be created during the initial login.

NOTE

The remote host must be able to act as a Telnet server to respond to Telnet access from a client. Some OSs, such as Windows 98, do not support Telnet access. Other OSs, such as Linux, support Telnet but the service may need to be enabled. Virtually all OSs provide a Telnet client.

TIP

Sometimes the Backspace and Delete keys will not work after attempting to use Telnet to access a remote UNIX system. Some Telnet programs provide an option that allows the user to define these keys. If the Telnet program does not allow these keys to be defined, type **stty erase** at the shell prompt after log in. Next, press the Backspace key, this will enter a ^H, followed by Enter. This allows the Backspace key to work properly.

TIP

On most systems, the Ctrl and d keys (Ctrl+d) can be used to log out or exit a Terminal window. C shell users also can choose to use the **logout** command. Any other commands, such as **bye**, might be an alias set up by the administrator that runs the **exit** command and might not work on another UNIX system.

Figure 2-6 Telnet Connect Screen

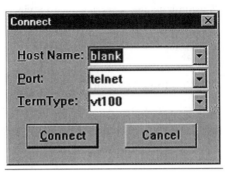

 e-Lab Activity 2.2 Using Command-Line Login

In this activity, you practice logging in and out from a UNIX system command-line environment. Refer to e-Lab Activity 2.2 on the accompanying CD-ROM.

Login Process

During the login process, the system refers to two special files to determine if a valid user is attempting to access the system. Those two files are the /etc/passwd and the /etc/shadow files. Figure 2-7 shows the UNIX login process and the interaction with these files.

Figure 2-7 Login Process

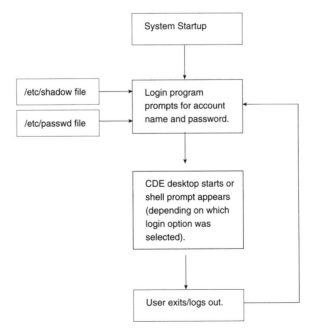

/etc/passwd File

The /etc/passwd file contains the master list of user information. It is consulted each time someone attempts to access the system. Each line in the passwd file represents a single user's account information and contains seven fields separated by a colon. Each entry has the following seven fields separated by a semicolon:

```
Name : placeholder for password : UID : GID : user information : users home directory :
shell program
```

Here is an example:

```
mmouse:x:1100:10:Micky Mouse in sales:/home/mmouse:/bin/ksh
```

Each of the seven fields has a unique meaning:

- The name field (mmouse) contains the username assigned to the user by the administrator. Usernames are typically some combination of a user's first and last name. If the username entered on the login screen does not match any username listed in the /etc/passwd file, that user will not have access to the system.

- The password placeholder field contains an "x" or an exclamation mark (!) in some versions of UNIX. These symbols tell the system to look for the encrypted password in the shadow password file /etc/shadow. The shadow file is protected from all users except the root user, to prevent hackers from trying to crack user passwords.

- The **user identification (UID) number** (1100) is assigned by the system administrator. The UID identifies the user to the system. This number relates to the username and is used to determine ownership of files that the user creates, as well as access to files and directories. The system administrator can assign the user ID, or the system will generate one automatically when a new user is created. The UID of the root user account is 0.

- The user's primary **group identification (GID)** membership number (10) relates to a group or set of users working on the same project. The GID is the name that is used to determine group ownership of files that the user creates, as well as access to files and directories. The system administrator assigns the group ID. For example, one group may be Finance, with a GID of xxx, for the accountants who access the system.

- The user information (Micky Mouse in sales) field typically contains the user's full name. This allows anybody viewing the /etc/passwd file to determine who is associated with a potentially cryptic username. It may also contain a department name or other information. This information is also used by mail systems and commands.

- The user's home directory (/home/mmouse) field contains the absolute path name of the user home directory. When users log in, the system automatically places the users in their home directory, where their personal files are located. User home directories are typically located under the /home directory and are a combination of characters descriptive of the user's name; mmouse, for example. The home directory of the root account is the root (/) directory with Solaris and the /root directory with Linux.

TIP

The user can find out
the UID number, user-
name, GID number, and
group name for an
account by typing the **id**
command at the com-
mand prompt.

■ The shell program field contains the path name (/bin/ksh). This path name leads to the program that UNIX uses as the command interpreter for the user. In this case it is the Korn shell (ksh). The shell program executes when the user first logs in and when a Terminal window is opened.

Proper UNIX System Shutdown

Because UNIX systems are multiuser and multitasking, they are typically left running continuously and are normally shut down by an administrator (the root account password is required) to install a new release of the operating system, add hardware, or perform routine system maintenance.

If the user must power off a UNIX system, it is important to shut down correctly. This is the case with most operating systems. It allows all system changes recorded in RAM to be written to disk and facilitates an orderly shutdown of processes and file systems. It is similar to clicking Start/Shutdown with Windows 9x or NT/2000/XP. Failure to do so can result in file corruption.

Using the system initialization state (**init**) and **shutdown** commands are the primary ways to shut down a UNIX system. The figure shows the use of the **init** command to begin the shutdown process. Most GUI desktops provide the ability to log out or exit from the current login session in order to log in as another user. The user must be logged in as the root user to shut down most UNIX systems. See Figure 2-8 for the actual commands:

Step 1 Either log in as root or switch to the root account using the **su** command, which is covered in Chapter 10.

Step 2 Shut down the system by using either the **init 0** or the **shutdown** commands. The system initialization state of 0 is off.

Step 3 Power off at the Type Any Key to Continue prompt on an Intel PC running Solaris or the OK prompt on a Sun workstation. The system may power off automatically with some versions of UNIX.

Figure 2-8 Proper System Shutdown

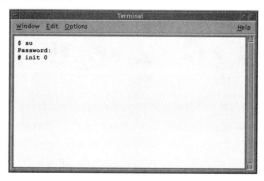

Changing a Password

Changing the user password frequently helps prevent unauthorized access to the system. The actual process of changing the password is the same whether the user is logged in through a graphical login manager or the command line. In either case, the password is changed at the command line.

Opening a Terminal Window

If logged in to a CDE session, right-click the background to bring up the Workspace menu, click Tools, and open a Terminal window, as shown in Figure 2-9. To open a Terminal window with GNOME, click the Terminal Emulation Program icon on the panel at the bottom of the screen, as shown in Figure 2-10.

NOTE

Some versions of Linux provide the option to shut down or reboot the system from within the GUI (GNOME, KDE, BlueCurve, and so on) without having to be root.

Figure 2-9 Opening a Terminal Window with CDE

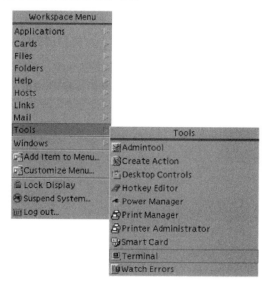

Figure 2-10 Opening a Terminal Window with GNOME

NOTE

On some CDE systems, the Terminal window program can be found under the Windows Workspace menu option or on the Applications submenu.

The Terminal window gives the user access to a command-line $ prompt. The dollar sign ($) represents a Korn, Bourne, or Bash shell. The percent sign (%) represents the C shell, and a number or pound sign (#) typically indicates that the user is logged in as root. After the Terminal window opens, type the **passwd** command after the system prompt and press Return (the Enter key on most keyboards). When prompted to enter the login password, type the current password and press Return. When prompted for a new password, type the new password following the rules discussed previously and press Return. The user then is prompted to retype the new password to confirm it. This is required for verification of the new password by the system. Use the accompanying e-Lab Activity to practice changing the password for user2 using the command line in a Terminal window. Follow the rules for valid passwords that were previously covered. Remember that passwords are case sensitive and can contain spaces and special characters.

Prompts to Change a Password

NOTE

The password will not appear on the screen as it is typed.

Figure 2-11 shows the series of prompts that results from the passwd command on a Solaris system. The prompts are similar on a Linux system.

Figure 2-11 Prompts to Change a Password

TIP

If you have problems accessing the account, contact the system administrator.

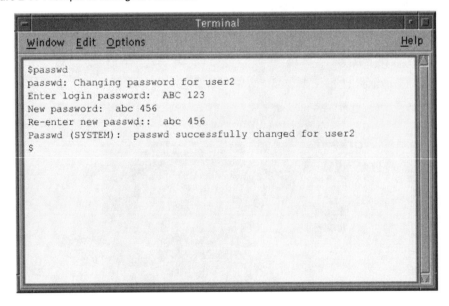

Password Aging

Password aging is a security feature that might or might not be implemented by the system administrator. Password aging options can include requiring a user to change the password after a certain number of days, setting an absolute expiration date when the account can no longer be accessed, and even locking the account after a certain number of days of inactivity.

Forgot the Password?

If the password is forgotten, the only option is to contact the system administrator. The administrator will not be able to tell the user what his password is, but will be able to assign a new, temporary one. When the new password is given, immediately use the **passwd** command to change the password to one that can be remembered.

e-Lab Activity 2.3 Changing a Password

In this activity, you change the login password using password rules discussed in this section. Refer to e-Lab Activity 2.4 on the accompanying CD-ROM.

Lab Activity 2.1.8 Accessing the System

In this lab, you review the requirements for UNIX login IDs and passwords. You practice logging in to a UNIX system using the CDE login screen. You then change your password, exit or log out, and return to the CDE login screen. Refer to the *Cisco Networking Academy Program Fundamentals of UNIX Lab Companion*, Second Edition.

> **NOTE**
>
> The system administrator, logged in as root, can change the password for any account by entering the **passwd** command followed by a username. For example, if the administrator wanted to change the password for user jsmith, the proper command would be **# passwd jsmith**. The administrator will then be prompted for the new password directly.

Becoming Familiar with CDE

CDE is a widely used UNIX graphical interface or shell. This section discusses ways in which you can familiarize yourself with the features and capabilities of the CDE.

Front-Panel Workspace Buttons

When you log in to a CDE session, four workspaces are available by default. (See Figure 2-12.) Each workspace is equivalent to a complete desktop environment. The following buttons surround the workspace:

- Workstation lock icon
- System busy globe icon
- Exit icon

Figure 2-12 Workspace Buttons

You can independently set the characteristics of each workspace as well as add more workspaces and desktops, if needed. You can alternate among the workspaces by clicking the appropriate workspace button. On the Sun workstation, use the keyboard metakey (diamond) combined with the left or right arrow keys.

Multiple workspaces or *virtual desktops* can be useful. The user could have one desktop arrangement for administrative tasks, one for applications and regular user tasks, one for special projects, and another for application development.

Front-Panel Arrangement

NOTE

In some locations, the function of the metakey differs. It might be necessary to use the Alt key or the spacebar with the arrow keys to perform the function described here.

The front panel allows the user to manage applications, files, and network services easily. The front panel has been organized to include icons for a web browser, text notes, and a performance meter. (See Figure 2-13.) The *subpanels* contain cascading submenus for ease of navigation. Click an up arrow button to open a subpanel, then click an item in a subpanel to run it. The spinning globe above the Exit button indicates that the system is busy. When the spinning globe is clicked, it becomes an Action: Go entry panel. It then prompts the user for a uniform resource locator (URL), path name, host, e-mail address, and so on to open. (See Figure 2-14.)

Front-Panel Menu Button

At the top-left side of the front panel is the front-panel window menu button. If this is selected, a menu of choices is displayed. (See Figure 2-15.) From this menu, it is possible to perform the following actions:

- Minimize the front panel display.
- Lower the front-panel display behind overlapping windows.

- Refresh the entire workspace display.
- Log out from the CDE session.
- Move the front panel to another location on the screen. Dragging the front panel to a new position by one of the move handles also can do this.

Figure 2-13 Front-Panel Arrangement

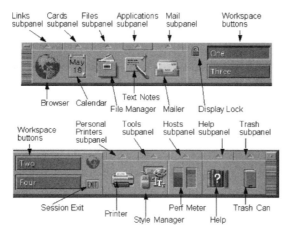

Figure 2-14 Action Button

Figure 2-15 Front-Panel Menu Button

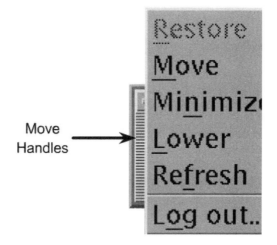

Using the Mouse and Keyboard

The mouse and the keyboard are the primary input devices for most computers. The user may be working with a Sun Solaris workstation or an Intel-based personal computer running either the Solaris or Linux operating system. It is helpful to understand the differences between the Sun workstation version and the typical PC version of these two input devices.

Mouse

A mouse is used with the CDE in a similar way as with other GUIs. The mouse settings can be modified to suit a user's preferences. When a setting has been modified, that setting can be stored into a user specific file. Any personalized settings will be the default whenever a CDE session is initiated. The mouse used with a Sun workstation has three buttons (a left, middle, and right button). (See Figure 2-16.) Most personal computers typically have two buttons, a left and a right button. The middle mouse button with the Sun workstation is used primarily as a paste button for copy/paste operations. We will focus on the function of just the left and right buttons.

Figure 2-16 Sun Mouse and a Typical PC Mouse

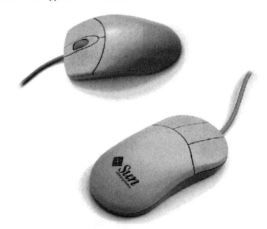

Left Mouse Button

Most actions use the left mouse button, alternatively known as button 1 or the Select button. This button is used to make selections in any of the following ways:

- **Make a window active**—Click the left mouse button while the mouse pointer is in that window area.
- **Invoke a window menu**—Click the left mouse button while the mouse pointer is on the window's menu box area.

- **Select an option from the front panel**.
- **Select a file or folder icon**—The user can do this while working with the *File Manager*.
- **Open an icon**—Double-click the left mouse button while the pointer is over the icon.
- **Highlight text to be selected**—Drag over the text area while the left mouse button is being pressed.

NOTE

For the purposes of this course, you will be instructed to click (indicating a left click) or right-click, to perform a specific action. These instructions are based on standard right-hand configuration of the buttons. You will also be instructed when a double-click is required.

Right Mouse Button

When the right mouse button, or the Menu button, is clicked or held down, a menu of choices appears. This is button 3 on a Sun workstation. The options available on the menu are determined by the position of the mouse pointer when the right button was pressed.

Keyboard

This section contrasts the Sun workstation and PC keyboards.

PC Keyboard

It is useful to compare the two keyboards so that you can work with either one. As with the mouse, the Sun workstation keyboard and the PC keyboards differ. (See Figure 2-17.)

A typical PC has a keyboard with 104 keys and 4 major sections or areas on the keyboard:

- Typewriter keys for letters, special characters, Ctrl, Shift, Alt, and others.
- Function keys labeled as F1, F2, F3, and so on.
- Cursor-management keys labeled as Insert, Home, End, arrow keys, and others.
- Numeric keypad

Figure 2-17 Sun Keyboard and a Typical PC Keyboard

Sun Workstation Keyboard

The Sun workstation keyboard is wider than the one for a typical PC. It has all the previously
mentioned keys and a few more, for a total of 118. Most of the additional keys are in two
additional sections of the keyboard. A section to the left of the keyboard provides 10 keys for
window management and common functions such as cut, copy, and paste. A large Help key is
in the top-left corner of the keyboard. In the typewriter portion of the keyboard are two keys
with a diamond-shape outline on them, known as metakeys. These two keys perform various
functions, such as alternating between workspaces. Another section exists at the top right,
which controls sound volume.

Managing Windows

Most PC users are accustomed to working in a graphical environment with windows. The
UNIX CDE is very similar in its operation. The following are common tasks that are
normally performed in a windowed environment.

Overlapping Windows

When an icon is selected from the front panel, a window opens on the workspace screen.
Windows on the workspace overlap each other, with the most recently opened window over-
lapping previously opened windows. (See Figure 2-18.)

Figure 2-18 Overlapping Windows

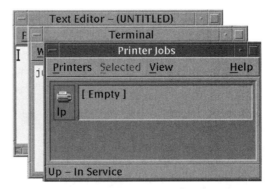

Lowering a Window

To choose the window menu, position the mouse pointer on the window title area and press
the right mouse button. One option in the resulting menu is to lower the window. This option
forces the window to the back of the overlapping windows on the screen display. (See
Figure 2-19.)

Figure 2-19 Lowering a Window

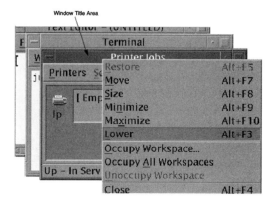

NOTE

There is no alternative to moving a window to the front of a set of overlapping windows. When selected, a window automatically comes to the front of any overlapping windows in a CDE display. On a Sun workstation keyboard, the Front key brings a window to the front of the display. (See Figure 2-20.)

The alternative keyboard action is to hold down the Alt key and press function key 3 (Alt+F3).

Figure 2-20 Sun Keyboard Edit Keys

Moving a Window

A window can be moved in two ways. One way is to choose the Move option from the window menu. The mouse pointer changes from an arrow pointer to a small cross pointer. Drag the cross pointer to move the window. As the cross moves, an outline of the window is displayed on the screen. When the outline is in the desired position, click once with the left mouse button and the window will move there. (See Figure 2-21.)

Figure 2-21 Moving a Window Using the Menu Method

| Text Editor – (UNTITLED) | |
| File Edit | |

Restore	Alt+F5
Move	Alt+F7
Size	Alt+F8
Minimize	Alt+F9
Maximize	Alt+F10
Lower	Alt+F3
Occupy Workspace...	
Occupy All Workspaces	
Unoccupy Workspace	
Close	Alt+F4

The other method is easier and uses the drag-and-drop technique. Place the mouse pointer over the window's title area, hold down the left mouse button, and drag the window to its new screen location. When the window is being moved, a pair of numbers is displayed on the screen. These are the x-axis and y-axis values. These numbers show the new position of the window on the workspace display. The number on the left represents the horizontal (X) position. The number on the right represents the vertical (Y) position. These numbers are useful to developers and programmers who want to have a window appear in the same position every time an application is invoked. (See Figure 2-22.)

Figure 2-22 Moving a Window Using the Drag-and-Drop Method

Minimizing and Restoring a Window

At the top-right side of the window is a Minimize button. Clicking this button converts the window into an icon. (See Figure 2-23.) By default, the icon of a minimized window is placed at the left edge of the workspace display. However, the icon can be moved to any

desktop location by dragging it to the desired position. Only one click of the left button is required to change a window to an icon. To change the icon back into a window, double-click the icon with the left button. Clicking once on an icon invokes the window menu. Select Restore to change the icon back into a window. (See Figure 2-24.)

Figure 2-23 Minimizing a Window

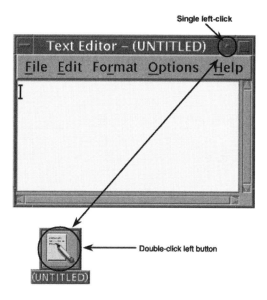

Figure 2-24 Restoring a Window

Restore	Alt+F5
Move	Alt+F7
Size	Alt+F8
Minimize	Alt+F9
Maximize	Alt+F10
Lower	Alt+F3
Occupy Workspace...	
Occupy All Workspaces	
Unoccupy Workspace	
Close	Alt+F4

Maximizing a Window

To make a window fill the entire workspace display, click the box button at the top-right side of the window. (See Figure 2-25.) To reduce the full display window to its previous window

NOTE

When a window occupies all of the workspace display, no other windows can be seen, because they are covered up. To switch to another window, either lower the full display window or reduce it to its previous size. Use the F9 and F10 function keys with the Alt key as keyboard alternatives to using the mouse.

size, select the box button again. When the window is reduced to its previous size, it is placed in its previous display position on the workspace.

Figure 2-25 Maximize a Window

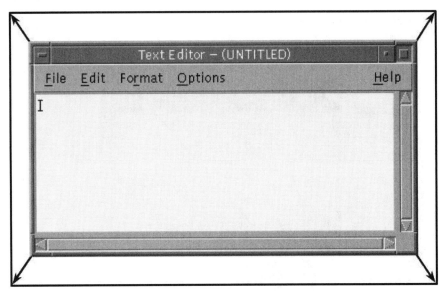

The Minimize and Maximize buttons are shown in Figure 2-26, along with the window menu equivalents.

Figure 2-26 Minimize/Maximize Menu Options (and with Buttons)

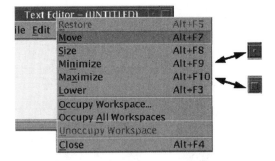

Closing a Window

To close a window, double-click the dash in the upper-left corner of the window with the left mouse button. (See Figure 2-27.) Windows can also be closed with a single click of the left

mouse button. In the upper-left corner, select the Close option from the menu that is displayed. UNIX will prompt the user to save information if closing the window may cause unsaved data to be lost. (See Figure 2-28.) The keyboard alternative to close a window is Alt+F4. Most applications will prompt a confirmation for closure of a window that contains unsaved data.

Figure 2-27 Closing a Window

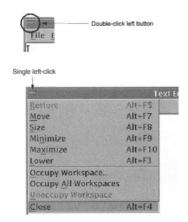

Figure 2-28 Prompt to Save Your Information

Locking the Display

Click the Display Lock button on the front panel to lock the screen whenever you leave your computer to prevent unauthorized access. The backdrop will be blank, by default, and the Password Prompt box will be displayed for a short time. Move the mouse or press a key on the keyboard, to redisplay the password prompt. A locked display can be unlocked only by entering the correct password for the user who locked the screen. (See Figures 2-29 and 2-30.)

NOTE

If a user locks the display and forgets the password, the root user can enter the root password to unlock the display. The Style Manager, discussed later, enables the user to choose a screen saver program while the display is locked.

Figure 2-29 Locking the Workstation Display

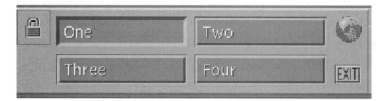

Figure 2-30 Unlocking the Workstation

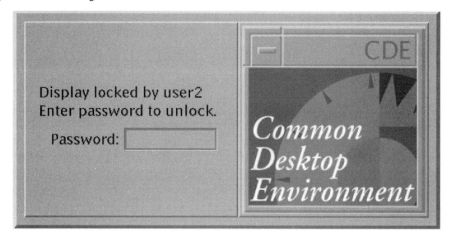

Workspace Management

Four workspaces are available when the first CDE session is started. (See Figure 2-31.) Additional workspaces can be created. Each takes up the whole display area of the screen. Click the right mouse button while the pointer is positioned over the workspace buttons area to get a menu of options. (See Figure 2-32.) One option is to add a workspace. A limited menu will appear if the pointer is positioned over the area between the workspace buttons instead of over the button itself. When a new workspace is added, it is given the name New.

Figure 2-31 Workstation Buttons

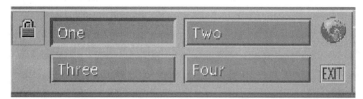

Figure 2-32 Adding a Workstation

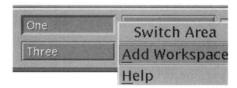

The name of a workspace can be changed by either of the following two methods:

- Choose the Workspace Buttons menu option Rename. (See Figure 2-33.)
- Double-click the workspace name in the central area of the front-panel display.

Figure 2-33 Renaming a Workstation

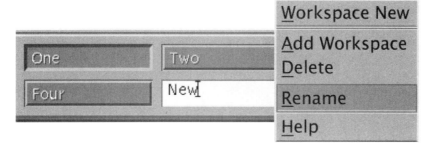

Do not give the workspace a name that is too long to be fully displayed. When the name is too long for the display, only the leftmost characters will be displayed in the front-panel display area.

Workspaces can be deleted from the front panel area by using the Delete option in the Workspace Buttons menu.

Minimizing and Maximizing the Front Panel

Click the Minimize button at the top right corner of the front-panel window to minimize the front panel. (See Figure 2-34.) The resulting icon shows the name of the current workspace immediately below it. To restore the front-panel display, double-click the minimized front-panel icon. (See Figure 2-35.) If the icon is hidden behind another window, lower the overlapping windows until the front-panel icon can been seen or press the Alt+Tab keys until the front-panel icon is brought to the front of the overlapping windows displayed on the screen.

Figure 2-34 Minimizing the Front Panel

Figure 2-35 Restoring the Front Panel

Workspace Menu

NOTE

The Workspace menu on the system might look different from the picture in the figure.

The Workspace menu provides easy mouse access to all applications, tools, and files through cascading submenus. (See Figure 2-36.) To display the menu, move the pointer to the backdrop and press the right mouse button.

Figure 2-36 Workspace Menu

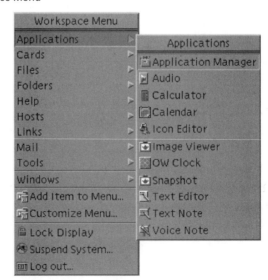

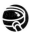

Lab Activity 2.2.7 Becoming Familiar with CDE

In this lab, you work with the standard GUI for most commercial versions of UNIX, the CDE. You become familiar with the front panel and use the mouse and keyboard to manage windows. You also practice locking the display, moving between workspaces, and using the Workspace menu. Refer to the *Cisco Networking Academy Program Fundamentals of UNIX Lab Companion*, Second Edition.

Introduction to the CDE Tutorial

Sun Solaris CDE provides a basic tutorial for users new to the CDE desktop. To access the tutorial, click the Help subpanel menu and then click Desktop Introduction. (See Figure 2-37.) This allows you to choose from the following topics:

- Basic Desktop Skills
- The Desktop at a Glance
- How to Get Help
- Keyboard Shortcuts for the Desktop
- Glossary

Figure 2-37 CDE Desktop Introduction Tutorial

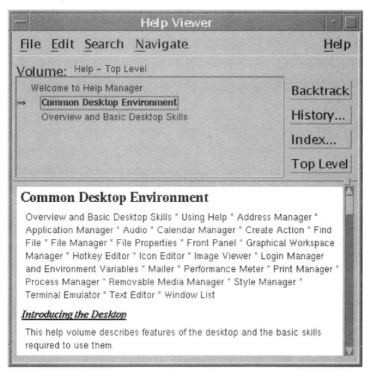

Using Style Manager Options

The Style Manager enables the user to customize the following workspace attributes, as shown in Figure 2-38:

- **Color**—Sets the color attributes of the windows and the workspace background
- **Font**—Sets the size of the font display in points
- **Backdrop**—Sets the workspace backdrop display
- **Keyboard**—Sets key click and key repeat characteristics
- **Mouse**—Sets mouse button positions, acceleration, and threshold values
- **Beep**—Sets the tone and duration of the beep
- **Screen**—Sets screen blanking characteristics and background lock programs
- **Window**—Sets the behavior controls for windows and icons
- **Startup**—Sets the logout and CDE session startup controls

Figure 2-38 Style Manager Options

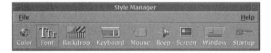

Color

The Color controls enable the user to select a color system for the backdrop, window borders, windowpane, and menu areas of the display. (See Figure 2-39.) Each display is set to a color based on the palette chosen from the list. After the palette is chosen, it can be modified to suit the user's needs by clicking Modify. Color changes will apply to all workspaces.

Font

Changing the font size alters the display character size of the next and subsequent windows opened. The text size in the Help Viewer documents is not affected by changing font size. Different font sets can be added to the list of Font Groups by clicking the Add button. The Attributes button enables the user to choose alternate character sets. (See Figure 2-40.)

Backdrop

The Backdrop choice enables the user to change the background for the current workspace. (See Figure 2-41.) Color choices that are made will also affect of the backdrop appearance. Each workspace can have a different backdrop applied to it.

Figure 2-39 Style Manager – Color

Figure 2-40 Style Manager – Font

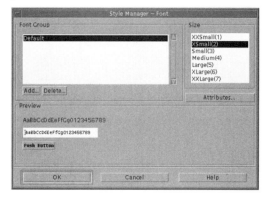

Figure 2-41 Style Manager – Backdrop

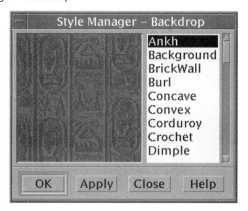

Keyboard

The Keyboard controls enable the user to turn keys repeating on and off. To have the keys make a sound when they are pressed, adjust the click volume to be as loud as possible. If the value is set to 0, the key click is effectively turned off. If any changes have been made to the settings, selecting the Default button restores the values to those shown in Figure 2-42.

Figure 2-42 Style Manager – Keyboard

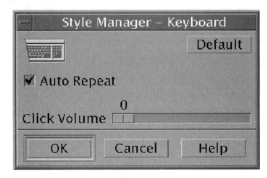

Mouse

Changing the left or right handedness of the mouse reverses mouse buttons 1 and 3. Button 2 can be used to select text or objects to adjust. Button 2 can also be used to drag and drop objects to transfer. Select Adjust for the transfer actions. Drag will require the use of mouse button 1. The maximum time between clicks of a double-click can be adjusted. Changes to this will become effective with a new login session. Acceleration changes how fast the mouse pointer moves across the display. Threshold determines the distance in pixels that the pointer moves at slow speed before moving at the accelerated rate. (See Figure 2-43.)

Figure 2-43 Style Manager – Mouse

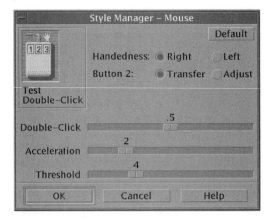

Beep

The volume of the beep noise can be set to a value between 0 and 100. A 0 setting for the beep noise effectively turns it off. Tone determines the pitch of the beep, from 82 to 9000 hertz (Hz). The duration of the beep noise can be set to last up to 2.5 seconds. (See Figure 2-44.)

Figure 2-44 Style Manager – Beep

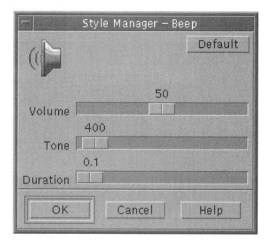

Screen

The Screen controls enable the user to designate which screen saver program will run when the workstation display is locked. The user can designate a number of screen savers to run, in succession, and have each of them run for a period between 0 and 120 minutes. The user also can set the period of screen inactivity at which the screen saver will automatically be invoked. (See Figure 2-45.)

Window

The Window controls allow the user to designate how windows and icons can be manipulated. (See Figure 2-46.)

Startup

Set the home session to save the current work session window as the default window to open when the next home session is started. Choose Set Home Session and it will override any previously saved information. The user can choose to return to the current session as it was when logging out, or to the home session when logging back in. Turn off the Logout Confirmation Dialog option and the user will automatically be logged out when the Exit button is selected,

without any further confirmation being requested. If the Logout Confirmation Dialog option is set to On, the user will be asked to confirm that he does want to log out when he chooses to exit. When the user starts his next work session, the data contained in any windows will be gone or be set to default values. (See Figure 2-47.)

Figure 2-45 Style Manager – Screen

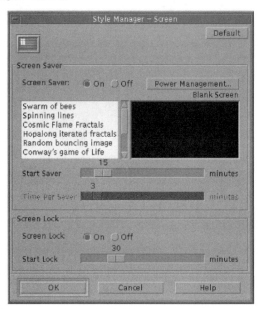

Figure 2-46 Style Manager – Window

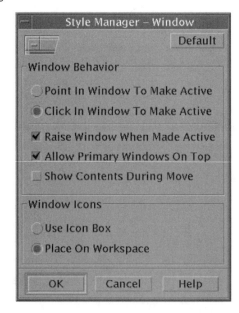

Figure 2-47 Style Manager – Startup

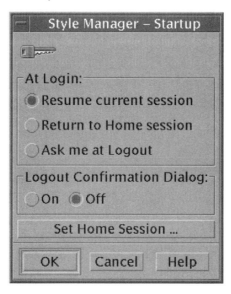

Adding and Removing Applications with Subpanels

The subpanels, or pull-up menus, located on the front panel enable the user to add desired applications for easier access. Users can add and delete new action buttons for launching their most frequently used applications or scripts. (See Figure 2-48.)

Adding Applications Icons

Add applications to the subpanel menu list by dragging the appropriate icon from the Application Manager window display and dropping it on the Install Icon area of the subpanel. Click the Applications icon on the Applications subpanel to find many frequently used applications.

Place the most frequently used icons on the front-panel display by clicking the Promote to Front Panel choice in the menu of options. This speeds up access to the most commonly used programs and helps reduce the need to open subpanel lists.

Removing Applications Icons

Right-click the desired icon to manipulate the icon on a subpanel or delete it from the subpanel. This displays a menu of options relating to the icon. (See Figure 2-49.) Subpanels can be placed on the workspace by using the same method that was used to move a window.

Figure 2-48 Working with Subpanels

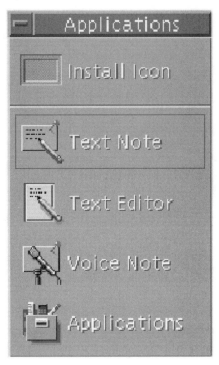

Figure 2-49 Adding and Removing Applications with Subpanels

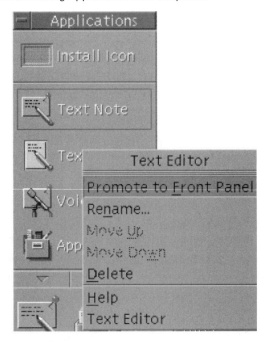

Application Manager

The Application Manager window contains six folders as shown in Figure 2-50. Open the desktop folders to see icons that can be added to a subpanel. To achieve this, drag and drop the desired icon on the Install Icon area of the subpanel. Add the icon to the subpanel, and that application can be invoked from the subpanel itself. Icons also can be added to the front panel by right-clicking a blank area of the front panel and then clicking Add Icon.

Figure 2-50 Application Manager

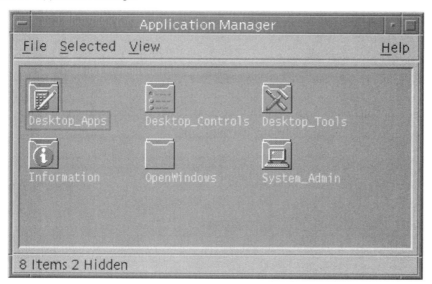

NOTE

An application icon can be placed on the work-space display in the same way. The application is then available directly from the workspace. The System_Admin folder contains icons that are useful for system administrators. The OpenWindows folder contains icons that can be used to open programs designed to run under Sun's Open-Windows GUI while working in a CDE environment.

Lab Activity 2.4.2 Customizing the Workspace

In this lab, you work with CDE Style Manager, Application Manager, subpanel menus, front panel, and the desktop to customize the workspace environment. Refer to the *Cisco Networking Academy Program Fundamentals of UNIX Lab Companion*, Second Edition.

Introduction to GNOME and KDE

Most distributions of the Linux operating system offer a choice of GUIs. The two most popular desktop managers are GNOME (GNU Network Object Model Environment) and KDE (K Desktop Environment). These GUI desktop managers are also available for many commercial versions of UNIX, including Solaris. Each offers a collection of applications and software tools that have been customized to work with its respective desktop control features. Both

GNOME and KDE are easy to use and configurable. The version of GNOME or KDE and included applications will vary depending on the Linux distribution. New graphical environments such as Red Hat's BlueCurve and Sun's Java Desktop point to many of the same GNOME and KDE applications found in the standard versions of GNOME and KDE. The introduction to GNOME and KDE presented here is compatible with the online Fundamentals of UNIX curriculum.

NOTE

In the following sections you will be introduced to both GNOME and KDE. However, after this chapter, discussions on topics dealing with the GUI under Linux will center on GNOME with Sawfish as the window manager, as delivered with the Red Hat distribution of Linux.

Most GNOME-enabled and KDE-enabled software, which is normally launched from menus and panel buttons, can run apart from either desktop manager. In GNOME there is a submenu that leads to the KDE menus. Select items from this menu to start them under GNOME. The items work fine, but without some of the more subtle integrative features of KDE. It is also possible to access most of the GNOME applications from the KDE menu.

The question of which desktop manager to use is a matter of personal preference. The user may install both desktop managers if enough disk space is available. The user would have the choice of either one when logging in. Both GNOME and KDE are widely supported.

With a future release of Solaris, GNOME will become the default desktop. However, CDE will remain as an option allowing users to choose either environment when they log in. GNOME for Solaris can be downloaded from www.sun.com/software/gnome.

Choosing the Login Session

When Red Hat Linux boots and starts graphics, its login window looks similar to the screen shown in the Figure 2-51.

Figure 2-51 A Linux Login Window

At the top of the login box or across the bottom of the screen is a series of labels that produce menus. First, if the choice of language required is not English, select the language preferred from the Language menu.

The Session menu has choices labeled Last, the default, Failsafe, Default, GNOME, and KDE:

- Last uses whatever login environment was selected the last time the user logged in.
- The default will be GNOME when the user has never logged in before and made no selection.
- The user can designate either GNOME or KDE if both are installed. If the choice made is not the user's normal default, a window will appear offering to let her make it the default.
- On occasion users make mistakes in configuring their login environments that prevent them from being able to log in. As a defense against locking oneself out, the Failsafe session logs the user in to a Terminal window, without attempting to evaluate any startup files.

Primary Differences Between GNOME and KDE

The purpose and overall functionality of GNOME and KDE are similar. However, their underlying basic architectures, technologies, and accompanying applications and tools are quite different. GNOME is more flexible than KDE, and easier to configure. KDE has been around longer, and a large number of KDE-compliant applications exist. Figure 2-52 shows the GNOME and KDE icons.

Figure 2-52 GNOME and KDE

The differences in the look, feel, and style of operation of the two user interface systems are covered in the following paragraphs.

Window Managers

KDE uses a single carefully integrated window manager. GNOME allows selection from a variety of window managers. The default window manager, presently best supported by GNOME, is Sawfish. Sawfish is programmable and extensible in a dialect of Lisp called librep. Other window managers such as Enlightenment, FVWM2, IceWM, and TWM are available in Linux distributions, and work fine under GNOME. However, they are less tightly integrated with GNOME.

Virtual Desktops

KDE allows a limit of eight virtual desktops, also known as workspaces. Each virtual desktop can have its own background and look. The default number of workspaces available with KDE is four.

In GNOME the number of virtual desktops allowed is a function of the window manager selected. There is no limit to the number under Sawfish, except the limitation of the system memory. Sawfish allows subdividing each workspace into a grid, with a user-definable number of columns and rows of viewports. All workspaces and viewports inherit the same background and appearance. As with KDE, the default number of workspaces available with GNOME is four.

Panels

Panels are like the taskbar in Windows. Panels are a place to locate menus, launch programs, and store buttons and icons that serve many purposes. GNOME allows the creation, deletion, moving around, and complete customization of any number of panels. Types of these panels include the following:

- Menu
- Edge
- Aligned
- Sliding
- Floating
- Drawer, as a special type of panel within a panel

KDE's implementation of panels is limited to one main panel and a taskbar.

File Managers

KDE's primary means of managing files is with Konqueror, which has been compared to Microsoft Internet Explorer. Konqueror doubles as a browser, although it does not support any of the popular plug-ins used by Mozilla, Netscape, and Explorer. Explorer is also not available for Linux.

GNOME's Nautilus is a graphical shell that enables users to explore files and also browse the Internet. Like Konqueror, Nautilus does not support plug-ins. However, a variety of browsers

are available for Linux that do use plug-ins. Mozilla, the open source version of Netscape, is now supplied as the default browser under GNOME, and may be run from KDE as well.

Also note that many veteran users of UNIX and Linux systems prefer to use a Terminal window and traditional UNIX shell-based commands to manage files.

Themes

Themes make integrated visual and functional changes to the desktop. Theme support under KDE is excellent, and includes a theme manager. GNOME theme support is even better. Using the Sawfish window manager it is possible to define separate themes for individual windows and groups of windows.

Control Center

Both KDE and GNOME enable configuration through well-designed graphical programs.

Introduction to GNOME and KDE Tutorials

Instruction is readily available in both GNOME and KDE. The abundance of information can seem confusing to new users, but the documentation is generally well indexed and quite readable.

Learning About GNOME

Logging in under GNOME for the first time, users are presented with a screen that looks similar to that in Figure 2-53. The large window is the Nautilus graphical shell.

Figure 2-53 GNOME Desktop with Nautilus Window Open

There are several ways to start learning about GNOME:

1. On the panel at the bottom of the page is an icon with a question mark inside a cartoon dialog balloon as shown in Figure 2-54.

Figure 2-54 GNOME Documentation Icon

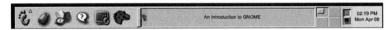

2. Click the documentation icon to bring up another Nautilus window with the GNOME Help index displayed. Below the title is a link that says GNOME User's Guide. Open the user's guide to go to the table of contents. Begin reading about GNOME in the table of contents.

3. Click the Help tab on the bottom left of the sidebar in the Nautilus window. This opens an index to several help documents, including the GNOME user's guide, and an introduction to GNOME as shown in Figure 2-55. To locate detailed information on any subtopic, click the expansion arrow to the left of any subject.

Figure 2-55 Nautilus Help Tab with Expanded Index

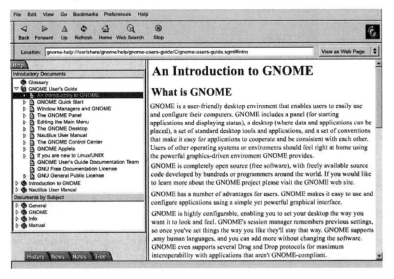

4. With Red Hat BlueCurve, GNOME help is available as an option off the main menu.

5. Help on Nautilus may also be accessed from the Help menus located at the top.

Learning About KDE

The documentation icon on the KDE toolbar is a red- and white-striped life preserver. (See Figure 2-56.)

Figure 2-56 KDE Documentation Icon

Click the icon to access the KDE Help Center. Notice the index in the sidebar on the left. This may be used to help find information on specific topics of interest. A book icon titled Tutorial provides an explanation of icons and an introduction to the KDE desktop. (See Figure 2-57.) With Red Hat BlueCurve, when KDE is selected at installation, KDE help is available as an option off the main menu.

Figure 2-57 KDE Help Center

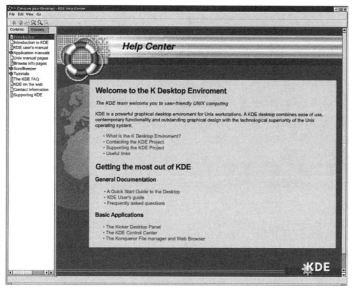

GNOME Customization

As with most graphical windowing environments, GNOME can be customized to meet the needs and desires of various users. Customization includes modifying user preferences; adding applets, launchers, panels, and drawers; as well as adding to menus.

User Preferences

GNOME and its window managers are highly configurable. To customize the most visible elements of GNOME's environment is simple and functions much the same as with other GUIs, such as Windows or CDE. These elements include screen backgrounds, choices of colors and fonts, themes, and screen saver behavior. Start Nautilus from the Start Here icon,

select the Preferences icon, followed by the subgroup of options that the user would like to change. (See Figure 2-58.) Continue to follow the guidance that is given on the screen.

Figure 2-58 GNOME Preferences Icons

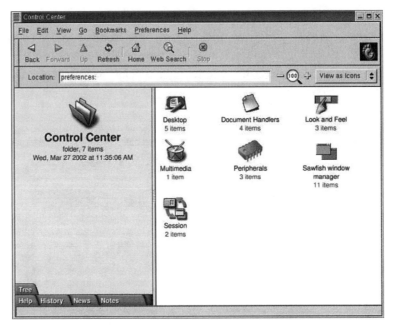

Adding to the GNOME Panel

Configuring the GNOME panel is simple. The user may add objects of various types to panels. These types include launchers, applets, menus, and drawers. Click the GNOME foot icon to bring up the main menus. Then select Panel, followed by Add to Panel to see a submenu that will list all of the object types that may be added.

In addition to adding objects to panels, the user may add panels of various types. The sections that follow cover how to add a launcher, an applet, a drawer, and how to create a new panel.

Adding a Launcher to the GNOME Panel

A launcher starts an application when its icon is clicked. For example, to add the GNOME CD-ROM player to the panel, click the GNOME foot icon and select Panel, then click Add to Panel, Launcher from Menu, Multimedia, and finally CD-ROM Player. The CD-ROM player icon will appear on the panel. The player will appear when its icon is clicked. (See Figure 2-59.)

Figure 2-59 Adding a Launcher from the Menus

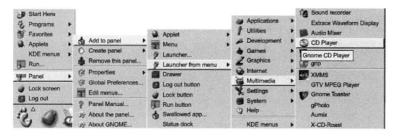

To add a launcher for something that is not in the menus, start as above, then select Launcher. A dialog box asks for specifics. The user can select an icon to use by clicking the blank box labeled No Icon. If no icon is selected, GNOME will insert a default placeholder.

Adding an Applet to the GNOME Panel

An applet is a small application that runs from within the panel, such as a clock or mail-notification utility.

To add an applet that monitors system CPU and memory use, click the GNOME foot icon and select Panel, Applets, Monitors, and finally CPU/MEM usage. The applet appears in the panel, and continues to update while the system is being used.

In this case, the user did not need to select Add to Panel, because an applet by definition runs in the panel. Selecting an applet causes it to be installed in the panel automatically.

Adding and Filling a Drawer on the GNOME Panel

A drawer is a collapsible panel within a panel. To add a drawer to the main panel, select the GNOME foot icon, then Panel, Add to Panel, and finally Drawer. A drawer icon appears on the panel with a small open arrow on the upper right.

Click once on the drawer and an empty panel will appear. Any sort of panel object may be added the same way an object was added to the main panel.

To close or reopen the drawer, click the drawer icon or the arrow at the end of the opened panel.

Figure 2-60 shows an opened drawer on the main panel. Shown from the top are the following:

- A menu
- A screen lock button
- A logout button
- A run button
- A launcher for GNU Emacs

- Another drawer opened to reveal system toys and games
- A final drawer opened to reveal several system resource monitor applets

Figure 2-60 Drawer on the Main Panel

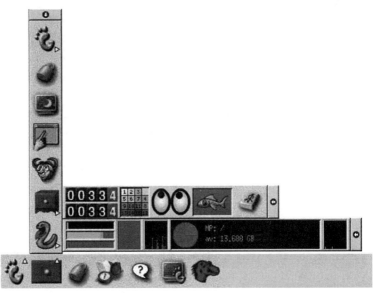

Creating a Floating Panel

The various panel types feature subtle differences in the way they are placed on the desktop, but are otherwise much the same. Here we show a simple example of how to create a floating panel.

You may add any number of panels to the desktop. We suggest that when you have time to explore them, create one of each type in order to learn the differences and to find what best suits your requirements.

To create a floating panel, follow these steps:

1. Click the GNOME foot icon and select Panel, Create Panel, and finally Floating Panel. An empty, vertically oriented panel with open and close arrows appears at the top left of the screen.

2. Press the right mouse button on either arrow and select Panel, Properties, and All Properties. The Panel Properties window appears. Options may be customized such as the panel's size, orientation, position, and background. Unlike other property setting windows, these properties apply as they are typed in. There are no Apply, OK, or Cancel buttons.

3. Click Close when finished with customizing the panel.

Figure 2-61 shows the top-left part of a screen where a panel has been created, with the Panel Properties window still open. Note that the panel's orientation has been changed to horizontal. The top-left corner has been relocated so it does not overlap desktop icons, and the background color has been set. An applet toy was added to give the panel some content.

Figure 2-61 New Floating Panel

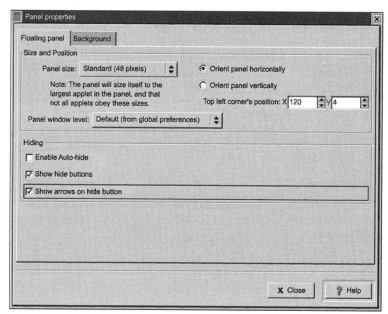

Further Panel Customization

Objects on panels may be moved, configured, or deleted. These operations are all initiated by pressing the right mouse button with the pointer over the panel object. This will bring up a menu.

To move objects, such as a desk guide or a task list, the pointer must be over the object's handle. Select Move from the menu and drag the icon to the position wanted. The icon may be moved to another open panel. Other icons automatically move over to make room for it.

Objects that are configurable show a Properties submenu. Details concerning the object's use may be added. This feature may also be used to select a custom icon for a program.

Lab Activity 2.6.2 Exploring GNOME

In this lab, you become familiar with the GNOME desktop management environment. You will use the Nautilus graphical shell to find their way around the system, and to customize GNOME according to your preferences. You will also learn to use the menus and launchers in the panel, how to modify what is in the panel, and how to add panels of your own. Refer to the *Cisco Networking Academy Program: Fundamentals of UNIX Lab Companion*, Second Edition.

Adding to the GNOME Menus

GNOME allows its menu system to be customized. Menu items may be added, deleted, reordered, and restructured. However, unless you are logged in as the superuser, or root, the only menu that may change is the Favorites menu. This happens because changes made to the other GNOME menus affect all users on the system.

Adding to Favorites from Another Menu

Sometimes, an item that is used frequently is nested deep within the menu structure. This requires the user to search for it every time. The user can add this item to their Favorites menu. As an example, to add the KDE version of the game Mahjongg, perform the following steps:

1. Click the GNOME foot menu.
2. Select Favorites.
3. Select Add from Menu.
4. Select KDE Menus.
5. Select Games.
6. Select Boardgames.
7. Select Mahjongg.

The game will be duplicated on the Favorites menu.

Adding to Favorites Using the Menu Editor

Click the GNOME foot icon, then Panel, and finally Edit Menus, to start the menu editor. You should remember that the only part of the menu system that you can change as a user is the Favorites menu.

As shown on Figure 2-62 there are buttons that allow you to create new submenus, add menu items, delete items, and to organize labels in a menu by moving the labels up or down, or by sorting them alphabetically.

Figure 2-62 Adding a Menu Item

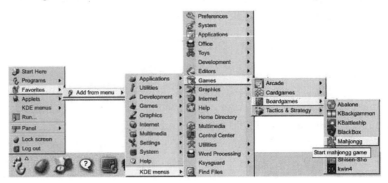

To add a new item, press the New Item button. The item is added as untitled with the name highlighted. This is just a label. We will use the GNOME version of the game Mahjongg as an example:

1. In the Name box, type **Mahjongg**.

2. In the Comment box, type **GNOME Mahjongg game**.

3. In the Command box, type **/usr/bin/mahjongg**.

4. Click the blank icon, labeled No Icon. This opens another window with a display of icons in the directory /usr/share/pixmaps.

5. Scroll down and find gnome-mahjongg.png and click it, then click OK.

6. Click Save at the bottom of the menu editor. The item added will now appear as a selection in Favorites.

Your input should match what is shown in Figure 2-63.

Figure 2-63 GNOME Menu Editor and Icon Selection Box

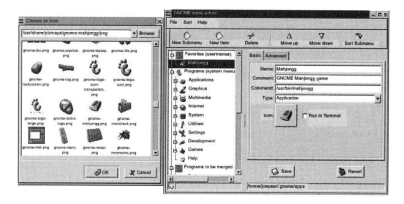

Executing GNOME and KDE Applications from the BlueCurve Menus

As previously mentioned, BlueCurve provides a Red Hat customized front end to either the GNOME or KDE desktop tools. Figure 2-64 shows a GNOME application being selected and Figure 2-65 shows a KDE application. Note that many of the applications are common to both GNOME and KDE environments. Also note the GNOME main menu is somewhat different from the KDE main menu under BlueCurve.

Figure 2-64 Selecting a GNOME Application with BlueCurve

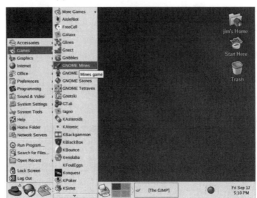

Figure 2-65 Selecting a KDE Application with BlueCurve

Summary

Now that you have completed this chapter, you should have an understanding of the following:

- Two types of accounts exist on a UNIX system, root and user. The root account has access to the entire system and can perform system administration tasks such as creating new users, setting up printers, and installing software. All other users have a regular user account to access applications and personal files.

- User accounts and passwords have specific rules that must be adhered to. These include minimum and maximum length and which characters they can contain. Users can change their passwords at the command line with the **passwd** command. Password rules do not apply to the root account for Solaris.

- You can log in via the GUI, from the command line, or using a Telnet program with a valid username and password. You must log out or exit the system properly before shutting it off. The **init** and **shutdown** commands are used to properly shut down a UNIX system.

- All current versions of UNIX provide a graphical desktop with a front panel, which is the main user interface. You should be familiar with the front-panel arrangements of both CDE and GNOME and should know the buttons and options available.

- The mouse and keyboard on a Sun workstation are different from those of a typical PC. The Sun keyboard has extra keys, and the mouse has three buttons instead of two, as with the PC mouse. You should be familiar with the functions of the left and right mouse buttons.

- The GUI desktop environment allows you to manage the windows by changing their location, size, and position relative to other windows. CDE provides up to four workspaces, which are separate desktop environments. The front panel includes a button for locking the workstation and buttons for changing between workspaces.

- You can use CDE Style Manager to customize each of the workspaces by changing items such as colors, fonts, screen savers, mouse settings, and keyboard settings. CDE subpanels are pull-up or pull-down menus that provide access to many desktop applications. You can add or remove icons or applications with subpanels.

- GNOME and KDE are two graphical desktop packages that are popular with Linux. Most distributions come with one or both. GNOME can also run on Solaris and will be the default desktop in a future OS release. As with CDE, GNOME can be customized with user preferences and by adding applications to panels and menus.

Check Your Understanding

1. Which of the following are characteristics of the root account? (Select two.)

 A. It can use only the command-line interface.

 B. It is created automatically during installation.

 C. Any user has access to it.

 D. It is used for system administration tasks.

 E. In Solaris, its password requirements are the same as for regular users.

2. User account names or login IDs must adhere to which one of these rules?

 A. They cannot be fewer than eight characters in length.

 B. They must be uppercase.

 C. They must be unique for the system.

 D. They must contain at least one numeric or special character.

3. A Solaris system user with the login ID of *dsmith* wants to change her password. Her current password is set to *Dbs-001*. Match each of the new passwords below to the word *valid* or *invalid*.

 Instructions: Put the words *valid* or *invalid* on the right. They might be used more than once.

Password	Valid or Invalid?
1. ABC$123	
2. Dbs-002	
3. Dbs-1	
4. Dbs 012	
5. dsmith	

4. When logging in at the CDE Login Manager, the Options menu has several choices. What should you use to log in when troubleshooting or having possible hardware problems?

 A. Remote Login

 B. Failsafe Session

 C. Open Windows Desktop

 D. Reset Login Screen

5. You currently are logged in and running CDE. You are ready to log off for the day and go home. You should click the _____ button on the front panel to log off.

6. The TCP/IP character-based utility that allows you to log in remotely to a command-line session is _____.

7. The _____ file contains the master list of user information.

8. If you perform several functions in your work, such as system administration and project management as well as application program development, which solution would be the best choice if you needed different applications and utilities available on the desktop for each function?

 A. Create a user account for each function, and create a custom desktop for each user.

 B. Define multiple desktops using the workspace buttons.

 C. Log in as root and create multiple desktop arrangements using the desktop-management function.

 D. Click the Style Manager button and select the desired workspace.

9. You need to leave your workstation for a while, and you are working on several projects with multiple windows open. What should you do to prevent another user from getting into your workstation and seeing your work?

 A. Click the lock icon on the front panel.

 B. Type **suspend** at the command line.

 C. Click the Suspend button on the front panel.

 D. Type **lock** at the command line.

10. The Workspace menu provides mouse access to all your applications, tools, and files through cascading submenus. How is the Workspace menu activated?

 A. Double-click the world icon on the front panel.

 B. Right-click one of the workspace buttons.

 C. Left-click the backdrop.

 D. Right-click the backdrop.

11. Which of the following desktop characteristics can be changed using the Style Manager? (Select three.)

 A. Screen resolution

 B. Startup session options

 C. Password

 D. Screen saver options

 E. Mouse settings

 F. Default printer

12. To add an application to a subpanel, you will need to do which of the following?

A. Open a folder in Application Manager and drag the application's icon to the Install Icon option on the subpanel.

B. Click the Add Icon option in the front panel and select the desired subpanel from the list.

C. Select the application's icon from the front panel and drag it to the appropriate subpanel.

D. Right-click the application's icon and select Cut from the menu; then select the subpanel and click Paste.

UNIX Command Summary

init 0 Its primary role is to create processes from information stored in the file /etc/ inittab. At any given time, the system is in one of eight possible run levels. A run level is a software configuration under which only a select group of processes exist. Run levels 0 and 6 are reserved states for shutting down and restarting the system. The **init** command can be run only by the root user.

passwd Changes login password and password attributes. Example:

```
$ passwd
passwd: Changing password for user2
Enter login password:  abc123
New password:  unix123
Re-enter new password:  unix123
passwd (SYSTEM): passwd successfully changed for user2
$
```

shutdown By default, **shutdown** brings the system to a state in which only the console has access to the operating system. This state is called single-user. **shutdown** can be run only by the root user. Example:

```
$ shutdown
```

stty Sets options for a terminal. Example:

```
$ stty erase ^H  sets the backspace key to erase one character to the left
```

Key Terms

/etc/passwd file File that contains the master list of user information and that is consulted each time someone attempts to access the system.

Application Manager The Application Manager window contains six folders containing icons that can be added to a subpanel.

file manager A graphical application used to manage files and directories. KDE's primary means of managing files is with Konqueror. GNOME's is with Nautilus, which also enables users to browse the Internet.

front panel The primary graphical access area for CDE that contains workspace buttons, pull-down/up menus, and other applications.

GID (group identifier) Contains the user's primary group membership number. This number relates to a group name that is used to determine group ownership of files that the user creates and access to files and directories.

home directory The user's own directory, which is set up by the system administrator.

login ID Your username or ID used to access a UNIX computer.

password aging Can be used to force users to change their passwords at regular intervals.

root The username of the superuser account on a UNIX system. The superuser is a privileged user with total system access. The terms *superuser* and *root* have the same meaning and are used interchangeably.

Style Manager A component of CDE that allows you to customize each of your workspaces by changing things such as colors, fonts, screen savers, mouse settings, and keyboard settings.

subpanel Pull-up or pull-down menus on the CDE front panel that provide access to many desktop applications. You can add or remove icons or applications with subpanels.

superuser Privileged user with total system access. The terms *superuser* and *root* have the same meaning and are used interchangeably.

Telnet A way to access a UNIX system remotely. To Telnet to another system, you must specify its IP address or host name.

UID (user identifier) Contains the unique user identification number assigned by the system administrator. This number relates to the username and is used to determine ownership of files that the user creates and access to files and directories. The UID of the root user account is 0.

virtual desktop A separate workspace that has its own background and look used to organize your applications. CDE, KDE, and GNOME all support the use of multiple virtual desktops.

workspace When you log in to a CDE session, four workspaces are available to you by default. Each workspace is equivalent to a desktop environment.

Objectives

After reading this chapter, you will be able to

- Use the CDE Mail Tool.
- Use CDE Calendar Manager.
- Use other built-in CDE applications.
- Use built-in GNOME and KDE applications.

Chapter 3

Graphical User Applications

Introduction

This chapter introduces you to several useful applications that are included with Common Desktop Environment (CDE). You will work with the Mail Tool to view and manage e-mail messages, and use the Calendar Manager to manage dates and appointments. CDE contains many other useful applications, such as Voice Notes and Text Notes, Address Manager, Audio, Icon Editor, Image Viewer, Snapshot, Calculator, and Clock. These applications and the use of a Terminal window in CDE are covered in this chapter. An overview of graphical applications that are available with GNU Network Object Model Environment (GNOME) and K Desktop Environment (KDE) is also provided.

Introduction to CDE Mail Tool

The *Mail Tool* is a full-featured graphical e-mail management program. The Mail Tool is an e-mail client that is a standard component of the Solaris CDE. With Mail Tool, you can perform all normal functions related to your e-mail. You can read mail and attachments, create new mail with attachments, and delete and manage e-mail.

Mail Tool's features include spell checking, message drafting, and template capabilities. It supports both the Post Office Protocol (POP3) and Internet Message Access Protocol (IMAP). Mail Tool saves copies of outgoing messages, creates views for reading selected mail messages, supports aliases, and handles vacation automessages.

Mail Icon

A mail icon appears on the front panel of the CDE. Click the Mail icon to start the Mail Tool program to read and work with your e-mail. When you receive a new e-mail, the icon changes slightly to alert you of new mail. (See Figure 3-1.)

Figure 3-1 Mail Icons

Mail Window

By default, the Mail window is divided into two areas, as shown in Figure 3-2. The upper portion displays a list of the e-mail messages that have been received. The lower portion displays the text content of the currently highlighted message. This enables you to view each message's content by clicking once on an e-mail's subject line. Click the Control button between the upper and lower portions of the screen window and drag it down or up to change the size of the message viewing area.

Figure 3-2 Mail Window

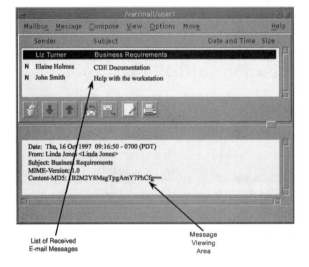

New Messages

When you have a new, or unread message, the letter N appears to the left of the sender's name in the top portion of the Mail window. (See Figure 3-3.) After you open the new message, the N disappears to indicate that the message is no longer new.

Figure 3-3 New E-mail Messages

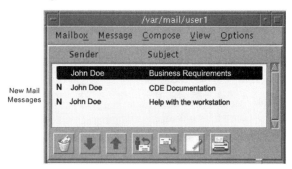

Attached Files

When an e-mail message contains attached files, a diamond-shaped character is displayed after the new message indicator (the letter *N*). To read an attachment, double-click its icon at the bottom of the window. (See Figure 3-4.)

Figure 3-4 An E-mail with an Attachment

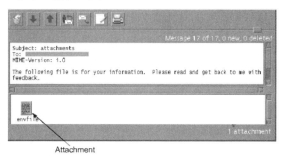

Working with E-mail Messages

You can compose a new mail message by clicking Compose > New Message from the main menu, as shown in Figure 3-5. A window appears where you can fill in the appropriate information. The address for the message must be complete. You can include more than one name, separated by commas, in the To and CC fields. After the message is created, click the Send button in the bottom-left corner of the pane to send the message to the addressees. (See Figure 3-6.)

Figure 3-5 New Message Menu Option

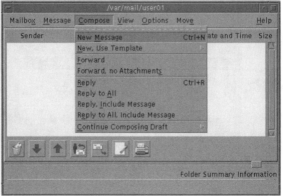

Figure 3-6 Composing a New Message

E-mail Addressing

As with regular mail, you need to specify the address of the person(s) to whom the e-mail is being sent. If the message is sent to someone whose computer is on the same local-area network (LAN) as yours, use the address username@hostname. For example, to mail a message to user05 on a computer named buckeye, enter user05@buckeye in the To field. To send Internet mail to someone outside your institution or company, the following format must be used to address the e-mail:

bjoy@institution.com

Below is a breakdown of this format:

- Username (bjoy) is usually a combination of the letters of a person's first and last name.
- The "at" symbol (@) separates the **username** from the rest of the e-mail address.
- **Domain name** (institution.com) is a unique, registered name; usually a company or Internet service provider (ISP) name followed by a "dot" (.) and then a domain name extension that determines the organization type. (For example: .com means a company in the commercial domain, .edu represents the education domain, .mil stands for military, and so on.)

Adding Attachments

Click the Attachments option from the New Message screen menu to attach a file to the composed message, as shown in Figure 3-7. Click Add File, and a window appears from which you can choose the file that is to be attached.

Figure 3-7 Adding Attachments to E-mail

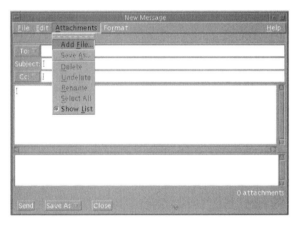

Responding to Received Messages

To reply to a received message, open the Compose menu to see the options, as shown in Figure 3-8. Your are given the choice of replying to the sender or replying to all recipients of the message. You are also given a choice of including the original message.

Mail typically is sent out in a mass mailing to many recipients who happen to be on a mail alias. Mail aliases are often large and general, so use the Reply to All option with caution. You can reply and include the message that you received. You can bypass the Compose menu and click the Reply, Include Message icon on the toolbar of the Mail Tool. After you choose a method of reply, a window appears so that you can type your response. (See Figure 3-9.) By default, the original subject text is used, preceded by Re: (Regarding). The To: entry is automatically set to the e-mail address of the original sender of the message.

Figure 3-8 Mail Reply Options

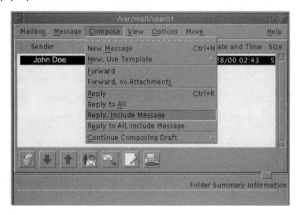

Figure 3-9 Replying to a Message

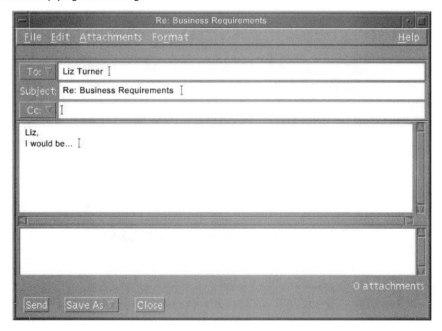

Deleting Mail

To keep the list of received mail messages to a minimum (and to save disk space), users should periodically delete mail messages. There are a number of delete options. (See Figure 3-10.) Choosing to delete the mail messages does not remove the mail. Rather, the messages are stored until the mail window is closed. This gives a user an opportunity to decide not to delete the message. Users can force the mail program to delete any mail messages that were previously selected for deletion by clicking Mailbox > Destroy Deleted Messages.

Figure 3-10 Mail Delete Options

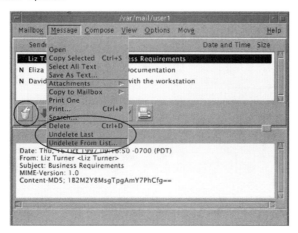

Undeleting Mail

While users continue to work with the mail program, a list of the deleted mail messages is available. You can undelete one or more messages from the list. (See Figure 3-11.) When a message is undeleted, it will re-appear in the list of received mail messages.

Figure 3-11 Deleted Messages

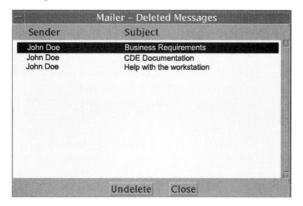

Mail Tool Options Menu

The Mail Tool Options menu enables you to create distribution lists and signatures, and it also gives you many other useful tools.

Alias Option

The e-mail addresses can be difficult to remember. Mail Tool provides a utility that enables you to set up aliases for either a particular person or a group of people whom you frequently

send mail to. A mail alias is similar to a group or distribution list with other mail systems. Click Options > Aliases, as shown in Figures 3-12 and 3-13, to access this utility. Choose a name for the alias, and enter the e-mail addresses of all users who are to be part of the alias, separated by commas. After an alias has been entered, click Add to place it in the list of aliases. When finished creating aliases, click OK.

Figure 3-12 Mail Tool Options Menu

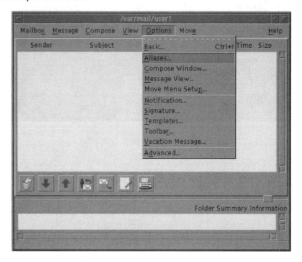

Figure 3-13 Mail Options: Aliases

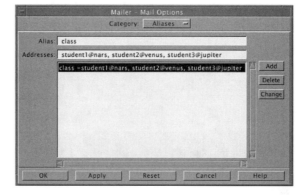

Creating and Using a Signature

A signature is text that you can include with each mail message that you send. A typical signature includes your name, institution or company, phone number, e-mail address, and website. Signatures appear at the bottom of the message.

To create a signature, choose Signature from the Options menu, and then enter the signature text in the Signature text area.

To include your signature in a specific message, or all messages, choose Include Signature from the Format menu of the Compose window.

Other Customizable Options

Many other options can be customized with the different categories listed under the Options menu. Some of these include the following:

- Saving copies of mail sent
- Specifying how often the system is to check for new mail
- Specifying how to be notified of new mail
- Setting a vacation message to be sent in reply to messages when you are unavailable
- Creating a custom signature that can be attached to all outgoing e-mail

Creating Alternative Mailboxes

Messages that you receive can contain information that you may want to access at a later time. In the CDE Mail Tool, you can create multiple mailboxes for the purpose of storing mail for later retrieval and organization. (See Figure 3-14.) These mailboxes can be named to reflect the contents that you intend to store in them. (See Figure 3-15.) After a new mailbox is created, you can use the Move menu to move received mail into it and save it for future reference, as shown in Figure 3-16.

Figure 3-14 Add Mailbox Menu Option

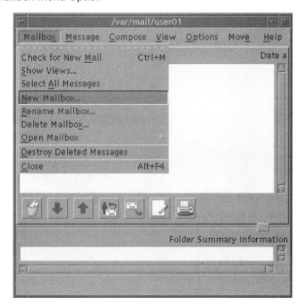

Figure 3-15 Add Mailbox Dialog Box

Figure 3-16 Move Mail to a Mailbox

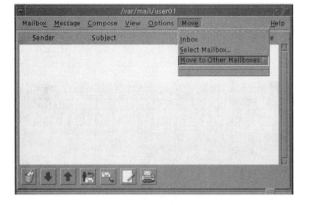

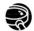

Lab Activity 3.1.6 Using CDE Mail Tool

In this lab, you work with the CDE Mail Tool, also known as Mailer. Mail Tool is a full-featured graphical e-mail management program. Refer to the *Cisco Networking Academy Program Fundamentals of UNIX Lab Companion*, Second Edition.

Netscape Mail Alternative

The CDE Mailer program has many advantages. It is integrated with other CDE tools and applications, aliases, vacation automessage capability, and so on. However, it also has the following disadvantages:

- It cannot attach multiple files simultaneously.
- It cannot choose addresses from an option list.
- It cannot create nested mailboxes easily; this must be done manually by creating a new directory using the **mkdir** (make directory) command or using the CDE File Manager program.
- Some files can be too large to mail.

As an alternative, some users choose to set up and use the Netscape Mail program that is built in to Netscape Communicator and loaded on a Solaris system along with the CDE. Microsoft has not developed a UNIX version of Internet Explorer. Netscape is also included in most distributions of Linux. If Netscape Communicator is not on your system, you can download it for free from http://www.netscape.com/. Figure 3-17 shows the Netscape Mail screen.

Figure 3-17 Netscape Mail

Non-Windows-Based Mail Programs

Sometimes a user may be working on a UNIX system without the availability of a graphical interface. This happens because it was set up that way (user preference) or because you used the Telnet program to access the system. If you cannot access the CDE Mailer or Netscape Mail, what can be done?

Fortunately, text-based and menu-based mail programs can be run from the command line. The two most popular programs are the following:

- **mailx (and the earlier, more basic mail program)**—This program comes with every version of UNIX and is an acceptable program for reading and sending mail. This program is worth learning for those times when you need a mail program but do not have access to CDE.

 The mailx program was designed for sending text-only messages, not for sending programs, formatted application files, or image attachments. If you need to send a nontext attachment, you will need to use the **uuencode** command to convert the file to text for attaching and sending. If you are receiving an attachment using mailx, you need to use the **uudecode** command on the detached file to use it. See the UNIX manual pages (man pages) for additional information on mailx and **uuencode**. The use of man pages is covered in Chapter 4, "Getting Help."

- **Pine**—This program is menu based and easier to use than the mailx program. Typing **pine** at the command prompt can access pine. Pine is installed by default with Linux but not with Solaris. It is available on the Solaris Software Companion CD-ROM and can also be downloaded from http://wwws.sun.com/software/solaris/freeware/.

Figure 3-18 displays Pine's main menu with the list of one-letter commands that can be chosen by either typing the letter or using the arrow keys and pressing Enter.

Figure 3-18 Pine Mail Menu

Introduction to Calendar Manager

Calendar Manager is a full-featured graphical schedule and appointment management program. It is a standard component of the Solaris CDE. With Calendar Manager, you can perform all normal scheduling functions and share their calendar with others. You also can set meetings on other people's calendars.

Calendar Manager Window

To start Calendar Manager, click the calendar icon on the CDE front panel. By default, the Calendar window displays a month view of the calendar. The view can be changed by clicking one of the four view icons at the top right side of the Calendar Manager window, as shown in Figure 3-19.

Figure 3-19 Calendar Manager Window

You can view the calendar in several different formats. Any of the following viewing formats can be selected with the icons on the Calendar Manager window.

The Day view of the calendar is shown in Figure 3-20. It can be selected by clicking the icon that is highlighted in the upper-right corner of the screenshot.

Figure 3-20 Calendar Day View

The Week view of the calendar is shown in Figure 3-21. It can be selected by clicking the icon that is highlighted in the upper-right corner of the screenshot.

Figure 3-21 Calendar Week View

The Month view of the calendar is shown in Figure 3-22. It can be selected by clicking the icon that is highlighted in the upper-right corner of the screenshot.

Figure 3-22 Calendar Month View

The Year view of the calendar is shown in Figure 3-23. It can be selected by clicking the icon that is highlighted in the upper-right corner of the screenshot.

Figure 3-23 Calendar Year View

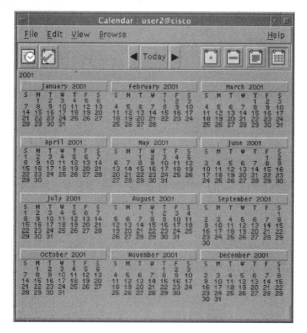

Setting Calendar Options

By setting the calendar options, you can customize your calendar by adjusting the display, print, and date settings. You also can add appointments.

Calendar Editor Defaults

The File, Options menu displays the calendar Editor Defaults window by default. (See Figure 3-24.) In the Editor Defaults window, you can set the options to suit your personal preferences. (See Figure 3-25.) After the values are modified, click either OK or Apply to save the updated details. Selecting the appropriate choice from the drop-down menu can set other options settings, as shown in Figure 3-26.

Display Settings

In Display Settings window, you can do the following, as shown in Figure 3-27.

- Set the time range for the working day
- Set the hour display as 12 or 24 hour
- Designate the default view for the Calendar Manager
- Designate the default calendar to view

Figure 3-24 File Options Menu

Figure 3-25 Editor Defaults Window

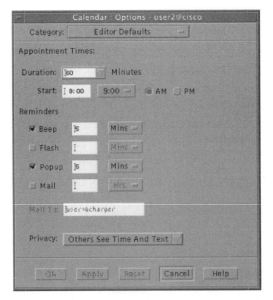

Figure 3-26 Other Calendar Options

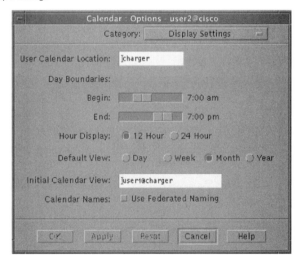

Figure 3-27 Display Settings

Printer Settings

The Printer Settings window enables you to set your personal options for the printing of calendar appointments. (See Figure 3-28.)

Figure 3-28 Printer Settings

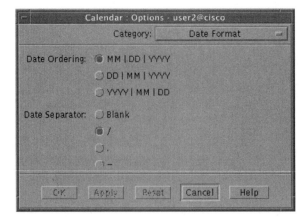

Date Format

The Date Format window enables you to set the format for date, display, and date entry. (See Figure 3-29.)

Figure 3-29 Date Format

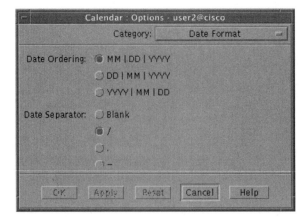

Working with Appointments

Appointments or things to do can be added to your calendar by clicking the appropriate icon at the top-left side of the window. (See Figure 3-30.)

Figure 3-30 Appointment Icons

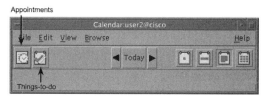

Adding an Appointment

Click the Appointment button and an Appointment Editor window is displayed. (See Figure 3-31.) Following are details that can be entered into this window:

- The date on which the appointment is to be made
- The start and end times of the appointment
- Details relating to the appointment (in the What box)

Figure 3-31 Appointment Editor

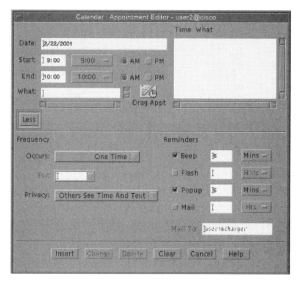

After the appropriate details are selected or entered into the relevant window areas, click Insert to add that appointment. When an appointment has been inserted, it will be displayed in the Time What area at the right side of the window and on the appropriate day of the calendar. The Drag Appointment icon can be used to drag an "appointment by e-mail" onto your calendar.

NOTE

By default, you can add several appointments on the same day to start at the same time. The Calendar Manager does not warn you of conflicting appointments.

Setting Start and End Times

Pick and point lists are provided to indicate the times that your appointments start and end. These lists can be selected by clicking the appropriate time box to the right of the start and end times.

Selecting a Date

Regardless of the current view of the calendar, you can scroll forward and backward along a timescale associated with that view. After an appropriate date is visible on the display, you can open the Appointments Editor by double-clicking the area in the window associated with that day. If you are looking at the weekly view, click the area at the bottom left of the window, and then double-click in the hourly section to set an appointment for that time, as shown in Figure 3-32.

Figure 3-32 Weekly View's Timescale

Appointment Editor Options

Additional options are available when adding an appointment. (See Figure 3-33.) By clicking More in the lower-left corner of the window, this display opens at the bottom of the Appointment Editor window. The following options are available:

- Frequency of the appointment
- Number of times that a frequent appointment is to be added to the calendar
- Privacy controls
- Appointment reminders
- Who to send e-mail to (when an appointment reminder is to be sent)

To close the additional options window area, click Less.

Figure 3-33 Appointment Editor Options

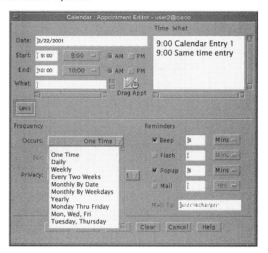

Finding Appointments

The Find window enables you to search for text in the appointment entries. (See Figure 3-34.) You can specify the time period to search, giving a start and end date. After appointments are found, you can double-click the details (shown in the lower portion of the window) to view the actual appointment details.

Figure 3-34 Finding Appointments

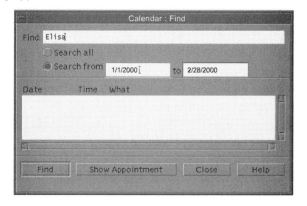


TIP

If someone sends an e-mail with an Appointment icon, you can drag the icon to an open calendar window or to the Calendar control on the front panel, to add it to his or her calendar. The Appointment icon cannot be dropped on a minimized calendar.

Working with Other Users' Calendars

It is frequently desirable to be able to access other people's calendars to check availability for meeting times. It is also common for managers to have an administrative assistant manage their calendar for them.

Setting Access to the Calendar

In this window, accessed by choosing Options from the File menu, a user can set the access rights for the calendar. (See Figure 3-35.) Users can designate who has the right to work with or view the calendar. By default, this is set to world, which means that everyone has access rights to your calendar.

Figure 3-35 Access List and Permissions

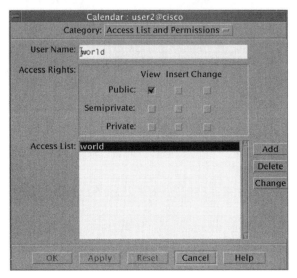

Browsing Other Calendars

If a user wants to check the appointments that have been made in other user's calendars, use the Browse, Show Other Calendar menu option. (See Figure 3-36.) With the correct permission settings to view other calendars, a user can compare people's appointments to help arrange meetings that do not conflict with existing appointments. The Browse menu option also provides a menu editor for configuring the menu options that are used by the Calendar window.

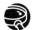

Lab Activity 3.2.5 Using CDE Calendar Manager

In this lab, you work with CDE Calendar Manager. Calendar Manager is a full-featured graphical schedule and appointment management program. Refer to the *Cisco Networking Academy Program Fundamentals of UNIX Lab Companion*, Second Edition.

Figure 3-36 Show Other Person's Calendar

Other Built-In CDE Applications

CDE provides a number of other useful applications for managing notes and addresses, tools for playing sounds, tools for viewing images, and a simple calculator.

Voice and Text Note Applications

Voice Notes

The Voice Notes application lets you personalize your mail messages. Select Voice Note from the Applications subpanel to record voice input. (See Figure 3-37.) Note that selecting Voice Note starts Audio in record mode. A microphone or voice input device is necessary for this application to work. (See Figure 3-38.)

Text Notes

The Text Notes application enables you to create "sticky notes"–style notes on your work-space. Select Text Note from the Applications subpanel to record text input. (See Figures 3-39 and 3-40.) The note then can be minimized and left on your workspace as a reminder. You can drag notes into mail messages as mail attachments.

Figure 3-37 Voice Note Subpanel

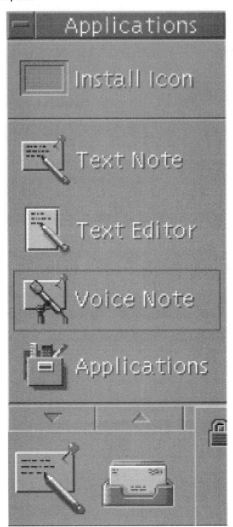

Figure 3-38 Audio Subpanel

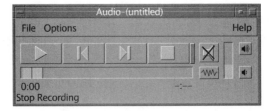

Figure 3-39 Text Note Subpanel

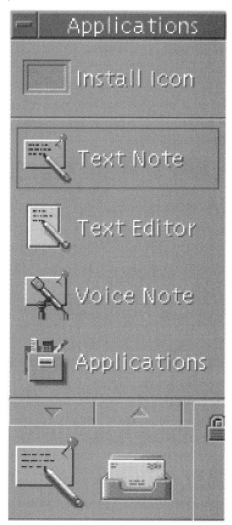

Figure 3-40 Text Editor Note

Address Manager

Address Manager enables you to search corporate name databases and organize your contacts in electronic cards. You can schedule appointments, send e-mail, and dial telephone numbers from the electronic cards. You can access the Address Manager in one of two ways. First, right-click the desktop to bring up the Workspace menu and then select Cards/Address Manager, or your can access the Address Manager from the Front Panel/Cards subpanel. (See Figures 3-41 and 3-42.)

Figure 3-41 Address Manager Subpanel

Figure 3-42 Address Manager Screen

Audio Tool

The Audio application provides a way to record and play sounds. A microphone is necessary to record sound files. Sound files can be played through the built-in speakers on a Sun workstation. Solaris for Intel systems must have a supported sound card and speakers. To activate the Audio application, right-click the desktop and choose Applications, then select Audio and Video.

TIP

Sample sound files are on Solaris systems in the /usr/demo/SOUND /sounds directory.

Figure 3-43 Audio Application

Calculator

The Calculator provides an online tool for quick calculations. It includes a basic simple calculator function and a more sophisticated scientific calculator function. You can place the calculator on the desktop to have it available whenever you need it. To activate the calculator, right-click the desktop and select Calculator. (See Figures 3-44 and 3-45.)

Figure 3-44 Calculator Menu Option

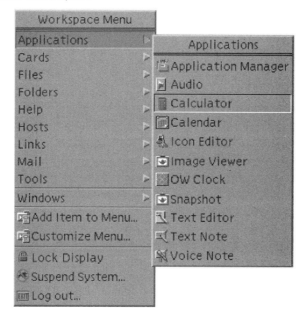

Figure 3-45 Calculator Application

Icon Editor

The Icon Editor application is used to edit or create icon images associated with an application. To activate the Icon Editor, right-click the desktop and choose Applications, Icon Editor. (See Figure 3-46.)

Figure 3-46 Icon Editor Application

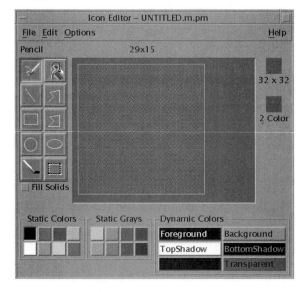

Image Viewer

The Image Viewer application is used to view and manipulate graphics images. To activate the Image Viewer, right-click the desktop and choose Applications, Image Viewer. (See Figure 3-47.)

TIP

Sample image files are located in the /usr /openwin/demo/kcms /images/tiff directory on Solaris for Intel systems and in the /usr/openwin /share/images directory on Solaris for SPARC systems.

Figure 3-47 Image Viewer Application

Snapshot

The Snapshot application is used to capture screen images into a file to be later inserted into a document. (See Figure 3-48.) Most images for this course were created with the Snapshot application. Snapshot supports the popular graphic file formats such as GIF, JPEG, PostScript, and TIFF. To activate the Snapshot, right-click the desktop and choose Applications, then select Snapshot.

Figure 3-48 Snapshot Application

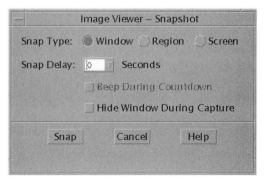

Clock

The Clock provides a graphical method of viewing the time, date, and time zone. To activate the Clock, right-click the desktop and choose Applications, OW Clock (Open Windows Clock). (See Figures 3-49 and 3-50.)

Figure 3-49 Clock Menu Option

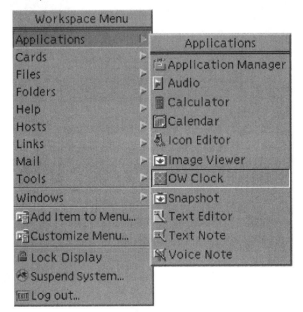

Figure 3-50 Clock Application

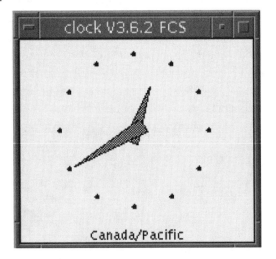

Other Clock display properties include the following and can be changed by right-clicking the Clock and choosing Properties:

- A digital versus an analog display
- A 12-hour or 24-hour display
- An option to select whether seconds are displayed
- An option to select the time zone
- An option to set a stopwatch
- An option to set an alarm

Terminal Windows

A Terminal window can be opened in the graphical environment to provide a command-line interface to the system, as shown in Figure 3-51. Multiple Terminal windows can be open at the same time. Each Terminal window represents a new shell and displays a shell prompt waiting for user input.

Figure 3-51 Opening a Terminal Window

TIP

You can open an additional Terminal window anytime by pressing Ctrl-t or entering the **dtterm&** (desktop terminal) command in an existing Terminal window in CDE. The ampersand (&) tells the shell program to run the **dtterm** command in the background and to return the shell prompt so that you can continue working in that Terminal window. To close a Terminal window, type **exit** or press Ctrl-D.

Anything you can do from the command line you can do from a Terminal window. You will be working in a Terminal window throughout much of this course as you learn various UNIX commands and their functions.

e-Lab Activity 3.1 Terminal Window Shell

In this activity, you enter the UNIX **date** command. This activity will demonstrate how a command is entered from the command line. The **date** command is similar to the CDE Clock application learned previously. Refer to e-Lab Activity 3.1 on the accompanying CD-ROM.

Lab Activity 3.3.7 Other Built-In CDE Applications

In this lab, you work with several additional user applications that are included with the CDE. These include Voice and Text Notes, Address Manager, Calculator, and Clock. You learn how to open a Terminal window that will give you access to the UNIX command line. Refer to the *Cisco Networking Academy Program Fundamentals of UNIX Lab Companion*, Second Edition.

NOTE

The version of GNOME or KDE and included applications vary depending on the Linux distribution. New graphical environments such as Red Hat's BlueCurve and Sun's Java Desktop point to many of the same GNOME and KDE applications found in the standard versions of GNOME and KDE. The introduction to GNOME and KDE presented here is compatible with the online Fundamentals of UNIX curriculum.

GNOME and KDE Applications Overview

The GNOME and KDE desktops both include many of the same types of applications that are found in CDE. The names of the applications may vary from one desktop operating environment to another but they perform essentially the same function. These applications include mail clients, browsers, schedulers, file managers, text editors, and helpful utility applications known as *applets*. Many open source applets are included with GNOME and KDE. In some cases they are common to both environments. GNOME applications can frequently be run from KDE menus and vice versa. This section will introduce some of the more useful GNOME and KDE applications and will provide a comparison to those of CDE. (See Figure 3-52.)

Figure 3-52 GNOME and KDE Applications

Web Browsers and Mail Clients

GNOME comes with three web browsers:

- Galeon
- Mozilla
- Netscape

Netscape and *Mozilla* also have mail capabilities built in. Mozilla is the default GNOME browser, but the GNOME *Nautilus* file manager also has web-browsing functionality. Netscape was covered previously under CDE Mail and is widely used in Windows and Macintosh in addition to UNIX environments. Mozilla is an open source web browser that includes the following applications:

- Navigator
- Mail reader
- Web page composer
- Address book

These functions can be accessed from the Tasks menu or by using the buttons on the lower-left corner of the screen. You can access the Mozilla browser window by clicking the red Mozilla head icon on the panel, as shown in Figure 3-53. This figure also shows the browser while accessing the http://www.mozilla.org/ website. KDE comes with the *Konqueror* web browser, which also serves as a file manager. It does not include an e-mail client, however. (See Figure 3-54.)

Figure 3-53 GNOME Mozilla Web Browser

Figure 3-54 KDE Konqueror Web Browser

Calendar Managers

GNOME includes a basic calendar manager tool called Gnome Calendar and a time-tracking tool called GTimeTracker. These are accessible by clicking the Programs and then the Applications menus in either GNOME or KDE. Figure 3-55 shows the Calendar and TimeTracker windows. KDE also has a Calendar/Organizer tool known as KOrganizer. Both include a task list. (See Figure 3-56.)

Figure 3-55 GNOME Calendar and GTimeTracker

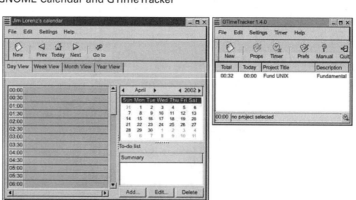

Figure 3-56 KDE KOrganizer

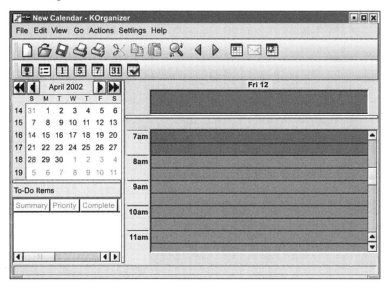

GNOME and KDE Applications and Utilities

Many open source applications and utilities are available from the main Programs menu, as shown in Figure 3-57.

Figure 3-57 GNOME Programs Menu

GNOME Applications Programs

The programs available will be determined by the standard installation routines and by which options are chosen during installation. Not all applications and utilities are available in all

distributions. This section focuses on the Programs and Utilities menus. The application submenu includes the following:

- Calendar
- Address book
- Gedit text editor
- Time-tracking tools
- Nautilus file manager
- Gnumeric spreadsheet
- Emacs editor
- Diagram editor

Sun's ***StarOffice*** (www.sun.com/staroffice) is a multiplatform (Solaris, Linux, and Windows) application suite, which includes a Windows-compatible word processor, spreadsheet, presentation software, and so on, similar to MS Office. StarOffice is included at no cost with some distributions of Linux, such as Red Hat. Figure 3-58 shows the GNOME Applications menu.

Figure 3-58 GNOME Applications Menu

GNOME Utility Programs

As shown in Figure 3-59, the following utility programs are included:

- GDict the gnome client for MIT dictionary server
- Simple Calculator
- Character Map
- gfloppy, a floppy disk formatter
- Font Selector
- Gnome Search Tool, which can be used to find files

Figure 3-59 GNOME Programs Utilities Menu

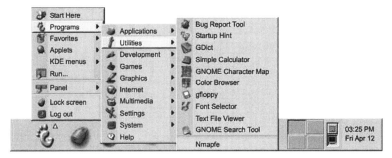

Other GNOME Programs Menu Submenus

A number of other programs and utilities are available through the submenus of the Programs menu. Some of those programs are listed as follows:

- The Games submenu contains several good games, and the Graphics menu contains ImageMagick for editing graphics. The Internet menu contains browsers such as Galeon, Netscape, and Mozilla, as well as dialup configuration options. *Gaim* is an AOL Instant Messenger client and *GFTP* is a graphical FTP file transfer utility.

- The Multimedia menu includes a sound recorder, audio mixer, CD player, volume controls, and the GTV MPEG player.

- The Settings submenu contains desktop options for backgrounds and screen savers, a menu editor, as well as peripheral settings for the keyboard and mouse. The System submenu provides access to a system monitor, system information, network, and printer configuration. It also allows you to create a boot disk and change your password.

GNOME Applets

Several useful small programs known as applets are also available. These are accessed from the Applets menu off the GNOME main menu under the following categories:

- Amusements
- Monitors
- Multimedia
- Network
- Utility

Following are some of the more interesting ones on the Utilities submenu:

- Gnotes, which can put sticky notes on your desktop
- GNOME Weather, which allows the tracking of weather in many different cities
- ScreenShooter, a screen-capture program

Terminal Windows

A Terminal window can be opened to provide a command-line interface to the system. Multiple Terminal windows can be open at the same time. Each Terminal window represents a new shell and displays a shell prompt waiting for user input.

Anything you can do from the command line you can do from a Terminal window. You work in a Terminal window throughout much of this course as you learn various UNIX commands and their functions.

To open a Terminal window with GNOME, click the Terminal Emulation Program icon on the panel at the bottom of the screen. To open a Terminal window using Red Hat's BlueCurve, click the Terminal program from the System Tools menu.

KDE Programs and Utilities

KDE also includes many open source applications and utilities. Some of these are the same as those included with GNOME. The logic is that whichever desktop you choose, you will have similar tools available. Figure 3-60 shows the KDE main menu.

Figure 3-60 KDE Main Menu

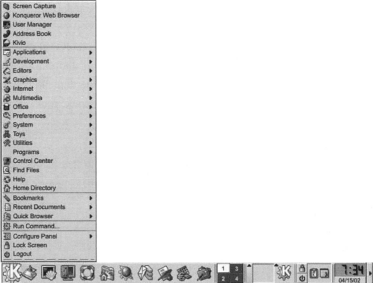

UNIX Graphical Desktop Applications Comparison

The following chart compares some of the more useful graphical applications and utilities that come with Solaris CDE, GNOME, and KDE. However, this is not a complete list. (See Table 3-1.)

The entries for GNOME and KDE are based on the Red Hat Distribution of Linux. The Sun StarOffice productivity suite is included with Solaris and Red Hat. StarOffice applications are installed under KDE with Red Hat. Although StarOffice is available, only the native GNOME and KDE applications are listed in the table. Note that some of the applications listed for GNOME are also available from the KDE menus and vice versa.

Table 3-1 UNIX GUI Desktop Applications Comparison

Feature or Application	Solaris CDE	GNOME	KDE
E-mail	Mailer, Netscape	Mozilla, Netscape	Kmail, Netscape
Web browsers and Internet applications	Netscape	Galeon, Mozilla, Netscape, gFTP	Konqueror, Netscape
Word processor	StarOffice Writer	AbiWord	Kword
Spreadsheet	StarOffice Calc	Gnumeric	Kspread
Database	StarOffice Base	Installed separately	Installed separately
Slide presentation	StarOffice Impress	Installed separately	Kpresenter
Drawing and graphics	StarOffice Draw	Installed separately	Paint, Kivio, Kontour, Krayon
File management	File Manager	Nautilus	Konqueror
Contact information	Address Manager	GnomeCard, Mozilla Address Book	Kmail, KaddressBook
Schedules and task lists	Calendar, StarOffice Schedule	Calendar	KOrganizer
Finding files	File Find	Search Tool	Find Files
File compress and archive	Files subpanel options	Not present	Archiver
Text editors	Text Editor	Gedit	Kate
Notes	Voice Notes, and Text Note	Gnotes	Popup Notes
Screen capture	Image Viewer SnapShot	Screen-Shooter	KSnapshot

continues

Table 3-1 UNIX GUI Desktop Applications Comparison (Continued)

Feature or Application	Solaris CDE	GNOME	KDE
Image viewer	Image Viewer	GQview, xpdf, Imagemagick, Gimp	Image Viewer, ps/pdf
Voice/sound	Java Media Player	Sound Recorder, CD Player	KDE Media Player and others
Calculator	Calculator	Calculator	Calculator
CPU and OS information	System Info	System Info	System info
Icon editor	Icon Editor	Not present	Icon Editor
User administration	Admintool	Red Hat User Manager	Kuser, Red Hat User Manager
System monitors/ meters	CPU and Disk	CPU, Disk, Memory, Network, Swap	CPU, Disk, Memory, Network, Swap

Summary

Now that you have completed this chapter, you should have an understanding of the following:

- CDE is a standard GUI for the commercial UNIX platform. CDE comes with several built-in productivity applications such as the Mail Tool and Calendar Manager. Several others also are included, such as Voice and Text Notes, Address Manager, Calculator, and Clock. You will also have the capability of opening a Terminal window at any time to access the command line.

- The Mail Tool is a graphical e-mail application that can perform all normal e-mail functions. It allows you to view e-mail and attachments, compose new e-mail with attachments, and delete old messages. Received messages can be saved and managed by filing them in alternative mailboxes.

- The Calendar Manager manages scheduling and appointments through the use of a powerful graphical interface that supports networking. You can view their calendar in several formats by clicking icons. You can add new appointments and find existing ones. Many options can be set with the calendar. The calendar can be shared with others, and you can make appointments on other people's calendars if they have given you permission to do so.

- Many other graphical applications are built in to the CDE. The ones that this chapter focused on include Voice and Text Notes, Address Manager, Calculator, Icon Editor, Image Viewer, Snapshot, and Clock.

- Opening a Terminal window from CDE starts a new shell. You have a command line available in the Terminal window, which enables them to enter commands and run command-line utilities. Pressing Ctrl-T or entering the **dtterm&** command opens another Terminal window.

- The GNOME and KDE desktops are included with most distributions of Linux. You can install either one or both of them. Both GNOME and KDE will also run with Solaris. These open source GUI desktops include applications and utilities that perform the same functions as CDE in the commercial UNIX environment.

Check Your Understanding

1. The Mail Tool is a basic command-line e-mail application that cannot accommodate attachments.

 A. True

 B. False

2. Marcia sends regular e-mail to the members of her project team. She wants to create a list to avoid having to specify each name when she sends out memos. Which Mail Tool feature should she use?

 A. Distlist

 B. Alien

 C. Groupname

 D. Alias

3. Which of the following are customizable options with Mail Tool? (Select three.)

 A. Specifying how often you would like the system to check for new messages

 B. Setting the location for deleted messages

 C. Creating a default forwarding address

 D. Specifying autoreturn for junk mail

 E. Setting a reply message to be sent when you are unavailable

 F. Creating a custom signature that can be attached to all outgoing e-mail

4. Which options can be changed in the Calendar Manager Display Settings menu? (Select two.)

 A. Default View (day, week, and so on)

 B. Printer Settings

 C. 12- or 24-hour clock

 D. Date Format

 E. Screen Resolution

5. Which features are available with the Calendar's Appointment Editor? (Select three.)

 A. Frequency of the appointment

 B. Number of times that a frequent appointment is to be added

 C. Time zone

 D. Appointment priority

 E. Appointment reminders

6. Everyone can see your calendar unless you limit access rights.

 A. True

 B. False

7. With Address Manager, which of the following can be performed using electronic cards?

 A. Track job performance

 B. Send e-mail

 C. Play games

 D. Put someone on hold

8. Calculator and Clock have which characteristic in common?

 A. They can be run only as command-line utilities.

 B. They are installed as optional components.

 C. They are graphical utilities that are part of the CDE.

 D. They are display utilities only and cannot accept input.

9. Which statements are true of Terminal windows? (Select two.)

 A. Each Terminal window represents a new shell.

 B. Terminal windows are initiated from a command-line session.

 C. Terminal windows give a user access to the command line.

 D. Once a Terminal window has been opened, a user cannot use CDE GUI features.

10. The UNIX command that performs the same function as the CDE Clock is _____.

11. Which item is a category of GNOME applet?

 A. Amusements

 B. Printers

 C. Appointments

 D. Databases

12. Match each application with the desktop that includes it. The desktop names may be used more than once.

Instructions: Put the words CDE, GNOME, and KDE on the right. They may be used more than once.

Application	Desktop
Mozilla	
Star Office	
Kate	
Voice Notes	
Krayon	
Snapshot	
Nautilus	

UNIX Command Summary

mailx Interactive message processing system. Example:

```
$ mailx user2@cisco.com < dante.doc
```

uuencode Used to convert a binary file into an ASCII-encoded representation that can be sent using e-mail. The encoded file is an ordinary ASCII text file.

Key Terms

applet A small useful program.

Calendar Manager A full-featured graphical schedule and appointment management program. It is a standard component of the Solaris CDE.

domain name The company and type portion of an e-mail address, such as jiml@company.com, where company.com is the domain name.

Gaim An AOL Instant Messenger client.

GFTP A graphical FTP file transfer utility.

Konqueror A web browser that comes with KDE.

Mail Tool A full-featured graphical e-mail–management program. It is an e-mail client that is a standard component of the Solaris CDE.

mailx The mailx (and the earlier, more basic mail) program comes with every version of UNIX and is an acceptable program for reading and sending mail. The mailx program basics are found in Appendix E and are worth learning for those times when you need a mail program but don't have access to the CDE.

Mozilla An open source web browser that is the default browser for GNOME.

Nautilus File manager for GNOME.

Pine The Pine mail program is menu-based and is easier to use than the mailx program. Pine was developed at the University of Washington and can be accessed by typing **pine** at the command prompt.

StarOffice Microsoft Office-compatible office suite software from Sun Microsystems that comes free with most Linux distributions.

username The login name of a UNIX user, and which is part of the user's e-mail address, such as jiml@company.com, where jiml is the username.

Objectives

After reading this chapter, you will be able to

- Use CDE Help.
- Reference Solaris HOWTO manuals (AnswerBook2).
- Use command-line help.
- Use Linux HOWTOs and the **info** command.
- Perform basic troubleshooting.
- Compare DOS and UNIX commands.

Chapter 4

Getting Help

Introduction

This chapter introduces various forms of help provided by the Solaris and Linux environments. It covers graphical help available with the Common Desktop Environment (CDE) including the ***Help Manager*** used for CDE and CDE application help, and ***AnswerBook2***, which contain online versions of the Solaris HOWTO manuals. This chapter also works with command line help known as the programmer's manual, or ***man pages***. These pages provide character-based help with ***UNIX*** commands and utilities. Linux HOWTOs and the hypertext-based Info help utility are also explained. This chapter also reviews some basic troubleshooting techniques and provides a DOS-to-UNIX cross-reference table for those who have a background in DOS.

Using CDE Help

A number of graphical help functions are built into CDE. This section identifies the location of these and describes the type of help they can provide.

Help Options

The Help icon is situated at the right side of the front panel. Click the icon with the left mouse button to open up the Help subpanel, as shown in Figure 4-1. Help options are listed here with a brief description of the type of help that each one provides:

- Help Manager is the primary help tool for CDE and CDE applications.
- SunSolve Online is a web-based online help from Sun Microsystems. The user must have Internet access.

- Solaris Support is a web-based Sun Microsystems Support contact information. The user must have Internet access.
- Information is the access to the Application Manager information read-me files.
- Desktop Introduction is a basic tutorial on using the desktop.
- Front Panel Help is help with the front-panel icons and features.
- On Item Help is specific onscreen information about an item, available by selecting that item.
- AnswerBook2 is the Solaris reference manuals in online format.

Figure 4-1 Help Subpanel

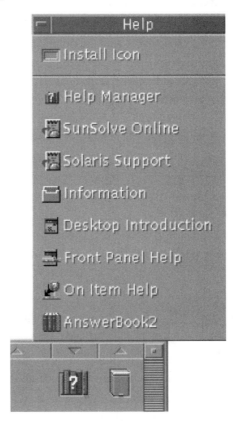

The Help Manager uses a graphical help and document-viewing program called Help Viewer. Help Viewer has hypertext link, searching, and printing capabilities. The hypertext links, shown as underlined text or boxed graphics, can quickly move the user to a related help page. Click the appropriate area of text in the Help window (see Figure 4-2) to show the Help

Viewer help window. The Backtrack button allows the user to retrace the path that they followed through the help screens. The Print button can be used to print a copy of a particular help topic.

Figure 4-2 Help Viewer Window

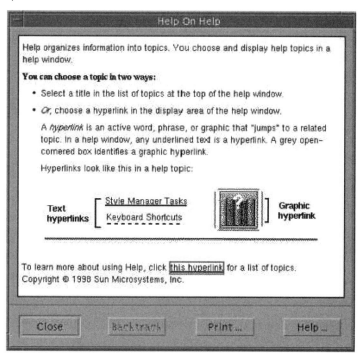

The index search enables the user to see all volumes of help. To access the Help Index Search, click the **Index** button while in the Help Viewer window to bring up the screen shown in Figure 4-3. These volumes are displayed as hyperlinks, which can be used to reference any help page. The user also can search for specific help items based on a keyword search. The number to the left of the help index item is the number of subtopics available.

The On Item Help icon is on the Help subpanel shown in Figure 4-3. Select this function and the mouse pointer changes from an arrow pointer to a question mark with an arrowhead at its base. The pointer can then be positioned over a front panel icon to access the appropriate help page for that item, which will be displayed in a Help Viewer window. The mouse pointer reverts back to an arrow pointer at this time. The On Item Help function works only on items in the Front Panel or an item in a subpanel.

Figure 4-3 Help Index Search

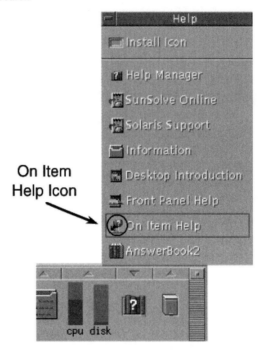

On Item
Help Icon

Figure 4-4 The On-Item Help Function

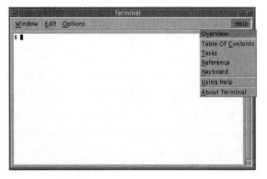

Other Ways to Access Help

Right-clicking any free space on the desktop displays the Workspace menu. From the Work-space menu, the user can select the Help option from the Programs submenu. Clicking the **Help** option in a *Terminal window* activates a drop-down help menu will be activated. From

this menu, the Help Viewer can be accessed. Most windows also have a Help menu option specific to the current application, as shown in Figure 4-5.

Figure 4-5 Application-Specific Help for a Terminal Window

Lab Activity 4.1.4 Using CDE Help

In this lab, you work with several Help functions built in to the CDE to assist you when performing CDE-related tasks. You will use the main CDE help viewer and search the Help index for help on specific topics. You will also use the On Item help feature to discover what desktop icons are. Refer to Lab 4.1.4 in the *Cisco Networking Academy Program Fundamentals of UNIX Lab Companion*, Second Edition.

Solaris HOWTO Manuals (AnswerBook2)

If AnswerBook2 is installed on the computer system or network server, the user will see the icon that is shown in Figure 4-6 on the Help subpanel. Use this icon to access AnswerBook2. Sun's AnswerBook2 (AB2) product is a browser-based online document system. AB2 contains a collection of printed Solaris HOWTO manuals, which include graphics and the UNIX man pages. The man pages will be covered in the next section. Several collections of online manuals contain a tremendous amount of information. The HOWTO manuals that come with AB2 are categorized as follows:

- Solaris 9 System Administrator Collection
- Solaris 9 User Collection
- Solaris 9 Software Developer Collection
- Solaris 9 Reference Manual Collection (man pages)

Figure 4-6 Help Subpanel Window

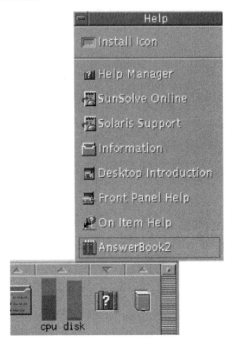

Hyperlinks in AB2 can be used to skip to the relevant pages of the online manual. AnswerBook2 uses the HotJava browser to display information. The user can perform searches on parts of AB2 or the entire collection. Figure 4-7 shows the initial AnswerBook2 screen.

Figure 4-7 Initial AnswerBook2 Screen

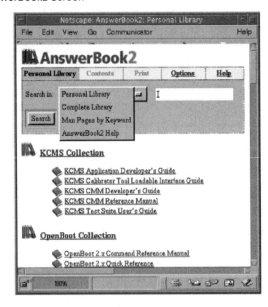

Because of the amount of disk space AnswerBook2 uses, the system administrator might not have installed AnswerBook2 on the computer's hard disk. However, it is possible to access AnswerBook2 files from a CD-ROM, or hard disk device connected to a remote host such as a server on the network.

If AnswerBook2 is accessible through the network, there will be a delay between requesting and displaying AnswerBook2 pages. The speed with which the pages are collected from the remote hard drive or CD-ROM device depends on network configuration and activity.

 Lab Activity 4.2.1 Referencing Solaris AnswerBook2 Help

In this lab, you work with Sun Solaris AnswerBook2 and become familiar with the various collections of available online manuals. The AnswerBook2 system enables you to use the Web browser to view online versions of many of the printed Solaris manuals, including the graphics. Refer to Lab 4.2.1 in the *Cisco Networking Academy Program: Fundamentals of UNIX Lab Companion*, Second Edition.

In addition to the graphical CDE help (Help Manager and AB2), you can get help on UNIX commands and other programming topics using command-line help known as **man pages**.

Man Pages

You will use the man pages often if you work in UNIX frequently, or if you do not have access to graphical-based help.

The UNIX Programmer's Manual, also called man pages, describes what you will need to know about commands, system calls, file formats, and system maintenance. The online man pages are part of the Solaris and Linux computing environments, and all other versions of UNIX. These man pages are installed by default. Man pages are in the form of simple character-based screen displays and are not graphical. However, they are accessible through the GUI Help interface in GNOME and KDE and AnswerBook2 on Solaris systems.

To access the man pages, the user needs to be at a shell prompt, such as that found in a Terminal window, or use one of the GUI Help interfaces like Answerbook2. Man pages are helpful when you want to use a command or utility and you have forgotten the syntax or information about how to use it. The man pages provide information on how to enter the command, a description of its purpose, and what options or arguments are available. In addition, man pages provide a "see also" list with additional commands that may be relevant. Some commands will not work with all UNIX shells. The Solaris man pages

tell which commands will work with which shells. They refer to the Bourne shell as (sh), the Korn shell as (ksh), and the C shell as (csh). The Linux man pages focus on the Bash shell.

man Command

Man pages are a quick and convenient way to check on UNIX command syntax while at a command prompt.

The **man** command displays online man pages for any of the hundreds of UNIX commands that are available. You can get a listing of all the UNIX commands with a brief description of what they do by entering **man intro** at the command line. You can even display a man page on the **man** command itself by typing **man man**.

You can use the **man** command in several ways. The basic form is **man** *name*, which is the name of the command for the information you want. There are several useful options to the **man** command for performing keyword searches and displaying specific sections of the Programmer's Manual. Several different ways to use the **man** command are listed here, with a brief explanation of each one:

- **$ man** *name* Provides help on a particular command, where *name* is the name of the command that the user wants help with, such as **ls**, **cat**, or **mkdir**.

- **$ man -k** *keyword* Searches the man pages' table of contents for the specified keyword and displays a one-line summary for each entry. Figure 4-8 shows an example of the output from this command.

Figure 4-8 man -k *keyword*

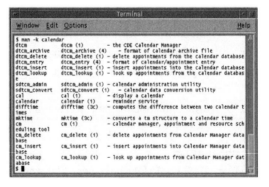

- **$ man -s** *section name* Displays a particular section of the man pages, which can include multiple commands. Figure 4-9 shows an example of the output from this command.

Figure 4-9 man -s *section name*

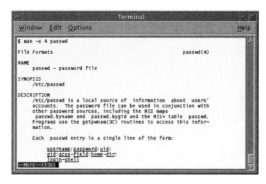

Man Page Headings

A number of different headings or informational areas are in a typical man page. The more common ones follow:

- **NAME**—Contains the name of the command and other commands that might accomplish the same thing.
- **SYNOPSIS**—Shows the syntax of the command with any allowable options and arguments.
- **DESCRIPTION**—Includes an overview of what the command does.
- **OPTIONS**—Shows switches that can change the function or effect of the command. They normally are preceded by a dash (-) or minus sign.
- **OPERANDS**—Shows the target of the command or what the command will take effect on such as a directory or a file.
- **SEE ALSO**—Refers the user to other related commands and subjects, such as name, synopsis, description, options, and operands.

These headings are displayed in the man page output in all capital letters. Depending on the command and its purpose, the man page might not contain all headings. For example, the **pwd** (print working directory) command does not have options or operands information headings because no options or operands can be used with the command. All commands will have at least a name, a synopsis, and a description.

A common UNIX command is **cd**, which allows the user to change directories. Figure 4-10 shows the results of the man page for the **cd** command. You will notice the different headings just discussed. Some of the output has been omitted because the output from the **cd** man page is normally about nine pages long.

Figure 4-10 Man Page Output

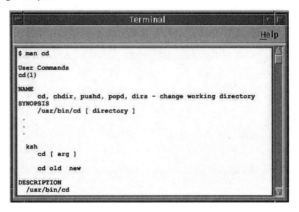

Scrolling in Man Pages

The output from some man pages can be as many as 10 to 20 screens. Several keys help move around in the man utility after the pages for a specific command have been located. Use the keys shown in Table 4-1 to control the scrolling capabilities while using the **man** command. This scrolling capability is the same as provided by the **more** command, used to view a long file page by page.

Table 4-1 Scrolling the Man Pages

Key Command	What It Does
Spacebar	Scroll one screen at a time
Enter	Scroll one line at a time
b	Back—Move back one screen
f	Forward—Move forward one screen
q	Quit—Exit the main menu
/string	Search—Forward for the text string specified
n	Next—Find the next occurrence of the string
h	Help—Give a description of all scrolling capabilities

Searching Man Pages by Section

The SEE ALSO part at the bottom of a man page lists alternate references that pertain to the topic addressed. When a number other than 1 in parentheses follows these references, it

indicates a section of the man pages that can be accessed using the **-s** option with the **man** command.

For example, executing $ **man passwd**, as shown in Figure 4-11, displays information on the **passwd** command and gives instructions on how to change a password. The SEE ALSO section of this man page reads in part as follows:

```
SEE ALSO
finger(1),login(1),nispasswd(1),crypt(3C),passwd(4)
```

Figure 4-11 Searching the Man Pages by Section

```
$ man passwd
...
... (Output Omitted)
...
SEE ALSO
finger(1), login(1), nispasswd(1),
crypt(3C), passwd(4)

$ man -s 4 passwd

$ man -s 3C crypt
```

Executing $ **man -s 4 passwd** (Solaris) or $ **man -S 5 passwwd** (Linux) displays information on the /etc/passwd file. Executing $ **man -s 3C crypt** (Solaris) displays information on password encryption. The other SEE ALSO items listed, **finger** and **login**, are related but do not have a separate section that can be searched.

UNIX vendors organize the man pages differently. Typically there are eight main sections of the UNIX manual broken down in any number of subsections (like 3C). Table 4-2 shows the basic manual sections for Solaris and Linux.

Table 4-2 Man Page Section Numbers for Solaris and Linux

Section Number	Topic (Solaris)	Topic (Linux)
1	User commands	User commands
2	Kernel system calls	Kernel system calls
3	Library functions	Library functions

continues

Table 4-2 Man Page Section Numbers for Solaris and Linux (Continued)

Section Number	Topic (Solaris)	Topic (Linux)
4	Administrative file formats	Special files (/dev directory)
5	Miscellaneous	Administrative file formats
6	Games	Games
7	Special files (/dev directory)	Macro packages
8	Administration commands	Administration commands

Most commands used by a typical user are located in Section 1, "User Commands." If no section number is specified, the **man** command searches the manuals starting from Section 1. If the command specified is located in Section 1 it will not continue searching even if the command exists in another section.

If the user knows in what section a command is, he would use the **man -s** command followed by the section as discussed above.

Searching Man Pages by Keyword

NOTE

The keyword lookup for searching man pages is enabled by default on a Linux system. To enable this feature with Solaris, the system administrator must execute the **#catman -w** command as the root user. This indexes the man pages so they can be searched using the **-k** option.

The **-k** option for the **man** command is also helpful. The user would use the **-k** option to specify a keyword as a subject. For example, use this option to look for a command that has to do with the word calendar when you are not sure what commands are available. Figure 4-12 shows example of this. The **apropos** (apropos keyword) command functions identically to **man -k**.

Figure 4-12 Searching Man Pages by Keyword

Displaying Man Page Headers with whatis

Using the **whatis** command displays the header line from the manual section, as shown in Figure 4-13. The man page then can be displayed by using the **man** command. The **whatis** command is helpful if the user can remember the command name but forgets what it does. The user can use **whatis** to get a brief definition of the command.

Figure 4-13 whatis command

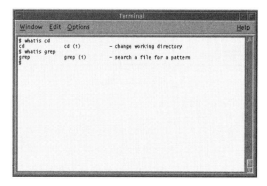

Saving Man Pages for Future Use

You can save a man page to a text file for editing or e-mailing. For example, use this command:

`$ man command_name | col -b > filename`

For example:

`$ man intro | col -b > ~/unix-cmnds.`

In this example, the **intro** command in Solaris contains a list of all UNIX commands:

- The vertical bar, or pipe (|), is covered in Chapter 7, "Advanced Directory and File Management."
- **col -b** formats the man page output.
- The greater than sign (>) means to send the output of any command to a file.
- **~/unix-cmnds** is the file (unix-cmnds) that gets created in the users' home directory. ~ represents the users' home directory.

Obtaining Quick Help on Command Options

In addition to the man pages, command options help can also be obtained by via the command itself. With Solaris, type the command followed by a **-?** An example would be **ls -?**. The question mark is an invalid option and, depending on the command, a list of valid options

TIP

You can print a man page by typing **$ man command_name lp** (or **lpr**). The line printer commands **lp** and **lpr** are covered in Chapter 11, "Printing." Basic features of the shell program are covered throughout this course. Advanced shell features can be learned by issuing the **man** command for the shell program that you use. For example, with Solaris, **man ksh** prints the manual pages for the Korn shell. Replace **ksh** with **bash** for the Bash shell, **sh** for the Bourne shell, and **csh** for the C shell. Linux gives man page information on the Bash and tcsh shells but not for the Korn, Bourne, or C shells.

may be displayed. Commands requiring arguments, such as **man**, when entered without any arguments will result in the display of brief help information. With Linux, type the command followed by two dashes and the word **help**. That example would be **ls --help**.

Lab Activity 4.3.7 Using Command-Line Help

In this lab, you work with and access command line help using the **man** command. The man pages are employed to determine the use of various UNIX commands as they work with the man pages and learn to navigate through them. Refer to Lab 4.3.7 in the *Cisco Networking Academy Program: Fundamentals of UNIX Lab Companion*, Second Edition.

Linux HOWTOs

The UNIX and Linux man pages are an excellent resource. However, they can prove to be confusing to a user hoping to turn the information that the pages provide into a process by means of which to get some work done. An example would be if the user has just purchased a CD-ROM burner to create CD-ROMs. Before the user can begin creating CD-ROMs, they must install and configure the device, learn what software is available, and how to use it. Or the user has a need to set up an e-mail server, but has no idea how to go about it. Both examples are daunting tasks for any user who must start from the beginning.

For such projects Linux users may consult a valuable library of HOWTO guides. Each one provides detailed information in outline form on a given topic.

Where to Find the HOWTOs

The HOWTOs are not installed by default in most Linux distributions. Red Hat puts the HOWTOs together with some Red Hat-specific extras on a CD-ROM that comes with the packaged version of the operating system. These may be viewed directly from the Documentation CD-ROM using Nautilus, a web browser, or even a text editor such as Emacs. They may also be installed on the user's system so they are always handy.

However, the HOWTOs exist independently from any distribution. The single most valuable source of documentation about Linux is the ***Linux Documentation Project***, which may be found on the Internet at www.tldp.org. (See Figure 4-14.) Notice that a link to the HOWTOs is prominently displayed at the very top. It is from here that the very latest version of the HOWTO files may be viewed or downloaded.

From the web page, follow the links to a number of indexes, organized by title and by category. This will lead ultimately to the HOWTOs themselves. For example, the HOWTO named CD-Writing-HOWTO is likely to provide all the information one is likely to need to get started creating CD-ROMs. The Mail-Administrator-HOWTO provides extensive background on all the functions of administering an e-mail server.

Figure 4-14 Linux Documentation Project

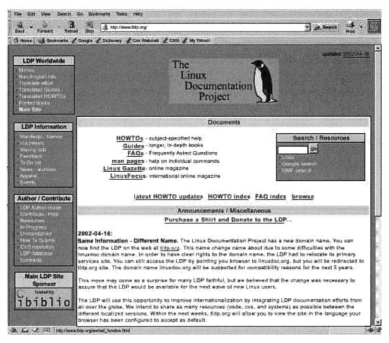

In addition to the *HOWTOs*, there are links on the leading to Guides, *(FAQs)*, and even the master man pages. The Guides are short books on such subjects as advanced Bash shell script writing, a Linux system administrator's guide, and kernel internals. FAQs are collections of frequently asked questions about a variety of topics.

info Command

Another way to read documentation is with the **info** command. Users of the Emacs and XEmacs editors will find **info** familiar, because info mode is built in to them, and works the same. These editors are covered in Chapter 9, "Using Text Editors." As a standalone Linux command, **info** is info mode from Emacs in terminal mode, together with a library of documentation.

Starting Info

The **info** command runs in text mode in a Terminal window. The user does not need to know exactly what is being looked for when starting Info.

You will see a startup window like Figure 4-15, with basic instructions at the top and a menu consisting of a catalog of topics, when they run Info without command-line options or arguments like this:

```
$ info
```

Figure 4-15 Info Started Without Options or Arguments

```
File: dir   Mode: Top    This is the top of the INFO tree

   This (the Directory node) gives a menu of major topics.
   Typing "q" exits, "?" lists all Info commands, "d" returns here,
   "h" gives a primer for first-timers,
   "mEmacs<Return>" visits the Emacs topic, etc.

   In Emacs, you can click mouse button 2 on a menu item or
   cross reference to select it.

* Menu:

Textinfo documentation system
*Standalone info program: (info-stnd).   Standalone Info-reading program.
* Textinfo: (texinfo).    The GNU documentation format.
* makeinfo: (texinfo)Invoking makeinfo.   Update info/dit entries.
* texi2dvi: (texinfo)Format with texi2dvi. Print Texinfo documents.
* texindex: (texinfo)Format with tex/texindex. Sort Texinfo index files.

Miscellaneous
* As: (as).      The GNU assembler
-----Info: (dir)Top. 363 lines --Top-----------------------------------
Welcome to Info version 4.0b Type C-h for help, m for menu item.
```

Like many Linux commands, Info has a help option that gives startup instructions that appear as shown in Figure 4-16.

Figure 4-16 Info Help Message

```
$ info --help
Usage: info [OPTION]... [MENU-ITEM...]

Read documentation in Info format.

Options:
--apropos=SUBJECT       look up SUBJECT in all indices of all manuals.
--directory=DIR         add DIR to INFOPATH.
--dribble=FILENAME      remember user keystrokes in FILENAME.
--file=FILENAME         specify Info file to visit.
--help                  display this help and exit.
--index-search=STRING   go to node pointed by index entry STRING.
--node=NODENAME         specify nodes in first visited Info file.
--output=FILENAME       output selected nodes to FILENAME.
--restore=FILENAME      read initial keystrokes from FILENAME.
--show-options, --usage goto command-line options node
--subnodes              recursively output menu items.
--vi-keys               use vi-like and less-like key bindings.
--version               display version information and exit.

The first non-option argument, if present, is the menu entry to
start from; it is searched for in all 'dir; files along INFOPATH.
If it is not present, info merges all 'dir' files and shows the result.
Any remaining arguments are treated as the names of menu
items relative to the initial node visited.

Examples:
```

The **info** command may also be started with a subject as an argument. There is Info documentation on Info itself. To start with a window like the one shown in Figure 4-17, run the following:

```
$ info info
```

Figure 4-17 The First Page of Info Documentation on Info Itself

```
File: info.info, Node: Top, Next: Getting Started, Up: (dir)

Info: An Introduction
*********************

    Info is a program for reading documentation, which you are using now.

    If you are new to Info and want to learn how to use it, type the
command 'h' now.  It brings you to a programmed instruction sequence.

    To learn advanced Info commands, type 'n' twice. This brings you to
'Info for Experts', skipping over the 'Getting Started' chapter.

* Menu:

* Getting Started::         Getting started using an info reader.
* Advanced Info::           Advanced commands within Info.
* Creating an Info File::   How to make your own Info file.
* Index::                   An Index of topics, commands, and variables.

--zz-Info: (info.info.gz)Top, 20 lines --All-----------------------------
Welcome to Info version 4.0b Type C-h for help, m for menu item.
```

Navigating with Info

Within Info, simple commands enable the user to navigate within the current page, to next or previous pages within the same document, or to Info documentation on different topics. Press the question mark to produce a reference guide to basic commands in Info windows. The top few lines of this, showing the most important commands, are shown in Figure 4-18.

Figure 4-18 Basic *info* Command Help Accessed with the Question Mark

```
Basic Commands in Info Windows
******************************

    CTRL-x 0   Quit this help.
    q          Quit Info altogether.
    h          Invoke the Info tutorial.

Moving within a node:
---------------------
    SPC        Scroll forward a page.
    DEL        Scroll backward a page.
    b          Go to the beginning of this node.
    e          Go to the end of this node.
    ESC 1 SPC  Scroll forward 1 line.
    ESC 1 DEL  Scroll backward 1 line.

Selecting other nodes:
----------------------
    n          Move to the 'next' node of this node.
    p          Move to the 'previous' node of this node.
    u          Move 'up' from this node.
    m          Pick menu item specified by name.
               Picking a menu item causes another node to be selected.
    f          Follow a cross reference. Reads name of reference.
    l          Move to the last node seen in this window.
    TAB        Skip to next hypertext link within the node.
    RET        Follow the hypertext link under cursor.
    d          Move to the 'directory' node. Equivalent to 'g (DIR)'.
```

Info Access with a Browser

Info can also be accessed conveniently using the Help tab of the Nautilus graphical interface in GNOME or using help in KDE. Hyperlinks are available when using the browser interface. Figure 4-19 shows the Nautilus Info screen while looking up information on the Bash shell.

Figure 4-19 Info Access with Nautilus

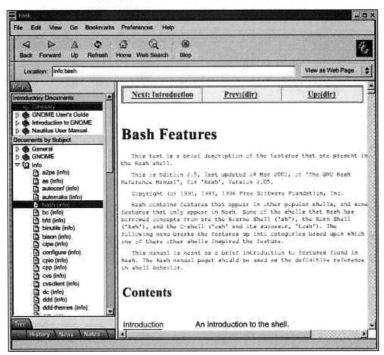

Basic UNIX Workstation Troubleshooting

The most common issues people have with operating their UNIX workstation are the following:

- Accessing applications
- Accessing and managing files
- Printing
- Troubleshooting an unresponsive Terminal window
- Troubleshooting an unresponsive application
- Troubleshooting an unresponsive workstation

By the end of this course, you will be more familiar with your workstation and will have the ability to do basic troubleshooting. For problems that you cannot fix, you should contact

the system administrator or service/help desk designated to help users with workstation problems.

If you contact the service/help desk, you will be asked for some information about your system before you are asked about the problem.

Workstation Information

Information about your workstation, the type, memory, OS release, and so on, can be viewed by choosing Hosts and then Workstation Info from the Workspace menu, as shown in Figure 4-20. If CDE is not available, you can use the following Solaris commands to obtain system information. Except for prtconf, these will work with Linux:

- **$ hostname** displays the name of the workstation or host.
- **$ uname -a** displays expanded system information, including the name of the workstation, the OS version, and more.
- **$ arp <hostname>** displays the host name, IP address, and Ethernet address. This command is in /usr/sbin in Solaris and Linux and may not be available unless logged in as root.
- **$ domainname** displays the domain that the workstation is in, such as Corp.East.Sun.com.
- **$ prtconf | grep Memory** displays the amount of system memory (Solaris only).

Figure 4-20 Workstation Information

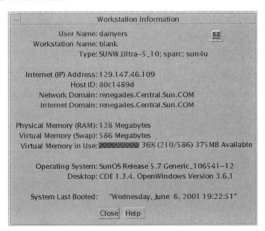

In CDE, you can open a *Console* window to display messages from the network and to inform you of system errors that might be helpful in troubleshooting, as shown in Figure 4-21. A Console window might look like a Terminal window, but do not use it for entering commands. Only one Console window should be open on the desktop if you choose to display

messages at all. To open a Console window, right-click the desktop and choose **Hosts**; then select **Terminal Console**.

Figure 4-21 Console Window

Accessing Applications

Typically, applications are installed and maintained by the system administrator. If you are having difficulty starting an application, you should call the service/help desk. If you have questions regarding using an application that did not come up in a training class, you also should call the service/help desk.

Accessing and Managing Files

Many problems with file access result from the user having inadequate permissions. Others can be caused by incorrectly specifying file/directory names or directory location. By the end of this course, you will have worked with files and directories enough that you feel comfortable doing some basic troubleshooting on your own.

Printing

Most printing will be done from an application and is easy. Printing files and managing print jobs is covered in Chapter 11, "Printing." If a printer is down because of repairs or other reasons and you cannot print, contact the service/help desk.

Unresponsive Terminal Window

If a Terminal window's prompt becomes unresponsive to keyboard entry, you may need to enable screen scroll, enter EOF (end of file), or interrupt the process.

To check an unresponsive terminal, follow these steps:

1. Enable screen scroll by using Ctrl+Q. Sometimes a user turns off screen scrolling, by using Ctrl+S, and does not turn it back on. Therefore, the terminal appears locked.

2. Interrupt the process by using Ctrl+C. This will cancel the current task and should restore the shell prompt.

3. Enter EOF (end of file) using Ctrl+D. You might be in the middle of a UNIX command that needs to be terminated by an EOF such as bc, mail, mailx, and so on.

4. Quit the window and start a new one.

Unresponsive Application

If an application becomes unresponsive, try to close the window by using the mouse. If that does not work, you have two options:

- Determine the process ID number associated with the application, and end that process. This process is covered in Chapter 13, "System Processes."

- Log out and log back in; then restart the application.

Unresponsive Workstation

If the window environment or the system in its entirety becomes unresponsive, you can perform a series of steps.

When attempting to unlock an unresponsive system, first go to another system, telnet or remote login to the unresponsive system, and terminate the login shell program. The **rlogin**, **ps**, and **kill** commands are covered in more detail in Chapter 13.

If the previous procedure does not work, you must reboot the system using one of the following actions:

- The Stop-A keyboard sequence on a Sun SPARC workstation is used to abort. This should be used only when the system is completely unresponsive to keyboard and mouse input for a period of minutes. The Stop-A sequence abruptly aborts and does not bring down the system cleanly. Stop-A brings down the system to a > (greater than) prompt, where you can issue the **b** (boot) command to reboot.

- If the abort (Stop-A) does not work, the last option is to power off the system, wait 10 seconds, and then power on the system.

> **NOTE**
>
> It's best to contact a system administrator or the help desk before attempting this procedure.

DOS and UNIX Command Comparison

Even though most operating systems, including Microsoft Windows 9x/NT/2000/XP, Solaris, Linux, and other types of UNIX, have graphical user interfaces, they all have a command prompt available. Knowledge of the command line and command syntax for any operating system is still quite useful and necessary in today's information technology world. Sometimes the command line is all that is available for performing critical system tasks and troubleshooting. For example, you might be at home and need to access your school or work system. Bringing up a GUI over a modem would be extremely slow; therefore, command-line access is a good option.

Command-line capabilities are generally more powerful and flexible than GUI interfaces, especially in the UNIX environment. System administrators frequently construct scripts similar to batch files with *DOS* or CMD (command) files with Windows NT/2000. These contain commands to support end users, perform system administration functions, and automate routine tasks. Scripts are more flexible than batch or CMD files and are actually programs that use a scripting language. They can be more powerful when combined with other UNIX tools such as grep, sed, and awk. An introduction to basic script writing is covered in Chapter 15, "Introduction to Shell Scripts and Programming Languages."

NOTE

All UNIX commands are lowercase, as shown in the figure.

Users who are new to the UNIX operating system and have a background in DOS may find learning UNIX commands easier. Administrators who work with NT/2000 command files will also see the benefits of scripts. NT/2000 command files are based on the DOS 5.0 command set. Table 4-3 shows a DOS/UNIX reference table that lists some of the more common DOS commands and their UNIX equivalent. Because UNIX predates DOS, most DOS commands are based on those found in UNIX. UNIX commands can do everything that DOS commands can do and more. The DOS DIR command lists the files in a directory. The UNIX **ls** (list) command does the same but has many more options available. There are also UNIX commands that DOS does not have an equivalent for, such as the **mv** (move) command. The reference table helps you transition from the DOS to the UNIX world. This is not intended to be an exhaustive list of all the commands in either operating system. You can do 80 percent of what they normally need to do on a daily basis with 20 percent of the tools or commands available.

Table 4-3 DOS and UNIX Reference Table

DOS Command	UNIX Command	Function
DIR	**ls**	Lists content of a directory
CD (show current dir)	**pwd**	Prints (displays) working directory
CD	**cd**	Changes working directory
MD	**mkdir**	Makes directory under current directory
RD	**rm**	Removes directories
DEL (or **ERASE**)	**rm**	Removes files
COPY	**cp**	Copies files
TYPE	**cat**	Displays files (cat also concatenates files)
REN	**mv**	Moves or renames files (DOS does not move files)
VER	**uname -rs**	Displays OS name and release number

Table 4-3 DOS and UNIX Reference Table (Continued)

DOS Command	UNIX Command	Function
SORT	**sort**	Sorts files
MORE	**more**	Displays file contents a screen at a time
CLS	**clear**	Clears the screen
DATE	**date**	Displays current date and time
EDIT	**vi**	Invokes an ASCII text editor
PRINT	**lp**	Prints a file
HELP	**man**	Provides help on a command

Summary

The Sun Solaris Operating Environment has many different forms of help available to users and administrators. With CDE help, you can use the Help Viewer window, search for a particular help topic, and use On Item help. Each CDE window and application also has a help option in the upper-right corner. The Help Viewer window can be accessed from the Workspace menu or the Help icon on the front panel.

AnswerBook2 is a useful online searchable version of the Solaris manuals. Several book collections are presented, including information for administrators, users, and developers.

Command-line help is available in the form of man pages and can be displayed using the **man** command. Man pages are installed with all varieties of UNIX. They cover nearly every UNIX command and provide a quick reference when you need to check the syntax or options available with a particular command. Several options are available with the **man** command, including keyword and section search capabilities. The **whatis** command provides a brief definition and purpose of the command.

Linux HOWTOS provide instruction on how to perform various common Linux tasks. Linux distributions include a command line and a hypertext help utility called Info, which is available for many UNIX commands and applications.

When problems occur, narrow the possibilities by following a systematic approach to identifying and correcting the problem. Contact a system administrator or the service/help desk for problems that you cannot resolve.

Users familiar with DOS commands will have an easier time learning UNIX because many of the DOS commands were derived from UNIX. There are hundreds of UNIX commands. These commands can be used to accomplish all the tasks that DOS users normally would need to do, but in a UNIX environment.

Check Your Understanding

1. Which of the following is the primary help tool for CDE desktop?

 A. AnswerBook2

 B. Front Panel Help

 C. Help Manager

 D. On Item Help

2. Which of the following contains the Solaris online reference manuals?

 A. AnswerBook2

 B. Information

 C. SunSolve Online

 D. Solaris Support

3. Which command is used to access the UNIX Programmers Manual?

 A. **help**

 B. **man**

 C. **manual**

 D. **progman**

4. Which of the following is used to obtain a listing of all UNIX commands in Solaris?

 A. **man all**

 B. **man cmd**

 C. **man intro**

 D. **man man**

5. Which three of the following are UNIX shells?

 A. bsh

 B. csh

 C. ksh

 D. sh

6. Match the man header with the correct description.

OPTIONS		1. Contains the name of the command and other commands that may accomplish the same thing
SEE ALSO		2. Shows the syntax of the command with any allowable options and arguments
DESCRIPTION		3. Gives an overview of what the command does
OPERANDS		4. The target of the command or what the command will take effect on such as a directory or a file
NAME		5. Are switches that can change the function or effect of the command. They normally are preceded by a dash (-) or minus sign
SYNOPSIS		6. Refers you to other related commands and subjects, such as name, synopsis, description, options, and operands

7. Which of the following are valid variations of the **man** command? (Select three.)

 A. **man** *page-number*

 B. **man** *command name*

 C. **man** *keyword*

 D. **man** *section name*

8. Which command displays extended system information such as workstation name, OS version, and so on?

 A. **arp**

 B. **domainname**

 C. **hostname**

 D. **uname -a**

9. When troubleshooting an unresponsive Terminal window, which of the following is the recommended sequence of keys to press to free up the Terminal window?

 A. Ctrl+C, Ctrl+D, Ctrl+Q

 B. Ctrl+D, Ctrl+Q, Ctrl+X

 C. Ctrl+Q, Ctrl+C, Ctrl+D

 D. Ctrl+X, Ctrl+Y, Ctrl+Z

10. Match the command with the correct description of what it does.

arp *hostname*		1. Displays the name of your workstation or host
domainname		2. Displays expanded system information, including the name of your workstation, the OS version, and more
prtconf \| grep Memory		3. Displays the host name, IP address, and Ethernet address
hostname		4. Displays the domain that the workstation is in
uname -a		5. Displays the amount of system memory on a Solaris system.

11. Given the list of steps required for troubleshooting an unresponsive workstation, organize them in the correct sequence.

 Turn off the system.

 Press the Stop-A keyboard sequence.

 Go to another system and do a remote login and terminate the login shell program.

1	
2	
3	

12. What are the DOS equivalents to the UNIX commands below?

UNIX Command	DOS Command
cp	
mv	
ls	
rm	
mkdir	

UNIX Command Summary

Ctrl-c Cancels the current activity. Example:

```
$ man intro <Ctrl c>
```

Ctrl-d Indicates the end of file or exit. Example:

```
$ bc
5280/3
1760
<Ctrl d>
$
```

Ctrl-q Resumes screen output. Example:

```
$ cat largfile <Ctrl s> <Ctrl q>
```

domainname Displays name of the current domain. Example:

```
$ domainname
elvis.central.Sun.com
```

hostname Displays name of current host system. Example:

```
$ hostname
buckeye
```

info Detailed and well-organized alternative to man pages. Uses an Emacs-type interface.

$info or $info date

man Displays information from the reference manuals. It displays complete manual pages that you select by name, or one-line summaries if selected by keyword. Example:

```
-s, -k
$ man man
$ man cd
```

prtconf Prints system configuration information. Example:

```
$prtconf | grep Memory
Memory size: 128 Megabytes
```

uname Displays the name of the current system. Example:

```
-n
```

```
$ uname -n
buckeye
```

whatis Looks up a given command and displays the header line from the manual section. Example:

```
$ whatis cd
cd    cd (1)   -change working directory
```

Key Terms

AnswerBook2 System that enables you to view an online version of the printed Solaris manuals, including graphics.

console The main input/output device that is used to access a system and display all system messages. This can be either a display monitor and keyboard or a shell window.

DOS An early single-user, single-tasking, character-based PC Disk Operating System developed by Microsoft and IBM.

FAQs A collection of Frequently Asked Questions about a variety of topics.

Help Manager The primary CDE help tool for most situations available from the front panel.

HOWTOs Online reference containing information and procedures on how to perform a task using the operating system. The Solaris HOWTOs are referred to as AnswerBook2. Linux HOWTOs are not installed by default in most Linux distributions.

Linux Documentation Project A valuable online source of documentation about Linux. Can be found on the Internet at www.tldp.org.

man pages Describe what you need to know about the system's online commands, system calls, file formats, and system maintenance. The online man pages are part of all versions of UNIX and are installed by default. Man pages are in the form of simple character-based screen displays and are not graphical. The **man** command is used to access man pages.

Terminal window A graphical window that can be opened within the CDE for access to the command line and UNIX commands. Multiple Terminal windows can be opened simultaneously. Terminal windows support scrolling and cut/copy/paste.

UNIX Multiuser, multitasking network operating system. Different computer manufacturers produce their own versions of UNIX.

Objectives

Upon completion of this chapter, you will be able to

- Understand and describe the structure of the UNIX and Linux file systems.
- Identify relative and absolute path names.
- Navigate the directory structure.
- List the contents of a directory.
- Define the function of the parts of the directory listing.
- Identify and use metacharacters.

Chapter 5

Accessing Files and Directories

Introduction

This chapter reviews the concept of a file system and introduces path names to identify locations of files and directories in the directory tree. You work with specific commands that allow access to files and directories. You work with the **cd** command to change directories and navigate the file system, and the **ls** command to list the contents of directories. The chapter also explains the meaning of various directory listing components. Metacharacters are also introduced, and you use several metacharacters known as wildcards to list groups of related files. The majority of information presented here is applicable to Solaris, Linux, and most other forms of UNIX. Exceptions are noted.

A file system is a hierarchy of directories, subdirectories, and files that organize and manage the information on hard disks. Knowing the directory structure of a file system and how to navigate the file system is essential to working with UNIX.

Sample User Directory Structure

Figure 5-1 shows a sample UNIX file system structure for a user. This is the class file tree structure, which you refer to throughout this and remaining chapters, exercises, and labs. This structure should exist in your home directory and was placed there as part of the setup for the course. Note that there are directories, subdirectories, and files in the structure. Directories and subdirectories have a folder icon and files have a document icon. The structure and names of directories within a user's home directory can vary considerably, depending on user needs. For example, a user could have major directories named Projects, WPDocs, Finances, and Hobbies under the home directory. The names of the directories are determined by their purpose and what they contain.

Figure 5-1 Class File Tree Structure

NOTE

Do not confuse *the* home directory (/home) with *your* home directory (/home/userxx for this course). The home directory (/home) is where user home directories reside. When you log in, you are automatically placed in *your* home directory as defined by the entry in the /etc /passwd file. References to your home directory like "… in your home directory" or "change directories back home" mean your login directory and not the /home directory.

UNIX file system and directories were introduced in Chapter 1, "The UNIX Computing Environment." Hard disks are divided into file systems and directories. These directories exist to group information into containers that categorize them. By organizing or grouping files into directories, applications and users can find needed files quickly and easily. The creation of directories and naming conventions are covered later in the course. Directories are created in one of four ways:

- **Directories are created by the operating system during installation**. Several directories are created when an operating system (OS) is first installed. In the UNIX environment, these include usr, dev, etc, home, and others. Figure 5-2 shows some of the UNIX directories created at installation. The directories created vary somewhat depending on the OS version. The OS uses them to store files critical to the operation of the computer, including the kernel itself.

- **Directories can be created by applications during installation**. When applications such as StarOffice are installed, directories are created automatically to give the application places to store installation files and for use by the application and users to store data files.

- **The system administrator can create directories**. When creating user accounts on a workstation or server, the system administrator (sysadmin) can create a particular directory or set of directories, depending on user needs.

- **Users can create their own directories**. Users can create directories, provided that they have proper permission. By default, users have permission to create subdirectories and files under their home directory. Directory and file permissions are covered in Chapter 10, "File Security."

Figure 5-2 Common UNIX Directories

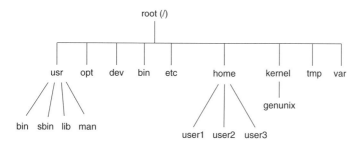

The directories that make up a file system form a hierarchical structure. This hierarchical structure looks like an inverted or upside-down tree with the root at the top. See Figure 5-1 or the inside-front cover of this book. Directories can contain subdirectories and files. This is similar to having a file drawer called Projects, or directory, containing folders in it with the names of individual projects or subdirectories. Subdirectories also can contain additional subdirectories and more files. All operating systems have some sort of directory structure to organize information on the computer's hard disks as well as floppy disks. With some operating systems, such as Windows and MacOS, directories are referred to as folders. With the UNIX file system, they are called directories but are used in the same manner.

Figure 5-3 shows a hierarchical directory structure with the ***root directory*** at the top and several subdirectories below. A common hierarchical system or structure that you may be familiar with is the family tree of your ancestors. The file system directory structure is similar to a family tree. With the exception of the root directory, each directory in the hierarchy has a ***parent directory***, and most have child directories, which are referred to as subdirectories. The root directory is always at the top of the hierarchy and is designated as a forward slash (/). There can be only one root directory in a UNIX file system.

Figure 5-3 Directory Tree

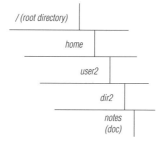

Each child directory is contained in a parent directory, as shown in Figure 5-4. This is similar to having a set of file folders, where each folder, or directory, has a folder and subdirectory inside. Each directory that you go through to access it can specify the location of a file or directory in the tree by name. A fully qualified filename or directory name also is known as an *absolute path name*. It includes the names of all parent directories above it. For example, to determine the location of the notes document, you must name all folders above it.

Figure 5-4 Location of the Notes Document

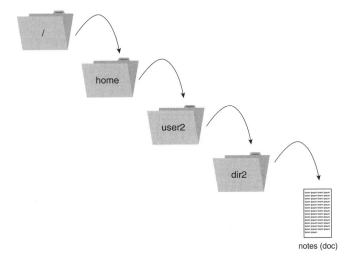

notes (doc)

Directory Paths

Understanding path names to directories and files is critical to understanding file systems and is fundamental to understanding UNIX or any other operating system.

Path Names

A path name uniquely identifies a particular file or directory by specifying its location. Path names are similar to a road map or a set of directions telling the user how to get from one place in the directory hierarchy to another. For example, if someone from another country was giving you directions on how to get to him, he would have to specify where he lives. The directories in a file system can be compared to a country, state, city, and so on. If the earth were like a hard disk with a file system, we would consider it the root of the file system. If we wanted to identify the location of a person to tell someone where he or she lives, we would specify the path name until we got to that person. We would use a fully qualified path name so that there would be no doubt that we are talking about that person of planet Earth, not some other planet. (See Figure 5-5.)

Figure 5-5 Solar System Hierarchy

Solar System Container	Solar System Location	Solar System Path Name	File System Term
Planet	Earth	/root	File System Root
Country	USA	/USA	Main Directory
State	Arizona	/USA/Arizona	Subdirectory
City	Phoenix	/USA/Arizona/Phoenix	Subdirectory
Address	Cactus St.	/USA/Arizona/Phoenix /Cactus	Subdirectory
Name	Brad	/USA/Arizona/Phoenix /Cactus/Brad	Filename

Figure 5-6 shows the hierarchical relationship between the root directory and the coffees subdirectory. The set of directories that must be specified, starting from the root directory, is considered the path name to the coffees subdirectory. Every file and directory in the file system has a path name.

Figure 5-6 Hierarchy of Folders

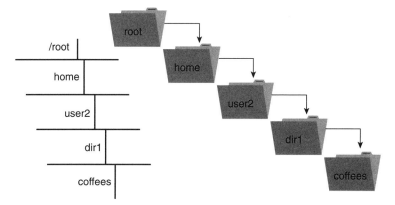

NOTE

Depending on the setup
of the system, users'
home directories can be
found in either /home
(Linux) or /export
/home (Solaris). In
Solaris, if the user's
home directory resides
on the local system, it
usually is found in
/export/home. If it is on
a server, it is usually in
/home. User home direc-
tories for this course are
in /home.

Path Components

Look at the individual components of the path to the /home/user2/dir1/coffees subdirectory, as shown in Figure 5-7. The slashes within the path name are *delimiters* between object names. The slashes act like separators. Object names can be directories, subdirectories, or files. DOS and Windows indicate directories using a backward slash (\), or backslash. All UNIX file systems use a forward slash (/) in path names. A slash (/) in the first position of any path name represents the root directory.

Figure 5-7 Path to the Coffees Folder

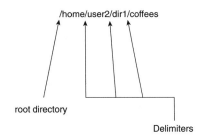

Types of Path Names

Path names specify the location of a directory or file in the directory structure. See Figure 5-1 or the inside-front cover of this book. To navigate the directory structure, it is necessary to have an understanding of path names. Two types of path names are used with UNIX and other operating systems, absolute and relative. Either method can be used at any time. An understanding of each is critical to understanding and navigating the file system.

Absolute Path Names

An absolute path name specifies a file or directory in relation to the entire UNIX file hierarchy. The hierarchy begins at the / (root) directory. If you refer to a directory using its absolute path name, you can always be sure that you get to the correct directory because it always will have the common starting point of the root directory. Figure 5-8 shows some examples of absolute path names that have the following characteristics:

- They always start at the root (/) directory and list each directory along the path to the destination file (or directory).

- They always use a slash (/) between each directory name in the path to indicate different directories.

Figure 5-8 Examples of Absolute Path Names

> • **Absolute path name to the user2 directory**
> /home/user2
>
> • **Absolute path name to the dir1 directory**
> /home/user2/dir1
>
> • **Absolute path name to the coffees file**
> /home/user2/dir1/coffee

Relative Path Names

A ***relative path name*** describes the location of a file or directory as it relates to the current directory, the one you are currently in. If you are in a directory and want to move down the directory tree, it is not necessary to type the absolute path name starting from the root directory (/). Type the path starting with the name of the next directory down in the directory structure. If a path name does not begin with a slash, it is a relative path name. Relative path names are useful. They are usually shorter than absolute path names. To use relative path names, you must know what directory you are currently in. This directory is the starting point. The directory that you are in at any point can change. You must know where you are in the directory tree or hierarchy. Absolute path names are usually longer than relative path names, but they are consistent because the user always specifies the full path from the root, regardless of what directory they are currently in. Figure 5-9 shows some example of relative path names.

Figure 5-9 Examples of Relative Path Names

> If your current directory is /home:
>
> • **Relative path name to the user2 directory**
> user2
>
> • **Relative path name to the dir1 directory**
> user2/dir1
>
> • **Relative path name to the coffees file**
> user2/dir1/coffees

e-Lab Activity 5.1 Path Names Exercise

In this activity, you enter the absolute or relative path name for the directory or file indicated in the exercise. Be sure to use forward slashes, and note that all directory, subdirectory, and filenames are case sensitive. Refer to the class file tree structure on the inside-front cover of this book or click the **tree** button on the CD-ROM e-Lab Activity. Refer to e-Lab Activity 5.1 on the accompanying CD-ROM.

Navigating the File System

To navigate the file system, you must learn the command that displays the current directory location within the file system and the command that is used to change to a different directory. First, however, you must know the proper syntax for using UNIX commands.

Command-Line Syntax

NOTE

Items in square brackets are optional, meaning that they are not always required.

When logged in at the command line or when using a Terminal window, a shell prompt appears on the screen. For the Bourne, Korn, and Bash shells, the basic shell prompt is a dollar sign ($). For a C shell user, the prompt is a percent sign (%). When logged in as root, the shell prompt changes to a hash symbol (#). At the shell prompt, you type commands. Commands are instructions that tell the shell to perform an action. Syntax refers to the structure of the command and specifies allowable options and *arguments*.

The general format for UNIX commands is shown here:

```
$command [option(s)] [argument(s)]
```

See Figure 5-10 for an explanation of each component.

Figure 5-10 Command-Line Syntax

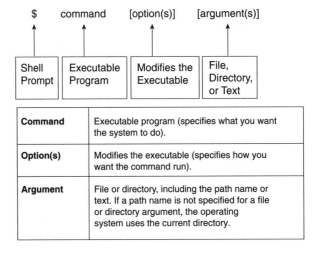

A space must be used as a delimiter between each part of the command entered. Up to 256 characters can be entered on a single command line, although this is not common. UNIX commands are always lowercase. Options are usually a single letter preceded by a hyphen (-), also called a dash or a minus sign. Multiple options can be combined using only one hyphen. The option might be uppercase or lowercase, depending on the command. Many commands do not require all three parts. Multiple commands can be entered on one line by separating

them with a semicolon (;). Figure 5-11 summarizes the syntax rules for using UNIX commands. Figure 5-12 illustrates some examples of UNIX commands with and without options and arguments.

Figure 5-11 UNIX Syntax Rules

• Space is used as a delimiter between command parts.

• Maximum of 256 characters on a single line.

• Commands are lowercase.

• Options can be upper- or lowercase.

• Options usually preceded by a hyphen.

• Multiple options can be used with one hyphen.

• Many commands do not require all three parts.

• Multiple commands can be entered on one line if separated by a semicolon (;).

Figure 5-12 UNIX Command Examples

```
$ cal (Command only)
$ cal 1987 (Command and argument)
$ date (Command only)
$ date -u (Command and option)
$ banner "hi there" (Command and argument)
$ ls  -F dir1 (Command, option, and argument)
$ clear ; date (Command, ; separator, command)
```

Lab Activity 5.3.1 Basic Command-Line Syntax

In this lab, you work with various UNIX commands to develop an understanding of UNIX commands and syntax. Refer to Lab 5.3.1 in the *Cisco Networking Academy Program: Fundamentals of UNIX Lab Companion*, Second Edition.

Displaying the Current Directory

It is often difficult for you to remember which directory you are currently working in. Use the **pwd** (print working directory) command to display the absolute path name of the current directory. The **pwd** command is used frequently to check the current location in the directory tree or hierarchy. When you know your location in the tree, you can move from one directory to another with the **cd** (change directory) command.

Type **pwd** at the shell prompt and press **Enter** to execute the command that determines the directory that you are currently in. Note that the **pwd** command does not have any options or arguments. It simply displays the directory you are in using the absolute path name, so there is no doubt. Assuming that are currently in the /home/user2 directory, you get the following response from the **pwd** command:

```
$pwd
/home/user2
```

 e-Lab Activity 5.2 Using the **pwd** Command

In this activity, you type what you think the result of the **pwd** command would be, depending on the directory you are currently in. Be sure to use forward slashes and note that all directory, subdirectory, and filenames are case sensitive. See the class file tree structure on the inside-front cover of this book or click the **tree** icon on the CD-ROM e-Lab Activity. Refer to e-Lab Activity 5.2 on the accompanying CD-ROM.

Changing Directories Using the cd Command

Files that you need to access often are stored in subdirectories below the home directory. It is often desirable to change directory locations because of the way in which a UNIX file system is set up. The **cd** (change directory) command is used to change to a new current directory. This command, like all UNIX commands, accepts both absolute and relative path names. An example of the **cd** command follows:

```
cd [directory_name]
```

You can move around in the directory hierarchy using the **cd** command along with an absolute or relative path name, as shown in the examples in Figure 5-13. In the first example, we use the **cd** command with an absolute path name. It does not make any difference where you currently are in the directory hierarchy because you are specifying to start at the root (/) directory. The second example uses the **cd** command with a relative path name. It assumes that you are currently in the /home directory, which you changed to in Example 1. If you were not in the /home directory, you would receive an error stating that the directory you were trying to change to does not exist. The third example shows a feature of the **cd** command that allows you to quickly return to the home directory (for example, /home/user2). Entering the **cd** command by itself, without specifying a path name, automatically places you in the home directory.

Figure 5-13 Using the **cd** Command

```
1. Using cd with an absolute path name:

   $ cd /home

2. Using cd with a relative path name:

   $ cd user2/dir1

3. Use cd without a directory name
   returns you to your home directory:

   $ cd
```

Navigation Shortcuts with **cd**

Path name abbreviations are a form of shorthand when moving between or referring to directories. They can save keystrokes when used with the **cd** command. The shortcuts covered include the following:

- **The dot (.), a single period**—Represents the current directory
- **The dot/dot (..), or two periods**—Represents the parent directory
- **The tilde (~)**—Represents the user's home directory
- **The dash or hyphen (-)**—Represents the previous directory visited

Directories always contain a link to their parent directory, which is designated by the dot/dot (..) and a link to themselves, which is the dot (.). The **ls -a** command, which is covered in the next section, shows a dot (.) and a dot/dot (..) even if the directory is empty. These shortcuts can be useful when changing directories using the **cd** command and others.

The **cd ..** command takes you up one directory from the current directory to its parent directory. The **cd ~** command returns you to your home directory (/home/userxx) regardless of where you are in the directory tree. It can also be used as a shortcut with other directories. For example, **cd ~/docs** takes you to the /home/userxx/docs directory. Use **cd ~username** as a quick way to change directories to another user's home directory, if multiple home directories reside on the same system. For example, **cd ~dano** would change to the /home/dano directory. Another navigation time saver for Korn and Bash shell users is **cd -**. The - represents the full path to the previous directory visited. For example:

```
$pwd
/home/dano
$cd ..
$pwd
/home
$cd ~/docs
$pwd
```

NOTE

All directory names, subdirectory names, and filenames are case sensitive.

```
/home/dano/docs
$cd  -
$pwd
/home
```

You can use path name abbreviations or shortcuts with the **cd** command to move around the file structure. Figure 5-14 shows some examples for using the shortcuts with the **cd** command, assuming that your current working directory is /home/user2/dir1.

Figure 5-14 Using Navigation Shortcuts

1. **Using the .. to change the parent directory:**
   ```
   $  cd ..
   $  pwd
   /home/user2
   ```

2. **Using the .. to move up two directory levels to root:**
   ```
   $  cd ../..
   $  pwd
   /
   ```

3. **Using the ~ to go to a directory under your home directory:**
   ```
   $  cd ~/practice
   $  pwd
   /home/user2/practice
   ```

Symbol	Meaning
. (dot)	Current (working) directory
.. (dot/dot)	Parent directory; the directory directly above the current directory
~ (tilde)	User's home directory (Korn and C shells)

 e-Lab Activity 5.3 Using the **pwd** and **cd** Commands

In this activity, you use the **pwd** and **cd** commands to move around the directory structure using absolute and relative path names as well as shortcuts. See the class file tree structure on the inside-front cover of this book or click the **tree** icon on the CD-ROM e-Lab Activity. Be sure to use lowercase command names and forward slashes. Refer to e-Lab Activity 5.3 on the accompanying CD-ROM.

 Lab Activity 5.3.3 Navigating the File System

In this lab, you work with the UNIX file system or directory tree, which has been set up for the class. You learn how to determine your current location in the directory tree and how to change from one directory to another. Refer to Lab 5.3.3 in the *Cisco Networking Academy Program Fundamentals of UNIX Lab Companion*, Second Edition.

Listing Directory Contents

The only way to know what files and directories are available to work with is by displaying a list.

ls Command

To determine the contents of a directory, use the **ls** (list) command. This command displays a listing of all files and directories within the current directory or specified directories. If no path name is given as an argument, **ls** displays the contents of the current directory. The **ls** command lists any subdirectories and files that are in the *current working directory* if a path name is specified. It also defaults to a wide listing display. Many options can be used with the **ls** command, which makes it one of the more flexible and useful UNIX commands.

Command format:

`ls` [-option(s)] [pathname[s]]

Figure 5-15 shows some examples using the **ls** command with various options, when the user's current directory is /home/user2. Refer to the class file tree structure while reviewing the examples. See Figure 5-1 or the inside-front cover of this book. Example 1 is the basic **ls** command by itself, with no options or directory specified. It returns a listing of all directories and files in the current directory. You cannot tell whether the listed item is a directory or a file unless the name indicates it. Example 2 specifies a relative path name dir1, which is a subdirectory of /home/users. Only files and directories in dir1 are listed. Example 3 specifies an absolute path name of /var/mail, which is in another part of the directory tree. Only files and directories from /var/mail are listed.

TIP

The output for the **ls** command is sorted alphabetically by default. However, because the operating system is case sensitive, the user might have files and directories that begin with lowercase letters, uppercase and even a number, such as 2004_budget. The **ls** command displays those beginning with a number first and then displays uppercase letters next and then lowercase letters. An example of this would be: 123, 1abc, Abc Doc, abc doc.

Figure 5-15 Using the **ls** Command

```
1. Using the basic ls command (from /home/user2)
   $ ls
   dante    dir1 dir3  file1 file3 practice
   dante_1  dir2 dir4  file2 file4

2. Using the ls command with a relative path name
   $ ls dir1
   coffees fruit      trees

3. Using the ls command with an absolute path name
   $ ls /var/mail
   user1    user2   user3   user4   user5
```

e-Lab Activity 5.4 The **ls** Command

In this activity, you use the **ls** command with relative and absolute path names to locate subdirectories in your home directory */home/user2*. Refer to the class file tree structure on the inside-front cover of this book or click the **tree** icon on the CD-ROM e-Lab Activity. Be sure to use lowercase command names and forward slashes. Refer to e-Lab Activity 5.4 on the accompanying CD-ROM.

Displaying Hidden Files

Filenames that begin with a period (.) are called dot or hidden files. Hidden files frequently are used to customize a user's work environment. They are not shown by default because they are edited infrequently. The current directory link (.) and the parent directory link (..) are also hidden and not displayed because they begin with a dot. Using the **ls** command with the **-a** (all) option lists all files in a directory, including hidden (.) files. Note that the **-a** option is lowercase. The example shown in Figure 5-16 shows the result of the **ls -a** command while in the home directory (/home/user2) of user2. The **-A** (uppercase A) option displays all files, including those that begin with a dot (.), with the exception of the current directory (.) and the parent directory (..).

Figure 5-16 Using the **ls -a** Command

			(Note files that start with a dot)			
$ **ls -a**						
.	.kshrc	dante1	dir2	dir4	file2	file4
..	dante	dir1	dir3	file1	file3	practice

e-Lab Activity 5.5 Displaying Hidden Files

In this activity, you use the **ls -a** command to view the hidden files in your home directory */home/user2*. Refer to the class file tree structure on the inside-front cover of this book or click the **tree** icon on the CD-ROM e-Lab Activity. Refer to e-Lab Activity 5.5 on the accompanying CD-ROM.

Displaying File Types

When using the **ls** command by itself, you can obtain a listing of directory contents, but cannot tell which are files and which are directories. By using the **ls** command with the **-F** (file type) option, you can display a listing with a symbol to indicate the file type. The symbol, if shown, will be found at the end of the file or directory name. Note that the **-F** option is an uppercase *F*. The list that follows shows the file types displayed using the **ls -F** command. The

last two are advanced file types and are covered in the IT Essentials 2: Network Operating Systems course:

- **Directory**—A forward slash (/) after the name indicates that this is a directory, or subdirectory. A directory is considered a type of file with UNIX.

- **ASCII text file**—If there is no symbol after the name, this indicates a plain ASCII text file with no formatting characters. ASCII is the American Standard Code for Information Interchange. An ASCII text file is similar to a DOS text file or a file created with the Windows Notepad editor.

- **Executable**—An asterisk (*) after the name indicates that this is a command, an application, or a script file that can be run or executed.

- **Symbolic link**—An at sign (@) after the name indicates a symbolic link. This is a way of giving a file an alternate name. Symbolic links allow a file to exist in more than one place, for convenience. Links are covered in Chapter 7, "Advanced Directory and File Management."

- **Named pipe**—A pipe symbol (|) after the name indicates a pipe. Pipes are used for interprocess communication. One process opens the pipe for reading, and the other opens it for writing, allowing data to be transferred. An example is the transfer of data to and from a disk.

- **Socket**—An equal sign (=) after the name indicates a socket. This is similar to a named pipe but permits network and bidirectional links.

Figure 5-17 shows two examples using the **ls -F** command to see the file type when the user is in his home directory, /home/user2. The first example shows only files and directories. The second shows a symbolic link, an executable, an ASCII text file, and a directory.

Figure 5-17 Using the **ls -F** Command

```
$ ls -F
dante          dir1/dir3/file1     file3     practice/
dante_1        dir2/dir4/file2     file4

$ ls -F /etc
cron@          asppp.cf* shadowuucp/
<output omitted>
```

e-Lab Activity 5.6 Displaying File Types

In this activity, you use the **ls -F** command to display the types of files in the */home /user2/dir2* directory. See the class file tree structure on the inside-front cover of this book or click the **tree** icon on the CD-ROM e-Lab Activity. Refer to e-Lab Activity 5.6 on the accompanying CD-ROM.

Displaying a Long Listing

The previous versions of the **ls** command displayed only the names of directories and files in a wide format that went across the screen. The **ls** command can be used with the -l (long) option to see more detailed information on each file or directory. The **ls -l** option also distinguishes between files and directories.

The **ls -l** command provides the file information shown in Figures 5-18 and 5-19. By default, the **ls** command lists files in alphabetic order. Using the **-t** (time) option lists files with the most recently modified at the top of the list. To get a detailed listing of files sorted by time, with the most recent at the top, use the **ls -lt** command.

Figure 5-18 Directory Information

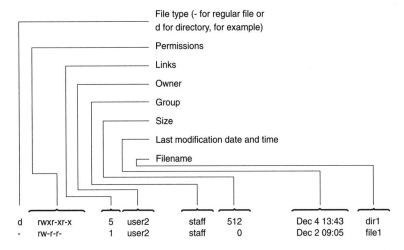

Figure 5-19 Detailed Information from the **ls -l** Command

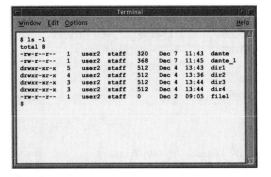

As with ls -**F**, the **ls -l** command can also be used to determine file type. The first character in the **ls -l** listing indicates the type of file being displayed. The most common ones are the dash (-)

and the letter *d*. A dash represents a regular data file. The file may be a text file, an application file, or an executable. The letter *d* in the first position indicates a directory. Other codes represent the other UNIX file types as shown in Table 5-1.

Table 5-1 File Type Codes Displayed by the **ls -l** Command

Code	Meaning
- (dash)	Data file
d	Directory
l	Symbolic link
P	Pipe
s	Socket
b	Block device
c	Character device

Two additional codes are represented with **ls -l** that are not with **ls -F**, the block device and the character device:

- *Block device* is a hardware device file for devices that transfer data in blocks of more than 1 byte such as floppy disks, hard disks, and CD-ROMs.
- *Character device* is a hardware device file for devices that transfer in units of 1 byte, such as a serial terminal or parallel printer.

e-Lab Activity 5.7 Displaying a Long Listing

In this activity, you use the **ls -l** command to view a long listing of the files and directories in the */home/user2/dir2* directory. See the class file tree structure on the inside-front cover of this book or click the **tree** icon on the CD-ROM e-Lab Activity. Refer to e-Lab Activity 5.7 on the accompanying CD-ROM.

Listing Individual Directories

Use the **ls -ld** command to display detailed information about a directory, but not its contents. This is useful when the user wants to see the permissions on a directory and not the information about its contents. Permissions are discussed in detail Chapter 10. As shown in Figure 5-20, the **ls -l** command lists detailed information on files and directories in dir1, whereas the **ls -ld** command lists detailed information only on dir1 itself.

Figure 5-20 Using the **ls -l** and **ls -ld** Commands

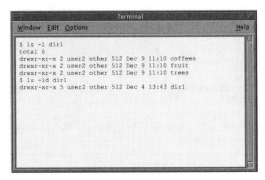

Listing Directories Recursively

Use the **ls -R** (recursive) command to display the contents of a directory and all of its subdirectories. Recursive means to do again and again. This option is useful if the user wants to see all directories, subdirectories, and contents for a particular part of the directory tree, as shown in Figure 5-21. If this is done at a high level in the directory structure, the output can be substantial.

Figure 5-21 Listing Directories Recursively

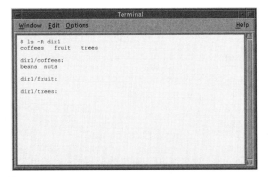

The **-R** option commonly is used with many UNIX commands to indicate a recursive action. However, it is sometimes a lowercase *r*, depending on the command. Recursive generally refers to the contents of a directory and all of its subdirectories.

Lab Activity 5.4.6 Listing Directory Information

In this lab, you use the **ls** command, which is used to determine the contents of a directory. Refer to Lab 5.4.6 in the *Cisco Networking Academy Program: Fundamentals of UNIX Lab Companion*, Second Edition.

Identifying and Using Metacharacters

Metacharacters are keyboard characters with special meaning to the shell. They are a powerful feature of any shell. A general definition of a metacharacter is any keyboard character that is not alphanumeric. Metacharacters are used with many UNIX commands to provide greater flexibility.

Identifying Metacharacters

Some of the metacharacters used with UNIX are similar in function to those used with DOS. The asterisk (*) and the question mark (?) are metacharacters that also are known as wildcards and are used to work with groups of files efficiently. Figure 5-22 shows some of the more common metacharacters and gives a brief description of their primary function. This chapter focuses on the *, ?, and [] metacharacters. Additional metacharacters are introduced throughout the remainder of the course.

It is important not to use metacharacters when naming files and directories. The dot (.) and the underscore (_) are the only two nonalphanumeric characters that are not metacharacters. This is why the user can use the dot (.) and the underscore (_) in filenames. A hyphen (-), even though it is a metacharacter can be used in filenames. As a metacharacter the hyphen (-) is used to delineate options in a command line. A space is also considered a metacharacter and can be used in a UNIX filename but is not recommended. Because spaces are used as a separator between command-line arguments, the shell sometimes has interpretation problems with filenames having spaces. Although some of the metacharacters listing in Figure 5-22 can be used in directory or filenames, it is not recommended.

Using Metacharacters

The asterisk (*), question mark (?), and square brackets ([]) are the three most often used metacharacters when manipulating groups of files.

Asterisk

The asterisk (*), also called splat or star, is a substitution symbol that represents zero or more characters, except the leading dot on a hidden file. The asterisk often is referred to as a wildcard character. The asterisk can be very helpful with many commands, such as **ls** (list), **cp** (copy), **rm** (remove), and **mv** (move). If there were a large number of files in a directory and the user wanted to get a listing of only files and directories that start with the letter *d*, they could use an example like the one shown in Figure 5-23. Note that the files beginning with the letter *d* (dante and dante_1) are listed first followed by the contents of directories that start with the letter *d*—dir1, dir2, dir3, and dir4 in this example.

Figure 5-22 Metacharacters

Metacharacter	Description	Command Format	Example(s)
; (semicolon)	Enables you to enter multiple commands on a single command line.	command;command	date;cal;who
* (asterisk)	Represents any character or characters.	*	ls d*
? (question mark)	Matches any single character.	?	ls dir?
[] (square brackets)	Matches a set or range of characters for a single character position.	[range]	ls [b-f]* ls [bf]* ls [cab]* ls [A-z]*
;>, <, 2>, >> (angle brackets for redirection)	Redirects the output of a command to a file rather than to the screen. < - Redirects the input to a command from a file rather than from the keyboard. 2> - Redirects error from a command to a file rather than to the screen. >> - Appends the output of a command to an existing file.	command > file command < file command 2 > file command >> file	ls /etc > etc.listmailx user2@saturn < /etc/hostsDate 2> errorfilecat errorfilecal 1 1996 >> mon00cat mon00
I (pipe)	Takes the output of one command and passes it as input into the following command.	command I command	ls -l /etc I more
$	Default Korn and Bourne shell prompt variable indicator	N/A	$
%	Default C shell prompt variable indicator	N/A	%
~	Shortcut to home directory in C and Korn shells (Tilde)	~	cd ~
!	Command Re-execution	! n where n is the number of the command entered	!! Repeats the last Command in C Shell Used in conjunction with the history command to repeat an earlier command:!

Figure 5-22 Metacharacters *(Continued)*

;>, <, 2>, >> (angle brackets for redirection)	Redirects the output of a command to a file rather than to the screen. < - Redirects the input to a command from a file rather than from the keyboard. 2> - Redirects error from a command to a file rather than to the screen. >> - Appends the output of a command to an existing file.	command > file command < file command 2 > file command >> file	ls /etc > etc.listmailx user2@saturn < /etc/hostsDate 2> errorfilecat errorfilecal 1 1996 >> mon00cat mon00
\| (pipe)	Takes the output of one command and passes it as input into the following command.	command \| command	ls -l /etc \| more

Figure 5-23 ls Command with the Asterisk

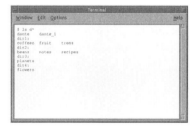

To list only those files that start with the first two characters *p1* you would use the **ls p1*** command. The **ls *doc** command would list all files that end in "doc." The **ls** command by itself displays all files in the current directory, as in Figure 5-24.

Figure 5-24 File Within the Current Directory

```
$ ls
dante       dir1    dir3    file1   file3   fruit    practice
dante_1     dir2    dir4    file2   file4   fruit2
```

Question Mark

The question mark (?) is a substitution character that matches any single character, except for the leading dot on a hidden file. The question mark also is referred to as a wildcard character. Figure 5-25 shows an example of the **ls** command using the question mark in the fourth position. This indicates that the file or directory name must start with the letters *dir*, but any character can be in the fourth position and the filename cannot be more than four characters long.

TIP

As a time saver, use the splat (*) with the **cd** command to change directories. For example, instead of typing **cd /usr/openwin/share /images**, type **cd /usr /open*/sh*/im***. Make sure that no other directories start with the same few characters.

If you enter **ls d***, you see all files that start with the letter *d*, plus all directories that start with *d*, followed by a colon, and then the directory contents.

Figure 5-25 ls Command with the Question Mark

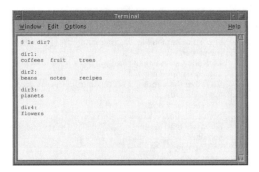

If no filename matches the wildcard character, whether * or ?, you receive the following error message:

```
$ls z?
z?: No such file or directory
$
```

Square Brackets

Square brackets ([]) can be used to match a set or range of characters for a single character position in the file or directory name. The characters inside the brackets generally do not need to be in any order. For example, [abc] is the same as [cab]. However, if the user is looking for a range of characters, they must be in proper order. For example, [a-z] or [3-9]. If the user wants to search for all alphabetic characters whether lowercase or uppercase, use [A-z] for the pattern to match. They can use alphabetic or numeric characters for the search pattern.

Figure 5-26 shows two examples using square brackets along with the asterisk wildcard character. The first example defines a range and lists all files and directories that start with the lowercase letters *b* through *f*, with anything after that. The second example specifies that the first character must be either the letters *a* or *f*, and anything can come after that. Notice that only files starting with *f* are displayed in Example 2.

Figure 5-26 ls Command with the Square Brackets

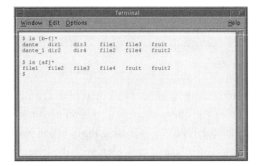

Semicolon

The semicolon (;) enables the user to enter multiple commands on a single command line before pressing Enter. Entering multiple commands on one command line is an efficient way to accomplish a task. The semicolon also is referred to as the command separator. Figure 5-27 shows two examples using the semicolon to separate commands. In the first example, the **clear** command clears the screen, the **cd** command returns the user to their home directory, and the **ls** command lists files in that directory. The second example displays the current date and time, and then displays the calendar for the current month.

Figure 5-27 Using a Semicolon to Separate Commands

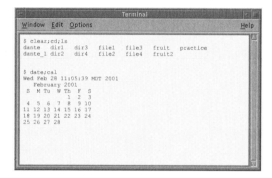

e-Lab Activity 5.8 Using Metacharacters

In this activity, you use the **ls** command with metacharacters (asterisk, question mark, and brackets) to locate files in your home directory */home/user2*. See the class file tree structure on the inside-front cover of this book or click the **tree** icon on the CD-ROM e-Lab Activity. Be sure to use lowercase command names and forward slashes. Refer to e-Lab Activity 5.8 on the accompanying CD-ROM.

Lab Activity 5.5.2 Directory Listings with Metacharacters

In this lab, you work with various metacharacters and use them with the **ls** command to refine your directory listings. Refer to Lab 5.5.2 in the *Cisco Networking Academy Program Fundamentals of UNIX Lab Companion*, Second Edition.

Summary

A UNIX file system is made up of directories, subdirectories, and files. The operating system, application programs, system administrators, and end users can create directories.

The location of all files and directories in the file system can be specified using an absolute or relative path name. Absolute path names always start with the root directory (/). Relative path names are specified based on where the users are in the directory structure.

Users can tell where they are in the directory structure using the **pwd** command. They can move around or navigate the directory structure using the **cd** command. Shortcuts make navigating the directory structure easier.

The **ls** command can be used to display the contents of a directory, showing the files and subdirectories that are there. Many options are available with the **ls** command to determine what is displayed and how.

Metacharacters are nonalphanumeric symbols that have special meaning to the shell. Metacharacters, including the asterisk and question mark wildcards, can be used with many UNIX commands for added flexibility. The use of metacharacters in directory or filenames is not recommended.

Check Your Understanding

1. Which of the following is a valid absolute path name?

 A. \home\user02

 B. /home/user02

 C. home/user02

 D. user02

2. The option portion in the command **ls –l dir1** is _____.

3. Which of the following shells have a $ for the prompt? (Select three.)

 A. Bourne

 B. C

 C. Bash

 D. Korn

4. Which three of the following commands are valid?

 A. Ls -l;grep data

 B. ls -l | grep data

 C. pwd;ls -l

 D. ls -l > data

5. What is the command to change your current directory to your home directory and show your location in the tree? The command must be entered like you would at the command prompt. The commands must be entered on one line. _____

6. Which character separates multiple commands issued on the same command line?

 A. Slash

 B. Comma

 C. Dash

 D. Semicolon

7. Which three of the following statements are true?

 A. UNIX commands are always uppercase.

 B. UNIX commands are always lowercase.

 C. The option in a command may be upper- or lowercase.

 D. Options are usually preceded by a dash.

8. Which two of the following change your current directory to your home directory?

 A. cd /

 B. cd

 C. cd ~

 D. cd .

9. Enter the option that you can use with the **ls** command to display hidden files. _____

10. Which UNIX command lists the files in the current directory including subdirectories?

 A. ls -l

 B. ls -al

 C. ls -R

 D. ls -r

11. Which of the following represents a directory when the command **ls -F** is issued?

 A. d

 B. -

 C. D

 D. /

12. Which of the following represents a directory when the command **ls -l** is issued?

 A. -

 B. d

 C. D

 D. /

UNIX Command Summary

cd The **cd** command changes the working directory of the current shell execution environment. Example:

```
$ cd
$ cd ..
$ cd /home/user2/dir1
$ cd ./dir1
```

ls For each file that is a directory, **ls** lists the contents of the directory; for each file that is an ordinary file, **ls** repeats its name and any other information requested. Example:

```
-a,-F,-l,-lt,-ld,-E
$ ls
dante   dir1   dir3
$ ls -l
-rwxr-xr-x  1  user2  staff  110 Apr 19  dante
drwxr-xr-x  5  user2  staff  110 Apr 19  dir1
drwxr-xr-x  4  user2  staff  110 Apr 19  dir3
```

pwd Writes an absolute path name of the current working directory to standard output. Example:

```
$ pwd
/home/user2/dir1
```

Key Terms

absolute path name Specifies a file or directory in relation to the entire UNIX file hierarchy. The hierarchy begins at the / (root) directory. If a path name begins with a slash, it is an absolute path name.

argument Used to specify how and on what the preceding command is to be performed.

ASCII file (American Standard Code for Information Interchange) A file with normal printable characters and no special control or formatting characters. Commonly referred to as a text file.

block device A hardware device file for devices that transfer data in blocks of more than 1 byte such as floppy disks, hard disks, and CD-ROMs.

character device A hardware device file for devices that transfer in units of 1 byte, such as a serial terminal or parallel printer.

current working directory The directory where you are currently located in the directory tree structure.

delimiter A special character, often a slash or a space, used to separate one string of characters from another.

executable file A file that can be executed by the system. An executable may contain command text, as in the case of a shell script, or binary instructions. Examples of executables include applications and programs.

file type code A one letter character that identifies the file type. Appears in the first character position of a long listing. Examples include *d* for a directory, - (dash) for a data file, *B* for a block device file, etc.

hidden files Files that have names beginning with a dot (.). Examples of a hidden file are .login and .profile.

hierarchy Structure with parent and child relationships that resembles an upside-down tree. The UNIX file system and UNIX system processes are examples of hierarchical structures.

metacharacters Keyboard characters with special meaning to the shell. A general definition of a metacharacter is any keyboard character that is not alphanumeric. Metacharacters are used with many UNIX commands to provide greater flexibility. Some of the metacharacters used with UNIX are similar in function to those used with DOS. The asterisk (*) and the question mark (?) are metacharacters that also are known as wildcards and that are used to work with groups of files efficiently.

named pipe Pipes are special files used for interprocess communication. One process opens the pipe for reading, and the other opens it for writing, allowing data to be transferred. An example is the transfer of data to and from a disk.

parent directory Directory that contains other directories. For example, the /usr directory is the parent directory of /usr/bin.

relative path name Describes the location of a file or directory as it relates to the current directory (the directory that you are currently in). If a path name does not begin with a slash, it is a relative path name.

root directory The top of the UNIX directory system. All other directories are subdirectories of the root (/) directory.

socket Similar to a named pipe, but permits network and bidirectional links.

symbolic link A link is a mechanism that allows several filenames to refer to a single file on disk. Symbolic (soft) links are pointer files that name another file elsewhere in the file system. Symbolic links may span physical devices because they point to a UNIX path name and not to an actual disk location. Some UNIX directories are symbolically linked to other directories for backward-compatibility purposes.

Objectives

After reading this chapter, you will be able to

- Manage directories and files using the command line.
- Manage directories and files using the graphical CDE File Manager.
- Manage directories and files using GNOME Nautilus.

Basic Directory and File Management

Introduction

In this chapter, you perform basic file and directory management tasks using the command-line interface, CDE File Manager, and GNOME Nautilus. The importance of learning command-line utilities is emphasized. We start with the command-line interface and work with a number of file information commands to discover the characteristics and contents of various file types. We cover the rules and procedure for creating files and directories and then discuss how to remove them. CDE *File Manager* is introduced. This is a utility that can perform many file and directory management functions through a graphical user interface (GUI). The Nautilus file manager, the primary GUI desktop management utility for GNOME, is also introduced.

Directory and File Management Using the Command Line

You can use the CDE interface for many file management tasks. However, it is important to know how to use the UNIX command line and UNIX commands. In some cases, using the command line to issue commands is faster than using a GUI such as CDE or Nautilus. The two main reasons for learning the command line are as follows:

- It gives the user access to the many command options, providing more flexibility.
- It gives the user the ability to perform file management on a remote system where a graphical interface is not available.

Using the Command Line

Knowledge of file and directory management using commands is important in building a solid foundation for further study of the UNIX operating system. UNIX power users and system

administrators must have a working knowledge of command-line capabilities and syntax. Many operating system management and device configuration tasks require an understanding of UNIX commands. In some cases, the command line is the only tool available. Power users and administrators frequently create executable shell scripts. These are useful tools for automating certain tasks such as backing up files or creating new user accounts. Script files contain a series of shell commands and are similar to batch files used with other network operating systems. Creating script files is covered in Chapter 15, "Introduction to Shell Scripts and Programming Languages."

Using Control Characters

Control characters are used to perform specific tasks. These tasks include stopping and starting screen output and others as listed below. When displayed on the screen, the Ctrl key is represented by the caret (^) symbol.

To enter a control character sequence, hold down the **Ctrl** key and press the appropriate character on the keyboard. **Ctrl-c** is a common control character sequence and is used to interrupt or cancel a program or process. The actual character in the shell appears as ^C, even though the user pressed the Ctrl key and the c key at the same time. The following control characters can be used:

- **Ctrl-s** stops screen output. The user might use Ctrl-s when viewing a large file with the **cat** command. The **cat** command is covered in the "Displaying File Contents with **cat** and More" section later in this chapter.

- **Ctrl-q** resumes screen output stopped by Ctrl-s. The Ctrl-s and Ctrl-q characters originated with Teletype operators and are rarely used today.

- **Ctrl-c** interrupts or cancels the current activity. Ctrl-c frequently is used to abort processes or long display outputs resulting from the **cat**, **ls**, or **find** commands. It is also used to return to a command prompt without executing a command in order to enter a different command.

- **Ctrl-d** indicates the end of the file or exit. Ctrl-d is used to exit UNIX utilities such as **bc**, **write**, and several others. It is also used to exit a shell (including a Terminal window shell), and log out of a terminal session or a command-line login session. The following information shows the basic calculator (**bc**) to demonstrate how Ctrl-d is used to exit a UNIX utility program:

```
$bc         (runs the basic calculator)
5280/3 (represents a division of 5280 by 3. The user can also use +, -,
   *, and ^ for exponents)
1760        (the answer to the problem presented)
Press Ctrl-d to exit bc and return to the shell prompt.
$
```

TIP

Use **Ctrl-c** to restore the shell prompt if an unrecognized command is typed and the secondary prompt (>) in the Korn or Bash shell appears.

- **Ctrl-u** erases the entire command line. Ctrl-u will erase a command line that the user decides not to execute. Users can use Ctrl-u in place of the backspace key, when they are logged in to a remote system.

- **Ctrl-w** erases the last word on the command line. Ctrl-w will erase the last argument, such as the path name or filename, on the command line. Users can use Ctrl-w in place of the backspace key, when they are logged in to a remote system.

- **Ctrl-h** erases the last character on the command line. Ctrl-h takes the place of backspace key when the user is logged in to a remote system and the backspace key does not work properly. This happens because the operator of that remote system has not configured the backspace key to act like the Ctrl-h key.

Other control characters used in UNIX for more advanced tasks will be introduced in future chapters.

e-Lab Activity 6.1 Using Control Characters

In this activity, you execute a UNIX utility called **bc** (basic calculator) from a Terminal window. You use the **Control-d** command to exit the utility. Refer to e-Lab Activity 6.1 on the accompanying CD-ROM.

Determining File Type

It is important for the user to know a file's type when opening or viewing the file. A file's type could be text, program file, shell script, and so on. Determining the file type can help a user decide which program or command to use when working with the file.

file Command

Many types of files are found on a UNIX system. The file type can be determined by using the **file** command:

```
file filename(s)
```

The output from this command most often is one of the following: text, executable, or data:

- **Text** is an example that includes ASCII (nonformatted) text, English text (text with punctuation characters), and executable shell scripts. This type of file can be read using the **cat** or **more** commands, which are discussed in this chapter. Text files can be edited using a text editor.

- **Executable** or binary are examples that include 32-bit executable and extensible linking format (ELF) code files and other dynamically linked executables. This file type

TIP

Use **Ctrl-u** to ensure that you are starting with a fresh user ID and password entry when logging in. Because passwords cannot be seen when they are typed, use **Ctrl-u** to erase the password and start over when an incorrect character) has been typed.

TIP

When you use the Telnet program to log on to a remote system, the backspace key might not work. See the tip at the end of the section "Remote Access Using Telnet," in Chapter 2, "Accessing a System and UNIX Graphical Interfaces," for instructions on how to assign the Ctrl-h function to the backspace key.

indicates that the file is a command or a program. The strings command prints readable characters in this type of file.

■ **Data** are **data files** that are created by an application running on the system. In some cases, the type of file is indicated. An example is the FrameMaker document. When the application in which this file was created cannot be determined by the **file** command, the output simply indicates that it is a data file. The only way to read a data file is to determine which application created it and open the file with that application.

NOTE

For information on other file types, see the man pages.

Figure 6-1 shows several examples using the **file** command. The first example is a *text file*. The second is a data file that must be read by FrameMaker. The third is the **cat** command file, which is an executable. In the first two examples, the directory is changed to where the file is located. In the third example, the file is specified using its absolute path name.

Figure 6-1 Using the **file** Command

```
Text File Example:
$ cd /home/user2
$ file dante
dante:       English text

Data File Example:
$ cd /home/user2/dir1/coffees
$ file beans
beans:       Frame Maker document

Executable File Example:
$ file /usr/bin/cat
/usr/bin/cat: ELF 32-bit MSB executable SPARC
Version 1, dynamically linked, stripped
```

strings Command

The **strings** command can be used to print readable characters in an executable or binary file. Because application programs like FrameMaker write the program name in the first few lines of a data file, the **strings** command can be used to determine what program was used to create the file. The command is introduced here solely as a method for demonstrating the printable characters of an executable file. The **strings** command must be used to read an executable file such as /usr/bin/cat. In Figure 6-2, the **strings** command is followed by the filename of the executable file, including the absolute path name. The **strings** command also shows the usage syntax of the command in most cases.

Figure 6-2 Using the **strings** Command

```
$ strings /urs/bin/cat
SUNW_OST_OSCMD
usvtebn
usage:    cat [ -usvtebn ] [ - | file ]
cat:    Cannot stat stdout
cat:    cannot open %s
cat:    cannot stat %s
cat:    input/output files '%s' identical
cat:    close error

```

 e-Lab Activity 6.2 Using the **file** and **strings** Commands

In this activity, you use the **file** and **strings** commands to find out information about files in the /home/user2/dir2 directory. See the class file tree structure on the inside-front cover of this book or click the **tree** icon on the CD-ROM e-Lab Activity. Refer to e-Lab Activity 6.2 on the accompanying CD-ROM.

Displaying File Contents with cat, more, and less

The **cat, more,** and **less** commands are the three most common commands used to view the contents of a text file.

Using the cat Command

The **cat**, short for *concatenate*, command displays the contents of a text file on the screen. It often is used to display short text files such as script files, similar to batch files. Because **cat** flashes through the entire file rapidly without pausing, you should be prepared to either stop and start the scrolling with the Ctrl-s and Ctrl-q keys (impractical with most modern high-speed computers) or use the **more** or **less** command, which is covered next. The **cat** command is a multipurpose command. It can be used to concatenate two or more files into one large file. See Chapter 7, "Advanced Directory and File Management." The **cat** command can also create short text files. See Chapter 9, "Using Text Editors."

`cat filename(s)`

Figure 6-3 shows the use of the **cat** command to display the dante text file in the /home/user2 directory. If the file fills more than one screen, the data scrolls off the screen. However, if the user is using a scrolling window, such as a Terminal window, within the CDE or GNOME environment, he can scroll up or down using the scroll arrows.

NOTE

The **cat** command is comparable to the **type** command used in DOS.

Figure 6-3 Using the **cat** Command

```
$ cat dante
The Life and Times of Dante
by Dante Pocai

Mention "Alighieri" and few may know about whom you
are talking. Say "Date," instead, and the whole world
knows who you mean. For Dante Alighieri, like Raphael
  .
  .
  .
$
```

Using the **more** and **less** Commands

Use the **more** command (UNIX and Linux) or the newer **less** command (Linux) to display the contents of a text file one screen at a time. If the information in a file is longer than one screen, the following message appears at the bottom of the screen, where *n* is the percentage of the file already displayed:

`--More --(n%)`

The online manual pages use **more** for display purposes:

`more filename(s) or less filename(s)`

At the **--More--** prompt, the user can use the keys in Figure 6-4 to control the scrolling capabilities. The scrolling keys are the same ones used to display man pages. Help can always be obtained in more by typing the command **h** at any time.

Figure 6-4 More Command Scrolling Keys

Scrolling Keys	Purpose
Spacebar	Scrolls to the next screen.
Return	Scrolls one line at a time.
b	Moves back one screen.
f	Moves forward one screen.
h	Displays a Help menu of more features.
q	Quits and return to the shell prompt.
/string	Searches forward for string.
n	Finds next occurrence of string.

The **less** command is an alternative to **more** and is considered by many to be better. The **less** command is available on most UNIX and LINUX distributions and uses many of the navigation keys used by the vi editor in addition to ones used with **more**. It contains additional features including backward movement, the ability to go to a specific line, and, unlike **more**, starts displaying the file before it is entirely loaded into memory.

e-Lab Activity 6.3 Using the **cat** and **more** Commands

In this activity, you use the **cat** and **more** commands to view the contents of files in the /home/user2 directory. See the class file tree structure on the inside-front cover of this book or click the **tree** icon on the CD-ROM e-Lab Activity. Refer to e-Lab Activity 6.3 on the accompanying CD-ROM.

> **TIP**
>
> When viewing a file with the **more** or **less** command, you can drop into the visual (vi) text editor at the current line if you decide to edit the file. (See Chapter 9.) To use vi on a file that you are viewing with the more command, enter the letters **vi** when **-- More -- (NN%)** appears on the screen.

Displaying File Contents with head and tail

System administrators frequently utilize the **head** and **tail** commands to quickly check portions of text files that they do not need to view in their entirety.

Using the **head** Command

The **head** command is used to display the first *n* lines of one or more text files. The first 10 lines are displayed by default if the **-n** option is omitted. The **head** command is useful when the user wants to check only the first few lines of a file, regardless of its length. Figure 6-5 uses the **head** command to display the first five lines of the /usr/dict/words file. In this example, the **head** command is used by itself, but it typically is used in a command line containing several commands in a pipeline. This is covered later in the course.

```
head [ -n ] filename((s)
```

Figure 6-5 Using the **head** Command

```
$ head -5 /usr/dict/words
1st
2nd
3rd
4th
5th
$
```

Using the **tail** Command

Use the **tail** command to display the last *n* lines of a text file. The last 10 lines are displayed by default if the **-n** option is omitted. The **tail** command is useful for checking the most recent entries in large log files like those for proxy servers, mail servers, and backup

TIP

You can use wildcards to display the head or tail of multiple files. For example, **$head chap* | more** displays the top lines of all files that begin with chap. You can split a file into two separate files using either **head** or **tail** in conjunction with the greater than (>) redirect symbol. (See Chapter 7.) For example, **$tail -25 us_states > bottom_25** creates a new file named bottom_25, containing the last 25 lines of the us_states file.

programs. Backup programs frequently write their results to a log file showing which files were backed up and when. The final entries in a backup log file are usually the total number of files backed up and messages indicating whether the backup finished successfully. Backup logs can be quite large, and the **tail** command allows the user to check the end result of the backup log without looking at the entire file. Like the **head** command, the **tail** command can be used by itself, but it typically is used in a command line containing several commands in a pipeline. This will be covered later in the course.

```
tail [ -n ] filename((s)
```

or

```
tail [ +n ] filename((s)
```

The previous command format shows two options with the **tail** command: **-n** and **+n**. The **-n** option displays the last n lines of the file. The **+n** option allows the user to start displaying lines from a specific point in a file. It starts at the nth line in the file and displays all lines from there to the end. The first example in Figure 6-6 shows the use of the **tail** command to see the last five lines of the /usr/dict/words file. The second example uses the **+23** option to start at line 23 of the file and displays the remaining lines.

Figure 6-6 Using the **tail** Command

```
$  tail -5 /usr/dict/words
zounds
z's
zucchini
Zurich
zygote
$

$  tail +23 /usr/dict/words
abase
abash
abate
...
Zurich
zygote
$
```

e-Lab Activity 6.4 Using the **head** and **tail** Commands

In this activity, you use the **head** and **tail** commands to view specific lines at the beginning and end of files in the /home/user2 directory. See the class file tree structure on the inside-front cover of this book or click the **tree** icon on the CD-ROM e-Lab Activity. Refer to e-Lab Activity 6.4 on the accompanying CD-ROM.

wc Command

The **wc** (word count) command can be used to display line, word, byte, or character counts for a text file. This command is useful when trying to determine characteristics of a file or when comparing two files. Using **wc** without options gives a line, word, and byte count of the contents of the file. Using it with individual options allows users to determine which of these they would like to see. Figure 6-7 lists the options that are available with the **wc** command.

Figure 6-7 wc Command Options

Option	Function
-l	Counts lines.
-w	Counts words.
-c	Counts bytes.
-m	Counts characters.

Like the **head** and **tail** commands, **wc** can be used by itself. However, it is typically used in a command line containing several commands in a pipeline when the user wants to count the output. This is covered later in the course.

```
wc [options] filename(s)
```

Figure 6-8 shows examples using the **wc** command. In the first example, the **wc** command by itself indicates that the file dante contains 33 lines, 223 words, and 1320 bytes. The second example shows only the line count.

Figure 6-8 Using the **wc** Command

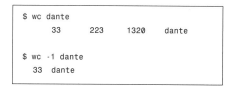

```
$ wc dante
      33      223      1320      dante

$ wc -1 dante
   33  dante
```

Comparing Files

The **wc** command also can be used as a quick way to see if two files are different by comparing the number of characters, words, and lines. However, if the user needs to see the actual differences, the **diff** command should be used.

Using the **diff** Command

The **diff** (difference) command compares two text files, then finds and displays the differences between them. The **wc** command also can be used to compare files. The **wc** command counts lines, words, and bytes. It is possible for two files to have the same line, word, and byte counts but have different characters and words. The **diff** command can find the actual differences between the files. For example:

```
diff [option] file1 file2
```

The output of this command displays line-by-line differences between two text files. Several options are available for the **diff** command; two of them are **-i** and **-c**.

TIP

Use the **cmp** (compare) command to quickly determine whether two files differ without displaying the differences. The **cmp** command displays no output if the files are identical, or it provides the character position and line number of the first occurrence of a difference.

- The **-i** option ignores the case of the letters; for example, *A* is equal to *a*.

- The **-c** option performs a detailed comparison and produces a listing of differences with three lines of context. With this option, the output begins with identification of the files involved and their creation dates.

Following a line of a dozen asterisks (*), the line numbers of file1 that are to be displayed are listed. The actual lines from file1 then are displayed, with a minus symbol (-) in front of the lines that are different from those in file2. The same display follows as it applies to file2, with a plus sign (+) for the lines that are different from those in file1. Figure 6-9 shows the contents of the individual fruit and fruit2 files using the **cat** command. Figure 6-10 shows the output from the comparison of the fruit and fruit2 files using **diff**.

Figure 6-9 Output of **cat** Command for fruit and fruit2

```
$ cat fruit
orange
apple
banana
pear
mango
tomato
pomegranate
```

```
$ cat fruit2
lemon
orange
apple
banana
tomato
guava
mango
pomegranate
```

Figure 6-10 Using the **diff** Command

```
$ diff -c fruit fruit2
*** fruit  Fri  May 8     11:32:49  1998
--- fruit2 Fri  May 8     14:55:21  1998
*********
***1,7****
orange
apple
banana
-pear
-mango
tomato
pomegranate
***1,8****
+lemon
orange
apple
banana
tomato
+guava
+mango
pomegranate
```

e-Lab Activity 6.5 Using the **wc** and **diff** Commands

In this activity, you use the **wc** command to count lines, words and bytes in a file. The **diff** command will also be used to compare two files in the /home/user2 directory. See the class file tree structure on the inside-front cover of this book or click the **tree** icon on the CD-ROM e-Lab Activity. Refer to e-Lab Activity 6.5 on the accompanying CD-ROM.

Lab Activity 6.1.6 File Information Commands

In this lab, you work with various informational commands. These are important because they allow you to investigate and discover information about files. You use commands to help determine what type a file is and what application created it. You also work with several commands that let you see the contents of the text files and compare them. Refer to Lab 6.1.6 in the *Cisco Networking Academy Program Fundamentals of UNIX Lab Companion*, Second Edition.

File and Directory Naming Conventions

This section covers the creation of files and directories. It is important to review the naming of UNIX files and directories before beginning. All operating systems have some basic guidelines or conventions that must be followed. The rules here apply to UNIX files and

TIP

File or directory names beginning with a dot (.) are considered hidden and can be displayed only using the **ls -a** (all) option. Dot files typically are reserved for initialization or customization files. See Chapter 14, "Shell Features and Environment Customization." However, you can name a file that begins with a dot if you do not want it to show up when the **ls** command is used without the **-a** option.

NOTE

To help distinguish between files and directories, some UNIX administrators prefer users to start filenames with lowercase letters and directory names with capital letters. They also might recommend including an uppercase letter D_ in the first position or including .dir on the end of directory names to distinguish them from filenames. If no convention is used to distinguish files from directories, you can always use the **ls -F** command to visibly show which is which. The **ls -l** and **ls -al** command, which shows a long listing, also indicates files and directories by the first character of the display.

directories. See Figure 6-11 for a summary of the UNIX file and directory naming guidelines or conventions.

- **Maximum length**—The maximum length of UNIX filenames and directory names is 255 alphanumeric characters.

- **Nonalphanumeric characters and allowable alphanumeric characters**—Underscores (_), hyphens (-), and periods (.) can be used multiple times in a file or directory name. An example is: Feb.Reports.Sales. Although the shell will allow asterisks (*), ampersands (&), pipes (|), quotes (" "), dollar signs ($), and spaces to be used in a filename, it is not recommended. Those characters have special meaning to the shell. When naming files and directories, it is recommended that choice of characters be limited to letters, numbers, dots, underscores and hyphens (-).

- **Filename extensions**—Filenames can contain one or more extensions. Extensions usually are appended to files by an application. Extensions are usually one to three characters that are appended to the end of a filename and are preceded by a period (.). You might choose to use this convention when naming files, but it is not a necessary part of a filename.

- **Directory name extensions**—Directory names generally do not contain extensions, but there are no rules against it.

Figure 6-11 UNIX File and Directory Naming Conventions

- Long file and directory names are not recommended, although combined they can be as long as 255 characters.

- Alphanumeric characters are recommended along with the nonalphanumeric characters of the dash (-) and underscore (_).

- Other nonalphanumeric metacharacters are allowed, but not recommended.

- Filenames normally contain one extension, but can have more than one.

- Directory names normally do not contain extensions but can.

Creating Files Using the touch Command

Files are created by administrators and users. Many applications also create files. Every time you create a new word processing document or spreadsheet, you are creating a new file and should adhere to the file-naming conventions previously mentioned. You also must have adequate permissions for the directory in which you are working to create files.

You can create new, empty files by using the **touch** command. If you list these files using the **ls -l** command (long listing), you will see that they exist but are 0 bytes in length. Using the

touch command, you can create one or more files simultaneously. Some applications require files to exist before they can be written to. The **touch** command is useful for quickly creating files to experiment with and is used throughout this course. You also can use the **touch** command to update the time and date that a file is accessed. This will reset the archive bit, making the file available for backup again. Absolute and relative path names can be specified when creating files or directories. Figure 6-12 shows the use of the **touch** command to create multiple files.

> **NOTE**
>
> The **touch** command creates an empty file if the filename specified does not exist. Otherwise, the access/modification time of the existing file is updated.

```
touch filename(s)
```

Figure 6-12 Using the **touch** Command to Create Files

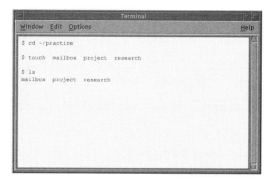

Creating Directories with the mkdir Command

The **mkdir** command creates directories or folders. Directories can contain other directories, which are referred to as subdirectories. They also can contain files. Directories can be created using either an absolute or a relative path name. You can specify more than one directory name on the same line to create more than one new directory.

You must have the appropriate permissions to create a directory. By default you can create files and directories in your home directory. Permissions are covered later in the course. If you change to a directory in which you do not have the correct permissions to create a new file or directory you will receive an error message similar to this one:

```
$mkdir /home/Olympic
mkdir :Failed to make directory "/home/Olympic ";Permission denied
```

Figure 6-13 starts with the **pwd** command to verify that you are in the home directory. It shows several examples of using the basic **mkdir** command. Variations of the **ls** command are used to list the directories created. The last example shows the use of the **mkdir** command with the **-p** (parent) option. This can create parent directories while creating lower-level directories. You can create multiple levels of directories, including all the directories in a path name, simultaneously. If you use the **-p** option and specify a directory in the path name that does not exist, it will be created.

```
mkdir [-p] directory_name directory_name
```

Figure 6-13 Using the **mkdir** Command to Create Directories

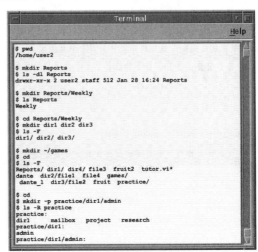

```
$ pwd
/home/user2

$ mkdir Reports
$ ls -dl Reports
drwxr-xr-x 2 user2 staff 512 Jan 28 16:24 Reports

$ mkdir Reports/Weekly
$ ls Reports
Weekly

$ cd Reports/Weekly
$ mkdir dir1 dir2 dir3
$ ls -F
dir1/ dir2/ dir3/

$ mkdir ~/games
$ cd
$ ls -F
Reports/ dir1/ dir4/ file3  fruit2  tutor.vi*
dante  dir2/file1  file4  games/
   dante_1  dir3/file2  fruit  practice/

$ cd
$ mkdir -p practice/dir1/admin
$ ls -R practice
practice:
dir1       mailbox    project    research
practice/dir1:
admin
practice/dir1/admin:
```

e-Lab Activity 6.6 Using the **mkdir** and **touch** Commands

In this activity, you use the **mkdir** command to create a new directory in the /home /user2/dir4 directory. You then switch to the new directory and create several new files using the **touch** command. See the class file tree structure on the inside-front cover of this book or click the **tree** icon on the CD-ROM e-Lab Activity. Refer to e-Lab Activity 6.6 on the accompanying CD-ROM.

Removing Files and Directories

Files that are deleted using the command line on a UNIX system are permanently deleted and cannot be recovered. However, using one of the GUI file managers such as those found in CDE, GNOME, or KDE, the user has the capability to recover a deleted file from the *Trash Can*. Moving the file from the Trash Can will undelete that file. The CDE and GNOME Nautilus file managers are covered later. The **rm** command is a versatile command. It can be used to remove files or directories from the UNIX file system.

Removing Files

The **rm** command can remove a single file or multiple files. The user can remove several files at once by specifying the filenames after the **rm** command, or they can use the asterisk (*), question mark (?) and square bracket ([]) metacharacters (wildcards).

Files that are deleted on a UNIX system cannot be recovered unless the user is using a graphical interface. As a safeguard, the **rm** command can be used with the **-i** (interactive) option.

This option prompts the user before removing files. Use the **rm -i** command as a precaution to avoid accidentally deleting files.

`rm [-i] filename(s)`

In the first example in Figure 6-14, the **cd** command is used to change to the letters subdirectory under the home directory. You can see by the results of the **pwd** command. The **ls** command lists the files currently in the letters directory. The **touch** command is used to create an empty file named projection, which is shown in the next listing. The **rm** command then is used to delete the research and project2 files. The **ls** command shows that the files were removed. The second example uses the **-i**, or interactive option with **rm** command to remove the projection file created earlier with the **touch** command.

Figure 6-14 Removing Files with the **rm** Command

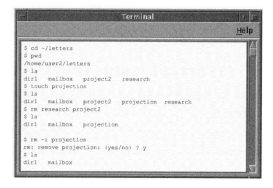

Removing Directories

The **rm -r** (recursive) command is used to remove directories. It removes the directory being targeted, including all subdirectories and files in it. When the **rm** command is used with the **-r** option, it can remove a single directory, empty or not, or an entire section of the directory tree. Figure 6-15 shows examples of removing files and directories using the **rm -ir** command.

`rm -r [i] directory_name(s)`

Figure 6-15 Removing Directories with the **rm** Command

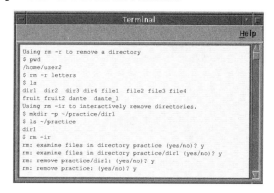

TIP

Many systems are set up with an alias for the **rm** command. See Chapter 14. The alias is set up so that when the user uses the **rm** command, the **rm -i** command is executed. This ensures that a user is prompted before removing a file. To temporarily bypass the alias, so that there is not a prompt, enter a backslash before the command. For example, **$\rm file1 file2** executes the original **rm** command and removes the files file1 and file2 without being prompted.

TIP

If the directory is empty, you can use either the **rm -r** command or the **rmdir** command. The **rmdir** command can be used only to remove empty directories.

e-Lab Activity 6.7 Using the **rm** Command

In this activity, you use the **rm** command to remove a file from a subdirectory of the /home/user2/dir4 directory. You will then remove the subdirectory. See the class file tree structure on the inside-front cover of this book or click the **tree** icon on the CD-ROM e-Lab Activity. Refer to e-Lab Activity 6.7 on the accompanying CD-ROM.

Lab Activity 6.1.10 Basic Command-Line File Management

In this lab, you work with file-management commands from the command line. The guidelines for file and directory naming, which are known as naming conventions, will be reviewed. You create a simple directory structure and then create some files in those directories. You practice creating and removing both files and directories. Refer to Lab 6.1.10 in the *Cisco Networking Academy Program Fundamentals of UNIX Lab Companion*, Second Edition.

Directory and File Management Using CDE

The CDE method of file and directory management allows you to do many of the same tasks that were performed earlier at the command line. The CDE provides a user-friendly graphical interface to file management and executes most of the same commands that are used from the command line behind the scenes. CDE File Manager can be accessed from the front panel or by right-clicking the desktop, as shown in Figure 6-16.

Figure 6-16 Accessing File Manager from the Workspace Menu

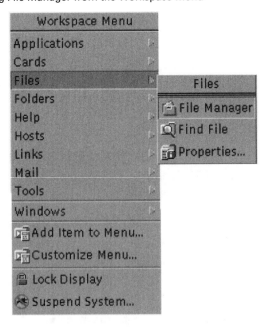

The File Manager, by default, opens a view of the home directory. The term "folder" is used interchangeably with the terms "directory" and "subdirectory." The initial screen displays the contents of the current folder, as shown in Figure 6-17. In the current folder, you can change to other folders, both up and down in the hierarchy, to view each directory's contents. The path to the current folder always is displayed in the top area of the File Manager window, as shown in Figure 6-18.

Figure 6-17 Contents of the Current Folder

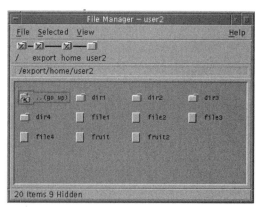

Figure 6-18 Path and Path Name for the Current Folder

File and Folder Icons

The File Manager enables files to be graphically organized into a hierarchical structure of folders (directories), and subfolders (subdirectories). Directories are displayed as folder icons. Files are displayed as appropriate icons, based on the type of file. File types are based on their function and the applications that created them. Examples of file types are shown in Figure 6-19 and include audio, binary, core, graphic, PostScript, and standard.

To help identify files and directories easily, the File Manager displays different icons depending on the content of the file. The standard file icon is the most common file icon as shown in Figure 6-20. A file that is associated with a particular application will automatically start when the user double-clicks the icon.

Figure 6-19 File and Folder Icons

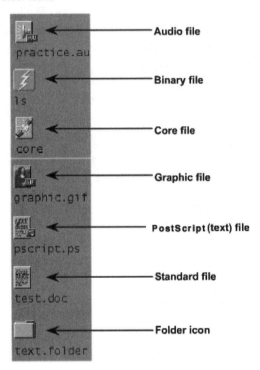

Figure 6-20 Standard File Icon

Double-click a folder icon and File Manager moves into that directory and displays its contents. You can move down through the file system hierarchy only in this way. A special icon always is displayed in the upper-left corner of the File Manager display, as shown in Figure 6-21. Double-click the **Go Up** icon to move to the next level up in the hierarchy.

Figure 6-21 Go Up Icon

File Menu Options

Click the **File** menu option from within File Manager to access options. The File menu option enables you to perform the tasks on the menu in Figure 6-22. These same tasks can be accomplished using the command line. The following is a listing of the File menu items, with a brief description of each:

- **New Folder**—Used to create a new directory or subdirectory, but you must have adequate permission. The command-line equivalent is **mkdir**.
- **New File**—Used to create new files in any directory where you have permission. The command-line equivalent is **touch**.
- **Go Home**—Used to change to the home directory if the current folder is different from the home folder. The command-line equivalent is **cd** or **cd ~**.
- **Go Up**—Used to go up one level of folder in the directory tree or hierarchy. The command-line equivalent is **cd ..** .
- **Go To**—Used to change to a specified directory. The command-line equivalent is **cd dir_name**.
- **Find**—Used to locate files based on the filename or content. The command-line equivalent is **find filename**. This is covered in Chapter 8, "File Systems and File Utilities."
- **Open Terminal**—Used to open a Terminal window with a shell prompt where you can enter UNIX commands.
- **Open Floppy**—Used to access a floppy disk in the drive, DOS, or UNIX format.
- **Open CD-ROM**—Used to access a CD-ROM in the drive.
- **Close**—Used to close the File Manager window.

e-Lab Activity 6.8 Comparing File Manager to Command Line

In this activity, you enter the command that accomplishes the same thing as each of the File Manager menu options listed. Refer to e-Lab Activity 6.8 on the accompanying CD-ROM.

Figure 6-22 File Manager's File Menu Options

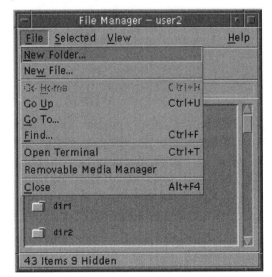

Creating New Folders and Files

The File Manager allows you to quickly and easily create folders and files. This is an alternative to using the **mkdir** command to create a new directory and the **touch** command to create a new, empty text file.

Creating New Folders

When the New Folder option is chosen, a separate window is displayed. You can enter the new folder name, as shown in Figure 6-23. Enter the name of the new folder or directory. Follow the directory naming conventions covered earlier. After the name has been applied, you have the choice of clicking either OK or Apply.

Figure 6-23 Creating a New Folder

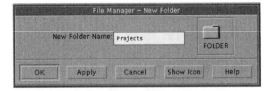

Clicking **OK** adds the new folder with the name just typed and closes the New Folder window. Clicking **Apply** adds the new folder and keeps the New Folder window on the

screen display. You then type in the name of another new folder. Figure 6-24 shows the newly created Projects folder.

Figure 6-24 New Projects Folder

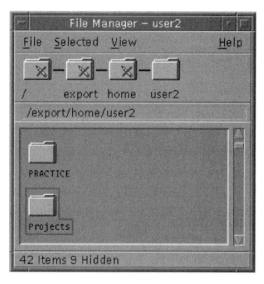

To create several new directories, click **Apply** for all new folder names except the last. When the last folder name has been typed, click **OK** to close the New Folder window.

Creating New Files

A New File window is displayed where you must type the name of the file to be created, as shown in Figure 6-25. Click **OK** and the file is created with the name typed, and the New File window closes. However, if you click **Apply**, the file is created and the New File window stays on the screen. You can then create another new file. By clicking **Apply** after each filename has been typed, you can add several new files from the same New File window. Figure 6-26 shows the newly created file.

NOTE

When you click **Apply**, the name is retained in the typing area of the New Folder window. You must remove the previous folder name using the **backspace** key or the equivalent mouse action.

Figure 6-25 Creating a New File

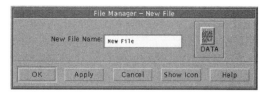

Figure 6-26 Newly Created File

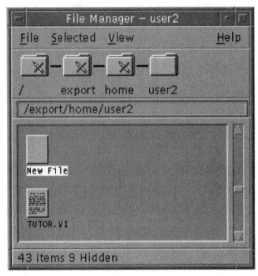

The File Manipulation Error window, as shown in Figure 6-27, alerts you if you attempt to create a folder or file with the same name as an exiting folder or file. Click **OK** and then type an alternative name for the folder or file that is to be created.

Figure 6-27 File Manipulation Error Window

Changing Folders

The Go To option on the File Manager's File menu enables you to specify which folder to change to by specifying a path name, as shown in Figure 6-28. Enter a valid path name into the appropriate entry box, and then click **OK**. If any permission controls prevent you from changing to the specified folder, you are notified with the window shown in Figure 6-29.

Figure 6-28 Changing Folders

Figure 6-29 Action Error Window

Recovering Files

An advantage of File Manager over the command-line environment is its capability to recover deleted files. This is also known as the "undelete" function. A file deleted using File Manager, can be undeleted, provided that the file has not been overwritten. Within the CDE, any file or directory that is deleted is placed within the Trash Can using the Put in Trash option from the File Manager Selected menu. You also can right-click the file or directory and select Put in Trash.

The Trash Can is accessed from the front panel, as shown in Figure 6-30. The file to be recovered can be selected, as shown in Figure 6-31. The files within the Trash Can can be "undeleted" by selecting the Put Back option from the File menu, as shown in Figure 6-32. The Trash Can also allows the user to shred the files or directories within the Trash Can, which permanently deletes the files.

Figure 6-30 Accessing the Trash Can

Figure 6-31 Selecting the File to Put Back

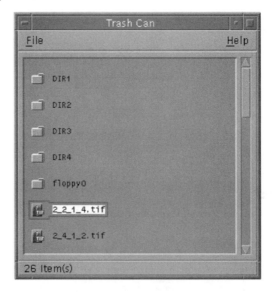

 Lab Activity 6.2.6 Basic CDE File Manager

In this lab, you work with Common Desktop Environment (CDE) File Manager. The CDE method of file and directory management allows you to do many of the same tasks that were performed earlier at the command line. Refer to Lab 6.2.6 in the *Cisco Networking Academy Program Fundamentals of UNIX Lab Companion*, Second Edition.

Figure 6-32 Using the Put Back Option

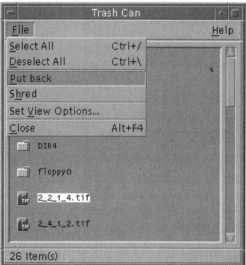

Directory and File Management Using GNOME Nautilus

The GNOME desktop provides several tools for managing files and directories. The most commonly used of these is the Nautilus File Manager. Note the process of performing file and folder management functions described here will vary depending on the version of GNOME and Nautilus you are using. Comparable functions, however, should be available and may be on a different menu.

Nautilus File Manager

Chapter 2 introduced Nautilus, a file and folder management utility that is a core component of the GNOME desktop environment. With Nautilus you may initiate any task that you normally perform on a computer with folders and files. You may organize folders and files, rename or delete them, control access levels to them, and view them, either with Nautilus itself or by launching applications that you choose. Using Nautilus you can also associate notes, custom icons, and emblems with any folder or file. *Emblems* are icons used to label and categorize objects, marking them as favorites, urgent, new, and so forth. Nautilus may also be used to view system documentation, and even as a web browser.

Nautilus is designed to be a useful tool to a user new to Linux or UNIX in general. Nautilus operation is intuitive and easy to discover by exploration. Start at the Help menu on the right end of the Menu Bar at the top of the Nautilus window. After that, try the Help tab in the sidebar to the left. Figure 6-33 shows a Nautilus window with the Help index open in the sidebar and the Nautilus User Manual in the main panel. Note that the Help menu on the right is open, and the user is about to open the Nautilus Quick Reference guide.

Figure 6-33 Nautilus Window Showing Ways to Locate Help

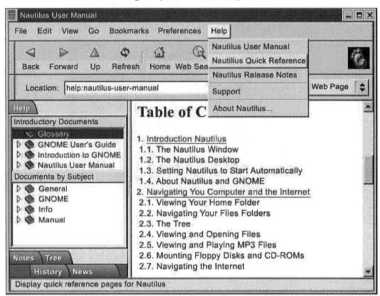

File and Folder Icons

Like most components of the GNOME desktop environment, Nautilus is highly configurable. Click the **Preferences** menu, the second from the right. You will see a choice that says Edit Preferences. From the Preferences window users may tailor the appearance and behavior of Nautilus to suit their needs. Figure 6-34 shows the Preferences window, with a list of categories to select from in the left panel, and the current settings for a user's view preferences on the right.

Figure 6-34 Nautilus Preferences Window

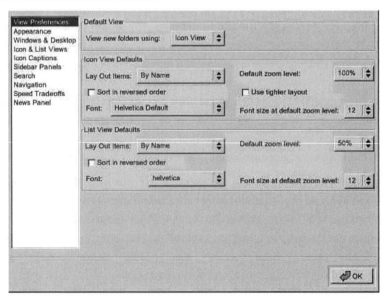

With desktop managers, a *folder* is a *directory*, the term that is commonly used by persons who work from a UNIX shell. The terms may be used interchangeably. Folders or directories contain files and sometimes other folders.

The default view for folders is set initially to Icon view. When a folder is opened with Icon view set, the user will see each object in it represented as an icon with its name and up to three additional pieces of information under the name.

Some users have many folders with large collections of files and subdirectories. When this is the case, the user might want to set the default view to List view. This List view shows folder contents in a table form, prefixed with a small icon, followed by the name, emblems, file size, file type, and date modified. Clicking the headers of any of these columns causes the display to be sorted on that field, toggling between normal and reverse sort order.

Whether the user chooses Icon view or List view as the default, the display of individual folders can be changed using the pull-down menu on the right end of the Location Bar. Nautilus remembers the setting the next time the user visits it. Figures 6-35 and 6-36 show two Nautilus windows viewing the same directory of files, the first in List view, and the second in Icon view. Some of the optional display features have been turned off using the View menu. See View menu options in Chapter 7.

Figure 6-35 Nautilus List View

File Menu Options

When Nautilus first starts, "start-here:" is in the Location Bar, the starting place for setting preferences. However, in real use GNOME users often begin by navigating folders and files. Click the **Home** icon on the toolbar to start this navigation. You can accomplish this more efficiently by double-clicking the **Home** icon at the top left of the desktop. Figure 6-37 shows which one to click for a user whose login name is student.

Figure 6-36 Nautilus Icon View

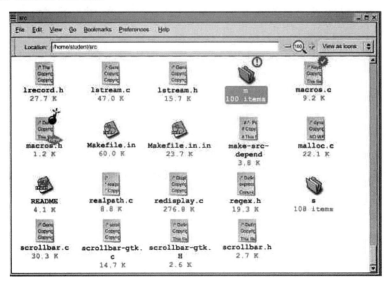

Figure 6-37 Home Icon Selected

Any of the options on the File menu may be selected while using Nautilus to manage folders and files. When a choice on the menu is shadowed out, it means that it is not valid at the moment. For instance, upon first opening a folder, no files are selected, so the menu options to open files are shadowed. If the Trash is empty, the Empty Trash selection is shadowed. Figure 6-38 shows the complete File menu.

Figure 6-38 Nautilus File Menu

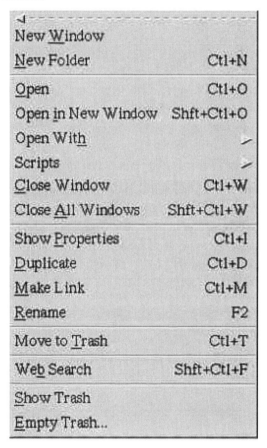

The sections that follow explain the functions of several File menu selections. Others are discussed in Chapter 7.

New Window

Another Nautilus window appears using the directory defined as the Home Location in the Navigation section of the Edit Preferences window.

Open

Highlight a file or folder and select **Open**. Nautilus tries to present that object to the user. With a folder, Nautilus opens it in the main panel within the current window, replacing what the user was looking at. With a plain text file, Nautilus will view the file, optionally with an editor or viewer of the user's choice. If Nautilus sees that it is executable, it will offer the user the choice of running it or displaying its contents. Graphic images are viewed and applications are launched. Users can teach Nautilus what to do with file types it does not recognize.

Open in New Window

If Nautilus is capable, the file or folder selected is presented to the user in a new window. This happens the same way as if the user had clicked Open.

Open With

If the user highlights a file, Open With offers a list of ways to open that file. If the user selects an image file, Nautilus suggests opening it with the Electric Eyes viewer or The Gimp, a graphics-editing program. Nautilus also enables the user the opportunity to add to the list Nautilus does not already know about.

Highlighting a folder and Open With gives users the option to open it with Icons Viewer, List Viewer, or with an application or viewer of their choice. The user will have to tell Open With what will work for that folder. For instance, it would not be feasible to open a directory with a word processor.

Scripts

Nautilus passes the names of the files or folders the users have selected as arguments to an executable script or program in any language. A list of available programs appears on the Scripts menu. The script chosen will execute using the files highlighted. Exactly what actions those scripts perform is limited only by the programmer's imagination. No scripts are supplied with Nautilus, so the list is initially empty. Users wanting to create scripts must put them in the directory *$HOME/.GNOME/Nautilus-scripts*.

Close Window

As suggested by the label, Close Window closes only the currently selected window.

Close All Windows

All open Nautilus windows work together within a single GNOME session. If the user chooses Close All Windows, they will all close. This happens even if the user opened some windows from different invocations (for example, by clicking his Home icon at different times in his session).

Show Properties

Click **Show Properties** on the Edit menu and a Properties window appears with three tabs in it. The primary property of a file is its name. The user may change the name here if they want.

A second tab allows the user to select emblems that display in List view. The third tab lets the user set permissions on the object.

Duplicate

Nautilus makes a copy of the user's file or folder. The name given to the file or folder is the user's original name, plus a space and the word *copy* in parentheses. For example, a duplicate of *myfile* is called *myfile (copy)*. This should be renamed immediately. See the section "File Menu Options" in Chapter 7. Spaces and parentheses in filenames are difficult to manage in UNIX. The duplicate is a full, independent copy that may be altered without affecting the original.

Web Search

Selecting **Web Search** turns Nautilus into a web browser that opens on the web search engine specified by the search option from Edit Preferences. Note that the Web Search icon on the toolbar accomplishes the same thing. The default is the popular Google search engine, at www.google.com. From there the user may enter words or phrases. Press **Google Search** and Google will return a list of links related to the user's request.

Creating New Folders

There are three primary ways to create folders within the GNOME desktop environment, two from within Nautilus and one to create folders on the desktop itself.

Creating New Folders Using Nautilus

To create a folder with Nautilus, the user must first view an existing folder. For example, press the **Home** icon on the toolbar to open the user's home directory. Be sure View as Icons is the current view type at the right end of the Location Bar. Then select **New Folder** from the File menu. A new folder is created as a subdirectory of the user's home directory. The folder appears, selected with its default name in a box and in a different color. Type in a new name and press **Enter**, or click the mouse anywhere else on the desktop.

Figure 6-39 shows the newly created folder in the main panel while viewing the directory with View as Icons set. Notice the name is a different color and waiting to be changed.

NOTE

You should rename the folder immediately, because the default is *untitled folder*, including the space. Filenames with spaces in them are difficult to handle on any UNIX system. Experienced users avoid filenames with spaces because they tend to cause scripts and shell commands to be troublesome.

Figure 6-39 Newly Created Folder in Icon View

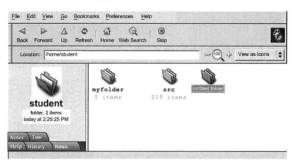

The operation is slightly different if the user has View as List set for the folder he is viewing. If View as List is chosen, New Folder again creates the folder with the default name *untitled folder*, but presents a Properties window with the name highlighted. Within this window the user may also set emblems and permissions if he wants to do so. Generally the defaults are good enough on newly created folders. Figure 6-40 pictures the new folder window that appears when selecting New Folder from the File menu, with the main Nautilus window behind it.

Figure 6-40 New Folder Window

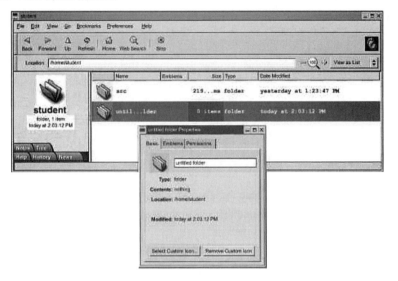

Creating New Folders on the Desktop

Making a new folder on the desktop is a simple operation. With the mouse pointer over any blank area of the desktop, right-click to bring up the Desktop menu, and select **New Folder**. It will appear as a selected icon named *untitled folder* on the user's desktop.

You will want to rename the folder right away. To do so, right-click the icon and select **Rename**. The file's name beneath the icon turns a different color, with a box around it, and is selected. Type in the new filename and press **Enter**, or click the mouse elsewhere on the desktop. Figure 6-41 shows a newly created folder with the Desktop menu open and Rename selected.

Changing Folders

Nautilus provides several ways to navigate to different folders on the user's computer:

- Double-click folder icons
- Back, Forward, and Up in the toolbar
- Sidebar tree
- Sidebar history

Figure 6-41 Renaming a Newly Created Desktop Folder

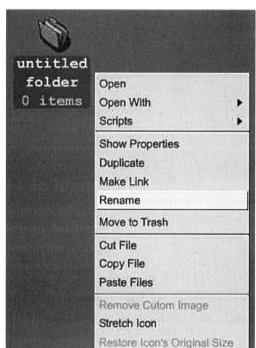

As discussed in Chapter 5, "Accessing Files and Directories," the files on a UNIX system are laid out in a tree-like structure, starting from the *root* (/) directory. Normally you will be viewing and working with files within your home directory.

Navigation Using the Icons

The simplest way to get to a different folder is to double-click its icon. The display in the main panel is replaced with whatever is found in the newly selected folder. This technique works the same whether viewing folders as icons or as a list.

Navigation Using the Toolbar and Location Bar

You have just changed to a subdirectory within your home directory and now want to return to where you were. Notice that the first three icons on the toolbar are arrows labeled Back, Forward, and Up:

- Clicking the **Up** button always takes you up one directory level, until you hit root directory. You can continue to explore the rest of the system from this point. However, you may find that you do not have permission to view some items and will not be able to make changes to files or folders outside your home directory.

- Clicking the **Back** button always takes you to the item you previously visited, regardless of where it was, even if it was a website located on a computer on the other side of the world.

- If you previously clicked the **Back** button, the Forward button will return you to the folder you just came back on.

- The **Home** button on the Nautilus toolbar always returns you to your home directory. This is helpful if you get lost.

- If you know the UNIX path name to a folder or file you want to visit, you can type that name in.

Navigation Using the Tree

If you click the **Tree** tab in the sidebar, you see an overview of your whole computer system. Click any folder icon and Nautilus views it as long as you have permission to view that folder. Use the small arrows to the left of the folder icons to expose and hide the contents of any given subdirectory alternately. Figure 6-42 shows Nautilus open to a user's home directory, with the Tree tab open in the sidebar. By default, the Tree view shows only folders, not files.

Figure 6-42 A Nautilus Window with the Tree Sidebar Open

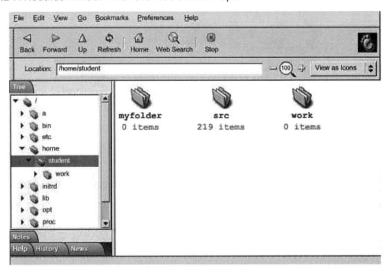

Navigation Using History

Click on the **History** tab in a Nautilus window to see a list of the files and folders you have visited in the current GNOME session. The list is in sequential order, with the most recent at the top. You can click on any of these to revisit them, which also reorders the history list. When you log out and log in again, thereby restarting GNOME, the history record starts again from the beginning.

Deleting and Recovering Files

Three selections on the (Edit) File menu deal with deleting and recovering files. The method Nautilus uses is essentially identical to that seen on Windows and Macintosh computers. The general idea is to move items to a Trash bin where they remain out of the way, but still recoverable. When you are sure that you no longer need the files in the Trash, you can empty it. This permanently destroys the files. The only way to retrieve objects after emptying the Trash is if you have made backups.

Move to Trash

Highlight files or folders that you want to delete and select **Move to Trash** from the File menu. Those objects will be relocated to the Trash, but will not be deleted from the system yet. If the Trash folder was previously empty, the appearance of the icon on the desktop will change to indicate that it has content, as seen in Figure 6-43.

Figure 6-43 Full Trash Icon

Show Trash

If you are unsure of what you have placed in the Trash, you might want to check it before permanently deleting the contents. Click **Show Trash** in the Edit menu to get what is just an ordinary folder view in either icon or list mode. Figure 6-44 shows a Trash folder with some content in it. Notice what it says in the Location Bar. The sidepanel has been turned off.

If there are items in the Trash that the user feels the need to hold on to a little longer, he can delay emptying the Trash, or else move them elsewhere temporarily.

Figure 6-44 Viewing a Trash Folder with Content

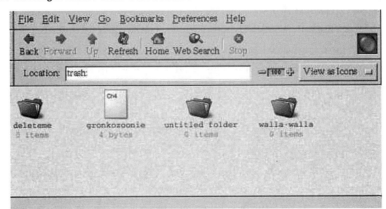

Empty Trash

When you click **Empty Trash** from the File menu, a window titled Delete Trash Contents? pops up and gives a last opportunity to confirm that you want to dispose of the files in the Trash. Click the **Empty** button to continue, or **Cancel** to stop. A progress window appears briefly while the files are being deleted and then disappears.

Lab 6.3.6 Basic GNOME File Management

In this lab, you work with Nautilus and other GNOME file and directory management tools. Refer to Lab Activity 6.3.6 in the *Cisco Networking Academy Program Fundamentals of UNIX Lab Companion*, Second Edition.

Summary

Knowledge of UNIX commands provides a good foundation for understanding UNIX and is critical to success as a power user or system administrator.

Control characters such as Ctrl-c, Ctrl-d, and Ctrl-u are used in the UNIX environment to perform special functions such as interrupting command output, logging out, and clearing screen entries.

A number of file information commands are available. These include the **file**, **strings**, **cat**, **more**, **less**, **head**, **tail**, **wc**, and **diff** commands. They can be used to find out information about the type and characteristics of a file as well as its contents.

When creating new files and directories, users should adhere to the naming conventions. These are the basic rules for naming files and directories, which include length and recommended characters.

New directories are created using the **mkdir** command, and new files are created using the **touch** command. Files and directories can be removed or deleted using the **rm** command.

CDE File Manager is a graphical utility that can be used to perform many of the same functions as the file and directory management commands entered at the command line.

GNOME also provides a graphical tool for file management called Nautilus. Nautilus performs many of the same tasks as CDE.

Check Your Understanding

1. Which two of the following are the two main reasons for learning to use the UNIX command line?

 A. It gives the user access to the many command options, providing more flexibility.

 B. It gives the user the ability to perform file management on a remote system where a graphical interface is not available.

 C. The graphical interface is more complicated to use and designed for advanced users.

 D. It limits the number of commands a user can perform thereby limiting user confusion and user errors.

2. A user is using the **cat** command to view the contents of a large text file. Which of the following sequences of keystrokes would be used to pause screen output and then resume it?

 A. **Ctrl - s** then **Ctrl - q**

 B. **Ctrl - s** then **Ctrl - z**

 C. **Ctrl - q** then **Ctrl - s**

 D. **Ctrl - d** then **Ctrl - q**

3. What is the function of the **Ctrl-c** keystroke

 A. **Ctrl - c** interrupts the current activity, returning the user to the command prompt.

 B. **Ctrl - c** resumes screen output.

 C. **Ctrl - c** suspends execution of a foreground process, returning the user to the command prompt. This process can later be restarted in the foreground or background.

 D. **Ctrl - c** copies the command line.

4. Given the following sequence of commands

    ```
    $bc
    1200/4
    300
    Ctrl+d
    ```

 What is the expected outcome after the **Ctrl-d** command has been executed?

 A. Return to shell prompt

 B. Reboot

 C. Repeat last command

 D. Copy answer to memory

5. Which of the following statements are true about the Bourne, Bash, or Korn shell? (Select three.)

 A. **Ctrl - u** erases the entire command line.

 B. **Ctrl - w** erases the last word on the command line.

 C. **Ctrl - h** erases the last character on the command line.

 D. **Ctrl - a** clears the entire screen.

6. Which two of the following commands would display the entire contents of the text file *someoutput.txt* to the screen?

 A. **cat someoutput.txt**

 B. **wc someoutput.txt**

 C. **more someoutput.txt**

 D. **diff someoutput.txt**

7. Which command displays the last 25 lines of the file *sample.output*?

 A. **tail –25 sample.output**

 B. **head 25 sample.output**

 C. **tail +25 sample.output**

 D. **tail sample.output**

8. Which command does a comparison of *text1.txt* and *text2.txt* while ignoring the case of the letters?

 A. **diff -i text1.txt text2.txt**

 B. **diff -c text1.txt text2.txt**

 C. **cmp text1.txt text2.txt**

 D. **wc text1.txt text2.txt**

9. What is the maximum length of a filename on a UNIX filesystem?

 A. 8 alphanumeric characters plus a 3 alphanumeric file extension

 B. 12 alphanumeric characters

 C. 55 alphanumeric characters

 D. 255 alphanumeric characters

10. Under the File menu of the CDE File Manager, what is the function of the Go To item?

 A. Go to the specified directory

 B. Go to the specified line number in the selected text file

 C. Go to the specified machine

 D. Open the specified file

11. Using the GNOME Nautilus file manager, which menu option will turn the file manager into a web browser?

 A. Web Search

 B. Open With

 C. Open in New Window

 D. New Window

12. Which four of the following specify the ways in which a user can navigate to different folders using Nautilus?

 A. Double-click folder icons

 B. Single-click folder icons

 C. Back, Forward, and Up in the toolbar

 D. Sidebar tree

 E. Sidebar history

UNIX Command Summary

bc Basic calculator command. Example:

```
$ bc
5280/3
1760
<Ctrl d>
$
```

cat Concatenate and display files. Example:

```
$ cat dante
The Life and Times of Dante
by Dante Pocai
Mention "Alighieri" and few may know about whom you are talking. Say "Dante," instead,
and the whole world knows whom you mean. For Dante Alighieri, like Raphael
$
```

Ctrl c Cancels the current activity. Example:

```
$ man intro <Ctrl c>
```

Ctrl d Indicates the end of a file or exit. Example:

```
$ bc
5280/3
1760
<Ctrl d>
$
```

Ctrl q Resumes screen output. Example:

```
$ cat largfile <Ctrl s> <Ctrl q>
```

Ctrl s Stops screen output. Example:

```
$ cat largfile <Ctrl s>
```

Ctrl u Erases the entire command line.

Ctrl w Erases the last word on the command line.

diff Compares the contents of two files and writes to standard output a list of changes necessary to convert the first file into the second file. No output is produced if the files are identical. Example:

```
$ diff -c fruit fruit2
*** fruit Fri May 8 11:32:49 1998
--- fruit2 Fri May 8 14:55:21 1998
***********
***2, 8****
orange
apple
banana
-pear
-mango
tomato
pomegranate
---2, 8-----
orange
apple
banana
tomato
+guava
+mango
pomegranate
```

file Determines file type. Example:

```
$ file dante
dante:    English text

$ file beans
beans:    Frame Maker Document

$ file da* fi*
dante:      English Text
dante_1:    English Text
file1:      English Text
file2:      ascii text
files.jar:  java program
files.tar:  USTAR tar archive
```

head Displays the first few lines of files. Example:

```
$ head -5 /usr/dict/words
1st
2nd
3rd
4th
5th
$
```

mkdir Creates the named directories in mode 777 (possibly altered by the file mode creation mask umask(1)). Example:

```
$ mkdir Reports
$ ls -dl Reports
drwxr-xr-x 2 user2 staff 512 Jan 28 16:24 Reports
```

```
$ mkdir -p practice/dir1/admin
$ ls -R practice
practice:
dir1 mailbox project research
practice/dir1:
admin
practice/dir1/admin:
```

more A filter that displays the contents of a text file on the terminal, one screen at a time. It normally pauses after each full screen. Example:

```
$ cat dante | more
```

rm Removes directory entries. Example:

```
-i,-r
$ rm -r dir1
```

strings Finds printable strings in an object or binary file. Example:

```
$ strings /usr/bin/cat
SUNW_OST_OSCMD
usvtebn
usage: cat [ -usvtebn ] [-|file] ...
cat: Cannot stat stdout
cat: cannot open %s
cat: cannot stat %s
cat: input/output files' %s' identical
cat: close error

```

tail Displays the last few lines of files. Example:

```
$ tail -5 /usr/dict/words
zounds
z's
zucchini
Zurich
zygote
$
```

touch Sets the access and modification times of each file. The file is created if it does not already exist. Example:

```
$ cd ~/practice
$ touch mailbox project research
$ ls
mailbox project research
```

wc Reads one or more input files and, by default, writes the number of newline characters, words, and bytes contained in each input file to the standard output. Example:

```
$ wc dante
33 223 1320 dante
$ wc -l dante
33 dante
```

Key Terms

concatenate To join the output of one or more files or commands.

control character Used to perform specific tasks, such as stopping and starting screen output and aborting processes. There are two control keys on most PC keyboards. They normally are labeled Ctrl and are found in the lower-left and lower-right corners of the keyboard. On a Sun workstation, there is one control key in the lower left of the keyboard and is labeled Control. When displayed on the screen, the Ctrl key is represented by the caret (^) symbol.

data file A file created by a particular application such as a word processor or database. These files must be opened with the application that created them.

file manager Can be accessed from the CDE front panel or by right-clicking the desktop. The CDE method of file and directory management allows you to do many of the same tasks that are performed at the command line. CDE provides a graphical interface to file management and executes most of the same commands used from the command line behind the scenes.

text file A file made up of standard ASCII characters and no special formatting characters. Script files are text files.

Trash Can A temporary holding place for files that are deleted. Files can be placed in the Trash Can. They then can be permanently deleted by shredding them, or they can be put back (or "undeleted").

Objectives

After reading this chapter, you will be able to

- Perform advanced directory and file management using the UNIX/Linux command line.
- Use the **cp** (copy) command to copy files and directories.
- Create, remove, and rename links to files.
- Use the **mv** (move) command to rename and move files and directories.
- Redirect input/output to and from commands.
- Pipe output from one command to another.
- Perform advanced directory and file management using the Common Desktop Environment (CDE) File Manager.
- Perform advanced directory and file management using GNOME Nautilus.

Advanced Directory and File Management

Introduction

In this chapter, you work with some of the more advanced file and directory management tasks using the command-line interface as well as the CDE File Manager and GNOME's Nautilus. You start with the command-line interface and work with the commands necessary to copy, link, move, and rename files and directories. You then learn about command *piping* and input/output *redirection*. The commands introduced in this chapter apply to both UNIX and Linux. You use the CDE File Manager and GNOME Nautilus to perform some of the same tasks that they accomplished earlier using the command line. Accessing a floppy disk is also discussed.

Copying Files Using the Command Line

The **cp** (copy) command copies files and directories. You focus on copying files in this section.

Copying files is a normal occurrence when working with the file system. A common use of the **cp** command is to make a backup of an existing file for safekeeping so that the original can be modified. Files can be copied in two different ways:

- A new file can be created with a different name in the same directory.
- A file or files can be copied to a different location in the directory hierarchy with the same name or a different name. They also can be copied to a floppy disk or a centralized server.

Depending on the need, you can copy files within a directory or copy them to another directory.

Copying Files Within a Directory

To copy a file resulting in a new file identical to the original located within the same directory having a different filename, use the format in Figure 7-1. This format copies from an existing filename (source_file) to a new filename (destination_file) in the same directory. This method

of copying files can be thought of as copying from old (original file) to new (new, identical file) in the same directory.

Figure 7-1 Copy Command Format

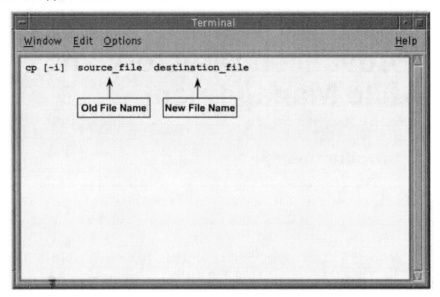

Figure 7-2 illustrates copying a file within a directory. The file3 file is being copied to a new file named feathers that will reside in the same directory, as can be seen with the **ls** command.

Figure 7-2 Copying a File Within a Directory

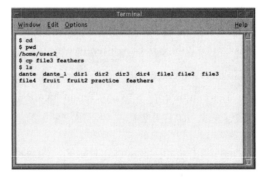

Copying Files to Another Directory

To copy one or more files to another directory, use the format in Figure 7-3. This format copies the existing file or files that the user wants to copy, to another directory in the directory structure. When copying a file in this way, the file normally keeps its original name. The user

can add a slash and a filename after the destination directory to give the file a different name, if desired. This version can be thought of as copying what to where.

Figure 7-3 Copy (**cp**) What to Where

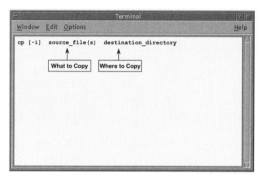

The **cp** command also can be used with metacharacters or wildcards, such as the asterisk (*) and question mark (?), to copy groups of files at the same time. Figure 7-4 shows how to copy several files using the format in Figure 7-3. The **cp** command assumes that the last entry (dir1) is a directory name and that the two previous entries (feathers and feathers_6) are files. Figure 7-4 also shows the use of the asterisk to copy the same files using an alternative command line.

Figure 7-4 Copying Files to a New Directory

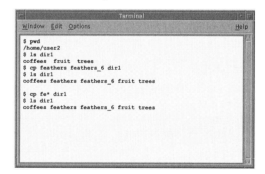

NOTE

If a file is copied and the name of the destination directory does not exist, a new directory is created with that name. Otherwise, the file is copied to the directory specified.

TIP

Most UNIX commands enable the user to specify multiple source files. To specify more than one file, separate the filenames with a blank character space. For example, the command **cp Chap1 Chap2 book.dir** copies both Chap1 and Chap2 files to the book.dir directory.

Preventing Overwriting of Files

A file that is copied and the target name already exits causes the user to *overwrite* or "clobber" the file. The user will not receive a warning to prevent this from happening. To prevent overwriting an existing file when copying, use the **cp -i** (interactive) option as a security measure. The **-i** option prompts the user only if he is about to overwrite an existing file, and it gives the user a choice. Answering **y** overwrites the file; answering **n** returns the shell prompt

without copying. You should always use **cp -i** to prevent accidental mistakes. Figure 7-5 shows an example of the **cp -i** command.

TIP

You can create an alias for the **cp** command to ensure that you will always be prompted before accidentally copying over an existing file. See Chapter 14, "Shell Features and Environment Customization," for details.

Figure 7-5 Copying a File Using the **-I** Interactive Option

```
$ cp -i feathers file3
cp: overwrite file3 (yes/no)? n
$
```

Copying Files to a Floppy Disk Using the Solaris Command Line

The following steps copy a file or files to a 3.5" 1.44 MB disk with Solaris:

NOTE

The concepts of mounting and mount points are discussed in Chapter 8, "File Systems and File Utilities." Copying files to a floppy disk using CDE and GNOME is covered later in this chapter. More information about accessing Solaris and Linux removable media devices is covered in Chapter 12, "Backing Up and Restoring."

Step 1 Insert the disk in the drive and type **volcheck** (volume check) at the shell prompt. This tells Solaris to check the floppy drive, determine the disk type (UNIX or PC), and temporarily places ("mounts") the floppy disk under the /floppy directory of the hard drive.

Step 2 Copy files to the floppy disk with Solaris using */floppy/floppy0* as the destination. For example, **$cp dante /floppy/floppy0**. The user can verify his copy by entering **$ls /floppy/floppy0**.

Copying Files to a Floppy Disk Using the Linux Command Line

Copy files to the floppy disk with Linux using this format:

```
$cp dante /mnt/floppy
```

The directory */mnt* is the standard ***mount point*** for the floppy drive and the CD-ROM with most distributions of Linux.

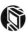

e-Lab Activity 7.1 Copying Files

In this activity, you use the **cp** command copy a file to a new name and copy a file to another directory. You also use the **cp -i** (interactive) option to copy a file. Your current working directory is: /home/user2/dir2. See the class file tree structure on the inside-front cover of this book or click the **tree** icon on the CD-ROM e-Lab Activity. Refer to e-Lab Activity 7.1 on the accompanying CD-ROM.

Copying Directories

Use the **cp -r** (*recursive*) command to copy a directory and its contents to another directory. If the destination directory does not exist, it is created. Without the **-r** option, files, and subdirectories contained within a directory are not copied. When used with the **-i** option, **cp** prompts for verification before overwriting an existing file:

```
cp -r [i ] source_directory(s) destination_directory
```

Copying a Directory Within the Same Directory

The **cp -r** command can be used to copy a directory and all of its contents to a new directory in the current directory. The user must use the **-r** option when copying directories. The first example in Figure 7-6 shows copying the dir3 directory to a new directory named ski.places without using the **-r** option, and it demonstrates the error that results. The error states that dir3 is a directory, indicating it cannot be copied without the **-r** option. The second example shows the proper use of the **cp -r** command to copy a directory. Notice that the dir3 directory is being copied to a new directory named ski.places, which has an extension of five characters. It is permissible to have multiple extensions of varying lengths with UNIX directory names.

Figure 7-6 Copying a Directory Within the Same Directory

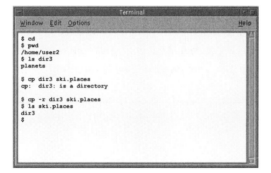

Copying a Directory to Another Directory

Figure 7-7 demonstrates how to copy a directory to another directory that is not in the current directory. The first example shows the planets directory is copied to dir1/constellation using a relative path name. The .. (two dots) moves up one directory and then down to the dir1 directory. The second example copies two directories at the same time, dir1 and ski.places, to the absolute path name of the /tmp directory.

Figure 7-7 Copying a Directory to Another Directory

```
                           Terminal
 Window  Edit  Options                              Help

 $ cd
 $ pwd
 /home/user2

 $ cd dir3
 $ cp -r planets ../dir1/constellation

 $ cd
 $ cp -r dir1 ski.places /tmp
 $ ls -F /tmp
 dir1/ ski.places/
 $
```

e-Lab Activity 7.2 Copying Directories

In this activity, you use the **cp -r** command to copy a directory to another name in the same directory and copy a directory to another location. Your current working directory is: /home/user2/dir3. See the class file tree structure on the inside-front cover of this book or click the **tree** icon on the CD-ROM e-Lab Activity. Refer to e-Lab Activity 7.2 on the accompanying CD-ROM.

Lab Activity 7.1.2 Copying Files and Directories

In this lab, you perform more advanced file and directory management tasks using the command-line interface and the **cp** (copy) command. Refer to Lab 7.1.2 in the *Cisco Networking Academy Program Fundamentals of UNIX Lab Companion*, Second Edition.

Linking Files

The **ln** (link) command is used to give a file an additional name so that the user can access it from more than one directory or by another name in the same directory. Linking can be useful if several users need to work on the same file from different locations without making a copy, or if they need to reference the file using a different or shorter name. When a user links a file to another file, the linked file is merely a name that references the actual file and, thus, saves disk space.

To link a file to another file in the same directory, use this format:

```
ln file1 newfilename
```

To link a file to another file in a different directory, use this format:

```
ln file1 directory/newfilename
```

NOTE

You need to determine when you should link or when you should copy a file. You should link a file if you need to access the same file, such as a shared team project file, from multiple directories. You should copy a file if you need to modify the file differently.

Using the ls -l Command to See File Linkages

When a file is created, a link is established between the directory and the file. Therefore the link count for every file is at least 1. The link count is displayed in the second column of a long listing (**ls -l**). Each time a link is established with another file, the link count increases by one. Figure 7-8 uses the **ls -l** (long listing) command to show the link count of two files after they were linked.

Figure 7-8 Using the **ls -l** Command to Check Link Count

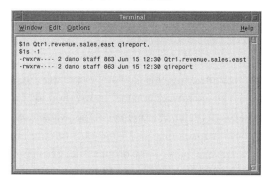

```
$ ln Qtr1.revenue.sales.east q1report.
$ ls -l
-rwxrw----  2 dano staff 863 Jun 15 12:30 Qtr1.revenue.sales.east
-rwxrw----  2 dano staff 863 Jun 15 12:30 q1report
```

Removing and Renaming Links

To remove a link, use the same **rm** command used to remove a file. Using the **rm** command on a link removes the link but not the original source file. After a link is removed, the link count for the original file decreases by one. Issuing the **rm** command on the original source file also removes the link that was created. To rename a link, use the same command used to rename any file. The **mv** (move) command, which is used to move or rename a UNIX file, is covered in the next section.

Renaming and Moving Files

Files and directories can be renamed and moved using the same multipurpose **mv** (move) command. There is no rename command in UNIX.

Renaming a File in the Current Directory

The command format in Figure 7-9 shows the syntax to rename a file in the same directory. This format changes the name of the source, the old filename, to a target filename, the new filename, in the same directory. This version can be thought of as moving from old (original file) to new in the same directory.

TIP

You also can link multiple files to the same directory. For example, **ln ~/book/chap* /home /brad** creates links for each chapter file and puts the new links in the /home/brad directory.

TIP

When a file is linked to another file in the same file system, it is called a hard link. A soft link, or symbolic link, occurs when the user links a file across file systems. This is accomplished using the **ln -s** command. For example, the user might have a file in his home directory, /home file system, that is linked to the /docs/training/unix file residing in the /docs file system. File systems are covered in Chapter 8.

Figure 7-9 Move Command Format

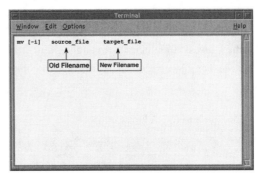

Figure 7-10 shows renaming a file using this format. Note that in Figure 7-9, the interactive option (**-i**) is also available with the **mv** command. The **mv -i** option prompts for confirmation whenever the move would overwrite an existing target file. An answer of **y** means that the move should proceed. Any keystroke other than **y** prevents **mv** from overwriting the target file. The **mv** command changes the name of the original file, whereas the **cp** command copies a file and gives it a new name, leaving the original file intact.

Figure 7-10 Renaming a File in the Current Directory

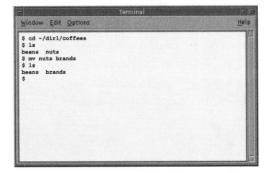

Moving a File to Another Directory

To move a file to a different directory, use the format in Figure 7-11. This format moves the source file or files to a new target directory. You can add a slash and a filename after the destination directory to give the file a different name, if desired. This format moves the source, what to move, to a target directory name, where to move. This version can be thought of as moving from what to where.

Figure 7-12 shows moving a file to another directory using this format. The example shows moving the brands file from the coffees subdirectory to the home directory using the tilde (~) shortcut.

Figure 7-11 Move (**mv**) What to Where

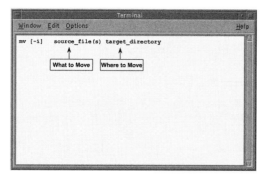

Figure 7-12 Moving a File to Another Directory

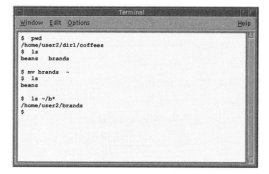

e-Lab Activity 7.3 Renaming and Moving Files

In this activity, you use the **mv** command to rename a file within a directory and then move a file to another directory. Your current working directory is: /home/user2/dir2. See the class file tree structure on the inside-front cover of this book or click the **tree** icon on the CD-ROM e-Lab Activity. Refer to e-Lab Activity 7.3 on the accompanying CD-ROM.

Renaming and Moving Directories

You can manipulate small portions or entire sections of the directory tree to manage file systems. For example, a user currently is storing her personal files on her hard drive. The user wants to have the system administrator move the files to a server so that she can back up easier. The administrator can do this quickly and efficiently by using the **mv** command. The **mv** command is a multipurpose command that can rename a directory or move it to a different location.

Renaming Within the Current Directory

The **mv** command has two basic formats used to rename and move directories. Figure 7-13 shows the format of moving an old directory name to a new directory name, which is used to rename directories within the current directory.

Figure 7-13 Move Old Name to New Name

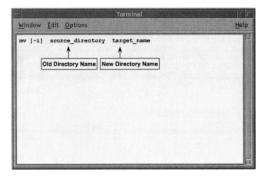

Figure 7-14 demonstrates using the **mv** command to rename a directory within the current directory. In the example, the **cd** command changes to the user's home directory, and the **pwd** command verifies this. Next, the **mkdir** command is used to create the maildir directory using a relative path name. The **mv** command then is used to rename the maildir directory to monthly.

Figure 7-14 Renaming Within the Current Directory

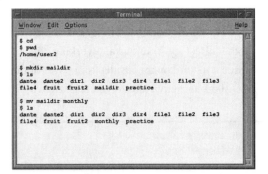

Renaming in a Noncurrent Directory

Figure 7-15 demonstrates how to use the **mv** command to rename a directory in a noncurrent directory. The **mv** command is used to rename the project subdirectory in the practice directory to project2 using a relative path name.

Figure 7-15 Renaming in a Noncurrent Directory

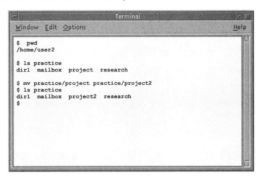

Moving a Directory and Its Contents

Figure 7-16 shows the command format to move a directory and its contents to another directory or location in the directory tree. Figure 7-17 demonstrates using the **mv** command to move the practice directory from /home/user2 to the existing dir3 directory. When moving a directory this way, if the target location exists, the source directory is copied into the target location. If the location does not exist, the source directory is renamed.

Figure 7-16 Move What to Where

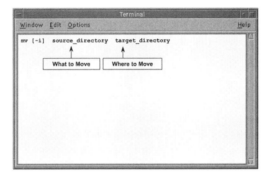

Figure 7-17 Moving a Directory to Another Directory

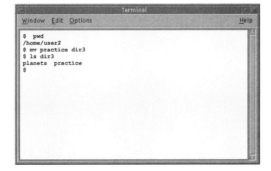

e-Lab Activity 7.4 Renaming and Moving Directories

In this activity, you use the **mv** (move) command to rename a directory within the current directory and then move a directory to another directory. Your current working directory is: /home/user2/dir2. See the class file tree structure on the inside-front cover of this book or click the **tree** icon on the CD-ROM e-Lab Activity. Refer to e-Lab Activity 7.4 on the accompanying CD-ROM.

Lab Activity 7.1.5 Renaming and Moving Files and Directories

In this lab, you work with the versatile **mv** (move) command to rename and move files and directories. Refer to Lab 7.1.5 in the *Cisco Networking Academy Program Fundamentals of UNIX Lab Companion*, Second Edition.

Input/Output Redirection

All central processing unit (CPU) operations have input or output (I/O). The keyboard, for example, provides standard input, while the monitor displays standard output and standard error, as shown in Figure 7-18. These operations are known to the OS (operating system) by their logical names of **stdin**, **stdout**, and **stderr**.

Figure 7-18 Input, CPU, and Output

Every UNIX command has a source for standard input and a destination for standard output. For this chapter's purpose, input and output are defined with respect to a UNIX command. The input to a command normally comes from the keyboard, although it also can come from a file. The output from a command normally goes to the monitor or screen. Errors that might result from a command are another form of output and also are displayed on the screen. Figure 7-19 shows input to a command and the two types of output from it. Input is sending data to a command. Output is receiving data from a command. Errors are generated when a command is entered incorrectly.

Figure 7-19 Command Input and Output

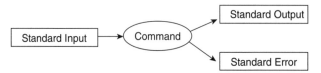

The UNIX computing environment enables command I/O to be controlled using redirection. This is useful when attempting to save the output of a command to a file for later viewing, sending the contents of a file as an e-mail message, or redirecting error messages to a file for use when debugging a program.

Several metacharacters are used as redirection symbols. Input redirection uses the left angle bracket (< or 0<), which is referred to as the less than symbol. Output redirection uses the right angle bracket (> or 1>), or the greater than symbol. Error output redirection uses the right angle bracket, preceded by the number 2 (2>). The general format for using redirection is shown next. The File after the redirection symbol can be a text file or a device file. All devices in UNIX are defined by filenames. An example for the screen or monitor device file is /dev/console. It is not necessary to specify this file because it is the default:

NOTE

Spaces between the command and a redirect symbol are optional.

```
$Command Redirection-Symbol File (text file or device file)
```

Redirecting Standard Input

Standard input is not often redirected. However, it is possible to substitute a text file instead of the normal keyboard input. In Figure 7-20, notice that the left angle bracket, or less than symbol is used. This allows the command to receive input no matter what file is present. The default input is the keyboard device.

Figure 7-20 Redirecting Standard Input of a File to a Command

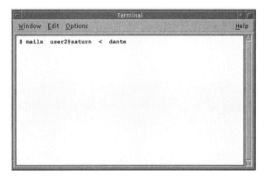

Figure 7-20 illustrates redirection of input using the **mailx** command. The dante file is sent to the e-mail address using the mailx program. The **mailx** command invokes the standard command-line mail program. Input redirection is used with more advanced UNIX commands and functions not covered in this course:

```
command < file
```

This command uses the file as input to the command.

Redirecting Standard Output

Standard output is redirected more frequently than standard input or standard error. Many commands, such as **ls**, **cat**, **head**, and **tail**, generate standard output to the screen. It is often desirable to redirect this output to a file for future viewing or manipulation.

By substituting a filename, the user can capture the output of a command rather than letting it go to the default monitor. As an example, if you wanted to get a listing of all files in a directory, you could redirect the output from the **ls** command. This would capture it in a file that then could be edited using a text editor or word processor. The output from commands shown in this course was captured in this way.

TIP

To prevent the accidental overwriting of a file during redirection, use the noclobber shell feature. To enable noclobber in the Korn or Bash shell, enter at the command line **set -o noclobber**. To disable clobbering, use **set +o noclobber**. You can override the noclobber feature by using the >|, greater than symbol followed by the pipe symbol. For example, **ls -l >| myfiles** would overwrite the existing myfiles file as if noclobber was disabled.

Creating a New Output File

The right angle bracket (>) allows the command to send output to a file. Using the single right angle bracket creates a new file if the filename specified does not exist. If the filename exists, it will be overwritten:

```
command > file
```

This command creates a new file or overwrites an existing one.

The first example in Figure 7-21 illustrates redirection of the output of the **ls** command. The listing of the contents of the /etc directory would be captured in a file called etc.list. This would be placed in the current directory. The second example captures the calendar for October 2000 to a file named mon2000. The third example captures the calendar for January 2001 and appends it to the October calendar in the mon00 file.

Figure 7-21 Redirecting Standard Output from a Command to a File

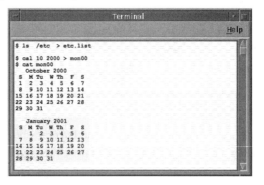

You can also use the > redirect symbol with the **cat** command to combine multiple files into one. For example, **$cat file1 file2 file3 > file4** would combine file1, file2, and file3 into one new file named file4.

The double right angle brackets (>>) can be used if the user wants to append, add to the end, to an existing file instead of overwriting it:

```
command >> file
```

This command creates a new file or appends to an existing file.

Redirecting Standard Error

Standard error is redirected when the user wants to capture the output of a command that might generate an error. It is useful when developing script files, and is normally used by system administrators and programmers. Standard output usually is redirected to a text file. Standard errors are redirected to an error file to assist in troubleshooting if the script or program does not execute properly. To redirect standard error, use the right angle bracket with the number 2 in front of it (2>). If a command executes with no problems, it will not generate an error:

```
command 2> file
```

This creates new file or overwrites an existing one.

Figure 7-22 illustrates the use of 2> to create an error file. This example captures the error generated from the **ls** command. This happens because the directory specified does not exist. Input/output redirection for standard input, standard output, and standard error is summarized in Figure 7-23.

Figure 7-22 Redirecting Standard Error to a File

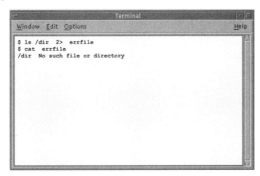

Figure 7-23 Command I/O Redirection Summary

Function	Logical Name	Normal File / Device	Command Format & Redirection Symbol Used
Input	stdin	Keyboard	Command < file
Output	stdout	Monitor	Command > file or command >> file
Error	stderr	Monitor	Command 2> file

 e-Lab Activity 7.5 Input Output Redirection

In this activity, you redirect standard output to a file and then view the contents of the file with the **cat** command. Your current working directory is: /home/user2/dir2. See the class file tree structure on the inside-front cover of this book or click the **tree** icon on the CD-ROM e-Lab Activity. Refer to e-Lab Activity 7.5 on the accompanying CD-ROM.

Command Piping

One of the most effective metacharacters is the pipe (|). The pipe passes the standard output of one command as standard input into a following command. In effect, pipes enable the user to build a miniature program. The pipe symbol sometimes is referred to as a double vertical bar. The user must always have a command on each side of a pipe. (See Figure 7-24.) Spaces between the commands and the pipe are optional:

```
command | command
```

Figure 7-24 Command Piping

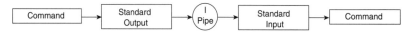

Displaying Command Output One Screen at a Time

A common use of the pipe metacharacter is to send the output of the **ls** command to the **more** command. This enables the user to see a long directory listing one screen at a time. The first example in Figure 7-25 shows this basic use of the pipe. The standard output from the **ls -l /etc** command to the left of the pipe becomes the standard input for the more command on the right side of the pipe.

Figure 7-25 Command Piping Examples

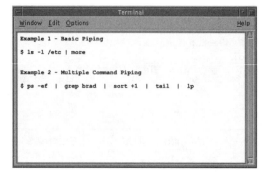

The second example in Figure 7-25 shows multiple command piping to demonstrate how effective piping can be. Several commands are introduced here that you will work with later in the course. In this example, the **ps -ef** command displays a detailed list of all processes running on the system. The output is passed as input to the **grep** command, which searches for the string "brad" in all processes. The resulting output of the **grep** command is passed as input to the sort command. This sorts the output using the process ID (PID). The sorted output then becomes input to the **tail** command. This selects only the last 10 lines of output. That output then is sent to the default line printer (**lp**).

Choosing to Redirect or Pipe

Both redirecting and piping have their advantages. Redirecting is preferable if the data stored in the file will be of further use. If not, a pipeline is better. With piping, the commands run simultaneously and the overhead of storing and retrieving data from the disk file is avoided. A pipeline can have as many as 20 to 30 commands strung together.

e-Lab Activity 7.6 Command Piping

In this activity, your pipe the directory listing output of the **ls** command to the **more** command. You also pipe a directory listing to the **wc** command to count the number of entries. Your current working directory is: /home/user2/dir2. See the class file tree structure on the inside-front cover of this book or click the **tree** icon on the CD-ROM e-Lab Activity. Refer to e-Lab Activity 7.6 on the accompanying CD-ROM.

Lab Activity 7.1.7 Redirection and Piping

In this lab, you use advanced UNIX commands to accomplish redirection and piping. Every UNIX command has a source for standard input and a destination for standard output. Refer to Lab 7.1.7 in the *Cisco Networking Academy Program Fundamentals of UNIX Lab Companion*, Second Edition.

Advanced Directory and File Management Using CDE

As you saw in Chapter 6, "Basic Directory and File Management," CDE File Manager can perform many basic file- and directory-navigation functions. File Manager can also perform more advanced functions such as copying and moving files and directories. You can access File Manager by right-clicking the desktop to bring up your Workspace menu. Click the **File** menu and then the **File Manager utility**.

Moving Files Using Drag and Drop

You can move files by using the select and drag-and-drop technique. To move a file from one folder to another, position the mouse pointer over the file icon, hold down the left mouse button, and drag the icon to the appropriate folder icon.

When the file icon is positioned over the folder icon, release the mouse button and the file will be moved to that folder.

TIP

If you want to move or copy files to the parent directory of the current folder, drag and drop the file icon to the (Go Up) icon.

Copying Files Using Drag-and-Drop

You can copy files using the Control key (Ctrl) and select, drag, and drop technique. Press the **Control** key before the file icon has been selected and hold it down while the drag and drop process takes place; the file is copied rather than just moved to the other folder.

Copying Files to a Floppy Disk

You can copy files to a UNIX or DOS disk by first selecting Open Floppy from the File menu. The Open Floppy command tells Solaris to check the floppy drive for a disk, determine the disk type, whether it is UNIX or DOS, and then open a File Manager window for the floppy. Use the drag-and-drop procedure discussed in the previous paragraph for copying files to or from the floppy.

File Manager Menus

Three main menus are available in File Manager:

- **File**—Enables the user to create new files and folders
- **Selected**—Enable the user to manipulate certain files once they are selected
- **View**—Enables the user to change options for viewing files in File Manager

This section covers the Selected menu options.

As a quick review, Figure 7-26 shows the basic menu options available on the File menu within File Manager. Figure 7-27 shows the options available with the Selected menu.

The Selected Menu

File and folder icons can be selected by clicking the left mouse button. When you select a file or folder, the File Manager Selected menu options enable you to perform a number of tasks. Table 7-1 provides a brief explanation of the options on the Selected menu.

Figure 7-26 File Manager—File Menu Options

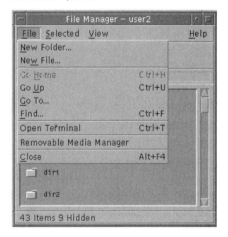

Figure 7-27 File Manager—Selected Menu Options

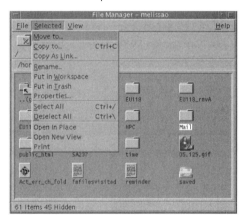

Table 7-1 File Manager—Selected Menu Functions

Move To	Move the selected object to another folder location.
Copy To	Copy the selected object to another folder location or to a different named folder or file.
Copy as Link	Link the folder or file to another folder or file name. (This option creates a symbolic link with the same name as the original file or folder.)
Rename	Allows changing the names of file and folders.

continues

Table 7-1 File Manager—Selected Menu Functions *(Continued)*

Put in Workspace	Place the object on the workspace area. This placement makes that object available whether or not a File Manager window is open.
Put in Trash	Place the object in the Trash Can. An alternative to this option is to drag and drop the object over the Trash Can icon on the Front Panel display. Note: Files deleted in this way can be recovered using the Trash Can Control icon on the front panel. Files deleted from the command line with the **rm** command cannot be recovered.
Properties	Change the permissions of a folder or file. Permissions are covered later in the course.
Select/Deselect All	Select or deselect all objects in the current folder. Once selected, they can be moved, copied, or deleted as a complete group of objects.
Open	Open a folder or file. This menu option is the same as double-clicking the object icon.
Print	Print the file. This is the same as using drag and drop with the Print Manager icon on the front panel.

NOTE

Different options display in the Selected menu, depending on the type of file or folder selected.

View Menu

The View menu in Figure 7-28 enables you to customize the File Manager windows. A number of options are available in the View menu. Table 7-2 provides a brief explanation of the options on the View menu.

Figure 7-28 File Manager—View Menu Options

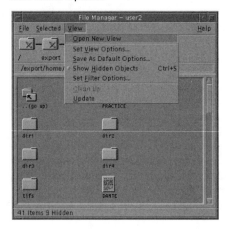

Table 7-2 File Manager—View Menu Functions

Open New View	Clicking **Open New View** in the View menu opens another File Manager window. This facilitates moving files between different directory hierarchies.
Set View Options	Enables a user to choose the way in which the File Manager information is displayed in the window. The choices available are covered below.
Save Default Options	Allows these settings to be retained after File Manager has closed.
Show Hidden Objects	The File Manager window can be set to Show Hidden Objects, allowing viewing of all objects in a directory.
Set Filter Options	Setting the Filter Options enables a user to decide what objects will be hidden objects. If chosen, these objects will not be displayed.
Update	The Update option of the View menu redraws the File Manager window screen. This is useful if objects have been hidden or moved around during the current File Manager session.

Set View Options Submenu

The Options from this submenu item enable you to change the way File Manager displays the files and folders in its windows. You can change the ordering of the display by name, file type, date, or size. These options are shown in Figure 7-29 and can be modified at any time.

Figure 7-29 Set View Options

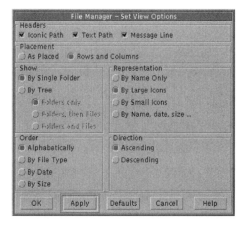

Tree Display

The file system can be displayed by a single folder or as a hierarchical tree, as shown in Figure 7-30. By using the Tree display for the folders, it becomes easier to move around the file system hierarchy. When a folder is double-clicked, another File Manager window automatically is invoked and the contents of the selected folder are displayed in the new File Manager window.

Figure 7-30 Tree Display

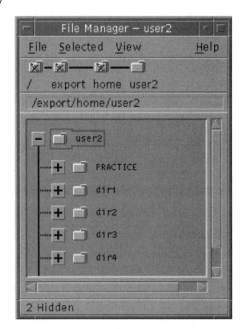

 Lab Activity 7.2.3 Advanced CDE File Manager

In this lab, you work with some of the more advanced features and functions of CDE File Manager. You perform additional file and directory management tasks, such as those that were performed earlier at the command line. Refer to Lab 7.2.3 in the *Cisco Networking Academy Program Fundamentals of UNIX Lab Companion*, Second Edition.

Advanced Directory and File Management Using GNOME

GNOME provides an easy-to-use interface for completing advanced management of folders (directories) and files. Note the process of performing file and folder management

functions described here may vary depending on the version of GNOME and Nautilus you use. Comparable functions, however, should be available and might be on a different menu.

Moving and Copying Files Using Drag and Drop

Users often want to make copies of files and folders they work on and to move those files and folder around. GNOME makes this task simple by means of the Nautilus file manager. A technique called ***drag and drop*** enables you to copy and move files by moving or pushing around their icons using the mouse.

Moving Files Using Drag and Drop

For example, you have a folder named Project in your home directory that contains several files related to work you are doing. There is a file named Notes that you refer to constantly. You would like easier access to the Notes file. You can move the Note file to your desktop. Here you can click on it anytime without having to search through folders for it.

To *move* a file to your desktop:

Step 1 Click the file's icon and continue to hold the mouse button.

Step 2 Move the pointer to some area on the desktop and release it.

The file's icon and name disappear from the window and appear on the desktop. The file has been moved and is no longer in its original location. Figure 7-31 shows the Notes icon in the process of being moved to the desktop. The cryptic appearance of the icon beneath the Trash is actually the beginning of the first three lines of this plain text file's content.

Figure 7-31 Moving the Notes File to the Desktop

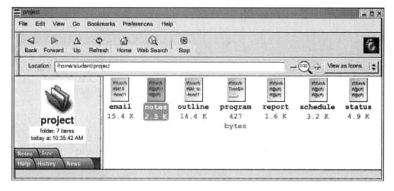

Figure 7-32 shows the results of the move after releasing the mouse button. Notice that the icon for notes is no longer in the Nautilus window, only on the desktop, and is highlighted.

Figure 7-32 Project Folder After Moving Notes to the Desktop

Use the same technique to move files to another folder. When viewing a folder that has a sub-directory within the folder, the user drags the file's icon on top of the folder icon and drops it in the folder icon. The file is now moved to that folder.

The simplest way to move a file to a folder that is not seen in the currently viewed folder is to open a second window viewing the new folder. You then drag the file's icon between windows. For example, you have created another folder in your home directory called Process and want to relocate materials that relate to dealing with others, such as email, reports, and status summaries. You would do the following:

Step 1 Open the folder called Project in the usual way.

Step 2 Select **New Window** from the File menu.

Step 3 In the new window, navigate to the directory called Process.

Step 4 In the window that shows the Project folder, click the icon for the file called email, and then drag it to the other window. The file now appears in the new window, but disappears from the original one.

Step 5 Multiple files can be selected by pressing the Shift key while clicking the file icons, or by dragging a box around a group of icons in a window that are together.

Step 6 To move the report and status files to the Process folder, click **report**, **Shift-click** status, and finally drag the files to the other window. Both files move at the same time.

Figure 7-33 shows two icons being dragged from one window to another, and Figure 7-34 shows the project and process windows after moving three files to the process window.

NOTE

Drag and drop applies to folders as well as to files. When you move a folder, its entire contents, including all subdirectories, move with it.

Figure 7-33 Icons Being Dragged Across Windows

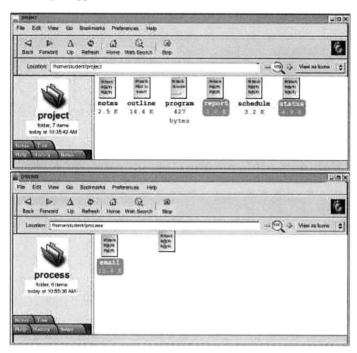

Figure 7-34 Projects and Process After Moving with Drag and Drop

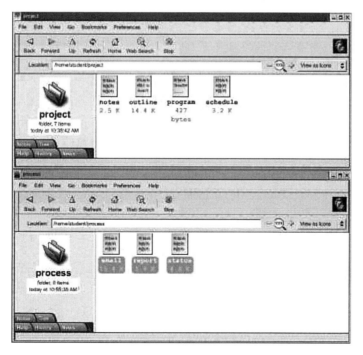

Copying Files Using Drag and Drop

Sometimes, a user wants to make a copy of a file rather than move the original. For example, a user would like to use last week's status report as a model for this week's, keeping the formatting, but changing the content. The technique described for *moving* files is similar for *copying* files. When copying files, the user presses the Control key, marked Ctrl on many keyboards while performing the drag-and-drop operation.

Upon completing the copy, the file's icon shows up in both the original and new locations. These are independent but identical duplicates.

File Menu Options (Rename and Link)

Files and folders can be renamed and linked using selections from the Nautilus menu.

Renaming from the File Menu

The Rename function appears on the File menu only when View as Icons is selected. If you click a single icon, the File menu enables you to select Rename. The file's name beneath the icon turns a different color, with a box around it. Type in the new filename and press **Enter**, or click the mouse elsewhere on the desktop.

Make Link from the File Menu

Symbolic links to files and folders can be created through Nautilus. If the original file is deleted, a *symbolic link* to it remains, but points to nothing. UNIX also makes *hard links*, which are simply new names for the same file. Hard links can be made very simply from a shell. Review Linking Files discussed earlier in this chapter if you are unsure what a link is.

To make a link, highlight a file or folder and choose **Make Link** from the File menu. Nautilus gives the newly created symbolic link the name *link to filename*, where filename is the name of the original. In View as Icons, a small arrow pointing to the upper right attaches itself to the upper right of the icon. In List View mode, the arrow in the emblems column indicates that it is a link. Figure 7-35 shows two windows in the same directory. The first window is shown with View as Icon. The second window is shown with View as List mode selected. In each window a new link to the file named status is seen and highlighted. Notice the small arrow on the upper corner of the icon above and in the Emblems column below. The file can safely be renamed, and the arrow reminds you that it is a link.

Figure 7-35 Link as Seen in List and Icon View

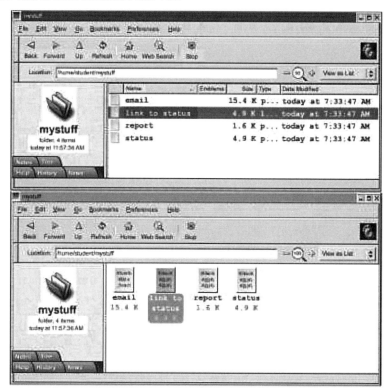

Edit Menu Options: Cut, Copy, and Paste

The Nautilus Edit menu includes functions that work to copy and to move files. The general sequence of operations is first to select a file or folder. Next select **Copy** or **Cut**, move to the target location, and then select **Paste**.

Copying a File from the Edit Menu

To use the Edit menu to copy a file, do the following:

Step 1 Highlight the file's icon by clicking it.

Step 2 Choose **Copy Files** from the Edit menu. The copy is not made yet.

Step 3 Open another Nautilus window viewing the folder where you want to copy the file.

Step 4 In that window, choose **Paste Files**. If you are in a different folder than the original, a copy by the same name as the original is made in that folder.

Step 5 You can also copy within the same folder; in that case the copied file is given the name *copy of filename*, which you should rename.

Figure 7-36 shows two windows, the top in a folder named mystuff and the bottom one in a folder named morestuff. After highlighting email in the first one, the sequence Copy File in the top window followed by Paste Files in the bottom window shows a copy of the file in each window.

Figure 7-36 Copy Made Using the Edit Menu

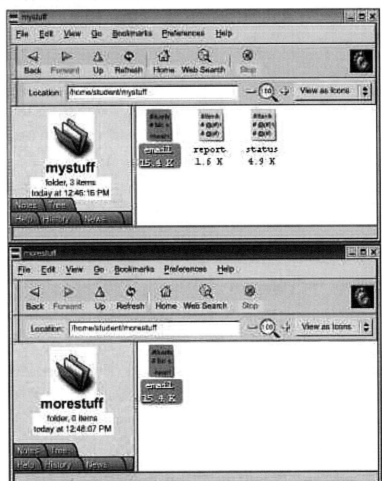

Moving a File Using the Edit Menu

To use the Edit menu to move a file to another folder, do the following:

Step 1 Click the file's icon to highlight it.

Step 2 Choose **Cut Files** from the Edit menu. The file is not yet deleted from the folder.

Step 3 Open another window on the folder where you want to move the file and click in it.

Step 4 In that window, choose **Paste Files**. The icon disappears from the first window and appear in new window, indicating that the file has been relocated.

NOTE

Selecting **Cut File** followed by **Paste Files** in the same folder has no effect.

In Figure 7-37 you can see the result after highlighting the file called Status in the first window, then choosing **Cut File** in the top window, followed by **Paste Files** in the bottom window. The file is no longer seen in the folder mystuff.

Figure 7-37 Move Made Using the Edit Menu

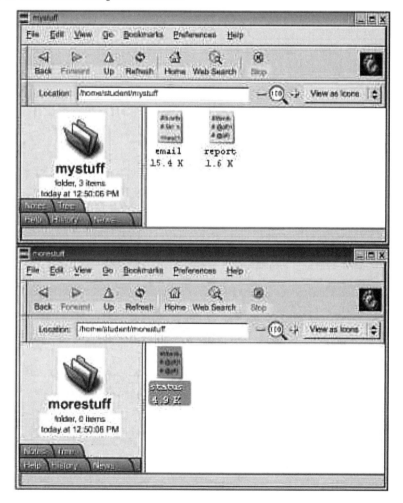

View Menu Options

The Nautilus View menu has several convenience options that enhance your ability to operate using the desktop manager. The most important options are covered below.

Refresh

If the actual contents of a folder appear inconsistent with the view that Nautilus presents, press **Refresh** from the View menu. This causes Nautilus to re-examine the folder and present an updated view. Note that the same thing can be accomplished with the Refresh button on the toolbar.

The component parts of any Nautilus window take up screen space. Sometimes it is desirable to hide away one or more parts. This allows more space for the main panel itself. Select **Hide** from the View menu for any Nautilus feature you want to hide.

Move/Hide/Show Window Components

The following components can be moved or hidden:

- Sidebar
- Toolbar
- Location Bar
- Status Bar

After selecting **Hide** for any of these, the menu changes to say Show instead of Hide. Choosing **Show** causes the relevant component to appear again.

Notice that the Menu Bar, toolbar, and Location Bar all have handles on the left. Grab one of these bars and drag it with the mouse. The bar detaches from the main panel and can be placed anywhere on the desktop. In Figure 7-38 you see a Nautilus window with the Location Bar and toolbar detached and moved below the main panel. The sidebar has been hidden.

Figure 7-38 Detached Nautilus Location Bar and Toolbar, Hidden Side Panel

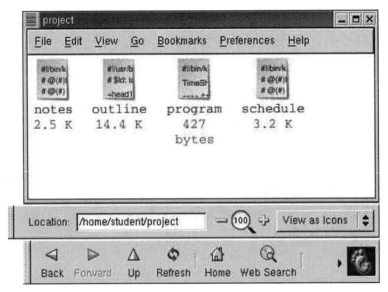

Reset View to Match Preferences

Details of the view mode, including the fonts used, spacing, and sorting order can be set on a per-folder basis. Select **Reset View to Match Preferences** from the View menu to return a folder to the conditions set by Edit Preferences.

Lay Out Items

When View as Icons is set on a folder, it is possible to show the contents of the folder in a variety of ways. Lay Out Items on the File menu leads to a submenu with eight choices. Select **Manually** and you can move icons around within a folder freely, without aligning them. Figure 7-39 shows a folder with its icons rearranged by hand according to a scheme that suits its user. That layout remains in effect every time the user visits the folder until she sets it to something else.

Figure 7-39 Folder with Icons Arranged Manually

The choices that start with *By* are all sort options. **By Name**, **By Size**, **By Type**, **By Modification Date**, and **By Emblems** can be useful in finding items easier in a large directory. For example, you have a folder with more than 100 items in it. You have recently been working on a file with a name that normally would appear far down the list if sorted by name, the default option. Select **By Modification Date** and the most recently modified files appears first.

Selecting **Tighter Layout** from Lay Out Items causes icons to be packed closer together, bringing more of them into view in a given window. Finally, any layout other than manual can be shown in reverse by selecting **Reversed Order**. For example, reversing By Modification Date causes the least recently modified files to appear first.

Clean Up by Name

If a window's icons are scattered in disarray, select **Clean Up by Name** to rearrange them all neatly in a grid of rows and columns, ordered by name.

Zoom Control

The following controls allow viewing a folder:

- Zoom In
- Zoom Out
- Normal Size

A folder can be viewed in a variety of sizes, in either icon or list view mode. Select Zoom In to make the contents larger, and Zoom Out to make them smaller, in a range from 25% to 400% of a standard size. Normal Size is the size that has been selected from Edit Preferences. The normal size can be different for list and icon view modes.

Notice there is also a tool on the Location Bar with a minus on the left, a plus on the right, and a number in the middle, as seen in Figure 7-40. Click the minus and plus symbols to shrink and increase the view size. Click the number to return to normal size.

Figure 7-40 Notice the Shrink and Grow Gadget in the Location Bar

Finally, the View menu allows the user to toggle between icon and list view modes as follows:

- View as Icons
- View as List
- View as ...

Most users find that it is simpler to use the pull-down menu on the right of the Location Bar to do this.

The View as ... choice is an advanced option. That option allows users to fine-tune what programs handle which file types when selected. Using it properly requires an understanding of MIME file types and a good knowledge of what UNIX programs are available on the user's system to handle various types.

Summary

Now that you have completed this chapter, you should have a firm understanding of the following:

- The command-line interface provides several more advanced file and directory-manipulation commands to enable them to manage the file system.

- Files and directories can be linked with the **ln** command, copied using the **cp** command, and moved and renamed using the **mv** command. When these commands are used with the **-i** or interactive option, the user is prompted before files are overwritten.

- The workstation keyboard is the standard input device and the monitor or screen is the standard output device. UNIX commands can receive input (*stdin*) and produce output (*stdout* and *stderr*). It is common to redirect output from the screen to a file to capture the results of a command such as **ls** or **cat** for future viewing or manipulating. The right angle bracket (>) is used to redirect command output.

- Command piping uses the output of one command as input to the next command. This enables the user to create mini programs or custom commands. The pipe symbol (|) is used to separate commands to accomplish this. File Manager has several advanced capabilities for manipulating files and folders. These include moving by select-drag-drop. Copying by Control-select-drag-drop. The Selected menu allows files and folders to be preselected and then copied, moved, renamed, or put in the Trash Can. File and directory permissions also can be changed using the Properties option from the Selected menu. The File Manager View menu can be used to customize the way File Manager displays files and folders, which includes displaying the file system as a tree.

- The Nautilus file manager that comes with GNOME in the Linux environment also has many of the same capabilities of CDE and, in addition, can act as a web browser.

Check Your Understanding

1. Your current working directory is /home/user2/dir2. You want to copy the notes file from your current directory to the /home/user2/dir3 directory. Which command should you use?

 A. copy notes /dir3

 B. cp notes ../dir3

 C. copy notes ../dir3

 D. cp /notes dir3

2. Your current working directory is /home/user2. You want to copy only the two files fruit and fruit2 to /dir4. Which of the following commands should you use?

 A. cp fruit fruit2 /dir4

 B. cp fruit? /dir4

 C. cp fru* /dir4

 D. cp f??????? /dir4

3. Your current working directory is /home/user2/. You need to copy the directory /home /user2/dir1 to another location as a backup. The new directory will be named dir.bak and will reside in the same directory as dir1. Which command should you use?

 A. cp dir1 dir1.bak

 B. cp dir1 ../dir1.bak

 C. cp -r dir1 dir1.bak

 D. cp -a dir1 dir1.bak

4. Your current working directory is /home/user2/backups/. You need to copy the file backup052402 to the backups directory, but you do not want to overwrite any existing files. Which command should you use?

 A. cp -F backup052402 ../backups

 B. cp -i backup052402 ../backups

 C. cp -r backup052402 ../backups

 D. cp -w backup052402 ../backups

5. To rename a directory you should use the command _____.

6. You can use redirection to send the output of a command to a file instead of the screen. Which command format is valid for output redirection?

 A. command > filename

 B. command < filename

 C. filename > command

 D. command << filename

7. When using the ksh shell, how can you prevent redirection from overwriting existing files?

 A. Use the interactive option

 B. Type the command **set -o noclobber**

 C. Use the right angle bracket

 D. Set overwrite to off

8. You are using the ksh shell with noclobber enabled. You want to send the output of the **ls** command to the file mydir, overwriting it if necessary. Which command should you use?

 A. **ls -a > mydir**

 B. **ls -a >> mydir**

 C. **ls -a 2> mydir**

 D. **ls -a >| mydir**

9. In ksh, which output redirection operator is used to send output to standard error?

 A. **A>**

 B. **B>**

 C. **C2>**

 D. **D>|**

10. The command piping operator is used to send the output of one command as input to another command. Which of the following would display a directory listing one screen at a time?

 A. **ls -l | more**

 B. **ls -l > more**

 C. **ls -l || more**

 D. **ls -l >> more**

11. Which three of the following are valid ways to copy a file in UNIX?

 A. Use the **cp** command from the command line

 B. Use the CDE File Manager Selected menu

 C. Use the **Ctrl-select**, then the drag-drop technique with File Manager

 D. Use the **copy** command

12. In which of the CDE File Manager menus is the tree display option available?

 A. File

 B. Selected

 C. View

 D. Options

UNIX Command Summary

> Redirects standard output. Example:

```
$ ls > myfiles
```

< Redirects standard input. Example:

```
$ mailx dano@buckeye < ski_listing
```

| Takes standard output of one command and passes it as standard input into a following command. Example:

```
$ ls -l | more
```

cp Copies files. Example:

```
-i, -r
```

```
$ cp ~/home/* /tmp
```

```
$ cp -i ~/home/user2/* /bkup
```

```
$ cp -ri ~/home/user2/* /bkup
```

ln Gives a file an additional name so you can access it from more than one directory. Example:

```
$ ln report  /HQ/reports/Jan02report
```

mv Moves files. Example:

```
-I
```

```
$ mv file1 file_april30
```

```
$ mv file1 /home/user2/bkup
```

noclobber Prevents the overwriting of files during redirection. Example:

```
$ set -o noclobber
```

```
$ cat fruit > fruit2
/bin/ksh: fruit2: file already exists
```

volcheck Volume check. Instructs Solaris to check the floppy drive, determine the disk type (UNIX or PC), and temporarily places ("mounts") the floppy disk under the /floppy directory of the hard drive.

Key Terms

drag and drop Process of copy and move files by moving or pushing around their icons using the mouse.

linking The **ln** (link) command is used to give a file an additional name so that you can access it from more than one directory (in the same or different file system) or by another name in the same directory.

mount point An empty directory in a file hierarchy at which a mounted file system or device (floppy disk, CD-ROM, and such) is attached.

overwrite If a file is copied and the target name already exists, you overwrite or "clobber" the file and will not receive a warning. The **-i** (interactive) option can be used with the **cp** and **mv** commands so that you are warned when a file is about to be overwritten.

piping The process of using the output of one command as input to the next command.

recursive To do repetitively. The **cp -r** (recursive) command can be used to copy a directory and all of its contents to a new directory in the current directory. You *must* use the **-r** option when copying directories.

redirection The process of redirecting the standard output from a command to another location, such as a file. If not redirected, the output normally goes to the screen.

stderr Any output that normally would result from an error in the execution of a command. stnderr normally goes to the screen.

stdin (standard input) Usually provided by the computer's keyboard, but can come from a file.

stdout (standard output) The results of issuing a command. stndout usually goes to the computer screen or monitor.

Objectives

After reading this chapter, you will be able to

- Describe hard disks, partitions, and file systems as they relate to Solaris and Linux.
- Display file system utilization and free space.
- Locate files and directories using the **find** command.
- Use the **grep**, **egrep**, and **fgrep** commands to find character strings within files and command output.
- Use **sed** to search and edit text in a file without using a text editor.
- Sort the contents of files and command output using the **sort** command.
- Find files using graphical tools.

Chapter 8

File Systems and File Utilities

Introduction

This chapter covers hard drive technology, partitions, and *file systems* in more detail than in previous chapters. In addition you use several file utility commands used for locating, searching, modifying, and sorting files in the file system. You use the **find** utility to locate files and directories on a hard drive. The **grep**, **egrep**, **fgrep**, and **sed** utilities are used to search for strings of characters within files. The **sort** utility is used to sort file contents and command output. Various graphical search tools that are available with CDE and GNOME are also covered.

Disk Technology Overview

A hard drive is the main permanent storage device for a computer. A drive consists of multiple platters. The platters are a rigid material with a magnetic coating that also accounts for the name "hard" drive. The platters are stacked on a common spindle that spins at various speeds. A series of read/write heads, one for each side of a platter, travels across the disk surfaces as a single unit, as shown in Figure 8-1.

Figure 8-1 Hard Disk Components

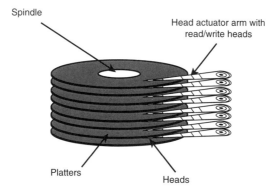

Drives are assembled in a special room, where the environment is managed to allow the hard drive to be vacuum sealed to protect it from contamination. After the drive is assembled, the platter surfaces are quality checked for defects and are formatted with concentric tracks. Each track is then segmented into sectors. A sector is defined as 512 bytes or 1 block in size.

The two prominent drive types at this time are IDE/EIDE (Intelligent Drive Electronics or Enhanced IDE) and *SCSI (Small Computer Systems Interface)*. With IDE drives, all drive activity is CPU dependent and supports only two devices. The devices are two hard drives, or one hard drive and a CD-ROM drive. EIDE drives improve upon the IDE limitations by increasing speed or transfer rates and offering the capability to support four devices. EIDE is more than adequate for most desktop systems. However, for high-performance workstations and servers requiring support for more than four devices, EIDE does not provide the best solution.

The big advantages of SCSI are device independence and fast data transfer rates. Interfaces earlier than SCSI were not intelligent and were designed for specific devices. These earlier interfaces had a hard disk interface for a hard drive, a tape drive interface for a tape drive, and so on. With SCSI, a standard interface was defined for all devices. Only a single adapter or SCSI host adapter or interface card was required. The other key advantage of SCSI over other disk interface technologies has been its capability to process multiple overlapped commands. This allows SCSI drives to fully overlap their read and write operations with other drives in the system. This also allows different SCSI devices to be processing commands concurrently rather than serially, leading to high data transfer rates. This design is better in a multiprocessing environment such as UNIX.

The current standard, SCSI-3, has data transfer rates up to 40 MBps (megabytes per second) and supports up to 15 devices connected to a single SCSI host adapter. Each device has a unique user selectable identifier or target number referred to as a SCSI ID. The higher the target number, the greater the priority given to the device. Hard drives normally are assigned a lower target number because they are faster than other SCSI devices such as tape drives and CD-ROMs.

Current PCs and UNIX-based workstations and servers can use either EIDE or SCSI drives. EIDE drives are typically less expensive and most often are found in workstations. SCSI drives are more expensive and usually offer higher performance capabilities. For these reasons, SCSI drives are used most often in servers.

Partitions and File Systems

Partitions and file systems are the building blocks of the hard disk. This section defines partitions and files systems and gives examples of each relative to UNIX in general and Solaris and Linux in particular.

Partitions

When the UNIX operating system first was developed, hard disks could store what is now considered a very small amount of data. Disks larger than 300 MB were developed and the operating system could not handle such a large amount of space. This necessitated the ***partitioning*** of the hard drive to allow the kernel to access smaller, addressable parts of the drive. Partitions are contiguous sections of the hard disk that hold data.

Solaris hard drives can be divided into as many as eight partitions or ***slices***. Linux supports a single extended partition that can hold multiple logical partitions. Each partition is treated by the operating system as an independent drive, similar to a drive letter in the PC world or a volume with Novell NetWare. Most hard disks in today's PCs are one physical partition, which is referred to as drive C:.

A PC hard disk also can be divided into smaller partitions. In DOS or Windows this is referred to as drive C:, drive D:, drive E:, and so on. In UNIX, these partitions are also referred to as slices. They are also associated with a directory name, referred to as a ***mount point***. Examples are / (root), /usr, and /home, as shown in Figure 8-2. A UNIX partition or slice is referenced by the OS using a cryptic-looking device filename such as /dev/dsk/c0t3d0s0 for the Solaris system, or /dev/hda1 for the Linux system. The next section describes the output of the **df** command, which can be used to see the partitions defined on a Solaris hard disk.

Figure 8-2 UNIX Partitions on a Hard Drive

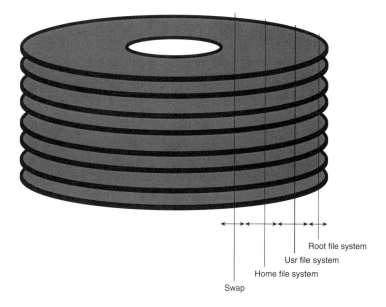

Root file system
Usr file system
Home file system
Swap

Current hard drives can have up to a ***terabyte*** (TB), or more of space on them, and the kernel can access all available space. A terabyte equals a trillion bytes. Despite this, the convention of partitioning a hard drive has persisted for various reasons. Partitioning allows an administrator to functionally organize data so that user files are on a different partition than the operating system, executables, or applications.

File Systems

The term *file system* has two meanings. To the user of the UNIX operating system, a file system is a hierarchy of directories and files. We have been calling this system the "directory tree." To the operating system, a file system is a structure created on a partition consisting of tables defining the locations of directories and files.

A partition does not necessarily have to contain a file system. At least one partition is used as a secondary memory location, the swap partition, and does not have a file system.

Before a disk partition can be used, a file system must be created to provide a structure for organizing and accessing data on the partition.

For example, a Solaris system might be configured to have the partitions and file systems as shown in Table 8-1.

Table 8-1 Solaris Partitions and File Systems

Partition (Slice) No.	File System	Description
0	Root	Contains standard UNIX system files, plus empty directories such as /home and /var that are used as mount points for other system files.
1	Swap	Used for temporary memory storage known as virtual memory. There is no file system created on the swap partition. Swap uses the partition in its "raw" state.
2	Entire Disk	By backing up this partition, you back up all file systems.
3	Usr	Contains many user commands and utilities. Contents change very little, so there is no need to back up frequently.

Table 8-1 Solaris Partitions and File Systems (Continued)

Partition (Slice) No.	File System	Description
4	Home	Contains a user's home directories. Having it as a separate file system allows for easy backup. Often home directories are located on a server and are mounted on /home of a workstation from over the network.
5	Unassigned	
6	Unassigned	
7	Unassigned	

Partitions on BSD systems are labeled using letters *a* to *h* instead of 0 to 7

One of the main advantages to partitioning is the ease with which daily backups can occur. By partitioning a hard drive, daily backups can be done only to those partitions on which the data changes frequently, without having to back up all information on the disk. Partitioning also cuts down on seek time. When the disk is partitioned, a user can specify a file to search for or a directory to change to. The name of the directory gives the kernel information about where the data is stored. This prevents the system from having to seek the information over the entire disk.

Other benefits of partitioning include security and reliability. For increased security, partitions on servers can be shared or not shared to the network with read-only or read/write properties. This means that a system administrator can make partitions unavailable for workstations to access when desired and control the type of access. Partitioning also makes a system more reliable. If a file system is corrupt, repair to the file system can happen while the remaining file systems are still accessible. For example, if the entire drive contains only the root file system and becomes corrupt, users would not be able to access the system while file system repairs were being made. Here are the characteristics and benefits of partitions:

- Subdivides a hard disk
- Functionally organizes data
- Must be mounted (covered in the next section) to be accessible
- Can be mounted with read-only or read/write access
- Facilitates daily backups
- Reduces data access time

- Provides security options
- Improves reliability
- Preserves user data during OS upgrades
- Examples include / (root), /usr, and /home
- Similar to PC drive letters and NetWare volumes

Mounting the File System

After file systems are created on disk partitions, all separate file systems are combined to form a single directory tree. This is accomplished by attaching, or *mounting*, the file system to an empty directory, the mount point, as shown in Figure 8-3. When the system boots, the root file system automatically is mounted by the kernel and contains system files, directories, and mount points for the other file systems. After the root file system is mounted, a file referred to as the mount table is read to determine what additional file systems are to be mounted and at what location or mount point. File systems can be manually mounted and unmounted anytime by the root user.

Figure 8-3 Directory Tree with Mounted File Systems

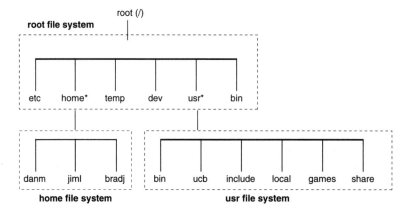

* Indicates an empty directory used as a mount point

The mounting of a file system is what gives the directory the ability to store files. Directories and files on an unmounted file system are inaccessible. The size of the partition when the file system was created determines the capacity.

The partition name and file system name is typically the same as its mount point in the directory structure. For example, /usr is the mount point for the user file system; this is also referred to as the user partition.

File System Statistics

File system statistics can be displayed using the **df** (disk free) command. System V–based systems list disk usage in 512-byte blocks (.5 KB), by default, instead of 1024-byte blocks (1 KB). Use **df -k** on these systems to display usage in kilobytes. Linux systems display the same information as **df -k** using only the **df** command. Usage is shown in 1-KB blocks by default. Figure 8-4 displays the output of the **df -k** command on a Solaris system.

Figure 8-4 Using the **df** (Disk Free) Command with Solaris File Systems

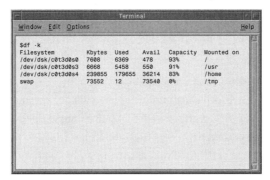

The **Filesystem column** lists the device filename for the file system that is created when the OS is installed or created manually by the system administrator. Each version of UNIX has a slightly different device file-naming convention. The output in Figure 8-4 is from a Solaris system with a SCSI disk and is interpreted as follows:

- **c0 (controller 0)** is the number of the disk controller or interface. 0 is the first controller.
- **t3 (target 3)** is the SCSI target number for the hard drive.
- **d0 (disk 0)** is the number of the disk installed. 0 is the first disk.
- **s0 (slice 0)** is the slice or partition number. 0 is the first slice.

The **Kbytes** column reports the size of the file system in kilobytes.

The **Used** and **Avail** columns report on the number of kilobytes that the file system is currently using and how much space remains available.

The **Capacity** column allows the user to quickly see how full a file system is. Some file systems remain static, so a capacity of more than 90 percent is not unusual.

The **Mounted On** column is the mount point and typically indicates the file system name. The previous output shows that the capacity of the home file system is at 83 percent and has 36 MB (36,214,000 bytes) of available space remaining.

The **df** command shows capacity and availability from a file system level. The **du** command displays disk space used by files and subdirectories and is frequently used by a user. The

du command is similar to the DOS **DIR** command, which shows available disk space at the end of the listing. Output is displayed in 512-byte blocks (.5 K) by default. Use **du -k** to display usage in kilobytes, as in **$du -k** or **$du -k /usr**. The -s displays only the summary.

Linux Partitions

Linux was originally developed primarily for the Intel x86 architecture; therefore, it uses the PC partitioning scheme. Hard drives frequently contain only one partition and therefore only one file system. Current x86 architecture allows dividing the hard drive into four primary partitions or three primary partitions and one extended partition. The extended partition can have multiple logical partitions defined within it. When Linux is installed on other computer architectures such as Sun's SPARC or IBM's RISC, it uses the partitioning native to those architectures.

Linux refers to an x86 partition and associated file system by its device name. Primary partitions 1 through 4 on an EIDE drive are numbered as /dev/hda1 through /dev/hda4. Logical partitions are numbered starting with /dev/hda5. As an example, /dev/hda1 would be the first partition of the master drive on the primary EIDE bus. Partition /dev/hdb2 would be the slave drive on the second EIDE bus. EIDE allows a primary and secondary bus and each can have a master and slave drive. SCSI drives are numbered similarly. As an example, /dev/sda2 would be the second partition on the first SCSI drive of the SCSI host adapter or chain. This partition-naming scheme for EIDE and SCSI drives is summarized in Table 8-2.

Table 8-2 Linux Partition Naming

EIDE Partitions		SCSI Partitions	
Example: /dev/hda1		Example: /dev/sdb2	
Name Element	**Description**	**Name Element**	**Description**
/dev	Device in the /dev directory	/dev	Device in the /dev directory
/hd	EIDE hard drive	/sd	SCSI hard drive
a	Master drive on the primary EIDE bus	b	Second physical SCSI drive in the chain
1	First primary partition on this drive	2	Second partition on this drive

Linux Partition Requirements

Linux must have at least one partition which is the root (/) partition mounted at the root directory. A standard workstation installation of Red Hat Linux creates a root partition, a boot partition, and a swap partition. The root and boot partitions will be formatted for a particular file system

such as ext2 (second extended file system) or ext3 (third extended file system). See the Linux
Filesystems HOWTOs for more information on Linux file system types.

The swap partition is not formatted as a user-accessible partition but instead is used only by the
OS as temporary memory storage. During installation, some administrators choose to divide
the hard drive into multiple logical partitions. The number and function of partitions created
depends on administrative policies and the role the computer plays. Workstations typically have
few partitions, two or three. Servers frequently have a greater number of partitions, three to six
per server. Some of the common Linux partitions are listed in Table 8-3. The partition name and
file system name is typically the same as its mount point in the directory structure. For example,
/usr is the mount point for the user file system; this is also referred to as the user partition.

Table 8-3 Common Linux Partitions and Mount Points

Partition Name and Mount Point	Description
/	Root—includes all other partitions
/boot	Linux kernel and startup files
/home	User's home directories
/mnt	Mount point for devices such as floppy disk drive and CD-ROM
/opt	Third-party programs and data
/swap	Not mounted—Used by operating system for temporary memory storage known as virtual memory
/tmp	Temporary files
/usr	Linux programs and data
/var	Transient system files

Finding Files in the File System

The **find** command is a powerful and useful command available to a UNIX user. This com-
mand can be used to find files based on specific criteria. When a file or group of files matching
a search criterion is found, another command can be executed on the matching files.

The **find** command can be used for many purposes, including deleting, backing up, and printing
files. The **find** command can be used to locate files on the user's local hard drive or on remote
servers. Avoid using the **find** command on remote server file systems. This use might place a
heavy load on the CPU and hard disk of the server, decreasing performance for other users.

When searching for files with the **find** command, start at the lowest point in the directory structure where the files are most likely to be found. The **find** command starts at the point in the directory hierarchy specified and searches all directories and subdirectories below that point. A search of the user's hard drive starting at the root can take a long time. When a file is found, it is listed with the starting directory and any subdirectories below it.

Path Options

The path in the syntax shown in Figure 8-5 indicates the directory where the search begins.

Figure 8-5 find Command Syntax

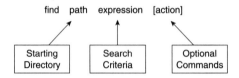

The path can be a tilde (~) representing the user's home directory, a dot (.) representing the current directory, an absolute or relative path name, or even the root directory, as shown in Figure 8-6.

Figure 8-6 Path Options for the **find** Command

Path Entry	Function
~ (tilde)	Start looking in a home directory.
. (dot)	Start looking in current directory.
/etc	Start looking in absolute path name.
dir2/beans	Start looking in relative path name.
/ (root)	Start looking in the root directory.

Search Expression Options

The expression is one or more search criteria options that indicate what to look for. It is specified by one or more values. Basic **find** options include filename, type, and size. If more than one expression is specified, **find** treats the statement as an "and" request. All listed expressions must be verified as true or present. The **-o** (or) option can be used between expressions to allow for and/or type of criteria definition. This means that if any of the expressions are true, the file will be found. Many search expressions require a value to match, and, in some cases, metacharacters or wildcards might be used for the arguments. Examples of search expressions are shown in Figure 8-7. The expressions used with the **find** command evaluate as true or false.

Figure 8-7 Search Expressions for the **find** Command

Search Expressions	Meaning	Definition
-name filename	Filename	Search for all files matching the specified filename, Metacharacters (i.e. * or ?) are acceptable but will be interpreted literally unless placed inside quotes.
-type filetype	Type of file	Search for all files matching the specified filetype (d = directory).
-mtime [+I-]n	Modified time	Search for all files whose modification time either matches, is older than (+), or is newer than (-) n days.
-atime [+I-]n	Access time	Search for all files whose access time either matches, is older than (+), or is newer than (-) n days.
-user loginid -group groupid	User ID and group ID	Search for all files that match the ownership of login ID or group of group ID.
-perm mode	Permissions	Search for all files matching the permission settings indicate (octal notation only).
-size [+I-]n[c]		Search for all files whose size either matches, is larger than (+), or is smaller than (-) n. The n represents 512-byte blocks, or characters (bytes) if followed by a c.

Action Options

The action at the end of the command is optional and can be used to execute various commands after the desired file or files have been found. Figure 8-8 shows examples of actions that can be performed.

NOTE
Some versions of UNIX require the print action to see the output from the **find** command on the screen.

Figure 8-8 Action Options for the **find** Command

-exec command {} \;	The **exec** option must be terminated by { } \;, which allows find to apply the specified command to each file that it identifies from the search criteria.
-ok command {} \;	Interactive form of -**exec**. This option is used with commands that require input from the user; for example, **rm -i**.
-ls	Prints the current path name using the long listing format. This expression is most commonly used in conjunction with a redirection of output to a file in order for the listing to be examined at a later time.

Using the find Command

Figure 8-9 shows several examples using the **find** command. A brief explanation of each example follows:

1. Specifies an absolute path name as a starting point and finds files and directories with a particular name.

2. Specifies an absolute path name as a starting point and finds filenames with a character string in a specific location using a metacharacter or wildcard. The quotes are necessary, or the **find** command will look for an asterisk in the first position.

3. Specifies the home directory (tilde, ~) as a starting point. Finds a particular file by name and performs the action of deleting it.

4. Specifies a relative path name as a starting point. Finds files that have a file type of directory (d).

5. Specifies the current directory (dot, .) as a starting point. Finds files that have a modification date (mtime) of older than X numbers of days.

6. Specifies an absolute path name as a starting point and finds files that are greater than a specified size.

7. Specifies the home directory (tilde, ~) as a starting point. Finds files with a specific permission level (777), is open permissions, and is covered later in the course. Redirects the output to a file for later viewing.

8. Specifies the home directory (~) as a starting point. Finds files that are owned by a particular user and lists them. Redirects listing output to a file for later viewing.

Figure 8-9 Using the **find** Command

```
1. Search for openwin starting at the /usr directory:
   $ find  /usr  -name  openwin
   /usr/openwin
   /usr/openwin/bin/openwin

2. Search for files ending in tif starting at the /usr directory:
   $ find  /usr  -name  '*tif'
   /usr/openwin/demo/kcms/images/tiff/ireland.tif
   /usr/openwin/demo/kcms/images/tiff/new_zealand.tif

3. Search for core files starting at the user's home directory and delete them:
   $ find  ~  -name  core  -exec  rm  {}  \;

4. Look for all files with a type of directory, starting at the current directory:
   $ find  dir3  -type d


5. Look for all files, starting at the current directory, that have not been
   modified in the last 90 days:
   $ find  .  -mtime  +90


6. Find files larger than 400 blocks (512-byte blocks) starting at /etc:
   $ find  /etc  -size  +400


7. Find files with open permissions starting at the user's home directory:
   $ find  ~  -perm  777  >  holes

8. Find files owned by a specific user or group in the current directory hierarchy,
   lists them, and puts the listing in a file:
   $ find  ~  -user  bradj  =ls  >  bradj-userfiles
```

e-Lab Activity 8.1 Finding Files

In this activity, you locate files using the **find** command with several different search expressions. Your current working directory is: /home/user2. Refer to the class file tree structure on the inside-front cover of this book or click the **tree** icon on the CD-ROM e-Lab Activity. Refer to e-Lab Activity 8.1 on the accompanying CD-ROM.

Searching for Text Strings in Files and Command Output

The **grep** (global regular expression print) family of commands— **grep**, **egrep**, and **fgrep**—are used to search for a text string inside the file or in the output of another UNIX command.

The **grep** command finds all occurrences of the text string and display the lines in which they occur.

The **egrep** (extended grep) and **fgrep** (fast grep) commands extend **grep**'s capabilities. Both use most of **grep**'s options, but have their own special features.

grep Command

Use the **grep** command to search a file or the output of a command for a specified text string. A string is one or more characters. The string can be a character, a word, or a sentence. A string can include whitespace or punctuation, if enclosed in quotations. The **grep** command searches a file for a character string and prints all lines that contain that pattern to the screen. The **grep** command frequently is used as a filter with other commands. For instance, you can issue the **ps** (process status) command and "grep" for all occurrences of a specific process. The **grep** command is case sensitive. You must match the pattern with respect to uppercase and lowercase letters, unless the **-i** option is used. The **-i** option ignores the case. The **-v** option searches for all lines that do not match the string specified.

Figure 8-10 shows the basic format of the **grep** command. Figure 8-11 shows examples of how to search lines in a file or standard output.

Figure 8-10 grep Command

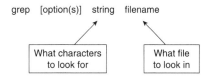

Figure 8-11 Using the **grep** Command

```
$ grep root /etc/passwd
root:x:0:1:Super-User:/:/sbin/sh

$ grep Raphael ./* (or just * if the shell is set
up to look in your current directory)
./dante: Dante Alieghieri like Raphael ...
./dante: one Raphael, one Michelangelo ...

$ ls -la ¦ grep -i 'jun 11'
drwzr-zr-z  3  user1  staff  512  Jun  11  13:13  dir4
```

Note: If the date is a single numeral date,
the grep string needs to have two spaces between
the month and the numeral; for example, Jun 3

TIP

It is useful to display the line number containing the text string that is being searched for. For example, use **grep** with the **-n** option to print the line number or numbers containing the text string. Then go into a text editor that supports line numbers, such as vi, and quickly go to the line and edit it.

In addition to searching for simple text strings, **grep** can be used to search for regular expressions. Regular expressions are special metacharacters and wildcards that help search for different parts of files, such as the beginning or end of a line. Examples of some regular expressions are shown in Figure 8-12.

Figure 8-12 Common Regular Expressions Used with the **grep** Command

Regular Expression	Function	Example	Result
. (dot)	Matches and character and can be used multiple times. Similar to using the **?** with the **ls** command.	**grep 'chap..' file**	Displays all lines containing chap followed by two characters.
* (asterisk)	Matches zero or more characters in the pattern.	**grep 'chap*' file**	Displays all lines containing chap followed by any number of characters.
\ (back slash)	Tells the shell to treat the special character after \ literally.	**grep dollar* file**	Displays all lines containing dollar*. The backslash tells the shell to literally look for a * instead of treating it like a wildcard.
^ (caret)	Match all lines beginning (^) with the pattern.	**grep '^Name' file**	Displays all lines containing Name at the beginning of a line.
$	Match all lines ending ($) with the pattern.	**grep '$800' file**	Displays all lies containing 800 at the end of a line.
[]	Matches one character in the pattern.	**grep 'chapters [1-5]' file**	Displays all lines containing chapters one thru five.
[^]	Matches one character not in the pattern.	**grep 'chapters [^1-3]'**	Displays lines not containing chap followed by a one, two, or three.

Note: Regular expressions (RE) are interpreted by the command and not by the shell. Quoting is not always necessary but ensures that the shell doesn't try to interpret and produce a different result.

 e-Lab Activity 8.2 Using the **grep** Command

In this activity, you use the **grep** command by itself to search files for a string. You then use it in a pipeline with **ls -l** command to find specific strings in the output. Your current working directory is: /home/user2. See the class file tree structure on the inside-front cover of this book or click the **tree** button on the CD-ROM e-Lab Activity. Refer to e-Lab Activity 8.2 on the accompanying CD-ROM.

egrep and fgrep Commands

Two commands, **egrep** and **fgrep**, have been added to compliment the basic **grep** command and perform enhanced searches.

egrep Command

The **egrep** (extended grep) command searches the contents of one or more files for a regular expression using extended regular expression metacharacters in addition to those used by **grep**. Table 8-4 lists the new regular expression metacharacters that you can use with **egrep**.

Table 8-4 Additional Regular Expression Metacharacters Used with **egrep**

Metacharacter	Function	Example	Result
+	Matches one or more occurrences of the previous character	**egrep '[a-z]+ing' file**	Displays all lines having one or more letters followed by "ing." Examples: ring, learning, computing, and so on.
?	Matches zero or one occurrence of the previous character	**egrep 'bel?ville' file**	Displays all lines containing "belville" or "bellville."
x\|y	Matches either x or y	**egrep '64\|128' file**	Displays all lines containing either 64 or 128.
(\|)	Matches multiple patterns	**egrep '(computer\|ing)' file**	Displays all lines containing either "computer" or "computing."

fgrep Command

The **fgrep** (fast grep) command differs from **grep** and **egrep** in that it does not accept a regular expression metacharacter as input. It recognizes only the literal meaning of these characters.

The **fgrep** command treats a $ as a dollar sign and a ^ as a caret. Metacharacters have no special meaning.

The **fgrep** command searches for literal strings only. Therefore, it is considerably faster than **grep**. Use **fgrep** instead of **grep** to search for a simple literal string in a file or a string that includes a metacharacter symbol. For example:

```
$fgrep '*' /etc/system
```

searches all lines in the /etc/system file and finds those containing the "*" string.

File Editing with sed

Another pattern matching utility with effective processing capabilities is **sed** (stream editor). The **sed** utility reads lines of a text file, one by one. It applies a set of editing commands to the lines without opening the file in a text editor like vi. Like **grep**, **sed** makes no changes to the original file and sends the results to standard output. In order to make the changes permanent, the user must redirect the output to a file. Similar to the **grep** command, **sed** uses a number of special metacharacters to control pattern searching. Figure 8-13 shows the basic format of the **sed** command.

Figure 8-13 sed Command

```
sed [option(s)]  [address]  filename  [>newfile] or
Command  |  sed [option(s)]  [address]
```

Suppressing the Default Output

By default **sed** always displays each line of input to the screen whether or not it gets changed. However, it is possible to display only a specific range of lines from a file. The **-n** option tells **sed** that the user does not want to print any lines unless directly told to do so. This is done with the **p** command. By specifying a line number or range of line numbers, the user can use **sed** to selectively print lines of text. The following example shows how **sed** prints all lines to standard output by default, duplicating lines containing the Dante pattern in addition to all other lines in a file:

```
sed '/Dante/p' dante
```

To suppress this default action, use the **-n** option with the **p** command. For example:

```
sed -n '/Dante/p' dante
```

This displays only lines containing Dante.

sed is a very powerful and flexible command when used from the command line and in shell scripts to modify files or user input to a script. See Chapter 15, "Introduction to Shell Scripts."

Table 8-5 shows more examples of **sed** command lines using regular expressions introduced with the **grep** command.

Table 8-5 Using the **sed** Command

Example	Result
sed -n '20,25' file	Displays only lines 20 through 25.
sed '5d' file	Deletes line 5.
ls -l \| sed '/ [Tt]est/d' > newfile	Deletes all lines containing "Test" or "test" in the **ls -l** output, placing the results in newfile.
sed 's/....//' file	Deletes the first four (....) characters from each line.
sed 's/....$//' file	Deletes the last four (....) characters from each line.
ls -l \| sed '5,$d' > newfile	Deletes lines 5 to the last line in the **ls -l** output, placing the results in newfile.
sed -n '/^$/d' file > newfile	Deletes blank lines from file placing the results in newfile.
ls -l \| sed 's/ */:/g'	Searches (**s**) for at least one or more spaces and globally (**g**) replaces them with a colon (:). Note: without the **g**.
sed '1,10s/Windows/UNIX/g' file	Search (**s**) for "Windows" and globally (**g**) replace all occurrences of Windows on every line wherever it appears in the first 10 (**1,10**) lines.
ls -l \|sed 's/$/EOL/'	Appends EOL at the end of every line.
sed 's/^/ /' file	Searches for the beginning of each line (^) of the file and adds spaces.
sed -e 's/Dante/DANTE/g' -e 's/poet /POET/g' dante >newdante	Performs two edits on the same command line and places the results in the newdante file.

Sorting Files and Command Output

The **sort** command provides a quick and easy way for operators to organize data in either numeric or alphabetic order. This command uses the ASCII character set as its sorting order. The **sort** command works from left to right on a character-by-character basis. By default,

sort relies on whitespace to delimit the various fields within the data of a file. Some **sort** features include the following:

- Performing multilevel sorting
- Performing field-specific sorting
- Accepting standard input
- Producing standard output

The following shows the syntax for the **sort** command:

```
sort [options] [input_filename]
```

Figure 8-14 shows the various options available with the **sort** command. These enable the operator to define the type of sort to perform, as well as the field on which to begin sorting. Figure 8-15 shows basic examples using the **sort** command with a simple format. The **cat** command displays the unsorted contents of fileA. The first **sort** command produces an ASCII type of sort, beginning with the first character of each line. The second **sort** example is a numeric sort on the second field. The **sort** command skips one separator with the **+1** syntax. An alternative to the **+x** syntax is the **-k** option which sorts on key fields starting with the first field number 1. Using the **sort** command with the **-k 2 file** would sort the file on the second field or column and is the same as **sort +1 file**.

Figure 8-14 sort Command Options

Option	Description
-n	Allow for a numeric sort. The n can be used alone with a dash or can follow a field reference.
(+l-)n	Begin (+) or end (-) the sort with the field following the nth separator. The default separator is whitespace.
-r	Reverse the order of the sort. The r can be used alone with a dash or can follow a field reference.
-f	Fold uppercase and lowercase characters together (ignore case in sort order).
+nM	Sort the first three characters of the field as abbreviated month names.
-d	Use dictionary order. Only letters, digits, and whitespace are compared; all other symbols are ignored.
-o *filename*	Place any output into the file filename.
-k	Sorts on key fields starting with the first field number 1.

Figure 8-15 Using the Basic **sort** Command

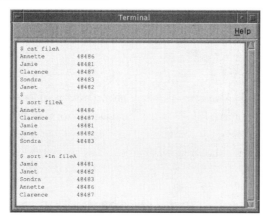

Figure 8-16 shows some more advanced options sorting on different fields within a file. The first example represents beginning a sort on another field other than the first and shows a numeric, reverse order example. The **sort** command line would read as, "Do a reverse order, numeric sort on the fifth field of the data in the file list, and place the output into a file called num.list."

Figure 8-16 Sorting on Different Fields Within a File

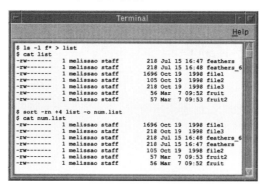

The second example represents a multilevel sort showing how the **M** option would work. This command would read as, "Do a month order sort beginning with the sixth field. Do a second level sort in numeric order, begin on the seventh field to sort the numeric day of the month correctly, and name the output file update.list."

e-Lab Activity 8.3 Using the **sort** Command

In this activity, you use the **sort** command with various options to sort the contents of a file. The file you are working with is named projects and is in the current directory. The contents of the file are: Project Name, Project Manager, and the Estimated Year of Completion. You also sort the output of the **ls -l** command using sort. Refer to e-Lab Activity 8.3 on the accompanying CD-ROM.

Finding Files Using Graphical Tools

The graphical desktops available with UNIX, such as CDE, GNOME, and KDE all provide good basic search capabilities.

CDE File Manager

The Find option on the File Manager File menu provides tools to locate files and directories based on various search criteria. File Manager Find can perform many of the functions of the **find** command as well as the **grep** command. The criteria can be either the name of a folder or file or, in the case of a file, the contents. Figure 8-17 shows the Find window.

Figure 8-17 Finding Files with CDE File Manager

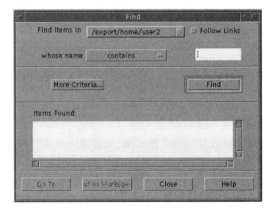

The Find Items In button displays a pull-down menu that allows you to select from various options, including the following:

- My Home Directory
- Floppy
- CD-ROM
- Other Host
- Other Folder

The Whose Name button allows you to select from three options:

- Contains
- Does Not Contain
- Equal To

The button labeled More Criteria gives you the option of finding files by the following criteria:

- Name, by default
- Content

- Size
- Date modified
- Owner
- Type
- Permissions

Wildcard characters can be used when specifying the name of the file to find. Some examples are shown in Figure 8-18.

NOTE

If you start in the root of the file system (the / directory), the find operation might take a considerable amount of time to complete.

Figure 8-18 Using Wildcards to Find Files with File Manager

Wildcard Example	Function
A*	Finds folder or filenames that start with an uppercase letter A.
s*	Finds folder or filenames that start with a lowercase letter s.
??a	Finds three-character folder or filenames where the last character in the name is a lowercase letter a.
[Aa]*	Finds folder or filenames that start with the letter a (either uppercase or lowercase).

Finding Files Using GNOME and KDE

GNOME also provides a way to locate files using Search Tool. Note the process of performing search functions described here may vary depending on the version of GNOME and Nautilus you use. Comparable functions, however, should be available and might be on a different menu.

Selecting the **Programs** and then the **Utilities** menu as shown in Figure 8-19 accesses the Search Tool.

Figure 8-19 GNOME Menus to Access Search Tool

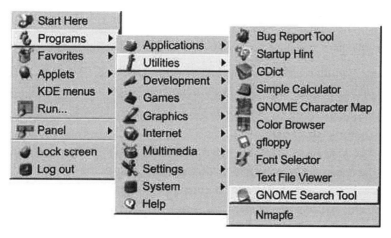

The GNOME Search Tool provides two options: Full find (full) and Quick find (locate). Either of these options can be chosen using the tabs on Search Tools initial screen.

Search Tool—Quick Find (Locate)

Click the **Quick find (locate)** tab as shown in Figure 8-20 to access the Quick find option. Using Quick find is faster than using Full find. Quick find searches only a special database of filenames instead of looking over the entire disk. Quick find is a GUI interface to the UNIX **locate** command. Quick find is not as flexible as the Full find option, because the search can only be done by filename. The database of files is usually updated on a regular basis but you might be searching for a file that was not included in the last update. A user with root privileges must run the command **updatedb** to update the locate database.

Figure 8-20 Quick Find (Locate) Option

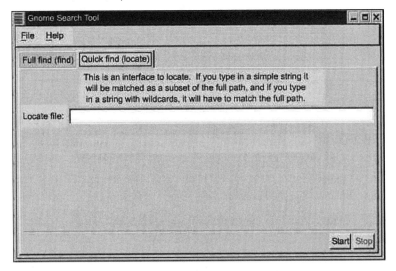

By entering a filename or string in the Locate field to find a file, you find all the files that contain the string in their full path name. The search can also be limited to a particular directory by specifying the path. It is important to remember that UNIX filenames are case sensitive.

The quick search mode is actually a front end to **locate** command. If you need more detailed information on **locate**, read the appropriate manual (man) page.

Search Tool—Full Find

The Search Tool window defaults to the Full find tab. This allows you to specify additional criteria for a more advanced search. Full find can perform many of the functions of the **find** command as well as the **grep** command. The criteria can be either the name of a folder or file or, in the case of a file, the contents. Wildcard characters can be used when specifying the name of

the file to find. Clicking the **double-arrow button** next to the **Add** button displays a menu of criteria that can be used to search for files and directories. Figure 8-21 shows a search for all files ending with doc that were created or modified in the last 14 days and that contain the string "Linux" within the file. Each criterion can be enabled or disabled by using the **Enable** check box. The **Remove** button allows the user to remove a criterion. The following is a list of the most commonly used search criteria that can be used to find files on a system. Additional information on these and more advanced criteria can be found using the Search Tool Help facility.

- **Filename**—Matches a string in the filename
- **Don't search subdirectories**—Limits the search to the current directory
- **File owner**—Looks for files based on the owner
- **File owner group**—Looks for files based on the primary group
- **Last modification time**—Finds files modified within the last # of days
- **Don't search mounted file systems**—Avoids the search of floppies, CD-ROMs, and so on
- **Filenames except**—Finds all filenames not matching the substring
- **Simple substring search**—Matches all files that contain a substring
- **Regular expression search**—Matches all files that contain given regular expression

> **NOTE**
>
> If the search is started in the root of the file system (the / directory), the find operation might take a considerable amount of time to complete.

Figure 8-21 Full Find Option

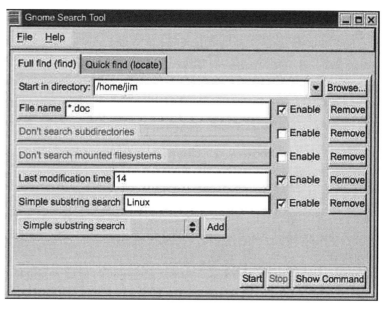

KDE—Find Files

Many KDE menu items are available from the GNOME main menu, including the Find Files utility. To access this utility click **KDE menus** and select **Find Files**. Similar options and

criteria are available to those of the GNOME Search Tool Full find option. Figure 8.22 shows the KDE Find Files Window.

Figure 8-22 KDE Find Files

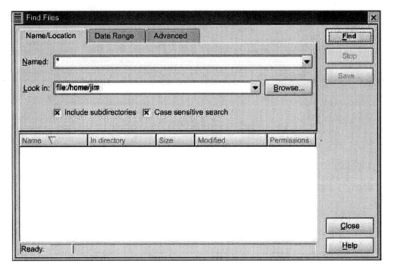

 Lab Activity 8.5.2 Finding, Searching, and Sorting Files

In this lab, you use advanced UNIX commands to find files and specific strings contained in files. You will practice using the **sort** command with various options. CDE File Manager also is used to locate files based on filename or file contents. Refer to Lab 8.5.2 in the *Cisco Networking Academy Program Fundamentals of UNIX Lab Companion*, Second Edition.

Summary

Now that you have completed this chapter, you should have an understanding of the following:

- Hard drives consist of a multiple platters stacked on a common spindle that spins at various speeds.
- UNIX hard drives are divided into any number of sections, called partitions or slices, with a file system to provide a structure for organizing and accessing data on the partition.
- At boot time, all file systems are combined to form a single directory tree file structure by mounting file systems to an empty directory called a mount point.
- To display the amount of available space on a file system, use the disk free (**df**) command.

- The **find** command can be used to find files and folders on the user's local computer or on a remote computer such as a server.

- The **grep**, **egrep**, and **fgrep** commands are used to search for strings of characters inside files or from the output of other commands, such as **ls** and **ps**, when used with the pipe (|).

- **fgrep** (fast grep) is a faster version of grep that does not interpret metacharacters. The extended version of **grep**, **egrep**, interprets metacharacters like **grep** and also interprets additional metacharacters.

- The CDE File Manager, the GNOME Search Tool, and KDE Find Files can perform some of the functions of the **find** command and the **grep** command using a graphical user interface.

- The **sed** (stream editor) command can be used to search for strings and perform processing actions on files.

- The contents of files and the output of commands can be sequenced using the **sort** command. The **sort** command has a number of options, including what field to start sorting, numeric or alphabetic sort, and reverse sorts.

Check Your Understanding

1. The two most prominent hard drive types today are _____ and _____.

2. Hard drives can be divided into smaller, addressable parts. Each one of these parts is called a _____.

3. Which UNIX partition contains standard UNIX system files and mount points?

 A. Swap

 B. Root

 C. Usr

 D. Home

4. Attaching a file system to an empty directory in the main file system is called _____.

5. Which two of the following commands display file system statistics?

 A. ds

 B. df

 C. dd

 D. dv

 E. du

6. Match each Linux mount point or directory with its description.

Mount Point	Description
/boot	1. Linux programs and data
/home	2. Third-party programs and data
/usr	3. Default for floppy and CD-ROM
/opt	4. Linux kernel and startup files
/mnt	5. User's home directories

7. Your current directory is /home/user2. You need to find all files that start with the letters *pr* in your /home/user2/projects subdirectory. Which command should you type?

 A. **find projects -name 'pr*'**

 B. **locate pr* in projects**

 C. **find pr* -name projects**

 D. **search projects -name pr***

8. Your current directory is /etc. You are looking for a text file in your home directory that contains the word "resume," but you don't remember the name of the file. Which command will find it for you?

 A. **grep home "resume"**

 B. **grep resume /***

 C. **grep resume ~/***

 D. **grep ./* resume**

9. Which command would display a listing of all files in the current directory owned by bsmith?

 A. **grep bsmith ./***

 B. **ls bsmith***

 C. **ls -al | grep bsmith**

 D. **grep bsmith | ls -al**

10. What command would locate all lines that have at least one (a–z) character on the line in the orderlist file?

 A. **grep '[a-z]+' orderlist**

 B. **egrep '[a-z]+' orderlist**

 C. **fgrep '[a-z]+' orderlist**

 D. **xgrep '[a-z]+' orderlist**

11. What does **sed 's/pc/workstation/g' chapter1** accomplish?

12. Which command displays a directory listing sorted from largest to smallest?

 A. **ls -l | sort +4nr**

 B. **sort +4nr | ls**

 C. **ls +4nr | sort**

 D. **ls -a | sort +4nr**

13. In the CDE File Manager, the File menu Find option allows you to search for files by filename as well as by the contents of the file. _____ (True or false.)

14. Which three of the following utilities can perform the functions of both **find** and **grep**?

 A. CDE File Manager Find

 B. GNOME Search Tool – Quick find

 C. GNOME Search Tool – Full find

 D. KDE Find Files

 E. CDE Fgrep Tool

UNIX Command Summary

df Displays the amount of disk space occupied by mounted or unmounted file systems, directories, or resources; the amount of available space; and how much of a file system's total capacity has been used. Example:

```
-k
```

```
$ df -k
```

du Reports the number of 512-byte blocks contained in all files and (recursively) directories within each directory and file specified. Example:

```
-k
```

```
$ du -k
```

egrep Searches the contents of one or more files for a regular expression using extended regular expression metacharacters in addition to those used by grep. Example:

```
egrep '[a-z]+ing' file
```

fgrep Differs from **grep** and **egrep** in that it will not accept a regular expression meta-character as input. It recognizes only the literal meaning of these characters. Example:

```
$ fgrep '*' /etc/system
```

find Recursively descends the directory hierarchy for each path, seeking files that match a Boolean expression. Example:

```
-o
$ find /home/user2 -name 'dir*'
/home/user2/dir2
/home/user2/dir3
```

grep Searches a file for a pattern. Example:

```
-I
```

```
$ grep banana ./*
/home/user2/fruit: banana
/home/user2/fruit.tar:banana
/home/user2/fruit2: banana
/home/user2/fruit2.tar:banana
```

sed Provides many of the editing capabilities of a text editor but via commands that can be entered at the command prompt or entered in a script. Example:

```
$ sed '5d' file
```

```
$ ls -l | sed '5,$d' > newfile
```

sort Sorts lines of all the named files together and writes the result on the standard output. Example:

```
$ sort file1
$ sort +1n file2
```

Key Terms

file system To a user, a file system is a hierarchy of directories and files also referred to as the directory tree. To the operating system, a file system is a structure created on a partition consisting of tables defining the locations of directories and files.

IDE/EIDE (Intelligent Drive Electronics or Enhanced IDE) One of the two prominent drives types today. Used primarily in standard workstations and home computers. EIDE can support up to four devices (hard disk drives or CD-ROMs).

logical device name Used by system administrators or users to access the disk (partitions) and tape devices for such tasks as mounting and backing up file systems. Logical device names are stored in the /dev/ directory in subdirectories. All logical device names are symbolic links to the physical device names in the /devices directory.

mounting The manual or automatic process of attaching a file system or device (floppy disk, CD-ROM, and such) to a mount point so that it can be accessed.

mount point An empty directory in a file hierarchy at which a mounted file system is logically attached. The **mount** command logically attaches a file system, either local or remote, to the file system hierarchy.

partition A smaller division or portion of a hard drive. UNIX hard drives can be divided into as many as eight partitions or "slices." Each partition is treated by the operating system as a logical, independent drive, similar to a drive letter in the PC world or a volume with Novell NetWare.

SCSI (Small Computer Systems Interface) One of the two prominent drives types today. Used primarily in high-end workstations and servers. Can support up to 15 devices (hard disk drives, CD-ROMs, and tape drives).

slice A logical subdivision of a physical disk drive. It is treated as an individual device.

string One or more characters. It can be a character (alphabetic or numeric), a word, or a sentence. A string can include whitespace or punctuation if enclosed in quotations.

terabyte Approximately one trillion bytes or a billion kilobytes.

Objectives

After reading this chapter, you will be able to

- Use the vi text editor to create and modify text files.
- Use the Emacs editor.
- Use the CDE Text Editor application to create and edit text files.
- Use the GNOME gedit application to create and edit text files.

Using Text Editors

Introduction

This chapter covers text-editing tools that are used in the UNIX and Linux environments. These include the *vi* (pronounced "vee eye") and vi improved (vim) editors, the Emacs (pronounced EE-maks) editor, and graphical text editors such as CDE Text Editor and GNOME's gedit. In this course, text editors primarily are used for creating and modifying files that customize the user's work environment and writing shell scripts to automate tasks. Both of these will be discussed in Chapter 14, "Shell Features and Environment Customization," and Chapter 15, "Introduction to Shell Scripts." They are also commonly used for editing HTML website files and creating code for computer programs. System administrators use text editors to create and modify system files used for networking, security, application sharing, and so on. Finally, this chapter includes a short discussion about UNIX word processor programs.

vi Editor

The vi editor has been a part of the UNIX operating system nearly since its inception in the early 1970s. The vi editor is universally available with all UNIX systems. It is a very small and powerful editor with many options and was originally designed to edit text files on a remote system over a slow dial-up connection. vi is small enough to fit on an emergency boot floppy. This can be helpful when troubleshooting.

vi is an interactive editor that is used to create or modify American Code for Information Interchange (ASCII) text files. ASCII text files contain only text characters without any formatting such as bold or italic. It is a character-based editor that is an integral part of all UNIX operating systems. The vi editor uses a full-screen display, but the user cannot use the mouse to position the cursor. All editing with the vi editor is done within a memory buffer. Changes can be written to the disk or can be discarded.

For users learning to become system administrators, it is important to know how to use vi. It is sometimes the only full-screen editor available to edit crucial system files. Examples of these include scripts and shell environment control files. The vi editor does not impart any special formatting characters. Therefore, it can be used to create programs for various programming

languages. Skill in using vi also is needed if the windowing system is not available. The vi editor is a useful tool when working remotely on other UNIX workstations or servers. Administrators routinely remotely log in or Telnet to another UNIX computer to perform maintenance and troubleshooting tasks using vi. The availability and operation of vi is consistent across all UNIX platforms including Solaris and Linux; therefore, it is a tool that will always be available.

Another reason to learn vi is that both the Korn and "Bourne-again shell" (Bash) shells enable the user to use vi as a command-line editor. This allows the user to bring up previously entered commands and modify them. See the section "Command-Line Editing" in Chapter 14 for details.

vi Modes

The three modes of operation in vi are command, entry/input, and last line. Understanding the function of these three modes is the key to working with vi. All commands available with vi can be classified in one of the three modes. Figure 9-1 lists the modes and gives a brief description of each. Figure 9-2 shows how to switch modes and get from one mode to another.

Figure 9-1 Mode Characteristics in vi

Mode	Function/Characteristics
Command mode	Initial default mode for creating and editing files, cursor positioning, and modification of existing text. All commands are initiated from this mode. Pressing Esc from either of the other modes returns you to command mode.
Entry/Input mode	Used for entry of new text. Entering an insert command such **i** (insert), **a** (append), and **o** (open new line) takes you from command mode to entry mode. Pressing Esc returns you to command mode. Entry commands are entered by themselves without pressing the Enter key.
Last-line mode	Used for saving your work and quitting vi. Type a colon (:) to get to this mode. Pressing the Enter key returns you to command mode.

Figure 9-2 Moving Between vi Modes

From Mode	To Mode	Command/Keys
Command	Entry	**i** (input), **o** (open new line), **a** (append to existing line).
Entry	Command	Press Esc (Escape).
Command	Last-line	Colon (:).
Last-line	Command	Press Enter.
Entry	Last-line	Press Esc to return to Command mode, and then enter a colon.
Last-line	Entry	Press Enter or Esc to return to command mode, and then enter an insert command.

Command Mode

When the vi editor is started, you are in command mode. You can enter cursor-positioning commands to move around the file, and editing commands to perform functions and modifications of existing text. Command mode is the starting point for the other modes. You can change to entry mode or last-line mode from here. To move from entry mode to last-line mode or vice versa, you first must switch back to command mode. Figures 9-3 and 9-4 show the commands necessary to move from command mode to entry mode and then back to command mode. Figures 9-5 and 9-6 show the commands necessary to move from command mode to last-line mode and then back to command mode.

Figure 9-3 Moving from Command Mode to Entry Mode

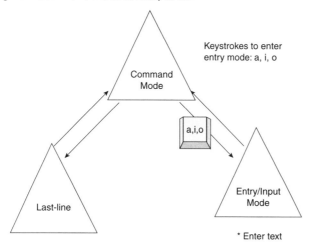

Figure 9-4 Moving from Entry Mode to Command Mode

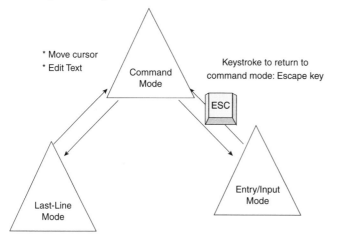

Figure 9-5 Moving from Command Mode to Last-Line Mode

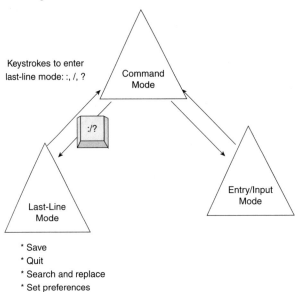

Figure 9-6 Moving from Last-Line Mode to Command Mode

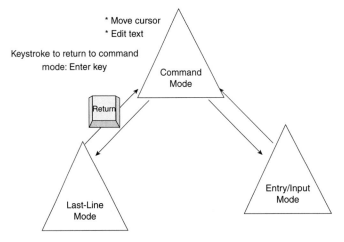

The Escape (Esc) key always puts you in command mode. Use the Escape key if you are unsure of the mode. Press Esc to return to command mode before issuing any other commands. While in command mode, you can move the cursor around the text on the screen and perform advanced editing commands.

Entry/Input Mode

You must be in entry mode, also known as input, insert, or edit mode to enter text. To enter text, type a vi command such as **i** (insert), **o** (open new line), or **a** (append). This takes vi out of

command mode and puts it into entry mode. In this mode, text will not be interpreted as editing commands. When you finish entering text in the file, press the Esc key to return to command mode.

Last-Line Mode

From command mode, type a colon (:) or another designated character to enter into last-line mode. This places the cursor at the bottom line of the screen. From last-line mode, you can enter commands to save work periodically while remaining in vi, or you can save and quit vi. You also can quit vi without saving the changes. Last-line mode is also used to search for characters or words and to set vi editor preferences. Last-line mode is also referred to as ex mode, pronounced "EE x," and is explained in more detail later in this chapter.

Opening Files with vi

The vi editor is a UNIX text-editing application that is started from the command-line prompt. Whenever you start vi, a file is opened. You can specify the name of the file that is to be created or edited when starting vi. You can also open a new file to be named later. The following shows the basic syntax of the vi command:

vi [*option(s)*] [*filename*]

The basic and common steps when using vi are, in this order:

1. Open a new empty or existing file.
2. Input some text or modifying existing text.
3. Save it to disk.
4. Exit vi.

Methods of Invoking

The vi editor can be invoked or started in one of two ways: using the **vi** command or the **vedit** command, which is used only with Solaris. **vedit** is a slightly modified version of vi that visually indicates the current entry mode command you are using. Many distributions of Linux come with vim (vi improved). This is actually run when vi is started:

- **vi** *filename* specifies the filename at the time vi is started. If the file exists, it is opened for editing. If the file does not exist, it is created. When you issue the **write** command in last-line mode, this file is updated.
- **vedit** is available only with Solaris. vedit starts the vi editor with show mode turned on. Show mode displays the entry or input command the user is currently using in the lower-right corner of the screen, whether it is insert, append, or open. If you are in command

mode, nothing is displayed. If you are in last-line mode, the cursor usually is in the lower-left corner with a colon displayed. You also can enable show mode after starting vi by entering **set showmode** at the colon in last-line mode. Use vedit when possible to show what mode the user is currently in. Linux vim has show mode enabled by default. Figure 9-7 shows examples of opening files using both vi and vedit.

■ **view** *filename* will start vi and open *filename* as read only. Changes can be made but they must be saved to a different filename.

Figure 9-7 Opening Files with **vi** and **vedit**

Command	Function
vi *filename*	Opens or creates a file.
vedit *filename*	Opens or creates a file with set show mode automatically enabled. (Solaris only.)

Input Commands (Entry Mode)

After starting vi and specifying a file to work with, you most often will use one of the input commands to add text to the file. These commands are entered from command mode and switch vi into entry mode. To use a different entry mode command, you must first return to command mode by typing the Esc key.

Working with vedit or having **set showmode** preference on, you will see append, insert, or open displayed in the lower-right corner of the screen when one of those entry/input commands are entered. If you are working with Linux vi (vim), the mode will show as insert for any of the three. If no mode appears, you are not in one of the entry or input modes. The single-letter commands shown in Figure 9-8 are case sensitive and are used to insert or append text.

Figure 9-8 Append, Insert, and Open Commands

Command	Function
a	Appends text after the cursor.
A (uppercase)	Appends text at the end of the line.
i	Inserts text before the cursor.
o	Opens a new line below the cursor.

Saving Files and Quitting vi (Last-Line Mode)

Several last-line mode commands are available for saving your work and exiting vi. You should save the work to disk periodically using the **:w** (write) command. This writes the file to disk and leaves you in vi. To save a copy of the file currently being edited to disk under a new name, use the **:w** command followed by a new filename. This is a good way to make a backup of the file. To save the file and quit, you can use either the **:wq** (write then quit) or the **ZZ** (uppercase zz) commands. If you accidentally made changes and want to discard the changes without saving, or want to exit vi and ensure that no changes have been made, use the **:q!** (quit) command. If a file has been opened read only, you can save changes and overwrite the existing file with the **:wq!** (write-quit) command. To discard all the changes since the last write or save and re-edit the file, use the **:e!** command. This will erase changes and start again. Figure 9-9 shows the various save/exit options.

Figure 9-9 Save and Quit Commands

Command	Function
:w	Write buffer (save changes and continue working in vi).
:w new_filename	Write buffer to new_filename.
:wq	Write buffer (save changes) and quit vi.
ZZ (uppercase)	Save changes and quit vi. Alternative to **:wq**.
:q!	Quit without saving changes.
:wq!	Write buffer (save changes) and quit vi (The **!** will override read-only permissions if you are the owner of the file).
e!	Discards your changes since your last save.

Positioning Commands (Command Mode)

Cursor-positioning commands are used in command mode when there is existing text and the user wants to move around the document. On most UNIX workstations, the cursor control keys can be used to position the cursor to begin editing. However, a number of additional shortcut keystrokes and key sequences are available that can be faster than using the cursor arrow keys. In addition, some terminals do not support arrow keys, and cursor movement must be done using the other positioning methods. Figure 9-10 lists the vi editor's cursor-positioning commands. These commands are helpful when moving around the screen. The vi editor is case sensitive, you should be sure to use the specified case when using the positioning commands.

Figure 9-10 Basic Cursor-Positioning Commands

Command	Function
j (or down arrow)	Moves down one line.
k (or up arrow)	Moves up one line.
h (or left arrow)	Moves back one character.
l (or right arrow)	Moves forward one character.
Space bar	Moves right (forward) one character.
w	Moves forward one word (including punctuation).
b	Moves back one word (including punctuation).
$	Moves to the end of the line.
0 (zero) or **^**	Moves to the beginning of the line.
Return	Moves down to the beginning of the next line.

Editing Commands (Command and Last-Line Mode)

Many editing commands can be used to modify existing text in a file. These include commands for deleting, undoing, repeating, and changing text, as well as those for copying and pasting. The majority of these commands are entered while in command mode.

Deleting Text

To delete text, the user must be in command mode. In the command mode, position the cursor to the desired location and use the options shown in Figure 9-11 to delete text. These commands are case sensitive and are entered without the Enter key.

Figure 9-11 Basic Text-Deletion Commands

Command	Function
x (lowercase)	Deletes character at the cursor.
dw	Deletes word (or part of word to right of cursor).
3dw	Deletes three words.
dd	Deletes line containing the cursor.
3dd	Deletes three lines.

Undoing, Repeating, and Changing Text

Use the commands shown in Figure 9-12 to change text or to cancel or repeat edit functions. Many of these commands put vi into insert mode until the user presses Esc.

Figure 9-12 Undo, Repeat, and Change Commands

Command	Function
cw	Changes word (or part of the word) at the cursor location to the end of the word. This command is a multistep operation: **1.** Position the cursor at the beginning of the word. **2.** Press **cw**. **3.** Type new word. **4.** Press Esc.
3cw	Changes three words.
r	Replaces character at cursor with one other character.
u	Undoes previous command.

Copying and Pasting Text

The user can save time and keystrokes by copying existing text and placing it another place or places in the file using the copy and paste vi commands. To copy and paste text, use the options shown in Figure 9-13.

Figure 9-13 Basic Copy and Paste Commands

Command	Function
yy	Yanks a copy of line to the clipboard.
p	Puts yanked or deleted line below current line.
P (uppercase)	Puts yanked or deleted line above current line.

NOTE

The delete (**dw** and **dd**) commands and yank (**yy**) write to a buffer or memory. When yanking, deleting, and pasting, the put commands (**p** and **P**) insert the text differently depending on whether the user is pasting words or lines.

Advanced Editing Options (Last-Line Mode)

The vi editor is part of the ex family of editors. vi is a screen-oriented editor containing commands that enable the user to move the cursor, add and delete text, and so on. With its own set of commands, ex is a line-oriented editor that can be used while in the vi editor. All of the last-line mode commands, those that begin with a :, ?, or /, discussed so far are actually ex editor commands.

The man pages for vi may or may not contain any descriptions of commands such as **:q**, **:w**, **:[line #]**, or **:set** depending on the UNIX version. You may need to read the ex man pages (man ex) to learn more about the last-line mode commands. With Red Hat Linux, entering the command **man vi** or **man ex** will take you to the vim man pages.

TIP

To automatically have vi
options enabled when
you enter vi, create a file
in the home directory
called .exrc (ex editor
run control). The set
options are placed in
this file, without the
preceding colon, one
command to a line.
When the .exrc file
exists, it is read by the
system each time the vi
editor is started. The **set
nu** option shows line
numbers and is used
frequently when writing
programs and script files.
The line numbers are not
part of the file.

Session-Customization Commands

The vi editor includes options for customizing your edit sessions. These are summarized in
Figure 9-14. They include displaying line numbers and displaying invisible characters such
as tab and end-of-line characters. The **ex editor set** command is used from last-line mode
to control these options.

Figure 9-14 Edit Session-Customizing Commands

Command	Function
:set nu	Shows line numbers.
:set nonu	Hides line numbers.
:set showmode	Displays current mode of operation (turned on automatically if the vedit command is used).
:set noshowmode	Turns off mode display.
:set	Displays all vi variables set.
:set all	Displays all possible vi variables and their current settings.

Advanced Editing and Searching

The commands in Figure 9-15 enable you to perform advanced editing such as finding lines
or conducting search and replace functions. The forward slash (/) and the question mark (?)
search options are also last-line commands. However, they do not require a colon first. The
next (**n**) and previous (**N**) commands can be used to find the next occurrence after the **/string**
or **?string** commands have found what was being searched for.

Figure 9-15 Positioning and Search Commands

Command	Function
G (uppercase)	Goes to last line of file.
:21	Goes to line 21.
/string	Searches forward for string.
?string	Searches backward for string.
n	Finds next occurrence of string.

Spell Checking Text Files

Before word processors became popular with a built in spell checker, the UNIX **spell** command was used.

The **spell** command compares the words contained in the specified text file against a dictionary file and displays suspected words not found in the dictionary. When the misspelled words are identified, you use an editor to search and replace the misspelled words.

If you will be using a text editor to create many text files that need spell checking, it would be better downloading the pico text editor. The pico text editor, to be discussed in the next section, is known for its ease of use and built-in spell checker. The following is the basic format of the **spell** command:

```
spell [-options ] file
```

Lab Activity 9.1.8 Using the vi Editor

In this lab, you use a UNIX text-editing tool: the vi editor. This text editor primarily is used for creating and modifying files that customize your work environment and for writing script files to automate tasks. Refer to Lab 9.1.8 in the *Cisco Network Academy Program Fundamentals of UNIX Lab Companion*, Second Edition.

Alternatives to vi

Many non-Windows-based UNIX text editors are available. Most people learn vi editor. The vi editor and the older ed (editor) text editors are part of almost every UNIX system. It is helpful to know the basics of vi editor even though easy-to-use Windows-based text editors are available. The CDE and GNOME Text Editors are covered later. The vi editor allows the user to edit a file after accessing a remote system where no GUI environment is available. Anyone planning to become system administrators might want to consider one of the other popular non-Windows-based editors such as Emacs or pico.

Emacs Editor

The Emacs (Editing MACroS) editor is considered to be easier than vi editor because there are no modes. Upon launching Emacs, you are, by default, in entry mode. However, Emacs commands are mostly a combination of the Control (Ctrl) key plus a letter, such as in Ctrl-d to delete a character and Ctrl-xs to save. The Emacs commands must be learned, as is the case with vi editor. In addition to its general text-entry operations, the Emacs editor contains many features that make it ideal for those editing large files for software development.

NOTE

The system dictionary, by default, is located in the file /usr/share/lib /dict/words (Solaris) and /usr/bin/spell (Linux). In addition to this, you can create a personal dictionary file containing a list of sorted uncommon words not contained in the default dictionary. For example, if your dictionary file is called my.dictionary, it will be included by using the following command:

spell -my .dictionary file

TIP

You can temporarily suspend the vi editor to check the spelling of a word by doing the following:

1. While in vi, type **:!spell**. Note: You can run any UNIX command from vi using **:![command]**.

2. Type the word in question, and then press **Enter**.

3. Press **Ctrl-D**. If the word is displayed, it is not in the dictionary. If nothing returns, the word is in the dictionary and is spelled correctly.

4. Press **Enter** to continue.

The most common version of Emacs is the GNU Emacs editor. This version is available for free at www.gnu.org. Another popular version is the graphical XEmacs editor. These two editors are covered in greater detail later in this chapter.

The Pico Editor

TIP

Several vi editors are available for DOS and Windows users. Search the Internet for "vi editor" to locate a download site.

The pico editor comes with the freely available Pine mail program. Like Pine, pico is an easy-to-use, menu-driven program. The pico editor is not as powerful as the vi editor, but it is capable of handling most user editing needs. To obtain a free version of pico, search the Internet for "pico editor" and choose from any of the download sites.

Creating Small Text Files Using cat

Chapter 6, "Basic Directory and File Management," introduced the **cat** command as a way to view the contents of a file. The **cat** command is a multipurpose command that also can be used to create, not edit, small text files as an alternative to using a text editor. The steps necessary to create a file using the **cat** command are listed here. The file will be placed in the default directory unless a path is specified. The basic syntax for using the **cat** command to create a file is shown here:

```
cat > filename
```

1. Type the lines of text, pressing **Enter** after each line. After you press Enter to go to the next line, it is not possible move back. Press **Enter** after the last line.

2. Press **Ctrl-d** to save the file.

Using Emacs

The Emacs editor is a powerful and flexible editing tool that is available for the UNIX environment.

Advantages of Emacs

Emacs is one of the more capable editing programs available. At this time there are two versions of Emacs: GNU Emacs, and XEmacs. See the next section for a comparison of the two. A partial list of Emacs features and advantages follows:

- **Free and open**—Emacs is one of the original open source programs. It has been developed since 1975, is free, and runs on every type of computer system you are likely to encounter. This includes all newer versions of UNIX, Macintoshes, and Windows.

- **Simple and easy**—Powerful does not mean difficult. It is as easy to perform simple operations in Emacs as with any other editing system.

- **Self-documenting**—Extensive help is available at every keystroke in Emacs. The ability to extend the help system is built in.

- **Customizable**—Every feature of Emacs can be changed to make it work according to your preferences.

- **Programmable**—Emacs executes a command interpreter in a programming language called *Emacs Lisp*. A large and developed library of add-on programs and modes is delivered with the standard implementations of Emacs.

- **Modes**—Modes for every type of text editing process exist for Emacs. These include special modes for any programming language the user can name. Some examples— programming languages like C, C++, and Java; markup languages such as the web's HTML, XML, SGML; powerful typesetting languages like TeX and LaTeX are also included.

- **Production oriented**—Some editing systems allow only one task at a time to be performed. Emacs allows you to have as many files and windows open at once as system memory will allow. Each one can be in a different mode, size, and appearance, if desired. Users will typically leave the same Emacs session running for days at a time.

- **Graphic or terminal based**—Emacs may be run either as a graphics program or in a character terminal like vi. The same Emacs process may even be run both ways at once, with some graphics windows and some terminal windows.

- **Desktop environment**—With its directory editor and internally operated shells, Emacs can also serve as a desktop manager like Nautilus.

- **E-mail**—Emacs comes with a choice of e-mail tools such as VM for Xemacs.

- **News**—Emacs also comes with a news group reader, which can serve as a mail tool.

- **Web browser**—Emacs has its own basic web browser, although it is also able to interact with standard external web browsers.

- **System integration**—Emacs integrates with other processes being run on the computer system it runs under.

Figure 9-16 shows a session of customized XEmacs in operation. It has several windows open on the desktop. The first shows an e-mail summary table with an e-mail message displayed below it. Below the e-mail message is a source text program in the Perl programming language. The window on the bottom left is running a shell, like a Terminal window. The upper-right window displays a piece of an Emacs Lisp program. Below that is a window showing the editing of an HTML file. On the bottom is a window doing directory editing. It is not uncommon for Emacs users to have this much and more going at once.

Figure 9-16 A Single Emacs Invocation Managing Many Tasks

Two Strains of Emacs: GNU Emacs and XEmacs

Richard M. Stallman, founder of what is now called the GNU Project, wrote the original version in 1985. Stallman still oversees Emits development. See www.gnu.org for more information on GNU Emacs.

The first versions of Emacs ran only on character terminals before graphical user interfaces became available. When graphics arrived and became widespread in the UNIX world, development teams focused their efforts on creating a graphical version of Emacs. The new version of Emacs came to be called XEmacs because it was based on UNIX X-terminal graphics. From the user's standpoint, the differences between GNU Emacs and XEmacs are small and primarily visual. The processes of opening, editing, and saving files are the same.

Figure 9-17 shows XEmacs on the top and GNU Emacs on the bottom, both having been started for the first time in a new user's environment.

Some differences between the versions follow:

- GNU Emacs is slightly more widely circulated than XEmacs, but not significantly so. Some Linux distributions, such as Red Hat, include GNU Emacs by default on a basic workstation installation, but XEmacs is also available as a selectable option.

- GNU Emacs demands fewer system resources than XEmacs, both in disk space and processing power.

■ XEmacs has had more work done in its graphics support than GNU Emacs. As a result XEmacs has a GUI look and feel.

Figure 9-17 XEmacs on Top, GNU Emacs on the Bottom

Perceived Disadvantages of Emacs

Some users have reluctance to learn Emacs, or have stopped using it after a while for some of the following reasons:

■ **Considered to be for experts only**—Emacs has extensive capabilities that require remembering a lot of different key strokes.

■ **Not always available**—UNIX or Linux systems that are designed as servers rather than user systems, are sometimes stripped down to the barest essentials, and in some cases do not have a GUI running. Generally, only administrators log in to these server systems, when they perform maintenance tasks. The vi editor is provided on almost

every UNIX system, no matter how sparsely built. Also, Emacs is not delivered by default on all UNIX systems. However, Emacs is a bundled with most Linux distributions and can be downloaded for free for most every commercial version of UNIX.

- **Keystroke-based editing**—Computer users who are used to GUI-based editors, for both text editing and word processing, are most comfortable performing tasks such as copying, cutting, pasting, and pointing and clicking menus with a mouse. Most commands in Emacs are traditionally accomplished with combinations of keys on the keyboard; however, recent versions of both GNU Emacs and XEmacs have enabled the use of a mouse in the same way as any other GUI-based program.

- **Size**—Either version of Emacs consists not only of the executable editor program itself, but also a large library of Emacs Lisp. In contrast, vi and similar editors are standalone single-file programs. With the hard disk storage capabilities of modern computers, however, this is generally not a problem. Emacs is, however, too large to fit on a floppy as with vi.

- **Speed and startup time**—Typical users of vi editor run vi to open a file, make quick edits, then save and quit. The loading of vi and other small editors is fast. While an Emacs startup may take longer, a single invocation can be run for days at a time. While running, Emacs can edit hundreds of files and perform a host of tasks, without having to be restarted.

Getting Safely In and Out of Emacs

The most important first steps in learning any editing tool are the following:

- Starting up
- Opening a file for edit
- Inserting and changing text
- Undoing mistakes
- Moving around
- Starting again
- Saving work
- Exiting
- Exiting without saving

The steps for performing these operations are identical in GNU Emacs and XEmacs. Everything may be accomplished through the menus. You will learn how to perform these operations just by exploring the menus. We will demonstrate here how to perform the operations in the traditional Emacs way, using keyboard commands. This operation, once learned, is much faster.

Table 9-1 provides a brief primer to help in understanding a little about Emacs key-binding notation.

Table 9-1 Emacs Key-Binding Notation Examples

Keys	Meaning
C-<*chr*>	Hold down the Ctrl key while typing the <*chr*> key. For instance, **C-a** means **Ctrl-A**.
C-x **C-f** **C-x s**	Some control keys, such as **Ctrl-X**, are prefixes to be followed by one or more other keys. This can be another control character or a plain character.
M-<*chr*>	Hold the **Meta** key while typing <*chr*>. If there is no Meta key, or you do not know where it is located, press **Esc** (Escape) followed by the <*chr*> key.
M-x	This is an important key that prompts you for a command to execute by name. This is useful when you do not remember the key combination.

Starting Emacs

Start Emacs either by simply launching the program, or with one or more filename arguments:

```
emacs
emacs myfile
```

Aborting Keyboard Entry

The single most important key in Emacs is **C-g**.

C-g runs a command called keyboard quit. This enables you to back out of any operation when it becomes difficult or complicated for the user. If in a situation that causes trouble, **C-g** will almost always get the user out of it.

Opening a File

To open a file for edit, press the following combination:

```
C-x C-f
```

A prompt at the bottom of the screen asks for the name of the file. Respond with

```
junkfile
```

or you can choose any name. The file does not have to exist.

NOTE

emacs starts GNU Emacs, which we use in this explanation. XEmacs is started with the command **xemacs**.

In Emacs the user is always in insert mode. This is unlike vi, where the user toggles between insert and command modes. Type in any text you would like to use.

Undoing Mistakes

To undo a mistake, press the following:

`C-/`

Repeat **C-/** to undo more changes.

Cursor Movement

Movement of the cursor can be accomplished with the following keys:

> **C-a**—Beginning of line
>
> **C-e**—End of line
>
> **C-n**—Next line
>
> **C-p**—Previous line
>
> **C-f**—Forward one character
>
> **C-b**—Backward one character

Restarting Editing

To restart editing the file from the last time you saved it, press the following:

`C-x C-v`

Enter the same filename that is being edited in response to the prompt. Then, you will be asked for verification and will reload if the answer is yes.

Killing Editing

To stop or kill the edit, leaving Emacs running, press the following:

`C-x C-k`

It prompts for the file buffer to kill, with the current file as default. Press **Enter**. If Emacs knows the user has made changes since the last save, it prompts for verification.

Saving Work

To save the current file at any time, type the following:

`C-x C-s`

You can still type **C-x u** (undo) anytime. Emacs continues to undo until it runs out of things that it remembers to undo.

Exiting Emacs

To exit Emacs smoothly, type the following:

`C-x C-c`

If Emacs sees there are unsaved file buffers, it prompts the user whether to save each one in return.

Aborting Emacs

If the operation gets difficult and you want to abort, type the following:

`M-x kill-emacs`

After typing **M-x**, the cursor occurs in what is called the echo area at the bottom of the window. Type **kill-emacs** there. Emacs quits unconditionally, without prompting you about saving work and so on. Figure 9-18 shows an XEmacs session about to be killed.

Figure 9-18 Killing Xemacs Unconditionally

Accessing the Emacs Tutorial

The Emacs Tutorial is always available for access within Emacs, and you may use it to experiment with. Every time you visit the Tutorial, Emacs makes a fresh copy.

To access the Tutorial at any time, press the following:

`C-h t`

The Tutorial is written in such a way that you can read it and do what it says, using the Tutorial text itself to make edits. Once the Tutorial is completed, you will know enough about Emacs to be comfortable using it. Figure 9-19 shows the beginning of the GNU Emacs version of the Tutorial.

Figure 9-19 The GNU Emacs Tutorial

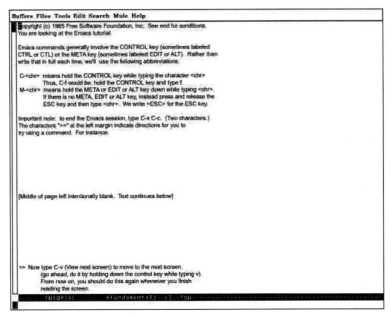

Getting Emacs Help

Help is available in Emacs at every keystroke. The prefix key reserved for Help, logically, is **C-h**.

Type just **C-h** and the program prompts you for further options. To see the options available, type the following:

```
C-h ?
```

In GNU Emacs a window is displayed with all the options explained. In XEmacs it shows a list in the echo line of all the help options the user has available. Press the question mark again to go to the detailed help screen in XEmacs. The descriptions differ slightly in the two versions, but the basic functions available are the same.

Figure 9-20 displays an XEmacs window displaying a summary of help options after pressing **C-h ? ?**.

Handy reference cards for both Emacs and XEmacs can be found at www.refcards.com/.

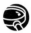

Lab Activity 9.2.6 Using Emacs

In this lab, you go through an example Emacs editing session step by step. Refer to Lab 9.2.6 in the *Cisco Network Academy Program: Fundamentals of UNIX Lab Companion*, Second Edition.

Figure 9-20 Emacs Help Has Many Options

DText Editor

The CDE Text Editor is a full-screen graphical text editor that supports a mouse and can be used to edit files. It is equivalent to the Windows Notepad. As with vi, this editor does not put any special formatting characters into the file. This editor is suitable for creating system environment and script files. To start the CDE Text Editor, click the **Text Note** subpanel from the front panel and open a Text Editor window. (See Figure 9-21.) The default name for the file that opens will be UNTITLED, as shown in Figure 9-22.

Figure 9-21 Text Note Subpanel

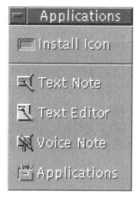

Figure 9-22 Text Editor Window

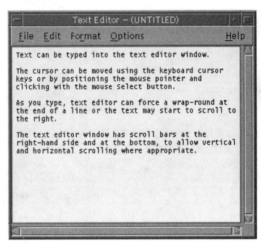

You can type any text into the Text Editor window. To insert characters into an area where you have already typed, position the pointer where the text is to be inserted and then click the left mouse button.

By default, Text Editor is in insert mode. That is, when you type the characters automatically are inserted into the text rather than overwriting any existing characters to the right of the pointer. You can change from insert to overwrite mode at any time while working with Text Editor by clicking the **Options** menu and selecting **Overstrike**.

File Menu

The File menu options shown in Figure 9-23 contains commands for creating new documents, saving work, opening and closing documents, and printing. The following is a description of each command:

- **New** starts a new Text Editor session in the same window, and discards any current text contents. If the current text has not been saved, you will be prompted to confirm saving or discarding it.

- **Open** will open an existing text file in the current Text Editor window. You will be provided with a window displaying a list of filenames to choose from.

- **Include** will include the contents of an existing text file. The contents of the included file will be inserted at the current cursor position.

Figure 9-23 Using File Options

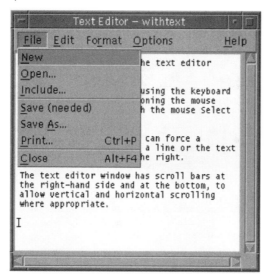

- **Save** will save the current text to the current filename. If you have altered the current text since the last time the text was saved, the menu option will display as Save.

- **Save As** will save the current Text Editor window contents under an alternative filename. This option automatically is chosen when you first use the Save menu option.

- **Print** will print the current text.

- **Close** will close the Text Editor window. If the current text has not been saved, you will be asked if the changes are to be saved. If you click the **No** button, any text that has been added or changed since the last save will be lost.

Editing Options

This section introduces you to many different editing options that are available.

Edit Menu

The Edit menu shown in Figure 9-24 contains the standard options to manipulate text, such as Cut, Copy, and Paste. However, if no text is selected, the Cut and Copy options will not be available. The Find option enables you to find text or to find and change text. This option is case sensitive. Anything that you are searching for will be found only if it is an exact match. Similarly, any text can be changed to be exactly the same as the text that you typed in the change box, as shown in the example in Figure 9-25. If the text string cannot be found in the document, you will see the window as shown in Figure 9-26.

Figure 9-24 Text Editor—The Edit Menu

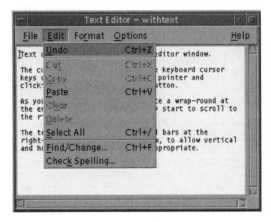

Figure 9-25 Text Editor—Find/Change

Figure 9-26 Search Item Not Found

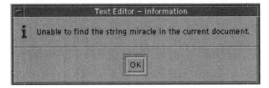

Editing Keys

The Sun workstation keyboard has a set of editing keys on the left side that can be used instead of the editing menu options. (See Figure 9-27.) By selecting text with the mouse, these keys can be used to copy, cut, and paste, among other things.

Text can be selected and replaced using any of the following four methods:

- Dragging over the text while pressing the left mouse button. This will highlight all of the text that the mouse pointer passes over.

- Double-clicking with the left mouse button on a word to highlight that word.
- Triple-clicking with the left mouse button to highlight the paragraph over which the mouse pointer is situated.
- Quadruple-clicking with the left mouse button to highlight all of the text in the current Text Editor file.

Figure 9-27 Sun Keyboard Editing Keys

When text has been highlighted using any of these four methods, it will be replaced by whatever characters are next typed at the keyboard. Figure 9-28 shows selected text. Instead of typing characters, you can cut, copy, or clear the highlighted text using the special keyboard keys or the options on the Text Editor Edit menu, as shown in Figure 9-29.

Figure 9-28 Selecting Text to be Replaced

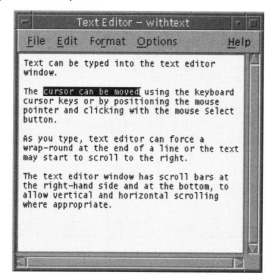

TIP

On a Sun workstation, the Find key is used to quickly find text in a file or e-mail. To use this quick find feature, highlight one occurrence of the text that is to be searched for and then press the Find key. Another way is to type the text at the top of the file and then highlight it. Press **Find** again to go to the next occurrence.

Figure 9-29 Replacing Text with the Edit Menu Options

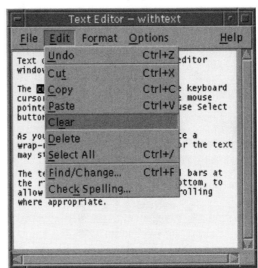

Format Menu Options

The Settings option under the Format menu, shown in Figures 9-30 and 9-31, will enable you to change margins and alignment of the text, either for a paragraph or for the entire document. When the settings have been defined, clicking the **Format** menu again gives a shortcut to changing settings for the current paragraph or the entire document.

Figure 9-30 Format Menu Options

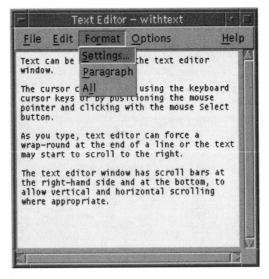

Figure 9-31 Format Settings

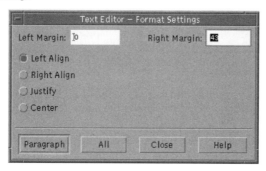

Text Editor Options Menu

The Options menu shown in Figure 9-32 enables you to switch between insert and overstrike modes. The chosen mode affects any new text typed into an existing text area. The wrap to fit mode formats the text in the current Text Editor window by automatically wrapping or moving text to the next line when it reaches the edge of the window. The status line can be switched on or off, using the Status Line menu option. When the status line is on, it shows the current line number on which the cursor is situated and the total number of lines in the text, as shown in Figure 9-33. Finally, the Backup on Save option creates a backup file each time you save the contents of the Text Editor session.

Figure 9-32 Text Editor Options

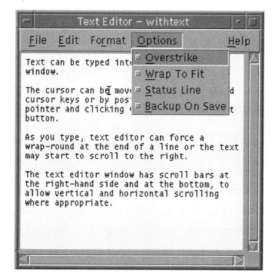

Figure 9-33 Status Line Option

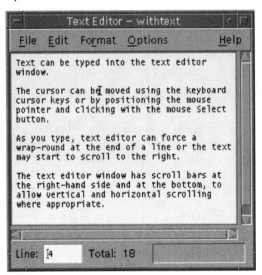

 Lab Activity 9.3.6 Using the CDE Text Editor

In this lab, you work with the Common Desktop Environment (CDE) Text Editor. Refer to Lab 9.3.6 in the *Cisco Network Academy Program Fundamentals of UNIX Lab Companion*, Second Edition.

GNOME gedit Text Editor

The GNOME gedit text editor is a graphical editor that is comparable to the CDE Text Editor. The insertion, deletion, and editing of text is very similar. Note the location and functionality of gedit described here will vary depending on the version of GNOME and gedit you use.

Opening Window

To access gedit, click the GNOME main menu, click **Programs**, and then select it from the Applications menu. Figure 9-34 shows the initial gedit screen with some text typed in. The upper portion of the window contains buttons that are used to create, open, save, and print files as well as standard text-editing buttons for cut, copy, and paste. Undo and redo buttons are also available.

Figure 9-34 GNOME gedit Window

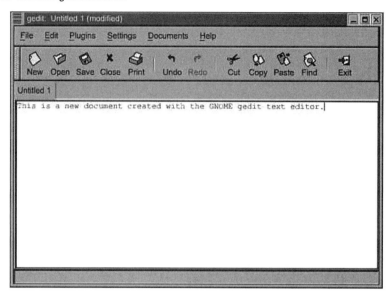

File Menu

The options available with the buttons are also on the File menu, along with additional useful options such as Save As and Print Preview. (See Figure 9-35.)

Figure 9-35 gedit File Menu

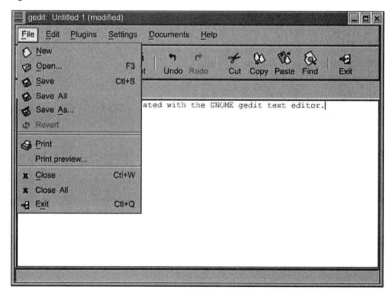

Edit Menu

The options available with the buttons are also on the Edit menu along with Go To and Find/Replace. (See Figure 9-36.)

Figure 9-36 gedit Edit Menu

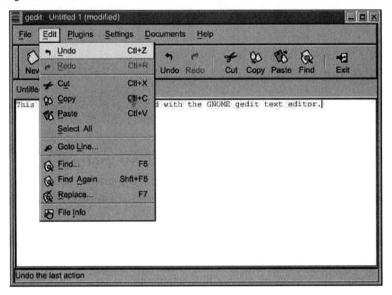

Plugins Menu

The Plugins menu shown in Figure 9-37 provides links to other related and useful functions. The Manager option allows the addition or removal of plug-ins. The standard plug-ins on the menu are as follows:

- **Browse**—Invokes the Lynx browser.
- **Diff**—Brings up a GUI front end to the UNIX **diff** command, which allows two files to be compared.
- **Email**—Allows the contents of the text created with gedit to be sent to an e-mail recipient.
- **Shell Output**—Brings up a shell prompt window and captures the results of any command you issue into the text document.
- **Insert Time**—Inserts the date and time.

Figure 9-37 gedit Plugins Menu

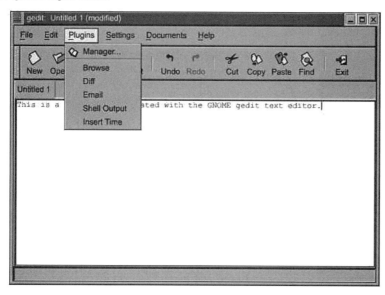

Settings Menu

The Settings menu provides access to the Preferences window shown in Figure 9-38, which allows you to set preferences for the gedit session. These include various options such as icons, documents, fonts, colors, printing, and paper.

Figure 9-38 Preferences Window

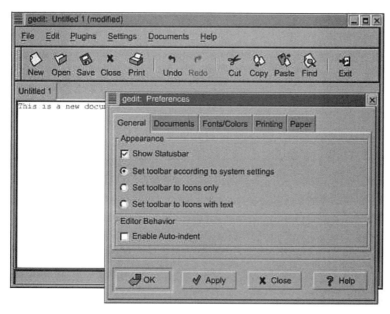

UNIX Word Processors

Word processors are different from text editors. Word processors are designed for creating documents that are easy to read. Word processors include features for formatting text as bold, underline, and so on. They also provide for embedding graphics and pictures, inserting tables, and flexible printing.

TIP

To open a file created with a word processor in a text editor, save the file using the text or text only file type option in the word processor. Doing so removes all formatting characters, pictures, tables, and so on, and saves only text. Files created with a text editor can be opened with a word processor. However, word processor files cannot be opened with a text editor because word processor files contain formatting characters.

Several full-featured word processing programs for UNIX also run on PCs.

The most popular word processor for UNIX has been WordPerfect, from Corel Corporation. See www.wordperfect.com for more information. In the past, WordPerfect has supported many UNIX varieties, but current releases are available only for Linux.

StarWriter from Sun Microsystems is a full-featured word processor program that is part of the complete StarOffice office productivity suite. StarOffice is available at no charge to educational users at www.sun.com/staroffice. Many Linux distributions also include StarOffice for free. StarOffice also includes spreadsheet, drawing, database, presentation, and scheduling programs. With StarOffice, users have the capability to access files created with Microsoft Office. StarOffice runs on Solaris, Microsoft Windows, and Linux, enabling users to access files across multiple platforms. Figure 9-39 shows the StarOffice desktop with the various applications available. Figure 9-40 shows the StarOffice word processor with a new open document.

Figure 9-39 StarOffice Applications

Figure 9-40 StarOffice Word Processor

Summary

Now that you have completed this chapter, you should have an understanding of the following:

- The vi editor is a simple but powerful text editor that can be used to create system and script files. It is an integral part of all UNIX and Linux operating systems. Sometimes you find that a graphical text editor will not be available. The vi editor might be the only available tool to perform administrative tasks and troubleshoot problems.

- The vi editor has three main modes of operation: command mode, entry or input mode, and last-line mode.

- Command mode is the starting point for the other modes and is used to edit existing text. All commands are entered from command mode. Pressing Esc always returns you to command mode. Entry or input mode is used for entering new text. Last-line mode primarily is used to save files and exit vi. Understanding the purpose of these modes and knowing how to switch between them is key to working with the vi editor. Numerous positioning, editing, and other commands also are available.

- In addition to vi, other non-Windows-based text editors can be downloaded for free and are considered easier to use. The two most popular editors are Emacs and pico. Emacs

is a powerful and extensible open source editor with many features that is included with most distributions of Linux. It can downloaded for most other UNIX versions.

- The CDE Text Editor is a graphical editor that performs a similar function to vi. As with vi, you can create text files that do not have any formatting in them. These can be user environment configuration files, script files, program files, or notes. The CDE editor provides mouse support, making it easier to work with existing text.

- The GNOME graphical text editor, known as gedit, is comparable to the CDE Text Editor and has the added feature of plug-ins.

Check Your Understanding

1. Which editor has been a part of the UNIX operating system nearly since its inception in the early 1970s?

 A. vi

 B. Emacs

 C. Wordpad

 D. Notepad

2. Which three of the following are valid modes of the vi editor in the UNIX environment?

 A. Command

 B. Entry

 C. Last-line

 D. Normal

3. What is the starting mode from which other modes can operate?

 A. Command

 B. Entry

 C. Last-line

 D. Normal

4. Which two of the following are ways that the vi editor can be invoked or started?

 A. **vi filename**

 B. **vedit**

 C. **viedit**

 D. **vi** *filename1 filename2*

5. Which of the following special keys returns the vi editor back to command mode?

 A. **Enter**

 B. **Esc**

 C. **Shift**

 D. **Ctrl-Tab**

6. Which is useful if you want to discard all the changes since the last write or save and reedit the file?

 A. **:wq**

 B. **:w**

 C. **ZZ**

 D. **:q!**

7. Which three delete commands write to a buffer or memory?

 A. **dd**

 B. **dw**

 C. **yy**

 D. **put**

8. Which key sequence saves a file when using the Emacs editor?

 A. **Ctrl-x, Ctrl-s**

 B. **Ctrl-d, Ctrl-s**

 C. **Ctrl-s**

 D. **Ctrl-x**

9. Which three of the following are advantages of the Emacs editor?

 A. Free and open

 B. Available on all UNIX platforms

 C. Simple and easy to use

 D. Customizable

10. Which of the following Emacs key combinations prompts a user for a command to execute by name?

 A. **Meta-x**

 B. **Ctrl-**<*chr*>

 C. **Ctrl-x**, then **Ctrl-f**

 D. **META-**<*chr*>

11. Which keystroke combination calls the Emacs keyboard quit command?

 A. **Ctrl-x**, then **Ctrl-f**

 B. **Ctrl-g**

 C. **Ctrl-x**

 D. **Ctrl-f**

12. Which of the following key combinations can be used to access the Emacs tutorial?

 A. **Ctrl-h**, then t

 B. **Ctrl-t**, then h

 C. **Ctrl-?**

 D. **Ctrl-t**

UNIX Command Summary

emacs Starts the GNU emacs text editor.

```
$ emacs backup.sh
```

spell Compares the words contained in the specified text file against a dictionary file and displays suspected words that are not found in the dictionary. Example:

```
$ spell memo
aint
partyiing
```

vedit Starts the vi editor with showmode turned on, which displays the current mode (entry or input) that you're in.

vi editor command mode Initial default mode for creating and editing files, cursor positioning, and modification of existing text. All commands are initiated from this mode. Pressing Esc from either of the other modes returns you to command mode.

vi editor entry mode Used for new text entry. Entering an insert command, such **i** (insert), **a** (append), and **o** (open new line) takes you from command mode to entry mode. Pressing Esc returns you to command mode. Entry commands are entered by themselves, without pressing the Enter key. Example:

```
a, i, o, A, I, O
```

vi editor-last line mode Used to save your work and quit vi. Type a colon (:) to get into this mode. Pressing the Return key returns you to command mode.

```
:w, :wq, ZZ, :q!, :wq!
```

xemacs Starts the graphical version of the GNU Emacs text editor.

```
$ xemacs backup.sh
```

Key Terms

command mode When using the vi editor, the command mode is the mode in which you can position the cursor and use **edit** commands to perform various actions. When you open a file with vi, you are in command mode. All commands are initiated from command mode.

entry mode When using vi, the entry mode is the mode in which you can type text. To enter text, you must type a vi insert command such as **i**, **o**, or **a**. This takes vi out of command mode and puts it into entry mode. In this mode, text is not interpreted literally and becomes part of the document. When you finish entering text in your file, press the Escape key to return to command mode.

gedit text editor A GNOME graphical editor that is comparable to the CDE Text Editor. The insertion, deletion, and editing of text is very similar.

last-line mode When using the vi editor, the last-line mode is the mode in which you can type advanced editing commands and perform searches. This mode is entered in a variety of ways (most commonly with a colon, a slash, or a question mark), all of which place you at the bottom of the screen.

Text Editor (CDE) A full-screen graphical text editor that supports a mouse and can be used to edit files. It is similar to the Windows Notepad. As with vi, this editor does not put any special formatting characters into the file, and it is suitable for creating system environment and script files.

vi An interactive editor that is used to create and modify ASCII text files. It is a character-based editor that is an integral part of all UNIX operating systems. The vi editor uses a screen display, but you cannot use the mouse to position the cursor.

Objectives

After reading this chapter, you will be able to

- Describe the components of a good security policy.
- Explain file system permissions.
- Determine current file system permissions.
- Change file and directory permissions from the command line.
- Change file and directory permissions using graphical tools.
- Identify and switch users.

File Security

Introduction

All network operating systems have some means of controlling access to resources. The file system is a key resource on any workstation or server. Protecting the file system from unauthorized access and allowing access as needed are key components in a comprehensive security policy. This chapter provides some guidelines for an overall security policy and specific information about file system security. UNIX file system security concepts are introduced, and examples are provided showing how to apply them. You will learn how to determine file and directory permissions, and discover what types and categories of permission exist. You will analyze the meaning of the various permission types as they relate to user and group access. You will work with directory and file permissions using the command line, CDE, and GNOME to determine and change file and directory permissions. You will also learn how to identify which users are logged in and how to determine current login status when switching between user accounts.

Security Policies

An organization's information is one of its most valuable assets. Network security is becoming increasingly important as networks become larger and more complex. Mobile and telecommuting users require access locally as well as from outside the network. Threats to an organization's resources can come from internal and external sources. Information theft and destruction as well as resource access denial are real concerns for users and system administrators. The overall goal of any information system is to ensure that information is accurate and available where and when needed. A comprehensive information systems security policy can help to ensure this. A number of components must interact in a comprehensive security policy. These components are shown in Figure 10-1 and are discussed in the following sections.

Figure 10-1 Security Policy Components

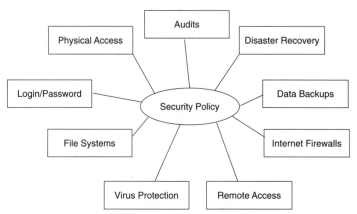

Physical Access Security

The first line of defense locally to protect network equipment such as servers, switches, and routers is to keep them in a locked, climate-controlled, and fire-protected environment. If equipment is not physically accessible to unauthorized personnel, there is less chance of accidental or intentional tampering.

Login/Password Security

Login and password security require that any user accessing a workstation or server have a valid login ID and password. As discussed in Chapter 2, "Accessing a System and UNIX Graphical Interfaces," UNIX has specific requirements for creating and changing passwords. The system administrator also can require that passwords be changed periodically. Setting screen savers that time out and activating the workstation lock are additional measures that enhance login and password security.

File Systems Security

A major component in any comprehensive security policy, file system security determines who can get to what data and what they can do with it. System administrators set up file system security based on users, *groups*, and *permissions*. Permissions are applied to files and directories in the file system to control access to these resources. Permissions are discussed later in the chapter.

Virus Protection

Viruses can do tremendous damage to individual workstations and network servers. Many network operating systems and workstations require antivirus software for adequate protection. UNIX is susceptible to virus attacks like other operating systems, but most viruses are written

for Windows-based systems. Viruses attached to Windows-based systems can affect more systems faster. In addition, most virus creators are not familiar with the UNIX environment enough to know how to create a UNIX virus.

Remote Access Security

With increases in telecommuting, the network must allow legitimate users to access resources remotely while protecting those resources from unauthorized access. Access servers and remote access software provide this function and control who can access the network.

Internet Firewalls

Organizations that provide their users with Internet access or that maintain Internet websites need protection from hackers. Various types of firewalls and user authentication solutions are available to help ensure that web servers are available to provide services to legitimate users and stop the attacks of hackers.

Data Backups

A comprehensive security policy must include regular backups of important data. This is to minimize downtime in the event of a security breach, loss of data, or a disaster such as fire or flood. Backup media, such as tapes, should be kept offsite in a climate controlled, secure environment. Test restores of data should be performed periodically to ensure that data could be recovered from the backups in case it is needed.

Disaster Recovery Plan

A *disaster recovery plan* is a written plan that identifies critical data and documents by functional department within an organization. It describes protective measures and steps necessary to ensure that the organization can continue to operate and get back to business quickly, with minimal impact to customers in the event of a disaster.

Audits

Security audits must be performed periodically to ensure that the organization and its users are following the security policy and preparing adequately for disaster recovery. Security audit tools are also available for system administrators to analyze and detect security loopholes such as files with open permissions.

e-Lab Activity 10.1 Security Policy Exercise

In this activity, you drag the security policy term on the left of the graphic to match the appropriate definition listed on the right. Refer to e-Lab Activity 10.1 on the accompanying CD-ROM.

Standard UNIX Security Features

The primary function of system security is to deny access to unauthorized users. Keeping computer information secure is important to the user and the system administrator. By protecting their files and accounts from unauthorized use, users also are protecting their jobs and reputations. Standard UNIX environment security features include the following:

- User accounts and passwords that restrict access to the system
- File and directory protection with permissions
- Tools that control remote logins and commands on individual workstations
- Other tools that enable system administrators to check for security breaches

User Accounts and File Security

UNIX operating systems have two default levels of security. First, users must supply a login ID and password to access a UNIX workstation or server. Second, files and directories automatically are protected by permissions when they are created. UNIX provides a special user account called *root* that has total access to the system. All permissions placed on files and directories can be overridden by the root user. The root account's user is also called the *superuser*. The superuser account runs system administration commands and edits critical system files such as the /etc/passwd file. Individuals with root access often are referred to as *system administrator*s.

Remote Access Control

Several tools exist on UNIX system that can be used to set up a *firewall*. Solaris includes the *SunScreen Secure Net* enterprise firewall product designed for access control, *authentication*, and network data *encryption*. It consists of a rules-based, dynamic packet-filtering engine for network access control. This firewall product has an encryption and authentication engine that enables enterprises to create secure virtual private network (VPN) gateways by integrating public key encryption technology.

Linux includes the **ipchains** and the more recent **iptables** utilities. These utilities can be configured by a system administrator to control which IP addresses can access a particular system or systems.

Additional measures can be taken to secure a UNIX system, which involve disabling unnecessary remote access services. Daemons such as Telnet, FTP, and rlogin should not be running if they are not required. Using remote access utilities such as SSH (Secure Shell), which encrypt messages between client and server, also helps to improve security.

Security Check Tools

UNIX system administrators can periodically check system log files to detect intruders. They can also run utilities such as *SATAN (Security Administrators Tool for Analyzing Networks)*. SATAN scans ports on computers in a network to probe for points of vulnerability and reports

them. SATAN can be downloaded from several websites on the Internet by searching for "UNIX security satan."

Another security tool that can be downloaded is known as *Tripwire* at www.tripwire.org. Tripwire runs as a daemon, keeping track of the status of files on the system and notifies the system administrator if anything unusual occurs. Tripwire is included with Red Hat Linux, although it must be installed. Commercial versions of Tripwire can be downloaded for Solaris and other versions of UNIX.

Included with Solaris is the ***Automated Security Enhancement Tool (ASET)***. ASET is a utility that improves security by allowing system administrators to check system file settings including permissions, ownership, and file contents. ASET warns users about potential security problems. Where appropriate ASET sets the system file permissions automatically according to the specified security level, as either low, medium, or high. Some of the security tasks ASET performs are as follows:

- Verifies system file permissions
- Checks integrity of /etc/password and /etc/group files
- Checks environment files to be discussed in Chapter 14, "Shell Features and Environment Customization"
- Allows establishment of a firewall by disabling the forwarding of Internet Protocol packets and hides routing information from the external network.

Network and Internet Security

Of all the security topics discussed previously, those that are the responsibility of a typical user include the following:

- **Account security**—Logging out or enabling the lock desktop or lock computer feature when a user leaves his system, and protecting and periodically changing his password.
- **File security**—Ensuring security permissions on files are set correctly. File permissions are discussed in the next section.

Most other topics are typically the responsibility of the system or network administrator where access to the root account is required.

Security is a huge topic that goes beyond the scope of this book. There are books and training courses, such as the Cisco Networking Academy Fundamentals of Network Security course, which are devoted only to network and Internet security.

For more information you may want to visit the SANS (SysAdmin, Audit, Network, Security) Institute website at www.sans.org. SANS was established in 1989 as a cooperative research and education organization. The SANS Institute is a global trusted leader in information security research, certification, and education. The SANS Institute enables security professionals, auditors, system administrators, and network administrators around the world to share the lessons they are learning and find solutions to security challenges.

Many SANS resources, such as security checklists, tools and utilities, glossary, news digests, research summaries, security alerts and award-winning papers are free.

Additionally, if you are interested in learning more about security you should consider taking the Cisco Networking Academy course ITE II: Networking Operating Systems sponsored by Hewlett-Packard. ITE II has an entire chapter devoted to network security for both the Windows 2000 and UNIX/Linux network operating systems and includes hands-on labs. Some of the topics covered include the following.

Implementing Security Measures to Protect Against Network Threats:

- File encryption
- IP security
- Secure Sockets Layer (SSL)
- E-mail security
- Public/private key encryption
- Locating and installing security patches and upgrades

Firewalls:

- Introduction to firewalls and proxies
- Packet filtering
- Firewall placement
- Common firewall solutions
- Using a NOS as a firewall

File System Permissions

Permissions determine which users are able to access files and directories in the file system and what those users can do with them.

Displaying File System Permissions

Directory and file permissions can be determined using the **ls** (list) command with the **-l** (long) option, as shown in Figure 10-2. The **ls -l** command displays a long listing of the contents of a directory. If the **-a** (all) option is included, all files will be displayed. This also includes hidden files, those files that begin with a dot. As previously discussed in Chapter 5, "Accessing Files and Directories," the long listing displays a separate line of output, which includes eight pieces of information for each file or directory. The permissions portion of the **ls -l** output is the focus of this chapter. Figure 10-3 shows the location and name of each component, and Figure 10-4 provides a brief definition of the components of the **ls -l** command output. The first character of the display indicates the type of file. This is typically a dash (-), meaning this is a file. A lowercase letter *d* means this is a directory. Other file type characters can also be present as described in Chapter 5.

Figure 10-2 Detailed Information from the **ls -l** Command

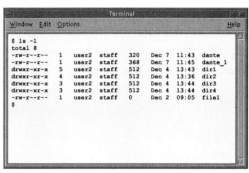

Figure 10-3 Directory Information Components

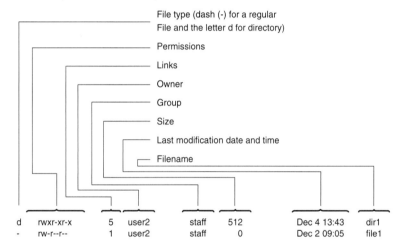

Figure 10-4 Directory Component Definitions

File Type	A dash (-) in the first position indicates a regular file. A d indicates directory.
Permissions	Three sets of permissions: User, Group, Others.
Links	Number of links that the file has to other files. Links are covered in Chapter 7.
Owner	User (login) ID of user who created the file or directory unless ownership was assigned.
Group	Primary group name that owner belongs to established by the system administrator.
Size	File size in bytes.
Modification Date/Time	Month, day, year (if not current year) and time the file was created or last modified.
Filename	File or directory name.

Permission Categories (Classes)

After the file type character, the next nine characters represent the permissions of the file or directory. These are divided into three sets of three permissions each. There is one set for each category of users: user, group, or other. Permissions of the user are the first set of three permissions. The second set applies to the group that the user belongs to. The third set applies to all other users:

- **File type** determines whether it is a directory or a file. This is not part of the permissions.
- **User (owner)** is the user who created or owns the file or directory.
- **Group** is the group of users defined by the system administrator.
- **Others (public)** is all other users other than user or group.

It is important to understand each of the categories or classes of users and how file and directory access permissions affect them. The categories and permissions associated with users determine who can access these resources and what they can do with them.

Figure 10-5 shows the **ls -l** listing for the .profile file. The first 10 characters of the display represent the file type and the permissions for the file. The dash in the first position indicates that this is a file. The user or owner (user2) permissions are read and write (**r w -**), the group (**staff**) permissions are read (**r - -**), and the other (all other users) permissions are read (**r - -**).

Figure 10-5 Directory Listing for the .profile File

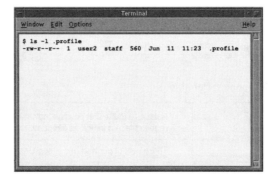

The following sections provide a more detailed explanation of the file type indicator and the three permission categories.

File Type

As previously mentioned, the first character is not a category, but it refers to the file type. An ordinary file is represented by a dash (-), and a directory is represented by a *d*. A dash anywhere

else in a permission set indicates no permission is given. The interpretation of permissions is slightly different for files and directories.

User (Owner)

The next three characters are the user or owner permissions. These three characters show the type of access that the owner of the file or directory has. User permissions are always listed first. When the user creates a new file or directory, the user owns it. The owner of the file .profile in Figure 10-5 is user2.

Group

The second set of three characters, called *group permissions*, identifies the permissions of the group that owns the file and always follows user permissions. A user group or system group is a set of users with common file access needs. System administrators define system groups and determine which users belong to which groups. For example, a system administrator may establish an accounting group or a management group. Users in the same group can access each other's files based on the group permissions. The group owner of the file .profile in Figure 10-5 is the group staff.

Others (Public)

The last set of characters, called others permissions, are the permissions that everyone else has. Others refer to anyone who is neither the file owner nor a member of the group that owns the file, but who has access to the system. Other permissions always follow group permissions.

Applying Permission Based on Category

Users own the files that they create. The group association on these files is the user's primary group. Access is determined by the highest category to which the user belongs. The user or owner category has a higher priority than the group category. The group category has a higher priority than the others category. A user who is the user or owner, even though a member of the group, will have only user category of permission applied. The permissions for others apply only to someone who is neither the owner of a file or directory nor a member of the group the owner belongs to. As an example, you are the owner of a file and have read, write, and execute permissions. The group you belong to has permissions for read access, and others have no access. User permissions have a higher priority than group permissions. Therefore, the user permissions will be read, write, and execute, which are the permissions of the user or owner category. If someone from the user's same group tries to access the file, that person will be able to read it only. Anyone else or others will not be able to access the file at all.

Permission Types

Every file or directory has a set of permissions that determines who can do what with that file or directory. Permissions are represented by characters. These characters control which users may read, write, and execute the contents of a file or directory. The set of permissions for each category of users (users, group, or other) consists of three possible permission types. These are used to control access to the file or directory with which the permissions are associated. The first position in each set is the read (**r**) permission, the second is write (**w**), and the third is execute (**x**). You might see a dash (**-**) in place of **r**, **w**, or **x**. This indicates that the permission of **r**, **w**, or **x**, where the dash is located is denied. Figure 10-6 shows the permissions for the .profile file in the /home/user2 directory. This is a text file that usually is placed in the user's home directory by the system administrator. When the user logs in, this file is read, and the environment is tailored to the user's needs. This file can be read or viewed. The file can also be written to or modified by the user. The set of permissions for user access to this file is **r w -**. The presence of the **r** allows the owner to read the file, and the **w** allows the user to write to or modify the file. The absence of an **x** means that the user cannot execute the file because this is not an executable file. A dash is used in place of a permission that is not allowed. The group and other categories of users can read the file but cannot write to it or execute it.

NOTE

To copy (**cp**) a file from a directory or move (**mv**) a file into or out of a directory, the user must have the execute (**x**) permission for the directory. The user also must have the read permission for the file being copied or moved. Changing the permissions on a folder does not change the permissions for that folder's subfolders and files. To change permissions on a folder and all of its subfolders, use the **chmod -R** (recursive) command covered later in the chapter. By default, directories have read and execute permissions. Without these permissions, a user would be unable to access any of the content within the directory. Access problems sometimes can be traced back to a user who accidentally or intentionally removed read and/or execute permissions on a directory.

Figure 10-6 Permissions for the .profile File

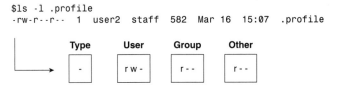

Figure 10-7 shows the permissions for the mkdir file in the /bin directory. This is an executable UNIX command file, which you have used previously to create new directories. Because all users need to be able to use the **mkdir** command, all three categories of users have the permission to read the file and to execute it. The set of permissions for user, group, and other access to this file is **r - x**. The presence of the **r** and **x** allows the user, group, and other to read and execute the file. The dash in place of the write permission prevents the user, group, or other from writing to or changing the file.

Figure 10-7 Permissions for the mkdir File

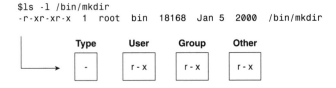

Meaning of Permissions for Files and Directories

The meaning of the **r**, **w**, and **x** permissions vary depending on whether the user is working with a file or a directory. Figure 10-8 shows the three possible permissions and the differences in the permission's effect on files and directories. For a directory to be of any practical use, at least read and execute permissions must be set. Figure 10-9 shows several examples of the different permissions for files and directories.

Figure 10-8 File Versus Directory Permissions

Permission	Symbol	Plain File	Directory
Read	r	File can be displayed or copied (copied file takes on new owner). Can't move or remove a file with only read permission.	Contents can be listed with the **ls** command Must also have execute permission to use **ls** command options.
Write	w	File can be modified, moved, and removed (only if the directory it resides in has write permission).	Files can be added or deleted. Directory must also have execute permission.
Execute	x	File can be executed (shell script or executables).	Controls access to the directory. A user can **cd** to the directory and list the contents. Files can be moved or copied to the directory.
No permission	-	A dash indicates permission is denied.	A dash indicates permission is denied.

Figure 10-9 Permission Examples

Permissions	Interpretation
-rwx------	The file is read/write/execute for user only.
dr-xr-x---	The directory is read/execute for user and group.
-rwxr-xr-x	The file is read/write/execute for user, and read/execute for group and others.
drwxr-x--x	The directory is read/write/execute for user, read/execute for group, and execute for others.
-r-xr-xr-x	The file is read/execute for user, group, and others. Common for scripts and executables.

Determining File and Directory Access

All files and directories have a user identifier (UID) and group identifier (GID) number associated with them. The kernel uses these numbers to identify ownership of files rather than the user or group name familiar to the user. The **ls -n** command displays the numeric UID and the GID, as shown in Figure 10-10. Note that in the figure, the **-a** (all) option was included to see the .profile file that normally is hidden. Figure 10-10 also shows two other useful commands when working with UIDs and GIDs. The **id** command displays numeric and alphabetic UIDs and GIDs for the effective user identifier (EUID – covered later). The **groups** command displays all the groups you are a member of.

Figure 10-10 Displaying the User Identifier (UID) and Group Identifier (GID)

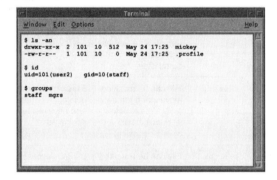

Process for Determining Permissions

Every system process is initiated by the operating system. Every system also has a UID and GID, depending on who initiated the process. When a process or user attempts to read, write to, or execute a file, the UID and GID of the process are compared. First compared to the UID of the file or directory and then to the GID. If neither matches, the other category of permissions is used. When a match is made, the permissions specified on the file or directory for that category of user as a user, group, or other, are applied. To determine whether the user should be permitted to perform the action, the user ID and group ID of a file or directory are compared to the allowable access list for the file or directory. The flowchart in Figure 10-11 illustrates the logic applied to determine access a file or directory. This flowchart is applied to a user attempting to perform an action such as viewing (**cat**) a file.

Default Permissions

When a user accesses the system, files and directories are protected by *default permissions*. These default permissions are put in place automatically when a file or directory is created. The default permissions for a new file are read/write for the user or owner who created the file, and read for group and other. For directories, the default permissions are read/write/execute

for the user and read/execute for group and other. Figure 10-12 shows the default permission for a new file created with the **touch** command and a new directory created with the **mkdir** command. The default size for a new directory is 512 bytes. A new empty file is 0 bytes.

Figure 10-11 User Attempting to View (**cat**) a File

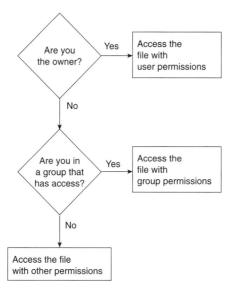

Figure 10-12 Default File and Directory Permissions

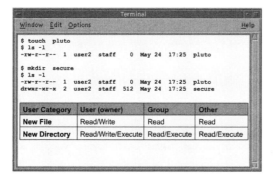

User Category	User (owner)	Group	Other
New File	Read/Write	Read	Read
New Directory	Read/Write/Execute	Read/Execute	Read/Execute

 e-Lab Activity 10.2 Access Permissions

In this activity, you list the permissions for some files and directories. You will then answer several questions regarding ownership and permissions. Your current working directory is /home/user2/dir2. Refer to e-Lab Activity 10.2 on the accompanying CD-ROM.

 Lab Activity 10.2.4 Determining File System Permissions

In this lab, you become familiar with file system permissions. You display permissions on files and directories, interpret the results, and evaluate the effect on various user categories. Refer to Lab 10.2.4 in the *Cisco Networking Academy Program Fundamentals of UNIX Lab Companion*, Second Edition.

Changing Permissions from the Command Line

File and directory permissions can be changed using the **chmod** (change mode) command or with a graphical file manager. The default permissions for a file or directory will be adequate for most security needs. However, the user may want to change the permissions on a file or directory. By default, all files are created with permissions that allow the user category of others to read the file. This means that *anyone* with a login ID can see the contents of the file and copy it. For classified files and private information, the user should remove the read permission from the others category.

Shell scripts are another example where the user would want to change permissions. When a user creates a shell script file or any file, the default permissions do not include execute. This is even the case for the owner or creator of the file. To run the shell script, the user must change the permissions by adding the execute permission, as shown in the Figure 10-13.

Figure 10-13 Changing Permissions

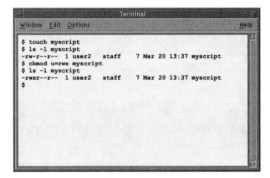

chmod Command

The **chmod** command is used by a file's owner, or superuser, to change file permissions. The two modes of operation with the **chmod** command are symbolic (or relative) and octal (or absolute):

- **Symbolic mode** uses combinations of letters and symbols to add or remove permissions for selected categories of users. Symbolic mode also is referred to as relative mode.

- **Octal mode** uses octal numbers to represent file permissions and is used to set permissions for all three categories of users. Octal mode also is referred to as absolute or numeric mode.

Symbolic (Relative) Mode

When using symbolic mode to set permissions, the user typically works with one category of users. However, the user can give all categories the same permissions simultaneously. The mode is referred to as relative because the user is assigning or removing permissions relative to the ones that already exist. The user can add one or more permissions to a specific category of users or take them away. The command format for symbolic mode is as follows:

```
chmod mode filename
```

The mode portion of the command format is made up of three parts, as explained here and shown in Figure 10-14:

- **Who** is the category of users the user is working with (**u**, **g**, **o**, or **a**).
- **Op** is the operator or what the user is going to do. For example: set (**=**), remove (**–**), or give (**+**).
- **Permissions** are permissions or permission assigned to the file or directory. For example: read (**r**), write (**w**), or execute (**x**).

Figure 10-14 Symbolic Mode Parts

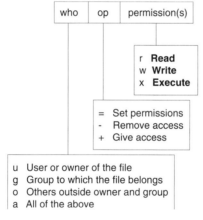

Figure 10-15 shows several examples of assigning permissions using symbolic mode.

e-Lab Activity 10.3 Changing Permission (Symbolic)

In this activity, you use **ls –l** command to verify the current permissions of files. You then use the **chmod** command to change permissions using the symbolic mode. Your current working directory is /home/user2/dir2. Refer to e-Lab Activity 10.3 on the accompanying CD-ROM.

Figure 10-15 Changing Permission with Symbolic Mode

```
Remove (deny) group read permission:
$ ls -l dante
-rw-r--r--  1  user2  staff2  Jun 11  1:44  dante
$ chmod g-r dante
$ ls -l dante
-rw-r--r--  1  user2  staff2  Jun 11  1:44  dante

Deny read permission to others:
$ chmod o-r dante
$ ls -l dante
-rw-------  1  user2  staff2  Jun 11  1:44  dante

Add execute permission for owner, and read permission for group and others:
$ chmod u+x,go+r dante
$ ls -l dante
-rwxr--r--  1  user2  staff2  Jun 11  1:44  dante
Note: There is no space after u+x and before go+r, although there is a
comma between them.

Set permissions to read and write for everyone:
$ chmod a=rw dante
$ ls -l dante
-rw-rw-rw-  1  user2  staff2  Jun 11  1:44  dante
```

Octal (Absolute) Mode

Octal mode provides a quick numeric means of changing permissions for all categories of users simultaneously. Octal mode will still allow each set of permissions to be different. This mode also is referred to as absolute because the permissions that the user applies will explicitly replace the existing ones even though the permission sometimes will be the same.

There are three sets of permissions, one set for each category of users, as a user, group, and other. There are three possible permissions for each set as **r**, **w**, and **x**. Each set of permissions for a category of users can be assigned a numeric value from 0 to 7, depending on which permissions are allowed. The mode is referred to as octal because there are eight possible values for each set of permissions.

Calculating Permission Values

Associating each of the three positions of permission types **r**, **w**, **x**, with a power of 2, each can be represented with a number. By adding the numbers, the user can get a total that represents all three permissions for that category of user. The category of user is the user, group or other. Figure 10-16 shows how this is accomplished using the first set of user permissions as an example (**rwx**). In this example, the user has read (**r**), write (**w**), and execute (**x**) permissions. If the permission is allowed, count the value in the total. If the permission is not allowed, then it is not counted.

Figure 10-16 also shows that each set of three permissions can be represented by one number, from 0 to 7, by adding the values of the three positions. After adding the position values, associate or assign that value with the category of user. Categories of users are user, group,

and other. The number 7, as 4 + 2 + 1, would be associated with the user category. Next, you could move on to group category, add its values, and assign that number to group. Finally you move on to other category and assigns that number to other. When all three categories of users are completed, you will have a three digit number representing the permissions for all three categories of users.

Figure 10-16 Octal Mode: User Permission

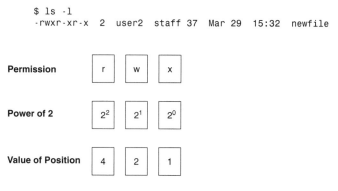

Value Assigned to 'User' Category of User: 7

Using chmod with Octal Mode

The command format for the octal method of changing permission is similar to that of the symbolic method. However, it is not necessary to specify the category of users because the position of each number represents the category. Figure 10-17 shows the value of each permission separately and the values of all possible sets or combinations of the three permissions.

The octal mode is made up of three numbers, each of which is the sum of the three permissions for one of the user categories. The categories are user, group, and other. Octal values are combined to identify the octal mode that is used with the **chmod** command. The following shows first the format for using the **chmod** command in octal mode with a file and then shows the format with a directory:

```
chmod octal_mode filename
```

or

```
chmod -R octal_mode directoryname
```

Some common examples of the combined octal values for all three categories are shown in Figure 10-18. The first octal value defines the user or owner permissions. The second octal value defines the group permissions. The third octal value defines others. Default permissions on files have an octal value of 644, and default permissions on directories have an octal value of 755. Most scripts and executable files have an octal value of 555.

NOTE

When using octal mode with the **chmod** command, you must list all three numbers, one for each category: user, group, and others.

Figure 10-17 Octal Values

Octal Value	Permissions
4	Read
2	Write
1	Execute

Octal Value	Sum of Permission Category Values	Corresponding Permissions	Definition
7	4 + 2 + 1	r w x	Read, write, and execute
6	4 + 2 + 0	r w -	Read and write
5	4 + 2 + 0	r - x	Read and execute
4	4 + 0 + 0	r - -	Read only
3	0 + 2 + 1	- w x	Write and execute
2	0 + 2 + 0	- w -	Write only
1	0 + 0 + 1	- - x	Execute only
0	0 + 0 + 0	- - -	No permissions

Figure 10-18 Combined Octal Mode Values and Common Permissions

Octal Value	Permissions	Notes
555	r-xr-xr-x	Standard permissions for executable UNIX commands such as **cat** and **pwd**.
644	rw-r--r--	Default permissions for file.
755	rwxr-xr-x	Default permissions for directories.
744	rwxr--r--	Typical permissions for user script file.
777	rwxrwxrwx	All permissions to everyone (open).

Figure 10-19 illustrates several examples using the **chmod** command to change permissions with octal mode. The first example shows the existing read and write permissions, as 4 + 2 + 0 = 6, are replaced by the read and execute permission, 4 + 0 + 1 = 5. The second example shows the two number 7s representing all permissions for user and group, as 4 + 2 + 1. The number 5 represents read and execute permissions for others, as 4 + 0 + 1, which remains unchanged. In the last example, the group permissions of read, write, and execute, as 4 + 2 + 1 = 7 are replaced with read and execute, 4 + 1 = 5.

Figure 10-19 Changing Permission with Octal (Absolute) Mode

```
Give user, group, and others read and execute permissions:
$ ls -l dante
-rw-rw-rw-  1  user2  staff2  Jun 11  11:54  dante

$ chmod 555 dante
$ ls -l dante
-r-xr-xr-x  1  user2  staff2  Jun 11  11:54  dante

Change user and group permissions to include write access:
$ chmod 775 dante
$ ls -l dante
-rwxrwxr-x  1  user2  staff2  Jun 11  11:54  dante

Change group permission to read and execute:
$ chmod 755 dante
$ ls -l dante
-rwxr-xr-x  1  user2  staff2  Jun 11  11:54  dante
```

The **-R** option recursively changes permissions on directories and all files. This is a quick way to change the permissions on all subdirectories and files in a directory at once.

e-Lab Activity 10.4 Octal Permission Conversion

In this activity, you practice converting file permissions into octal mode. The first 10 positions of the **ls -l** listing for a file are given and you must enter the correct three-digit octal equivalent. Click **New Permission** to present a new set of permissions and then click **Check Answer** after you have entered the octal value. Remember to strip off the file type in the first position. Refer to e-Lab Activity 10.4 on the accompanying CD-ROM.

e-Lab Activity 10.5 Changing Permissions (Octal)

In this activity, you will use **ls –l** command to verify the current permissions of files. You will then use the **chmod** command to change permissions using the octal mode. Your current working directory is /home/user2/dir2. Refer to e-Lab Activity 10.5 on the accompanying CD.

Lab Activity 10.3.3 Changing Permissions from the Command Line

In this lab, you analyze and change UNIX file system security permissions using command-line utilities. Refer to Lab 10.3.3 in the *Cisco Networking Academy Program Fundamentals of UNIX Lab Companion*, Second Edition.

Changing Default Permissions with umask

Discussed earlier in this chapter, default permissions automatically are applied to new files of 644 (user=rw, group=r, other=r) and directories of 755 (user=rwx, group=rx, other=rx). In

most cases, the default permissions are adequate. However, in some case you might want to change the default permissions to create a group of files with different permissions. Your options are to create the files using default permissions and then changing permissions with the **chmod** command, or to use the **umask** command.

The **umask** command tells which permissions to withhold or mask out. The **chmod** command specifies which permissions to grant. Execute (**x**) permissions are not considered when determining the umask. Therefore, you cannot set the default permissions to include execute permissions for user protection.

The easy way to calculate the umask is to take 666 (rw-rw-rw-) for files, the maximum permissions for a nonexecutable file, and 777 (rwxrwxrwx) for directories, and subtract the desired new permission. For example, if the desired new permission for new files is 740, you subtract 740 from 666, which results in an umask of 026. Omit negative numbers from the calculation. Put as a subtraction problem, it would look like this:

<div style="float:left">

TIP

To return the umask to the original value, either use the **umask** command or log out and log back in again. The default umask on UNIX systems is 022. Changes to the umask are lost when the user logs out of the system unless it is placed in the login initialization file.

</div>

```
rw-  rw-  rw- (permissions start calculation with 666)
minus
rwx  r--  --- (desired new file permissions 740)
equals
---  -w-  rw- (calculated umask of 026)
```

Use the **umask** command to display and set the umask:

```
umask (displays current umask)
umask umask_value (sets umask)
```

The umask value applies to both files and directories. Users often calculate the umask for files without applying it to directories. In some cases, the umask is sufficient for files but is not desirable for directories. For example, an umask of 026 would result in file permissions of 640 and directory permissions of 751. An umask of 027 would result in the same file permissions of 640, but directory permissions of 750. This would mean no execute permission for the directory. Refer back to Figure 10-8 to realize the impact of having no execute permissions on a directory.

Changing Ownership

When a file or directory is created, the owner or user is automatically assigned. In Linux, only the superuser or root can change ownership. In Linux, using the **chown** (change owner) command transfers ownership from one user to another. In Solaris both the current file owner and root can use the **chown** command.

When the ownership is changed for a file, the user is no longer the owner. The user may or may not be able to access the file even though it is in the user's directory. Because the user is

no longer the owner, group or other permissions will determine the access. The following shows the syntax for the **chown** command for a file and then for a directory:

```
chown new_owner filename
```

or

```
chown -R new_owner directoryname
```

Like the **chmod** command, the **-R** option recursively changes ownership on directories and all files. This is a quick way to change ownership on all files in a directory at once.

If a user copies a file to your home directory, that user is still the owner. You cannot use the **chown** command to make yourself the owner. Only the owner (Solaris) or root (Solaris and Linux) can change ownership. In most cases, there will be read permissions on the file allowing you to make a copy. When the file is copied, you become the owner of that copied file. Some systems might be set up to prevent the use of the **chown** command for security reasons. When this is the case, contact the system administrator.

Primary and Secondary Groups

A user can belong to two types of groups:

- **Primary group**—Each user must belong to a primary group. A user's primary group is determined by the system administrator at the time the user account is created, and it is stored in the /etc/password file. See Chapter 2, "Accessing a System and UNIX Graphical Interfaces." The primary group is the group the operating system assigns to files and directories created by the user. The **chgrp** command, to be mentioned later, is used to change primary group ownership of a file.

- **Secondary group (or groups)**—Each user also can belong to between 8 and 16 secondary groups. The number of these secondary groups depends on the version of UNIX/Linux. These groups are stored in the /etc/group file.

When a user logs on, that user obtains a primary group from the /etc/passwd file. Next, the /etc/group file is scanned looking for the login name and any additional groups that the user belongs to. This enables a user to belong to several groups at the same time for file and directory access purposes.

Figure 10-20 shows how group membership is assigned when user2 logs on. In this example, the /etc/passwd file is read to determine the primary group of staff. The /etc/group file is read to determine that the user is also a member of the managers (mgrs) and the accounting (acctg) secondary groups. As a result, user2 will have permissions to any files and directories assigned to any of the three groups, primary or secondary.

TIP

To determine the user's primary and secondary groups, use the **id -a** command or the **groups** command. The **id** command is covered later in the chapter.

Figure 10-20 Primary and Secondary Groups

After logging in, User2 is a member of the staff primary group as well as the managers (mgrs) and accounting (acctg) secondary groups.

Changing the Primary Group

Current group functionality came from BSD UNIX and was implemented in SVR4. When a user logged on prior to SVR4, that user could belong to only one group at a time, the primary group, by default. A user would use the **newgroup** command to switch to another group temporarily. A user could switch to only another group in which she was a member.

Today, the **newgroup** command is used to temporarily change primary group membership to another group. The user must be a member of that group, in order to run programs or create files with other than the primary group membership.

Changing Group Ownership

When a file or directory is created, the user's primary group automatically is assigned. In Linux, only the superuser (root) can change group ownership using the **chgrp** (change group) command to transfer group ownership from one group to another. In Solaris both the current file owner and root can use the **chgrp** command. The format for the **chgrp** command is shown here:

```
chgrp new_group filename
```

or

```
chgrp -R new_group directoryname
```

Like the **chmod** command, the **-R** option recursively changes group ownership on directories and all files. This is a quick way to change the group ownership on all files in a directory at once.

Changing Permissions with CDE File Manager

The CDE File Manager utility provides a graphical interface to the file system and can be used to view or change file and directory permissions. The user must have adequate

permissions to change permissions. The user can view and change the properties for a file or directory. The user selects the file or directory from the File Manager window and then chooses Properties from the Selected menu. (See Figure 10-21.)

Figure 10-21 Properties from the Selected Menu

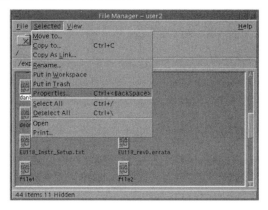

An alternate method is to right-click the file or directory and choose **Properties** from the menu displayed, as shown in Figure 10-22.

Figure 10-22 Properties by Right-Clicking

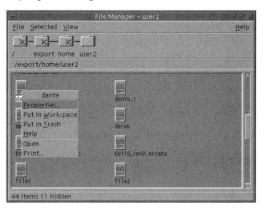

Figure 10-23 shows the Properties window for the dante file. Clicking the **Information Category** button enables you to view information about the file, such as file size and last modification date. Clicking the **Permissions** button enables you to view and change permissions. To change permissions for a user category, select the desired permission by clicking the check box. The user categories are the user or owner, group, or other. With this screen, you also can see the access control list for the file.

Figure 10-23 Properties Window

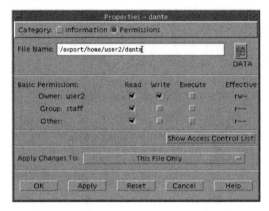

When working with files, click the **Apply Changes To** button. This allows you to have the option of applying the changes to the following:

- This file only
- All files in the parent folder
- All files in the parent folder and its subfolders

When working with directories, click the **Apply Changes To** button. This allows you to have the options of applying changes to the following:

- This folder only
- This folder and its subfolders

Lab Activity 10.4.1 Changing Permissions with File Manager

In this lab, you work with the Common Desktop Environment (CDE) File Manager to analyze and make changes to file system permissions. The CDE File Manager utility provides a graphical interface to the file system and can be used to view or change file and folder permissions. Refer to Lab 10.4.1 in the *Cisco Networking Academy Program Fundamentals of UNIX Lab Companion*, Second Edition.

Changing Permissions with GNOME Nautilus

The Nautilus desktop manager that comes with GNOME provides a graphical interface for file management similar to CDE. This desktop manager can be used to view and change permissions for files and directories. As with command line and CDE, a user must have adequate permissions to change permissions. Note the process of changing permissions described here will vary depending on the version of GNOME and Nautilus you are using. Comparable functions, however, should be available and may be on a different menu.

The properties for a file or directory can be viewed and changed by clicking the **Tree** tab and then navigating to the file. The projects file icon in the /home/user2 directory is highlighted in Figure 10-24. Choose **Show Properties** from the File menu or right-click the file icon and select from the pop-up menu.

Figure 10-24 Selecting the Projects File in Nautilus

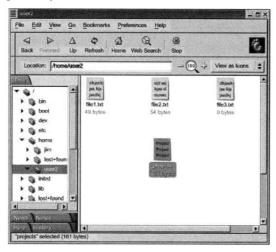

Figure 10-25 shows the Properties window for the projects file. Clicking the **Basic** tab enables you to view information about the file, such as file size, last modification date, and MIME type. Clicking the **Permissions** button enables you to view and change permissions. To change permissions for owner or user, group, or other, select the desired permission by clicking the check box. Click the **X** to close the window when finished to save changes.

Figure 10-25 Properties Window for the Projects File

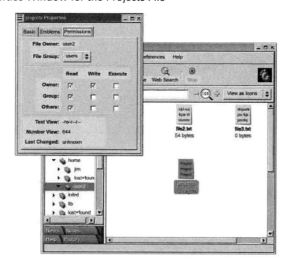

When working with file and directory permissions using Nautilus, you can change only the permissions for an individual file or directory.

Identifying and Switching Users

Working on a multiuser system sometimes you need to know information about a particular user or see a list of those users currently logged on the system. In addition, as you are working on a system it is sometimes necessary to switch user accounts in order to access directories, files, and commands because your account does not have permission.

Identifying Users with the who and finger Commands

Two main commands display who is using the system: **who** and **finger**. The **who** command displays information about all users currently logged on to the local system. This command lists the user's name, terminal, login time, idle time on the terminal line, and the host machine name. Figure 10-26 shows some examples using the **who** command. The host name is the name of the computer the user is logged in from.

Figure 10-26 Using the **who** Command

```
Displaying Users on the System
$ who
user2 console May 24 10:17   (buckeye)
user3 pts/4    May 24 17:36  (wildcat)
$

Use the who -H option to print column headings
above the regular output.
$ who -H
NAME     LINE      TIME
user2    console   May 24 10:17  (buckeye)
user3    pts/4     May 24 17:36  (wildcat)
$

Use the who -q option to display only the names
and the number of users currently logged on.
$ who -q
user2 user3
# users=2
$
```

TIP

Use the **finger** command plus a specific user's address to find out about users on other local (**finger jdoe@hal**) or remote (**finger jdoe@ informance.com**) systems. Many times when you **finger** a remote system, you might not get a response, or you might get a "connection refused" message because access was prevented for security reasons.

The **finger** command displays the same information as the **who** command. The **finger** command also has more specific user information such as the user's full name from the /etc /password file, how long since the user has been idle, the host name, if logged in remotely and last login. When one or more username arguments are given (**finger mmouse dduck**), more detailed information is given for each username specified. This is true whether that user is logged in or not. Figure 10-27 shows some examples using the **finger** command.

Figure 10-27 Using the **finger** Command

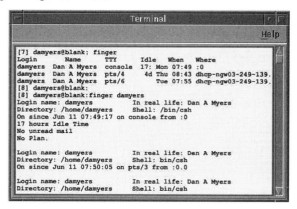

Switching to Another User Account

A user can temporarily switch to another user account to access files and directories that belong to that user by using the **su** (substitute or switch user) command. The user will sometimes need to switch to another user account to modify files that the user owns or to do something on that user's behalf. Administrators typically utilize the **su** command when troubleshooting user problems or to test authorization and account behavior with certain applications. When switched to another user's account, the user will have access to the same files that the other user has. The following shows the syntax for the **su** command:

su [-] *username*

To switch user IDs, the password must be supplied of the user ID that you are switching to. However, if you are currently logged in as root then the password does not need to be supplied. When switching to another user account, you become that user and has all access and privileges that the user has. To switch back to your previous user ID, type **exit**.

Figure 10-28 shows two examples of the **su** command. In the first example, **su** is used without options. When **su** is used without options, the user does not change directory locations. Environmental settings customized for the original user ID also remain in effect. To switch to another UID and have the system read the new user's initialization files, you must use a dash (-) or hyphen between the command and the new user ID, as shown in the second example.

If **su** is used without specifying options or a user account to switch to, the user switches to the superuser or root account. To acquire the superuser's environment settings you must use the **su -** command. This command can be especially important when trying to run commands as root. This is because the superuser or root account will usually have a path to executable programs in directories that users do not have. System administrators normally work under their regular user account. However, system administrators will use **su** to root when necessary to perform administrative tasks. As with switching to another user account, the root account requires knowledge of the root password before the system allows the user to switch accounts.

Figure 10-28 Switching Users with the **su** Command

User Account Information

The login ID that the user used to initially log in to a UNIX system is the ***real user ID (RUID)***. While logged in, you can switch to another user's ID. You can become that user for a period of time to modify files that the user owns or to do something on that user's behalf. You will have all the same characteristics and permissions of that account. This now becomes your ***effective user ID (EUID)***.

Table 10-1 shows the **who am i** and **id** commands that can be used to help determine user identity when working with different user accounts. The **who am i** command shows the user RUID (real user ID). The **id** command in Figure 10-29 shows the user EUID (effective user ID). The **id** command also can be used with the **-a** (all) option to show all groups that the effective user is a member of.

Table 10-1 User ID Commands

Command	Function
who am i	Displays information about your real user ID (RUID). If you use the **su** command to switch from one UID to another, the **who am i** command will display your original login UID (RUID) and lists the terminal line, and the date and time logged on.
id [*option(s)*]	Displays the username corresponding effective UID (EUID). Use the **id -a** command to identify the username, user ID, and all of the groups to which the user belongs. In this example the user is identified as guest and belongs to the groups staff and sysadmin. The listing for **gid** identifies the user's primary group and the groups listing identifies all groups to which the user belongs.

Figure 10-29 Displaying RUID and EUID

Note: In this example you are logged in as user2

```
Displaying your current or Effective UID
$ id
uid=115(guest) gid=10(staff)

Displaying your EUID with group information
$ id -a
uid=115(guest) gid=10(staff) groups=10(staff) 14(sysadmin)
```

```
Displaying your Real UID with login information
$ who am i
user2 console May 24 10:17
```

e-Lab Activity 10.6 Identifying Users

In this activity, you use the **who** command to identify users logged in to your system. You will use the **who am i** command to display your real user ID (RUID) and then use the **su** command to switch to another user. Next, you use the **id** command to see your new effective user ID (EUID). Your current working directory is: /home/user2. Refer to e-Lab Activity 10.6 on the accompanying CD-ROM.

Lab Activity 10.5.3 User Identification Commands

In this lab, you use advanced UNIX commands to determine your identity and the identity of other users logged on to a system. Refer to Lab 10.5.3 in the *Cisco Networking Academy Program Fundamentals of UNIX Lab Companion*, Second Edition.

Summary

After having completed this chapter, you should have an understanding of the following:

- File system security is a key component of an overall network security policy.
- An overall network security policy should include the following:
 - Physical equipment access security
 - Login/password security
 - File system security
 - Virus protection
 - Remote access security
 - Internet firewall
 - Data backups
 - Disaster recovery plan
 - Audits

- Files and directories are protected by access permissions. The **ls -l** (list long) command lists the permissions of a file or directory. These permissions are assigned to three user categories: user, group, and other. The user is the owner of the file or directory. Group is the primary group that the user belongs to, and other represents all other users.

- Three types of permissions can be applied to each file or folder, one set for each user category. These are read, write, and execute. Read protects a file but allows its contents to be viewed. Write allows the contents to be modified, and execute allows programs and shell scripts to be run. The meaning of permission types varies somewhat between file and directories.

- Permission can be changed from the command line by using the **chmod** (change mode) command. This command can be used in symbolic (relative) mode or octal (absolute) mode. Symbolic mode uses characters to represent the user category and permission types. The characters for the user category are: u = user, g = group, and o = other. The characters for the permission types are: r = read, w = write, and x = execute. Octal mode uses numbers from 0 through 7 to represent the permissions based on their total value of the permission for one of the three user categories.

- File and directory ownership can be changed using the **chown** command. Group ownership can be changed using the **chgrp** command.

- Users are always a member of a primary group that is defined by the system administrator. Users also can be a member of other secondary groups.

- Permission also can be changed using the CDE File Manager or GNOME Nautilus utilities. By selecting a file or directory and clicking Properties, the user can view statistics for a file or directory and view or change its permissions.

- Several commands are available to discover information about logged-in user accounts. The **who** command can display all the users currently logged on to a particular machine. The **finger** command displays more detailed information about who is logged on to a local or remote machine. The **who am i** command displays the user's RUID, and the **id** command display the user's EUID if the user has switched to another user's account. The **id** command also can be used to see what groups a user is a member of. The **su** (switch user) command allows you to temporarily assume another user's account for access to that user's files or for testing and troubleshooting purposes.

Check Your Understanding

1. File system security is part of an overall network security policy that includes other areas. Which of the following is another facet of the comprehensive security policy?

 A. Weekly log rotation

 B. Network performance review

 C. Cable testing

 D. Periodic audits

2. File- and directory-level security permissions are assigned to allow or disallow access to which of the following?

 A. User, superuser, and group

 B. User, group, and other

 C. Machine, group, and domain

 D. User, team, and world

3. Each user category can be assigned three types of permissions to files and directories with the UNIX file system. When issuing the **ls -l** command, permissions are displayed in what order?

 A. Read, write, and execute

 B. Copy, modify, and delete

 C. Execute, write, and read

 D. View, change, and execute

4. To allow a user to view or modify the contents of a file, the user would need which of the following permissions?

 A. Read and change

 B. Read and modify

 C. Read and execute

 D. Read and write

5. You create a script file using vi, but you are unable to run the script. What is the problem?

 A. You have not compiled the script to an executable.

 B. You are not assigned the execute permission to the file.

 C. You are not the owner of the file.

 D. You must belong to the administrators group to run a script file.

6. A file has the following permissions: **- r w x r - - r - -**. Which of the following actions can the group perform?

 A. Execute the file

 B. View the file

 C. Change the file

 D. Delete the file

7. Which of the following file permissions allow the user to view, modify, and run a file, allow the group to view and modify the file, and allow others to view the file?

 A. -rw-rw-rw-

 B. drwxrw-rw -

 C. -rwxrw-r--

 D. -r--rw-rwx

8. Using symbolic mode, which of the following commands would add the execute permission to the group for the file *filename*?

 A. chmod g+x *filename*

 B. chmod u+e *filename*

 C. chmod g-e *filename*

 D. chmod o+x *filename*

9. Which of the following commands would grant read, write, and execute permissions to a user, read and write permission to a group, and read permission to others?

 A. chmod 742 *filename*

 B. chmod 764 *filename*

 C. chmod 754 *filename*

 D. chmod 761 *filename*

10. File Manager can be used to set permission on files using which of the following options from the Selected menu?

 A. Attributes

 B. Permissions

 C. Rights

 D. Properties

11. Which of the following commands can be used to display a listing of who is currently logged on to the system, sorted by user ID and displayed one screen at a time?

 A. **whoami | sort | more**

 B. **who | sort | more**

 C. **whois | sort | more**

 D. **id | sort | more**

12. You are logged in as user2, and use the **su** command to switch to the user3 account. Your home folder did not change to that of user3. What could be the problem?

 A. You did not actually switch to the user3 account.

 B. You specified the RUID option when switching.

 C. You must be logged in as root to switch to another user's account.

 D. You did not specify the dash (-) option when switching accounts to invoke user3's environment.

UNIX Command Summary

chgrp Changes the group association of a file. The group might be either a decimal group ID or a group name found in the group ID file /etc/group. Example:

`-R`

`$ chgrp marketing chap15`

`$ chgrp -R engineering cad_dwgs.dir`

chmod Changes file or directory permissions. Example:

To deny execute permission to everyone:

`$ chmod a-x filename`

To allow only read permission to everyone:

`$ chmod 444 file1`

To make a file readable and writeable by the group and others:

`$ chmod go+rw file2`

chown Changes the owner of a file. The owner might be either a decimal user ID or a login name found in the /etc/passwd file. Example:

`-R`

`$ chown bradj chap15`

`$ chown -R jiml book.dir`

finger Displays information about local and remote users. Example:

```
$ finger
damyers  Dan Myers  Console  Thu 19:07
```

```
$finger jdoe@hal
```

groups Displays all the groups that a user is a member of. Example:

```
$ groups user1 user2
user1 : staff
user2 : staff
```

id Returns the current user identity (EUID). Example:

```
-a
```

```
$ id
uid=1002(user2) gid=10(staff)
```

```
$ id -a
uid=1002(user2) gid=10(staff) groups=10(staff)
```

su Allows a user to become superuser or another user. Example:

```
username
```

```
$ su -student6
Password:
$
```

who Lists who is on the system. Example:

```
0H,-q
$ who
user2 console  Apr 30 12:37   (:0)
user2 pts/4    Apr 30 12:40   (:0.0)
```

who am I Displays the identity of who you originally logged in as (RUID). Example:

```
$ who am I
user2 pts/4    Apr 30 12:40   (:0.0)
```

Key Terms

ASET (Automated Security Enhancement Tool) ASET is a Solaris utility that improves security by allowing system administrators to check system file settings, including permissions, ownership, and file contents. ASET warns users about potential security problems. Where appropriate ASET sets the system file permissions automatically according to the specified security level, as either low, medium, or high.

authentication The ability to verify a person's identity.

default permissions The permissions that are assigned automatically when a new file or directory is created.

encryption The software encoding, or scrambling, of information using specific algorithms, usually a string of numbers known as public and private keys.

EUID (effective user ID) If you switch to another user's ID, you have all the same characteristics and permissions of the account that you switched to; this is now your EUID. The **whoami** and **id** commands show your EUID.

firewall A machine running special software to protect an internal network from attacks outside. Internal hosts connect to external networks and systems through the firewall. Can be configured with additional software to act as a proxy server.

group Identifies the users associated with a file. A user group is a set of users who have access to a common set of files. User groups are defined in the /etc/group file and are granted the same sets of permissions.

mode The permissions that currently are set for a file or directory. The mode can be changed using the **chmod** command.

octal (absolute) mode Method of setting permissions that uses numbers to represent file permissions and is used to set permissions for all three categories of users at the same time. Octal mode also is referred to as absolute or numeric mode.

owner The user who creates a file or directory. A different user can be made the owner of a file or directory using the **chown** (change ownership) command.

permission category Category or class of users: *User (owner):* The user who created or owns the file or directory. *Group:* Group of users defined by the system administrator. *Other (public):* All other users (other than user or group).

permissions Attributes of a file or directory that specify who has read, write, or execute access.

primary group Each user must belong to a primary group. A user's primary group is determined by the system administrator at the time the user account is created, and it is stored in the /etc/password file.

RUID (real user ID) The login ID that you use to initially log in to a UNIX system. The **whoamI** command shows your RUID.

SATAN (Security Administrators Tool for Analyzing Networks) SATAN scans ports on computers in a network to probe for points of vulnerability and reports them.

secondary group Each user also can belong to between 8 and 16 secondary groups (depending on the version of UNIX), stored in the /etc/groups file.

superuser A user that can access the root account is called the superuser. The superuser account runs system administration commands and edits critical system files such as the /etc/passwd file. Individuals with root access often are referred to as system administrators. The terms superuser and root have the same meaning and are used interchangeably.

symbolic (relative) mode Method of setting permission that uses combinations of letters and symbols to add or remove permissions for selected categories of users. Symbolic mode also is referred to as relative mode.

Umask The system setting that determines what the default permissions will be for newly created files and directories. The umask can be changed using the **umask** command.

■ Objectives

After reading this chapter, you will be able to

- ■ Describe the components of the UNIX and Linux printing environments.
- ■ Perform command-line printing using the **lp** and **lpr** commands.
- ■ Manage print queues and print jobs using the **lpstat** and **cancel** commands (SVR4) and **lpq** and **lprm** commands (BSD).
- ■ Use the CDE Print Manager to print files and manage print queues.
- ■ Use the GNOME Printer Applet to print files.

Chapter 11

Printing

Introduction

Printing services are an essential component of any network operating system. UNIX and Linux provide local and remote printing capabilities. In this chapter, you learn about the various hardware and software elements that provide printing services in the UNIX and Linux environments. You work with several methods of printing. You learn printing from the command line, CDE File Manager, CDE Print Manager, and the GNOME Print Applet. You learn how to determine the status and availability of network printers that can be printed to. You learn how to monitor the print queue status. You learn how to manage print requests using UNIX and Linux commands and CDE and GNOME print managers.

UNIX Printing Environment

All network operating systems must provide users with the capability to print to local and remote printers. With the UNIX printing environment, users can have local printers attached to their workstations and also can print to remote network printers.

Printing Environment Components

Three main components exist in the UNIX printing environment:

- *Printer* is a physical printing device. The printer can be attached to a workstation or network server using a parallel cable or, in some cases, a serial cable, as with plotters. Network printers have an Ethernet or other network interface card (NIC) built in. Ethernet and NIC cards are very common in the business environment. These cards can be attached directly to a networking concentration device such as an Ethernet hub or switch. A network cable such as Category 5 (CAT 5) unshielded twisted-pair (UTP) typically is used to connect the printer to the network. Printers can be reserved for use by a particular user or can be centralized to provide access for many users. In Figure 11-2 parallel cables connected to computers attach Local Printer1 and Network Printer3. Network Printer2 is connected directly to the Ethernet switch via a network cable, as are the computers themselves.

- *Printer Name* (**Queue**) is the name of a print queue associated with the physical printer. It is a logical name for the printer, which is assigned by the system administrator. This is the name that the users print to. A name such as hplaser1 describes a particular type of printer, and the number 1 indicates this is the first one installed. A name such as acctg1 might be used to refer to the first printer in the accounting department. A printer description also can be included when defining a printer to specify its location or other characteristics. A print queue is a directory on the hard disk of a print server where print requests from users are stored.

- *Print Server* is the computer that manages incoming print requests and releases those requests, as the printer is ready. Print servers run the printer daemon lpsched, which manages print requests. The print queue is located on the hard disk of the print server. Print requests or print jobs are stored on the hard disk until they are printed, and then are deleted or purged. A print server can be a workstation or a network server. Printers that are attached to a workstation typically use the workstation as the print server and keep the queue with its print requests locally. Printers that are attached to either a network server or directly to the network typically use a network server as the print server, and requests from many users are processed centrally. Centralized print servers can handle multiple printers and queues.

The system administrator sets up the printing environment by installing printers and defining print queues and servers to support them. The system administrator manages the printing environment. The administrator can control the availability of printers, define *default printers*, and decide who can print to which printers. The administrator also can manage the print queue for each printer. The print queue is the list of jobs waiting to be printed. Figure 11-1 shows the printing process. Figure 11-2 shows the major components for printing. Printer1 is attached to the UNIX workstation where the queue for Printer1 resides. Printer2 is directly attached to a network hub. The queue for Printer2 could be on a workstation or server but is typically on a print server. Printer3 is directly attached to the server. The queue for Printer3 is also on the server.

Figure 11-1 UNIX Printing Process

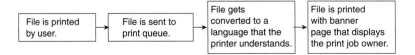

Figure 11-2 UNIX Printing Environment Components

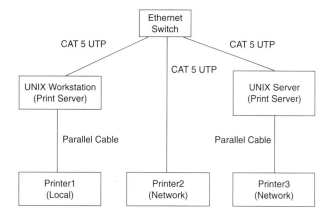

Printer	Physical printing device
Printer Name	Name of the print queue associated with the printer
Print Server	Workstation or server providing printing services

Printing Process

When the user sends a print request to a printer, the request is actually sent to a print queue. The print queue is a special directory that is stored on the hard disk of the user's workstation or on a remote network server. All requests or print jobs go to the queue first. If the printer is available, the request is serviced immediately. If the printer is busy, the request is queued until the printer is available. Every printer, whether attached to a computer or attached directly to the network, must be assigned to a print queue that is located on a computer. Printers usually do not have hard disks or the capability to store print requests.

Figure 11-3 illustrates the process that a print request goes through to be printed. In this illustration, the user at the UNIX workstation is printing a document to network printer Printer2 whose print server is the UNIX server. The user's print request must first go through the Ethernet switch to the UNIX server's print queue. The UNIX server sends it back through the switch to the network attached printer when the printer is ready for it. The user also could print to the local printer, if desired, in which case the user's workstation acts as the print server.

NOTE

A few printers do have a hard disk to store print jobs.

Figure 11-3 Print Request Process

Command-Line Printing with the lp and lpr Print Spoolers

Printing *ASCII* text or *PostScript* files can be done from the command line using the **lp** (line printer) **print spooler** command. Do not use this method to print data files or binary files. Data files are files created in applications such as FrameMaker or Sun's Star Office. The function of the **lp** command is to queue text for printing. The Berkeley version of UNIX (BSD) uses a variation of the **lp** command known as **lpr print spooler**. The Solaris computing environment supports the **lp print spooler**. BSD UNIX systems use the **lpr** command. Solaris supports both **lp** and **lpr** (/usr/ucb/lpr) print commands. Table 11-1 shows the options available for use with the **lp** command, the syntax for which is as follows:

```
lp [-options] [filename(s)]
```

Table 11-1 Print Spooler Options with **lp**

Option	Meaning	Purpose
-d	Destination	Specifies the desired destination printer (if you are printing to your *default printer*, the **-d** option is not necessary).
-o nobanner	Option	Specifies that the *banner page* is not to be printed.
-n	Number	Prints a specified number of copies.
-m	Mail	Sends mail message to user after the print job is complete.

Table 11-2 provides a comparison of System V and BSD print commands.

Table 11-2 System V and BSD Print Commands

Function	System V	BSD
Print file1 to default printer	**lp file1**	**lpr file1**
Print file1 to the hplaser printer	**lp -d hplaser file1**	**lpr -Phplaser file1**
Print file1 with no banner page	**lp -o nobanner file1**	**lpr -h file1**
Print two copies of file1	**lp -n 2 file1**	**lpr -#2 file1**
Print file1 and notify by mail when finished	**lp -m file1**	**lpr -m file1**
Check the print queue	**lpstat**	**lpq**
Check the print queue of the hplaser printer	**lpstat -d hplaser**	**lpq -Phplaser**
Cancel a print job	**cancel** [*job #*]	**lprm** [*job #*]
Cancel all print jobs owned by you	**cancel -u** [*username*]	**lprm -**

TIP

To receive a system-generated e-mail after the print job is complete, use the **lp -m** [*filename(s)*] command. This command is useful if the printer is busy and the user wants to be notified only when the print job is available for pickup.

Most Linux systems implement LPR next generation (LPRng), which also supports both System V and BSD commands. LPRng software is an enhanced, extended, and portable implementation of the Berkeley LPR print spooler functionality. As a result, System V commands such as **lp** and **lpstat** can be used on most Linux systems. The examples in this chapter use the System V commands.

Sending Files to a Printer

Figure 11-4 shows some examples using the **lp** command with various options to print files. The first example sends a file from the user's home directory (~) to the default printer, which is printer1. A system administrator must set up the default printer in advance. The **-7** after the printer name indicates that this is the seventh print job received since the printer came online. Although this example prints only one file, it is possible to send multiple files simultaneously to the printer. Wildcard metacharacters such as * and **?** also can be used.

Figure 11-4 Using the **lp** Command to Print

```
Print the file feathers in your home directory on the default printer:
$ lp ~/feathers
request id is printer1-7 (1 file(s))
$

Use the -d option to specify another printer (if one is available):
$  lp -d staffp ~/feathers
request id is printer1-8 (1 file(s))
$

Use the -o nobanner option to suppress banner page:
$  lp -o nobanner ~/feathers
request id is printer1-9 (1 file(s))
$

Use the -m option to send mail to a user:
$  lp -m dmyers@xyz.com ~/feathers
request id is printer1-10(1 file(s))
$

Use the -n option to specify the number of copies:
$  lp -n 3 ~/feathers
request id is printer1-11(1 file(s))
$
```

Printing Banner Pages

By default, a sheet called a *banner page* is printed before every print job. A banner page identifies who submitted the print request, the print request ID, and when the request was printed. Banner pages make it easy to identify the owner of a print job. This identification is especially helpful when many users submit jobs to the same printer. Printing banner pages uses more paper and might not be necessary. The banner page is undesirable, if a printer has only a few users or if a printer has special paper or forms.

To submit a print job without a banner page, use the following command:

`lp -o nobanner` *filename(s)*

 e-Lab Activity 11.1 Using the **lp** Command

In this activity, you use the **lp** command with the destination (**-d**) and copies (**-c**) options to send print jobs to a default printer and a specified printer. Your current working directory is /home/user2/dir2. Refer to e-Lab Activity 11.1 on the accompanying CD-ROM.

Locating the User's Printout

The system administrator assigns a default printer for each user. The default printer name can be displayed with the **lpstat -d** command. However, that will tell the user the printer name, but not its location. In small organizations, this is not a problem. In larger organizations, the user might have to ask where that particular printer is located so the print job can be located.

Managing Printer Queues

Using the **lp** command sends the print request to a ***printer queue***. The printer queue is a special directory stored on the hard disk of the user's workstation or network print server. Because printers usually do not have hard disks to store documents, all requests or print jobs must be spooled or go to the print queue first. If the printer is available, the request is serviced immediately. If the printer is busy, the request is queued until the printer is available. On large networks with centralized printers, print queues can become quite large, with many print jobs waiting to be printed. An administrator can monitor and manage the print queues for multiple printers.

The **lpstat** (line printer status) command, or **lpq** on BSD systems, displays the status of the default printer queue. To see the print requests for a specific printer, use the **lpstat -d** followed by the printer name or queue to display. The basic command and an explanation of the output are shown in Figure 11-5. Figure 11-6 shows the options available with the **lpstat** command, and Figure 11-7 shows examples using the command.

Figure 11-5 lpstat Command Format

```
lpstat  [ -options ]

$ lpstat staffp

staffp-2  user2  551  Dec 10  16:45
staffp-3  user3  632  Dec 10  16:47
```

Figure 11-6 Print Queue Options with **lpstat**

Option	Meaning	Purpose
Printer name	Name of printer (queue)	Displays requests for a specific printer's queue.
-p	Printers	Displays status of all printers.
-o	Output (or Outstanding)	Displays status of all output or outstanding print requests sent to any printer.
-d	Default	Displays which printer is the system default.
-t	Tell All	Displays complete status information for all printers.
-s	Summary	Displays a status summary for all Printers configured on your system.
-a	Accepting	Displays which printers are accepting requests.

Figure 11-7 Using **lpstat** to Check Print Queue Status

```
Displaying the status of all of your default printer output requests:
$ lpstat
printer1-7    user2  391  Dec 10  16:30  on  printer1
printer1-12   user2  649  Dec 10  16:41  on  printer1

Displaying the status of all of your output requests (any printer):
$ lpstat -o
printer1-7    user2  391  Dec 10  16:30  on  printer1
staffp-2      user2  551  Dec 10  16:45  filtered

Displaying requests on a specific printer's queue:
$ lpstat staffp
staffp-2      user2  551  Dec 10  16:45
staffp-3      user2  632  Dec 10  16:47

Determining the status of all configured printers:
$ lpstat -t
scheduler is running
system default destination: printer1
system for printer1: venus
system for staffp: mars
printer1 accepting requests since Wed May 6 08:20:00 EST 1998
staffp accepting requests since Mon May 25 09:43 EST 1998

Determining which printers are configured on your system:
$ lpstat -t
scheduler is running
system default destination: printer1
system for printer1: venus
system for staffp: mars

Displaying which printers are accepting requests:
$ lpstat -a
scheduler is running
printer1 accepting requests since Thu Mar 22 15:57:02 PST 2001
staffp accepting requests since Mon May 25 09:43 PST 1998
```

Print Process Control Points

When a file gets printed, it is first placed in the queue. When the current print job is finished, the print daemon sends the next request from the queue to the printer. As a result, two control points are available to the administrator to manage the print process. The control points are when print jobs are entering the queue and when print jobs are exiting the queue. See Figure 11-8.

Figure 11-8 Print Process Control Points

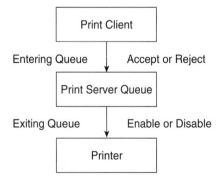

Print Jobs Entering the Queue

The administrator usually rejects requests if the printer is to be removed from service or moved to another location. This stops the queue from accepting any new requests. Existing queued requests will continue printing as long as the printer is enabled. An administrator can specify a reason for rejecting further requests, and the reason is displayed in the **lpstat -a**, **-p**, or **-t** output. If the printer is accepting requests, the message "destination, with the printer name, accepting requests" is displayed. An example would be: "destination hplaser1 accepting requests."

Print Jobs Exiting the Queue

The administrator usually disables print requests when the printer needs to be taken offline for short-term maintenance. Even though print jobs in the queue are not being printed, the queue still is accepting requests and can become backed up. An administrator can specify a reason for disabling a printer, and the reason is displayed in the **lpstat -a**, **-p**, or **-t** output. If the printer is enabled and printing jobs in the queue, the message "printer, with the printer name, enabled" is displayed. An example would be "printer hplaser1 enabled."

Canceling a Print Request

Sometimes a user will want to remove a print request from the print queue. This can occur if the user accidentally prints the wrong document, especially if the document is lengthy. You might have to remove a print request for a document that has already been printed and then requested again accidentally. In either case, if the print job is still in the print queue, you can cancel it before it prints.

Users can only cancel those print requests that they initiate. One user cannot remove another user's print requests. Only the system administrator can cancel print jobs for other users. The **cancel** command enables the user to cancel print requests previously sent with the **lp** command. On BSD systems it is the **lprm** command. To do this, you must first use the **lpstat** command to identify the request ID. Figure 11-9 shows an example using the **lpstat** command to find the request ID and then the cancel command to delete the print request from the queue. If the user cancels a print job, it does not affect the request ID numbers of the other jobs still in the queue. To cancel a print request, use the following format:

```
cancel request-ID
```

 e-Lab Activity 11.2 Using the **lpstat** and **cancel** Command

In this activity, you use the lpstat command to show the default and a specific print queue. You use it with the output (**-o**) option which shows all printer queues and the **-t** option to see detailed information for all printers. You also use the **cancel** command to remove a print job from a queue. Refer to e-Lab Activity 11.2 on the accompanying CD-ROM.

TIP

Knowing how the print queue works will enable you to print wisely. Before printing, check the queue of the destination printer for the following:

- Is the printer "accepting requests"?

- Is the printer "enabled"?

- Does the queue contain any or few requests?

If all of these conditions exist, then print to the printer. If any of these conditions do not exist, check the queue of other printers until a printer is found that can process your print request quickly. Then, using the **lp -d** command, print to that printer.

Figure 11-9 Canceling a Print Request

```
Use the lpstat command to determine the request ID:
$ lpstat staffp
staffp-2   user2  551  Dec 10  16:45  on  staffp
staffp-3   user3  632  Dec 10  16:47  on  staffp

Use the cancel command to remove the print request on all printers:
$ cancel staffp-3
request "staffp-3" cancelled
$

Use the cancel -u username (login ID) to remove all
requests owned by you:
$ cancel -u user2
request "staffp-2" cancelled
```

Lab Activity 11.3.2 Command-Line Printing

In this lab, you work with UNIX printing commands to send jobs to printers and manage print queues. Refer to Lab 11.3.2 in the *Cisco Networking Academy Program: Fundamentals of UNIX Lab Companion*, Second Edition.

Using Graphical Printing Tools

Several graphical printing tools exist with the CDE and GNOME desktops. These help the user to manage print queues, define printer properties as well as providing drag and drop printing capabilities.

CDE Print Manager

Print Manager is a graphical tool for managing print queues. Print Manager performs many of the same functions as the **lpstat** command. To activate Print Manager, click the Printer icon on the Front Panel. Figure 11-10 shows the Printer Jobs window, which displays a list of the current printers. Double-clicking the printer icon displays any outstanding print requests in the print queue, as shown in Figure 11-11. Only one printer icon is displayed in the Printer Jobs window. This represents the printer chosen by the user, which may be the same as the system default printer.

Viewing Printer Properties

When the printer icon is selected, you can display the properties of the default printer by choosing the Properties menu option from menu bar. A window appears that provides details regarding that printer. The user can change the label name associated with the printer using the Printer Properties window. In addition, if the printer has been disabled or there is a problem with the printer, this window will display information regarding the problem. See Figure 11-12.

Figure 11-10 Printer Jobs

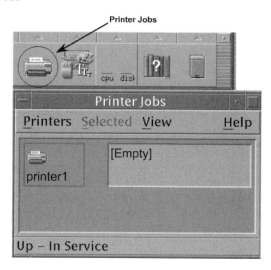

Figure 11-11 Outstanding Print Requests

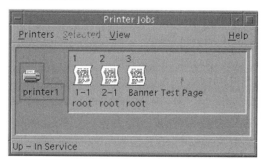

Figure 11-12 Viewing Printer Properties

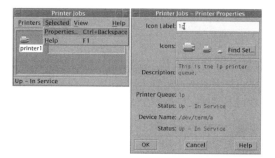

Setting Printer Job Options

From the View menu, select **Set Options**. This enables the user to configure how the print queue requests are displayed. See Figure 11-13. The user also can set the time interval that the Print Manager uses to check the current print queue.

Figure 11-13 Setting Printer Job Options

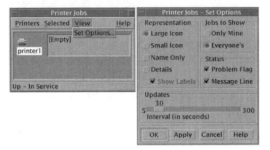

Printing from CDE File Manager and Print Manager

The user can print a file from the File Manager window by dragging and dropping it on the Print Manager icon. The user can also print a file by dropping the file directly into the Print Manager Printer Jobs window as shown in Figure 11-14. Once the file object has been dropped into the Print Jobs window, another window will be displayed in which a user can

- Designate an alternative printer to print the file
- Designate the number of copies of the file to be printed

Figure 11-14 Printing from the File Manager

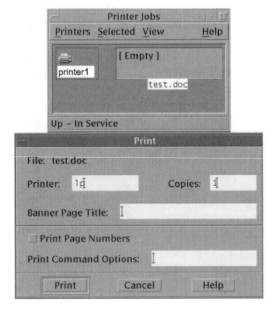

- Set a banner title (which will be displayed in the Print Manager window alongside the print object)
- Select specific pages to print
- Designate which UNIX print command options should be used as an alternative to the default print command

Once the Print button is selected, the file will be sent to the appropriate printer queue.

Displaying the Banner Page Title

When a banner page title has been entered for a print request, that text will be displayed in the Print Manager window. The name of the user who submitted the print request will be displayed below the banner text. See Figure 11-15.

Figure 11-15 Displaying the Banner Page Title

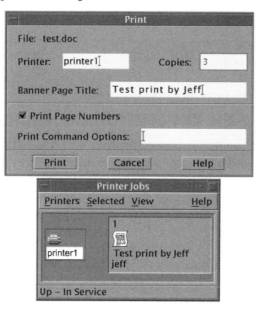

Canceling a Print Request

To cancel a print request, the user must first select the Print Manager display object corresponding to that print request. When the object has been selected, use the menu **Cancel** option. The user is asked to confirm that the print request is to be cancelled, as shown in Figure 11-16. Again, only those printing requests that were initiated by that user can be canceled by the user. If the user attempts to cancel another user's print job from the Print Manager, the print job will reappear in the printer queue.

Figure 11-16 Canceling a Print Request

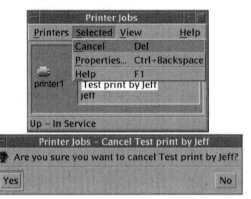

 Lab Activity 11.4.3 Using CDE Print Manager

In this lab, you work with the Common Desktop Environment (CDE) Print Manager and File Manager to control your printing environment. Refer to Lab 11.4.3 in the *Cisco Networking Academy Program: Fundamentals of UNIX Lab Companion*, Second Edition.

Printing Using the GNOME Printer Applet

If the user or a system administer has already configured one or more printers for the system, printing files from GNOME is a simple matter. To prepare the user's desktop to print files using the drag and drop technique, follow the steps below. Note the location of the Printer Applet and process described here may vary depending on the version of GNOME and Printer Applet you are using. Comparable functions, however, should be available and may be on a different menu.

Step 1 Click the GNOME main menu and select **Applets**, **Utility**, and **Printer Applet**. The Printer applet will appear in the panel. The user may move it if desired.

Step 2 Right-click over the **Printer Applet** and select **Properties**. In Figure 11-17 the user will see the Printer Applet below and the Printer Properties window above.

Figure 11-17 GNOME Printer Applet Properties

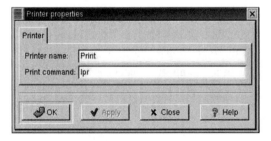

Step 3 The Printer name field is just a label. The user can rename the printer.

Step 4 The default printer command is **lpr**, and is often all that is needed. If the user knows that the printer command is something different, then enter it here. For example, **lpr** takes a **-P***printername* option to specify a non-default printer if there is more than one. Therefore, the user might change this field to **lpr -Pljet5**, or to whatever the printer's identifier is.

Step 5 If more than one printer is available, the user can also have more than one Printer Applet on the printer panel. The user should give each printer a unique name and the correct command for each in the Properties window. To print a file using the applet, just drag the file's icon from the desktop or from a Nautilus window to the Printer Applet's icon and drop it.

Summary

Now that this chapter is completed, you should understand the following:

- Printing to local and remote printers is an essential function in a network environment. There are three main components in the UNIX printing environment. The first component is the printer as the physical device. The second component is the printer name called the print queue. The third component is the print server, the computer that manages the print queue. The system administrator sets up the printing environment by installing printers and defining print queues and servers to support them. Printers can be attached to workstations, servers, or directly to a network hub or switch.

- When a user prints a document, a print request is generated. This request passes through the network to the print server that manages the print queue for the printer name that the user selected. The print server stores the documents on its hard drive temporarily and then forwards the documents to the physical printer when it becomes available.

- Understanding the print queue enables the user to print wisely by knowing whether the printer is accepting requests, is enabled, and has few print jobs in the queue. Files can be printed using the **lp** or **lpr** commands from the command line or with the CDE File Manager. A number of options are available, including printer selection, banner output, and number of copies. With the File Manager, documents can be dragged with the mouse to the printer icon or Print Manager window to print them. GNOME provides a similar function with the Printer Applet.

- Print requests residing in print queues can be viewed and managed using the **lpstat** or **lpq** commands or with the CDE Print Manager. Users can see their outstanding requests in the queue and can remove those requests using the **cancel** command or with a graphical Print Manager utility. Users can cancel only their own print jobs.

Check Your Understanding

1. Which of the following are the main components in the UNIX printing environment? (Select three.)

 A. Printer

 B. Printer name

 C. Print server

 D. Printer spooler

2. Printing ASCII text or PostScript files from Solaris can be done from the command-line using which two of the following commands?

 A. lp

 B. lpr

 C. spool

 D. lprint

3. You are logged as user jdoe. Which command will cancel all print jobs for user jdoe?

 A. cancel -u jdoe

 B. cancel -print jdoe

 C. cancel -u

 D. cancel -a jdoe

4. Which of the following is a graphical tool for managing print queues?

 A. Printer Manager

 B. Print Manager

 C. Printer Console

 D. Queue Manager

5. Which three of the following are things that a user can do while having the Printer Jobs window open?

 A. Designate an alternative printer to print the file

 B. Designate the number of copies of the file to be printed

 C. Designate which UNIX print command options should be used as an alternative to the default print command

 D. Update printer driver

6. Which two of the following accounts have the right to cancel print jobs by default?

 A. Print job owner

 B. Administrators

 C. All users

 D. Print managers

7. What is the name of the computer that manages and releases incoming print requests?

 A. Print queue

 B. Print manager

 C. Print server

 D. Printer

8. Which command would the Berkeley version of UNIX (BSD) use as a variation of the **lp** command?

 A. lpr

 B. lp -b

 C. lprn

 D. lpbsd

9. Which command is used to receive a system-generated e-mail after the print job is complete?

 A. lp -m *filename(s)*

 B. lpr *filename(s)*

 C. lp *filename(s)*

 D. lpr -m *filename(s)*

10. Which command is used to print a file called test1 in a BSD environment with no banner page?

 A. lp -o nobanner test1

 B. lpr -h test1

 C. lp -n 2 test1

 D. lpr -#2 test1

11. Which command is used to print a file called *test1* in a System V environment with no banner page?

 A. lp -o nobanner test1

 B. lpr -h test1

 C. lp -n 2 test1

 D. lpr -#2 test1

12. Which three of the following are valid options that can be used with the **lpstat** command?

 A. -q

 B. -a

 C. -p

 D. -t

UNIX Command Summary

lp Submits print requests to a destination. Example:

```
-d, -o, -n, -m

$ lp ~/fruit2
request id is printer1-203 (1 file(s))
```

lpstat Displays information about the current status of the LP print service to standard output. Example:

```
$ lpstat printer1
printer1-106   root    587 Mar 22 16:06 on printer1
printer1-107   user2    85 Mar 22 16:10 on printer1
$
```

Key Terms

ASCII American Standard Code for Information Interchange (ASCII) consists of standard text, numbers, and special characters. ASCII files have no formatting (that is, bold, italic, and so on) or graphics.

banner page The first page of the print job that identifies who submitted the print request, the print request ID, and when the request was printed.

default printer Printer your print requests are sent if no other printer is specified.

PostScript A programming language used on many high-end printers. PostScript is optimized for displaying text and graphics on the printed page.

print job number In the lp system, a number that automatically is assigned to each print request, known as a job.

Print Manager A graphical tool for managing print queues. It performs many of the same functions as the **lpstat** command. To activate the Print Manager, click the Printer icon on the front panel.

printer A physical printing device. The printer may be attached to a workstation or network server, or it may contain a network interface card (NIC) and be attached directly to the network.

printer name The name of a print queue associated with the physical printer. It is a logical name for the printer, which is assigned by the system administrator. This is the name that the users print to.

printer queue A directory located in the hard disks of the print server. Print requests or print jobs are stored on the hard disk until they are printed, and then they are deleted or purged.

print server The computer that manages incoming print requests and releases them as the printer is ready. Print servers run the printer daemon **lpsched**, which manages print requests. A print server can be a workstation or a network server.

spool To spool items is to place them in a queue, each waiting its turn for some action, such as printing.

Objectives

After reading this chapter, you will be able to

- Describe the requirements and strategies for network backups.
- Compare and contrast different backup methods and media.
- Back up and restore files using the **tar** utility.
- Access floppy disks and CD-ROM devices with Solaris and Linux.
- Use **compress** and **uncompress** to manage file space.
- Use the **jar** command to perform backup and compression.
- Back up Files with the **cpio** utility.
- Describe the use of third-party backup programs.
- Use the CDE graphical tools to back up, compress, and restore files.

Backing Up and Restoring

Introduction

This chapter deals with one of the most important areas of network security and support, the backing up and restoring of data. ***Backups*** are another key component in a comprehensive security plan. This chapter covers the most common network and workstation backup strategies. This chapter introduces the built-in UNIX and Linux backup utilities. To back up or easily transfer files via e-mail, FTP, or another method, you will need to be able to package and ***restore*** the files easily. In this chapter, you will work with the tape archive (**tar**), Java archive (**jar**), and **cpio** utilities to perform backups of data as well as restore data from backups. This chapter also covers specific instructions for backing up and restoring the your home directory. In addition, the popular ***compression*** programs such as Zip and **gzip** are introduced. Finally, the use of the CDE File Manager to perform basic backup tasks is covered.

Importance of Backups

Good backups are critical to the health of a network. The value of a good backup system is most appreciated when it is needed in an emergency. When a system is down and data becomes unavailable, users cannot get work done and companies cannot do business.

A well-managed network includes regular backups performed by a system administrator. Having a good backup system and a tested restoration process can save an organization millions of dollars and thousands of hours in lost productivity.

Causes for Lost or Corrupted Data

Data can be lost or corrupted from a number of causes, as summarized in the Figure 12-1 and discussed in the following sections.

Figure 12-1 Causes of Data Loss and Corruption

- Hard disk failure

- File corruption

- Malicious destruction

- Disasters

- Accidental deletion/overwrites

Hard Disk Failure

Disk drives, such as floppies, hard disks, and CD-ROMs, are the most likely components in a computer to fail. These disk drives fail because they are electromechanical devices, containing electrical and mechanical components, with moving parts that wear. Most other components in a computer, such as the CPU and RAM, are electronic with no moving parts. When a hard drive fails, some or all of the data on the drive can be damaged or can become inaccessible. This is why fault-tolerant disk systems such as Redundant Array of Independent Disks-Level 5 (*RAID 5*) were developed for network servers. RAID 5 combines three or more drives as a group so that if one fails, the others take over. The bad drive can be replaced with no loss of service to the users. Another fault-tolerant technique, *RAID 1*, or mirroring, uses two drives, with the second drive storing the same data as the first. If one of the drives fails, the other takes over. A more durable version of RAID 1 that uses dual drive controllers as well as dual drives is known as *duplexing*. Fault-tolerant disk systems are the first line of defense in a solid backup strategy.

File Corruption

File corruption can occur as the result many things. Improper system shutdown, magnetic fields from motors and other electrical devices near the data, or an area of the disk going bad can cause file corruption. The data becomes inaccessible in any of these situations. A good backup system will allow the administrator to find and recover a specific file or group of files that might be lost because of corruption.

Malicious Destruction

Files also can be lost because of intentional destruction of data. File deletion can result from disgruntled employees, virus attacks, or hackers who can remotely access a system. Damage can vary from deletion of one or two files to the loss of all data on a hard drive.

Most virus attacks come from the Internet. Firewalls can help in some cases. Fortunately, not many viruses can infect UNIX systems. However, this is not the case with most other network operating systems and desktop operating systems. For non-UNIX operating systems, virus protection software can be installed to help detect and remove viruses before the viruses can do damage. Firewalls also can help to prevent destruction of data from remote access hackers by detecting and blocking the attacks. Proper file permissions provide good protection in the case of a disgruntled employee deleting data. No amount of preventive measures can provide complete protection, and the best defense is having good backups of important data.

Disasters

Disasters such as fires and floods can destroy computers, datacenters, and entire buildings. Chapter 10, "File Security", discussed the importance of a disaster recovery plan. If a fire were to destroy a place of business, how would the company recover? How much would it cost per day or per hour to not be capable of doing business?

Backups are a big part of a disaster recovery plan. To get systems back up and running quickly, it is important to have good quality, current backups of critical data. The backups also should contain copies of operating system and applications software so that they can be reinstalled. Copies of the operating system and applications software should be stored offsite at a nearby location.

Accidental Deletion/Overwrite

It is not uncommon for a user to accidentally delete a file. Files deleted from the command line cannot be recovered, except from a backup. A file that cannot be recovered from a backup may need to be re-created. Not having a backup causes a loss of productivity for the business or user. Files deleted using the CDE File Manager can be recovered from the Trash Can. Files deleted using the **rm** command cannot be recovered.

Work also can be lost because of accidental overwrites. Overwrite occurs when a user makes a copy of a file and then makes substantial changes to that file. The user then opens the original file and saves it over the one with changes. It is also possible to overwrite files when copying the files from one location to another where the file already exists. When this occurs, the only way to recover the original file is from data backups.

Backup Methods

Several different backup types or methods can be compared, based on how long the backup takes and how easy it is to restore data. The three most common types of backups are full,

incremental, and *differential backups*. All the methods discussed in this chapter assume that backups to a tape drive occur daily on critical user data. Alternatives to tape backup *media* are discussed later in the chapter. The operating system and applications software are not typically backed up. The operating system and application software can be reinstalled from the original media.

It is common to have a set of 5 to 7 daily backup tapes, 4 or 5 weekly backup tapes, and 12 monthly backup tapes. The daily tapes can be overwritten each week. The weekly tapes can be overwritten each month. The monthly tapes usually are kept and are not overwritten. Weekly and monthly tapes should be kept offsite.

If the volume of data to be backed up requires multiple tapes, it might be necessary to install a larger capacity tape drive or a tape changing system. If a larger capacity tape drive or a tape changing system is not used, a user or system administrator would need to manually change tapes when each tape is finished. Backup methods performed by organizations vary. However, all organizations take a number of factors into account when determining which method to utilize:

- The criticality of the data
- The amount of data to be backed up
- The time window available to do backups
- Funds available for a backup system

Loss of data can be just as damaging for a small business as for a large corporation. The backup system is not the place to cut costs. Figure 12-2 compares the three different backup methods. Figure 12-3 shows the relationships between quantities of data backed up each day. The assumption is that the hard disk crashed and each day's backup is on a separate tape.

Figure 12-2 Comparison of Backup Methods

Backup Method	Total Time to Backup	Ease of Restore	Number of Tapes Required to Restore if Hard Drive Fails on Friday Morning
Full	Longest	Simplest	1
Incremental	Shortest	Most Complicated	5
Differential	Moderate	Moderate	2

Figure 12-3 Quantities of Data Backed Up with Each Method

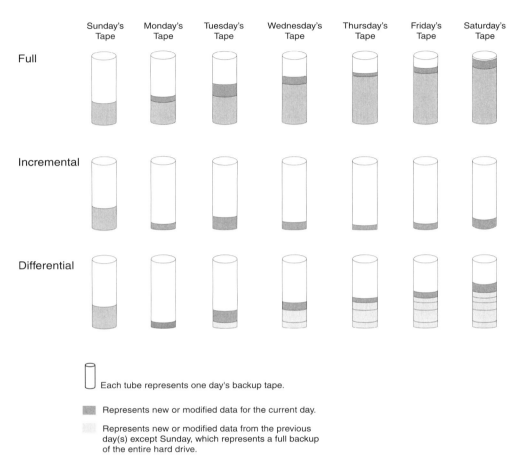

Backup Methods

Each tube represents one day's backup tape.

Represents new or modified data for the current day.

Represents new or modified data from the previous day(s) except Sunday, which represents a full backup of the entire hard drive.

Full Backup

With *full backup*, all critical data is backed up daily. Every night after close of business, all data is backed up, whether the data has changed or not. This method takes the longest and could require multiple tapes, depending on the amount of data. A larger capacity drive or tape changing system might be required if data volumes get too large.

If an organization has a large volume of data or a short window of time to back it up, the full backup method might not work. However, a full backup is the most effective method because all data is backed up every day to one or more tapes. A full backup also can make it easier to find and restore data. Full backup is usually all on one tape or a set of tapes for a given day. For purposes of comparison to the other methods, this chapter assumes that the user can do a full backup on one tape.

Incremental Backup

With incremental backup, data is backed up in increments. All critical data is backed up once a week on a particular day. For example, the user may backup data every Sunday evening. Only changes will be backed up each day after the weekly backup. The next backup on Monday will back up only new files or those that have changed since the Sunday night backup. Tuesday's backup will back up only the new and changed files since Monday's backup. Wednesday's backup will get only the new and changed file since Tuesday's, and so on, until the user gets back to Sunday and then does another full backup. The Sunday night full backup creates the baseline backup and might take a significant amount of time. However, the successive incremental backups on the weekdays will take much less time. The amount of data and the time that it takes to back up on each weekday varies depending on the number of new and changed files. This weekday backup time will be relatively small compared to the full backup.

With the incremental backup, each tape has a piece of the whole backup. As a result, the overall time required to back up the data is significantly less than doing a full backup each day. The disadvantage of the incremental backup is the number of tapes that it might require to rebuild the data. If a hard drive fails on Monday morning, the Sunday night backup tape will be the only tape needed to restore the data. However, if the drive fails on Friday morning, it will require Sunday's full backup tape plus Monday through Thursday's incremental backup tapes to fully restore the data. This means that user must successfully read and restore data from five tapes, any of which could have a problem. This results in a more complicated and time-consuming restoration process. Incremental backups back up only a portion of the data each day to multiple tapes. A failure of any of the tapes will result in a corrupt backup. Therefore, if the user needs five tapes to do the restore, the entire backup will be bad if any one of the tapes cannot be read.

Differential Backup

With differential backup, the user still does a full backup once a week. For example, the user may back up data every Sunday evening. The user would back up anything that has changed since Sunday on Monday. On Tuesday, the user would also back up anything that has changed since Sunday. On Wednesday, again the user would back up anything that has changed since Sunday, and so on. Monday's backup might not take much time because the user is backing up only one day's worth of data same as done in the incremental backup. However, every day after Monday the backup will take longer. On Saturday night, everything that has changed since last Sunday, which is 6 days' worth of data, is backed up.

The differential backup is a compromise between a full backup and an incremental backup. It takes less time than a full backup because the user is not backing up all the data every night. However, differential backup takes more time than an incremental backup. If a hard drive

fails and the user needs to restore all the data, it will take only two tapes. As an example, if the hard drive fails on Friday morning, the user will need only the Sunday baseline tape and the Thursday night tape. The tape from Thursday night's backup includes everything from Sunday night through Thursday night. This makes restoration a little easier than the incremental backup, but not as simple as the full backup.

Data Restoration Issues

The backup methods discussed allow all critical data to be restored in the event of loss. The capability to restore data quickly is the true test of a good backup system. It is not enough to do nightly backups and not actually practice the restoration process.

Users typically are not required to back up their own files. The backup of files is the job of the network administrator or network support staff. The network support staff not only must do regular backups but also must test the backups periodically. The backups are tested to verify that the backups are good and that the network support staff can restore data from them.

Backups should be checked regularly by conducting test restores. The test restores verify that the tapes are good and that the staff can perform the necessary steps to restore data under a variety of conditions. To adequately test the capability to recover from data lost, the network support staff should be able to accomplish the following restoration tasks, which are summarized in Figure 12-4:

- **Restore a file**—Thousands of files typically are backed up in any organization. If a user accidentally deletes or overwrites a file, an administrator should be able to find that file on the backup tapes and restore it to the user's home directory on a server or on the workstation.
- **Restore a directory**—If a directory is damaged, an administrator should be able to restore the entire directory structure, with all subdirectories and files intact.
- **Restore a file system**—If necessary, an administrator should be able to restore an entire file system.
- **Restore a hard drive**—In the event of a total failure of a hard drive, an administrator should be able to re-create the contents of the original drive, including the operating system, applications software, and data, if applicable.

Figure 12-4 Restore Capabilities

- Restore a file
- Restore a directory
- Restore a file system
- Restore a hard drive

Backup Media

A number of different media options exist for backing up the data. These options range from very-low-capacity floppy disks to very-high-capacity tape drives. Figure 12-5 shows the variety of backup media available.

Figure 12-5 Types of Backup Media

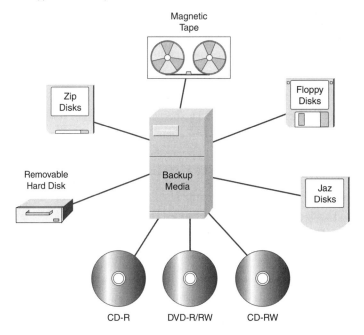

Magnetic Tape

Streaming magnetic tape is the most common media for backing up large amounts of data because it is inexpensive and can store large amounts of data. Tape drives are sequential recording devices. Sequential recording means that the data is laid down in a stream of bits from one end to the other as the tape passes the magnetic read and write heads.

To locate a specific file on a tape, the tape must be rewound or advanced to the location where the file was recorded. This can take several minutes, depending on the speed of the drive and where the file is located. However, modern tape drives will continue to be widely used because tape drives are efficient, they are cost effective, and they serve as a proven backup solution.

New technology tape drives are small and very fast, and they have very large recording capacities. The cost per megabyte for tape backup is the lowest of any recording media. A single tape about the size of a videocassette can record more than 100 GB (gigabytes, or billion bytes) of data with compression. Autoloader systems with multiple tapes can exceed that capacity significantly.

Magnetic and Optical Disks

Tape drives traditionally have been the media of choice. However, new forms of backup media are starting to become popular, including CD recordable (CD-R) disks, CD rewriteable (CD-RW), as well as DVD-R and DVD-RW optical disks. Optical CDs can store more than 700 megabytes (MB) and DVDs can store nearly 5 gigabytes (GB). To backup files to optical media the computer must have an optical drive that can support writing to CD-ROMs and DVDs.

Various forms of magnetic media, such as removable hard drives and Jaz and Zip disks, are also becoming more common. Most of these backup media are not intended to back up large volumes of data. However, these new forms of backup are a flexible alternative that is very fast, and they can be treated as another disk drive on the computer.

Disk drives, whether magnetic or optical, have one characteristic in common. Disk drives are random-access devices. Instead of advancing or rewinding, as with tape, disk drives can seek and find the desired file in a fraction of a second. This makes disk drives flexible for backing up relatively small amounts of data, usually less than 5 GB. Writeable CD changers can handle very large amounts of data with maximum flexibility. However, writeable CD changers are relatively expensive. Figure 12-6 lists backup media in order of capacity.

Figure 12-6 Comparison of Backup Media

Backup Media	Media Type	Access Method	Capacity
Streaming Tape	Magnetic Tape	Sequential	High
Removable Hard Drives	Magnetic Disk	Direct Access	Med—high
Jaz Disk	Magnetic Disk	Direct Access	Low—medium
CD-R (CD Recordable)	Optical Disk	Direct Access	Low—medium
CD-RW (CD Read/Write)	Optical Disk	Direct Access	Low—medium
DVD-R/RW (DVD Recordable and Read/Write)	Optical Disk	Direct Access	High
Zip Disk	Magnetic Disk	Direct Access	Low
Floppy Disk	Magnetic Disk	Direct Access	Very Low

Accessing Floppy Disks and CD-ROM Devices with Solaris

Tape drives are the most common backup device. However, floppy disks are commonly used on desktop systems, like UNIX and Windows, to exchange files between systems when a remote connection is not available to do a direct transfer.

This section will focus on how to store and retrieve files on floppy disks and CD-ROMs in both the Solaris and Linux environments and from the command line and graphical interfaces. (See Figure 12-7.)

Figure 12-7 Accessing Floppy Disks and CD-ROMs with UNIX

Solaris Volume Management Feature

The Solaris volume management feature provides users with a standard method of handling data on floppy disks and CD-ROMs. This management feature gives users access to these types of devices automatically without having to become a superuser and *mounting* them.

The characteristics for Solaris volume management are as follows:

NOTE

If volume management is not running on a system, the **vold** daemon is not running and only the superuser can have access to floppy disks and CD-ROMs.

- Runs by default
- Manages floppies, CD-ROMs, and removable hard drives
- No need to become superuser and mount
- Automatically detects CD-ROM insertion
- Does not automatically detect floppy insertion

By default, volume management is always running on the system to automatically manage CD-ROMs, floppy disks, and removable SCSI disks, such as Zip and Jaz disks.

When the user inserts a CD-ROM into the drive, it is automatically detected. However, volume manager does not automatically detect when the user inserts a floppy into the floppy drive. The user must inform volume manager by using the **volcheck** command.

Working with Solaris Floppy Disks

The **volcheck** (volume check) command or **Open Floppy** option on the CDE File Manager File menu instructs Solaris to do the following:

- Check the floppy drive
- Determine the disk type, whether UNIX or DOS
- Temporarily place or mount the floppy disk under the /floppy directory of the hard drive

If Solaris detects a floppy disk in the drive, the message "media was found" is displayed. When the disk is mounted, the user can access files on disk either from the command line or from the CDE File Manager Floppy window. (See Figure 12-8.)

Figure 12-8 File Manager: Open Floppy Window

To access a formatted disk from the command line, follow these steps:

Step 1 Change directories to **/floppy**.

Step 2 Type **ls** and press **Enter**. The name of the disk is displayed as the name of a directory.

Step 3 Type **cd diskette-name** and press **Enter**.

Step 4 Type **ls** and press **Enter**. The files on the disk are displayed. You can copy to and from the disk using the **cp** command.

To eject a floppy disk the user must not be in the /floppy directory. The "Device busy" message will appear if the user is in the /floppy directory. Once out of the /floppy directory, the user types **eject fd** or **eject floppy**. This will unmount the floppy from the file system on Sun Solaris systems. The user must then manually eject the floppy. To eject or unmount a floppy using the CDE File Manager select **Eject** from the File menu.

Floppies can also be mounted and unmounted under Solaris using the **mount** and **umount** commands described in the subsequent Linux section on floppies and CD-ROMs.

Formatting a Floppy Disk with Solaris

To create a floppy disk for storing Solaris UNIX files, the disk must be low-level formatted and a UNIX File System (UFS) created. Most floppy disks are sold with the low-level format already done. A user will need to do it only in exceptional cases. Such cases would be when the user thinks a disk has corruption or one or more bad blocks. Any user can format a 1.44 MB high-density UNIX disk from the command line with the **fdformat** (floppy disk format) command without any arguments, but only the superuser can create a new UFS using the **newfs /vol/dev/rdiskette0/unnamed_floppy** command.

For this reason it is best for users to use the Format option from the CDE File Manager, Removable Media menu. Select the floppy disk and click the **Selected** menu and then **Format**. The Format option allows the user to format a disk and specify that either a UNIX or MS-DOS file system be created with out having to be the superuser.

Using Disks with **tar** and **cpio**

Later in this chapter you will be introduced to two popular UNIX backup commands, **tar** and **cpio**.

To copy files to a disk using either **tar** or **cpio**, the disk must be formatted, using **fdformat** or the CDE **format** command. If a UNIX file system does not exist, **tar** and **cpio** will create their own unique file system when files are copied to the disk. Access the floppy disk using the device filename of **/vol/dev/aliases/floppy0** when using either **tar** or **cpio**.

Working with Solaris CD-ROMs

The volume manager automatically detects the presence of a CD-ROM, unlike floppy disks, and temporarily mounts it under the /cdrom directory of the hard drive. If the CDE File Manager is running, a new File Manager window displays the contents of the CD-ROM. A user can access data from this window and the command line interchangeably using the path name **/cdrom/cdrom0**. (See Figure 12-9.)

Figure 12-9 File Manager: CD-ROM Contents

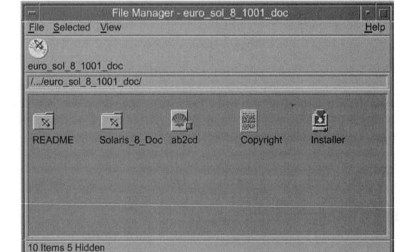

To eject the CD-ROM the user must not be in the /cdrom directory. The "Device busy" message will appear if the user is in the /cdrom directory. Once out of the /cdrom directory the user types **eject cd** or **eject cdrom**. To eject the CD-ROM using the CDE File Manager, select **Eject** from the File menu.

Linux Floppy and CD-ROM Access

The principles of working with removable media are the same in Linux as for other versions of UNIX. Before using a new floppy disk, the disk must first be formatted. Then either a UNIX or DOS file system must be put on the floppy disk. A floppy with a UNIX file system can be mounted and files can be copied to it just the same as a hard disk partition. With a DOS file system, the device acts like the floppy disk in a PC. Files can be copied, listed, and deleted using the Mtools utilities. Mtools is a collection of utilities to access MS-DOS disks from UNIX without mounting the disks. The Mtools come with many distributions of Linux including Red Hat. However, the Mtools may need to be installed in order to make them available. Mtools can also be downloaded, along with instructions for their use, from http://mtools.linux.lu.

Formatting the Floppy

The **fdformat** command is used to do a low-level format on a new floppy disk, the same as in Solaris. The user does not have to be root to do this. As previously mentioned, this is not usually necessary. A standard HD (high-density) floppy is usually purchased preformatted with 80 tracks and can be used by UNIX or DOS.

Device names tend to vary between versions of UNIX. The standard floppy disk drive in a Linux system is accessed using the device path **/dev/fd0**. To perform a low-level format of a 1.44-MB high-density floppy disk, use the following command:

```
fdformat /dev/fd0
```

Figure 12-10 shows the output normally seen on a Terminal screen. After formatting the 80 tracks of the disk, **fdformat** proceeds to verify the format track by track. To skip the verification, the user inserts the **-n** option to **fdformat** before the device name.

Figure 12-10 Output of **fdformat** in a Terminal Window

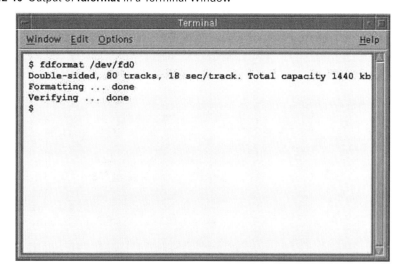

```
$ fdformat /dev/fd0
Double-sided, 80 tracks, 18 sec/track. Total capacity 1440 kb
Formatting ... done
Verifying ... done
$
```

Putting a File System on the Floppy

To create a UNIX file system on a floppy disk, the user uses the **mkfs** command. Only root may make file systems on a hard disk, but nonroot users may use **mkfs** to do so on a floppy disk. The command to create a file system on a standard floppy is as follows:

```
mkfs -t ext2 /dev/fd0 1440
```

The **-t ext2** tells **mkfs** what file system type to make, **/dev/fd0** is the device path, and **1440** is the number of blocks to create. A standard 1.44-MB floppy has 80 tracks with 18 sectors each, or 1440 blocks. The ext2 file system is the most common with Linux systems. Ext3 is a newer "journaled" file system for Linux, which is becoming increasingly popular. Ext3 can track changes and recover from system failures more easily.

Putting a DOS File System on the Floppy

Even if a floppy disk already has a UNIX file system and files on it, it may be reformatted as a DOS disk quickly with the **mformat** command from the Mtools utilities. However, a UNIX-formatted disk must be unmounted first. (See "Mounting a Floppy.") **mformat** takes an argument that corresponds to its device identifier in a DOS system, normally A:. The command used to make a DOS floppy is as follows:

```
mformat a:
```

This format should take only a couple of seconds to run. The user may then use **mtools** commands on the floppy in the drive.

GNOME gfloppy Floppy Formatter

NOTE

It is necessary to have the Mtools utilities installed in order to have the option to format DOS floppies with **gfloppy**.

The GNOME **gfloppy** program is used to format a floppy disk and create a file system on it. The **gfloppy** program can be executed from the shell prompt or the Utilities menu. Note the location and functionality of **gfloppy** will vary depending on the version of GNOME and **gfloppy** you are using.

Figure 12-11 shows a **gfloppy** window open. DOS (FAT) is selected as the File system type, the usual High Density 3.5∀ (1.44 MB) type selected as Floppy Density, and the Quick format check box selected. The command runs quicker with Quick format selected.

Figure 12-11 gfloppy Window

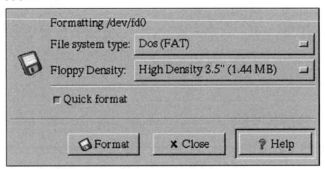

Mounting a Linux Floppy Disk

The **mount** command is used to mount a Linux floppy disk with a UNIX file system on it. It can also be used with any other version of UNIX. It is not necessary to mount a DOS floppy disk. Linux does not run a volume manager or support the **volcheck** command for mounting floppies as with Solaris.

Most Linux distributions configure systems so that nonroot users may mount and unmount floppy disks. If a correct set of options has been defined in the file /etc/fstab to allow this operation, the command to mount a floppy disk is as follows:

```
mount /mnt/floppy
```

Thereafter the directory **/mnt/floppy** may be accessed as any other directory on the system, as the location to put and read files on the floppy disk.

When the user is finished with a UNIX mounted floppy, it must be unmounted. The **umount** command is used to accomplish this. Notice that there is no *n* in the spelling of **umount**.

```
umount /mnt/floppy
```

On Intel based Linux systems the **eject** command does not unmount a floppy as it does with Solaris. Instead on Intel based Linux systems the **eject** command defaults to ejecting the CD-ROM.

Mounting and Unmounting in GNOME

In GNOME, user-mountable drives may be mounted and unmounted using the Drive Mount Applet. You may add as many copies of this applet in a panel as there are removable devices in the system. The default configuration is for floppy drives, but it may also be set for CD-ROM, Zip, Jaz, and even hard drives. Note the location and functionality of the Drive Mount Applet will vary depending on the version of GNOME and the applet you are using.

To use the Drive Mount Applet to mount and unmount floppies, drop the applet's icon from a menu into a panel. Right-click the icon to bring up the Drive Mount Applet Properties window, as shown in Figure 12-12. From the Drive Mount Applet Properties window, any options you would like can be customized.

After the Drive Mount Applet has been installed in a panel, click the icon after inserting a floppy disk or CD-ROM. The media will mount, the icon's appearance will change, and an icon will also appear on the desktop. Click the applet's icon again to unmount the drive.

NOTE

Never simply remove a UNIX-mounted floppy disk from the drive. Floppy drives do not have a locking mechanism that prevents the user from popping a disk out while mounted, as other devices do. To remove the floppy disk without unmounting it will confuse the operating system and could also damage files on the floppy.

NOTE

The *mount point* must be an existing empty directory. Unless another mount point has been defined in the file /etc/fstab by a system administrator, the user should not change this option. Changing this option will cause mounts to fail, and the applet to crash.

Figure 12-12 Drive Mount Applet Properties Window

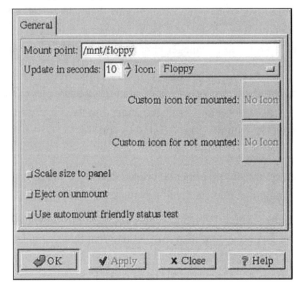

Working with CD-ROMs in Linux

The manner of working with CD-ROM disks in Linux is similar to working with floppy drives, except that CD-ROM disks do not need to be formatted. However, data CD-ROMs must be mounted and unmounted like a floppy disk or hard disk partition.

GNOME enables users to mount data CDs automatically upon inserting the CDs in the drive. To do this, follow the steps below. Note the process of working with CD-ROMs described here will vary depending on the version of GNOME and Nautilus you are using. Comparable functions, however, should be available and may be on a different menu.

Step 1 Open a Nautilus window by clicking on the **Start Here** icon.

Step 2 Click **Preferences**, **Peripherals**, and finally **CD Properties**.

Step 3 Data CD-ROMs will mount in the path /mnt/cdrom when the user inserts the CD-ROMs in the drive.

Step 4 If there is an autorun program on the CD-ROM, it will begin to execute.

Step 5 The Nautilus file manager will open a window on the CD-ROM.

Figure 12-13 shows the CD Properties window with the available options selected.

As previously discussed the user may also install a Drive Mount Applet in a panel and configure its properties to work with the CD-ROM drive.

Figure 12-13 The CD Properties Window

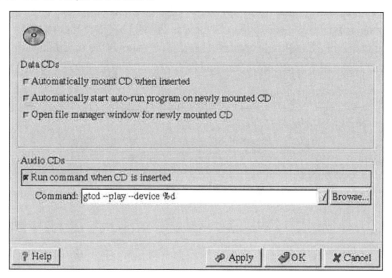

NOTE

CD-ROMs that contain recorded music and sound are quite different from data disks. CD-ROMs that contain recorded music and sound are not mounted. In Figure 12-13 the option to run a command has been selected when the system recognizes the media inserted as an audio disk. The command entered in the example, the default, will run the GNOME audio CD player, and will start playing the CD-ROM.

The user may mount and unmount CD-ROMs as nonroot from a Terminal window using these commands:

```
mount /mnt/cdrom
umount /mnt/cdrom
```

Backing Up, Compressing, and Restoring Files

The UNIX operating system has several integrated utilities that allow multiple files to be backed up and compressed. These include **tar** (tape archive), **compress**, **uncompress**, and **jar** (java archive).

Backing Up Files with tar

The **tar** (tape archive) command enables you to back up single or multiple files in a directory hierarchy. The **tar** command is standard with all versions of the UNIX operating system. **tar** originally was developed for use with tape drives. However, **tar** can copy files to other locations on the hard disk or to a floppy disk and other removable media. The **tar** command can create an archive from a single file. However, **tar** is primarily used to combine multiple files, such as the contents of a directory, into a single file and then extract contents later, if they are needed. By itself, **tar** does not compress the files as it bundles them, like the PKZIP and WinZip programs for PCs. Many types of applications and upgrade packages for Linux are distributed in the form of Tarballs, which are groups of files combined into one.

The most frequently used options available with the **tar** command are **c**, **t**, and **x**. Some versions of **tar** require the hyphen (-), as with other UNIX command options. For example, **tar cvf** is the same as **tar -cvf**. The command syntax is shown here. See Figure 12-14 for an example with an explanation of the syntax. Figure 12-15 shows the functions, letters, and modifiers that are used with the **tar** command.

```
tar function [modifier ] [output file ]filename(s)/directory(s)
```

TIP

When specifying the name of the output file to be created, be sure to specify a .tar extension so that tar files can easily be distinguished from others.

Figure 12-14 tar Command Format Example

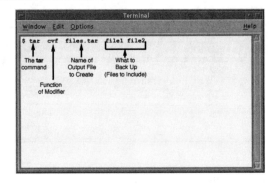

tar Functions

tar functions are one letter characters used to create a tar file, view the contents of a tar file, or extract files from a tar file. These functions are summarized here:

- **c** (create or combine) is used to create an archive(tar) file containing one or more files or directories.
- **t** (table of contents) is used to display a table of contents of the tar file. This is a listing of the files that were combined to make the one tar file.
- **x** (extract) is used to extract the file or files from a tar file. The tar file still exists after this is done.

Function Modifiers

tar function modifiers are one-letter characters used in conjunction with a function character when creating, viewing, or extracting from a tar file. The two most common function modifiers are summarized here:

- **f** (file) allows you to specify a tar file to create (**c**), extract from (**x**), or see the table of contents of (**t**).
- **v** (verbose) executes the command in verbose mode, which enables you to see the detailed results of the **tar** command as they occur.

These modifiers are explained in greater detail in Table 12-1.

Table 12-1 **tar** Command Modifiers

Modifier	Meaning	Description
f	Filename	Specifies the tar file to be created as either a file on the hard disk (/tmp/file.tar) or a device file for an output device (/dev/xxx) such as a floppy disk (/vol/dev/aliases/floppy0 in Solaris), optical drive, or tape drive (/dev/rmt0 in Solaris).
v	Verbose (view)	Execute in verbose mode. This mode enables you to view what the **tar** command is doing as it is copying, displaying the table of contents, or extracting to or from the backup file or device. This option normally is used with the **c**, **t**, and **x tar** options.

Figure 12-15 illustrates some examples using the **tar** command.

Figure 12-15 **tar** Command Examples

```
Archive the user2 directory to tape:
$ cd /home
$ tar cv user2
a user2/file1 2k
a user2/fruit2 1k
... (output omitted)
$

Archive the dir2 directory to a subdirectory for backup:
$ cd
$ tar cvf /home/user2/backup/dir2.tar dir2
a dir2/  0K
a dir2/beans/  0K
a dir2/recipes/  0K
a dir2/notes  2K

Archive selected files to hard drive:
$ cd
$ tar cvf files.tar file1 file2 file3
a file1  1K
a file2  1K
a file3  1K

View the table of contents of the archive file:
$ cd
$ tar tvf files.tar
-rw-r-r--  1002/10  512  mar 28  5:53  2001  file1
-rw-r-r--  1002/10  512  mar 28  5:53  2001  file2
-rw-r-r--  1002/10  512  mar 28  5:53  2001  file3

Archive selected files to floppy disk:
$ cd
$ tar cvf /vol/dev/aliases/floppy0 file1 file2 file3
-rw-r-r--  1002/10  512  mar 28  5:53  2001  file1
-rw-r-r--  1002/10  512  mar 28  5:53  2001  file2
-rw-r-r--  1002/10  512  mar 28  5:53  2001  file3
```

TIP

To append another file or files to an existing archive, use the **-r** option. For example, **$tar rvf files.tar newfile** adds or appends the new file to the existing files.tar archive file.

These examples are explained in greater detail:

- The first example archives all files in the user2 directory to tape. If no filename (**f**) option is specified, the default output device is tape /dev/rmt/0. Raw magnetic tape 0 is the first tape drive on a Solaris system. Device filenames vary between UNIX flavors. A tape drive used with Linux may be called /dev/st0 (SCSI tape 0) or something similar.

- The second example archives all files and subdirectories in the dir2 to a tar file called dir2.tar, and places it in the /home/user2/backup directory. Refer to the class file tree and you will see that beans and recipes are subdirectories, whereas notes is a file. Any files in subdirectories also will be included in the resulting tar file.

- The third example combines several files to create an archive file called files.tar in the default directory of the hard drive. This default directory is usually your home directory.

- The fourth example views the table of contents of the tar file in verbose mode, which displays the detail of the files including permission and size.

- The fifth example archives three files to the Solaris floppy disk for backup.

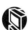 **e-Lab Activity 12.1** Archiving Files with **tar**

In this activity, you work with the **tar** command using various functions and modifiers to archive multiple files as well as a subdirectory. Your current working directory is: /home/user2. See the class file tree structure on the inside-front cover of this book or click the **tree** icon on the CD-ROM e-Lab Activity. Refer to e-Lab Activity 12.1 on the accompanying CD-ROM.

Compressing Files

You should archive files that have not been used for a while and then compress the files so they take up less disk space. It is also a good idea to compress files before transferring them to another UNIX user, who has the **uncompress** command. Compressing the files will save time. Any file, including those archives created with **tar**, can be compressed. Compression is a valuable tool because it reduces the amount of disk space that files occupy, while still keeping the files readily available.

The **compress** command is used to compress files and is included with all versions of the UNIX operating system. The compress utility uses a special format to reduce the size of the file anywhere from 20 percent to 80 percent, depending on the type of file. If the compress utility determines that the file cannot be compressed or that there will be no reduction in file size, the file will remain unchanged. (See Figure 12-16.)

Figure 12-16 Compressing Files

```
List the files to determine the current file size:
$ ls -l bin.file
-rw-r--r-- 1  user2   staff 57380  Mar 22 09:17 bin.file

Compress the file:
$ compress -v bin.file
bin.file: Compression: 53.81% -- replaced with bin.file.Z

List the files again to see the compressed size:
$ ls -l bin.file.Z
-rw-r--r-- 1 user2 staff  26500 Mar 22 09:17 bin.file

Change to your home directory (/home/user2):
$ cd

Compress all files in the current directory beginning with da:
$ compress -v da*
dante:  Compression: 32.12% -- replaced with dante.Z
dante_1: Compression: 17.66% -- replaced with dante_1.Z
```

When files are compressed with the **compress** command, the existing file is replaced using the same name but with a .Z suffix appended. Note that this is an uppercase letter Z. Figure 12-16 shows an example of the **compress** command with the verbose (**-v**) option. The figure also shows the name of the input (bin.file) and output files (bin.file.Z) and the amount of compression achieved. Use the **ls -l** (list long) command before compressing a file to see its original size in bytes. Use the **ls -l** command again after the file has been compressed to see the compressed size. Multiple files can be compressed simultaneously, and wildcard metacharacters are supported. Compressed files are considered binary and cannot be viewed with the **cat** or **more** commands.

```
compress option file1 file2
```

Uncompressing Files

The corresponding command used to reverse the effects of the **compress** command is **uncompress**. Files cannot be used in their compressed form. It is necessary to use the **uncompress** command to restore the files to their original size. The **uncompress** command is a UNIX utility and can be used only to uncompress files compressed with the UNIX compress command. Figure 12-17 shows an example of the **uncompress** command with the **v** (verbose) option. This allows you to see the results of uncompressed process.

NOTE

It is not necessary to specify the .Z extension with the **uncompress** command. This command can uncompress multiple files and support the use of wildcard metacharacters such as ? and *.

Figure 12-17 Uncompressing Files

 e-Lab Activity 12.2 Compressing and Uncompressing Files

In this activity, you the compress command with the verbose option to reduce the
storage size of a file, verify the new compressed size and then use the uncompress
command to expand it to its normal size. Your current working directory is: /home
/user2. See the class file tree structure on the inside-front cover of this book or click
the **tree** icon on the CD-ROM e-Lab Activity. Refer to e-Lab Activity 12.2 on the
accompanying CD-ROM.

Backing Up and Compressing the Home Directory

Because most work is done in a user's home directory, system administrators often schedule
these directories for backup on a nightly basis. If the system administrator is not backing up
the user's home directory, it is good practice to perform a regular nightly backup of changing
data. This section describes the process used to archive your home directory files to a tar file
and then compress it. Figures 12-18 through 12-21 summarize the steps necessary to accom-
plish this. The section following this one describes how to restore the files that were backed
up and compressed.

Figure 12-18 Backing Up and Compressing the Home Directory – Step 1

Create the tar file. This example creates a tar file
named home.tar in the /tmp directory combining
all file in the user1 directory using a relative path name:

$ cd /export/home

$ tar cvf /tmp/home.tar user1

Figure 12-19 Backing Up and Compressing the Home Directory – Step 2

Display the table of contents. The **t** option lets you
see a list of files that were archived into the
home.tar file:

$ tar tvf /tmp/home.tar

Figure 12-20 Backing Up and Compressing the Home Directory – Step 3

Compress the tar file. To save space on the disk where
the tar file is stored, it is compressed using the
compress command. Notice the new name of the
tar file: home.tar.Z.

$ compress -v /tmp/home.tar

/tmp/home.tar: Compression: 80.85%
--replaced with /tmp/home.tar.Z

Figure 12-21 Backing Up and Compressing the Home Directory – Step 4

Back up the compressed file to the default tape drive.
Change the directory to /tmp and use the **tar** command to
copy the compressed tar file to the default tape drive.

$ cd/tmp

$ tar cv home.tar.Z

Restoring Files

This section describes the process of restoring the compressed tar file of your home directory
that previously was created. Just as **tar** can combine files to a single archive file, it can be
used to restore them. The following steps will allow you to restore files to your home direc-
tory from a tape archive:

Step 1 Make a new directory and change to it. In the home directory, make a new
directory and change to it to prevent overwriting files. This will create a sepa-
rate directory to temporarily hold the restored archived file.

```
$cd
$mkdir newhome
$cd newhome
```

Step 2 Extract the home directory from tape. The **x** option extracts the previously
tarred file from tape, using the default tape device, to the current directory
(/home/newhome). The **v** (verbose) option lets you see the activity as the file is
copied. Because no file is specified, home.tar.Z, which is the only file on the
tape, will be copied to the current directory.

```
$tar xv
```

Step 3 Uncompress the compressed tar file. After the file has been copied from tape to the newhome directory, you can uncompress the home.tar file.

```
$uncompress home.tar.Z
```

Step 4 Extract the tar file. After the file is copied from tape to the newhome directory, you can extract all files or individual files from the home.tar file.

```
$tar xvf home.tar (extracts all files from home.tar)
$tar xvf home.tar filename1 filename2 (extracts individual files from
home.tar)
```

Step 5 Move files as needed. The files in the newhome directory now can be moved to replace those in the real home directory.

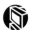

e-Lab Activity 12.3 Extracting files with **tar**

In this activity, you work with the **tar** command and various functions to extract previously archived files. Your current working directory is: /home/user2. See the class file tree structure on the inside-front cover of this book or click the **tree** icon on the CD-ROM e-Lab Activity. Refer to e-Lab Activity 12.3 on the accompanying CD-ROM.

jar Command

The **jar** (Java archive) command is similar to the **tar** command, but it compresses the resulting file in the same step. It is a Java application that combines multiple files into a single jar file. It is also a general purpose archiving and compression tool, based on ZIP and the ZLIB compression format. The **jar** command originally was created for Java programmers to download multiple files with one request, rather than having to issue a download request for each separate file. The **jar** command is standard with the Solaris operating system. However, the **jar** command is available on any system that has Java Virtual Machine (JVM) installed. The syntax for the **jar** command is almost identical to the syntax for the **tar** command. Figure 12-22 shows the options available with the jar command.

Figure 12-22 jar Command Options

Option	Function
c	Creates a new jar file.
t	Lists the table of contents of the jar file.
x	Extracts the specified files from the jar file.
f	Specifies the jar file (/tmp/file.jar) or tape drive (/dev/rmt/x) if other than default.
v	Executes in verbose mode.

Command format: jar *options* [*output file*] *filename(s)/directory(s)*

It is not necessary to use a hyphen (-) before options when issuing the **jar** command. Figure 12-23 provides an example of the use of the **jar** command to archive and compress all directories and files in the /home/user2 directory.

Figure 12-23 Archiving and Compressing Files with **jar**

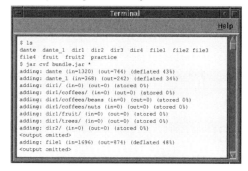

e-Lab Activity 12.4 Archiving and Compressing Files with **jar**

In this activity, you work with the **jar** command to simultaneously compress and archive a group of files. You then use it to extract those files. Your current working directory is: /home/user2. See the class file tree structure on the inside-front cover of this book or click the **tree** icon on the CD-ROM e-Lab Activity. Refer to e-Lab Activity 12.4 on the accompanying CD-ROM.

Lab Activity 12.5.1 Command-Line Archive Tools

In this lab, you work with the tape archive (**tar**) and Java archive (**jar**) utilities to perform backups of data, as well as restore data from backups. You work with the UNIX file compression utility. You will also use the **tar** and **compress** commands to back up and restore your home directory. Refer to Lab Activity 12.5.1 in the *Cisco Networking Academy Program Fundamentals of UNIX Lab Companion*, Second Edition.

Open Source Command-Line Programs

Many third-party compression programs are available for UNIX. This section covers the most popular ones that can be downloaded and used as an alternative to those that come with a particular version of UNIX.

GNU Compression Commands

GNU provides several commands that can supplement the **tar** and **jar** commands. **gzip**, **gunzip**, and **gzcat** are available in most types of UNIX. If not, these commands can be downloaded

from www.gzip.org. The **gzip** utility is similar to jar. The **gzip** utility is a popular open source tool for combining and compressing files. **gzip** is bundled with most Linux distributions.

gzip and **gunzip** work the same way as **compress** and **uncompress**. **gzip** typically produces a smaller file than **compress** and adds a .gz extension instead of .Z. An advantage of **gunzip** is that it can uncompress files created with **compress** and several other compression programs.

Figure 12-24 shows an example of using the **gzip** and **gunzip** commands.

Figure 12-24 Using the **gzip** and **gunzip** Commands

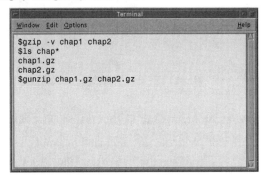

The GNU **tar** command supports compression. The **-z** option compresses with **gzip** and **-Z** compresses using the **compress** command. For example **tar -cvzf /temp/bkup.tar /home/ user2** will use the **gzip** command to create a compressed bkup.tar file of the user2 directory tree.

Another feature GNU **tar** supports is the ability to span a backup across multiple (**-M**) volumes, whether disks or tapes. For example the command below would backup all files in the current directory to the Solaris floppy disk and prompt the user to insert a second disk if required. This is similar to the **-k** option with the Solaris **tar** command.

```
tar -cvf /vol/dev/aliases/floppy0 -M *
```

NOTE
If the version of UNIX that you are using does not have the **zip** command, you should do an Internet search to locate a download site. Use the UNIX **zip** command if you will be exchanging files with a PC user.

zip and unzip Commands

Due to the popularity of the PKZIP and WinZip programs used in the DOS and Windows world, there are now UNIX versions that work in the same way and can read files zipped on a PC.

The **zip** command is similar to the **jar** command and is capable of compressing multiple files into a single zip file. The **unzip** command is used to uncompress a file created with zip. Figure 12-25 shows an example of using the **zip** and **unzip** commands.

Figure 12-25 Using the **zip** and **unzip** Commands

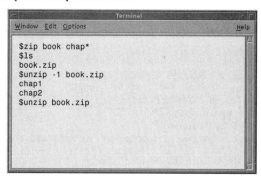

```
$zip book chap*
$ls
book.zip
$unzip -1 book.zip
chap1
chap2
$unzip book.zip
```

Backing Up Files with cpio

The **cpio** (copy in-out) is another popular UNIX backup command and is used to copy files to and from a backup device. Like the **tar** command, **cpio** creates a single archive containing multiple files. A big difference is that **cpio** uses a generated list of files or path names from the output of another command, like **ls** or **find**, instead of specifying file and directory names. **cpio** then writes the selected files to standard output, which is usually redirected to a file or device. The general syntax for the cpio command is as follows:

`cpio options filename(s)`

Table 12-2 shows the options available with the **cpio** command.

Table 12-2 cpio Command Options

Option	Function
o	Creates a file archive. Copies a list of files or path names to a file or device (copy out).
i	Extracts the file archive from the device or file (copy in).
p	Reads from the device or file to get path names.
t	Lists the table of contents of the device without restoring the files.
v	Executes in verbose mode displaying each filename to the screen.
O	Directs the output to a file.
I	Reads the contents of a file as an input archive.

NOTE

The user must specify one of the following options: **o**, **i**, or **p** on the **cpio** command line.

Creating and Viewing the Archive

Because the **cpio** command uses only standard input, the user can use **ls** or **find** to generate a list of filenames to serve as input to **cpio**. The examples that follow illustrate using the **cpio** command to back up files and view the archive:

NOTE

Backing up using absolute path names can be risky because the user can overwrite the original files when restoring.

```
Example 1: $ls | cpio -ov > /vol/dev/aliases/floppy0   (/dev/fd0 in Linux)
Example 2: $ls | cpio -ov -O /vol/dev/aliases/floppy0
Example 3: $find . | cpio -ov -O mydir.cpio
Example 4: $cpio -ivt < mydir.cpio
Example 5: $cpio -ivt -I mydir.cpio
Example 6: $find - -type f -mtime -7 | cpio -ov -O modified.cpio
```

Examples 1 and 2 copy the files in the current directory to the Solaris floppy disk. Example 1 uses redirection. Example 2 uses **-O** option and specifies the device filename as the output file.

Example 3 finds all files in the current directory and copies them to a file named mydir.cpio.

Examples 4 and 5 list the file names in the mydir.cpio archive file. Example 4 uses input redirection. Example 5 uses the **-I** option and specifies mydir.cpio as the input file.

Example 6 finds all files in the home directory that have been modified within the last 7 days and copies the files to a file named modified.cpio.

Restoring Files

A complete archive or selected files can be restored with the **-i** option using either input redirection or the **-I** option. The examples that follow illustrate using the **cpio** command to restore files from the archive.

NOTE

cpio always restores files to the current directory unless the files were backed up using a full path name.

```
Example 1: $ cpio -iv < mydir.cpio
Example 2: $ cpio -iv "chap" < mydir.cpio
Example 3: $cpio -iv -I /vol/dev/aliases/floppy0
```

Example 1 retrieves all files from the mydir.cpio archive to the current directory, assuming the archive was created using relative path names.

Example 2 retrieves all files beginning with "chap" from the mydir.cpio archive to the current directory, assuming the archive was created using relative path names.

Example 3 retrieves all files from the floppy diskette. Input redirection could have been used instead of the **-I** option.

GUI Backup Tools

In addition to the UNIX command-line archive and compression tools discussed so far, there are many other graphical tools available, some of which are very expensive and sophisticated and some of which inexpensive, and are built in to the desktop as with CDE. GNOME does not have a built-in archive tool.

Third-Party Dedicated Backup Tools

Third-party vendors have created dedicated backup application packages for use with the UNIX and Linux systems that utilize a graphical interface. Many production servers utilize one of these packages for regular backups. These application packages typically provide more advanced features with greater flexibility in scheduling and managing backups and restores. These packages also have sophisticated logging and error reporting capabilities for monitoring backup results to help ensure successful backups. (See Figure 12-26.)

Figure 12-26 Features of Dedicated Backup Applications

- Designed specifically to work with various backup media
- More flexibility with scheduling of backups
- Graphical user interface
- Drag and drop capabilities for backup and restore

Using CDE to Archive, Compress, and Restore

The Files subpanel on the front panel in conjunction with File Manager can be used to archive and compress files. This creates the same results as using the **tar**, **compress**, and **uncompress** commands.

Archiving a File

Click the **File** subpanel from the CDE front panel. Then select the **Archive** menu option, as shown in Figure 12-27. The Archive window, shown in Figure 12-28, will open to allow you to enter the following information:

- Folder for archive is the folder where the archive or tar file will be placed. The default is the home folder. For example, /home/user2.
- Name for archive is the name that you want to give the archive file.
- File or folder to archive is the name of a folder, file, or group of files to be combined into an archive.

You can use wildcard metacharacters such as ? and *.

Figure 12-27 Archive Menu Option

Figure 12-28 Archive Window

Restoring an Archive

Open File Manager and navigate to the folder where the archive file was placed, the default is the home directory. Select the archive, which should have a .tar extension. Then use either the Selected menu or right-click the mouse to get to the Archive Unpack option. (See Figure 12-29.) If the original file exists in the directory where the archive is unpacked, it will be overwritten by the unpacked version.

Figure 12-29 Archive Unpack

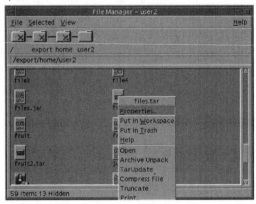

Compressing a File

Click the **File** subpanel from the CDE front panel, and then select the **Compress File** menu option, as shown in Figure 12-30. The Compress window, shown in Figure 12-31, will open to allow you to enter the name of the file to compress. The compressed file will be renamed with a .Z extension, and it will reside in whatever directory it was in before the compress. The default is the home directory. To uncompress a file, open File Manager and navigate to the folder where the compressed file was placed. The default is the home directory. Select the compressed file; it should have a .Z extension. Then either use the Selected menu or right-click the mouse to get to the Uncompress File option, as shown in Figure 12-32. The file will be uncompressed and renamed back to its original name, with the .Z extension removed.

Figure 12-30 Compress File Menu Option

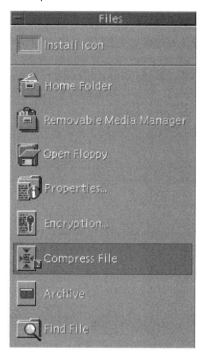

Figure 12-31 Compress Window

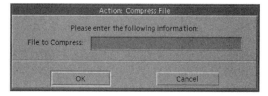

Figure 12-32 Uncompressing a File

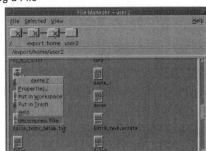

Lab Activity 12.6.3 CDE Archive Tools

In this lab, you work with the Common Desktop Environment (CDE) utilities to back up, compress, and restore files and folders. The Files subpanel on the front panel, in conjunction with File Manager, can be used to archive, compress, and restore files creating the same results as using the **tar**, **compress**, and **uncompress** commands. Refer to Lab 12.6.3 in the *Cisco Networking Academy Program: Fundamentals of UNIX Lab Companion*, Second Edition.

Summary

Now that you have completed this chapter, you should have an understanding of the following:

- Backing up data is one of the most important functions that a network administrator can perform. Data can become lost or corrupted for a variety of reasons. The most important thing is to have good backups available to restore the lost data quickly and accurately.

- Three basic backup strategies exist: full, incremental, and differential backups. Full backups take the longest but are the easiest to restore. Incremental backups take less time but are harder to restore because more tapes are involved. Differential backups are a compromise, taking less time than a full backup and being easier to restore than an incremental backup. Magnetic tape traditionally has been the primary backup media because of its high capacity and relatively low cost. Recently, some newer technologies such as removable drives, Jaz disks, and writeable CDs have begun to replace tape drives for backing up quantities of data of less than 1 GB.

- Solaris and Linux have different ways of working with removable media devices. The Solaris volume manager automatically mounts CD-ROMs and disks when the **volcheck** command is used. This is similar to the Linux Drive Mount applet. Both Solaris and Linux use the **fdformat** command to format a floppy disk.

- The UNIX operating system has several command-line backup utilities available, including **tar** (tape archive), **jar** (Java archive), **compress/uncompress** commands, and **cpio**. The **tar** command combines multiple files into an archive file but does not compress them. The **tar** command can be used to archive and extract files. The **compress** command is used to reduce the disk space taken up by a file. The **uncompress** command expands files back to their original size so that user can work with the file. The **jar** command combines the capabilities of the **tar** and **compress** commands, and simultaneously can archive and compress files. When files are extracted, they are automatically uncompressed. **cpio** is a flexible backup command allowing the user to copy files in to a cpio archive by reading a list of files generated by the **ls** or **find** commands.

- Several other open source UNIX compression programs are available for free. The **gzip** and **gunzip** commands are used to compress and uncompress files. **gzip** creates a smaller file than **compress**.

- The **zip** and **unzip** commands work the same way as the PKZIP commands on a PC. The **zip** and **unzip** commands should be used if exchanging files with a PC user.

- CDE has some graphical tools to archive and compress files, which are available from the Files subpanel on the front panel. The CDE File Manager can be used to extract and uncompress files.

Check Your Understanding

1. Which of the following options to the **cpio** command will list the contents of the archive file mydir.cpio?

 A. -v

 B. -iv

 C. -l

 D. -it

2. Which of the following commands will copy the files in the current directory to the /home/data directory? (Select two.)

 A. ls | cpio -ov > /home/data

 B. ls | cpio -ov < /home/data

 C. ls | cpio -ov -O /home/data

 D. ls | cpio -ov -l /home/data

3. Which three of the following are forms of magnetic media?

 A. CD-R

 B. Removable hard drive

 C. Jaz disk

 D. CD-RW

 E. Zip disk

4. Which of the following users can format a floppy with the **newfs** command?

 A. All users with file write permissions

 B. No users, since the **newfs** command is only for hard drives

 C. The root user only

 D. All users who have full permissions on the floppy

5. Which two of the following commands will unmount a floppy from the file system on a Solaris system?

 A. open floppy

 B. eject floppy

 C. volcheck

 D. eject fd

6. Which of the following will back up files to an archive file, but not compress the data?

 A. jar

 B. jar -c

 C. gzip

 D. tar

7. Which file will bc created with the command **compress -v files.tar**?

 A. files.tar

 B. files.tar.z

 C. files.tar.Z

 D. files.Z

8. Which two of the following will uncompress the file dante.Z?

 A. **unzip dante.Z**

 B. **uncompress dante**

 C. **uncompress dante.Z**

 D. **uncompress -c dante.Z**

9. Which option is used with the **tar** command to view the contents of a file called file.tar?

 A. **-v**

 B. **-x**

 C. **-t**

 D. **-l**

10. Which two files contain backup data that has been compressed?

 A. file.tar.Z

 B. file.tar

 C. file.jar

 D. file.Z

11. Which command will only extract the file dante from the backup file home.tar?

 A. **tar cvf home.tar dante**

 B. **tar xvf home.tar dante**

 C. **tar tvf dante home.tar**

 D. **tar vf home.tar dante**

12. Which CDE File Manager option will mount the floppy disk under the /floppy directory?

 A. Floppy Mount

 B. Eject Floppy

 C. Mount Floppy

 D. Open Floppy

UNIX Command Summary

compress Attempts to reduce the size of the named files. Example:

```
-v, -f
$ compress -vf file
file: compression 37% -- replaced with file.Z
```

cpio Popular UNIX backup and restore command and is used to copy files to and from a backup device. Example:

```
$ ls | cpio -ov > /vol/dev/aliases/floppy0  (/dev/fd0 in Linux)
$ cpio -ivt < mydir.cpio
```

eject [cdrom or cd] Ejects the CD on a Solaris system. Example:

```
$ eject cd
```

eject [fd or floppy] Unmounts the floppy from the file system on Sun Solaris systems. The user must then manually eject the floppy. Example:

```
$ eject  fd
```

fdformat Formats a floppy disk in Solaris. **fdformat /dev/fd0** formats a disk in Linux.

gfloppyLinux Formats a floppy disk for either a DOS or UNIX system.

gunzip Uncompresses files created with the **gzip** command. Example:

```
$ gunzip chap1.gz chap2.gz
gzcatEnables you to read a gzipped file without uncompressing it. Example:
$ gzcat bookfile
chap1
chap2
```

gzip A compression utility (short for "GNU zip") designed to be a replacement for compress. Its main advantages over compress are much better compression and freedom from patented algorithms. The GNU Project uses it as the standard compression program for its system. Example:

```
-v

$ gzip -v chap1 chap2
$ ls chap*
chap1.gz
chap.gz
```

jar Combines backup and compress into one tool. Example:

```
-c,-t,-x, -f, -v
```

```
$ jar cvf bundle.jar *
adding 0.au
adding 1.au
adding 2.au
adding 3.au
$
```

mformat Quickly formats a disk as a DOS disk on a Linux system. Example:

```
$ mformat /dev/fd0
```

mount Attaches a file system to a directory known as a mount point so that the files can be accessed. Example:

```
mount /mnt/floppy  (mounts a floppy disk in Linux to the /mnt/floppy directory)
```

newfs New file system. Makes a UNIX file system on a Solaris system. Can be executed only by root.

tar Archives and extracts files to and from a single file called a tar file. Example:

```
c, t, x, f, v
$ tar cvf backup.tar /home/user2/*
```

uncompress Returns a previously compressed file to its original size. Example:

```
-v
$ uncompress -vf file.Z
```

umount Unmounts a file system, floppy disk, or CD-ROM. Example:

```
$ umount /mnt/floppy (unmounts the floppy disk on a Linux system)
```

unzip Uncompresses files created with the **zip** command. Example:

```
$ unzip bookfile.zip
$ls
chap1 chap2 chap3
```

volcheck The volume check command instructs Solaris to check the floppy drive, determine the disk type (whether UNIX or DOS), and then temporarily places or mounts the floppy disk under the /floppy directory of the hard drive.

zip A compression utility designed to be compatible with the PC zip utility. Example:

```
$ zip bookfile chap*
$ls
book.zip
```

Key Terms

backup A copy of file system data that is stored separately from the disk drive on which the data resides.

compression Removing redundant characters and space from a file to reduce its size. Programs such as Zip, PKZIP, WinZip, and the UNIX compress command can be used to compress files.

differential backup A full backup is still done once a week. Each day after, all changed data from the full backup is backed up again. The amount of data being backup up increases each day until the next full backup. A differential backup is a compromise because it takes less time than a full backup and might be easier to restore than an incremental.

full backup All selected data is backed up daily, whether it has changed or not. This method takes the longest time and might require multiple tapes, depending on the amount of data. It is the safest and easiest to restore.

GNU An operating system similar to UNIX that includes source code that can be copied, modified, and redistributed. The GNU project was started by a group known as the Free Software Foundation (FSF).

incremental backup Data is backed up in increments. A full backup is performed once a week on a particular day (such as Sunday in the evening). Each day after the full backup, only the changes (new and modified files) are backed up. An incremental backup takes the least amount of time, but it is potentially more difficult to restore because it generally requires more tapes.

media Various types of storage media for data, including magnetic tape, fixed and removable magnetic disks, and recordable optical media such as CD-R and CD-RW.

mounting The process of attaching a file system, floppy, or CD-ROM to a directory in the file system hierarchy so the files can be accessed.

mount point A directory in a file hierarchy at which a mounted file system or device (floppy disk, CD-ROM, and so on) is logically attached. The mount command attaches a file system, either local or remote, to the file system hierarchy.

RAID 1 (Redundant Array of Independent Disks-Level 1) RAID 1, or mirroring, uses two drives, with the second drive storing the same data as the first. If one of the drives fails, the other will take over. A more robust version of RAID 1, which uses dual drive controllers as well as dual drives, is known as duplexing.

RAID 5 (Redundant Array of Independent Disks-Level 5) Combines three or more drives as a group so that if one fails, the others take over. The bad drive can be replaced with no loss of service to the users.

restore To bring data back from tape or other backup media and replace the corrupted or lost data on the original disks.

volume management Solaris feature that provides users with a standard method of handling data on floppy disks and CD-ROMs. This management feature gives users access to these types of devices automatically without having to become a superuser and mounting them.

Objectives

After reading this chapter, you will be able to

- Describe the different types of UNIX and Linux system processes.
- Display system processes for yourself and other users.
- Interpret the information displayed for system processes.
- Identify process hierarchy (parent and child) process relationships.
- Terminate system processes.
- Manage foreground and background processes.
- Use the **at** command and **crontab** utility for process scheduling.

Chapter 13

System Processes

Introduction

Knowledge of processes is critical to understanding the inner workings of the UNIX and Linux operating systems (OS). This chapter introduces UNIX and Linux processes and process management. All program execution and tasks performed on a UNIX and Linux system are accomplished with processes that are managed by the operating system kernel. In this chapter, you will learn how to view and manage processes. You will learn how to interpret the process information displayed with the **ps** (process status) command, including parent and child processes, process identification numbers, and process names. In addition, you will learn how to terminate unwanted or unresponsive processes. Finally, you will learn how to work with foreground and background processes and how to schedule one-time-only and recurring tasks.

UNIX System Processes

All operating systems have some means of managing tasks. The UNIX network operating system manages tasks using **processes**.

Introduction to UNIX and Linux Processes

Processes can be initiated either by the operating system or by users. The majority of tasks performed in the UNIX and Linux environments start a process. A process can start a subprocess. This creates a process hierarchy or tree similar to the file system structure with parent/child relationships. For example, when you use **vi** to edit a file, or send a file to the printer with the **lp** command, a new process is started. The shell where the process was started is the *parent process*. The command being executed is the *child process*. The parent process provides an environment for the child process to run. The parent process waits in a suspended state until the child process is finished. Once the child process is completed, or terminated by a user, the parent process reassumes control and the shell prompt returns. When a process is placed in the background,

as in **$sort largefile&** (the ampersand at the end of the command line instructs the shell to process the sort in the background), the shell does not wait in a suspended state for the child process to finish. The shell prompt returns immediately and the user may enter another command while the ***background process*** continues to execute. This is basically how multiprocessing works in UNIX.

Process Identifiers

Each program that is run creates a process, which is assigned a unique ***process identification number (PID)***. The PID is used by the system to identify and track the process until it is completed. However, some simple commands, such as **cd**, are executed by the shell itself and do not create a separate process. With the exception of certain system initialization processes, every process in the system also has a ***parent process identifier (PPID)***, which indicates the PID of the process that spawned it.

Processes and the OS Kernel

The OS kernel manages the initiation and termination of all processes. Every process requires system resources, such as central processing unit (CPU) time and random access memory (RAM) space to work in. The OS allocates these system resources to each process when it starts and de-allocates them when the process ends.

Figure 13-1 shows the relationships between the OS kernel, the CPU, RAM, and processes.

Figure 13-1 Kernel Allocation for Processes

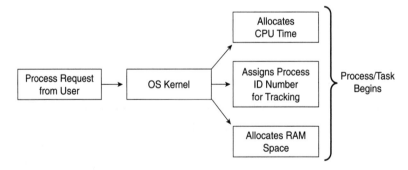

System Startup Processes

The first two processes started when a System V-based system is booted are sched (scheduler – process ID of zero) and init (initialization – process ID of one). These two processes manage all other processes. Linux does not have a scheduler process but instead starts the init process (process ID of one) and various memory and kernel handlers.

The init process is the parent of the login program that verifies the login name and password entered. On a successful login, the login program starts the login shell specified for that user in the /etc/password file. Init, the parent process of the login shell, goes to sleep and waits for the child process, the login shell, to shut down or die when the user logs out. The parent process then wakes up and starts another login program.

Types of Processes

Several different types of UNIX processes exist, as discussed in the next several sections and summarized in Figure 13-2.

Figure 13-2 Types of UNIX Processes

Daemon—Processes started by the UNIX kernel

Parent—The process that spawned another

Child—The process spawned by the parent

Orphan—Result of parent process terminating before child returns

Zombie (or defunct)—Child process that does not return to the parent

Daemon

Daemons are processes that are started by the UNIX kernel and that exist for a specific purpose. For instance, the lpsched (line printer scheduler) daemon exists for the sole purpose of handling print jobs. When no printing is taking place on the system, the lpsched daemon is running but inactive. When a print job is submitted, this daemon becomes active until the job is finished. The dtlogin daemon provides the CDE login screen at the beginning of a user's session and again after the user exits CDE. UNIX daemons are similar to services in Windows NT/2000 and NetWare Loadable Modules (NLMs) with Novell NetWare.

Parent

A process that generates another process is referred to as its parent. Every process except init has a parent process. The login daemon is generated by init and, therefore, init is referred to as the parent process of the login daemon. The login daemon is a child process of init.

Child

A process that is started by another process is referred to as a child process, as with the login daemon in the previous example. When a user is working in a Terminal window in the CDE, that terminal's PID is the parent process ID (PPID) of any commands issued in the terminal. These commands are child processes of the terminal process. The parent process receives and displays the output from the child process and then shuts down or kills the process. When the user issues a command from the shell, the shell generates a child process and waits for it to execute. When it is finished, control returns to the parent shell.

Orphan

If a command is issued in a Terminal window and the window is closed before the command returns output, that process becomes an orphan. The system passes the ***orphan process*** to init, which is the master system process. Init then becomes the parent process and ends the child process.

Zombie (or Defunct)

Occasionally, a child process does not return to the parent process with an exit status indicating it is finished. This process becomes "lost" in the system. The only resource that this process uses is a slot in the process table. The process cannot be stopped in a conventional manner. This type of process is called a zombie or defunct process. Defunct processes do not harm or slow a system and are automatically removed when the system reboots.

Displaying Processes with the ps Command

The **ps** (process status) command is used to list the processes currently running on the system. This normally is done if a process is taking too long or appears to have stopped, as indicated by a Terminal window not responding. By listing the processes, you can see the name of the command or program that initiated the process. You will also see any child processes that it might have generated. By executing the **ps** command more than once, you can see if a process is still running by looking at the time for the process. This is the amount of CPU time that the process is using. If the amount of time does not increase, then the process might have stopped. The student can use the **ps** command to check the PID of the process and then shut down or kill the process if it is taking too long or has stopped.

The output of the **ps** command will display the PID number and the command or program associated with it. The PID number normally is used to terminate a process. The following show the syntax for the **ps** command:

```
ps [-options ]
```

As shown in Figure 13-3, there are three main options with the **ps** command: **-e** (every process), **-f** (full listing), and **-u** (user). The column information displayed for these various commands is defined in Figure 13-6.

- **ps** The **ps** command by itself displays PID, TTY (terminal type), TIME (CPU time), and CMD (command that initiated the process) for only the processes running in the current shell. Open a Terminal window under the CDE File Manager, and you will not see any of the other processes that you have initiated.

- **ps -e** The **ps** command with the **-e** (every) option displays PID, TTY, TIME, and CMD for all processes running on the system.

- **ps -f** The **ps** command with the **-f** (full) option shows a listing of all information: UID, PID, PPID, C, STIME, TTY, TIME, and CMD. However, only for those processes running under the current shell or Terminal window.

- **ps -u** The **ps** command with the **-u** (user ID) option displays PID, TTY TIME, and CMD for every process running on the system for a particular user.

Figure 13-3 ps Command Options

Option	Meaning	Function
ps	No Options	Displays information for current user processes in current shell or terminal window.
ps -e	Every	Displays information about every process on the system.
ps -f	Full	Generates a full listing with all available information on each process.
ps -u *userid*	User	Displays all processes for a particular user.

Figure 13-4 shows the output of the basic **ps** command with no options. Multiple options can be used with most commands. The **ps -ef** command combines the **-e** and **-f** options. The **ps -ef** command shows every process on the system and all information available in a full listing. Because of the number of processes usually running on a system, it is useful to pipe the **ps -ef** command to **more**. There the output can be read a page at a time, as shown in the example in Figure 13-5. Note that root initiated the /etc/init daemon as process 1. User aster with PID 1292 is running a Korn shell (**-ksh**) process from the console. User rose with PID 1400 is running a clock program under Open Windows.

Figure 13-4 Displaying a List of Your Processes with **ps**

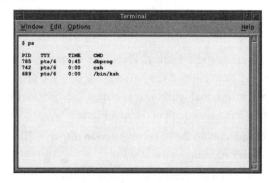

Figure 13-5 Displaying a Full Listing of All Processes with **ps -ef**

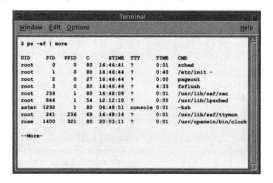

NOTE

The equivalent process status command on a BSD system is **ps -aux**.

Figure 13-6 describes the column headings from the **ps -ef** command. The controlling terminal for system daemons appears as a question mark (**?**). The word **<defunct>** appears in the CMD column if a process is a zombie or defunct process. Note: The CPU time might be a bit higher for a defunct process than for other processes.

Figure 13-6 Column Headings for the **ps -ef** Command

Value	Description
UID	The user ID of the user that initiated the process.
PID	The process identification number of the process. PID kills a process.
PPID	The parent process identification number of the process.
C	The priority of the process.
STIME	Start time of the process.
TTY	Terminal type—The controlling terminal for the process.
TIME	The amount of CPU time used by the process.
CMD	The command name or daemon (name of the program executed).

Searching for a Specific Process

As mentioned earlier, to stop a process, you first must determine the PID. On most systems, hundreds of processes are running, and the **ps -ef** listing can be quite long. If you know the name of the executable program that started the process, you can find the PID faster. If you pipe the output of the **ps** command to **grep**, you can search for the specific process that is to be terminated and determine the correct PID. The student should recall from Chapter 8, "File Systems and File Utilities," the **grep** command can search for any type of character string in the output of another command. Specific to Solaris is the **pgrep** command used to search for a specific process by name rather than by PID number. The **-l** (long output) option displays the names of the processes associated with the PID found. Figure 13-7 compares the **ps -e** command using **grep** with **pgrep -l**. The **-e** option displays the PID and the name of the initiating command, which allows **grep** to search on this information.

Figure 13-7 Displaying Processes Using **ps** and **pgrep**

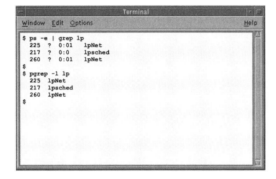

e-Lab Activity 13.1 Displaying System Processes

In this activity, you use the **ps** command with the -**f** and -**e** options to display processes. You also pipe the output of the **ps** command to **grep** to search for specific processes. Refer to e-Lab Activity 13.1 on the accompanying CD-ROM.

Terminating Processes

When working with UNIX systems it is sometimes necessary to terminate unwanted or unresponsive processes. This involves identifying the process and then killing it using the proper signal.

Identifying the Process to Terminate

The **ps -ef** command displays a full listing of every process, including the PID and its PPID. When a user is trying to terminate a program or release a hung Terminal window, it might not be enough to kill the PID that is associated with the unresponsive application. The user might find it necessary to kill the parent of that process and, on rare occasions, even the parent of the parent. It is important to look at a PID and PPID to be able to trace from the child up the hierarchy to the parent processes that generated them.

To do this, the user first must identify the PID of the lowest level unresponsive process. Normally, the user would try to kill that process's PID. If this does not stop the process, the user might need to kill its parent. Killing a parent process will kill all child processes generated by the parent process. Therefore, it is quicker to kill a parent process rather than killing several child processes.

Figure 13-8 shows three processes and the relationships among them. In this figure, the first process was started when the user opened a Terminal window from the CDE File Manager, which started the default Korn shell (ksh). From there, the user started a C Shell with the **csh** command. Next, the user ran a program called **sleep 500&**, which suspended execution for 500 seconds. The ampersand (**&**) tells the shell to run the command in the background and return the shell prompt so that the user can continue working.

The **ps -f** command in Figure 13-8 is used to see only those processes initiated from the current Terminal window shell.

Figure 13-8 Parent and Child Process Relationships

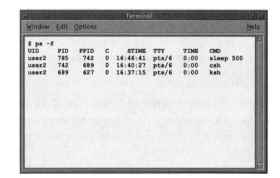

The sleep process has a PID of 785, and its PPID is 742, which is the PID of the C Shell (csh). If the user terminates PID 742, they also will terminate 785. If the user terminates the PID of the Korn shell (ksh), which is 689, they will terminate all processes initiated from that shell including the terminal window itself. Linux supports the GNU long options variations

of the **ps** command where options are preceded by two dashes. A particularly useful command is **ps** with the **-forest** option. This option displays a hierarchical relationship between parent and child processes.

Signals

Currently, 30 to 40 *signals* are defined in UNIX, depending on the implementation. Each signal is associated with a number and a name. Signals are used to terminate, suspend, and continue processes. Information on the different signals can be found by using the following **man** command:

```
$man -s 3C signal or man signal
```

Using Ctrl-c sometimes can terminate a process that is not responding. This sends an interrupt (INT) signal to the process, terminating it and any child processes that it might have spawned.

kill Command

The **kill** command provides a direct way to terminate unwanted command processes. It is useful when you want to stop a command that takes a long time to run. The student also uses the **kill** command to terminate a process that you cannot quit in the normal way. Specifying the user's PIDs normally kills processes. *Background processes*, those submitted using the ampersand, also are assigned a job ID. The student can kill background processes by using either the **process id** or the **job id** command. To view all jobs running in the background and the job IDs, use the **jobs** command. The number returned in brackets is the job ID number. The syntax of the **kill** command is shown here:

```
kill [-signal ] process-id or %job-id
```

To terminate a process with the **kill** command, you must first type **ps** to find out the PID or PIDs for the process or processes. Then type **kill** followed by the PID or PIDs. If you use the **kill** command without specifying a signal, signal 15 (SIGTERM) is sent to the process with the specified PID number. This is referred to as a "soft kill" and usually causes the process to terminate. It is best to use a soft kill on a process, if possible, because it closes files properly and terminates the process or processes properly.

If you need to forcibly terminate a process, you can use the **-9** option to the **kill** command. This option is referred to as a "sure kill" and is necessary for killing shells and processes that will not respond to any other signal to terminate. The following syntax shows the **kill** command with the **-9** or sure kill option:

```
$kill -9 PID#
```

NOTE

The **sleep** command frequently is used in shell scripts to cause the machine to pause for a specified number of seconds before continuing on to the next command. It is used in this example only for purposes of illustration.

NOTE

For processes other than shells, use the **kill -9** (SIGKILL) command as a last resort. The **kill -9** command is an abrupt method and does not allow for proper process termination.

Finding and Terminating a Process by User

The **ps** command can be used with the **-u** (user) option to find processes for a specific user. The student might find processes for users by the user's login name or UID number. A user can terminate only his or her own processes. However, the superuser can terminate any process running on the system. If multiple windows are open on a user's desktop, the output of the **ps** command will show pts/# under the TTY heading for every window open.

A **pseudoterminal** (pts) is the device name given to windows and remote login sessions. Each window the user opens after logging in gets a new pts#. Figure 13-9 shows the results of the **ps -u** command for user2 and uses the **kill** command to terminate the find process, which is PID 12932. The syntax for the **ps -u** command is shown here:

```
ps -u login-ID or UID
```

Figure 13-9 Finding and Terminating Processes for a User

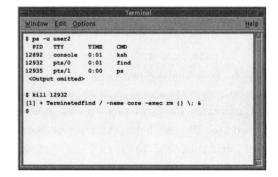

pkill Command

The **pkill** command is specific to Solaris and works exactly like the **pgrep** command. However, the **pkill** command terminates the process by matching the command name (CMD) of the process or processes and sends a kill signal. Figure 13-10 shows using the **pkill** command to kill a process by its name: **sleep**. The syntax of the **pkill** command is shown here:

```
$pkill CMD name (Solaris)
```

or

```
$killall [-i] CMD name (Linux)
```

Caution should be used with the **pkill** and **killall** commands. The **pkill** and **killall** commands will kill all processes running with the command name the user specified. In addition, the

killall command on some versions of UNIX works very differently from the Linux **killall** command. You should not use the **killall** command until you have done research. You should find out how the command works with the particular version of UNIX you are running by consulting the killall man page.

Figure 13-10 Terminating a Process with **pkill**

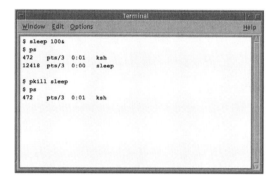

e-Lab Activity 13.2 Terminating Processes

In this activity, you use the ps command with the -u option to find processes for a specific user and then use the kill command to terminate those processes. Refer to e-Lab Activity 13.2 on the accompanying CD-ROM.

Lab Activity 13.3.2 Managing System Processes

In this lab, you work with UNIX commands to identify system processes and control them. Refer to Lab 13.3.2 in the *Cisco Networking Academy Program: Fundamentals of UNIX Lab Companion*, Second Edition.

Foreground and Background Processes

UNIX is a multitasking OS with the capability to work on many different tasks at the same time. As you are working in a Terminal window or accessing the Internet browser in the foreground, the system is running many processes in the background, enabling the system to properly function. See Figure 13-11.

Figure 13-11 Foreground and Background Process Examples

Foreground Processes

Communication between the user and the shell happens interactively, one task at a time. For example, when you enter a command in a Terminal window, the shell processes the command and displays the output. The student must wait until the shell completes the task before requesting another task. This is considered *foreground processing*.

Background Processes

UNIX is a multitasking operating system. However, running processes in the foreground can unnecessarily tie up a Terminal window and limit the execution of commands and programs to a serial process in which they run one after another. If programs are to run simultaneously, they must either run from a different Terminal window or run in the background.

The student can run a process in the background by adding an ampersand (**&**) to the end of the command line. Background processes run concurrently with other system processes and shell programs. The student might want to run processes in the background because processes are time consuming. Processes can take time sorting a large file or searching the file system for a file. Instead, you might want to start a program and be able to continue interacting with the shell. For example, if you started Netscape from a Terminal window by typing **netscape** at the command prompt, Netscape would start but the Terminal window would appear locked. That is because the Terminal window shell is the parent process of the Netscape program running in the foreground. As soon as Netscape is exited, the shell prompt returns. If you type **netscape&**, Netscape would start as a background task and the shell prompt would return to the Terminal window, allowing you to continue working.

Controlling Foreground and Background Jobs

Job control gives you the capability to place a job or process currently running in the foreground into the background. The student places the process in the background because it is taking longer than expected. The student needs the shell prompt to work on something else.

Job control also enables you to manage background jobs by moving them to the foreground, suspending, or terminating them. For example, if you used the Windows Telnet program to log into the school's computer and began downloading a file using the **ftp** command. See Chapter 16, "Network Concepts and Utilities." You then realize that you are just waiting for the download to finish. You can suspend or pause the job and then place the job in the background. You can now continue to work from a shell prompt.

After a period of time, you might decide to bring the download job back to the foreground to check on the progress. Figure 13-12 lists the commands that enable you to manage jobs.

Figure 13-12 Controlling Foreground and Background Processes

Command	Meaning
Ctrl-Z or stop %job#n	Suspends (not terminates) the foreground process.
jobs	Displays all background jobs.
bg %job#n	Places job# in the background and restores the shell prompt.
fg %job#n	Places job# in the foreground.
Ctrl-C	Cancels the current foreground job.
kill %job#n	Terminates job#.

Figure 13-13 shows a sequence of starting a job in the background, displaying the job number, moving to the foreground, suspending, moving back to the background, and finally terminating it. Note that the number in the square brackets ([x]) is the job number. The job preceded by a plus sign (+) is the current job and can be manipulated with **fg** (foreground) or **bg** (background) without specifying the job number.

Figure 13-13 Foreground and Background Jobs

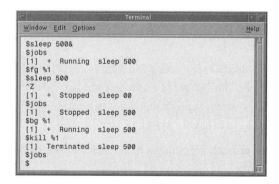

TIP

When you log off, all background processes are terminated. Use the **nohup** (no hang up) command to enable a background job to complete even after logging off. For example, the command line **$nohup sort customerids > custfile &** followed by you logging off allows the sort to continue. After logging back on, you could view the custfile for the results of the **sort** command.

Process Scheduling

The multitasking capability of UNIX is not limited to running processes only in the present. UNIX contains programs that enable you to schedule programs to run one time only at a specified time using the **at** command. The student can also schedule repeated operations using the **crontab** covered in the next section.

at Command

The **at** command enables you to run programs, commands, or shell scripts at some future date and time. For example, you would like to e-mail a friend the contents of a file on January 1 at exactly 12:01 p.m./1201. Or, to be considerate, you schedule the **find** command to search the entire hard drive for a missing file to run at 3:00 a.m./0300, when user activity is low.

TIP

To run a script file at a specified time, use the command **$at** [*time spec*] [*script file name*]. For example, **$at midnight whoison** would run the whoison shell script that runs the **who** command to see what users are accessing the system at midnight and then would redirect the output to a file to be viewed in the morning. Shell scripts are covered in Chapter 15, "Introduction to Shell Scripts and Programming Languages."

To schedule a one-time job using the **at** command, perform these steps:

1. Enter the **at** command followed by a time specification, where the time specification can be $at 10:30am today, $at midnight, $at 12:01 1 Jan 2002, and so on. See the man page for many more examples.

2. At the **at** prompt (**at>**), enter the first command to run at the specified time, and then press **Enter**.

3. Enter the next command to run, followed by **Enter** or press **Ctrl-D**, if finished. An **at** job number is assigned to track the **at** job. Use the **atq** command to view the **at** job queue. Use the **atrm [at job#]** command to remove a scheduled job.

On some UNIX systems the user might not be permitted to use the **at** command for security reasons and will need to ask the system administrator to grant permission.

crontab Utility

The **crontab** utility allows a user to schedule a command or program to run at scheduled intervals. This utility is useful for scheduling backups, finding and removing core files in the user's home directory tree, or even e-mailing a friend a birthday note automatically on his birthday.

The **crontab** command is used to view and edit a user's crontab file that stores scheduled program information. By default in Solaris a user can edit her own crontab file that initially is empty. On some UNIX systems the user might not be permitted to have a crontab file for security reasons and will have to ask the system administrator to grant permission.

Each crontab entry in the crontab file consists of six fields separated by spaces or tabs. For example:

```
17  *  *  5  /usr/bin/banner  "Weekend Is Here!" > /dev/console
```

Refer to Table 13-1 for a definition of the six fields in the crontab file.

Table 13-1 Fields in the crontab File

Field Number and Name	Event
1 — The minute field	Represents the minutes past the hour between 0 and 59
2 — The hour field	Represents the hour of the day between 0 and 23
3 — The day-of-the-month field	Represents the day of the month between 1 and 31
4 — The month field	Represents the month between 1 and 12
5 — The day-of-the-week field	Represents the day of the week between 0 (Sunday) and 6 (Saturday)
6 — The command field	Represents the name of the command or script to be run

In the preceding example, the message "Weekend Is Here" would be displayed in the console window (**Workspace Menu > Hosts > Console Terminal**) at 5:00 p.m./1700 every Friday of the week of every month. The **banner** command may not be in the /usr/bin directory on some systems. To find the directory location for any command or other file on a Solaris or Linux computer, enter the command **whereis** followed by the name of the command or the file you wish to find.

The first five fields can have the following:

- A single value
- Multiple values (that is, 1,3,5) in the sixth field, which would mean Monday, Wednesday, Friday
- A range of values that is 1 through 5 in the sixth field which would mean Monday thru Friday
- An, * to mean any or all values

To edit the crontab file use the **crontab -e** (edit) command. In CDE this will bring up the Text Editor and allow the user to enter a new crontab entry or edit an existing entry. All six fields must be accounted for in a new crontab entry. If the user is using Linux or is not in CDE the default editor is vi.

Once the user adds a new entry or edits an existing entry the user saves the file. To list the entries in the crontab file use the command **crontab -l** (list). To delete the crontab file use the **crontab -r** (remove) command.

The cron daemon is started when the system boots and checks all user crontab files once every minute for commands to run at that time.

NOTE

If the user mistakenly types crontab without any arguments, **Ctrl-C** should be used to exit.

Summary

Now that you have completed this chapter, you should have an understanding of the following:

- UNIX initiates, manages, and terminates programs using system processes. When a program such as the **sort** command or the vi editor starts, the operating system kernel assigns it a unique process identification number (PID). The kernel also allocates CPU time and RAM space for the program to run. UNIX processes are hierarchical, similar to the UNIX file system. Every process has a parent process except the init process, which is process 1.

- Five types of system processes exist on a UNIX system:
 - **Daemon** is a process started by the UNIX kernel.
 - **Parent** is a process that spawns another process.
 - **Child** is the process spawned by the parent.
 - **Orphan** is the result of a parent process terminating before the child returns.
 - **Zombie** is a child process that does not return to the parent.

- The **ps** command is used to display processes and has several options. The command **ps -ef** displays every process with full information:
 - **-e**—Every process
 - **-f**—A full listing of information
 - **-u**—User processes

- The output of the **ps** command can be piped to the **more** command to see one screen at a time, or to the **grep** command to search for specific strings such as program names.

- UNIX is a multitasking operating system capable of running jobs in the foreground and the background.

- Placing a job in the background is accomplished using the **&** (ampersand). Several commands can be used to manage background jobs, including **jobs**, **stop**, **fg**, **bg**, and **kill**.

- Long-running or unresponsive processes can be terminated using the **kill** command while specifying the PID of the process. Most processes can be terminated with the basic **kill PID#** command, also called a soft kill. Killing a shell process requires the **kill -9 PID#** command, also called a sure kill. The Solaris **pkill** command and Linux **killall** command can be used to kill a process by specifying the command name instead of the PID.

- The **at** command and the **crontab** utilities can be used to schedule jobs to run at specific times.

Check Your Understanding

1. Every process created on a UNIX system has a unique _____.

2. The two resources used by processes are CPU and _____.

3. Which type of system process is started by the kernel and performs system support services?

 A. zombie

 B. wizard

 C. daemon

 D. orphan

4. Look at Process A and Process B below. What is the PID of the child process?

Process A	Process B
PID 347	PID 296
PPID 296	PPID 253

5. If a user wants to display only their own processes in the current shell, which command should they use?

 A. ps -ef

 B. ps -e

 C. ps -u

 D. ps

6. When displaying a process listing with full information, what does the TIME column mean?

 A. The amount of CPU time that the process has used

 B. The amount of RAM time that the process has used

 C. The time that the process started

 D. The time that the user logged on

7. To search for all process IDs that have to do with the *wizbang* program, which command should a user type?

 A. ps -f -s wizbang

 B. ps -e | more wizbang

 C. ps -e grep | wizbang

 D. ps -e | grep wizbang

8. A user is working in a Terminal window where the user recently ran a program. The program seems to be taking a long time to finish and the user would like to end it. The user checks the process status and sees that its PID is 1234 and that the time is not changing. Indicate which command the user should try first, then second.

 A. **kill 1234 then kill PID 1234**

 B. **kill 1234 then kill -15 1234**

 C. **kill 1234 then kill -9 1234**

 D. **kill 1234 then kill -9 PID1234**

9. A user is working in a Terminal window where he recently killed a program. Now the Terminal window is unresponsive and the user cannot enter any commands. Which method would provide a sure kill to terminate the Terminal window?

 A. Open a new Terminal window

 B. Check the PID of the TTY for the unresponsive Terminal window

 C. Kill the unresponsive Terminal window with a **-9** option

 D. Kill the unresponsive Terminal window with a **-15** option

10. Which two statements are true of *background* processes?

 A. The user must wait until the process completes before starting another process.

 B. They are started by putting an **&** at the end of the command line.

 C. They are normally terminated when the user logs off.

 D. Communication between the user and the shell happens interactively, one task at a time.

11. What are the correct commands and keystrokes used to run the **who** command at 2:00 p.m. using the default configuration.

 A. ```
 at 14:00
 who > wholist
 Ctrl + D
       ```

    B. ```
       at 2:00
       who >> wholist
       Ctrl + D
       ```

 C. ```
 at 2:00
 who > wholist
 Ctrl + C
       ```

    D. ```
       at 2:00
       who > wholist
       :q
       ```

12. Given the crontab entry below, when will the **dothis** script run?

<u>8 15 5 * * dothis</u>

A. 8:15 a.m. each Friday

B. 8:15 a.m. on the 5th of each month

C. 3:08 p.m. every day in May

D. 3:08 p.m. on the 5th of each month

UNIX Command Summary

& Runs job/process in the background and restores the shell prompt. Example:

```
$ Netscape&
```

at Executes specified commands (read from standard input) or script file at a later time that you specify. Example:

```
$ at 10:30am whoson
```

bg Places a job in the background. Example:

```
$ bg %3
```

Ctrl-Z Suspends the foreground process. Example:

```
$ sleep 500&
[1] 453
$ jobs
[1] Running sleep 500
$fg %1
$ sleep 500
^Z
[1] Stopped sleep 500
```

crontab[e l r] Used to view and edit a user's crontab file that stores scheduled program information. Example:

```
0 17  *  * 5  /usr/bin/banner  "Weekend Is Here!" > /dev/console
```

This crontab entry will display the message "Weekend Is Here" would be displayed in the console window (**Workspace Menu -> Hosts -> Console Terminal**) at 5:00 p.m./1700 every Friday of the week of every month.

fg Places a job in the foreground. Example:

```
$ sleep 500&
[1] 453
$ jobs
[1] Running sleep 500
$fg %1
$ sleep 500
```

jobs Lists all jobs running in the shell. Example:

```
$ jobs
[1] Running find ~ -name memo1
```

kill Sends a signal to the process or processes specified by each PID operand. Example:

```
-9
```

```
$ kill -9 100 -165
$ kill -s kill 100 -165
```

killall Specific to Linux. Terminates a process by matching the command name rather then its PID number. See **pkill** command for Solaris. Example:

```
$ killall -i vi
```

pgrep Examines the active processes on the system and reports the process IDs of the processes whose attributes match the criteria specified on the command line. Example:

```
Obtain the process ID of sendmail:
$ pgrep -x -u root sendmail
283
```

pkill Specific to Solaris. Terminates a process by matching the command name rather then its PID number. See **killall** command for Linux. Example:

```
$ pkill vi
```

Terminate the most recently created xterm:

```
$ pkill -n xterm
```

ps Prints information about active processes. Example:

```
-e, -f, -u
$ ps
```

sleep Suspends execution for at least the integral number of seconds specified in the time operand. Example:

```
$ sleep 60&
```

Key Terms

background job number In the C shell or Korn shell, a job number is assigned to commands (jobs) executed in the background. Several commands are used to manage background jobs, including **jobs**, **stop**, **fg**, **bg**, and **kill**.

background process You can run a process in the background by adding an ampersand (**&**) to the end of the command line. Background processes run concurrently with other system processes and shell programs. You might want to run processes in the background because they are time-consuming (such as sorting a large file or searching the file system for a file), or you might want to start a program and be able to continue interacting with the shell.

child process A process that is spawned by another process. When a user is working in a Terminal window in CDE, that terminal's PID is the *parent process ID* (PPID) of any commands issued in the terminal.

foreground process The process that is currently in control of the cursor or mouse. Usually in the front window.

orphan process If a command is issued in a Terminal window and the window is closed before the command returns output, that process becomes an orphan.

paging The process of moving memory pages between physical memory and the swap space on the disk.

parent process A process that spawns another process. Following system bootup, a process called the init daemon is invoked. Every process except init has a parent process.

physical memory All computers have physical or system memory microchips. This most often is referred to as random access memory (RAM). This memory is controlled directly by the processor in conjunction with the memory management unit (MMU).

PID Each program run on a UNIX system creates a process, which is assigned a unique *process identification number* (PID). The PID is used by the system to identify and track the process until it has completed.

process A unit of work or task on a UNIX system that is managed by the kernel. Each process is assigned CPU time, RAM, and a process ID (PID) until it completes.

process scheduling The capability to run a process at a predetermined time. The **at** command and the **crontab** command can be used to schedule UNIX jobs or processes.

signals Currently 30 to 40 signals are defined in UNIX, depending on the implementation. Each signal is associated with a number and a name. Signals are used to terminate, suspend, and continue processes. The **kill -9** command uses a signal 9 to terminate a shell.

spawn A process can start or spawn a subprocess, thus creating a process hierarchy or tree similar to the file system structure with parent/child relationships.

virtual memory The swapping process uses swap space on the disk, which is limited. The combination of RAM plus swap space constitutes virtual memory, which is the maximum space that processes can use.

zombie process Occasionally, a child process does not return to the parent process with its output. This process becomes "lost" in the system.

Objectives

After reading this chapter, you will be able to

- Identify the most common UNIX and Linux shells.
- Describe the features of the Korn and Bash shells.
- Create custom prompts and aliases with the Korn and Bash shells.
- Use history and re-execute commands with the Korn and Bash shells.
- Work with local and global variables.
- Identify and edit key shell initialization files.

Shell Features and Environment Customization

Overview

The shell is the primary user interface to a UNIX system. The concept of the shell was introduced in Chapter 1, "The UNIX Computing Environment." Also introduced in Chapter 1 were other key UNIX operating system components such as the kernel and the file system. UNIX provides support for many shells, such as Bourne, C, Korn, and Bash. UNIX also provides support for third-party shells. This chapter provides a brief review of the function of the shell and focuses on two of the most widely used shells today: the Korn and Bash shells. The Korn shell is the default shell for Solaris users and the Bash shell is the default for Linux users.

This chapter goes into greater detail about the unique features of each shell including custom prompts, aliases, history, and re-execution of commands. Finally, the chapter discusses variables and initialization files used to customize the work environment.

Review of the Shell

A shell is an interface between the user and the kernel. The shell acts as an interpreter or translator. In other words, the shell accepts commands issued by the user, interprets these commands, and executes the appropriate programs.

Shells can be command line or graphical. UNIX Shells are also interchangeable, making it possible to initiate or switch between the shells at any time to use certain features not available in other shells.

The following list reviews the popular command-line shells available within the UNIX and Linux environment:

- **Bourne shell** (/bin/sh) was the original shell program for UNIX. It is the default shell for the Solaris computing environment. Stephen Bourne developed the Bourne shell for the

AT&T System V.2 UNIX environment. This shell does not have aliasing or history capabilities and is used mostly by system administrators.

- **Korn shell** (/bin/ksh) is a superset of the Bourne shell and was developed by David Korn at Bell Labs. It has many of the Bourne shell features, plus added features such as aliasing and history. This is the most widely used shell and is the industry standard for users of System V-based systems.

- **C shell** (/bin/csh) is based on the C programming language. Similar to the Korn shell, it has additional features such as aliasing and history. The C shell was developed by Sun's Bill Joy and is still widely used today.

- **Bourne-Again shell** (/bin/bash) has the feel of the Bourne and Korn shells and incorporates features from the C and Korn shells. Bash is the most popular shell with Linux and is the default for most distributions. Bash can be downloaded from GNU (www.gnu.org).

- **TC shell** (/bin/tcsh) is a popular variant of the C shell that supports command-line editing and command-line completion.

The shell is the first program to run when the user logs onto the system. In addition to the shell's primary role as a command interpreter, the shell program has numerous features and built-in commands that facilitate interacting with the system and completing tasks. Several of the shell features have already been addressed in this book including:

- **Wildcard matching** uses special characters to select one or more files as a group for processing. For example, **$lp chap***. See Chapter 5, "Accessing Files and Directories," for more information.

- **Input/output redirection** uses special characters for redirecting input (> or >>) and output (<). For example, **$who > userlog**. See Chapter 7, "Advanced Directory and File Management," for more information.

- **Pipes** are used to connect one or more simple commands to perform more complex operations. For example, **$who | sort | lp**. See Chapter 7 for more information.

- **Background processing** enables programs and commands to run in the background while the user continues to interact with the shell to complete other tasks. For example, **$sort largefile &**. See Chapter 13, "System Processes," for more information.

- **Programming language features** are used to create shell scripts that perform complex operations. For example, a shell script was written to set up all the user accounts,

create home directories, and copy lab files into each user's home directory for the Fundamentals of UNIX class. See Chapter 15, "Introduction to Shell Scripts and Programming Languages," for more information.

This chapter focuses on additional features of the Korn (ksh) and Bash (bash) shells that make working with the shell easier and more productive.

Alias Shell Feature

An alias is a way to give a command a different or shorter name for use in the shell. Aliases provide an excellent way to improve efficiency and productivity when using shell commands. For example, a user can create an alias named **ll** (for long listing) that when entered on the command line executes the **ls -l** command.

When an alias is set from the command line, it is activated only for the shell in which the alias is created. Adding aliases to the initialization file (covered later in this chapter) activates the alias upon login or whenever a new terminal window or shell is opened. The following shows the basic syntax of the **alias** command used to create an alias in both the Korn and Bash shells:

```
alias aliasname=value
```

> **NOTE**
>
> There is a space after the **alias** command and the **aliasname**. There are no spaces before or after the equals sign (=).

There are several reasons to use aliases:

- **Substitute a short command for a long one**—The user can reduce the number of keystrokes for commonly used long commands by creating an alias for the command.

- **Create a single command for a series of commands**—The user can string together several commands and assign the commands one short alias name, to reduce keystrokes.

- **Create alternate forms of existing commands**—Some commands, such as **rm** (remove files and directories) and **cp** (copy files), can be risky. If the user is not careful, an important file could be accidentally overwritten. An alias allows the user to change the meaning of these commands to include the **-i** option so that the alias prompts the user before overwriting a file or directory.

Figure 14-1 shows some examples creating aliases. Examples 1 and 2 in the figure show how to substitute a short command for a long one, the third example shows how to create a single command for a series of commands, and the fourth example shows how to create alternate forms of existing commands.

> **NOTE**
>
> Use single quotes for commands with options, spaces, or other special characters. For example, **alias ll='ls -l'**.

Figure 14-1 Creating Aliases

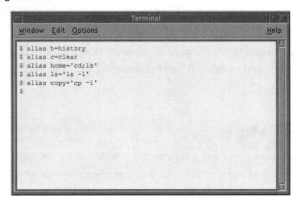

Displaying Aliases

To display usable aliases, use the **alias** command with no argument. Figure 14-2 shows using the **alias** command to display all aliases set for the current session. Some aliases are predefined as part of the Korn and Bash shell.

Figure 14-2 Displaying All Aliases Set for the Current Session

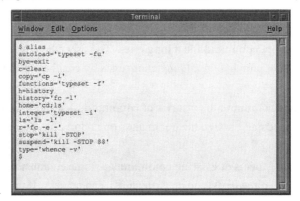

Removing an Alias in the Current Shell

A user can unset a previously defined alias with the **unalias** command. Figure 14-3 shows using the **unalias** command to unset the bye alias, which then no longer will appear in the alias listing. An alias also can temporarily bypassed. To bypass the alias and use the original version of a command, use a backslash, as shown in Figure 14-3. The following shows the basic syntax of the **unalias** command used to remove an alias:

```
unalias aliasname
```

Figure 14-3 Unsetting a Previously Defined Alias

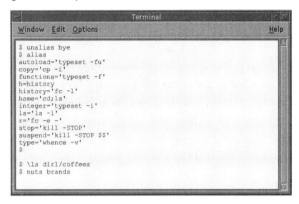

 e-Lab Activity 14.1 Using Korn and Bash Shell Aliases

In this activity, you use the alias command to create an interactive version of the **cp** command which prompts when an overwrite will occur. You then remove the alias with the unalias command. Refer to e-Lab Activity 14.1 on the accompanying CD-ROM.

Using the Shell History Feature and Repeating Commands

The history feature in the Korn and Bash shells keeps a record of the exact command lines that the user enters, in the order that they were entered. The shell assigns each command an event number and saves the last *n* number of commands in a history file. This lets the user recall previous commands, modify the commands if required, and re-execute the commands by referring to the event number.

In the Korn shell the history list is stored in the user's home directory in a file named .sh_history. By default, the Korn shell keeps a record of the last 128 commands entered.

The Bash shell history list is stored in the user's home directory in a file named .bash_history. By default, the Bash shell keeps a record of the last 1000 commands entered.

The number of commands stored in the history list file for both the Korn and Bash shells is determined by the HISTSIZE variable. Variables are covered later in this chapter. For example, HISTSIZE=500 will store the last 500 commands.

Command History in the Korn Shell

The **history** command displays the command history list with an event number to the screen.

The following shows the basic syntax of the **history** command:

`history [options]`

Specifying a number preceded by a dash as an option displays the last *x* number of history lines. Specifying a number without a dash shows the history lines from that number to the last command entered. Figure 14-4 shows the listing from the **history** command. In the first example, using the **history** command by itself, the last 16 commands are displayed. The second example displays only the last three commands because the –3 option was used.

Figure 14-4 Displaying History in the Korn Shell

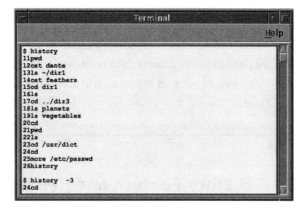

Repeating Commands in the Korn Shell

The **r** (repeat) command is one of many predefined aliases in the Korn shell. This command enables the user to re-execute commands from the history list, saving retyping time. The following shows the basic syntax of the **r** command:

`r [argument(s)]`

The argument passed to the **r** command is the history line number of a particular command, or a letter indicating the most recent command in the history list that started with that letter. In Figure 14-5, the first example shows the **r** command by itself, which repeats the last command entered (**-pwd**). This command is similar to the F3 key in DOS. The second example uses the **history** command to see the commands from the 27th command onward and then uses the **r** command to repeat the 27th command. The third example repeats the last command that started with the letter p.

Figure 14-5 Repeating Commands in the Korn Shell

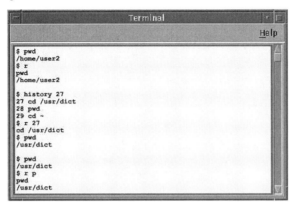

Command History in the Bash Shell

The **history** command in Bash is very similar to history in the Korn shell. The difference is
Bash does not use a dash (-) before the number of last commands to display. For example,
history 3 in the Bash shell is equivalent to **history -3** in the Korn shell.

Repeating Commands in the Bash Shell

The simplest way to repeat commands in the Bash shell is to press the up arrow, or Ctrl+P
keys, and down arrow, or Ctrl+N keys. These keys will scroll through the previous commands
from the history list. After displaying the command to repeat, press Enter. The Bash shell
offers additional features for repeating previous command lines not available in the Korn
shell. Figure 14-6 shows an example using the exclamation mark (!) to repeat the history
command line number 32 from the previous history file output (cd home/user2/practice).
Figure 14-7 shows options available with the **history** command. Figure 14-8 shows how to
re-execute commands with the history options in the Bash shell.

Figure 14-6 Repeating a Bash History Command

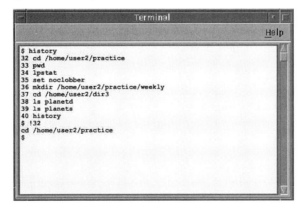

Figure 14-7 Bash **history** Options

Feature	Function
!!	Executes the previous command
!*	Repeats all arguments from the previous command
!$	Repeats the last argument from the previous Command
!number	Executes command number from the history list
!n:p	Views command n from the history list without executing it

Figure 14-8 Repeating Commands with Bash **history** Options

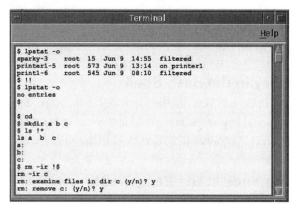

The following are detailed explanations of the Bash history options in Figure 14-7:

- **!!**—Use the double exclamation marks (**!!**) to repeat the most recent command exactly as it was executed previously as shown in the first example in Figure 14-8.

- **!***—Use the exclamation mark (**!**) and asterisk (*) to repeat all arguments of the previous command, as shown in the second example in Figure 14-8.

- **!$**—Use the exclamation mark (**!**) and the dollar sign (**$**) to repeat the **last** argument of the previous command, as shown in the third example in Figure 14-8.

- **!***number*—Use the exclamation mark (**!**) followed by a command number to repeat a specific command from the command list.

- **!n:p**—With the **!n:p** option, the user can see a previous command but not execute it. This is useful for editing the command, which is covered in the next section.

e-Lab Activity 14.2 Repeating Commands in the Korn and Bash Shells

In this activity, you use the history command and repetition options available with the Korn and Bash shells. Your current working directory is /home/user2. Refer to e-Lab Activity 14.2 on the accompanying CD-ROM.

Command-Line Editing in the Korn and Bash Shells

There is no simple way to edit a previous command line in the Korn shell. In the Bash shell the user can recall a previous command line with the arrow keys, make a change, then press **Enter**. To modify a previous command line, use the left arrow (or Ctrl+B keys) and right arrow (Ctrl+F) keys to move the cursor to the location of the edit, then either insert or delete characters before pressing **Enter**.

Both the Korn and Bash shells offer a more powerful way to edit previous commands with the command-line editing feature. The command-line editing feature requires a simple setup and knowledge of basic vi or emacs editor commands.

When enabled from the command line, the command-line editing feature is activated only for the shell in which it was set. Adding the command-line editing feature to the initialization file (covered later in this chapter) enables this editing feature upon login or whenever a new Terminal window or shell is started. The following shows the basic syntax of the **set** command used to enable command-line editing:

```
set [- | +] o vi   or   set [- | +] o emacs
```

Using **set -o vi** turns on command-line editing and informs the shell the user wants to use vi **editor** commands to position the cursor and perform inserts, edits, and search and replace. Use **set -o emacs** if the emacs **editor** is preferred. Use **set +o vi or emacs** to turn the editor off. When command-line editing has been turned on with the vi mode, pressing the **Esc** key activates the inline editor. The user will then have access to **vi** commands to edit the command line.

In Figure 14-9, the use of the **more** command generates an error because there was a misspelling of words. The **set -o vi** command is used to turn on vi editing, the **Esc** key activates the feature, and the **k** key is used to repeat the previous command so that the command can be corrected. In this example, the user edited the command to change worfs to words. The **k** key moves up through the command list, and the **j** key moves down. A way to remember the use of these keys is that **k** is for kick up and **j** is for jump down. The **vi** commands shown in the figure can be used to edit a command line. The **Enter** key is pressed after all changes are made.

NOTE

The Korn shell does not support the use of arrow keys. Therefore, the arrow keys cannot be used to reposition the cursor during inline editing.

Figure 14-9 Editing the Command Line

```
$ more /usr/dict/worfs
/usr/dict/worfs: No such file or directory

$ set -o vi
(Press the Esc key and then the k key until the desired command
displays then edit appropriately.)

$ more /usr/dict/words
```

vi Command	Meaning
k	Move backward through history list
j	Move forward through history list
l	Move to the right one character
h	Move to the left one character
r	Replace one character
cw	Change word
x	Delete one character

Filename and Command Completion in the Korn and Bash Shells

Both the Korn and Bash shells contain another feature that completes the name of a file or command. This feature allows the user to type the first few characters of a filename or command. The user presses a specific sequence of keys that instructs the shell to complete the remainder of the filename or command.

Turning on the command-line editing feature (**set -o vi**) also gives the user the ability to do filename and command completion.

Completing a Filename

To use the completion feature to complete a filename:

Step 1 Type a command, such as **ls, cat, rm**, and so on, followed by one or more characters of a filename.

Step 2 Press the Esc and backslash keys (**Esc **) in sequential order, for the Korn shell, or the **Tab** key, for the Bash shell.

If the shell finds more than one file in the current directory that begins with the letters that were entered, the user then enters the next one or more characters in the desired filename. Then the user presses **Esc ** for the Korn shell or **Tab** for the Bash shell.

Another way to use the completion feature is to request the shell to display a list of files that matches the entered filename. To display this list the user uses **Esc=** for the Korn shell or **Tab + Tab** (Tab entered twice), in the Bash shell. When the desired file is determined from

the list, the user reenters the command using an additional one or more characters then presses the **Esc ** or **Tab** again.

Figure 14-10 shows how to use filename completion to request a list of files matching files beginning with doc.

Figure 14-10 Using Filename Completion

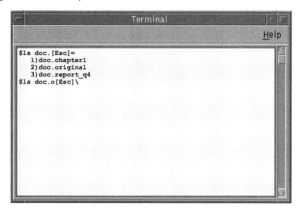

Completing a Command

In the newer versions of the Korn shell and the Bash shell the completion feature also works on commands. To use the **telnet** command, type **tel[Esc]** in the Korn shell or **tel[Tab]** for the Bash shell, instead of typing the entire command. To see a list of commands that begin with **tel**, type **tel[Esc]=** for the Korn shell or **Tab + Tab** for Bash.

Shell Variables

All the work that is done and processes that are executed from the time of login to the time of logout are completed within an environment. The environment consists of shell options that are turned on such as command-line editing, noclobber, and so on. The environment also consists of variables that shell programs and processes access during execution. This section covers setting and unsetting Korn and Bash shell variables.

A variable is a placeholder for information required by processes so the processes can function properly. For example, the LPDEST (line printer destination) variable is used by the system to recognize what a user's default printer is. Many variables are predefined and set automatically when the user logs in. Predefined variables include the default terminal prompt (PS1 – Prompt String 1), which is set to a dollar sign ($) by default, and others listed in Table 14-1. Variables also can be defined by the user.

Table 14-1 Common Variables Set by the Shell at Login

Variable	Meaning
HOME	The directory that cd changes to when no argument is supplied on the command line
LOGNAME	Sets the login name of the user
PATH	A list of directories to be searched when the shell needs to find a command to be executed
SHELL	The name of the login shell (/bin/sh, /bin/ksh, or /bin/bash)
LPDEST	Line printer destination; stores the name of the default printer

Predefined variables or variables created by a user can be modified. All variables are one of two types:

- *Local (shell) variables* are variables that are available for the current shell session only:
 - Also called Shell variables
 - Apply to current shell session
 - Created by users and administrators
 - Can be exported for use by subshells
- *Environment (global) variables* are variables that are available to the current and all child or subshells that the user or the system might start:
 - Also called global variables
 - Apply to all shell sessions
 - Typically created by administrators or during OS install
 - Several predefined by UNIX (HOME, LOGNAME, SHELL, and PATH)

Local (Shell) Variables

When a variable is first created, the variable is available only in that shell. This is referred to as a *local variable*. If a new subshell is created, either manually or by the system, the variables created in the parent shell are not available. However, the parent shell is still running. When the subshell is exited, either automatically by the system or manually by typing **exit**, the variables will be available again. When the shell where the local variables were created is exited, the variables of that shell are terminated. Local variables are available only to the specific shell where they are created.

To make a local variable available in all subshells, the variable must be exported. Exporting is discussed later in this chapter.

NOTE

See the man pages on **ksh** and **bash** for more on Korn and Bash shell variables.

Setting Local Shell Variables

The standard for the Korn and Bash shells is to use capital letters for shell variable names. The following shows an example for a shell variable:

```
PS1="MyPrompt$"
```

The **unset** command removes the variable from the current shell and subshells, but this command rarely is done. The following shows the basic syntax used to set and unset shell variables:

```
VARIABLE=value
unset VARIABLE
```

Displaying Shell Variable Values

To display the value of a single variable, use the **echo** command. For example, **echo $PS1** would return "MyPrompt$" assuming the PS1 variable was set to Myprompt$. The dollar sign (**$**) metacharacter preceding a variable tells the shell to use the value of the variable, not the name of the variable. Because this is a local variable, the customized PS1 variable would not be available if a new subshell is started.

To display all variables in the local shell and the variable's values, type the **set** command, as shown in Figure 14-11.

Figure 14-11 Displaying Shell Variables by Using the **set** Command

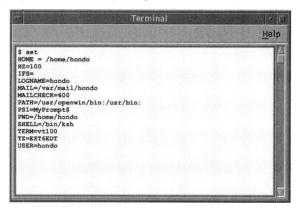

Environment (Global) Variables

Environment variables are global variables available to all shells and subshells, not just the local shell. To make a variable known to a subshell, it must be exported with the **export** command. For example, in Figure 14-12, the PS1 variable is set to MyPrompt$. MyPrompt$ will appear in that shell only. If the user were to start a subshell by typing **ksh** and pressing **Enter**,

the prompt in the new shell would display the default $ prompt, not MyPrompt$. The reason this happens is because when the PS1 variable was set, it was set for use in that shell only. If, after the PS1 variable was set it was then exported (**export PS1**), all subshells will receive or inherit the value. Think of an environmental variable as something valuable that a parent, the current shell, is passing down to the child, the subshell.

Figure 14-12 Exporting a Local Variable

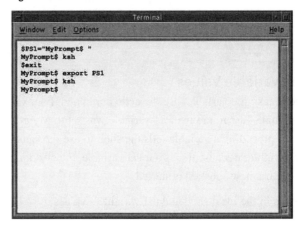

UNIX automatically creates subshells to complete a task, and it is important that the environment set up in the parent shell is passed to any child subshells. The following shows the basic syntax used to create an environment variable:

```
VARIABLE=value ;export VARIABLE
```

or

```
export VARIABLE=value
```

or

```
export VARIABLE (if variable is already defined)
```

For example, to set a default printer to xerox1, do the following:

```
$LPDEST=xerox1;export LPDEST
$echo $LPDEST
xerox1
```

To have line numbers automatically turned on when starting vi, the user can set the ex initialization variable (EXINIT) and then export the variable:

```
$EXINIT='set number';export EXINIT
$echo $EXINIT
set number
```

Environment variables and their values can be displayed by typing the **export** command by itself:

`export or env`

UNIX provides several important predefined environment variables, such as HOME, LOGNAME, SHELL, and PATH. These variables have been defined by the shell to have a specific function. The variables are available to the login shell and all subshells.

Variables can be set up to be exported automatically upon login by modifying the initialization files. This feature will be discussed later in this chapter.

Exporting variables in an initialization file read at login enables the variables to be used by the system, processes, scripts, users, and all shells. Exporting variables at the command line makes the variables available to the current shell and all child processes and shells. A variable set in a subshell and exported will be available to any process or shell started afterward, but it will not be available to the parent shell.

Custom Prompts with the Korn and Bash Shells

The default prompt for the Korn and Bash shell is the dollar sign (**$**). The user can customize the shell prompt to the user's own preferences by using the predefined PS1 (prompt string 1) shell prompt variable (**PS1=***value*). The PS1 variable can include a wide range of expressions, such as character strings, commands, or other variables. Figure 14-13 shows several different ways the standard PS1 prompt (**$**) can be customized. The variable PS1 is a shell variable. Any change in the variable setting remains until the shell is exited or until a subshell is opened.

Figure 14-13 Customizing the Shell Prompt

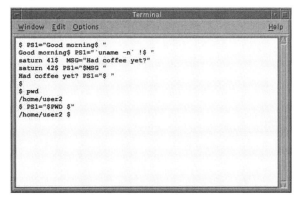

To make the customized prompt available from one session to the next, the PS1 variable can be placed in the initialization file, which is covered in the next section. The following shows

the basic syntax used to customize the shell prompt:

`PS1=value`

The following are several customized prompts that include examples of text or output of a command. Note that prompts all end in a dollar sign ($), representing the Korn or Bash shell. The prompts ending in a dollar sign ($), is the usual way, but not required:

- **$ PS1="Good morning$"**—Assigns the prompt to a character string. The prompt is changed from the conventional **$** to a greeting (Good morning), with the **$** at the end. The double quotes are necessary because of the space, or metacharacter, between good and morning. Single quotes also tell the shell to display a metacharacter literally, and the single quotes also could have been used in this case. Double quotes have an additional function, as discussed next.

- **Good morning$ PS1=" 'uname -n' !$"**—Demonstrates using a command (-**uname -n**) with the history line number (**!**) for a unique prompt. This command causes the prompt to show the name of the host on which the user is working. The back quotes (**'**) are used to substitute the output of the **uname** command instead of interpreting it literally. Double quotes surround the entire string.

- **saturn 41$ PS1="$"**—Sets the prompt back to the original dollar sign ($) prompt. Single or double quotes are necessary because of the space metacharacter.

- **$ PS1='$PWD $'**—The prompt is customized to reflect the current working directory. Single quotes surrounding the string containing the PWD variable (**$PWD**) tells the shell to evaluate the current value of the PWD variable every time the working directory changes. Note: Double quotes are used to print characters literally and for evaluating the value of a variable. See the first three examples above for information. However, double quotes are not used here with the PWD variable because of the unusual nature of the variable being reevaluated every time the working directory changes.

Importance of Quotes

The previous examples use various quoting characters recognized by the shell to do something different. Quoting is an important feature used with many different commands. For example, Chapter 8, "File Systems and File Utilities," introduced the **grep** command to look for a string of characters inside a file. It was noted that the string could include whitespace or punctuation if enclosed in quotations. An example would be as in **grep "howdy doody" file1**. As in the previous PS1 examples, the quotes are necessary because of the space metacharacter between howdy and doody. Quotes are used anytime the user wants the shell to interpret any metacharacter (*, ?, >, |, and so on) literally, not just spaces. For example, to print in large letters ***HELLO*** to the screen using the **banner** command in Solaris, you would need to put ***HELLO*** in quotes to make sure that the shell does not try to interpret the * as a wildcard.

For simple prompt settings in the Bash shell, the user can also set the PS1 variable to the following:

NOTE

Single or double quotes must surround any or all of the components that define the PS1 variable.

- **\u** for username
- **\d** for the date
- **\h** for the hostname
- **\$** for the dollar sign
- **\w** for the working directory

PS1='\u@\h\$' for example, would result in the prompt similar to **jamie@colorado$**.

e-Lab Activity 14.3 Customizing a Korn Shell Prompt

In this activity, you will demonstrate your ability to customize your Terminal window prompt within your Korn shell environment.

e-Lab Activity 14.4 Customizing Your C Shell Prompt

In this activity, you will demonstrate your ability to change the Terminal window prompt in a C shell window.

Lab Activity 14.3.4 Korn and Bash Shell Features

In this lab, you work with UNIX initialization files. You will customize the shell login environment and tailor various options to your needs.

Shell Initialization Files

As part of creating a user account, the system administrator chooses the login shell. The login shell determines which initialization files are read during login.

Initialization files or scripts contain a series of commands, settings, and variables. These commands, settings, and variables are executed and set when a shell is started to establish the working environment for the system and the user. The shell reads these files when the user logs in (login script), when a subshell is run from the login shell by the user or automatically by the system (environment script), and when a user logs out (logout script). Only the Bash and C shell programs have logout scripts.

Two levels of initialization files exist:

- Systemwide initialization files, which are maintained by a system administrator and reside in the /etc directory.
- User-specific initialization files, which reside in a user's home directory.

During the login process the systemwide initialization file is read first, and the user-specific files are read next. Figure 14-14 shows where the systemwide and user-specific initialization files are found in the directory tree structure.

Figure 14-14 Initialization Files in the Tree Structure

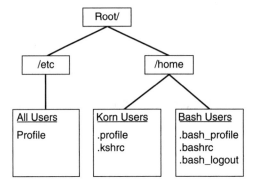

Variables are either predefined, usually global, and set automatically when the user logs in or can be defined by a user. When a predefined global variable such as PS1 is placed in the systemwide initialization file, it is recognized in any shell. Users can customize many of these variables and define additional variables to customize their own working environment by placing them in a personal initialization file that gets read after the systemwide initialization file. For example, if a user did not like the PS1 prompt established by the system administrator in the systemwide initialization file, he can customize the prompt by placing it in the personal initialization file with a different setting. Each shell program, Korn, Bash, C, Bourne, and so on, contains predefined or built-in variables common to all shell programs and others that are shell specific. See the shell program man pages (for example, man ksh) for a complete list of variables recognized by that specific shell.

Unlike variables, aliases and shell option settings cannot be exported or made available to all subshells. In order to make aliases and shell options available in a subshell, they must be placed in a secondary initialization file that is read each time a subshell is started.

System-Wide Initialization Files for Korn and Bash Shell Users

The primary systemwide initialization file for Korn and Bash shell users is the profile file, which resides in the /etc directory. The /etc/profile file is created by default when the operating system is installed. The /etc/profile can be edited and customized by the root user, typically a system administrator. The system reads the /etc/profile first when a Korn or Bash shell user logs in. The /etc/profile file contains variables, settings, and one-time-only commands to

create a default working environment for all Korn and Bash shell users. The main functions provided by the /etc/profile file are summarized as follows:

- Exports environment variables: The file makes environment variables available to sub-shells, such as LOGNAME for login name.

- Exports PATH for default command path: The default path is a list of directories where the shell will look when a command is executed. Exporting the default path makes the list of directories available to all shells and subshells.

- Sets TERM variable for default terminal type: This defines the screen and keyboard characteristics of the user's workstation.

- Displays contents of /etc/motd file: The message of the day file is used by the system administrator to display greetings or news, or to provide system information.

- Sets default file creation permissions: The file sets the umask value that determines the default permissions when a new file or directory is created. The **umask** command is covered in Chapter 10, "File Security."

- Checks for mail: The file checks mail and will print a mail message upon login.

- Stores other one-time-only commands such as **cal** or **banner "$LOGNAME"**, and so on.

User-Specific Initialization Files

After the systemwide initialization file is read, the user initialization files for the appropriate shell are read. The user initialization files provide great flexibility to the user for customizing the working environment. Customization of the login process and working environment can be accomplished using the systemwide file /etc/profile by itself or in combination with the user-specific initialization files. Depending on network administration policy, many settings can be placed in the /etc/profile file to create a default working environment for all users, and no user-specific initialization files are used. The user initialization files can be set up as templates by the system administrator and then can be modified by the user. The user-specific initialization file or files are stored in the home directory of the user. Depending on network administration policy, user-specific initialization files can perform all or part of the following:

- Sets a default prompt that determines what the prompt looks like when the user initially logs in or opens a new Terminal window. The default prompt for a Korn and Bash shell user is a dollar sign.

- Defines a default printer.

- Sets default permissions for new files and directories.

- Sets a default terminal type used by the vi editor and other tools.

- Sets a new mail location.

- Sets noclobber to prevent the accidental overwriting of files during redirection.
- Sets the command path so the shell knows what directories to look in for commands and executable files.
- Defines user command aliases.

The user-specific initialization files are different for the Bourne, Korn, and Bash shells and are covered next. Table 14-2 summarizes the initialization files for the Bourne, Korn, and Bash shells.

Table 14-2 Initialization File Summary

Shell	Systemwide (Read First)	User Specific (Read Next)
Bourne	1. /etc/profile	2. $HOME/.profile
Korn	1. /etc/profile	2. $HOME/.profile (ENV=$HOME/.kshrc;export ENV) 3. $HOME/.kshrc
Bash	1. /etc/profile	2. $HOME/*.bash_profile* (BASH_ENV=$HOME/*.bashrc*;export BASH_ENV) (optional) 3. $HOME/.bashrc 4. $HOME/.bash_logout

Korn Shell User-Specific Initialization Files

NOTE

The tilde (~) or the variable $HOME can be used to represent the user's home directory.

The Korn shell uses two user-specific initialization files to set the user's environment and are read after /etc/profile:

- ~/.profile typically contains one time only commands and variable definitions.
- ~/.kshrc typically contains aliases, turns on shell features, and sets the custom prompt.

.profile File

If a Korn shell user wants to customize the environment, that user needs to create or modify the .profile file and then the user must export the ENV variable, as shown here:

```
ENV =$HOME/.kshrc;export ENV
```

The ENV variable defines the path to the .kshrc (Korn shell run control) file. This variable can be added anywhere in the .profile file to inform the shell that the .kshrc file exists and is to be read each time a Korn shell, a new Terminal window, is started.

The previous command sets the environment variable to point to the .kshrc file in the home directory. HOME is a variable that is defined by the system to be the absolute path to the

user's login directory. Preceding the HOME variable with the dollar sign ($) metacharacter enables the system to use the value of the HOME variable. This variable has no meaning outside the Korn shell. Figure 14-15 shows a sample .profile file.

Figure 14-15 Contents of a Sample .profile File

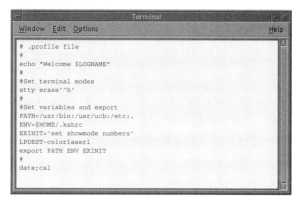

Each element within the sample .profile file in Figure 14-15 is explained as follows:

- **# .profile file**—The pound sign (#) indicates a comment line that is not acted upon when the file is read. Anything after a # on a line is considered a comment and ignored by the shell.

- **echo "Welcome $LOGNAME"**—The **echo** command displays "Welcome [*user name*]". The double quotes tell the shell to display any text and the value of any variables, in this case, **$LOGNAME**.

- **stty erase '^h'**—The Backspace, or erase, key function is set to move one character to the left. The user has to do this only if the user will be logging on remotely using the **telnet** command or a Telnet program such as Windows Telnet.

- **PATH=/usr/bin:/usr/ucb:/etc**—The PATH variable is used by the shell to locate commands in directories in the order specified by the PATH statement. The colon (:) separates each directory. The dot (.) at the end of the PATH variable enables the system to search the current working directory for commands and executable scripts.

- **ENV=$HOME/.kshrc**—The ENV (environment) variable defines the Korn shell specific startup file to read. Normally this startup file is .kshrc, but it does not have to be. The .kshrc file is discussed in the next section.

- **EXINIT='set showmode numbers'**—The EXINIT (ex initialization) variable holds vi/ex editor preferences to be set automatically by vi at startup. See Chapter 9, "Using Text Editors," for other preferences.

- **LPDEST=colorlaser1**—The LPDEST (line printer destination) variable is used to set the default printer. If set, the LPDEST variable overrides the default printer set in the /etc/profile system file.

- **export PATH ENV EXINIT**—This exports the PATH, ENV, and EXINIT variables, making these variables available to all shells and subshells.

- **date;cal**—This displays the output of the **date** command, followed by the calendar of the current month.

.kshrc File

Korn shell specific commands and features should be placed in the .kshrc file. The .kshrc file automatically is read each time a new shell, such as a new Terminal window, or subshell is started, so there is nothing to export. The contents of the .kshrc file typically include the following:

- A customized prompt
- Custom variables
- Aliases

Figure 14-16 shows a sample .kshrc file.

Figure 14-16 Contents of a Sample .kshrc File

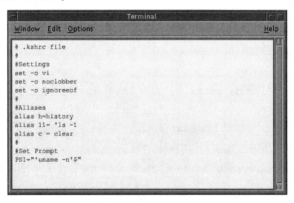

Each element within the sample .kshrc file in Figure 14-16 is explained as follows:

- **set -o vi**—Informs the shell which editor's editing capabilities to use with command line editing.

- **set -o noclobber**—Turns on the noclobber option, preventing accidental overwriting or clobbering of an existing files when using redirection. See Chapter 7 for more information.

- **set -o ignoreeof**—Turns on the ignore end of file option, preventing a user from accidentally logging off by typing Ctrl-D. This is for users with a single screen command-line login, such as a user who logged in using a Telnet program.
- **Aliases**—Defines personal aliases for the history (**h**) command and the long listing (**ll**) command, and clears the screen or Terminal window using the clear (**c**) command.
- **PS1=" 'uname –n'$"**—Defines a custom shell prompt.

Korn Shell Login Process

As a review, Figure 14-17 illustrates what happens when a Korn shell user logs into a UNIX system.

Figure 14-17 Korn Shell Login Process

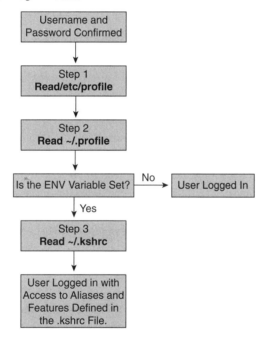

When any user logs into the system, the system /etc/profile file is always read first. The Korn shell user's .profile file in the home directory is read next. Then, if the ENV variable in the .profile file is assigned and exported, the .kshrc file is read. The .profile file is read only once, while the .kshrc file is read every time a new Korn shell is started. To have the system reread the .kshrc or .profile files after changes have been made, the user either can log out and log back in or can type the following from the command line:

```
$. (dot) ~/.kshrc  (or $. .kshrc from the home directory)
$. (dot) ~/.profile (or $. .profile from the home directory)
```

For example, if a new alias is added to the .kshrc file the user can type **. (dot) .kshrc** to tell the shell to reread the file and place the new alias in memory so it can be used.

e-Lab Activity 14.5 Customizing the Korn Shell

In this activity, you modify your .profile file to export the ENV variable file so that the next time you log in, your .kshrc file will be read and your environment will be customized. Refer to e-Lab Activity 14.5 on the accompanying CD-ROM.

Bash Shell User-Specific Initialization Files

Similar to the Korn shell, the Bash shell uses two user-specific initialization files to set the user's environment and are read after /etc/profile:

- *.bash_profile* typically contains one time only commands and variable definitions.
- *.bashrc* typically contains aliases, turns on shell features, and sets the custom prompt.

Both files are located in the user's home directory. The .bash_profile file is read only when a user logs in to the system. In contrast to the Korn shell, the .bashrc (bash shell run control) file is automatically read at login and each time a new subshell is started. The Bash shell does have a BASH_ENV variable but it is only necessary if you want to use a different filename than the default .bashrc. For example, if you decide to place your aliases and other customization in a file named .mystuff you would need to place BASH_ENV=$HOME/.mystuff;export BASH_ENV in .bash_profile. As with the Korn shell, similar entries can be made in the .bashrc file to customize the shell prompt and define aliases. To have the system reread the .bash_profile or .bashrc file after changes have been made, the user can either log out and log back in or type the following from the command line:

```
$. (dot) ~/.bash_profile or $source ~/.bash_profile
$. (dot) ~/.bashrc or $source ~/.bashrc
```

Figure 14-18 shows the login sequence for a typical Bash shell user.

NOTE

A *.bash_logout* file is available for Bash shell users that allows for customization after the user logs out. Clear the screen and print **Bye**, for instance.

Lab Activity 14.4.5 Customizing the Korn and Bash Shell

In this lab, you work with UNIX initialization files. You customize the Korn shell login environment and tailor various options to your needs. Refer to Lab Activity 14.4.5 in the *Cisco Networking Academy Program: Fundamentals of UNIX Lab Companion*, Second Edition.

Figure 14-18 Bash Shell Login Sequence

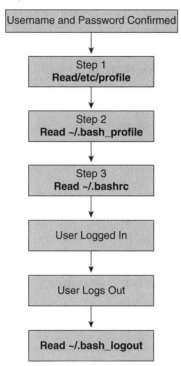

Summary

Now that you have completed this chapter, you should have an understanding of the following:

- The UNIX shell is a key component of the UNIX operating system. The shell is the interface between the user and the kernel. This chapter focused on the two most popular shells used today, the Korn and Bash shells.

- The default prompt for the Korn and Bash shell is the dollar sign (**$**) and can be customized by changing the value of the PS1 variable.

- Both Korn and Bash shells support aliases and history. Aliases allow the user to create new command names and associate the new names with existing commands to increase productivity. The **history** command allows the user to repeat previous commands to avoid having to type the commands again.

- Additional features supported by both the Korn and Bash shells include command-line editing and filename completion. Command-line editing allows the user to use vi editor commands to modify previous command lines. **set -o vi** turns on both the command

line editing feature and filename completion. Filename completion saves typing time by entering the first few characters of a filename then pressing the Esc and backslash keys (**Esc**) in sequential order for the Korn shell or the **Tab** key for the Bash shell.

■ Variables are either local or global. Local variable are available only in the current shell. Global variables are exported to all subshells. To set a variable, use the format **VARIABLE=value**. To make it available to all subshells, export it with the **export** command. To display the value of an individual variable, use the **echo $VARIABLE** command. Use the **set** command to display a list of local variables, and use the **export** command to display a list of all environment variables.

■ When a user logs into a UNIX system, several initialization files are read and processed. These files contain settings for variables that customize the user's environment. Two types of initialization files exist, the systemwide and the user specific. The etc/ profile file is the systemwide initialization file that affects all Korn and Bash shell users. The /etc/profile file can perform the following:

 — Exports environment variables

 — Exports PATH for the default command path

 — Sets the TERM variable default terminal type

 — Displays the contents of the /etc/motd file

 — Sets default file creation permissions

 — Checks for mail

■ Two additional user-specific initialization files that are kept in the user's home directory are .profile and .kshrc for Korn shell users and .bash_profile and .bashrc for Bash shell users. These user specific files are read after /etc/profile to provide additional customization for the user's environment. The run control files, .kshrc for Korn shells users and .bashrc for Bash shell users, are also read every time a new shell is started or Terminal window is open. The user-specific initialization files can perform some or all of the following:

 — Set the default prompt

 — Define the default printer

 — Set default permissions

 — Set the default terminal

 — Set the new mail location

 — Set noclobber

 — Set the command path

 — Define aliases

Check Your Understanding

1. A *shell* is an interface between the user and the _____.

2. Which two of the following accurately describes a UNIX shell?

 A. Interprets what is entered on the command line

 B. Only accessed through GUI

 C. Command line or graphical

 D. Started at boot time

3. Which three of the following are features of the UNIX shell?

 A. Wildcard matching

 B. Input/output redirection

 C. Background processing

 D. Automatic backups

4. A(n) _____ is a way to give a command a different name for use in the shell.

5. Which command, in ksh, represents the correct syntax for creating an alias called *barry* which performs a long listing including hidden files?

 A. **alias barry='ls -al'**

 B. **alias -'barry' ls -al**

 C. **alias -a barry 'ls -al'**

 D. **alias barry 'ls -al'**

6. Which three of the following are reasons to use an alias in UNIX?

 A. To substitute a short command for a long one

 B. To create a single command for a series of commands

 C. To change a command

 D. To create alternate forms of existing commands

7. Which command lists the three previous commands in the Bash shell?

 A. **history 3**

 B. **history –3**

 C. **history +3**

 D. **history three**

8. Which command lists the three previous commands in the Korn shell?

 A. history 3

 B. history –3

 C. history +3

 D. history three

9. Which command, in Bash, will repeat the most recent command exactly as it was executed?

 A. !

 B. !!

 C. !*

 D. !$

10. Which command is used to customize a Korn shell prompt to include the absolute path to the current directory?

 A. $ PS1="$CWD $"

 B. $ PS1= '$PWD $'

 C. $ PS1="$DIR $"

 D. $ PS1='PG $'

11. Which three of the following describes *initialization files* or *scripts*?

 A. Are read when a user logs on

 B. Contain commands, settings, and variables

 C. Are read when a new shell is started

 D. Are read-only files

12. The _____ file, which is one of the Bash user-specific initialization files, typically contains one-time-only commands and variable definitions.

UNIX Command Summary

. (dot) Used to re-execute a Korn shell initialization file after changes are made. Example:

```
$ .  .kshrc
```

!! Re-executes the last command in Bash shell. Example:

```
$ !!
```

!$ Repeats the last argument from the previous command in Bash shell. Example:

```
$ !$
```

!* Repeats all arguments of the previous command in Bash shell. Example:

```
$ !*
```

!number Repeats a specific number command from the Bash shell history file. Example:

```
170 pwd
171 ls
172 cd ~
$ !171
```

aliasalias and **unalias** utilities create or remove a pseudonym or shorthand term for a command or series of commands. For example, change copy (cp) to include a confirmation prompt before overwriting a file:

```
alias cp="cp -i"
```

bash Starts a Bash shell.

echo Echoes (displays) arguments. Example:

```
$ echo "hi mom"
hi mom
```

```
$ echo $SHELL
/bin/ksh
```

ENV Variable used in conjunction with personalizing the login environment. Example:

```
ENV=$HOME/.kshrc; export ENV
```

exit Leaves the current terminal window or current shell and returns to the previous one. Also used to log out of the login shell.

export Displays all environmental variables available to all shells. Example:

```
$ export
FRAME=/opt/fm/
HOME=/home/hondo
PS1=MyPrompt$
SHELL=/bin/ksh
TERM=vt100
```

history Lists or edits and re-executes commands previously entered into an interactive shell. Example:

```
$ history
339 man grep
340 pwd
341 grep banana ./*
342 history
$ r 340
pwd
/home/user2
$
```

ksh Starts a Korn shell subshell.

PS1 A variable that can be changed by the user to alter the appearance of the default shell prompt. Example:

```
$ PS1="new prompt$ "
$ PS1="$PWD $ "
```

r Repeats a command from the history list. Example:
```
170 pwd
171 ls
172 cd ~
$ r 170
```

set Displays all variables in the local shell. Example:

```
$ set
HOME=/home/hondo
PS1=MyPrompt$
SHELL=/bin/ksh
```

set + o vi Turns on command-line editing.

set - o vi Turns off command-line editing.

sh Starts a Bourne shell subshell.

source Re-executes a Bash shell initialization file after changes are made.

unalias The **alias** and **unalias** utilities create or remove a pseudonym or shorthand term for a command or series of commands. Example:

```
$ alias cp="cp -i"
$ unalias cp
```

unset Removes the variable from the current shell and subshells. Unsetting variables is rarely done. Example:

```
unset LPDEST
```

unset history Turns off history tracking.

Key Terms

.bash_logout Allows for customization after a Bash shell user logs out. Clears the screen and prints "Bye", for instance.

.bash_profile Bash shell initialization file read once at login. Typically contains one-time-only commands and variable definitions.

.bashrc Bash shell run control file is automatically read each time at login and when a new subshell is started. Typically contains aliases, turns on shell features, and sets the custom prompt.

.kshrc file Korn shell run control file. User-specific initialization file stored in the home directory that typically contains aliases, turns on shell features, and sets the custom prompt. Read for Korn shell users.

.profile file User-specific initialization file stored in the home directory that contains one-time-only commands and variable definitions. Read for both Bourne and Korn shell users.

/etc/profile file The primary systemwide initialization file for Bourne and Korn shell users is located in the /etc directory. The profile file is created by default when the operating system is installed, and it can be edited and customized by a system administrator. When a Bourne or Korn shell user logs in, the system reads the /etc/profile file first.

Environment (global) variable Variables that are available to all shell sessions.

Local (shell) variable Variables that are available only for the current shell session.

Objectives

After reading this chapter, you will be able to

- Create, execute, and debug a basic shell script.
- Create, execute, and debug a more advanced shell script.
- List today's popular programming languages for the UNIX/Linux environment.

Introduction to Shell Scripts and Programming Languages

Introduction

In addition to the many features of the shell already covered in this course, the UNIX shell has its own built-in programming language used to create shell programs or scripts. Scripts are similar to batch files in DOS or CMD (command) files in NT/2000. All UNIX shells support shell scripting.

It is not a requirement that you write *shell scripts* to use or manage a UNIX system. However, the more UNIX is used, the more a user will find instances when a repeatedly performed task has no single UNIX command. Writing a shell script is a way to create a custom command that can repeatedly perform a single task or series of tasks.

In this chapter, you will learn how to write, execute, and debug both simple and more complex shell scripts. Basic shell scripts are small files consisting of several UNIX commands that display basic system information or manipulate files. More complex shell scripts consist of *variables* and built-in programming commands, which include the **read** command for interactive input, the conditional commands of **if**, **test**, and **case**, and the looping commands **for**, **while**, and **until**.

Shell Script Basics

This section introduces and provides an overview of shell scripts. It covers the creation, execution, and *debugging* of a basic shell script based on a series of UNIX commands.

Overview of Shell Scripts

UNIX commands and options are numerous, can be difficult to remember, and involve a lot of typing. To avoid having to remember UNIX command syntax, or to be able to execute multiple

commands simultaneously, a user may want to either create an alias or write a shell script. Shell scripts are written using a text editor such as vi.

An alias is typically used to execute one or more simple commands separated by a semicolon (;). A shell script is a text file that contains a sequence of commands for the shell to execute one line at a time. Complex tasks involving variables and other programming functions are accomplished using shell scripts.

In addition to commands, shell scripts include comments. Comments are text used to document what the script does and describe what the lines within the script are supposed to do when it is executed. Comments are preceded by a hash (#) symbol and can be on a line by themselves or on the same line following a command. Figure 15-1 shows a simple shell script named userstat created using vi. This script contains comments (preceded by #) and uses three UNIX commands: **echo**, **date**, and **who** to give a summary of users on the system.

Figure 15-1 Simple Shell Script

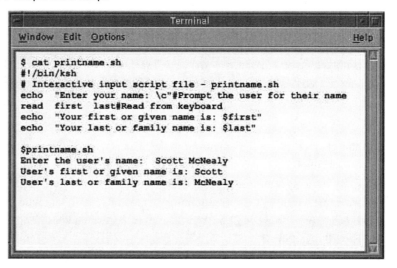

Shell programs are interpreted, not compiled. The commands are read and passed to the shell to execute one at a time, in sequence. A *compiled program* like C or Fortran, on the other hand, is initially read and converted to a form that can be directly executed by the CPU. Because shell scripts are interpreted, even the fastest shell script always runs more slowly than an equivalent program written in a compiled language.

Creating a Simple Shell Script

The process of creating a shell script is simple. However, the contents of a shell script can be quite complex depending on what the shell script is to accomplish. The list that follows

outlines the general steps for creating a shell script. Steps 1 through 6 involve creating the script, Step 7 is executing the script, and Step 8 is debugging.

Step 1 Decide what the script will do. For example, you want a script that performs the following functions:

- Clears the screen
- Displays the number of users currently logged on the system
- Displays the current date followed by the calendar of the current month

Step 2 Make a list of the commands the script will execute to produced the desired result.

Simple script files use many of the commands covered in this course. Some of the commands typically found in simple shell scripts include:

- File manipulation commands such as **ls**, **mv**, **cp**, and **rm**
- File-processing commands such as **grep**, **sort**, and **find**
- **tar** and **jar** backup commands
- The **echo** command (**echo** *string* and **echo** *$VARIABLE*)
- Others such as **date**, **clear**, **who**, and **cal**

In addition, it is common for shell scripts to include pipes and redirection.

For example, the script described in Step 1 would use the following commands: **clear**, **who**, and **cal**.

Step 3 Create a new file for the script using a text editor.

Use a preferred text editor to create the shell script file. Choose a filename descriptive of what the script does and avoid using the name of an existing UNIX command or alias name. For example, the script named backup.sh is easily identified as a script used to backup files. By convention, script files end in .sh (dot sh) so they are easily identified as a shell script file, but this is not a requirement.

Script files can reside in the user's home directory but are typically in the ~/bin subdirectory below home if there are a lot of them. If script files will reside in the ~/bin directory, the user must modify the PATH variable. The PATH variable is typically in the ~/.profile file. Modifying the PATH variable ensures the ~/bin directory is in the search path and can be searched by the shell when the script is executed on the command line. Refer to Chapter 14, "Shell Features and Environment Customization," for the procedure to add another directory to the search path.

To see what directories are in the current search path enter the command **echo $PATH**.

Step 4 Identify which shell the script will use to interpret the lines in the script.

This is accomplished by entering **#!/bin/ksh** or **#!/bin/bash** on the first line of the script. If the script does not begin with the characters #! on the first line then the parent shell is used to execute the script. After the first line of a script, any line beginning with a # is treated as a comment line and is not executed as part of the script.

Step 5 Add commands and comments to the script file.

Add the commands listed in Step 2 to the file, one command per line. Using the **echo** command to display a text string before the output of a command is typical. For example: **echo "Below is the current month calendar"** would appear on the line above the **cal** command in the script file.

In the above example the entire argument is enclosed in double quotes ("). Double quotes tell the shell to display a metacharacter literally. A space is considered a metacharacter. Table 15-1 summarizes how the shell interprets quote characters. Quote characters are used frequently in shell scripts to produce a desired result for a command line in the file.

Table 15-1 Meaning of Quote Characters

Quote Character	Meaning	Example Command/Result
Single quote (') must occur in pairs.	Tells the shell to display anything in single quotes, including metacharacters, literally. Does not allow for variable expansion.	$echo '*** $LOGNAME ***' *** $LOGNAME ***
Double quote (") must occur in pairs.	Tells the shell to display any metacharacters literally. Allows for variable expansion.	$echo "*** $LOGNAME ***" *** user10 ***
Back quotes (`) must occur in pairs.	Tells the shell to display the output of the command instead of interpreting it literally.	$echo `uname -n` sunblade 1

Comments at the beginning of the script describe the purpose of the script. Comments are used throughout a complex script to explain its sections and are valuable to anyone trying to interpret and debug the script. Typically the second line in a script describes the script file's purpose and is sometimes followed by

the author and creation date. For example:

```
#!/bin/ksh
# Backup script that backs up all chapter files to ~/bkup and to a
   floppy.
# Created on May 25, 2002 by Dan Myers
```

Step 6 Save the script file and exit the text editor.

Step 7 Execute the script file (described in the next section, "Executing a Script").

Step 8 Debug and modify the script if errors occur (described in the section, "Debugging a Script").

 e-Lab Activity 15.1 Creating a Simple Shell Script

In this activity, you create a simple shell script similar to the one in the prior example and the execute it. Refer to e-Lab Activity 15.1 on the accompanying CD-ROM.

Executing a Script

Shell scripts always run in a separate shell. If a shell script is executed from a Terminal window shell, a subshell is started to run the script.

There are two ways to execute a shell script:

- You can use the **ksh** (or **bash**) command followed by the script filename.
- You can make the shell script file an executable file, then type the script name to execute.

If the shell script is not an executable file, it can be executed by starting a new shell program followed by the script filename as the argument.

The other way to execute a shell script is to change its permissions so that it has at least read and execute permissions (**chmod 555 filename**). The script file should also have write permission (**chmod 755 filename**) if you will be modifying and debugging the script. Note that both of the previous **chmod** examples give all user categories (owner, group, and other) read and execute permissions. If you do not want everyone to be able to execute the script (or to be able to read the contents) you must remove these permissions from the file. Changing file permissions is covered in Chapter 10, "File Security."

To run the shell script located in the current directory, type the name of the script file followed by **Enter**. If the current directory (dot) is not in the directory search path you might have to enter **./scriptfile** (dot slash scriptfile).

Figure 15-2 shows the two ways a shell script file can be executed. The first example shows starting a new shell program followed by the script filename as the argument. The second example shows making the file executable then typing the name of the shell script file.

Figure 15-2 Executing a Shell Script New

Debugging a Script

A common problem when writing shell scripts is that the shell does not interpret the command the way you expect.

You can use the **ksh** (or bash) command with the **-x** (echo) and **-v** (verbose) options to help identify where the problems are.

Figure 15-3 shows the output of a script named debug1 run with the **ksh -x** option. The **-x** option displays each line after it has been interpreted by the shell and places a plus sign (+) after each line is executed. The lines below them show the output of the commands.

Figure 15-3 ksh –x Output

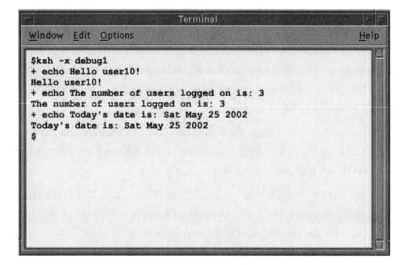

Figure 15-4 shows the output of the debug1 script run with the **ksh -v** option. The **-v** option is similar to the **-x** option except it displays the commands before the substitution of variables and commands is done.

Figure 15-4 ksh -v Output

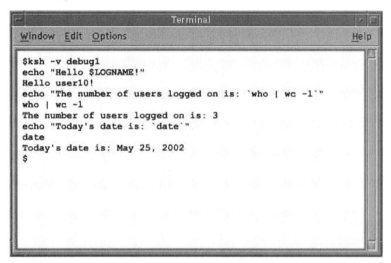

```
$ksh -v debug1
echo "Hello $LOGNAME!"
Hello user10!
echo "The number of users logged on is: `who | wc -l`"
who | wc -l
The number of users logged on is: 3
echo "Today's date is: `date`"
date
Today's date is: May 25, 2002
$
```

Together the **-x** and **-v** options enable you to look at each line in the script file before and after it is executed and see the output. This is very helpful in pinpointing where the script problem is. Figure 15-5 shows the output of the **debug1** script run with the **ksh -xv** options.

Figure 15-5 ksh -xv Output

```
$ksh -xv debug1
echo "Hello $LOGNAME!"
+ echo Hello user10!
Hello user10!
echo "The number of users logged on is: `who | wc -l`"
who | wc -l
+ echo The number of users logged on is: 3
The number of users logged on is: 3
echo "Today's date is: `date`"
date
+ echo Today's date is: Sat May 25 2002
Today's date is: May 25, 2002
$
```

Shell Programming Concepts

This section provides information on programming techniques used to create more sophisticated and powerful shell scripts. It covers variables, positional parameters, interactive input, and programming commands such as **if**, **test**, and **case**. Flow-control concepts such as looping are also introduced.

Overview

A complete programming language is built in to every UNIX shell. The language consists of commands and constructs that can create more complex scripts beyond simply listing a series of commands.

In addition to containing built-in shell programming commands such as **if**, **else**, **read**, **case**, **while**, and **exit**, complex scripts use predefined and user-defined variables. Figure 15-6 is an example of a more complex shell script containing shell commands and variables.

Figure 15-6 Example of a Complex Shell Script

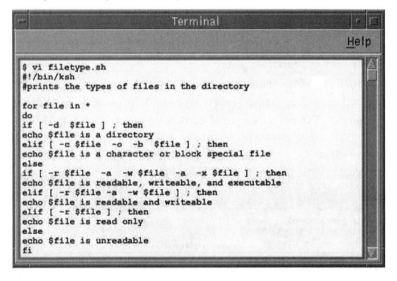

```
$ vi filetype.sh
#!/bin/ksh
#prints the types of files in the directory

for file in *
do
if [ -d $file ] ; then
echo $file is a directory
elif [ -c $file  -o  -b  $file ] ; then
echo $file is a character or block special file
else
if [ -r $file  -a  -w $file  -a  -x $file ] ; then
echo $file is readable, writeable, and executable
elif [ -r $file -a  -w $file ] ; then
echo $file is readable and writeable
elif [ -r $file ] ; then
echo $file is read only
else
echo $file is unreadable
fi
```

Variables in Scripts

A *variable* is a placeholder for information required by processes so that they can function properly. A variable has a name and holds a value. Changing the value of a variable is called setting the variable. There are two types of variables used in shell scripts:

- **Shell variables**—Maintained by the shell and are only known to the current shell. These variables are **local** variables and can be viewed with the **set** command.

■ **Environment variables**—Known to the current and all children (subshells). Some examples of predefined environment variables are:

— SHELL—The login shell

— LOGNAME—The login name

— PATH—The search path used to look for commands

— TERM—The terminal settings

Environment variables can be displayed with the **env** command.

Local variables are set using this format:

VARIABLE=value

For example, **BACKUPDIR =/home/user2/myfiles** sets the variable named BACKUPDIR (backup directory) equal to the value of /home/user2/myfiles. Predefined or built-in variables are typically entirely uppercase. User-defined variable names are capitalized by convention but can be lowercase. Use the **echo** command to display the value of a variable.

Figure 15-7 illustrates how to set and display the BACKUPDIR variable. The dollar sign before a variable name instructs the shell to use the value of the variable. Otherwise, **echo BACKUPDIR**, without the dollar sign would return the text string BACKUPDIR, as illustrated in the last example.

Figure 15-7 Setting and Displaying Variables

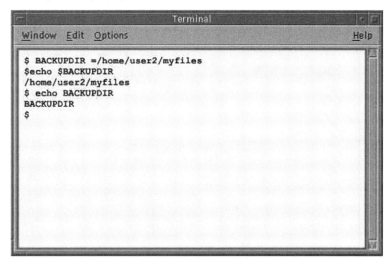

Variables also can be set to equal the output of a command. For example **DATE='date'** would assign the value of the current date to the DATE variable. When the variable is to be displayed, the back quotes (') tell the shell to use the current date instead of the word date. Back quotes and other quote characters were covered earlier in this chapter in Table 15-1.

The advantage of a variable is that once it is set it can be referenced many times throughout a script. If the value of the variable is changed then all occurrences referencing the variable use the new value and no other modifications are needed.

Positional Parameters

Positional parameters are special built-in shell variables that can provide the name of the script file or arguments to the script as it executes. Their values are taken from arguments on the command line. Positional parameters are referenced in a script as $1, $2, $3, (up to $9), where $1 represents the first argument on the command-line, $2 represents the second argument, and so on. Table 15-2 summarizes the command-line argument number positional parameters ($1 through $9) as well as three other special parameters.

Table 15-2 Positional Parameters

Parameter	Meaning/Purpose
$0	Represents the command or the name of the script
$1 through $9	Represents the command-line argument number
$*	Represents all arguments entered on the command line
$#	Represents the number of arguments on the command line

Figure 15-8 shows an example of a shell script called ppdemo.sh that uses positional parameters.

Figure 15-8 Shell Script Using Positional Parameters

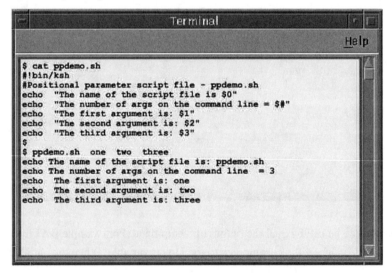

```
$ cat ppdemo.sh
#!bin/ksh
#Positional parameter script file - ppdemo.sh
echo  "The name of the script file is $0"
echo  "The number of args on the command line = $#"
echo  "The first argument is: $1"
echo  "The second argument is: $2"
echo  "The third argument is: $3"
$
$ ppdemo.sh  one  two  three
echo The name of the script file is: ppdemo.sh
echo The number of args on the command line  = 3
echo  The first argument is: one
echo  The second argument is: two
echo  The third argument is: three
```

The arguments to the script are used as variables when the script is run. The top portion of the figure shows the contents of the shell script using the **cat** command. The bottom portion shows running the script while providing three arguments (positional parameters). The example assumes that the script has been made executable.

Interactive Input

To make a shell script more flexible and user-friendly the user can pause the script and ask for a single line of input. This is accomplished with the **echo** command to prompt the user for input and the **read** command to pause and take input from the keyboard. Whatever the user enters is stored in the variable name specified after the **read** command. Interactive input is a very powerful feature of shell scripts.

The **echo** command can be used in conjunction with an *escape character* to position the cursor. For example, **\c** positions the cursor at the end of the current line instead of on the next line. **echo** also accepts other escape characters such as

> **\t**—Inserts a tab
>
> **\n**—Inserts a new line

Figure 15-9 shows an example of a script file called grepfor.sh that prompts for a search pattern and a file to search. The search pattern entered by the user is read by the shell and becomes the value of the *pattern* variable. Similarly, the filename entered by the user is read by the shell and becomes the value of the *filename* variable. In the example, root is the pattern to search for and /etc/passwd is the file searched.

> **NOTE**
>
> In order to use escape characters with the Bash shell, you must use **echo -e**. For example, **echo -e "Enter the pattern to search for: \c"**

Figure 15-9 Shell Script Using Interactive Input

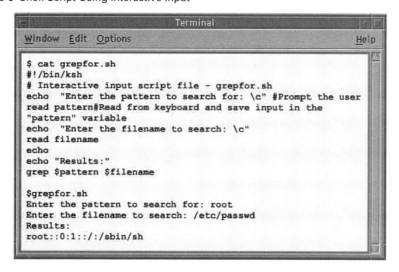

If a single variable is specified after the **read** command, that variable will contain the entire line the user entered. If several variables are specified after the **read** command, each variable will contain a single word from the user input. Figure 15-10 shows an example of a **read** command with multiple variables.

Figure 15-10 read Command with Multiple Variables New

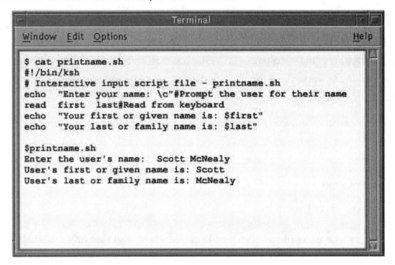

```
$ cat printname.sh
#!/bin/ksh
# Interactive input script file - printname.sh
echo    "Enter your name: \c"#Prompt the user for their name
read    first  last#Read from keyboard
echo    "Your first or given name is: $first"
echo    "Your last or family name is: $last"

$printname.sh
Enter the user's name:   Scott McNealy
User's first or given name is: Scott
User's last or family name is: McNealy
```

Conditional Programming in Scripts

To be useful, a program must be able to test for conditions and make decisions. The program must be able to examine the result of a command and choose between two or more courses of action. The simplest test is to determine whether a condition is true or false. If the condition is true, execute any number of subsequent commands; if not, continue with the script.

Commands that perform some tasks based on whether a condition succeeds or fails are called conditional commands. The three most frequently used conditional commands are **if**, **test**, and **case**.

if Command

The simplest form of a conditional command is the **if** command.

The **if** command is a built-in shell command that enables you to test a condition and then change the flow of a shell script's execution based on the results of the test.

Three formats for the **if** command are described in the following sections. The **fi** (if backward) command is always at the end of an **are** conditional.

if-then Command Format

```
if <command is successful>
then
     <execute command(s)>
fi
```

Figure 15-11 shows an example of a shell script using the **if-then** command format.

Figure 15-11 if-then Example

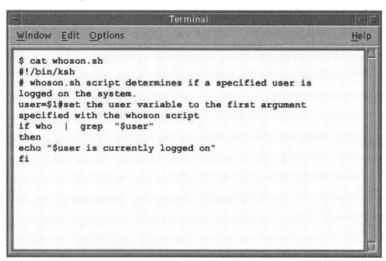

if-then-else Command Format

```
if <command is successful>
then
     <execute command(s)>
else
     <execute command(s)>
fi
```

if-then-elif (else if) Command Format

```
if <command is successful>
    then
        <execute command(s)>
    elif    <command is successful>
    then
        <execute command(s)>
    else
        <execute command(s)>
    fi
```

Figure 15-12 shows an example of a shell script using the **if-then-elif** command format.

Figure 15-12 if-then-elif Example

```
                          Terminal
 Window  Edit  Options                           Help

 $ cat greeting.sh
 #!/bin/ksh
 # Time of day greeting
 #
 hour=`date +%H`
 if [ $hour -lt 12 ]
 then
 echo "Good Morning"
 elif [ $hour -lt 17 ]
 then
 echo "Good Afternoon"
 else
 echo "What are you doing working this late!"
 fi
```

Exit Status

Whenever a command completes execution, within a script or on the command line, it returns an exit status back to the shell. The exit status is a numeric value that indicates whether the command ran successfully.

Every command that runs has an exit status set by the person who wrote the command. Usually an exit status of zero (0) means the command executed successfully and any non-zero value means that the command failed. Failures can be caused by invalid arguments passed to the command or by an error condition that is detected. Check the man pages for a given command to determine its exit status.

Reviewing the **if-then** format discussed in the previous sections, the command following the **if** statement is executed and its exit status is returned.

If the exit status is 0 (zero) the command succeeded, and the command(s) that follow between the **then** and **fi** statements are executed. The **fi** terminates the **if** block.

If, however, the first command is executed and the exit status is non-zero, it means the command failed. Anything after the **then** statement is ignored and control goes to the line directly after the **fi** statement. Failures can be caused by invalid arguments passed to the program or by an error condition that is detected.

The shell variable **$?** is automatically set by the shell to the exit status of the last command executed. The **echo** command is used to display its value.

Figure 15-13 shows how to view the exit status of a successful (exit status 0) and unsuccessful (exit status 2) execution of the **mkdir** command.

Figure 15-13 Exit Status of the **mkdir** Command

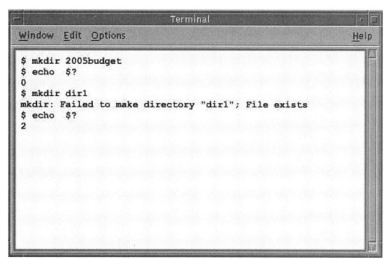

When writing shell scripts you can add **exit 0** to the end of the shell script to indicate success-ful completion. Exiting with any other value would indicate an error occurred with the script.

test Command

The **test** built-in shell conditional command is often used for testing one or more conditions following the if command.

The **test** command evaluates an expression, and if the result is true, it returns an exit status of zero. Otherwise the result is false, and it returns a non-zero exit status.

The expression typically compares two numbers or two strings to see if the values are identical. It is also used to test the status of a file.

The command format for the **test** command is as follows:

```
if test expression   or  if [expression ]
then
    <execute command(s)>
fi
```

In the example that follows, **test** evaluates the variable **$answer** to determine if the user answered **y** to the question. If true, the screen is cleared and the contents of the current direc-tory are listed. If false, the contents of the current directory are displayed but the screen is not first cleared.

```
#!/bin/ksh
echo "Do you want to clear the screen before listing files?"
echo " enter  y  for Yes or  n  for No:\c"
read answer
if test "$answer" = y
```

```
then
    clear;ls
else
    ls
fi
```

The **test** command is used so often in shell scripts that the square brackets ([]) can be used as an alternative to typing **test**. For example, the **if test "$answer" = y** line above could also be written as **if [$answer = y]**.

test Command Operators

Almost every advanced shell script works with files. The **test** command provides operators to test file type, file permissions and whether or not a file contains any data. Table 15-3 lists the most commonly used file operators used with test.

Table 15-3 Common Test File Operators

Operator	Returns TRUE (Exit Status of 0) If
-e *file*	File exists
-s *file*	File exists and is not empty
-d *file*	File exists and is a directory
-f *file*	File exists and is a plain file
-r *file*	File exists and is readable
-w *file*	File exists and is writeable
-x *file*	File exists and is executable

The exclamation mark or "bang" (!) negates a test, so **[! -w file]** negates **[-w file]**. For example, the following filetest.sh shell script accepts a filename as an argument then performs a number of tests to determine file permissions:

```
$ cat filetest.sh
#!/bin/ksh
if [ ! -f $1 ] #test: if the first file specified doesn't exists then echo message
then
    echo "Sorry, file does not exist"
elif [ ! -r $1 ]    #test: if the first file specified doesn't have read perms then
  echo message

then
    echo "File is not readable"
elif [ ! -w $1 ]
then
    echo "File is not writeable"
else
    echo "File is both readable and writeable"
fi
```

case Command

The **case** built-in shell command is used when there are many conditions to test.

The command format for the case command is as follows:

```
case value in
value1 )
    <execute command>
    <execute command>
    ;;
value2 )
    <execute command>
    <execute command>
    ;;
*)
    <execute command>
    ;;
esac
```

The value of a case variable is matched against *value1*, *value2*, and so on, until a match is found.

When a value matches the case variable, the commands following that value are executed until double semicolons (;;) are reached. Then control goes to the entire line directly after the **esac** statement.

If the value of a case variable is not matched, the program executes the commands after the default value *) until double semicolons or **esac** is reached.

Figure 15-14 shows an example of how the case command is used.

Figure 15-14 case Example

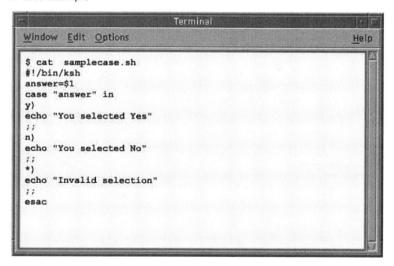

In the example, the case command evaluates the variable $answer. For example, the result of typing **samplecase.sh n** would display "You selected No."

The value of the case variable **$answer** is matched against each value in the shell script until a match is found. Then the result is displayed to the screen.

Flow Control

You can use loops to control the flow of execution in a script. A loop repeats a sequence of instructions repeatedly until a predetermined condition is satisfied.

Often a script is concerned with performing the same operation or set of operations on each file in a directory or list, each line in a file, or each word in a line. The shell provides three looping constructs to accomplish this type of action: the **for** loop, **while** loop, and **until** loop.

for Loop

The **for** loop executes a list of commands one time for each value of a loop variable. The command format for the **for** loop is as follows:

```
for    variable in list
do
<execute command(s)>
done
```

The value of the variable is changed with each pass through the loop to the next value in *list*. Each time a value is assigned, commands are executed in the body of the loop. When no more values in *list* remain, the loop terminates.

Figure 15-15 shows an example of the **for** loop.

Figure 15-15 for-do Example

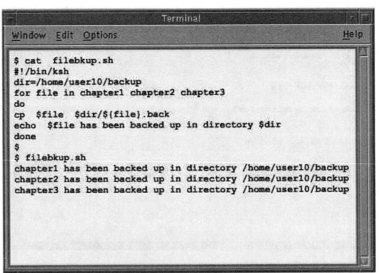

while Loop

The **while** loop repeatedly executes a group of commands within the body of the loop until the test condition in the expression becomes false. In other words, while the expression is true, execute these commands. The command format for the **while** loop is as follows:

```
while   <command>
do
<execute command(s)>
done
```

Figure 15-16 shows an example of the **while** loop.

Figure 15-16 while-do Example

```
$ cat  counter1.sh
#!/bin/ksh
# counts from 1 to 5 then displays "I can count!"
#
num=1#initialize the count variable
while  [ $num  -lt  6  ]#loop while $num is less than 6
do
echo"number: $num"
num=`expr  $num + 1`#increment count by one
done
echo "I can count !"
$
$ counter1.sh
number: 1
number: 2
number: 3
number: 4
number: 5
I can count!
```

until Loop

The **until** loop is very similar to the **while** loop but it executes a series of commands while a command continues to fail (non-zero exit status). When the command finally executes successfully, the loop is terminated and execution passes to the first statement following **done** construct. The **until** condition is checked at the top of the loop, not at the bottom. The command format for the **until** loop is as follows:

```
until  <command>
do
<execute commands>
done
```

Figure 15-17 shows an example of the **until** loop.

Figure 15-17 **until-do** Example

```
$ cat counter2.sh
#!/bin/ksh
# counts from 1 to 5 then displays "I can count!"
#
num=1#initialize the count variable
until [ $num -gt 4 ]#loop until $num is greater than 4
do
echo"number: $num"
num=`expr $num + 1`#increment count by one
done
echo "I can count !"
$
$ counter2.sh
number: 1
number: 2
number: 3
number: 4
I can count!
```

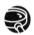

Lab Activity 15.2.8 Writing Shell Scripts

In this lab, you write, execute, and debug several shell scripts to practice everything covered in this chapter including variables, positional parameters, interactive input, conditional, and flow control commands. Refer to Lab 15.2.8 in the *Cisco Networking Academy Program: Fundamentals of UNIX Lab Companion*, Second Edition.

Popular Programming Languages

In addition to the built-in programming language of each shell, many other scripting and conventional programming languages are available in the UNIX/Linux environment. This section summarizes several of the popular programming languages used by both system administrators and developers of Web-based applications.

According to a special report published in the September 29, 2003 issue of *InfoWorld* (http://www.infoworld.com/pdf/special_report/2003/2003Issue38Developer.pdf), the most commonly used programming languages used for development today are (in order of popularity):

1. Java

2. Visual Basic

3. C++

4. JavaScript/EMCAScript

5. UNIX shell scripts

6. C

7. Perl

8. C#

9. PHP

10. Other interpreted languages

11. Python

All languages listed here are used in the UNIX/Linux environments except Visual Basic and C# (pronounced C-sharp), which are used only for developing Windows-based applications.

Compilers and Interpreters

All program source code, regardless of platform, must be either compiled or interpreted before it can be executed. *Conventional programming languages* like C, C++, and Java use special programs called compilers to translate the entire program into a single executable file that the computer understands, which typically has an extension of .bin, .exe, or the like.

Interpreted or scripting languages like Perl, PHP, and those built into each UNIX shell (bash, korn, c, and so on), use interpreters to translate the source code to the native code or machine language for that computer. *Interpreted languages* analyze each line in the source file as the program executes and do so each time the program is run. One disadvantage of an interpreted language is that if a program or programmer repeats an instruction, the interpreter must reanalyze and convert that instruction for each occurrence before executing it. Compiled languages therefore typically execute faster than interpreted languages. One advantage of interpreted languages is that the programmer may enter one instruction at a time on the keyboard without writing a source code file. Interpreted languages also do not need to be compiled. This makes interpreted languages very popular for short programs that accomplish a limited number of related tasks.

Conventional Languages

Conventional programming languages are compiled languages such as C, C++, and Java and require variables to be declared.

C

The *C* programming language was developed in early 1970s by Dennis Ritchie and Ken Thompson working at AT&T Bell Labs and is mainly used for system programming, creating operating systems, device drivers, and compilers. Most of the UNIX operating system including the UNIX and Linux kernels, support tools, C compiler, shells, and X-Windows is written in C (and to a lesser extend C++). C is a fast, efficient, general-purpose language. It is also a

machine-independent, portable language which means a C program written for one type of computer (i.e. Sun SPARC system) can run on another (i.e. Intel-based system) with little or no modification. C is the language of choice for many programmers developing programs for business, scientific, and other applications. C has spawned a number of descendants, including Objective-C, C++ (also developed at the Bell Labs), and Java.

C++

The *C++* language was developed in the 1980s as an object-oriented language based on C. *Object-oriented programming (OOP)* is relatively new technique in programming. It reduces development time by grouping different reusable functions and data, or objects, into an application.

A number of C (and C++) compilers are available for UNIX/Linux, both free and commercial. Of these, the most widely used compiler is GNU C. The GNU C (gcc) compiler offers support for C, C++, and Objective C (an object-oriented C spin-off that never gained much popularity) and can be installed as a cross-platform compiler, allowing you to develop code for other systems on your computer.

As a general rule, if you can't solve a computing problem using the normal UNIX/Linux tools, utilities or scripts, use C. If C doesn't work, try C++. For more information on C and C++, visit www.cprogramming.com.

Java

As a programming language, *Java* is considered a better object-oriented version of C than C++ and offers a number of advantages over both C and C++.

However, Java is not only a language used to develop applications for computers but is considered a platform for development of applications for mobile phones and other electronic gadgets and devices. Sun's new Java Desktop System discussed in Chapter 1 is written in Java.

The Java platform is based on the power of networks and the idea that the same software should run on many different kinds of computers, consumer gadgets, and other devices. Since its initial commercial release in 1995, Java technology has grown in popularity and usage because of its true portability. The Java platform allows you to run the same Java application on many different kinds of computers.

Any Java application can easily be delivered over the Internet, or any network, without operating system or hardware platform compatibility issues. For example, you could run a Java technology-based application on a PC, a Machintosh computer, a network computer, or even new technologies like Internet screen phones. Furthermore, the Java platform was designed to run programs securely on networks, which means that it integrates safely with the existing systems on your network.

Programs written in the Java programming language are able to run on so many different kinds of systems thanks to a component of the platform called the Java Virtual Machine or JVM—a kind of translator that turns general Java platform instructions into tailored commands that make the devices do their work.

Recognizing that "one size doesn't fit all," Sun has grouped its Java technologies into three editions: Java 2 Platform—Micro Edition (J2ME technology), Java 2 Platform—Standard Edition (J2SE technology), and the Java 2 Platform—Enterprise Edition (J2EE technology). Each edition is a robust collection of developer tools and supplies that can be used with a particular product.

For more information, see http://java.sun.com/.

Scripting Languages

Scripting languages are those languages that are (more or less) interpreted rather than compiled, at least during the program development phase, and that do typically not require variable declarations. Some of the more popular scripting languages are JavaScript, Perl, PHP, and Python.

JavaScript

JavaScript was designed by Sun Microsystems and Netscape as an easy-to-use object-based scripting language for developing client and server Internet applications. Other than the word Java in the name, JavaScript has little in common with Java.

JavaScript code can be added to standard HTML pages to create interactive documents. As a result, JavaScript has found considerable use in the creation of interactive Web-based forms to add special effects, customize graphics selections, pop-up calendars, and so on. Most modern browsers, including those from Microsoft and Netscape, contain JavaScript support.

For more information see http://wp.netscape.com/eng/mozilla/3.0/handbook/javascript/.

Perl

Perl is a text- and file-manipulation language, originally intended to scan large amounts of text, process it, and produce nicely formatted reports from that data. It works something like a combination of awk, sed, the C language, and the C shell.

However, as Perl has matured, it has developed into an all-purpose scripting language, capable of doing everything from managing processes to communicating via TCP/IP over a network and is particularly well-suited for tasks involving system utilities, software tools, system management tasks, database access, graphical programming, networking, and World Wide Web programming. For more information see www.perl.com.

PHP

PHP (for the recursive acronym Hypertext Processor) is a widely used general-purpose scripting language that is especially suited for Web development and can be embedded into HTML. PHP also provides easy access to system resources and can pull data from almost any database you're likely to want to use.

The three main areas where PHP scripts are used follow:

- Server-side scripting. This is the most traditional use for PHP where program output is accessed with a Web browser.
- Client-side GUI applications. PHP is not considered the best language to write windowing applications but it can be done.
- Command-line scripting. Ideal for scripts regularly executed using cron or for simple text-processing tasks.

PHP is supported on all major operating systems (UNIX, Linux, Microsoft Windows, and Mac OS X) and most Web servers including Apache, Microsoft Internet Information Server, Personal Web Server, Netscape, and iPlanet servers and many others.

As an open-source project, PHP is free. For more information see www.php.net.

Python

Python is an interpreted, interactive, object-oriented programming language well-suited for simple scripting, complex business solutions, full-scale GUI applications, and Web development.

Python programmers claim that because of its clean object-oriented design and extensive support libraries it offers two- to tenfold programmer productivity increases over languages like C, C++, Java, VisualBasic, and Perl. It is available for most platforms, including Windows, UNIX, Linux, and Mac OS.

The Python implementation is copyrighted but freely usable and distributable, even for commercial use. For more information about python see www.python.org.

Summary

UNIX enables you to create your own commands, called scripts.

Simple shell scripts are small files consisting of several UNIX commands that display basic system information or manipulate files. More complex shell scripts consist of variables and built-in programming commands including the **read** command for interactive input, the conditional commands of **if**, **test**, and **case**, and the looping commands of **for**, **while**, and **until**.

The eight steps for creating a shell script follow:

Step 1	Decide what the script will do.
Step 2	Make a list of commands.
Step 3	Create a new file for the script.
Step 4	Identify the shell the script will use.
Step 5	Add commands and comments.
Step 6	Save the script file.
Step 7	Execute the script.
Step 8	Debug and modify the script if errors occur.

Commands that perform some tasks based on whether a condition succeeds or fails are called conditional commands. The three most frequently used conditional commands are **if**, **test**, and **case**.

You can use loops to control the flow of execution in a script. A loop repeats a sequence of instructions repeatedly until a predetermined condition is satisfied. The shell provides three looping constructs to accomplish this type of action: the **for** loop, **while** loop, and **until** loop.

All program source code, regardless of platform, must be either compiled or interpreted before it can be executed.

Conventional programming languages like C, C++, and Java use special programs called compilers to translate the entire program into a single executable file the computer under-stands which typically have an extension of .bin, .exe, and the like.

Scripting languages are those languages that are (more or less) interpreted rather than compiled, at least during the program development phase, and that do not typically require variable declarations. Some of the more popular scripting languages are JavaScript, Perl, PHP, and Python.

Check Your Understanding

1. Which three of the following are characteristics of a shell program?

 A. Execute faster than a compiled C program

 B. Executed one line at a time

 C. Interpreted rather than compiled

 D. Execute more slowly than a compiled C program

 E. Initially read and converted to a form that can be directly executed by the CPU

2. Nine steps are usually involved in creating a useful shell script. Place the number 1 next to the first step in creating a script file, a 2 next to the second step, and so on.

 ____ Make a list of commands

 ____ Save the script file

 ____ Create a new file for the script

 ____ Type the name of the script to execute it

 ____ Debug and modify the script if errors occur

 ____ Decide what the script will do

 ____ Make the script file executable

 ____ Identify the shell the script will use

 ____ Add commands and comments

3. Which **ksh** command will display the directories that are in your search path?

 A. **echo PATH**

 B. **echo $PATH**

 C. **echo %PATH**

 D. **echo &PATH**

4. You are logged into the UNIX workstation called *galaxy* and your username is *user1*. What would be the output of the command **echo 'uname –n'**?

 A. galaxy

 B. uname -n

 C. There will be no output

 D. user1

5. Which two options would be useful with the **ksh** command if a script needed to be debugged?

 A. **-x**

 B. **-e**

C. -f

D. -v

E. -m

6. What are the two types of variables used in shell scripts?

 A. Shell

 B. Elective

 C. Environment

 D. Constant

 E. Preferred

 F. Discretionary

7. The value of the variable STUFFDIR is /home/user1/stuff. The command **echo STUFFDIR** would display _____.

8. The following script is called demo2.

   ```
   echo "$2 , $1 , $0"
   ```

 What would be the output of the command **demo2 unix linux dos**?

 A. unix ,demo2

 B. linux ,unix ,demo2

 C. linux unix demo2

 D. unix demo2

 E. unix ,linux ,dos

9. What would be the output of the following script?

   ```
   #!/bin/ksh
   echo "This is my \n output."
   ```

 Select from the following options:

 A. This is my \n output

 B. This is my output

 C. This is my

 output

 D. This is my

 output

10. You would like to echo the exit status of a command in your script. Following the command, enter the line **echo** _____.

11. You run the following script with the value of the variable NAME being equal to "Smith".

```
if test "$NAME" != "Smith"
then
        echo wrong
else
        echo right
fi
```

Displayed on the screen will be the word _____.

12. There is a file in the current directory called myfile, which has 0 bytes.

```
if [ -s myfile ]
then
    echo good file
else
    echo bad file
fi
```

Displayed on the screen will be the phrase _____.

13. Match the shell script commands to an appropriate description.

if _____	(A) Executes as long as the test condition is true
case _____	(B) Executes as long as the test condition is false
for _____	(C) The simplest form of conditional command
while _____	(D) Executes commands once for each value of a variable
until _____	(E) Used when many conditions need testing

14. What programming language is known as the "Write Once, Run Anywhere" language that uses a "virtual machine" to translate instructions?

15. What is the difference between a compiled language and an interpreted language?

16. For each programming language indicate if it is a compiled or interpreted language.

JavaScript	
C	
PHP	
Perl	
C++	
Java	

UNIX Command Summary

#!/bin/ksh or **#!/bin/bash** First line of a script that identifies which shell the script will use to interpret the lines in the script. If the script does not begin with the characters #! on the first line then the parent shell is used to execute the script.

Case Execute the first set of commands (*commands1*) if *value* matches *pattern1*, execute the second set of commands (*commands2*) if *value* matches *pattern2*, and so on. Example:

```
Case value  in
    Pattern1) commands1;;
    Pattern2) commands2;;
.
.
esac
```

env Displays the values of all variables known to the current environment including the current and all parent shells. See **set** command.

for For variable *n* (in optional list of values) do *commands*. Example:

```
for  n  [in list]
do
    Commands
done
```

if If *condition1* is met, do *commands1*; otherwise, if *condition2* is met, do *commands2*; if neither is met, do *commands3*. *Conditions* are usually specified with the **test** command. Example:

```
if condition1
then commands1
[ elif condition2
    then commands2]
.
.
[else  commands3]
fi
```

read Read one line of standard input, and assign each word to the corresponding *variable*, with all leftover words assigned to the last variable. If only one variable is specified, the entire line will be assigned to that variable. Example:

```
read  name address
```

set With no arguments set, displays the values of all variable known to the current shell.

test Generally used with conditional constructs in shell scripts. **test** evaluates a condition and returns a zero exit status if its value is true; otherwise, returns a nonzero exit status. An

alternate form of the command uses [] rather than the word test. Example:

```
read answer
if test "$answer" = y
then
    clear;ls
else
    ls
```

until Until *condition* is met, do *commands*. *Condition* is usually specified with the **test** command. Example:

```
until condition
do
    Commands
done
```

while While *condition* is met, do *commands*. *Condition* is usually specified with the **test** command. Example:

```
while condition
do
    Commands
done
```

Key Terms

C The C programming language was developed in early 1970s by Dennis Ritchie and Ken Thompson working at AT&T Bell Labs and is mainly used for system programming, creating operating systems and compilers.

C++ The C++ language was developed in the 1980s as an object-oriented language based on C. Object-oriented programming (OOP) is relatively new technique in programming. It reduces development time by grouping different reusable functions and data, or objects, into an application.

compiled program A text file containing programming code that is read and converted to a form that can be directly executed by the CPU. C or Fortran programs are examples of compiled programs. Compiled programs typically end in .bin, .exe, and so on.

conventional programming languages Compiled languages such as C, C++, and Java and require variable declarations.

debugging The process of tracing the execution of a program to see where it is failing.

escape characters Special characters used with the **echo** command that informs the shell to do something. Must be preceded by a backslash (\). Example:

echo would Bill \t Joy print Bill followed by a TAB, followed by Joy.

intrepreted programming language Interpreted or scripting languages analyze each line in the source file as the program executes and does so each time the program is run. JavaScript, Perl, PHP, and Python are examples of interpreted languages.

Java Developed by Sun Microsystems, Java is considered a better object-oriented version of C than C++ and offers a number of advantages. The Java language is *platform-neutral*. That is, Java programs are written to run on a *Java Virtual Machine* instead of on a physical computer—it's the Virtual Machine that runs on a real computer. Thus a programmer can develop a program that will work on any computer because the Java code runs inside of the Java Virtual Machine on those computers. However, Java is not only a language used to develop applications for computers but is considered a platform used to develop applications for mobile phones and other electronic gadgets and devices.

JavaScript Developed by Sun Microsystems and Netscape, JavaScript is an easy-to-use object-based scripting language for developing client and server Internet applications. Other than the word Java in the name, JavaScript has little in common with Java.

OOP (object-oriented programming) A programming technique that reduces development time by grouping different reusable functions and data, or objects, into an application. C++ and Java use OOP.

Perl A text- and file-manipulation language, originally intended to scan large amounts of text, process it, and produce nicely formatted reports from that data. It works something like a combination of awk, sed, the C language, and the C shell.

PHP Hypertext processor. The recursive acronym is a widely used general-purpose scripting language that is especially suited for Web development and can be embedded into HTML. PHP also provides easy access to system resources and can pull data from almost any database you're likely to want to use.

positional parameters Special built-in shell variables that can provide the name of the script file or arguments to the script as it executes. Their values are taken from arguments on the command line. Positional parameters are referenced in a script as $1, $2, $3, (up to $9), where $1 represents the first argument on the command line, $2 represents the second argument, and so on. Three other special variables are $0 (which represents the command or the name of the script), $* (which represents all arguments entered on the command line), and $# (which represents the number of arguments on the command line).

Python An interpreted, interactive, object-oriented programming language well-suited for simple scripting, complex business solutions, full-scale GUI applications, and Web development.

shell script A text file that contains a sequence of commands for the shell to execute one line at a time. Complex tasks involving variables and other programming functions are accomplished using shell scripts.

variable A placeholder for information required by processes so that they can function properly. A variable has a name and holds a value. Changing the value of a variable is called setting the variable. There are two types of variables used in shell scripts: shell (see **set**) and environment.

Objectives

After reading this chapter, you will be able to

- Explain the concepts of Client/Server computing.
- Work with key TCP/IP networking commands, such as **ping**, **telnet**, and **traceroute**, and SSH.
- Work with key UNIX networking commands such as **rlogin** and **rcp**.
- Explain the concepts and give examples of naming services.
- Describe the characteristics and benefits of the Network File System (NFS) and Server Message Block (SMB) resource-sharing protocols.

Chapter 16

Network Concepts and Utilities

Introduction

This chapter explains the concept of *client* and server (*client/server*) computing and the benefits in networked environments. You will work with UNIX network commands and utilities such as **ping** (packet internet groper), **telnet** (terminal emulator), and **rlogin** (remote login) for troubleshooting. The **ftp** (file transfer protocol) and **rcp** (remote copy) commands for transferring files to and from other systems are covered. An overview and benefits of naming services such as *Domain Name Service (DNS)* and *Network Information System (NIS)* is also provided. Network resource sharing *protocols* such as *Network File System (NFS)* and *Server Message Block (SMB)* also are covered.

Client/Server Computing

The client/server computing model distributes processing over multiple computers. Distributed processing enables access to remote systems for the purpose of sharing information and network resources. In a client/server environment, the client and server share or distribute processing responsibilities. Most modern network operating systems, and especially UNIX, are designed around the Client/Server model to provide network services to users. Computers on a network can be referred to as a *host*, a server, or a client:

- A **host** is a computer system on a UNIX network. Any UNIX computer running the TCP/IP protocols, whether a workstation or server, is considered a host computer. The local host is the machine on which the user currently is working. A remote host is a system that is being accessed by a user from another system.

- A **server** provides resources to one or more clients by means of a network. Servers provide services in a UNIX environment by running daemons. Examples of daemons include Printer, FTP, and Telnet.

- A **client** is a machine that uses the services from one or more servers on a network. A computer can be a printer client, an FTP client, and a Telnet client simultaneously.

A simple example of a client/server relationship is an FTP session. FTP, or the File Transfer Protocol, is a basic industry-standard method of transferring a file from one computer to another. For the client to transfer a file to or from the server, the server must be running the FTP daemon or service. In this case, the client requests the file to be transferred. The server provides the services, via the FTP daemon, necessary to receive or send the file.

The Internet is also a good example of a distributed processing client/server computing relationship. The client or front end typically handles user presentation functions such as screen formatting, input forms, and data editing. This is done with a browser such as Netscape or Internet Explorer. The server or back end handles the client's requests for Web pages and provides HTTP or WWW services. Another example of a client/server relationship is a database server and a data entry or query client in a LAN. The client or front end might be running an application written in the C or Java language, and the server or back end could be running Oracle or other database management software. In this case, the client also would handle formatting and presentation tasks for the user. The server would provide database storage and data retrieval services for the user.

In a typical file server environment, the client might have to retrieve large portions of the database files to process the files locally. This retrieval of the database files can cause excess network traffic. With the client/server model, the client presents a request to the server, and the server database engine might process 100,000 records and pass only a few back to the client to satisfy the request. Servers are typically much more powerful than client computers and are better suited to processing large amounts of data. With client/server computing, the large database is stored and the processing takes place on the powerful server. The client has to deal with only creating the query. A relatively small amount of data or results might be passed across the network. This satisfies the client's query and results in less usage of network bandwidth. Figure 16-1 shows an example of client/server computing. Note that the workstation and server normally would be connected to the LAN by a hub or switch.

Figure 16-1 Client/Server Environment

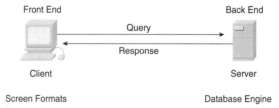

Front End — Query → Back End
Client ← Response — Server
Screen Formats — Database Engine

Network and Remote Access Utilities

As UNIX computer networks began to develop, commands and utilities were added to make it easier to work with programs and files residing on other client or server computers on the

network, and transferring files. These commands were either specific to UNIX such as **rlogin**, **rsh**, **ssh**, and **rcp** or common to TCP/IP such as **ping**, **traceroute**, **telnet**, and **ftp**. The **rlogin**, **rsh**, **ssh**, and **telnet** commands provide access to remote computers. The **ping** and **traceroute** commands can serve as network connectivity troubleshooting tools. **telnet** can also be useful in troubleshooting network connections. This section describes some of the most common and most useful of the UNIX and TCP/IP network utilities (see Figure 16-2).

<table>
<tr><td>**NOTE**</td></tr>
<tr><td>To use some network commands in Solaris and Linux, it may be necessary to login as root or specify the full path such as /usr/sbin/ ping. Use the **whereis** command to determine the directory location for a particular command, for example, **$whereis ping**.</td></tr>
</table>

Figure 16-2 Network and Remote Access Utilities

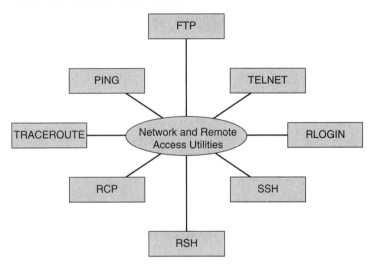

Ping Utility

Ping (Packet Internet Groper) is a useful utility that is part of the basic TCP/IP protocols package and is standard with every UNIX system. A computer that is running the TCP/IP protocol stack can make use of the **ping** command.

```
ping   hostname or ping ip address
```

Ping is a good low-level troubleshooting tool. The **ping** command tests basic connectivity between TCP/IP hosts. The **ping** command sends an Internet Control Message Protocol (ICMP) echo request to another computer or "host" on a TCP/IP network. If there is a reply from the destination host, there is a good connection between them. Ping uses IP datagrams to pass connection information. Therefore, a ping will test physical connections and IP addressing. If you are incapable of running an application on a remote host, you can ping the host as a basic connectivity test. If you do not get a response, the problem might not be with the application. The problem might be that the host or the network link is down.

TIP

In Linux, **ping** continuously sends packets until interrupted with Ctrl-C. In Solaris, the **ping -s** command performs the same function. Typing the **ping** command alone produces a list of options available.

Any network operating system that is running the TCP/IP protocol can send and respond to **ping**. You can **ping** the name of a host computer if a naming service such as DNS is running. You can also **ping** if the host name and IP address has been entered in your /etc/hosts file. If neither of these options is used, you can directly **ping** the IP address of the host. This direct option is preferred. This option is a simpler test of connectivity and does not depend on name resolution. Figure 16-3 shows an example using the **ping** command.

Figure 16-3 ping Command

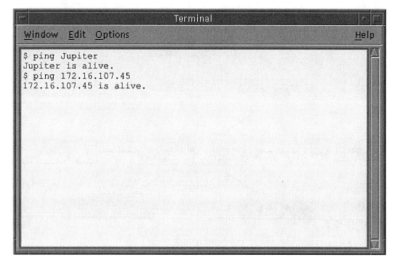

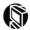 **e-Lab Activity 16.1** Using the **ping** Command

In this activity, you verify connectivity with an IP host by pinging it using its host name and IP address. Refer to e-Lab Activity 16.1 on the accompanying CD-ROM.

Traceroute Utility

Traceroute is another useful utility that is part of the basic TCP/IP protocol suite. Any computer running TCP/IP can use the **traceroute** command.

traceroute *hostname* or **traceroute** *ip address*

Traceroute is a good troubleshooting tool for checking the connection between computers that are interconnected with routers. Routers provide for connection of private networks and the public Internet. The **traceroute** command checks the time it takes for a packet to get from one router to the next and can help isolated slow links. Each router the packet goes through to reach its destination is listed in the command output and is referred to as a hop. As with **ping**,

traceroute tests physical connections and IP addressing from one host to another on a TCP/IP network. Figure 16-4 shows an example using the **traceroute** command.

Figure 16-4 traceroute Command

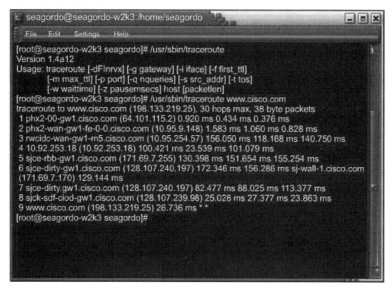

Telnet Utility

Another very useful TCP/IP utility is Telnet, which is standard on most operating systems, including UNIX. Telnet is a client/server terminal emulation program that allows the user to connect to another system. The Telnet server simulates a terminal to authorize a user or Telnet client to connect to a remote system and work in that environment. When telnetting to another host, you are prompted for a username and password. After a session is established from the Telnet client, you can enter commands as if you were entering the commands directly on the system console. You can Telnet to several different hosts and have multiple Telnet sessions open simultaneously. Telnet is currently the most widely used tool for managing remote systems and networking devices.

All operating systems that support TCP/IP provide at least a Telnet client. Not all operating systems provide a Telnet server or daemon. However, UNIX provides both a Telnet client and a Telnet server or daemon. In addition to connecting to other hosts, Telnet can be used to connect to and manage network devices such as switches and routers. These devices are actually microcomputers with a CPU and RAM, but they do not have a keyboard or monitor. Telnet allows you to use the computer's keyboard and monitor to remotely access and administer these devices.

NOTE

The procedure for Telnetting to another system depends on the Telnet program that you use. For example, you could use the UNIX **telnet** command, the Windows Telnet program, NCSA Telnet for Macintosh users, or a shareware Telnet program. Each command or program is slightly different.

TIP

If the Backspace and Delete keys do not work after establishing a telnet session to a remote UNIX system, look for an option in the Telnet program that allows you to define these keys. If your Telnet program does not allow these keys to be defined, you should do the following:

- Type **stty erase** at the shell prompt after you log in.

- Hit the **Backspace** key which will enter a ^H.

- Hit **Enter**.

`stty erase '^h'`

This will allow the Backspace key to work properly. You should type **stty erase '^h'** somewhere in the .profile file located in the home directory of the remote system. This is to keep from having to do this procedure each time you Telnet to the system. See Chapter 14, "Shell Features and Environment Customization," for more details.

Telnet is another good network troubleshooting tool. Telnet is a nongraphical communications utility that can be used to check the upper layers of the *OSI model*. Telnet runs at Layer 7, the application layer. If you are having trouble executing another client/server application, you can try to Telnet to the host or server to verify that the TCP/IP protocol stack is functioning correctly. You must remember that not all network operating systems support the Telnet server function. For example, you can Telnet from a Windows 9x or NT/2000/XP workstation to a UNIX server, but cannot Telnet to the Windows 9x or NT workstation. The Windows 9x and NT operating systems include a Telnet client but not a Telnet daemon or server. Windows 2000 and XP both include Telnet servers but they are not enabled by default. You can Telnet to the host operating system as long as the system is running a Telnet daemon or server. If a Telnet daemon is running, it may be desirable to disable the server to block Telnet requests as a security measure. You can telnet to the name of a host computer if there is a naming service running such as DNS. You can telnet to the host by entering the host name and IP address in the /etc/inet/ hosts files. If none of these apply, you can telnet the IP address of the host. When using Telnet, you can do the following:

- Open a session on a remote machine
- Alternate between the remote session and the local session
- Access multiple machines simultaneously
- Access machines that do not run under the UNIX environment

Figure 16-5 shows an example of using Telnet to connect to a remote system called beach. Notice that the host name beach is converted to an IP address using name to IP-address resolution. You also could telnet directly to the IP address of the host if you knew the IP address. Figure 16-6 shows alternating between the remote session and a local session.

Figure 16-5 Using the Telnet Utility

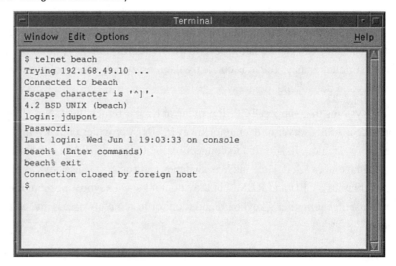

```
$ telnet beach
Trying 192.168.49.10 ...
Connected to beach
Escape character is '^]'.
4.2 BSD UNIX (beach)
login: jdupont
Password:
Last login: Wed Jun 1 19:03:33 on console
beach% (Enter commands)
beach% exit
Connection closed by foreign host
$
```

Figure 16-6 Using Telnet to Alternate Between Sessions

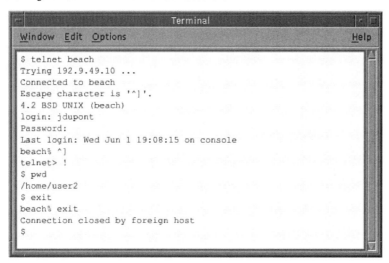

 e-Lab Activity 16.2 Using Telnet

In this activity, you telnet to a remote host, provide a user login and then exit the telnet session. Refer to e-Lab Activity 16.2 on the accompanying CD-ROM.

rlogin Utility

Like the TCP/IP telnet utility, the UNIX **rlogin** (remote login) command is used to establish a login session on another remote UNIX workstation. Telnet will always prompt for username and password. **rlogin** can be setup so no password is required as a convenience to users and for security reasons. If a password is not typed a hacker cannot view it.

Remotely logging into a workstation is helpful under the following circumstances:

- To access information on another workstation that is not available otherwise
- To access a user's workstation remotely to read mail
- To kill a process that has caused the user's workstation to hang

Figure 16-7 lists some functions that can be performed with **rlogin**. Figure 16-8 shows how to log into another host under your current user ID.

Figure 16-7 Functions Performed with **rlogin**

- Login remotely to a server to run applications

- Login remotely to your workstation to kill process

- Access information on another workstation that is not available otherwise

- Access your workstation remotely to read mail

Figure 16-8 Remotely Logging into Another Host

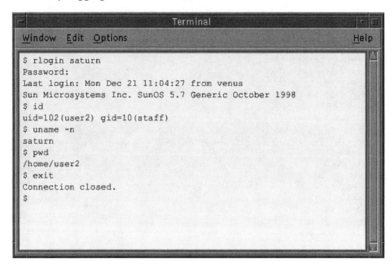

Specifying a Different Login ID

Use the **-l** option to specify a different login ID for the remote login session. The system administrator can set up a guest account so that users can remotely log onto a server. Figure 16-9 shows how to log in remotely as another user. The syntax for the **rlogin** command is as follows:

`rlogin` *hostname* `-l` *username*

Figure 16-9 Logging in Remotely as Another User

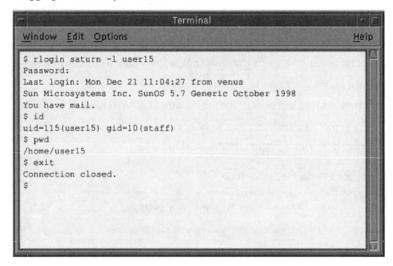

You must have an account on the desired remote host before attempting to remotely log into another host system as a different user. If you do not have an account on the remote host, you must check with the system administrator. You will need to know the following information:

- Host name
- Login ID
- Password of the new account

Terminating a Local Process from a Remote Machine

If your system is not responding and you do not want to reboot you might be able to kill a process on the system remotely. You log onto another machine and using the **rlogin** command to access your system. After successfully killing the process that caused the system to not respond, the **exit** command ends your **rlogin** session. Figure 16-10 shows an example of terminating a process from a remote machine.

Figure 16-10 Terminating a Process from a Remote Machine

```
$ rlogin hostname
Password:
Last login: Tue Jun 8 17:40:30 from venus
Sun Microsystems Inc. SunOS 5.7 Generic October 1998
You have mail.
$ ps -e
PID    TTY      TIME  CMD
10153  console  0:03  cm
12892  console  0:01  sh
217term  /a0:0 /usr/lib/lpsched
14490pts  /20:03  maker3ol
12932pts  /00:01  /bin/sh
13162pts  /70:08  admintool
10138console  0:04  clock
10159console  7:29  mailtool
10140pts  /10:05  cmdtool
10151console  12:42  xnews
10614pts  /10:27  cmdtool
10109console  0:00  xinit
$ kill 14490
```

Using **rlogin** and **pkill** to Recover from a Hung CDE Session

If the workstation does not appear to be responding to mouse or keyboard input, the chances are that the problem originates from within your CDE session. The problem is not with the underlying operating system itself. In these cases, you can use another workstation to access your workstation by way of **rlogin** or **telnet**. You then use the **pkill** command to terminate the corrupted CDE session, all without rebooting your workstation.

Figure 16-11 shows how to use **rlogin** and **pkill** to recover from a hung CDE session. If you know the default shell, use the first example of **pkill**. If you do not know the default shell, use the second example of **pkill**. This will determine and terminate all instances of your login shell automatically. Either variant returns you to the CDE Login Manager screen, enabling you to start a new CDE session.

Figure 16-11 Using **rlogin** to Recover from a Hung CDE Session

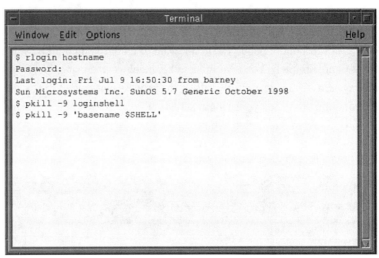

 e-Lab Activity 16.3 Using rlogin

In this activity, you rlogin to a remote host, provide a user password, issue a command, and then exit the rlogin session. Refer to e-Lab Activity 16.3 on the accompanying CD-ROM.

FTP Utility

The File Transfer Protocol (FTP) application is part of the TCP/IP protocol suite and is standard with most operating systems. This application can be used to transfer files using ASCII or binary mode between systems using similar or dissimilar operating systems. This provides a basic means of transferring files from one file format to another. For instance, a UNIX file normally would be unreadable by a Windows operating system. However, because both operating systems support FTP, the file is converted from one file format to another as it is transferred.

An ASCII file is an ordinary text file with no formatting characters. An example would be a file created with **vi** in UNIX or Notepad in Windows. A binary file is any other type of file such as a file from a word processor, a program file, a zip file, and so on. When transferring ASCII text files between two different operating systems, such as UNIX to Windows, or

vice versa, the default ASCII transfer mode saves the file in a format that makes the file readable by the different operating systems.

Most computers running servers with sites set up for downloading files provide an ***anonymous FTP*** account so that users can pull files off the server. For this kind of an account, at the Name prompt, the word **anonymous** is entered instead of accepting the default displayed. If a password is required for the anonymous account, it usually is the user's full e-mail address. Although the FTP client is normally enabled, most OSs that support FTP do not usually start the server as a default. However, if the FTP server is running, it may be desirable to disable it to block FTP requests as a security measure.

To start an FTP session, you type **ftp** at the shell prompt. After supplying an account name and password, you will receive the FTP program prompt (**ftp>**). This prompt indicates that you are in the FTP program and ready to transfer files. The syntax for the **ftp** command is shown here:

`ftp` *hostname* or `ftp` *ip address*

After you successfully use the **ftp** command to access a remote site, some familiar file and directory access commands such as **cd** and **ls** are available. To view a list of FTP available commands, you enter the **?** at the **ftp>** prompt. If permissions are set by the site's system administrator for a user to see the contents of a directory, the **ls** command displays files in that directory. If permissions are set so that a user does not have access to the files, when the **ls** command is entered, a prompt is returned in response. As on your local system, **cd** will change directories on the remote system. If it is necessary for you to change directories on your own system in the middle of the FTP session, the **lcd** (local change directory) command can be used. To end an FTP session, type **bye** at the prompt.

In addition to the previous commands, other commands that you will use often are **put**, **mput**, **get**, and **mget**. The **put** command is used to transfer a file to the remote host. The **mput** (multiple put) command allows you to transfer more than one file at a time by specifying a space-delimited list of files. Wildcards are accepted. The **get** and **mget** commands are used to transfer one or more file from a remote host to your system.

Figure 16-12 shows an example using the **ftp** command to transfer two files, hosts and /tmp/hosts, in binary mode from another host. In this case, we are initiating an FTP session to the host name **venus**. As with **ping** and **telnet**, you can FTP directly to the host's IP address.

TIP

Type **asc** or **ascii** to switch back to ASCII transfer mode from binary mode.

TIP

FTP supports approximately 50 UNIX and FTP commands. Refer to the man pages on the **ftp** command for a complete list.

TIP

You should use the **cd** and **lcd** commands mentioned previously to change to the desired directory before transferring files. Files are **put** into the current directory on the remote system, and files that you **get** are placed in the current directory on your system.

e-Lab Activity 16.4 Using FTP

In this e-Lab Activity, you connect to an FTP server as a client, login as user2 and provide a password. You set the mode to binary, retrieve (get) a file from the remote host and then exit the session. Refer to e-Lab Activity 16.4 on the accompanying CD-ROM.

Figure 16-12 Retrieving a File from Another Host with FTP

```
Terminal
Window  Edit  Options                                    Help

$ ftp venus
Connected to 129.150.212.16.
220 venus FTP server (UNIX(r) System V Release 4.0) ready.
Name (129.150.212.16:lister): Return <CR>
331 Password required for lister.
Password: xxx
230 User lister logged in.
ftp> cd /etc/inet
250 CWD command successful.
ftp> bin
200 Type set to I.
ftp> get hosts /tmp/hosts
200 PORT command successful.
150 Binary data connection for hosts (129.159.129.38,33425)
(77 bytes)
226 Transfer complete.
local: /tmp/hosts remote: hosts
77 bytes received in 0.0014 seconds (5,25 Kbytes/s)
ftp> bye
$
```

NOTE

In order for one system to copy a file to another system a .rhosts file needs to be created in the home directory of the receiving user account. The .rhosts file lists all hosts and username pairs it with *trusts*.

A system is said to trust another by allowing access without requiring a username and password. This condition must exist before a remote copy is permitted between the two systems. For example, in order for user jiml on the host named wildcat to remote copy a file to user dano on the host named buckey, dano must create an .rhost file in the home directory and place **wildcat jiml** on one line. Placing just the hostname **wildcat** on one line would permit any user on wildcat to remote copy a file to dano's home directory on buckeye.

 Lab Activity 16.2.6 Using Network Commands

In this lab, you work with UNIX and Transmission Control Protocol/Internet Protocol (TCP/IP) networking commands. Refer to the Lab 16.2.6 in the *Cisco Networking Academy Program: Fundamentals of UNIX Lab Companion*, Second Edition.

rcp Utility

The **rcp** (remote copy) command is another command from the **r** (remote) family of commands. Like **rlogin**, the **rcp** command is a UNIX, not a TCP/IP, command for use between UNIX systems. The **rcp** command works in much the same way the **cp** (copy) command does. The **rcp** command is used to *get* or copy and *put* or paste files and directories to and from a remote UNIX system. The syntax for the **rcp** command is shown here:

```
rcp source_file hostname:destination_file ("put ")
rcp hostname:source_file destination_file ("get ")
```

For example, to copy the memo file to the /tmp directory on the host buckeye, use this command:

```
$rcp memo buckeye:/tmp
```

To copy the budget file from dano's home directory on buckeye to the current directory, use this command:

```
$rcp buckeye:~dano/budget .(dot)
```

To remotely copy the chapters directory to the /book directory on the host production1, use this command:

```
$rcp -r ~/chapters production1:/book
```

Secure Shell

As previously discussed **telnet**, **rlogin**, and **ftp** allow remote access to other UNIX computers or network devices. The disadvantage to using these utilities, however, is that all data and passwords are transmitted unencrypted. Secure Shell *(SSH)* is a relatively new utility that provides secure access to a remote computer by encrypting all transmission between client and server. SSH is becoming increasingly popular as a replacement for Telnet and FTP for use in managing Web and other servers remotely. SSH also replaces an early UNIX utility called remote shell or rsh, which used unencrypted communication.

As with Telnet, FTP, and other UNIX client/server applications, SSH requires two components. The server component must be installed on the system to be managed remotely and the client must be installed on the managing system. SSH is included as part of several Linux distributions such as Red Hat. Depending on the Linux distribution and the role the system will play it may be necessary to install SSH.

SSH can also be downloaded at no cost from www.openssh.com. OpenSSH is a suite comprised of four utilities. Three of these provide support for the SSH client:

- **ssh** (replaces **rsh**, **rlogin**, and **telnet**)
- **scp** (replaces **rcp**)
- **sftp** (replaces **ftp**)

Also included is **sshd** (ssh daemon) which provides the SSH server functionality. In addition to character-based sessions, X-Windows or graphical connections are also supported. See Figure 16-13.

Figure 16-13 Secure Shell Utilities

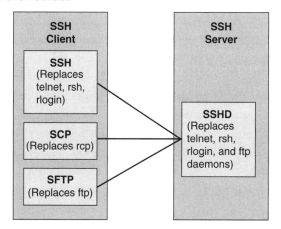

Naming Services and Host Name Resolution

Name services store information in a central place that users, workstations, and applications must have to communicate across the network. These services include the following:

- Host names and addresses
- Usernames
- Passwords

Without a central name service, each workstation would have to maintain its own copy of this information. Name service information may be stored in files, maps, or database tables. Centrally locating this data makes it easier to administer large networks.

Name Services Overview

The goal of a naming service is to allow centralization of network administration. The administration of a group of machines grows in complexity with the number of machines and users to manage. As a result, decentralized administration is conceivable for two or three machines, but it becomes more complex if the number exceeds that limit. For example, there is a group of five machines. If all the users have to be able to log in as themselves on each machine, the administrator must duplicate the /etc/passwd file on every machine. Although putting this in place initially is possible, maintenance becomes difficult. In effect, each modification of one element of the password file makes it necessary to reproduce the change on each machine. The problem that is raised by the /etc/passwd file is greatly increased by necessary changes to many other administrative files, such as the group and hosts files.

Centralized Administration

Administrators should set up networks with a centralized administration that distributes a database to all the machines known by the distributed administration. This database can be centralized on one server, which provides the administrative services. The group of machines using the database on the server is called a *domain*. This centralized administration uses a naming service as the framework for the domain or domains. The Domain Name System (DNS) and Network Information Service (NIS) are two naming services that can be set up for use in the UNIX networked environment. *NIS+* is another naming service developed by Sun Microsystems for Solaris. Each naming service is discussed in greater detail in the following sections. The name services discussed in this chapter are as follows:

- **Name Services**—A distributed database that contains information about all the hosts, users, and shared resources on the network.
- **DNS (Domain Name Service)**—A network information service provided by the Internet and TCP/IP networks.

- **NIS (Network Information Services)**—Provides centralized administration of network information users, workstations, applications and so on.
- **NIS+**—Sun's newest naming service for Solaris.

Domain Name Service (DNS)

The Domain Name System (DNS) is the name service provided by the Internet for TCP/IP networks. DNS was developed so that workstations and servers on the network could be identified with common names instead of Internet addresses. DNS performs resolution or translation of host name to Internet (IP) address between hosts within the user's local administrative domain and across domain boundaries.

For example, the user starts her **browser** and types in a Website such as cisco.netacad.net or www.sun.com. A DNS server within the user's domain or at the user's ISP tries to translate the Internet domain name to an IP address. If the server cannot, it requests help from other DNS servers on the Internet. If none of the DNS servers can translate the name that the user entered, the user will get an error from her browser. In the example of www.sun.com, the name of the Web server (www) in the sun.com domain would be translated to an IP address such as 172.16.133.89. Because of the DNS server the user is capable of entering www.sun.com and have it translated to the IP address of the Website to which she wants to go. If the DNS server is down or unavailable, the user will not be able to connect to the desired Website using the domain name. If the user knows the IP address of the server, though, the user could enter the IP address and connect. Without an IP address, the user's request would never make it to the Web server at Sun Microsystems.

The collection of networked workstations that use DNS is referred to as the ***DNS namespace***. The DNS namespace can be divided into a hierarchy of domains. A DNS domain is simply a group of workstations. With the Internet, the top of the DNS tree is called the root domain and is controlled by the NIC (Network Information Center). Below the root domain are the top-level domains. Some examples of top-level domain names are as follows:

- **com**—Commercial organizations
- **edu**—Educational organizations
- **gov**—Government (U.S.) organizations
- **mil**—Military (U.S.) organizations
- **net**—Networking organizations and ISPs
- **org**—Non-profit and other organizations
- **us**—Country code-based domains (in this case, **us** for United States)

The sun.com domain is controlled by administrators of Sun Microsystems not NIC.

An organization may decide to break up its domain into subdomains based upon organizational structure. An example of a subdomain would be suned.sun.com.

/etc/hosts File

The original host based UNIX naming system was developed for standalone UNIX machines and then was adapted for network use. Many older UNIX operating systems and machines still use this system, but this system is not well suited for large, complex networks. With this system, name resolution is performed on each machine and requires that a static **hosts** file be created on each machine to translate host names to IP addresses. This file is typically placed in the /etc directory. The addition of a new machine to the network means updating the /etc/hosts file on every machine on the network.

Likewise, if all the users have to be able to log in as themselves on each machine, the administrator must duplicate the **/etc/passwd** on every machine. This method of constantly updating the etc files on each machine on the network can take up an enormous amount of time with a medium or larger network. A typical /etc/hosts file might look like the following:

```
$cat /etc/hosts
# Internet host table
127.0.0.1          localhost
192.168.100.10     mars
192.168.100.11     jupiter
192.168.100.12     venus
```

Network Information Service (NIS)

The Network Information Service (NIS) was developed by Sun Microsystems and has become the recognized industry standard for UNIX network information services. NIS is frequently implemented in Linux and other UNIX environments. NIS has a slightly different focus than DNS. DNS focuses on making communication simpler by using host and domain names instead of numerical IP addresses. NIS focuses on making network administration more manageable by providing centralized control over a variety of network information. NIS stores information about workstation names and IP addresses, users, the network itself, and network services. This collection of network information is referred to as the **NIS namespace**. NIS namespace information is stored in **NIS maps**. NIS maps were designed to replace UNIX /etc files, as well as other configuration files, so these maps store much more than names and addresses. As a result, the NIS namespace has a large set of maps.

NIS uses a client/server arrangement similar to that of DNS. Replicated NIS servers provide services to NIS clients. The principal servers are called master servers. To be more reliable, NIS servers have backup servers, or slave servers. Both master and slave servers use the NIS information retrieval software, and both store NIS maps. The characteristics of

NIS can be summarized as follows:

- Provides centralized administration of network information
- Runs on top of TCP/IP
- Widely used by UNIX and non-UNIX vendors
- Easy to implement
- Works well in small, flat domains
- No security features

Network Information Service Plus (NIS+)

The Network Information Service Plus (NIS+) is similar to NIS, but with many more features. NIS+ is not an extension of NIS. NIS+ is Sun's new, proprietary naming service for Solaris.

NIS+ enables the user to store information about workstation addresses, security information, mail information, Ethernet interfaces, and network services in central locations where all workstations on a network can have access to the information. This configuration of network information is referred to as the NIS+ namespace.

The NIS+ namespace is hierarchical and is similar in structure to the UNIX directory file system. The hierarchical structure allows an NIS+ namespace to be configured to conform to the logical hierarchy of an organization. The namespace's layout of information is unrelated to its physical arrangement. An NIS+ namespace can be divided into multiple domains that can be administered autonomously. Clients may have access to information in other domains, in addition to their own, if the client's have the appropriate permissions.

NIS+ uses a client/server model to store and control access to the information contained in an NIS+ namespace. Each domain is supported by a set of servers. The principal server is called the master server, and the backup servers are called replicas. The network information is stored in 16 standard NIS+ tables in an internal NIS+ database. Both master and replica servers run NIS+ server software, and both maintain copies of NIS+ tables. Changes made to the NIS+ data on the master server are reproduced automatically to the replicas.

NIS+ includes a sophisticated security system to protect the structure of the namespace and its information. NIS+ uses authentication and authorization to verify whether a client's request for information should be fulfilled. Authentication determines whether the information requester is a valid user on the network. Authorization determines whether a particular user is allowed to have or modify the information requested. The characteristics of NIS+ can be summarized as follows:

- Sun's newest naming service for Solaris
- Enhanced security features

- Difficult to configure
- Scales well for large hierarchical domains

Network Resource Sharing

Various protocols exist to allow centralized and remote network resources such as files and printers to be shared by network users. These include the Network File System (NFS), Server Message Block (SMB), and Netware Core Protocol (NCP). All of these are designed to allow Servers to advertize their services and clients to request services. NFS and SMB are covered here.

Network File System

The **Network File System (NFS)** is a distributed file system developed by Sun Microsystems. It is a network service that allows users to transparently access files and directories located on another disk on the network. NFS enables computers of different architectures running different operating systems to access remote resources as if they were local. NFS has become adopted as the industry-standard networked file system for most UNIX vendors.

NFS provides users with several benefits:

- **Centralized files**—Centralized files allow multiple computers to use the same files. Because the files reside on one or more computers and are shared to the network, others can access them.

 Centralized files are useful with login directories or common data files. It is easier for an administrator to back up a home file system containing many users' home directories residing on one system instead of individual workstations.

- **Common software**—Common software allows systems to share software programs. It is easier to install and upgrade a network version of a program on one server than to install the program on each individual workstation.

- **Files that appear to be local**—Accessing files is transparent to the user. A user might work on an application or change to a directory residing on another computer on the network and not even realize it. The automounter feature makes the files appear to be on the user's own computer. Shared files typically are made available at bootup or automounted (shared) as needed. Figure 16-14 shows a shared directory structure (rdbms) on an NFS server that has been mounted on the client's /opt/rdbms mount point. Thus the server's directories appear to be locally available to the client.

Figure 16-14 The Network File System - NFS

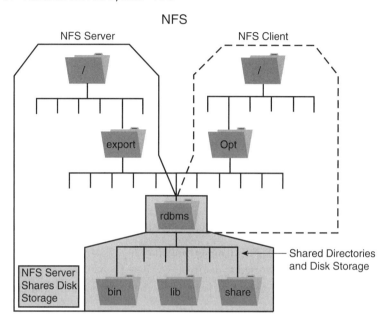

Server Message Block

Computers running one of the Microsoft operating systems such as Windows 9x, NT, 2000, or XP, use a protocol called Server Message Block (SMB) for sharing files and printers on a network. SMB performs a similar function for Microsoft clients as NFS does for UNIX clients or Netware Core Protocol (NCP) does for Novell Clients. Although the term SMB is still commonly recognized, it has been renamed to Common Internet File System or CIFS. The SMB/CIFS protocol is implemented in the UNIX world to allow Microsoft clients to access UNIX servers and UNIX clients to access Microsoft servers. *Samba* is an open-source version of SMB that comes with most Linux distributions and provides both client and server applications. Commercial versions of Samba are also available for Solaris and other UNIX varieties. With Linux, SMB support may be selected during OS installation or installed later.

With the Samba server daemon running on a UNIX server, Microsoft clients can access UNIX shares as though they were connecting to a Microsoft server. Running the Samba client software on a UNIX workstation allows users to access Microsoft server shares. For the UNIX client, two utilities help provide access to Microsoft servers. The smbclient utility allows access to shares using commands similar to FTP and provides short-term access. The smbmount utility allows the user to mount the shared folder so that it appears as part of the user's local file system for continued use. The characteristics of SMB/CIFS shares

can be summarized as follows:

- Microsoft OSs share resources using the SMB/CIFS protocol
- SMB performs a similar function to NFS
- Samba is an open-source version of SMB for UNIX
- Samba server supports Microsoft and UNIX clients
- Samba provides both client and server software
- Samba server supports Microsoft and UNIX shares
- The UNIX client utilities are smbclient and submount

Summary

Now that you have completed this chapter, you should have an understanding of the following:

- A client/server architecture is a popular computing model used with the Internet. The client/server architecture is used to distribute or share processing loads when performing tasks. The server or backend runs software such as a daemon to provide services for client requests.
- Several TCP/IP and UNIX networking utilities are available including **ping**, **telnet**, **traceroute**, **rlogin**, and **ftp**.
- The **ping** command is a low-level troubleshooting tool to test connectivity between systems. The **telnet** command can be used to take over the console of a remote host. The **rlogin** command is used to log in and run programs on another computer. The File Transfer Protocol is a useful utility that can be used to transfer file between computers with dissimilar operating systems. The **rcp** command is used to copy file and directories between UNIX computers.
- Secure shell (SSH) is an open-source suite of utilities that can provide a secure, encrypted replacement for **telnet**, **rsh**, **rcp**, **rlogin**, and **ftp**.
- The Domain Name System (DNS) is the name service provided by the Internet for TCP/IP networks. DNS was developed so that workstations and servers on the network could be identified with common names instead of Internet addresses. DNS performs resolution or translation of host name to IP address between hosts.
- Sun developed NIS, NIS+, and NFS. NIS and NIS+ simplify network administration by providing a centralized database for user account authorization. NFS provides for distributed processing by allowing a file system on a remote computer to appear as part of the local hosts file system.
- The SMB/CIFS protocol provides for sharing of files and printers between Microsoft and UNIX systems. Samba is the most common implementation of this protocol and comes with most Linux distributions.

Check Your Understanding

1. Which type of processing is supported by the client/server model and allows processing to occur over multiple computers?

2. Match the best definition to each term for computers on a UNIX network.

Term	Definition
Host _____	A) Any UNIX computer running TCP/IP
Server _____	B) A computer that provides resources to clients through the network
Client _____	C) A computer that uses the services from one or more servers through the network

3. Which utility should be used when you need to verify where a connection has failed or isolate a slow link?

 A. telnet

 B. ftp

 C. traceroute

 D. ping

4. The TCP/IP utility used to remotely configure a switch is _____.

5. Which two things are required for a Telnet session?

 A. Telnet client on the host that initiates the Telnet session.

 B. A Telnet server on the host that initiates the Telnet session.

 C. A Telnet client on the remote system that a session is opened.

 D. A Telnet server on the remote system on which a session is opened.

6. You need to remotely login to a UNIX workstation with the username of Jacob. The host name of the workstation is ILuvUNIX. What is the correct command syntax to perform the required operation? (Do not use **telnet**.)

7. File type is an important consideration when transferring a file using FTP. Which two statements are true?

 A. An ASCII file is a file that was created with formatting characters using an application such as a word processor.

 B. A binary file is a file that was created with formatting characters using an application such as a word processor.

 C. FTP defaults to a transfer mode of ASCII for file types.

 D. FTP defaults to a transfer mode of binary for file types.

8. Which three commands are used to transfer files in an FTP session?

 A. copy

 B. put

 C. get

 D. mget

 E. rget

 F. mcopy

9. You need to copy the file mytext.txt to a remote host with the name of venus. The file should be saved with the name of mytxtv1.txt on venus. Your computer's hostname is mars. Write the command with the proper syntax to perform the required operation.

10. Which UNIX utility provides secure access to a remote computer by encrypting all transmission between the client and server?

11. Which three of the following lists correctly associates ssh components with the utilities they replace?

 A. **ssh** replaces **rsh**, **rlogin**, and **telnet**

 B. **ssh** replaces **rsh**, **rlogin**, and **rcp**

 C. **scp** replaces **rcp**

 D. **stelnet** replaces **telnet**

 E. **sftp** replaces **ftp**

 F. **smb** replaces **rlogin**

12. DNS translates _____ to _____ .

13. Which of the following are two network management features developed by Sun Microsystems?

 A. DNS

 B. NIS

 C. INS+

 D. NIS+

 E. DNS+

14. The _____ file system is the industry standard for UNIX systems file sharing.

UNIX Command Summary

ftp The File Transfer Protocol (FTP) application is part of the TCP/IP protocol suite and is standard with the UNIX operating system. It can be used to transfer files using ASCII or binary mode between systems using similar or dissimilar operating systems. Example:

```
$ ftp venus
Connected to 129.150.212.16.
220 venus FTP server (UNIX(r) System V Release 4.0) ready.
Name (129.150.212.16:lister): Return <CR>
331 Password required for lister.
Password: xxx
230 User lister logged in.
ftp> cd /etc/inet
250 CWD command successful.
ftp> bin
200 Type set to I.
ftp> get hosts /tmp/hosts
200 PORT command successful.
150 Binary data connection for hosts (129.159.129.38,33425)
(77 bytes)
226 Transfer complete.
local: /tmp/hosts remote: hosts
77 bytes received in 0.0014 seconds (5,25 Kbytes/s)
ftp> bye
ftp> get hosts /tmp/hosts
200 PORT command successful.
150 Binary data connection for hosts (129.159.129.38,33425)
(77 bytes)
226 Transfer complete.
local: /tmp/hosts remote: hosts
77 bytes received in 0.0014 seconds (5,25 Kbytes/s)
ftp> bye
```

ping Tests basic connectivity between TCP/IP hosts by sending an Internet Control Message Protocol (ICMP) echo request to another computer or "host" on a TCP/IP network. If there is a reply from the destination host, there is a good connection between them. Example:

```
-s
```

```
$ ping jupiter
jupiter is alive
$ ping 192.13.145.10
192.13.145.10 is alive
```

rcp Copies to or from one UNIX system to another. Example:

```
$ rcp big10schedule spartan:/tmp
```

```
$ rcp buckeye:~dano/budget.
```

rlogin Use the **rlogin** command to establish a remote login session on another workstation. Example:

```
$ rlogin saturn
Password:
Last login: Mon Dec 21 11:04:27 from venus
Sun Microsystems Inc. SunOS 5.7 Generic October 1998
$
```

scp Secure Copy (**scp**). Part of the SSH suite of utilities that replaces the remote copy (**rcp**) command. Example:

```
$ scp big10schedule spartan:/tmp
$ scp buckeye:~dano/ budget.
```

sftp Secure File Transfer Protocol (**sftp**). Part of the SSH suite of utilities that replaces the File Transfer Protocol (**ftp**) command. Example:

```
$ sftp bronco
$ sftp 124.36.78.2
```

ssh Secure Shell (SSH) is a utility that provides secure access to a remote computer by encrypting all transmission between client and server. SSH is becoming increasingly popular as a replacement for Telnet and FTP for use in managing Web and other servers remotely. SSH also replaces an early UNIX utility called remote shell or rsh, which used unencrypted communication. Example:

```
$ ssh bronco
$ ssh 124.36.78.2
```

telnet Another good network troubleshooting tool. Telnet is a nongraphical communications utility that can be used to check the upper layers of the OSI model. Example:

```
$ telnet beach
Trying 192.168.49.10 ...
Connected to beach
Escape character is '^]'.
4.2 BSD UNIX (beach)
login: jdupont
Password:
Last login: Wed Jun 1 19:03:33 on console
beach% (Enter commands)
beach% exit
Connection closed by foreign host
$
```

traceroute A good troubleshooting tool for checking the connection between computers that are interconnected with routers. Example:

```
$ traceroute cisco.com
$ traceroute 154.63.24.3
```

Key Terms

Anonymous FTP A site that is set up for general use and that does not require an account to obtain files. The word *anonymous* is the username, and the user's e-mail address is the password.

browser A graphical program that allows convenient access to the World Wide Web (WWW). The first browser was Mosaic. Some browsers are Netscape Navigator, Microsoft Internet Explorer, and HotJava.

client A machine that uses the services from one or more servers on a network. Your computer can be a printer client, an FTP client, and a Telnet client simultaneously.

client/server Computing model that distributes processing over multiple computers. This enables access to remote systems for the purpose of sharing information and network resources. In a client/server environment, the client and server share or distribute processing responsibilities. Computers on a network can be referred to as a host, a server, or a client.

DNS Domain Name System. The name service provided by the Internet for TCP/IP networks. It was developed so that workstations and servers on the network could be identified with common names instead of Internet addresses. DNS performs resolution or translation of host name to Internet (IP) address between hosts within your local administrative domain and across domain boundaries.

domain The name assigned to a group of systems on a local network that share administrative files. The domain name is required for the network information service database to work properly.

host A computer system on a UNIX network. Any UNIX (or other OS) computer running TCP/IP (workstation or server) is considered a host computer. The *local host* is the machine on which the user is currently working. A *remote host* is a system that is being accessed by a user from another system.

hub A multiport networking device that interconnects client and servers repeating (or amplifying) the signals between them. Hubs act as wiring concentrators in networks based on star topologies (rather than bus topologies, in which computers are daisy-chained together).

Internet The largest network in the world. It consists of a large national backbone network that contains the Military Network (MILNET), the National Science Foundation Network (NSFNET), the European Laboratory for Particle Physics (CREN), and a myriad of regional and local campus networks all over the world. To be able to log on the Internet the user must have Internet Protocol (IP) connectivity; that is, the user be capable of communicating with other systems by using **telnet** or **ping**. Networks with only e-mail connectivity are not classified as being on the Internet.

LAN Made up of groups of computers (nodes) that have simultaneous access to common high-bandwidth media. Site has a link to every other site. With a partial mesh, each site has a link to more than one site, but not to every site.

name service Provides a means of identifying and locating resources (traditionally host names and IP addresses) available to a network. The default name service product available in the Solaris 2.x environment is NIS+.

namespace A collection of machines using a network information service such as domain name service (DNS), (yp), NIS, or NIS+, all sharing a common name.

NFS (Network File System) Sun's distributed computing file system. It is a network service that allows users to transparently access files and directories located on another disk on the network. NFS has become adopted as the industry-standard networked file system for most UNIX vendors.

NIS (Network Information Service) Focuses on making network administration more manageable by providing centralized control over a variety of network information. NIS stores information about workstation names and IP addresses, users, the network itself, and network services. This collection of network information is referred to as the NIS namespace.

NIS+ Enables you to store information about workstation addresses, security information, mail information, Ethernet interfaces, and network services in central locations where all workstations on a network can have access to it. This configuration of network information is referred to as the NIS+ namespace.

OSI model Open System Interconnection. Developed by the International Organization for Standardization (ISO) to describe the functions that occur as two nodes on a network communicate. OSI is an internationally recognized, structured, and standardized architecture for network design. The seven-layer OSI reference model, or just OSI model, is one of the most useful tools we have for analyzing and comparing various technologies and networking products from different vendors.

protocol A formal description of a set of rules and conventions that govern how devices on a network exchange information. The Transmission Control Protocol (TCP) is the protocol of most networks and the internet today.

router A device that moves data between different network segments and can look into a packet header to determine the best path for the packet to travel. Routers can connect network segments that use different protocols. They also allow all users in a network to share a single connection to the Internet or a WAN (wide-area network).

Samba An open-source version of SMB that comes with most Linux distributions and provides both client and server applications allowing for the sharing of files and printers. Commercial versions of Samba are also available for Solaris and other UNIX varieties.

server Provides resources to one or more clients by means of a network. Servers provide services in an UNIX environment by running daemons. Examples of daemons include Printer, FTP, and Telnet.

SMB (Server Message Block) Computers running one of the Microsoft operating systems such as Windows 9x, NT, 2000, or XP use the SMB protocol for sharing files and printers on a network. SMB performs a similar function for Microsoft clients as NFS does for UNIX clients or Netware Core Protocol (NCP) does for Novell Clients. The SMB/CIFS protocol also provides for sharing of files and printers between Microsoft and UNIX systems.

SSH Secure Shell. A suite comprised of four utilities. Three of these provide support for the SSH client.

- **ssh** (replaces **rsh**, **rlogin**, and **telnet**)
- **scp** (replaces **rcp**)
- **sftp** (replaces **ftp**)

switch A device that improves network performance by segmenting the network and reducing competition for bandwidth. When a switch port receives data packets, it forwards those packets only to the appropriate port for the intended recipient. This capability further reduces competition for bandwidth between the clients, servers, or workgroups connected to each switch port.

TCP/IP The Defense Advance Research Projects Agency (DARPA) originally developed TCP/IP to interconnect defense department computer networks across the country to form a fault-tolerant network. It was adopted and further developed as the standard networking communications component of the UNIX operating system.

Objectives

After reading this chapter, you will be able to

- Understand the role and responsibilities of a UNIX/Linux system administrator.
- Appreciate career opportunities as a UNIX/Linux system administrator.
- Describe the Sun certification path for system administrators.
- Describe the Sun Academic Initiative program.
- Describe Linux certification options.

Chapter 17

Career Guidance

Introduction

This chapter provides information and resources for those who want to learn more about UNIX, specifically Solaris and Linux. This chapter covers careers in UNIX/Linux system administration and the process of obtaining certification in Solaris system administration. An overview of the Sun Academic Initiative, a program that offers Solaris system administration courses to authorized educational institutions, is discussed. The chapter concludes with information about the vendor-neutral CompTIA Linux+ certification and vendor-specific certifications.

UNIX | more

The Fundamentals of UNIX course was designed to give you a strong understanding and foundation of the UNIX and Linux operating systems. After you have completed this course, there are numerous options allowing you to continue to learn about UNIX/Linux. The UNIX OS has evolved into a powerful operating system that you can spend a lifetime learning. As a user, you can continue to learn more about the UNIX world from a variety of sources, including websites, newsgroups, user groups, and, of course, books. However, if you really enjoy working with UNIX, the next step might be a career in system administration.

Careers in UNIX System Administration

Job-placement sites, such as www.monster.com, www.dice.com, and others, illustrate that plenty of jobs are available for UNIX system administrators. What is a system administrator?

System administration is a broad topic, which can make it difficult to define. Generally, a system administrator sets up UNIX systems, workstations and servers, on a network. The system administrator would handle daily tasks for maintaining a large number of systems. These tasks can include creating and maintaining user accounts, installing software, ensuring system security, backing up data, and solving computer and network problems.

In large organizations, system administrators often have specialized roles. Some administrators focus entirely on creating and maintaining user accounts. Others system administrators focus on

system security, and others spend their time ensuring that data is successfully backed up in case of a system failure or disaster.

An excellent article on "Careers in System Administration" is written by Barbara Dijker for the *Dr. Dobb's Journal* in the Fall 1999 publication. The majority of the information presented in this article is still accurate and there is a greater demand and higher compensation for UNIX professionals today than when it was written. The article discusses the following topics:

- Careers in system administration
- Specialties and career advancement paths
- Market areas and industries
- Market demands and trends
- Salaries and salary trends
- Consulting and contracting versus direct employment
- Job requirements
- Training and education

Careers in System Administration

Dr. Dobb's Journal, Fall 1999

The Future Looks Bright for Problem Solvers

By Barbara Dijker

What are system administrators? In general, sysadmins are those people we complain to when our computer systems aren't working the way we expect. If they can make everything right, then they must be system administrators. Therefore, a system administrator is someone who solves problems in computer and network systems operations.

The problem set in computing and network operations generally includes all those system tasks users might want to offload—specification, evaluation, installation, configuration, integration, maintenance, data-integrity management, upgrade management, automation, security management, performance analysis, failure analysis, failure mitigation, recovery design, recovery implementation, testing, and more. In reality, the definition of system administration is usually a subset of all those tasks specific to the organization doing the hiring. For example, some organizations have a separate staff of network administrators to handle network administration, while in other organizations system administrators manage both computers and network infrastructure. Other organizations have separate staff dedicated to security administration. Some organizations allow users a high degree of self-administration that makes the system administrator's job focus more on the integration and systemic issues.

Specialties and Career Advancement Paths

Because system administration is so broad, room exists for specialization. Examples of where you can specialize are security, data encryption, networks, heterogeneous integration, specific operating systems or platforms (Sun, NT, or Linux), specific subsystems (file sharing, mail, or naming systems), specific applications (supercomputing), and (more recently) Web-server administration. Web-server administrators specialize in the operational issues specific to Web servers, usually in the area of performance, security, reliability, and redundancy.

Careers in System Administration (Continued)

System administration is often thought of as a job in the trenches. However, good system administrators, through experience, hone unique problem solving skills, people skills, organizational skills, and a keen sense of the big picture and potential implications of change. These skills are invaluable for someone interested in a management track that can lead up the chain all the way to corporate information technology director and even chief technical officer.

Because system administrators seem to enjoy the challenge of actually fixing problems, career advancement often tends to stay on a more technical track. System administrators have plenty of responsibility for the operational integrity of the systems they administer, so the lure of responsibility for staff or budgets is less appealing. Advancement technically can be toward:

- Consulting, which often provides the ability to select work or truly focus on a specialty.
- Back-line, away from the "front-line" of interruptions to the more challenging problems.
- Specialties, focused and more detailed work, more available in larger organizations.

Large organizations may provide pre-defined advancement from the front-line of basic user support or "help-desk" through multiple levels of system administration toward the back-line of elite troubleshooters. Some companies even have a "special forces" team of system administrators to swoop in and fix really tough problems.

Market Areas and Industries

Every organization that has computing systems needs someone to perform system administration tasks. While every such site may have that need, solving it does not always involve hiring a full-time system administrator. When the load of system administration tasks is low, they are usually delegated to an existing staff person whose primary responsibility is something else. Interestingly, this is often the genesis of a system administrator. That person finds he enjoys the system administration tasks more than his other work.

The affect of this on the market for system administrators is that you can find a job in system administration in any industry in any market sector. Small, growing, and changing organizations feed the free-lance consulting and contract system administrator markets. Other organizations feed the consulting and contract pools with experienced system administrators who are looking for a change. In short, system administrators work for everything from churches and hospitals to multinational and Fortune 500 companies.

Market Demands and Trends

Some people have long predicted that the need for system administration would die out like dinosaurs as computers and applications become more automated and sophisticated and solved their own problems. The opposite is actually the case. As computers and applications have become more sophisticated, they've created different problems from those they may have solved. For example, ubiquitous computer networks have solved many problems in transport of information and resource sharing. However, for each problem solved, networking has introduced at least a dozen in the areas of security and data integrity. As problems crop up, system administrators have to figure out what to do about them to allow users to continue the "real" work.

There has never been a market glut of systems administrators. In fact, there are probably five jobs available for every existing sysadmin today. In fact, most experienced system administrators find they are doing the work of five people. Demand has out-paced supply for at least the last six years.

continues

Careers in System Administration (Continued)

Of course, this is mostly subjective information. There are at least two problems with clearly quantifying trends in the system administrator job market. The first problem is that most system administrators have a job title that has nothing to do with system administration—a member of technical staff, systems programmer, systems analyst, and so on. According to studies conducted by the Systems Administrators' Guild (SAGE; http://www.usenix.org/sage/jobs/salary_survey/index.html), fewer than half of all system administrators are given title recognition for it. The second problem is that market analysts don't usually track system administrator as a unique job title because of the first problem. Any surveys of system administrators are based on self-identification, not job title.

Salaries and Salary Trends

As you would expect with increasing demand and shortage of qualified applicants, salaries for system administrators are attractive and competitive. According to SAGE studies, the average salary for all system administrators—regardless of experience, industry, or geography—was approximately $62,000 in 1998. System administrators with 1–2 years of experience on average earned $47,000, while those with 10 or more years of experience earned more than $70,000. About five percent of all sysadmins earned over $100,000 in 1998. As with most jobs, salaries are higher in the commercial sector than they are in education, government, and other organizations. Salaries are also higher in parts of the country where there is more demand and higher costs of living, such as California and New England.

Salary increases for system administrators tend to be larger than those in other jobs, usually to keep someone from leaving for greener pastures. The increase in average salary from 1997 to 1998 was 6 percent. Salary disparities between men and women are significantly less in system administration than other fields. In fact, the 1998 survey referenced here indicates women made about 15 percent more than men. However, that could be attributed to more men coming into the field than women. System administration tends to attract more women than other technical and computing fields. Sixteen percent of system administrators are women.

Note: Latest survey results from SAGE can be viewed by going to http://www.usenix.org/sage/jobs/salary_survey/salary_survey.html.

Consulting and Contracting Versus Direct Employment

Because of the large demand for system administrators, there is also a large market for "on-demand" system administrators through contract employment or consulting. Some system administrators prefer consulting or contracting because it provides greater variety and flexibility.

System administrators who are independent consultants tend to be specialists and make significantly more money than those who work for a firm and are contracted out. (For more information, see the SANS Salary Survey, http://www.sans.org/newlook/publications/1998salarysurvey.htm). As with most other computing contract employment, those who work for contract firms tend to make slightly more money than those who are directly employed. In this respect, system administration is similar to other technical fields. The only difference may be that due to significant demands for system administrators, making a go of it as an independent may be more readily lucrative than in other fields. There are plenty of opportunities regardless of which employment structure is most attractive.

Careers in System Administration (Continued)

Job Requirements

Becoming a system administrator is relatively straightforward. Anyone curious to explore a challenge while possessing a reasonably solid background in computing fundamentals may find himself or herself drafted anyway. Due to demand, organizations are also more likely to consider offering entry-level positions with training than in other computing fields.

Gaining a background in computing fundamentals is pretty easy. A degree in computer science isn't required, just a basic understanding of how computers, operating systems, and applications work and interact; logic; binary numbers; a little electronics; and some common sense. The most important traits of a new system administrator are the abilities to find and digest information, solve problems, develop creative strategies, and recognize and work within one's own limits. System administrators who have formal education and a degree tend to be preferred and sometimes required for jobs. However, that's not necessarily because the education is particularly relevant to the job; it's more because it is evidence of follow through and perseverance. Many practicing system administrators hold degrees in technical fields other than computer science, such as physics.

System administrators solve problems daily. The problems change every day and there is no step-by-step guide for solving them. So a system administrator has to be able to think on his/her feet, learn about the aspects of the problem, find the cause, find a fix, and then implement one that actually works within the constraints of the situation. Sysadmins are usually working on production systems, because it is expensive to duplicate a system purely for the system administrator's benefit. Consequently, it is imperative that a system administrator knows when he/she is in over his/her head—and how not to create more problems. Other than that, it's all about experience and system-specific—UNIX, NT, applications—training.

Training and Education

There is no widely accepted formal curriculum for system administration. Unfortunately, you can't go to the local university and sign up for a degree program in system administration.

Still, there are plenty of education and training opportunities for system administrators, including commercial education programs, university continuing education, vendor-specific courses, conference and seminar tutorials, and self-education through books. Commercial technical training companies, such as Technology Exchange Company (http://www.technologyexchange.com/) and Global Knowledge Network (http://www.globalknowledge.com/), also provide system-administration courses. Major platform vendors (Sun, Microsoft, Novell, and the like) provide system-administration training as well.

Nonetheless, universities are starting to develop system-administration curricula. The University of Indiana, for instance, offers an independent study program in system administration called "UNIX System Administration Independent Learning" (USAIL; http://www.uwsg.indiana.edu/usail/). The System Administrators' Guild (SAGE; http://www.usenix.org/sage/) provides publications, conferences, and tutorial programs on system administration. The number of books on system administration increases all the time. There are currently about 75 books in print on various aspects of system administration. Two books stand out as required reading for UNIX system administrators: *UNIX System Administration Handbook*, by Nemeth, Hein, Snyder, and Seabass (http://www.admin.com/); and *Essential System Administration*, by Frisch (http://www.ora.com/catalog/esa2/).

continues

Careers in System Administration (Continued)

Furthermore, there are certification programs for system administration. Most existing certification programs are vendor-specific; such as Solaris and/or NT administration, for instance. The Linux Professional Institute (http://www.lpi.org/) is developing certification for Linux professionals, who are essentially system administrators. SAGE is conducting an occupational analysis of system administration to begin the process of the only platform-independent system administration certification program.

Conclusion

The profession of system administration and programs for system administrators are growing all the time. In part, to meet this demand, SAGE is currently conducting a pilot program in mentoring and plans to have an established mentoring program next year. Furthermore, companies such as Sun are creating new multifaceted programs to spawn and encourage new system administrators. Why? Because system administration is a career that is in high demand—with no let-up in sight.

UNIX System Administrator Resources

There are plenty of resources for the system administrator beyond the man pages. The following list shows many popular resources that are worth visiting if you are interested in system administration:

- Websites
 - SAGE located at http://sageweb.sage.org/. SAGE is an international organization for professional system administrators.
 - UNIX Guru Universe located at www.ugu.com. Large collection of UNIX resources.
 - Stokely Consulting located at www.stokely.com. Resource for UNIX system administrators.
 - UNIX Insider located at http://www.itworld.com/Comp/2378/UnixInsider/. A collection of UNIX news and information.
 - Slashdot located at http://slashdot.org/. "News for nerds. Stuff that matters." News, articles, and technical information about the industry.
 - UNIX Review located at http://www.unixreview.com. Tools, tips, book reviews and books for system administrators.
 - Sun Microsystems, Inc. (System Administration Site) located at www.sun.com/bigadmin.
- Newsgroups
 - comp.unix.admin
 - comp.unix.advocacy

— comp.os.linux.admin

— comp.unx.solaris

■ User Groups

— Usenix (Sage) located at http://sageweb.sage.org/about/groups/ sage-localgroups.html.

Sun Solaris Certification

The Solaris operating environment is the foundation on which some of the world's leading companies are built. Offering unparalleled reliability, availability, security, and scalability, Solaris systems meet today's demands while anticipating tomorrow's innovation. Sun's Solaris operating environment certification tests are rigorous and include real-world scenarios. Certification also prepares you for today's challenging system issues. Figure 17-1 shows the current Sun courses, the required exams, and the sequence in which these are to be taken for Sun certification.

> **NOTE**
>
> For further information on certification for the Solaris operating environment, visit http://suned.sun.com/.

Figure 17-1 Solaris Certification Path

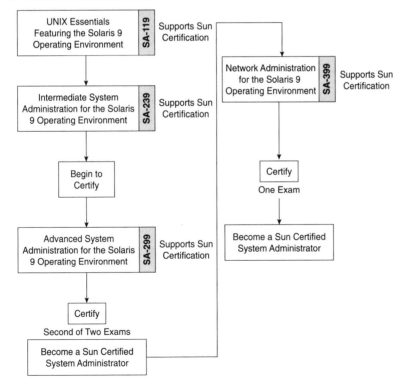

All other certifications from Sun can rapidly expand your professional opportunities. Sun offers the following professional certification for the Solaris operating environment:

- Sun Certified System Administrator for Solaris Operating Environment
- Sun Certified Network Administrator for Solaris Operating Environment

Sun Academic Initiative

The Sun Academic Initiative (SAI) is designed to give students the skills needed to fast track their career in system administration and Java. The course paths and learning tools included in the Sun Academic Initiative help prepare students for certifications in the Java programming language and the Solaris operating environment. The certifications will enable one to stand out in this competitive market with potential employers. The Academic Initiative offers the following UNIX-based courses to students whose school is an Authorized Sun Education Center.

Figure 17-2 Sun Academic Initiative

Solaris Education Track:

- **UNIX Essentials Featuring the Solaris 9 Operating Environment (formerly called Fundamentals of the Solaris Operating Environment for System Administrators)**— This course is equivalent to the Cisco Fundamentals of UNIX course sponsored by Sun. Students taking either course will be adequately prepared for the Intermediate System Administration for the Solaris 9 Operating Environment course offered by Sun Microsystems.

- **Shell Programming**—This course provides students with the knowledge to read, write, and debug shell scripts. Students are taught how to develop simple scripts to automate frequently executed sequences of commands, and how to use conditional logic, user interaction, loops, and menus to enhance the productivity and effectiveness of the user.

- **Intermediate System Administration for the Solaris 9 Operating Environment (formerly called Solaris System Administration I)**—This course provides students with the necessary knowledge and skills to perform essential system administration tasks in the Solaris operating environment. Instructional topics include standalone Solaris installation, file system management, backup procedures, process control, security measures, user administration, printing services, and device management.

■ **Intermediate System Administration for the Solaris 9 Operating Environment (formerly called Solaris System Administration II)**—This course provides students with the skills necessary to administer Sun systems running the Solaris operating environment in a network environment. Students are taught how to maintain Sun systems, configure and troubleshoot the network file system (NFS), and configure the network information system (NIS) environment.

NOTE

For further information on the Sun Academic Initiative, visit http://www.sun.com/academic or contact a local Sun Microsystems office.

Linux Certifications

With the rapidly increasing popularity of Linux and its entry into the high-end workstation, server, and mainframe markets, opportunities for Linux trained professionals will continue to increase over the coming years.

CompTIA Linux Certification

The Computing Technology Industry Association (CompTIA) has developed the Linux+ certification to measure basic Linux operating system proficiency. (See Figure 17-3.)

Figure 17-3 Linux Certification

Permission to use this image is granted by lewing@isc.tamu.edu and The Gimp.

According to CompTIA, "Linux+ certification measures vendor-neutral Linux knowledge and skills for an individual with at least 6 months practical experience." Visit the CompTIA website at www.comptia.org/certification to find out more about the Linux+ exam and to see what other exams CompTIA has developed.

This course, Fundamentals of UNIX, along with the follow-on Cisco Academy course, IT Essentials II: Network Operating Systems, can help you prepare to take the CompTIA Linux+ exam.

Vendor-Specific Linux Certification

As with Sun Solaris, several distributors of Linux offer vendor specific training and certifications. One of the more widely recognized programs is the Red Hat Certified Technician (RHCT) and Red Hat Certified Engineer Program (RHCE).

According to Red Hat, "Red Hat training and certification focuses on practical skills. Once Red Hat classes are completed you can take a performance based test that measures actual competency on live systems." Visit the Red Hat website at www.redhat.com for more information on the RHCT and RHCE.

The Linux Professional Institute (www.lpi.org) has developed the Linux Professional Institute Certification (LPIC). The LPIC program is designed in three levels. Determining which tasks were suitable to each level was done using a "Job Task Analysis" (JTA) survey. More information is available by selecting "Certification" from the lpi.org site.

Cisco Courses Supporting Linux+ Certification

Cisco has two courses that prepare a student for the Linux+ Certification. The Fundamentals of UNIX course plus the IT Essentials II: Network Operating Systems curriculum will help prepare students to take the Linux+ certification exam (http://www.comptia.com/certification/linux/default.asp) offered by CompTIA.

The IT Essentials II course sponsored by Hewlett-Packard is a lab-based course designed to be an overview of network operating systems and specifically covers the Linux Red Hat network operating system. The course reviews major concepts covered in the Fundamentals of UNIX course and introduces advanced topics including basic system administration, networking basics including LAN and WAN topologies and TCP/IP processes. Also covered are network administration, configuration of network services, basic network security, and troubleshooting.

In addition to Linux, an overview of the Windows 2000 network operating system and basic administration is provided as well.

Summary

The Fundamentals of UNIX course was designed to give you a good basic understanding of the UNIX network operating system and to provide specific information on Solaris and Linux. The UNIX OS has evolved into a powerful operating system that you can spend a lifetime learning. As a user, you can continue to learn more about the UNIX world from a variety of sources including websites, newsgroups, user groups, and, of course, books. Training and certifications are available from Solaris, CompTIA, and Red Hat, as well as other UNIX and Linux vendors.

Appendix A

Answers to Chapter "Check Your Understanding" Quizzes

This appendix contains the answers to the "Check Your Understanding" questions at the end of each chapter.

Answers to Chapter 1 "Check Your Understanding" Quiz

1. A, B, E
2. AGP
3. C, D, E, F
4. multitasking
5. multiuser (3), distributed processing (4), multitasking (2), security (1)
6. device
7. SVR4
8. B, C
9. B, C
10. kernel
11. B
12. A, C, E

Answers to Chapter 2 "Check Your Understanding" Quiz

1. B, D
2. C
3. 1 - valid, 2 - invalid, 3 - invalid, 4 - valid, 5 - invalid
4. B
5. **exit**
6. **telnet**
7. /etc/passwd
8. B
9. A
10. D
11. B, D, E
12. A

Answers to Chapter 3 "Check Your Understanding" Quiz

1. False
2. D
3. A, E, F
4. A, C
5. A, B, E
6. True
7. B
8. C
9. A, C
10. **date**
11. A

12.

Mozilla	GNOME
StarOffice	CDE
Kate	KDE
Voice Notes	CDE
Krayon	KDE
Snapshot	CDE
Nautilus	GNOME

Answers to Chapter 4 "Check Your Understanding" Quiz

1. C

2. A

3. B

4. C

5. B, C, D

6.

NAME	Contains the name of the command and other commands that may accomplish the same thing.
SYNOPSIS	Shows the syntax of the command with any allowable options and arguments.
DESCRIPTION	Gives an overview of what the command does.
OPERANDS	The target of the command or what the command will take effect on such as a directory or a file.
OPTIONS	Are switches that can change the function or effect of the command. They normally are preceded by a dash (-) or minus sign.

7. B, C, D

8. D

9. C

10.

Hostname	Displays the name of your workstation or host.	
uname -a	Displays expanded system information, including the name of your workstation, the OS version, and more.	
arp *hostname*	Displays the host name, IP address, and Ethernet address.	
domainname	Displays the domain that the workstation is in.	
prtconf	grep Memory	Displays the amount of system memory on a Solaris system.

11.

1	Go to another system and do a remote login and terminate the login shell program.
2	Press the **Stop+A** keyboard sequence.
3	Turn off the system.

12.

cp	copy
mv	move
ls	dir
rm	del
mkdir	md

Answers to Chapter 5 "Check Your Understanding" Quiz

1. B

2. **-l**

3. A, C, D

4. B, C, D

5. **cd;pwd** or **cd ~;pwd**

6. D

7. B, C, D

 8. B, C

 9. -a

 10. C

 11. D

 12. B

Answers to Chapter 6 "Check Your Understanding" Quiz

 1. A, B

 2. A

 3. A

 4. A

 5. A, B, C

 6. A, C

 7. A

 8. A

 9. D

 10. A

 11. A

 12. A, C, D, E

Answers to Chapter 7 "Check Your Understanding" Quiz

 1. B

 2. A

 3. C

 4. B

 5. mv

 6. A

7. B

8. D

9. C

10. A

11. A, B, C

12. C

Answers to Chapter 8 "Check Your Understanding" Quiz

1. SCSI, EIDE

2. partition or slice

3. B

4. mounting

5. B, E

6.

/boot	Linux kernel and startup files
/home	User's home directories
/usr	Linux programs and data
/opt	Third-party programs and data
/mnt	Default for floppy and CD-ROM

7. A

8. C

9. C

10. B

11. Searches all instances of **pc** and replaces them with **workstation** in the file **chapter1**

12. D

13. True

14. A, C, D

Answers to Chapter 9 "Check Your Understanding" Quiz

1. A
2. A, B, C
3. A
4. A, B
5. B
6. D
7. A, B, C
8. A
9. A, C, D
10. A
11. B
12. A

Answers to Chapter 10 "Check Your Understanding" Quiz

1. D
2. B
3. A
4. D
5. B
6. B
7. C
8. A
9. B
10. D
11. B
12. D

Answers to Chapter 11 "Check Your Understanding" Quiz

1. A, B, C
2. A, B
3. A
4. B
5. A, B, C
6. A, B
7. C
8. A
9. A
10. B
11. A
12. B, C, D

Answers to Chapter 12 "Check Your Understanding" Quiz

1. D
2. A, B
3. B, C, E
4. C
5. B, D
6. D
7. C
8. B, C
9. C
10. A, C
11. B
12. D

Answers to Chapter 13 "Check Your Understanding" Quiz

1. PID
2. RAM
3. C
4. 347
5. D
6. A
7. D
8. C
9. C
10. B, C
11. A
12. D

Answers to Chapter 14 "Check Your Understanding" Quiz

1. kernel
2. A, C
3. A, B, C
4. alias
5. A
6. A, B, D
7. A
8. B
9. B
10. B
11. A, B, C
12. .bash_profile

Answers to Chapter 15 "Check Your Understanding" Quiz

1. B, C, D
2. Step 1: Decide what the script will do.

 Step 2: Make a list of commands.

 Step 3: Create a new file for the script.

 Step 4: Identify the shell the script will use.

 Step 5: Add commands and comments.

 Step 6: Save the script file.

 Step 7: Execute the script file.

 Step 8: Debug and modify the script if errors occur.
3. B
4. B
5. A, D
6. A, C
7. STUFFDIR
8. B
9. D
10. $? or "$?"
11. right
12. bad file
13.

if C	A) Executes as long as the test condition is true
case E	B) Executes as long as the test condition is false
for D	C) The simplest form of conditional command
while A	D) Executes commands once for each value of a variable
until B	E) Used when many conditions need testing

14. Java
15. *Compiled languages* use a compiler to translate the entire program into a single executable file the computer understands. *Interpreted languages* analyze each line in the source file as the program executes and does so each time the program is run.

16.

JavaScript	Interpreted
C	Compiled
PHP	Interpreted
Perl	Interpreted
C++	Compiled
Java	Compiled

Answers to Chapter 16 "Check Your Understanding" Quiz

1. distributed

2.

Term	Definition
Host A	A) any UNIX computer running TCP/IP
Server B	B) a computer that provides resources to clients through the network
Client C	C) a computer that uses the services from one or more servers through the network

3. C

4. **telnet**

5. A, D

6. **rlogin ILuvUNIX -l Jacob** (The switch is a lowercase *l*)

7. B, C

8. B, C, D

9. **rcp mytext.txt venus:mytxtv1.txt**

10. SSH

11. A, C, E

12. host names to IP addresses

13. B, D

14. NFS

Appendix B

Master Command List

This appendix is a compilation of all the commands and symbols used in this book, along with a brief description of their purpose and an example of their use. The list is alphabetical, starting with special characters; use it as a quick reference. You also can go to the chapter indicated, which is where the command is introduced, to get more detailed information. The first line in some of the examples lists the most frequently used options of the command before giving examples.

Command	Description	Example	Chapter Reference
. (dot)	Used to re-execute a Korn shell initialization file after changes are made.	`$. .kshrc`	14
&	Runs job/process in the background and restores the shell prompt.	`$ Netscape&`	13
>	Redirects standard output.	`$ ls > myfiles`	7
<	Redirects standard input.	`$ mailx dano@buckeye < ski_listing`	7
* ? []	Metacharacters commonly referred to as wildcards that manipulate groups of files.		5
\|	Passes standard output of one command as standard input into a following command.	`$ ls l \| more`	7
!!	Re-executes the last command in Bash shell.	`$!!`	14

continues

Continued

Command	Description	Example	Chapter Reference
!$	Repeats the last argument from the previous command in Bash shell.	`$!$`	14
!*	Repeats all arguments of the previous command in Bash shell.	`$!*`	14
!number	Repeats a specific number command from the Bash shell history file.	`170 pwd` `171 ls` `172 cd ~` `$!171`	14
#!/bin/ksh or #!/bin/bash	First line of a script that identifies which shell the script uses to interpret the lines in the script. If the script does not begin with the characters "#!" on the first line, the parent shell executes the script.	`#!/bin/ksh` or `#!/bin/bash`	15
alias	alias and unalias utilities create or remove a pseudonym or shorthand term for a command or series of commands.	Change copy (**cp**) to include a confirmation prompt before overwriting a file: `alias cp="cp -i"`	14
arp	Displays the host name, IP address, and Ethernet address of the system.	`$ arp buckeye` `buckeye (127.134.45.109)` `8:0:20:c2:43:9d`	4
at	Executes specified commands (read from standard input) or script file at a later time that you specify.	`$ at 10:30am whoson`	13
bash	Starts a Bash shell.		14
bc	Basic calculator command.	`$ bc` `5280/3` `1760` `<Ctrl d>` `$`	6

Command	Description	Example	Chapter Reference
bg	Places a job in the background.	`$ bg %3`	13
cal	Writes a Gregorian calendar to standard output.	`$ cal` `$ cal 2000` `$ cal 9 2005`	4
cancel	Cancels print requests.	`$ cancel printer1-203` `request "printer1- 203"` `cancelled` `$ cancel -u <username>`	13
case	Executes the first set of commands (*commands1*) if *value* matches *Pattern1*; executes the second set of commands (*commands2*) if *value* matches *Pattern2*, etc.	Format: case *value* in *Pattern1*) commands1;; *Pattern2*) commands2;; . . esac	15
cat	Concatenates (combines) and displays files.	`$ cat dante` `The Life and Times of` `Dante` `by Dante Pocai` `Mention "Alighieri" and` `few may know about whom` `you are talking. Say` `"Dante," instead, and` `the whole world knows` `whom you mean. For Dante` `Alighieri, like Raphael` `$`	6
cd	Change the working directory of the current shell execution environment.	`$ cd` `$ cd ..` `$ cd /home/user2/dir1` `$ cd ./dir1`	5
chgrp	Used to change the group association of a file. The group may be either a decimal group ID or a group name found in the group ID file /etc/group.	`-R` `$ chgrp marketing chap15` `$ chgrp R engineering` `cad_dwgs.dir`	10

continues

Continued

Command	Description	Example	Chapter Reference	
chmod	Changes file or directory permissions.	Deny execute permission to everyone: `$ chmod a-x filename` Allow only read permission to everyone: `$ chmod 444 file1` Make a file readable and writeable by the group and others: `$ chmod go+rw file2`	10	
chown	Changes the owner of a file. The owner can be either a decimal user ID or a login name found in the /etc/passwd file.	`-R` `$ chown bradj chap15` `$ chown R jiml book.dir`	10	
compress	Attempts to reduce the size of the named files.	`-v, -f` `$ compress -vf file` `file: compression 37% --` `replaced with file.Z`	12	
cp	Copies files.	`-i, -r` `$ cp ~/home/* /tmp` `$ cp -i ~/home/user2/ *` `/bkup` `$ cp -ri ~/home/ user2/*` `/bkup`	7	
cpio	Copy in-out. Popular UNIX backup and restore command that copies files to and from a backup device.	`$ ls	cpio -ov >` `/vol/dev/aliases` `/floppy0 (/dev/fd0` `in Linux)` `$ cpio -ivt < mydir.cpio`	12

Command	Description	Example	Chapter Reference
crontab[e l r]	Used to view and edit a users crontab file that stores scheduled program information.	Example: `0 17 * * 5 /usr/bin/banner "Weekend Is Here!" > /dev /console` This crontab entry displays the message "Weekend Is Here" in the console window (**Workspace Menu > Hosts > Console Terminal**) at 5:00 P.M./1700 every Friday of the week of every month.	13
Ctrl-C	Cancels the current activity.	`$ man intro <Ctrl c>`	4, 6
Ctrl-D	Indicates the end of the file or exits.	`$ bc` `5280/3` `1760` `<Ctrl d>` `$`	1, 4, 6
Ctrl-Q	Resumes screen output.	`$ cat largfile <Ctrl s>` `<Ctrl q>`	4, 6
Ctrl-S	Stops screen output.	`$ cat largfile <Ctrl s>`	6
Ctrl-U	Erases the entire command line.		1, 6
Ctrl-W	Erases the last word on the command line.		6
Ctrl-Z	Suspends the foreground process.	`$ sleep 500&` `[1] 453` `$ jobs` `[1] Running sleep 500` `$fg %1` `$ sleep 500` `^Z` `[1] Stopped sleep 500`	13

continues

Continued

Command	Description	Example	Chapter Reference
df	Displays the amount of disk space occupied by mounted or unmounted file systems, directories, or resources; the amount of available space; and how much of a file system's total capacity has been used.	`-k` `$ df -k`	8
diff	Compares the contents of two files and write to standard output a list of changes necessary to convert the first file into the second file. No output is produced if the files are identical.	`$ diff -c fruit fruit2` `*** fruit Fri May 8` `11:32:49 1998` `--- fruit2 Fri May 8` `14:55:21 1998` `**********` `***2, 8****` `orange` `apple` `banana` `-pear` `-mango` `tomato` `pomegranate` `---2, 8-----` `orange` `apple` `banana` `tomato` `+guava` `+mango` `pomegranate`	6
domain name	Displays the name of the current domain.	`$ domainname` `elvis.central.Sun.com`	4
du	Reports the number of 512-byte blocks contained in all files and (recursively) directories within each directory and file specified.	`-k` `$ du -k`	8
echo	Echoes (displays) arguments.	`$ echo "hi mom"` `hi mom` `$ echo $SHELL` `/bin/ksh`	1, 14

Command	Description	Example	Chapter Reference
egrep	Extended grep. Searches the contents of one or more files for a regular expression using extended regular expression metacharacters in addition to those used by grep.	`$ egrep '[a-z]+ing' file`	8
eject [cdrom or cd]	Ejects the CD-ROM on a Solaris system.	`$ eject cd`	12
eject [fd or floppy]	Unmounts the floppy from the file system on Sun Solaris systems. The user must then manually eject the floppy.	`$ eject fd`	12
emacs	Editing MACroS. Starts the GNU emacs text editor.	`$ emacs` `$ emacs backup.sh`	9
env	Displays the values of all variables known to the current environment including the current and all parent shells. See set command.	`$ env`	14, 15
ENV	Variable used in conjunction with personalizing the login environment.	`ENV=$HOME/.kshrc;` `export ENV`	14
exit	Leaves the current terminal window or current shell and returns to the previous one. Also used to log out of the login shell.		14
export	Displays all environmental variables available to all shells.	`$ export` `FRAME=/opt/fm/` `HOME=/home/hondo` `PS1=MyPrompt$` `SHELL=/bin/ksh` `TERM=vt100`	14

continues

Continued

Command	Description	Example	Chapter Reference
fdformat	Floppy disk format. Formats a floppy disk. Used by both Solaris and Linux.	`$ fdformat` `(Solaris)` `$ fdformat /dev/fd0` `(Linux)`	12
fg	Places a job in the foreground.	`$ sleep 500&` `[1] 453` `$ jobs` `[1] Running sleep 500` `$fg %1` `$ sleep 500`	13
fgrep	Fast grep. Differs from grep and egrep in that it will not accept a regular expression metacharacter as input. It recognizes only the literal meaning of these characters.	`$ fgrep '*' /etc/system`	8
file	Determines the file type.	`$ file dante` `dante: English text` `$ file beans` `beans: Frame Maker` `Document` `$ file da* fi*` `dante: English Text` `dante_1: English Text` `file1: English Text` `file2: ascii text` `files.jar: java program` `files.tar: USTAR tar` `archive`	6
find	Recursively descends the directory hierarchy for each path, seeking files that match a Boolean expression.	`-o` `$ find /home/user2 -` `name 'dir*'` `/home/user2/dir2` `/home/user2/dir3`	8
finger	Displays information about local and remote users.	`$ finger` `damyers Dan Myers` `Console Thu 19:07` `$finger jdoe@hal`	10

Command	Description	Example	Chapter Reference
for	For variable *n* (in optional list of values) do *commands*.	Format: `for n [in list]` `do` ` Commands` `Done`	15
ftp	Part of the TCP/IP protocol suite and is standard with the UNIX operating system. The application can be used to transfer files using ASCII or binary mode between systems using similar or dissimilar operating systems.	`$ ftp venus` `Connected to` `129.150.212.16.` `220 venus FTP server` `(UNIX(r) System V` `Release 4.0) ready.` `Name` `(129.150.212.16:liste r):` `Return <CR>` `331 Password required` `for lister.` `Password: xxx` `230 User lister logged` `in.` `ftp> cd /etc/inet` `250 CWD command` `successful.` `ftp> bin` `200 Type set to I.` `ftp> get hosts /tmp/` `hosts` `200 PORT command` `successful.` `150 Binary data` `connection for hosts` `(129.159.129.38,33425)` `(77 bytes)` `226 Transfer complete.` `local: /tmp/hosts` `remote: hosts` `77 bytes received in` `0.0014 seconds (5,25` `Kbytes/s)` `ftp> bye`	16

continues

Continued

Command	Description	Example	Chapter Reference
gfloppy	Linux GNOME graphical utility used to format a floppy disk for either a DOS or UNIX system.		12
grep	Searches a file for a pattern.	`-i` `$ grep banana ./*` `/home/user2/fruit:` `banana` `/home/user2/` `fruit.tar:banana` `/home/user2/fruit2:` `banana` `/home/user2/` `fruit2.tar:banana`	8
groups	Displays all the groups that a user is a member of.	`$ groups user1 user2` `user1 : staff` `user2 : staff`	10
gunzip	Uncompresses files created with the gzip command.	`$ gunzip chap1.gz` `chap2.gz`	12
gzcat	Enables you to read a gzipped file without uncompressing it.	`$ gzcat bookfile` `chap1` `chap2`	12
gzip	A compression utility (short for "GNU zip") designed to be a replacement for compress. Its main advantages over compress are much better compression and freedom from patented algorithms. The GNU Project uses it as the standard compression program for its system.	`-v` `$ gzip v chap1 chap2` `$ ls chap*` `chap1.gz` `chap.gz`	12
head	Displays the first few lines of files.	`$ head -5 /usr/dict/` `words` `1st` `2nd` `3rd` `4th` `5th` `$`	6

Command	Description	Example	Chapter Reference
history	Lists or edits and re-executes commands previously entered into an interactive shell.	`$ history` `339 man grep` `340 pwd` `341 grep banana ./*` `342 history` `$ r 340` `pwd` `/home/user2` `$`	14
hostname	Displays the name of the current host system.	`$ hostname` `buckeye`	4
id	Returns the current user identity.	`-a` `$ id` `uid=1002(user2)` `gid=10(staff)` `$ id a` `uid=1002(user2)` `gid=10(staff)` `groups=10(staff)`	10
if	If *condition1* is met, do *commands1*; otherwise, if *condition2* is met, do *commands2*; if neither is met, do *commands3*. *Conditions* are usually specified with the test command.	**Format:** **if** *condition1* **then** *commands1* **[elif** *condition2* **then** *commands2*] . . [*else* **commands3**] `fi`	15
ifconfig	Interface configuration (ifconfig). Used to determine the IP address (Inet addr in example) of a UNIX host. Use the –a option to see all interfaces (network adapters).	`$ ifconfig -a` `Link encap: Ethernet` `Hwaddr 00:23:45:5A:4D:F0` `Inet Addr: 192.168.1.102` `Bcast: 192.168.1.255` `Mask: 255.255.255.0` `(output omitted)`	16

continues

Continued

Command	Description	Example	Chapter Reference
info	Detailed and well-organized alternative to man pages. Uses an emacs-type interface.	`$info` or `$info date`	4
init 0	Has a primary role to create processes from information stored in the file /etc/inittab. At any given time, the system is in one of eight possible run levels. A run level is a software configuration under which only a selected group of processes exists. Run levels 0, 5, 6 are reserved states for shutting down the system. init can be run only by the root user.	`init 0`	2
jar	Combines backup and compress into one tool.	`-c,-t,-x, -f, -v` `$ jar cvf bundle.jar *` `adding 0.au` `adding 1.au` `adding 2.au` `adding 3.au` `$`	12
jobs	Lists all jobs running in the shell.	`$ jobs` `[1] Running find ~ -` `name memo1`	13
kill	Sends a signal to the process or processes specified by each PID operand.	`-9` `$ kill -9 100 165` `$ kill -s kill 100 - 165`	13
killall	Specific to Linux. Terminates a process by matching the command name rather than its PID number. See pkill command for Solaris.	`$ killall -i vi`	13

Command	Description	Example	Chapter Reference
ksh	Starts a Korn shell subshell.		14
ln	Short for "link." Gives a file an additional name so that you can access it from more than one directory.	`$ ln report /HQ/` `reports/Jan02report`	7
lp	Submits print requests to a destination.	`-d, -o, -n, -m` `$ lp ~/fruit2` `request id is printer1-` `203 (1 file(s))`	11
lpstat	Displays information about the current status of the LP print service to standard output.	`$ lpstat printer1` `printer1-106 root 587` `Mar 22 16:06 on printer1` `printer1-107 user2 85` `Mar 22 16:10 on printer1` `$`	11
ls	For each file that is a directory, lists the contents of the directory; for each file that is an ordinary file, repeats its name and any other information requested.	`-a,-F,-l,-lt,-ld,-E` `$ ls` `dante dir1 dir3` `$ ls l` `-rwxr-xr-x 1 user2 staff` `110 Apr 19 dante` `drwxr-xr-x 5 user2 staff` `110 Apr 19 dir1` `drwxr-xr-x 4 user2 staff` `110 Apr 19 dir3`	5
mailx	Interactive message-processing system.	`$ mailx user2@cisco.com` `< dante.doc`	3
man	Displays information from the reference manuals. It displays complete manual pages that you select by name, or one-line summaries if selected by keyword.	`-s, -k` `$ man man` `$ man cd`	4

continues

Continued

Command	Description	Example	Chapter Reference
mkdir	Creates the named directories using current permissions (default is 755) as established with the file creation mask (unmask).	`$ mkdir Reports` `$ ls -dl Reports` `drwxr-xr-x 2 user2 staff` `512 Jan 28 16:24 Reports` `$ mkdir -p practice/` `dir1/admin` `$ ls -R practice` `practice:` `dir1 mailbox project` `research` `practice/dir1:` `admin` `practice/dir1/admin:`	6
mkfs	Make file system. Makes a UNIX file system on a Linux system.	`$ mkfs -t ext2 /dev/fd0` `1440` `(creates a UNIX` `filesystem on a 1.44MB` `floppy)`	12
mformat	Quickly formats a disk as a DOS disk on a Linux system.	`$ mformat /dev/fd0`	12
more	Acts as a filter that displays the contents of a text file on the terminal, one screen at a time. It normally pauses after each full screen.	`$ cat dante I more`	6
mount	Attaches a file system to a directory known as a mount point so the files can be accessed.	Mount a floppy disk in Linux to the /mnt/floppy directory: `$ mount /mnt/floppy`	12
mv	Moves and renames files and directories.	`-i` `$ mv file1 file_april30` `$ mv file1 /home/ user2/` `bkup`	7
newfs	New file system. Makes a UNIX file system on a Solaris system. Can be executed only by root.		12

Command	Description	Example	Chapter Reference
noclobber	Prevents the overwriting of files during redirection.	`$ set -o noclobber` `$ cat fruit > fruit2` `/bin/ksh: fruit2: file` `already exists`	7
passwd	Changes login password and password attributes.	`$ passwd` `passwd: Changing` `password for user2` `Enter login password:` `abc123` `New password: unix123` `Re-enter new password:` `unix123` `passwd (SYSTEM): passwd` `successfully changed for` `user2` `$`	2
pgrep	Examines the active processes on the system and reports the process IDs of the processes whose attributes match the criteria specified on the command line.	Obtain the process ID of sendmail: `$ pgrep -x -u root` `sendmail` `283`	13
ping	Tests basic connectivity between TCP/IP hosts by sending an Internet Control Message Protocol (ICMP) echo request to another computer or "host" on a TCP/IP network. If there is a reply from the destination host, then there is a good connection between them.	`-s` `$ ping jupiter` `jupiter is alive` `$ ping 192.13.145.10` `192.13.145.10 is alive`	16
pkill	Specific to Solaris. Terminates a process by matching the command name rather than its PID number. See killall command for Linux.	`$ pkill vi` `Terminates the vi` `editor.` `$ pkill -n xterm` `Terminates the most` `recently created xterm.`	13

continues

Continued

Command	Description	Example	Chapter Reference	
prtconf	Prints system configuration information.	`$prtconf	grep Memory` `Memory size: 128` `Megabytes`	4
ps	Prints information about active processes.	`-e, -f, -u` `$ ps`	1, 13	
PS1	A variable that can be changed by the user to alter the appearance of the default shell prompt.	`$ PS1="new prompt$ "` `$ PS1="$PWD $ "`	14	
pwd	Writes an absolute path name of the current working directory to standard output.	`$ pwd` `/home/user2/dir1`	5	
r	A Korn shell command repeats a command from the history list.	`170 pwd` `171 ls` `172 cd ~` `$ r 170`	14	
rcp	Copies to or from one UNIX system to another.	`$ rcp big10schedule` `spartan:/tmp` `$ rcp buckeye:~dano/` `budget .`	16	
read	Reads one line of standard input and assigns each word to the corresponding *variable*, with all leftover words assigned to the last variable. If only one variable is specified, the entire line will be assigned to that variable.	`read name address`	15	
rlogin	Establishes a remote login session on another workstation.	`$ rlogin saturn` `Password:` `Last login: Mon Dec 21` `11:04:27 from venus` `Sun Microsystems Inc.` `SunOS 5.7 Generic` `October 1998` `$`	16	
rm	Removes directory and file entries.	`-i,-r` `$ rm -r dir1`	6	

Command	Description	Example	Chapter Reference	
scp	Secure copy (**scp**). Part of the SSH suite of utilities that replaces the remote copy (**rcp**) command.	`$ scp big10schedule` `spartan:/tmp` `$ scp buckeye:~dano/` `budget .`	16	
sed	Stream editor (**sed**). Provides many of the editing capabilities of a text editor but via commands that can be entered at the command prompt or entered in a script.	`$ sed '5d' file` `$ ls -l	sed '5,$d' >` `newfile`	8
set	With no arguments set displays the values of all variable known to the current shell.	`$ set` `HOME=/home/hondo` `PS1=MyPrompt$` `SHELL=/bin/ksh`	14, 15	
set + o vi	Turns off command-line editing.		14	
set − o vi	Turns on command-line editing.		14	
sftp	Secure File Transfer Protocol. Part of the SSH suite of utilities that replaces the File Transfer Protocol (**ftp**) command.	`$ sftp bronco` `$ sftp 124.36.78.2`	16	
sh	Starts a Bourne shell subshell.		14	
shutdown	By default, brings the system to a state in which only the console has access to the operating system. This state is called single-user. shutdown can be run only by the root user.	`$ shutdown`	2	
sleep	Suspends execution for at least the integral number of seconds specified in the time operand.	`$ sleep 60&`	13	
sort	Sorts lines of all the named files together, and writes the result in the standard output.	`$ sort file1` `$ sort +1n file2`	8	

continues

Continued

Command	Description	Example	Chapter Reference
source	Re-executes a Bash shell initialization file after changes are made.	`$ source .bashrc`	14
spell	Compares the words contained in the specified text file against a dictionary file, and displays suspected words not found in the dictionary.	`$ spell memo` `aint` `partyiing`	9
ssh	Secure Shell (SSH) is a utility that provides secure access to a remote computer by encrypting all transmission between client and server. SSH is becoming increasingly popular as a replacement for telnet and FTP for use in managing Web and other servers remotely. SSH also replaces an early UNIX utility called remote shell or rsh, which used unencrypted communication.	`$ ssh bronco` `$ ssh 124.36.78.2`	16
strings	Finds printable strings in an object or binary file.	`$ strings /usr/bin/ cat` `SUNW_OST_OSCMD` `usvtebn` `usage: cat [-usvtebn]` `[-\|file] ...` `cat: Cannot stat stdout` `cat: cannot open %s` `cat: cannot stat %s` `cat: input/output files` `'%s' identical` `cat: close error` `<some output omitted>`	6
stty	Sets options for a terminal.	`$ stty erase ^H sets the` `backspace key to erase` `one character to the` `left`	2

Command	Description	Example	Chapter Reference
su	Switches users. Allows a user to become a superuser or another user.	```- username``` ```$ su - student6``` ```Password:``` ```$```	10
tail	Displays the last few lines of files.	```$ tail -5 /usr/dict/``` ```words``` ```zounds``` ```z's``` ```zucchini``` ```Zurich``` ```zygote``` ```$```	6
tar	Archives and extracts files to and from a single file called a tar file.	```c, t, x, f, v``` ```$ tar cvf backup.tar /``` ```home/user2/*```	12
telnet	Another good network troubleshooting tool. It is a nongraphical communications utility that can be used to check the upper layers of the OSI model. Telnet allows you to take over the console of another host or network device.	```$ telnet beach``` ```Trying 192.168.49.10 ...``` ```Connected to beach``` ```Escape character is '^]'``` ```.``` ```4.2 BSD UNIX (beach)``` ```login: jdupont``` ```Password:``` ```Last login: Wed Jun 1``` ```19:03:33 on console``` ```beach% (Enter commands)``` ```beach% exit``` ```Connection closed by``` ```foreign host``` ```$```	16
test	Generally used with conditional constructs in shell scripts; test evaluates a condition and, if its value is true, returns a zero exit status; otherwise, returns a nonzero exit status. An alternate form of the command uses [] rather than the word test.	```read answer``` ```if test "$answer" = y``` ```then``` ``` clear;ls``` ```else``` ``` ls```	15

continues

Continued

Command	Description	Example	Chapter Reference
touch	Sets the access and modification times of each file. The file is created if it does not already exist.	`$ cd ~/practice` `$ touch mailbox project` `research` `$ ls` `mailbox project research`	6
traceroute	A good troubleshooting tool for checking the connection between computers that are interconnected with routers.	`$ traceroute cisco.com` `$ traceroute 164.78.34.1`	16
umount	Unmounts a file system, floppy, or CD-ROM.	`$ umount /mnt/floppy` `unmounts the floppy disk` `on a Linux system.`	12
unalias	The alias and unalias utilities create or remove a pseudonym or shorthand term for a command or series of commands.	`$ alias cp="cp -i"` `$ unalias cp`	14
uname	Displays the name of the current system.	`-n` `$ uname n` `buckeye`	4
uncompress	Returns a previously compressed file to its original size.	`-v` `$ uncompress -vf file.Z`	12
unset	Removes the variable from the current shell and subshells. Unsetting variables is rarely done.	`$ unset LPDEST`	14
unset history	Turns off history tracking.		14
until	Until *condition* is met, do *Commands*. *condition* is usually specified with the test command.	Format: `until condition` `do` ` Commands` `done`	15
unzip	Uncompresses files created with the zip command.	`$ unzip bookfile.zip` `$ls` `chap1 chap2 chap3`	12

Command	Description	Example	Chapter Reference
uuencode	Used to convert a binary file into an ASCII-encoded representation that can be sent using e-mail. The encoded file is an ordinary ASCII text file.		3
vedit	Starts the vi editor with show mode turned on, which displays the current mode that you're in.		
vi	Invokes the visual text editor.	`vi filename`	9
vi editor Command Mode	Initial default mode for creating and editing files, positioning the cursor, and modifying existing text. All commands are initiated from this mode. Pressing Esc from either of the other modes will return you to command mode.		9
vi editor Entry/Input Mode	Used for entry of new text. Entering an insert command such as **i** (insert), **a** (append), and **o** (open new line) will take you from command mode to entry mode. Pressing Escape (Esc) returns you to command mode. Entry commands are entered by themselves without pressing the Enter key.	`-a, -i, -o, -A, -I, -O`	9
vi editor Last Line Mode	Used for saving your work and quitting vi. Type a colon (:) to get to this mode. Pressing the Enter key returns you to command mode.	`:w, :wq, ZZ, :q!, :wq!`	9

continues

Continued

Command	Description	Example	Chapter Reference
volcheck	volume check (volcheck). Instructs Solaris to check the floppy drive, determine the disk type (UNIX or PC), and temporarily places (mounts) the floppy disk under the /floppy directory of the hard drive.		7, 12
wc	Reads one or more input files and, by default, writes the number of lines, characters, words, and bytes contained in each input file to the standard output.	`$ wc dante` `33 223 1320 dante` `$ wc -l dante` `33 dante`	6
whatis	Looks up a given command and displays the header line from the manual section.	`$ whatis cd` `cd cd (1) - change` `working directory`	4
whereis	Displays the directory where a command is located so that the full path can be specified to execute the command.	`$ whereis traceroute` `traceroute: /usr/sbin/` `traceroute`	13
while	While *condition* is met, do *Commands*. *condition* is usually specified with the test command.	Format: `while condition` `do` ` Commands` `done`	15
who	Lists who is logged on to the system.	`-H, -q` `$ who` `user2 console Apr 30` `12:37 (:0)` `user2 pts/4 Apr 30 12:40` `(:0.0)` `$`	10
who am I	Displays the effective original username specified at login, not the current user you might have switched to.	`$ who am I` `user2 pts/4 Apr 30 12:40` `(:0.0)`	10

Command	Description	Example	Chapter Reference
xemacs	Starts the graphical version of the GNU emacs text editor.	`$ xemacs` `$ xemacs backup.sh`	9
zip	A compression utility designed to be compatible with the PC zip utility.	`$ zip bookfile chap*` `$ls` `book.zip`	12

vi Editor Quick Reference

The vi editor is a powerful command-line editor that has many commands. This appendix contains the basic commands that you must know, followed by additional commands that make working with vi easier and faster if you use the editor often.

To edit an existing file or create a new file, use either of the following commands:

```
vi filename
```

or

```
vedit filename (Solaris only)
```

Three Modes of vi

The three modes of the vi editor are as follows:

- **Entry/input**—Used to enter or input text
- **Command**—Used to move the cursor and modify text
- **Last line**—Used to save the file, quit vi, set editor preferences, and search for text

Basic vi Commands That You Must Know—Don't Leave Home Without Them

vi Command	Function
i	Inserts new text.
Esc	Puts you in command mode, where you can edit text and mover the cursor.
j (jump down)	Moves the cursor down one line (same as the down arrow).
k (kick up)	Moves the cursor up one line (same as the up arrow).

continues

Continued

NOTE

Press **Esc** to move from entry/insert mode to command mode. Command mode is the default mode when entering vi.

vi Command	Function
G	Goes to the last line in the file.
:n	Goes to line number *n*.
a	Appends text to the right of the cursor.
A	Appends text to the end of the current line.
o	Opens a new line below the cursor and leaves you in input mode.
x	Deletes the character that the cursor is on. (**3x** deletes three characters.)
u	Undoes the last operation.
dw	Deletes the word that the cursor is on. (**3dw** deletes three words.)
cw	Changes the word. Press **cw**, type the new word, and press Esc.
r	Replaces the current character with a new character.
dd	Deletes the current line. (**3dd** deletes three lines.)
dd then **p**	Deletes and pastes. Same as cut and paste.
yy then **p**	Yanks and pastes. Same as copy and paste.
/ *<search string>*	Searches for the search string specified. Press **N** to find the next occurrence.
Shift-ZZ or **:wq!**	Saves (writes) the file to disk and exits vi. Must use **:wq!** for admin files.
:q!	Quits vi without saving any changes.

Other vi Commands That Are Nice to Know

The following are additional vi commands categorized by command type that make working in vi easier.

Entry/Input Text Commands

These commands are used while you're in entry mode.

Command	Function
i	Inserts text to the left of the cursor
I	Inserts text at the beginning of a line

Command	Function
a	Appends text to the right of the cursor
A	Appends text at the end of a line
o	Opens a new line below the cursor
O	Inserts a new line above the cursor

Cursor-Movement Commands

These commands are used while you're in command mode.

Command	Function
Left arrow or **h**	Moves left
Right arrow or **l**	Moves right
$	Moves the cursor to the end of the line
0 (zero)	Moves the cursor to the beginning of the line
w	Moves the cursor to the beginning of the next word
b	Moves the cursor backward to the previous word

Save Commands

These commands are used during the saving process.

Command	Function
Shift-ZZ or **:x** or **:wq!**	Saves the file to disk and exits vi
:q!	Exits without saving changes
:w	Writes changes and saves what you have done so far

Other Handy Commands

These commands are used while you're in command mode.

Command	Function
U	Undoes all changes that you have made to the current line.
R	Replaces multiple characters from the current cursor location onward. This is like a word processor "type-over" mode.

Appendix D

e-Lab Activities Master List

This is a master listing of all interactive e-Lab Activities in the online curriculum to assist the student and instructor in planning classroom and study time effectively. The activity number and title are provided, as is a brief description of the activity, the estimated difficulty rating (1 = easy and 3 = more difficult), and the approximate time required to complete the activity. These activities are referenced in this textbook at the appropriate place where they should be performed. They are on the CD-ROM that accompanies this book.

Number	Title	Description	Difficulty	Estimated Time (Minutes)	Type
1.1	Server Functions and Protocols	In this activity, you identify protocols and services that provide key server functions.	2	5	Drag-and-Drop
2.1	Using the CDE Login Screen	In this activity you practice logging in and out of a UNIX system using the CDE Login Manager screen.	1	5	Activity
2.2	Using Command-Line Login	In this activity, you practice logging in and out from a UNIX system command-line environment.	2	5	Activity
2.3	Changing a Password	In this activity, you change the user login password using password rules discussed in this section.	1	5	Terminal

continues

Continued

Number	Title	Description	Difficulty	Estimated Time (Minutes)	Type
3.1	Terminal Window Shell	In this activity, you enter the UNIX date command to demonstrate how a command is entered from the command-line.	1	5	Terminal
5.1	Path Names Exercise	In this activity, you enter the absolute or relative path name for the directory or file indicated in the exercise.	1	10	Q&A
5.2	Using the **pwd** Command	In this activity, you type what you think the result of the **pwd** command would be, depending on the directory you are currently in.	1	5	Q&A
5.3	Using the **pwd** and **cd** Commands	In this activity you use the **pwd** and **cd** commands to move around the directory structure using absolute and relative path names as well as shortcuts.	2	10	Terminal
5.4	Using the **ls** Command	In this activity, you use the **ls** command with relative and absolute path names to locate subdirectories.	1	5	Terminal
5.5	Displaying Hidden Files	In this activity, you use the **ls -a** command to view the hidden files in your home directory.	1	5	Terminal/ Q&A

Number	Title	Description	Difficulty	Estimated Time (Minutes)	Type
5.6	Displaying File Types	In this activity, you use the **ls -F** command to display file types.	1	5	Terminal
5.7	Displaying a Long Listing	In this activity, you use the **ls -l** command to view a long listing of the files and directories.	1	5	Terminal/ Q&A
5.8	Using Meta-characters	In this activity, you use the **ls** command with metacharacters (asterisk, question mark, and brackets) to locate files.	2	10	Terminal
6.1	Using Control Characters	In this activity, you execute a UNIX utility called bc (basic calculator) from a Terminal window. You use the **Control-d** command to exit the utility.	1	5	Terminal
6.2	Using the **file** and **strings** Command	In this activity, you use the **file** and **strings** commands to find out information about files.	1	5	Terminal
6.3	Using **cat** and **more** Commands	In this activity, you use the **cat** and **more** commands to view the contents of files.	1	5	Terminal
6.4	Using **head** and **tail** Commands	In this activity, you use the **head** and **tail** commands to view specific lines at the beginning and end of files.	1	5	Terminal

continues

Continued

Number	Title	Description	Difficulty	Estimated Time (Minutes)	Type
6.5	Using the **wc** and **diff** Commands	In this activity, you use the **wc** command to count lines, words, and bytes in a file. The **diff** command is also be used to compare two files.	1	5	Terminal
6.6	Using the **mkdir** and **touch** Commands	In this activity, you use the **mkdir** command to create a new directory in the /home/user2/dir4 directory. You then switch to the new directory and create several new files using the **touch** command.	2	5	Terminal
6.7	Using the **rm** Command	In this activity, you use the **rm** command to remove a file from a subdirectory.	2	5	Terminal
6.8	Comparing File Manager to Command-Line	In this activity, you enter the command that accomplishes the same thing as each of the File Manager menu options listed.	1	5	Q&A
7.1	Copying Files	In this activity, you use the **cp** command copy a file to a new name and copy a file to another directory. You will also use the **cp -i** (interactive) option to copy a file.	3	10	Terminal

Number	Title	Description	Difficulty	Estimated Time (Minutes)	Type
7.2	Copying Directories	In this activity, you use the **cp -r** command to copy a directory to another name in the same directory and copy a directory to another location.	2	5	Terminal
7.3	Renaming and Moving Files	In this activity, you use the **mv** command to rename a file within a directory and then move a file to another directory.	2	10	Terminal
7.4	Renaming and Moving Directories	In this activity, you use the **mv** (move) command to rename a directory within the current directory and then move a directory to another directory.	2	10	Terminal
7.5	Input/ Output Redirection	In this activity, you redirect standard output to a file and then view the contents of the file with the **cat** command.	2	5	Terminal
7.6	Command Piping	In this activity, you pipe the directory listing output of the **ls** command to the more command. You also pipe a directory listing to the **wc** command to count the number of entries.	2	5	Terminal/ Q&A

continues

Continued

Number	Title	Description	Difficulty	Estimated Time (Minutes)	Type
8.1	Finding Files	In this activity, you locate files using the **find** command with several different search expressions.	3	10	Terminal
8.2	Using the **grep** Command	In this activity, you use the **grep** command by itself to search files for a string. You then use it in a pipeline with the **ls -l** command to find specific strings in the output.	2	10	Terminal
8.3	Using the **sort** Command	In this activity, you use the **sort** command with various options to sort the contents of a file.	2	5	Terminal
10.1	Security Policy Exercise	In this activity, you drag the security policy term on the left of the graphic to match the appropriate definition listed on the right.	2	5	Drag-and-Drop
10.2	Access Permissions	In this activity, you list the permissions for some files and directories. You then answer several questions regarding ownership and permissions.	2	5	Terminal/Q&A

Number	Title	Description	Difficulty	Estimated Time (Minutes)	Type
10.3	Changing Permissions (Symbolic)	In this activity, you use **ls -l** command to verify the current permissions of files. You then use the **chmod** command to change permissions using the symbolic mode.	2	10	Terminal
10.4	Octal Permission Conversion	In this activity, you practice converting file permissions into octal mode. The first 10 positions of the **ls-l** listing for a file are given and you must enter the correct 3-digit octal equivalent. Click **New Permission** to present a new set of permissions and then click **Check Answer** after you enter the octal value. Remember to strip off the file type in the first position.	1	5	Q&A
10.5	Changing Permissions (Octal)	In this activity, you use the **ls -l** command to verify the current permissions of files. You then use the **chmod** command to change permissions using the octal mode.	3	15	Terminal

continues

Continued

Number	Title	Description	Difficulty	Estimated Time (Minutes)	Type
10.6	Identifying Users	In this activity, you use the **who** command to identify users logged in to your system. You use the **who am I** command to display your real user ID (RUID) and then use the **su** command to switch to another user. Next, you will use the **id** command to see your new effective user ID (EUID).	1	5	Terminal
11.1	Using the **lp** Command	In this activity, you use the **lp** command with the destination (**-d**) and copy (**-c**) options to send print jobs to a default printer and a specified printer.	1	5	Terminal
11.2	Using the **lpstat** and **cancel** Commands	In this activity, you use the **lpstat** command to show the default and a specific print queue. You use it with the output (**-o**) option, which shows all printer queues, and with the **-t** option to see detailed information for all printers. You also use the **cancel** command to remove a print job from a queue.	2	10	Terminal

Number	Title	Description	Difficulty	Estimated Time (Minutes)	Type
12.1	Archiving Files with **tar**	In this activity, you work with the **tar** command with various functions and modifiers to archive multiple files as well as a subdirectory.	3	10	Terminal
12.2	Compressing and Uncompressing Files	In this activity, you work with the **compress** command to see how it reduces the size of a file. You also work with the **uncompress** command to restore the compressed file back to its original size.	2	5	Terminal
12.3	Extracting Files with **tar**	In this activity, you work with the **tar** command and various functions to extract previously archived files.	3	5	Terminal
12.4	Archiving and Compressing Files with **jar**	In this activity, you work with the **jar** command to simultaneously compress and archive a group of files. You then use it to extract those files.	2	5	Terminal
13.1	Displaying System Processes	In this activity, you use the **ps** command with the -**f** and -**e** options to display processes. You also pipe the output of the **ps** command to grep to search for specific processes.	1	5	Terminal

continues

Continued

Number	Title	Description	Difficulty	Estimated Time (Minutes)	Type
13.2	Terminating Processes	In this activity, you use the **ps** command with the **-u** option to find processes for a specific user and then use the **kill** command to terminate those processes.	2	5	Terminal
14.1	Using Korn and Bash Shell Aliases	In this activity, you use the **alias** command to create an interactive version of the **cp** command, which prompts when an overwrite will occur. You then remove the alias with the **unalias** command.	2	10	Terminal
14.2	Repeating Commands in the Korn and Bash Shells	In this activity, you use the **history** command and repetition options available with the Korn and Bash shells.	1	5	Terminal
14.3	Customizing a Korn Shell Prompt	In this activity, you will demonstrate your ability to customize your Terminal window prompt within your Korn shell environment.	3	10	Terminal
14.4	Customizing your C Shell Prompt	In this activity, you will demonstrate your ability to change the Terminal window prompt in a C shell window.	3	10	Terminal

Number	Title	Description	Difficulty	Estimated Time (Minutes)	Type
14.5	Customizing the Korn Shell	In this activity, you modify your .profile file to export the ENV variable file so that the next time you log in, your .kshrc file will be read and your environment will be customized.	3	10	Terminal
15.1	Creating a Simple Shell Script	In this activity, you create a simple shell script similar to the one in the prior example and then execute it.	2	10	Terminal
16.1	Using the **ping** Command	In this activity, you verify connectivity with an IP host by pinging it using its host name and its IP address.	1	5	Terminal
16.2	Using **telnet**	In this activity, you Telnet to a remote host, provide a user login, and then exit the Telnet session.	1	5	Terminal
16.3	Using **rlogin**	In this activity, you rlogin to a remote host, provide a user password, issue a command, and then exit the rlogin session.	1	5	Terminal
16.4	Using **ftp**	In this e-Lab activity, you connect to an FTP server as a client, log in as user2, and provide a password. You set the mode to binary, retrieve (get) a file from the remote host, and then exit the session.	1	5	Terminal

Appendix E

Hands-On Lab Listing

This appendix contains a brief description of the lab activities that are referenced throughout this book. These activities can be found in *Cisco Networking Academy Program: Fundamentals of UNIX Lab Companion*, Second Edition. The estimated difficulty rating is described as 1 being easy and 3 being the most difficult.

Lab Number	Title	Brief Description	Difficulty	Estimated Time (Minutes)
1.4.3	UNIX Computing Environment	This lab helps reinforce the UNIX computing environment terminology and concepts introduced in Chapter 1. You investigate the use of UNIX at your institution and research websites to see what organizations are using Solaris UNIX.	2	30
2.1.8	Accessing Your System	In this lab, you review the requirements for UNIX login IDs and passwords. You will practice logging in to a UNIX system using the CDE login screen. You will then change your password, exit or log out, and return to the CDE login screen.	2	30

continues

Continued

Lab Number	Title	Brief Description	Difficulty	Estimated Time (Minutes)
2.2.7	Becoming Familiar with CDE	In this lab, you work with the standard graphical user interface (GUI) for most commercial versions of UNIX known as Common Desktop Environment (CDE). You become familiar with the front panel and use the mouse and keyboard to manage windows. You also practice locking the display, moving between workspaces, and using the Workspace menu.	1	30
2.4.2	Customizing Your CDE Workspace	In this lab, you work with CDE Style Manager, Application Manager, subpanel menus, front panel, and the desktop to customize the workspace environment.	2	30
2.6.2	Exploring GNOME	In this lab, you become familiar with the GNOME desktop management environment. You use the Nautilus graphical shell to find their way around the system, and to customize GNOME according to your preferences. You also learn to use the menus and launchers in the panel, how to modify what is in the panel, and how to add panels of your own.	2	30
3.1.6	Using CDE Mail Tool	In this lab, you work with the CDE Mail Tool, also known as Mailer. Mail Tool is a full-featured graphical e-mail management program.	1	30

Lab Number	Title	Brief Description	Difficulty	Estimated Time (Minutes)
3.2.5	Using CDE Calendar Manager	In this lab, you work with CDE Calendar Manager. Calendar Manager is a full-featured graphical schedule and appointment management program.	1	30
3.3.7	Other Built-in CDE Applications	In this lab, you work with several additional user applications that are included with the Common Desktop Environment (CDE). These include: Voice and Text Notes, Address Manager, Calculator and Clock. You will learn how to open a Terminal window that will give you access to the UNIX command-line.	2	30
4.1.4	Using CDE Help	In this lab, you work with several Help functions built in to the CDE to assist you when performing CDE related tasks. You use the main CDE help viewer and search the Help index for help on specific topics. You also use the On Item help feature to discover what desktop icons are.	1	30
4.2.1	Referencing AnswerBook2 Help	In this lab, you work with Sun Solaris AnswerBook2 and become familiar with the various collections of available online manuals. The AnswerBook2 system enables you to use the Web browser to view online versions of many of the printed Solaris manuals, including the graphics.	1	30

continues

Continued

Lab Number	Title	Brief Description	Difficulty	Estimated Time (Minutes)
4.3.7	Using Command-Line Help	In this lab, you work with and access command-line help using the **man** command. The man pages are employed to determine the use of various UNIX commands as they work with the man pages and learn to navigate through them.	2	30
5.3.1	Basic Command-Line Syntax	In this lab, you work with various UNIX commands to develop an understanding of UNIX commands and syntax.	1	30
5.3.3	Navigating the File System	In this lab you work with the UNIX file system or directory tree, which has been set up for the class. You will learn how to determine your current location in the directory tree and how to change from one directory to another.	2	20
5.4.6	Listing Directory Information	In this lab, you use the **ls** command, which is used to determine the contents of a directory.	2	30
5.5.2	Directory Listings with Meta-characters	In this lab, you work with various metacharacters and use them with the **ls** command to refine your directory listings.	3	30

Lab Number	Title	Brief Description	Difficulty	Estimated Time (Minutes)
6.1.6	File Information Commands	In this lab, you work with various informational commands. These are important because they allow you to investigate and discover information about files. You use commands to help determine what type a file is and what application created it. You also work with several commands that let you see the contents of the text files and compare them.	2	30
6.1.10	Basic Command-Line File Management	In this lab, you work with file management commands from the command-line. The guidelines for file and directory naming, which are known as naming conventions, will be reviewed. You create a simple directory structure and then create some files in those directories. You practice creating and removing both files an directories.	2	30
6.2.6	Basic CDE File Manager	In this lab, you work with Common Desktop Environment (CDE) File Manager. The CDE method of file and directory management allows you to do many of the same tasks that were performed earlier at the command-line.	2	30
6.3.6	Basic GNOME File Manager	In this lab, you work with Nautilus and other GNOME file and directory management tools.	2	30

continues

Continued

Lab Number	Title	Brief Description	Difficulty	Estimated Time (Minutes)
7.1.2	Copying Files and Directories	In this lab, you perform more advanced file and directory management tasks using the command-line interface and the **cp** (copy) command.	3	45
7.1.5	Renaming and Moving Files and Directories	In this lab, you work with the versatile **mv** (move) command to rename and move files and directories.	3	45
7.1.7	Redirection and Piping	In this lab, you use advanced UNIX commands to accomplish redirection and piping. Every UNIX command has a source for standard input and a destination for standard output.	3	45
7.2.3	Advanced CDE File Manager	In this lab, you work with some of the more advanced features and functions of CDE File Manager. You perform additional file and directory management tasks, such as those that were performed earlier at the command-line.	2	30
8.5.2	Finding, Searching, and Sorting Files	In this lab, you use advanced UNIX commands to find files and specific strings contained in files. You practice using the **sort** command with various options. CDE File Manager also is used to locate files based on filename or file contents.	3	45

Lab Number	Title	Brief Description	Difficulty	Estimated Time (Minutes)
9.1.8	Using the vi Editor	In this lab, you use a UNIX text-editing tool: the vi editor. This text editor primarily is used for creating and modifying files that customize your work environment and for writing script files to automate tasks.	3	45
9.2.6	Using Emacs	In this lab, you go through an example Emacs editing session step by step.	3	45
9.3.6	Using the CDE Editor	In this lab, you work with the Common Desktop Environment (CDE) Text Editor.	2	30
10.2.4	Determining File System Permissions	In this lab, you become familiar with file system permissions. You display permissions on files and directories, interpret the results, and evaluate the effect on various user categories.	3	30
10.3.3	Changing Permissions from the Command Line	In this lab, you analyze and change UNIX file system security permissions using command-line utilities.	3	45
10.4.1	Changing Permissions with File Manager	In this lab, you work with the Common Desktop Environment (CDE) File Manager to analyze and make changes to file system permissions. The CDE File Manager utility provides a graphical interface to the file system and can be used to view or change file and folder permissions.	2	30

continues

Continued

Lab Number	Title	Brief Description	Difficulty	Estimated Time (Minutes)
10.5.3	User Identification Commands	In this lab, you use advanced UNIX commands to determine your identity and the identity of other users logged on to a system.	3	45
11.3.2	Command-Line Printing	In this lab, you work with UNIX printing commands to send jobs to printers and manage print queues.	2	30
11.4.3	Using CDE Print Manager	In this lab, you work with the Common Desktop Environment (CDE) Print Manager and File Manager to control your printing environment.	1	30
12.5.1	Command-Line Archive Tools	In this lab, you work with the tape archive (**tar**) and Java archive (**jar**) utilities to perform backups of data, as well as restore data from backups. You work with the UNIX file-compression utility. You also use the **tar** and **compress** commands to back up and restore your home directory.	3	45
12.6.3	CDE Archive Tools	In this lab, you work with the Common Desktop Environment (CDE) utilities to back up, compress, and restore files and folders. The Files subpanel on the front panel, in conjunction with File Manager, can be used to archive, compress, and restore files creating the same results as using the **tar**, **compress**, and **uncompress** commands.	2	20

Lab Number	Title	Brief Description	Difficulty	Estimated Time (Minutes)
13.3.2	Managing System Processes	In this lab, you work with UNIX commands to identify system processes and control them.	3	50
14.3.4	Korn and Bash Shell Features	In this lab, you work with the Korn and Bash shells to understand their features and capabilities.	2	45
14.4.5	Customizing the Korn and Bash Shell	In this lab, you work with UNIX initialization files. You will customize the Korn shell login environment and tailor various options to your needs.	3	45
15.2.8	Writing Shell Scripts	In this lab, you write, execute, and debug several shell scripts to practice everything covered in this chapter including variables, positional parameters, interactive input, and conditional and flow-control commands.	3	45
16.2.6	Using Networking Commands	In this lab, you work with UNIX and TCP/IP networking commands.	2	45

Appendix F

Website Resources

Additional Web Resources

The following Sun, Linux, and independent sites contain more information and helpful resources to assist in the installation and administration of UNIX systems.

Sun Microsystems Sites

- Sun Product Documentation site: http://docs.sun.com/
- Solaris for Intel OE site—This site contains product information, documentation, software patches, FAQs, and so on: www.sun.com/software/intel/
- Solaris OE download site: wwws.sun.com/software/solaris/get.html
- Solaris Freeware: www.sunfreeware.com/
- The Solaris Developers Connection (discussion forums): http://forum.sun.com
- Sun's BigAdmin site—Sun's one-stop location for system administrators: www.sun.com/bigadmin

Linux Sites

- Comprehensive site for Linux: www.linux.com
- Linux Online: www.linux.org
- The Linux Documentation Project site: www.linuxdoc.org

Independent Sites

- College Resource and Instructor Support Program (CRISP): http://snap.nlc.dcccd.edu/
- Solaris on Intel FAQ site: http://sun.drydog.com/faq
- Solaris for Intel information site: www.execpc.com/~keithp/bdlogsol.htm
- Solaris for Intel mailing list: www.egroups.com/group/solarisonintel
- UNIX and cross-platform software site: http://freshmeat.net

Appendix G

Summary of Chapter Changes—
From 1st Edition to 2nd Edition

Chapter 1: The UNIX Computing Environment
A number of changes and additions were made throughout this chapter to introduce Linux concepts and terminology.

Chapter 2: Accessing Your System and UNIX Graphical Interfaces
Some changes were made in the "Login ID and Password Requirements" section. Two new sections were added to cover the Linux GNOME and KDE graphical interfaces.

Chapter 3: Graphical User Applications
The chapter title changed to be more generic and accommodate other graphical applications such as those included with GNOME and KDE. A new section was added to cover GNOME and KDE built-in graphical applications.

Chapter 4: Getting Help
This chapter includes additions to the "Command-Line Help" section on man page headings. A new section on Linux HOWTOs and the **info** command has also been added.

Chapter 5: Accessing Files and Directories
This chapter includes additions to the "Listing Directory Contents" section for file type definitions and file type codes. The other sections of this chapter apply to most versions of UNIX, including Solaris and Linux.

Chapter 6: Basic Directory and File Management
This chapter includes a new section on management of directories and files using GNOME. The focus is on the use of the Nautilus file manager utility.

Chapter 7: Advanced Directory and File Management

This chapter adds to the "Copying Files" section information that describes the steps necessary to copy a file to a disk for Solaris and Linux. Some corrections to the I/O redirection section were made. A new section has also been added on advanced management of directories and files using GNOME.

Chapter 8: File Systems and File Utilities

This chapter provides additional general information on partitioning and file systems as well specific information on Linux partitions and file system statistics. The **egrep** and **fgrep** commands have been added to the section on searching for strings. A new section on file editing with **sed** has been added for searching and processing files. Another new section covers finding files using GNOME and KDE. Objectives and utilities related to user identification and switching users have been moved to Chapter 10.

Chapter 9: Using Text Editors

This chapter adds a new section on the use of the powerful and flexible Emacs editing tool. A new section on the use of the GNOME gedit application to create and edit text files is also included.

Chapter 10: File Security

New information pertaining to remote access control and security check tools has been added to the "Standard UNIX Security" section. This chapter includes a new section on changing permissions with graphical tools and the use of GNOME Nautilus to view and change file properties. Also, a section on identifying and switching users was moved to this chapter from Chapter 8.

Chapter 11: Printing

New information pertaining to Linux and LRPng has been added to the "lp and lpr Print Spooler" section. This chapter also includes a new section on using graphical printing tools and the use of GNOME Printer Applet.

Chapter 12: Backing Up and Restoring

This chapter includes a new section on accessing floppy disks and CD-ROM devices with Solaris and Linux. The Solaris volume management feature as well as formatting and mounting in both environments are discussed. Another new section has been added on backing up files with the cpio utility.

Chapter 13: System Processes

This chapter provides additional information on Solaris and Linux startup processes in the "System Process Overview" section. The Linux GNU long options variations of the **ps** command are introduced in the section "Identifying Processes to Terminate." Also, a new section has been added on the use of the crontab utility. In addition, the last section (on memory management), which covered virtual memory and swap files, was moved to Chapter 1 where these concepts were introduced.

Chapter 14: Shell Features and Environment Customization

A number of changes and additions were made throughout this chapter relating to Linux and the Bash shell. The basic content is a merger of first edition Chapters 14 and 15.

Chapter 15: Introduction to Shell Scripts

This is a new chapter that has been added to the course. It builds on the basic shell concepts and UNIX commands covered in previous chapters. It includes how to use the built-in programming language to create simple and complex shell scripts used to automate tasks. It is intended to replace the existing Chapter 15 in its entirety. The majority of the previous Chapter 15 was moved to the new Chapter 14.

Chapter 16: Network Concepts and Utilities

This chapter provides new information on network and remote access utilities such as traceroute and Secure Shell (SSH). The "Naming Services and Host Name Resolution" section includes expanded information on DNS, NIS, and NIS+. Also, the SMB/CIFS protocol has been added to the "Network Resource Sharing" section. The previous sections on network infrastructure concepts and network protocols have been removed from this chapter to avoid redundancy with other Cisco Networking Academy courses.

Chapter 17: Career Guidance

The major change to this chapter is the addition of information on Linux certification options. These include proprietary certifications such as Red Hat and the more generic Computer Technology Industry Association (CompTIA) Linux+ certification.

Appendix A, "Answers to Chapter 'Check Your Understanding' Quizzes," provides the answers to the "Check Your Understanding" questions that you find at the end of each chapter. Updated to include new questions and answers.

Appendix B, "Master Command List," provides an alphabetized list of commands used in this book. Updated to include new commands.

Appendix C, "vi Editor Quick Reference," provides a list of the most frequently used vi editor commands. No changes.

Appendix D (first edition), "Solaris for Intel Download and Installation Instructions." Omitted from second edition.

Appendix D, "e-Lab Activities Listing," lists all the activities on the accompanying CD-ROM. Updated to include new e-Labs.

Appendix E (first edition), "mailx," provides information on how to use the UNIX mailx command-line mail program. Omitted from second edition.

Appendix E, "Hands-On Lab Listing," provides an outline of the lab activities that are referenced throughout this book. Updated to include new labs. The full labs can be found in *Cisco Networking Academy Program: Fundamentals of UNIX Lab Companion.*

Appendix F, "Website Resources," provides recommended sites for further study.

Appendix G (new), "Summary of Chapter Changes—From 1st Edition to 2nd Edition," is new appendix that provides a brief overview of the differences, by chapter, between the first edition and second edition companion guides.

Glossary. The Glossary defines the terms and abbreviations used in this book.

Common UNIX System Files

.bash_logout Allows for customization after a Bash shell user logs out. Clears the screen and prints "Bye," for instance.

.bash_profile Bash shell initialization file read once at login. Typically contains one-time-only commands and variable definitions.

.bashrc Bash shell run control file is automatically read each time a new subshell is started. Typically contains aliases, turns on shell features, and sets the custom prompt.

.cshrc file C shell run control file. User-specific initialization file stored in the home directory that typically contains aliases, turns on shell features, and sets the custom prompt. Read for C shell users.

.dtprofile Desktop profile file. User-specific initialization file that resides in the user's home directory and determines settings for the CDE. This file is standard system-wide and is created in a user's home directory the first time that the user logs in to the CDE.

.kshrc file Korn shell run control file. User-specific initialization file stored in the home directory that typically contains aliases, turns on shell features, and sets the custom prompt. Read for Korn shell users.

.login User-specific initialization file stored in the home directory that contains one-time-only commands and variable definitions. Read for C shell users.

.logout file File available for C shell users that allows for customization after the user logs out. Clears the screen and prints "Bye," for example. Read for C shell users.

.profile file User-specific initialization file stored in the home directory that contains one-time-only commands and variable definitions. Read for both Bourne and Korn shell users.

/etc/group file File that contains user login names and any supplemental groups they belong to.

/etc/hosts file With /etc/hosts name resolution, each machine requires that a static /etc/hosts file be created to translate host names to IP addresses.

/etc/passwd file File that contains the master list of user information and is consulted each time someone attempts to access the system.

/etc/profile file The primary system-wide initialization file located in the /etc directory. The profile file is created by default when the operating system is installed, and it can be edited and customized by a system administrator. When a Bourne, Korn, or C shell user logs in, the system reads the /etc/profile file first.

absolute path name Specifies a file or directory in relation to the entire UNIX file hierarchy. The hierarchy begins at the / (root) directory. If a path name begins with a slash, it is an absolute path name.

Admintool Administration Tool, a Solaris system-administration utility run under the root account with a graphical interface that enables administrators to maintain system database files, printers, serial ports, user accounts, and hosts.

Anonymous FTP Anonymous File Transfer Protocol (FTP), a site that is set up for general use and does not require an account to obtain files. The word *anonymous* is the username, and the user's e-mail address is the password.

AnswerBook2 System that enables you to view an online version of the printed Solaris manuals, including graphics. Also known as AB2.

applet A small useful program.

Application Manager The Application Manager window contains six folders containing icons that can be added to a subpanel.

argument Used to specify how and on what the preceding command is to be performed.

ASCII file American Standard Code for Information Interchange. A file with normal printable characters and no special control or formatting characters. Commonly referred to as a text file.

ASET Automated Security Enhancement Tool. ASET is a Solaris utility that improves security by allowing system administrators to check system file settings including permissions, ownership, and file contents. ASET warns users about potential security problems. Where appropriate ASET sets the system file permissions automatically according to the specified security level, as either low, medium, or high.

authentication The ability to verify a person's identity.

background job number In the C shell or Korn shell, a job number is assigned to commands (jobs) executed in the background. Several commands are used to manage background jobs, including **jobs**, **stop**, **fg**, **bg**, and **kill**.

background process You can run a process in the background by adding an ampersand (**&**) to the end of the command line. Background processes run concurrently with other system processes and shell programs. You might want to run processes in the background because they are time-consuming (such as when sorting a large file or searching the file system for a file) or because you want to start a program and be able to continue interacting with the shell.

backup A copy of file system data that is stored separately from the disk drive on which the data resides.

banner page The first page of the print job that identifies who submitted the print request, the print request ID, and when the request was printed.

block device A hardware device file for devices that transfer data in blocks of more than one byte such as floppy disks, hard disks, and CD-ROMs.

Bourne shell The default shell for the Solaris computing environment. It does not have aliasing or history capabilities. The Bourne shell prompt is a dollar sign (**$**).

browser A graphical program that allows convenient access to the web. The first browser was Mosaic. Some browsers are Netscape Navigator, Microsoft Internet Explorer, and HotJava.

BSD Berkeley Software Distribution. One of two main versions of UNIX that is not an industry standard but is still fairly widely used. Some varieties of UNIX, such as Linux, are based on BSD.

C shell Based on the C programming language. Like the Korn shell, the C shell (/bin/ csh) has additional features such as aliasing and history. The C shell was developed by Sun's Bill Joy and is still widely used today. The C shell prompt is a percent sign (%).

Calendar Manager A full-featured graphical schedule and appointment-management program. It is a standard component of the Solaris CDE.

CDE Common Desktop Environment. A standard and consistent graphical user interface desktop developed by a consortium of UNIX platform vendors, including Hewlett-Packard, IBM, Novell, and Sun Microsystems, along with many other companies and members of the Open Software Foundation (OSF), X/Open, and the X Consortium. CDE is Motif-based.

character device A hardware device file for devices that transfer in units of 1 byte, such as a serial terminal or parallel printer.

child process A process spawned by another process. When a user is working in a Terminal window in CDE, that terminal's PID is the parent process ID (PPID) of any commands issued in the terminal.

client A machine that uses the services from one or more servers on a network. Your computer can be a printer client, an FTP client, and a Telnet client simultaneously.

client/server Computing model that distributes processing over multiple computers. This enables access to remote systems for the purpose of sharing information and network resources. In a client/server environment, the client and server share or distribute processing responsibilities. Computers on a network can be referred to as host, server, or client.

Command mode When using the vi editor, the command mode is the mode in which you can position the cursor and use edit commands to perform various actions. When you open a file with vi, you are in command mode. All commands are initiated from command mode.

compiled program A text file containing programming code that is read and converted to a form that can be directly executed by the CPU. C or Fortran programs are examples of compiled programs.

compression Removing redundant characters and space from a file to reduce its size. Programs such as zip, pkzip, and winzip, and the UNIX **compress** command can be used to compress files.

concatenate To join the output of one or more files or commands.

console The main input/output device that is used to access a system and display all system messages. This can be either a display monitor and keyboard or a shell window.

control character Character that performs specific tasks such as stopping and starting screen output and aborting processes. There are two control keys on most PC keyboards. They are normally labeled Ctrl and found in the lower-left and lower-right corners of the keyboard. On a Sun workstation, there is one control key in the lower left of the keyboard, labeled Control. When displayed on the screen, the Control key is represented by the caret (^) symbol.

CPU central processing unit. The brains of the computer that performs calculations and data manipulation. Usually a microchip, data moves from RAM to the CPU and back.

CSMA/CD carrier sense multiple access collision detect. Access method used by Ethernet to allow more than one user to share the network.

current working directory The directory where you are currently located in the directory tree structure.

daemon Programs or processes that perform a particular task or monitor disks and program execution. Daemons are special processes that begin after the OS loads. Daemons then wait for something to do in support of the OS. For instance, the lpsched daemon exists for the sole purpose of handling print jobs. When no printing is taking place on the system, the lpsched daemon is running but inactive. When a print job is submitted, this daemon becomes active until the job is finished.

data file A file created by a particular application, such as a word processor or database. These files must be opened with the application that created them.

debugging The process of tracing the execution of a program to see where it is failing.

default permissions The permissions that are assigned automatically when a new file or directory is created.

default printer Printer your print requests are sent if no other printer is specified.

delimiter A special character, often a slash or a space, used to separate one string of characters from another.

differential backup Backup method in which a full backup is done once a week and each day afterward, all changed data from the full backup is backed up again. The amount of data being backed up increases each day until the next full backup. Differential backup is a compromise because it takes less time than a full backup and is potentially easier to restore than an incremental backup.

directory A location for files and other directories. The UNIX file system or directory structure enables you to create files and directories that can be accessed through a hierarchy of directories.

distributed processing Enables the use of resources across the network. For instance, a user might be sitting at a workstation and be able to access files and applications on the hard disk of another computer or a printer located on a remote part of the network.

DNS Domain Name System. The name service provided by the Internet for TCP/IP networks. It was developed so that workstations and servers on the network could be identified with common names instead of Internet addresses. DNS performs resolution or translation of host name to Internet (IP) address between hosts within your local administrative domain and across domain boundaries.

domain The name assigned to a group of systems on a local network that share administrative files. The domain name is required for the network information service database to work properly.

domain name The company and type portion of an e-mail address such as jiml@company.com, where company.com is the domain name.

DOS An early single-user, single-tasking, character-based PC Disk Operating System developed by Microsoft and IBM.

drag and drop Process of copy and move files by moving or pushing around their icons using the mouse.

driver A piece of software written for a particular operating system to allow it to control a particular hardware device properly.

entry mode When using vi, the mode in which you can type text. To enter text, you must type a vi insert command such as **i**, **o**, or **a**. This takes vi out of command mode and puts it into entry mode. In this mode, text is not interpreted literally and becomes part of the document. When you finish entering text in your file, press the Esc key to return to command mode.

encryption The software encoding, or scrambling, of information using specific algorithms, usually a string of numbers known as public and private keys.

environment (global) variable Variables that are available to all shell sessions.

escape characters Special characters used with the echo command that informs the shell to do something. Must be preceded by a backslash (\). Example: echo Bill \t Joy would print Bill followed by a tab, followed by Joy.

Ethernet Popular LAN architecture or technology based on IEEE 802.3 standards. Used in most modern networks, Ethernet uses the CSMA/CD access method. It is a broadcast network, which means that all the workstations on the network receive all transmissions. Ethernet has evolved from speeds of 10 Mbps to 100 Mbps (Fast Ethernet) and now to 1000 Mbps (Gigabit Ethernet).

Ethernet address The physical address of an individual Ethernet controller board. It is called the hardware address or Media Access Control (MAC) address. The Ethernet address of every Sun workstation is unique and coded into a chip on the motherboard.

EUID effective user ID. If you switch to another user's ID, you will have all the same characteristics and permissions of the account that you switched to; this is now your EUID. The **id** command displays your EUID.

executable file A file that can be executed by the system. An executable may contain command text, as in the case of a shell script, or binary instructions. Examples of executables include applications and programs.

FAQs A collection of frequently asked questions about a variety of topics.

file A named collection of related data stored on a disk.

File Manager A graphical application used to manage files and directories. Can be accessed from the CDE front panel or by right-clicking the desktop. KDE's primary means of managing files is with Konqueror. GNOME's is with Nautilus that also enables users to browse the Internet.

file system To a user, a file system is a hierarchy of directories and files also referred to as the "directory tree." To the operating system, a file system is a structure created on a partition consisting of tables defining the locations of directories and files.

file-type code A one-letter character that identifies the file type. Appears in the first character position of a long listing. Examples include d for a directory, - (dash) for a data file, B for a block device file, and so on.

firewall A machine running special software to protect an internal network from attacks outside. Internal hosts connect to external networks and systems through the firewall. Can be configured with additional software to act as a proxy server.

foreground process The process that is currently in control of the cursor or mouse. Usually in the front window.

FTP File Transfer Protocol. A protocol for transferring files over TCP/IP networks.

front panel The primary graphical access area for CDE, which contains workspace buttons, pull-down/up menus, and other applications.

full backup Backup method in which all selected data is backed up daily, whether it has changed or not. This method takes the longest and might require multiple tapes, depending on the amount of data. It is the safest and easiest to restore.

Gaim An AOL Instant Messenger client.

gedit text editor A GNOME graphical editor that is comparable to the CDE Text Editor. The insertion, deletion, and editing of text is very similar.

GID group identifier. Contains the user's primary group membership number. This number relates to a group name that is used to determine group ownership of files that the user creates and access to files and directories.

GFTP A graphical FTP file transfer utility.

global variable Variables that are available to all shell sessions.

GNOME GNU Network Object Model. The latest windowing system to emerge in the UNIX world. GNOME is part of the GNU open source software project. GNOME has been developed as a free, easy-to-use desktop environment for the user and a powerful application framework for the software developer.

GNU Pronounced "ga-new." Means Gnu's Not UNIX. Mainly refers to the components of the OS have been added through the efforts of independent developers and the Free Software Foundation's GNU project (www.gnu.org). The GNU operating system uses the Linux kernel.

group Identifies the users associated with a file. A user group is a set of users who have access to a common set of files. User groups are defined in the /etc/group file and are granted the same sets of permissions.

GUI graphical user interface. An alternative to a command-line interface. A GUI enables users to use a mouse to access programs, run commands, and change configuration settings.

Help Manager The Primary CDE help tool for most situations, available from the front panel.

hidden files Files that have names beginning with a dot (.). Examples of a hidden file are .login and .profile.

hierarchy Structure with parent and child relationships that resembles an upside-down tree. The UNIX file system and UNIX system processes are examples of hierarchical structures.

Home directory The user's own directory, which is set up by the system administrator.

host A computer system on a UNIX network. Any UNIX (or other OS) computer running TCP/IP (workstation or server) is considered a host computer. The local host is the machine on which the user currently is working. A remote host is a system that is being accessed by a user from another system.

HOWTOs Online reference containing information and procedures on how to perform a task using the operating system. The Solaris HOWTOs are referred to as AnswerBook2. Linux HOWTOs are not installed by default in most Linux distributions.

HTTP Hypertext Transfer Protocol. A protocol used for transferring Web pages from a Web server to a Web browser.

I/O device (input/output) Peripheral devices provide a means to get data into and out of a computers. Input devices include a keyboard, a mouse, and a scanner; output devices include a printer and a monitor.

IDE/EIDE Intelligent Drive Electronics/Enhanced IDE. One of the two prominent drives types today. Used primarily in standard workstations and home computers. EIDE can support up to four devices (hard disk drives or CDs).

incremental backup Backup method in which data is backed up in increments. A full backup is performed once a week on a particular day (for example, Sunday evening). Each day after the full backup, only the changes (new and modified files) are backed up. An incremental backup takes the least amount time but is potentially more difficult to restore because it generally requires more tapes.

Internet The largest network in the world. It consists of a large national backbone network that contains the Military Network (MILNET), the National Science Foundation Network (NSFNET), the European Laboratory for Particle Physics (CREN), and a myriad of regional and local campus networks all over the world. To be able to log on to the Internet the user must have Internet Protocol (IP) connectivity; that is, the user must be capable of communicating with other systems by using **telnet** or **ping**. (Networks with only e-mail connectivity are not classified as being on the Internet.)

IMAP Internet Messaging Access Protocol. A protocol for exchanging mail messages. The recipient initiates an IMAP session. IMAP differs from POP in that IMAP allows the recipient to leave messages in organized folders on the server; POP requires that the recipient download the messages to organize them.

ISP Internet service provider. A company that provides Internet access and other related services for a fee.

KDE K Desktop Environment. A Windows-like GUI popular in Linux, similar in function to GNOME.

kernel The master program (core) of the UNIX operating system. It manages devices, memory, swap, processes, and daemons. The kernel also controls the functions between the system programs and the system hardware.

Konqueror A web browser that comes with KDE.

Korn shell A superset of the Bourne shell. The Korn shell (/bin/ksh) has many of the Bourne shell features, plus added features such as aliasing and history. This is the most widely used shell and is the industry standard for system users. The Korn shell prompt is also a dollar sign (**$**).

LAN local-area network. Made up of groups of computers (nodes) that have simultaneous access to common high-bandwidth media.

last-line mode When using the vi editor, the mode in which you can type advanced editing commands and perform searches. This mode is entered in a variety of ways (most commonly with a colon, a slash, or a question mark), all of which place you at the bottom of the screen.

linking The **ln** command is used to give a file an additional name so that you can access it from more than one directory (in the same or different file system) or by another name in the same directory.

Linux An open-source version of UNIX that is becoming increasingly popular and runs on different CPUs.

Linux Documentation Project A valuable online source of documentation about Linux. Can be found on the Internet at www.tldp.org.

local (shell) variable Variables available only for the current shell session.

logical device name Used by system administrators or users to access the disk (partitions) and tape devices for such tasks as mounting and backing up file systems. Logical device names are stored in the /dev directory in subdirectories. All logical device names are symbolic links to the physical device names in the /devices directory.

Login ID Username or ID used to access a UNIX computer.

Mail Tool A full-featured graphical e-mail–management program. It is an e-mail client that is a standard component of the Solaris CDE.

mailx The mailx (and the earlier, more basic mail) program comes with every version of UNIX and is an acceptable program for reading and sending mail.

man pages Pages describing what you need to know about the system's online commands, system calls, file formats, and system maintenance. The online man pages are part of all versions of UNIX and are installed by default. Man pages are in the form of simple character-based screen displays and are not graphical. The **man** command is used to access man pages.

media Various types of storage media for data, including magnetic tape, fixed and removable magnetic disks, and recordable optical media such as CD-R and CD-RW.

metacharacters Keyboard characters with special meaning to the shell. A general definition of a metacharacter is any keyboard character that is not alphanumeric. Metacharacters are used with many UNIX commands to provide greater flexibility. Some of the metacharacters used with UNIX are similar in function to those used with DOS. The asterisk (*) and the question mark (?) are metacharacters that also are known as wildcards and are used to work with groups of files efficiently.

mode The permissions that currently are set for a file or directory. The mode can be changed using the **chmod** command.

Mozilla An open-source web browser that is the default browser for GNOME.

mounting The manual or automatic process of attaching a file system or device (floppy disk, CD-ROM, and so on) to a mount point so that it can be accessed.

mount point An empty directory in a file hierarchy at which a mounted file system or device (floppy disk, CD-ROM, and so on) is logically attached. The mount command logically attaches a file system, either local or remote, to the file system hierarchy.

multitasking A feature of the UNIX computing environment and UNIX that enables more than one tool or application to be used at a time. Multitasking enables the kernel to keep track of several processes simultaneously.

multiuser A feature of UNIX that enables more than one user to access the same system resources.

Nautilus File manager for GNOME.

name service Provides a means of identifying and locating resources (traditionally host names and IP addresses) available to a network. The default name service product available in the Solaris environment is NIS+.

named pipe Pipes are special files used for interprocess communication. One process opens the pipe for reading, and the other opens it for writing, allowing data to be transferred. An example is the transfer of data to and from a disk.

namespace A collection of machines using a network information service such as Domain Name Service (DNS), NIS, or NIS+, all sharing a common name.

NFS Network File System. Sun's distributed computing file system. It is a network service that allows users to transparently access files and directories located on another disk on the network. NFS has become adopted as the industry-standard networked file system for most UNIX vendors.

NIC network interface card. Allows computers to communicate with each other via a central hub device using a cabled or wireless connection.

NIS Network Information Service. Focuses on making network administration more manageable by providing centralized control over a variety of network information. NIS stores information about workstation names and IP addresses, users, the network itself, and network services. This collection of network information is referred to as the NIS namespace.

NIS+ Enables you to store information about workstation addresses, security information, mail information, Ethernet interfaces, and network services in central locations where all workstations on a network can have access to it. This configuration of network information is referred to as the NIS+ namespace.

NOS network operating system. Group of programs that runs on servers and provides access to network resources for users.

octal (absolute) mode Method of setting permissions that uses numbers to represent file permissions and that is used to set permissions for all three categories of users at the same time. Octal mode also is referred to as absolute or numeric mode.

ONC Open Network Computing protocols. A family of published networking protocols and distributed services that enable remote resource sharing, among other things.

open-source software Software that can be modified and redistributed without a fee or restrictions.

Open Windows Sun's original graphical user interface developed for the Solaris environment. It is similar to CDE but is proprietary and not as well supported. The user has a choice when logging in to a Solaris workstation to select either CDE or Open Windows.

orphan process If a command is issued in a Terminal window and the window is closed before the command returns output, that process becomes an orphan.

OSI model Open Systems Interconnection. Developed by the International Organization for Standardization (ISO) to describe the functions that occur as two nodes on a network communicate. OSI is an internationally recognized, structured, and standardized architecture for network design. The seven-layer OSI reference model, or just OSI model, is one of the

most useful tools we have for analyzing and comparing various technologies and networking products from different vendors.

overwrite If a file is copied and the target name already exists, you will overwrite or "clobber" the file and will not receive a warning. The -**I** (interactive) option can be used with the **cp** and the **mv** commands so that the user is warned when a file is about to be overwritten.

owner The user who creates a file or directory. A different user can be made the owner of a file or directory using the **chown** (change ownership) command.

paging The process of moving memory pages between physical memory and the swap space on the disk.

parent directory A directory that contains other directories. For example, the /usr directory is the parent directory of /usr/bin.

parent process A process that spawns another process. Following system bootup, a process called the init daemon is invoked. Every process except init has a parent process.

partition A smaller division or portion of a hard drive. UNIX hard drives can be divided into as many as eight partitions, or slices. Each partition is treated by the operating system as a logical, independent drive, similar to a drive letter in the PC world or a volume with Novell NetWare.

password aging Can be used to force users to change their password at regular intervals.

peripheral components Components independent of the CPU, RAM, and mass storage. Some of the more common peripherals are keyboard, printer, audio, and video components.

permission category Category or class of users: The user (owner) is the user who created or owns the file or directory. The group is a group of users defined by the system administrator. Other (public) refers to all other users (other than the user or group).

permissions Attributes of a file or directory that specify who has read, write, or execute access.

physical memory All computers have physical, or system, memory microchips. This is most often referred to as random-access memory (RAM). This memory is controlled directly by the processor in conjunction with the memory management unit (MMU).

PID process identification number. Each program run on a UNIX system creates a process, which is assigned a unique PID. The PID is used by the system to identify and track the process

until it has completed. Most processes also have a parent process identifier or PPID that identifies the process that spawned them.

Pine Mail program that is menu-based and easier to use than the mailx program. Pine was developed at the University of Washington and can be accessed by typing **pine** at the command prompt.

piping The process of using the output of one command as input to the next command.

POP3 Post Office Protocol. A mail server protocol in which the recipient initiates transfer of messages. Differs from IMAP in that POP doesn't provide any means for the recipient to organize and store messages on the server.

positional parameters Special built-in shell variables that can provide the name of the script file or arguments to the script as it executes. Their values are taken from arguments on the command line. Positional parameters are referenced in a script as $1, $2, $3, and so on (up to $9), where $1 represents the first argument on the command line, $2 represents the second argument, and so on. Three other special variables are $0, which represents the command or the name of the script, $*, which represents all arguments entered on the command line, and $#, which represents the number of arguments on the command line.

PostScript A programming language used on may high-end printers. PostScript is optimized for displaying text and graphics on the printed page.

primary group Each user must belong to a primary group. A user's primary group is determined by the system administrator at the time the user account is created; it is stored in the /etc/password file.

print job number In the lp system, a number that is automatically assigned to each print request, known as a job.

Print Manager A graphical tool for managing print queues. It performs many of the same functions as the **lpstat** command. To activate Print Manager, click the Printer icon on the front panel.

printer A physical printing device. The printer can be attached to a workstation or network server or can contain a network interface card (NIC) and be directly attached to the network.

printer name The name of a print queue associated with the physical printer. It is a logical name for the printer, which is assigned by the system administrator. This is the name that the users print to.

printer queue A directory located on the hard disks of the print server. Print requests or print jobs are stored on the hard disk until they are printed; then they are deleted or purged.

printer server The computer that manages incoming print requests and releases them as the printer is ready. Print servers run the printer daemon lpsched, which manages print requests. A print server can be a workstation or a network server.

process A unit of work or task on a UNIX system that is managed by the kernel. Each process is assigned CPU time, RAM, and a process ID (PID) until it completes.

process scheduling The capability to run a process at a predetermined time. The **at** command and the **crontab** command can be used to schedule UNIX jobs or processes.

PROM programmable read-only memory. A chip containing permanent, nonvolatile memory and a limited set of commands used to test the system and start the boot process.

protocol A formal description of a set of rules and conventions that govern how devices on a network exchange information. The Transmission Control Protocol (TCP) is the protocol of most networks and the Internet today.

proxy server A server on the network that stands in for remote servers. Proxy servers provide security and access control.

RAID 1 Redundant Array of Independent Disks–Level 1. RAID 1, or mirroring, uses two drives, with the second drive storing the same data as the first. If one of the drives fails, the other takes over. A more robust version of RAID 1 that uses dual drive controllers as well as dual drives is known as duplexing.

RAID 5 Redundant Array of Independent Disks–Level 5. Combines three or more drives as a group so that if one fails, the others take over. The bad drive can be replaced with no loss of service to the users.

RAM random-access memory. The microchips that make up the real memory of a computer. RAM is the working storage area of the computer where programs (sequence of instructions) and data related to the programs are stored while the program is running. When a program is running, it is copied off the hard disk into RAM, and space is allocated in RAM for the program to do its work.

recursive To do repetitively. The **cp -r** (recursive) command can be used to copy a directory and all its contents to a new directory in the current directory. You must use the –**r** option when copying directories.

redirection The process of taking the standard output from a command and directing it to another location such as a file. If not redirected, the output normally goes to the screen.

relative path name Describes the location of a file or directory as it relates to the current directory (the directory you are currently in). If a path name does not begin with a slash, it is a relative path name.

restore To bring data back from tape or other backup media and replace the corrupted or lost data on the disk.

root The username of the superuser account on a UNIX system. The superuser is a privileged user with total system access. The terms *superuser* and *root* have the same meaning and are used interchangeably.

root directory The top of the UNIX directory system. All other directories are subdirectories of the root (/) directory.

router A device that moves data between different network segments and can look into a packet header to determine the best path for the packet to travel. Routers can connect network segments that use different protocols. They also allow all users in a network to share a single connection to the Internet or a WAN.

RUID real user ID. The login ID that you use to initially log in to a UNIX system is your RUID. The **who am I** command shows your RUID.

Samba An open-source version of SMB that comes with most Linux distributions and provides both client and server applications allowing for the sharing of files and printers. Commercial versions of Samba are also available for Solaris and other UNIX varieties.

SATAN Security Administrators Tool for Analyzing Networks. SATAN scans ports on computers in a network to probe for points of vulnerability and reports them.

SCSI Small Computer Systems Interface. One of the two prominent drive types today. It is used primarily in high-end workstations and servers, and it can support up to 15 devices (hard disk drives, CDs, tape drives).

secondary group Each user also can belong to between 8 and 16 secondary groups (depending on the version of UNIX) stored in the /etc/groups file.

server Provides resources to one or more clients by means of a network. Servers provide services in an UNIX environment by running daemons. Examples of daemons include Printer, FTP, and Telnet.

service A process that provides a service such as remote file access, remote login capability, or electronic mail transfer.

shared Ethernet The original version of Ethernet using a linear bus and (more recently) hubs in which only one node could have a packet on the network at a time. Shared Ethernet uses half-duplex technology, in which a workstation can be transmitting or receiving but cannot do both at the same time. It is prone to collisions and performance degradation due to excessive traffic.

shell An interface between the user and the kernel. It acts as an interpreter or translator. The shell accepts commands issued by the user, interprets what the user types, and requests execution of the programs specified. Execution is performed by the kernel.

shell script A text file that contains a sequence of commands for the shell to execute one line at a time. Complex tasks involving variables and other programming functions are accomplished using shell scripts.

signals Currently, 30 to 40 signals are defined in UNIX, depending on the implementation. Each signal is associated with a number and a name. Signals are used to terminate, suspend, and continue processes. The **kill -9** command uses a signal 9 to terminate a shell.

slice A logical subdivision of a physical disk drive. It is treated as an individual device.

SMB Server Message Block (SMB). Computers running one of the Microsoft operating systems such as Windows 9x, NT, 2000, or XP use the SMB protocol for sharing files and printers on a network. SMB performs a similar function for Microsoft clients as NFS does for UNIX clients or Netware Core Protocol (NCP) does for Novell Clients. The SMB/CIFS protocol also provides for sharing of files and printers between Microsoft and UNIX systems.

SMTP Simple Mail Transfer Protocol. The TCP/IP protocol used to transfer e-mail across the Internet. SMTP communicates with the SMTP server at the other end and directly delivers the message. Sendmail is the most common implementation of SMTP.

socket Similar to a named pipe (see named pipe) but permits network and bidirectional links.

SPARC Scalable Processor Architecture. Sun Microsystems' proprietary CPU chip designed strictly for Sun's line of workstations and servers.

spawn A process can start or spawn a subprocess, thus creating a process hierarchy or tree similar to the file system structure with parent/child relationships.

spool To place items in a queue, each waiting its turn for some action, such as printing.

SSH Secure Shell. A suite comprised of four utilities. Three of these provide support for the SSH client: ssh (replaces rsh, rlogin and telnet), scp (replaces rcp), sftp (replaces ftp).

StarOffice Microsoft Office-compatible office suite software from Sun Microsystems that comes free with most Linux distributions.

star topology The most common topology, and the one used with Ethernet hubs and switches. The hub or switch is the center of the star, and cables radiate out to nodes like spokes on a wheel. If more than one hub or switch is interconnected, it becomes an extended star topology.

stderr Standard error. Any output that normally would result from an error in the execution of a command. Stderr normally goes to the screen.

stdin Standard input. Usually provided by the computer's keyboard but can come from a file.

stdout Standard output. The results of issuing a command. Stdout usually goes to the computer screen or monitor, but can go to a file.

string One or more characters; it can be a character (alphabetic or numeric), a word, or a sentence. A string can include whitespace or punctuation if enclosed in quotation marks.

Style Manager A component of CDE that enables you to customize each of your workspaces by changing things such as colors, fonts, screen savers, mouse settings, and keyboard settings.

subdirectory Any directory below another directory. For example, the /usr directory is a subdirectory of the root (/) directory.

subpanel Pull-up or drop-down menus on the CDE front panel that provide access to many desktop applications. You can add or remove icons or applications with subpanels.

superuser A user that can access the root account is called the superuser. The superuser account runs system administration commands and edits critical system files such as the /etc/passwd file. Individuals with root access often are referred to as system administrators. The terms *superuser* and *root* have the same meaning and are used interchangeably.

SVR4 System Five Release Four. One of the two main versions of UNIX. There are currently a number of varieties or flavors of UNIX, and most are similar because they are based on the industry-standard SVR4. System V is a version of the UNIX operating system developed by AT&T. Sun Solaris SunOS is based on SVR4.

swap space A reserved part of the hard disk for the kernel to use during processing. Portions of running programs can be swapped out to the hard disk and then brought back in later, if needed. This swap space is actually on the hard disk, but it looks like additional memory or RAM and is sometimes called virtual memory. Swap space is a raw slice or disk file that is set aside during system installation for the purpose of paging programs out to disk temporarily while they are not being used.

symbolic (relative) mode Method of setting permission that uses combinations of letters and symbols to add or remove permissions for selected categories of users. Symbolic mode also is referred to as relative mode.

symbolic link A mechanism that allows several filenames to refer to a single file on disk. Symbolic (soft) links are pointer files that name another file elsewhere in the file system. Symbolic links might span physical devices because they point to a UNIX path name and not to an actual disk location. Some UNIX directories are symbolically linked to other directories for backward compatibility purposes.

tape drive Common backup device used primarily on high-end workstations and servers.

TCP/IP Transmission Control Protocol/Internet Protocol. The Defense Advance Research Projects Agency (DARPA) originally developed TCP/IP to interconnect defense department computer networks across the country to form a fault-tolerant network. It was adopted and further developed as the standard networking communications component of the UNIX operating system.

Telnet A way to access a UNIX system remotely. To Telnet to another system, you must specify its IP address or host name.

terabyte Approximately 1 trillion bytes or 1 billion kilobytes.

Terminal window A graphical window that can be opened within CDE for access to the command line and UNIX commands. Multiple Terminal windows can be opened simultaneously. Terminal windows support scrolling and cut/copy/paste.

Text Editor (CDE) Full-screen graphical text editor that supports a mouse and can be used to edit files. It is similar to the Windows Notepad. As with vi, this editor does not put any special formatting characters into the file and is suitable for creating system environment and script files.

text file A file that is made up of standard ASCII characters and no special formatting characters. Script files are text files.

topology The layout or arrangement of network components. Some architectures support more than one topology. Examples of topologies include a bus, a star, a ring, and a mesh.

trash can A temporary holding place for files that are deleted. Files can be placed in the trash can. They can then be permanently deleted by shredding them, be put back, or undeleted.

UID user identifier. Contains the unique user identification number assigned by the system administrator. This number relates to the username and is used to determine ownership of files that the user creates and access to files and directories. The UID of the root user account is 0.

umask The system setting that determines what the default permissions will be for newly created files and directories. The umask can be changed using the **umask** command.

UNIX Multiuser, multitasking network operating system used by several major computer manufacturers.

username The login name of a UNIX user that is part of the user's e-mail address, such as jiml@company.com, where jiml is the username.

variable A placeholder for information required by processes so that they can function properly. A variable has a name and holds a value. Changing the value of a variable is called *setting* the variable. There are two types of variables used in shell scripts: shell variables and environment variables.

vedit Starts the vi editor with showmode turned on, which displays the current mode (entry or input) that you're in.

vi visual display. An interactive editor that is used to create or modify American Code for Information Interchange (ASCII) text files. It is a character-based editor that is an integral part of all UNIX operating systems. The vi editor uses a screen display, but you cannot use the mouse to position the cursor.

virtual desktop A separate workspace that has its own background and look used to organize your applications. CDE, KDE, and GNOME all support the use of multiple virtual desktops.

virtual memory The swapping process uses swap space on the disk, which is limited. The combination of RAM plus swap space constitutes virtual memory, which is the maximum space that processes can use.

Volume Management Solaris feature that provides users with a standard method of handling data on floppy disks and CD-ROMs. This management feature gives users access to these types of devices automatically without having to become a superuser and mounting them.

WAN wide-area network. Connections between multiple LANs in different geographical locations.

workspace When you log into a CDE session, four workspaces are available to you by default. Each workspace is equivalent to a desktop environment.

X Terminal Allows a user simultaneous access to several different applications and resources in a multivendor environment through implementation of X Windows.

X Windows Distributed, network-transparent, device-independent, multitasking windowing and graphics system originally developed by MIT for communication between X Terminals and UNIX workstations.

zombie process Occasionally, a child process does not return to the parent process with its output. This process becomes "lost" in the system.

Index

Solaris™ 9 Operating System

Resources for Developers, System Administrators, and Educators

Welcome to Solaris!

Sun makes it easy for developers, systems administrators, and students to get started with the Free Solaris™ Binary License Program. Now you can use the Solaris 9 Operating System at home, work, or school without paying a license fee. You can use Solaris on an unlimited number of computers with a capacity of eight or fewer CPUs. Free downloads are available (you must have a fast Internet connection, such as DSL or a cable modem, and the ability to create CDs) or you might want to purchase a Solaris Media Kit. Both the SPARC™ and Intel® platform edition is available for $50 (Slim Kit) or $95 (full System Administrator kit) and includes the StarOffice suite of office-productivity tools, Netscape browser, Forte tools, Java, and dozens of other freeware tools. To view a list of Media Kit contents go to **wwws.sun.com/software/solaris/binaries/package.html**. To download or order a Media Kit go to **wwws.sun.com/software/solaris/get.html**.

Useful Sites

Solaris 9 Operating System (www.sun.com/solaris)—Learn everything you need to know about the Solaris platform, with links to datasheets, white papers, guided tours, press releases, family comparison chart, customer success stories, documentation, and more.

Sun Open Net Environment (Sun ONE) (www.sun.com/sunone)—Find out about the Sun ONE framework for developing web services based on the Solaris platform.

Free Solaris 9 Binary License Program (www.sun.com/solaris/binaries)—Download Solaris binaries here. Or for the cost of media and shipping, order the Solaris 9 Media Kit (SPARC or Intel Platform Edition).

Solaris 9 Operating System (Intel Architecture Edition) (www.sun.com/intel)—Links to information and resources including hardware compatibility lists, drivers, FAQs, support, forums, and documentation for the Intel platform.

User Communities

BigAdmin™ Portal (www.sun.com/bigadmin)—Sun's one-stop location for system administrators. Tap into the community through discussion forums, newsgroups, scripts, and FAQs. Plus, find up-to-date information on software updates, patches, downloads, and services.

Solaris Developer Connection™ Program (http://soldc.sun.com)—Free community forums, technical articles, certification programs, and much more.

Solaris™ 9 Operating System

Resources for Developers, System Administrators, and Educators

Java Developer Connection™ Program (http://developer.java.sun.com/developer)—
A central place for developers to learn about the latest Java™ technologies. Access
to downloads, tutorials, technical articles, book excerpts, and more.

Support

Support, Training, and Consulting Services (www.sun.com/service)—Links to the online
service center as well as complete information about Sun's wide range of consulting,
training, and support programs.

Sun SupportForum™ Site (http://supportforum.sun.com)—Free support through user
discussion forums, documentation, and downloads, as well as links to valuable resources
and tools.

U.S. Sun Store—http://store.sun.com